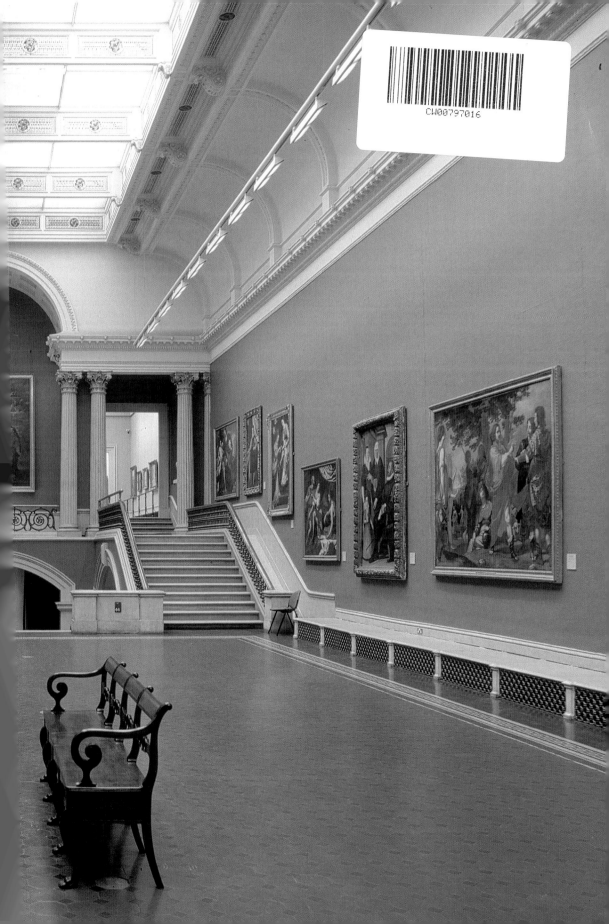

1854-2004 THE STORY OF THE NATIONAL GALLERY OF IRELAND

1854-2004 THE STORY OF THE
NATIONAL GALLERY OF IRELAND

PETER SOMERVILLE-LARGE

Commissioned by the Board of Governors and
Guardians of the National Gallery of Ireland to
mark the 150th anniversary of its founding by
Act of Parliament in 1854

Published by the National Gallery of Ireland
2004

Peter Somerville-Large has asserted his right to
be identified as the author of this work.

ISBN 1-904288-08-1

Edited by Elizabeth Mayes
Additional research, picture captions and index
by Adrian Le Harivel
Gallery photography by Roy Hewson, assisted
by Chris O'Toole

Design by Jason Ellams
Typeset in Trajan (headings) and Spectrum
Printed in Belgium by Die Keure

Research funded by the Jesuit Fellowship

FRONTISPIECE: Upper room of Dargan Wing
with Irish paintings, around 1930, including
works by Murphy, Brennan, Orpen, Osborne,
Haverty and Yeats (NGI Archive).

IN MEMORY OF THREE FRIENDS:
GILES GORDON
JOHN KEVENY
ADRIAN PHILLIPS

Editorial Notes

For ease of usage, artists and titles are referred to in their present form, with additional information about changes of name and subject where appropriate. 'Attributed to' an artist is used in scholarly sense of there still remaining some doubt over authorship.

Much of the information in this book derives from the NGI Archive. This consists of dossiers for letters etc. related to specific artworks (Curatorial department); Minute Books of Board Meetings, the Register and Manuscript Catalogues (used until the 1980s) and administrative material (Library), Yeats family material (Yeats Archive) and some items transferred to the Centre for the Study of Irish Art (Millennium Wing).

The *Letter Books* are a compilation of letters charting the founding of the Gallery and construction of the first building.

The *Damp Press Books* are carbon copies of outgoing correspondence from the early years.

PRICES FOR ART WORKS

Until 1979, the Irish pound (or punt – Ir£) was the same value as the pound sterling (Stg£). Shillings (s.) and pence (d.) were in use until decimalisation was introduced in 1971. A guinea was £1. 1s. The Irish currency was replaced by the euro (€) on 1 January 2002.

In the modern numbering system, blocks of numbers are allocated for different media:

1-1999 are for paintings
2000-3999 for drawings, watercolours and miniatures
4000-5999 for more paintings (partly used)
6000-7999 for more drawings, watercolours and miniatures
8000-9999 for sculpture (partly used)
10000-11999 for prints
12000-13999 for decorative arts and furniture (partly used)
14000-15999 for loans (partly used)
16000-17999 for future paintings
18000-19999 for more drawings, watercolours and miniatures (partly used)
20000-21999 for more prints (partly used)

ABBREVIATIONS

BATU	Building and Allied Trades Union
DNB	Dictionary of National Biography
FNCI	Friends of the National Collections of Ireland
NGI	National Gallery of Ireland
NLI	National Library of Ireland
OPW	Office of Public Works
RA	Royal Academy
RDS	Royal Dublin Society
RHA	Royal Hibernian Academy
RIC	Royal Irish Constabulary
TCD	Trinity College Dublin
UCD	University College Dublin

CONTENTS

FOREWORD

A hundred and fifty years ago the National Gallery of Ireland was established by an Act of Parliament. Ten years later, when it first opened, a hundred and thirty paintings hung on its walls. Today there are over 2,500 paintings and oil sketches, around 8,500 drawings, watercolours and prints, 350 sculptures, 12 stained glass panels, a tapestry, *objets d'art* and furnishings. Although the NGI does not begin to compete with the great galleries of Europe, it has succeeded, with few resources, in assembling a collection of particular individual merit.

Poverty, misfortune, good luck, moments of great generosity, drama, courage, cowardice, and the idiosyncratic foresight and taste of twelve Directors have contributed to this history. The names of the great benefactors must be mentioned – Dargan, Brady, Milltown, Lane, Chester Beatty, Shaw, Sweeney, Beit, and, not least, the Society of Jesus. We have been fortunate.

For a century and a half a rolling selection of seventeen Governors and Guardians have worked with the Directors. They are still created in the old way, ten appointed and seven *ex-officio* members from the same sources that were named in the original Parliamentary Bill. Without salary or gain to themselves, they continue to influence the Gallery's fortunes. Some guided their Directors, some gave them free rein, others fought bitterly with them. For decades the Governors and Guardians were a conservative and cautious group, and, following the taste of their times, suspicious of anything resembling modern art. The presidents of bodies like the Royal Hibernian Academy and the Royal Dublin Society were not going to gamble with paintings that might be considered subversive. For too long the chief problems they and their Directors faced were lack of money and indifference from various governments and the public. A large part of the story details the changes that have transformed the NGI in recent years. Today, as at no time in its history, has it been more popular and its facilities more advanced.

I have been familiar with the Gallery for a long time. I can remember when there was glass on the paintings and Thomas MacGreevy, red ribbon in his buttonhole, would walk through the empty rooms to inspect his beloved Poussins. Writing this history has given me great pleasure and I would like to thank in particular the current Board of Governors and Guardians for giving me the commission and allowing me access to the Gallery archives.

The Director, Raymond Keaveney, has been sympathetic and helpful. Others whom I wish to thank are Bruce Arnold, Sergio Benedetti, Síghle Bhreathnach-Lynch, Marie Bourke, Geoffrey and Elizabeth Cope, Fionnuala Croke, Desmond Fitzgerald, Peter Gahan, Geraldine Hone, Anne Kelly, Adrian Le Harivel (especially), Marie McFeely, Andrew O'Connor, Eunan O'Halpin, Mick O'Shea, Hilary Pyle, Brendan Rooney, Orna Somerville and Beatrice Somerville-Large.

Gillian and I are immensely grateful to Elizabeth Mayes for her indispensable work editing the text. We thank the Library Staff for their assistance, in particular the Chief Librarian, Andrea Lydon; Leah Benson, the archivist, who rounded up material, and Mary Wynne. We are also indebted to the staff of the Archive Department in University College, Dublin, the Early Manuscripts Department at Trinity College Dublin, the Archive Department of the National Library, Kildare Street, and the Dublin City Library.

I owe most to Gillian, researcher, editor and keeper of the computer.

CHAPTER ONE

Opening Day

Dubliners were familiar with the sight of the Lord Lieutenant and his entourage clattering through the city streets. On a cold Saturday, 30 January 1864, the watching crowd shivered as flags and pennants waved briskly, and George Howard, 7th Earl of Carlisle, accompanied by other carriages containing 'various gentlemen'[1] together with the usual soldiers and outriders, was driven to Merrion Square to open the newly completed National Gallery of Ireland.

He was used to lending his presence to auspicious occasions on Leinster Lawn. Eight years earlier he had laid the foundation stone of the Natural History Museum on its north side, and a little more than a year later he had officially opened the completed Museum.

The elderly Earl was a bachelor who did not enjoy entertaining; nevertheless, two days earlier he had dutifully held his first Levée and Drawing Room of the season in Dublin Castle. Those who attended included the Lord Chancellor of Ireland, Maziere Brady, Sir Bernard Burke, Ulster King of Arms, and Dr Stokes, Physician-in-Ordinary to the Queen in Ireland, all present or future Governors and Guardians of the National Gallery of Ireland. In the evening yet another Governor, Lord Talbot de Malahide, went to the Drawing Room, where among other guests were Sir William and Lady Wilde, whose train and corsage was of richest white satin trimmed handsomely in scarlet velvet and gold cord.

Perhaps because of the weather, Lord Carlisle was late. He should have arrived by two o'clock, but those assembled outside the new building had to wait in the cold on the Duke's Lawn for an extra half hour before his carriage drew up. They waited still longer while he performed his first duty of the afternoon, which was to unveil a statue of William Dargan positioned in front of the new Gallery, atop a colossal plinth of County Roscommon granite. It was surrounded by a substantial platform approached by three flights of steps, capable of accommodating several hundred 'gentlemen', which had been erected by Messrs Martin of the

North Wall. 'The portion reserved for His Excellency and the principal visitors was covered with a rich Brussels carpet of considerable value contributed by the firm of Todd Burns and Company for the occasion'.

After speeches from the Trustees of the Dargan Committee, which must have chilled the restive audience still further, His Excellency directed the statue to be unveiled. The green baize which concealed it was removed and William Dargan appeared. The sculptor Thomas Farrell's representation of the railway magnate, the nation's hero, whose liberality had initiated today's proceedings, portrayed a stout coun-tryman dressed in an unbuttoned frock coat showing his waistcoat, and creased pantaloons.

The Irish Times commended 'a colossal bronze figure, the embodiment and type of the great apostle of Irish industry and self reliance...the pose is easy and natural, the whole figure massive and bold'. The image, which Thomas Bodkin later considered 'one of the best works of this mediocre sculptor'[2] prompted 'the delight and satisfaction of all present.' The like-ness was evident, as Lord Carlisle was able to observe to his audience:

'My Lords and Gentlemen, we have performed our part together in a most just and becoming tribute to the excellent public servant whose statue we have now unveiled. (Applause.) His natural modesty, almost as remarkable as his merit, has prevented our seeing him by my side this day; but at all events I believe the talent of another citizen, Mr Farrell, enables us to recognise the form and features of William Dargan. (Applause.)'

His Excellency then went indoors, leading a procession which included George Frederick Mulvany, the first Director of the National Gallery of Ireland, and fifteen of its seventeen Governors and Guardians. Among them was Farrell, who, as President of the Royal Hibernian Academy, was an *ex-officio* Governor. The absent Dargan was also a Governor, while Lord Carlisle was another in his *ex-officio* role of President of the Royal Dublin Society.

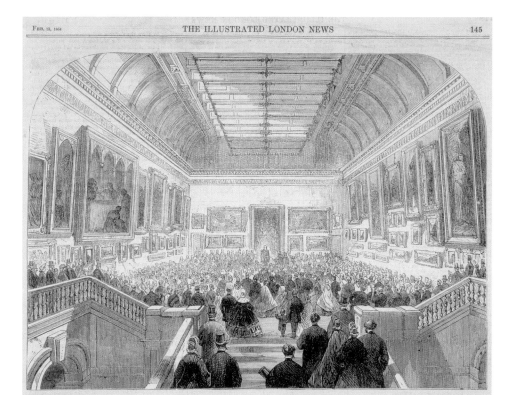

HIS EXCELLENCY THE EARL OF CARLISLE OPENING THE NATIONAL GALLERY OF IRELAND.—SEE PAGE 151.

*The Opening of the National Gallery of Ireland by the
Lord Lieutenant, 7th Earl of Carlisle, on 30 January 1864,
from the* Illustrated London News, *13 February
1864,* wood engraving (NGI 11595). While the
architecture is fairly accurate, the paintings are
only an impression.

*Reconstruction of original exterior of Gallery as it
appeared in 1864, 1981* ink drawing by Jeremy
Williams (b.1946), purchased 1981 (NGI 7945)
(© The Artist).

Lord Carlisle stepped into the small Nineveh and Egyptian Court, an awkward annexe to the new building, which served as a vestibule. Its walls were covered with plaster casts of reliefs taken from excavated finds in Babylon, winged Nimrods, bearded priests, and gods and goddesses. In one mural warriors hunted a lion. Mulvany had written in his new catalogue (price four pence) how 'the wounded lion in his agony and rage is finely conceived. It is a peculiarity of the lions represented in these bas-reliefs that there is a claw or hook at the extremity of their tails which has been referred to by ancient writers'.

Beyond the Court was the Sculpture Hall lined with Corinthian columns whose entablature was decorated with festoons of shamrock and Irish harps contained in laurel wreaths. The walls were painted silver grey and there were crimson blinds over the windows.[3] 'On entering the Sculpture Hall', wrote the enthusiastic correspondent of the *Daily Express*, 'you are struck with the airy lightness and beauty of the room itself. A strange sense of richness, luxuriance and harmony creeps stealthily over you as you cast your eyes upwards and view the elegance of the ceiling'.[4]

The hall was crowded with statues, reliefs and busts, after Greek and Roman originals. There were huge, 'life-sized statues and colossal groupings...all mounted on movable pedestals and judiciously placed'.[5] Nearly all of them were plaster casts, whose purpose was to enlighten the public and teach students how to draw from the Antique. Apart from the statue of Dargan, the Gallery possessed only four pieces of sculpture: a marble bust of Daniel Murray, the recently deceased Catholic Archbishop of Dublin (NGI 8034) by John Hogan (1800-58), another of playwright and politician, Richard Lalor Sheil (NGI 8065) by Christopher Moore (1790-1863) and two nineteenth-century copies of the *Crouching Venus* (NGI 8186) and

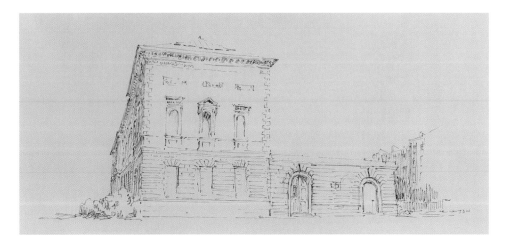

the *Spinario* or *Boy Extracting a Thorn* by Giacomo Vanelli (NGI 8085).

Through these reproductions of ancient statuary the Lord Lieutenant and his party proceeded to the grand double staircase which led up to the Queen's Gallery, one of the most up to date picture galleries in the world. Their footsteps took them over floors that used the Fox and Barrett Patented Fire-Proof Floor Principle laid with an early form of precast concrete; above them were numerous gas jets and a plate glass roof through which filtered the pale January light. This natural light still illuminates the Gallery during the day.

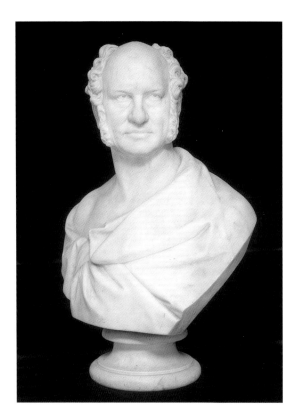

Photo of 1863 statue of William Dargan by Thomas Farrell against original NGI entrance and side of 88, Merrion Square, from Hon John F Finerty Ireland in Pictures (Chicago c.1898), (courtesy Trinity College Library, Rare Books).

William Dargan (1799-1867), Railway builder and sponsor of the Dublin Industrial Exhibition, 1854 marble bust by John Edward Jones (1806-72), presented 1905 (NGI 8204).

The decor had been carefully chosen by Mulvany. He had been to Paris and reported how 'I should be particularly disposed to suggest for the colour of the walls of the larger gallery that adopted in the newly arranged portions of the Louvre, namely a maroon leading to crimson'.[6] Heavy curtains on large ornamental brass poles separated the main gallery from the small galleries. 'It is noble, princely in its dimensions and its decorations are gorgeous,' enthused the reporter of the *Daily Express.*[7]

In the Queen's Gallery more members of the nobility and gentry were gathered, totalling upwards of fifteen hundred people. Most were ladies, spared the wait in the cold outside, 'whose appearance lent a charm to the scene'. On the walls above them clustered tiers of paintings; there were more in the smaller galleries, separated by curtains on large ornamental brass poles, which were reached by stairs to the left and right above the main staircase.

On this day the Gallery displayed one hundred and thirty pictures. Sixty-five had been bought, including a consignment of paintings from Rome, acquired through the energy and generosity of Maziere Brady, one of the most enthusiastic members of the Board of Governors. Twenty-

eight pictures had been deposited on loan from the National Gallery in London. Others had been donated through the Gallery's predecessor, the Irish Institution, which had been founded a decade before for the promotion of art in Ireland and eventually the formation of an Irish National Gallery. The Gallery possessed a few Irish pictures, all but one of them donations. Back in 1854 one of the earliest paintings to be given to the Irish Institution had been a landscape (NGI 1909) by the Dublin artist George Barret (1728/32-84). Other paintings associated with Ireland were *Creeping to School* (NGI 384) by George Sharp (1802-77), presented by the patriot William Smith O'Brien, and a full-length portrait by Stephen Catterson Smith the Elder (1806-72) of William Dargan (NGI 141). There was also the writer Lady Morgan (NGI 133) by French artist René Berthon (1776-1859), which she had bequeathed to the Gallery in 1860. Eight accomplished watercolours, amongst those on display in Gallery D, were by Cork artist James Mahony (1810-79), whose sketches of West Cork in the *Illustrated London News* in 1847 had brought the Famine to the notice of English readers.

Mulvany had purchased only one Irish picture, a portrait (NGI 1756) by Nicholas Crowley (1813-57) of the same dead Archbishop of Dublin whose bust was on display downstairs. He did not hang the portrait or mention it in his new catalogue. He was not interested in Irish painting; his aim was to fill the Gallery with representations of Old Masters, over half of which at this stage were Italian. Dutch and Flemish pictures were also reasonably well represented.

Two full-sized copies of Raphael's cartoons were hung in Gallery B above the Queen's Gallery: *Sts Peter and John at the Beautiful Gate* (NGI 171) and *Elymas the Sorcerer Struck with Blindness* (NGI 172). These had been presented by Mrs Nicolay in London and came to the Gallery in 1862 through Stewart Blacker, who for many years had been promoting the idea of a National Gallery. According to the catalogue, the cartoons 'were found by Sir Joshua Reynolds during his tour in the Low Countries at some town where they had lain from the time they had been used as models for tapestry. They remained in Sir Joshua's possession until his death'. Around four metres high and five metres wide, they were good wall covering. In general the walls were satisfactorily covered. Until recently it had seemed there would be no National Gallery and very few pictures.

The obstacles of the past years and hope for the future were outlined in a speech to the assembly. 'When the Governors and Guardians look back on the efforts fruitlessly made to establish a National Gallery in Dublin previous to 1853 and to the difficult task that was then before the

promoters of the project, they feel satisfied that they may congratulate themselves and the public at large on the result of their labours to the present time. A commencement has been made, a Collection of Works of Art has been brought together as a nucleus in point of interest and excellence far beyond their most sanguine expectations and they can only say that it now lies with the Irish public to improve and extend it to the requirements of the Nation. The greatest Masters are not yet adequately represented...'[8]

The Earl of Carlisle responded somewhat patronisingly: '...the previous course of Irish history has scarcely run smooth enough to foster the growth of galleries or museums of the fine arts, while at the same time neither the Irish mind nor the Irish hand have shown any want of susceptibility to them. It is my very earnest wish that the Institution which we now inaugurate may by the display of foreign excellence supply a fresh incentive and starting point of your own'.

Afterwards the Earl spent considerable time examining the building and the paintings. He inspected the smaller cabinet rooms which were painted 'a peculiar shade of green'. He was shown what was perhaps the most distinguished picture in the Gallery, *David's Dying Charge to Solomon* (NGI 47) by Ferdinand Bol (1616-80), a pupil of Rembrandt. Before driving away in the gathering dusk the Lord Lieutenant was also shown his own gift to the Gallery, hanging in Gallery C beside the portrait of William Dargan, a showy full-length portrait of James Butler, 1st Duke of Ormonde (NGI 136) by Sir Peter Lely (1618-80),[9] now considered mostly by his Studio.

In a few months Carlisle would retire to England and by the end of the year he would be dead. In Dublin he would be commemorated by a statue in Phoenix Park, now vanished, the work of Farrell's rival, John Foley. He had occupied his office in Ireland from 1855 to 1864 with a break of sixteen months because of a change of government. His long stay almost coincided with the years covering the conception of the Gallery to its inauguration.

1 Accounts of the opening of the NGI from *The Irish Times* 5 Feb. 1864 and the *Illustrated London News* 13 Feb. 1864

2 Thomas Bodkin, NGI *Catalogue of Oil Pictures in the General Collection* (Dublin 1928) p. vi

3 Catherine de Courcy, *The Foundation of the National Gallery of Ireland* (Dublin 1985) p. 70

4 *ibid*

5 *The Irish Times* 27 Jan. 1864

6 Minutes of the NGI Board of Governors and Guardians, 15 July 1862

7 Quoted by de Courcy (as no. 3) p. 70

8 Draft Address in Minutes, 14 Jan. 1864

9 G F Mulvany, *Catalogue, descriptive and historical, of the Works of Art in the NGI* (Dublin 1864) p. 22

CHAPTER TWO

MOVES TO CREATE
A GALLERY FOR IRELAND

Although abstract configurations in the Book of Kells and on High Crosses offer proof of the sublime achievement of Celtic art in Ireland, almost nothing exists of painting from medieval times. A handful of damaged frescoes survive, among them those in Cormac's Chapel at Cashel; at Holy Cross; the three skeleton kings at Abbeynockmoy and the animals and men in slate blue, crimson and yellow in St Bridget's Church on Clare Island.

Centuries of turbulence divide those frescoes from the collections of the Planters. There was little place for paintings in the period following the Middle Ages. When Maynooth Castle was sacked in 1535 and its rich contents were listed as loot in Richard Stanihurst's *A Description of Ireland* (1587), no mention was made of paintings, only of 'many goodly hangings'. Among the few sixteenth-century paintings connected with Ireland to survive are portraits of the O'Brien family of Lemanagh and Dromoland, County Clare, which include a fierce likeness of Maire Ruadh O'Brien decked in lace and wearing a fabulous Renaissance jewel. This was painted in 1577, probably by a Flemish artist travelling in Ireland.[1]

One of the earliest identifiable collectors in Ireland was the entrepreneur, Richard Boyle, the 1st Earl of Cork (1566-1647) who recorded in his 'remembrancer' or diary how on 30 July 1617 he acquired from a Dutch merchant twelve paintings for his dining room at Lismore Castle. On 16 November 1621 he recorded buying a number of family portraits, paying 'the ffrench Lymner XII £ ster for making my own, my wives, my mothers, Saraes, Dick and Joanes pictures, which picture of Saraes were sent to Mellifont and Dicks picture and Jynnes to Sir Edward Villiers'.[2] In 1996 the National Gallery of Ireland received a portrait of the 1st Earl of Cork (NGI 4624) painted around 1630, donated by a descendant.[3]

It can be said that organised artistic activity only began in Ireland after the restoration of the monarchy in 1662, when painters were admitted to the Guild of St Luke. The 1st Duke of Ormonde, Lord Lieutenant of

Ireland, who possessed numerous paintings in his Castle at Kilkenny, helped to found a native school of painters and encouraged artists to come to Ireland from outside the country. The earliest Irish painter of note was Garret Morphy, six of whose portraits of Jacobite personalities were acquired for the Gallery from Malahide Castle in 1976.

The 2nd Duke of Ormonde took up the losing Jacobite cause and his declining fortunes forced a sale of the contents of Kilkenny Castle in 1719. Two pictures traced to the original Ormonde collection are in the NGI: a double portrait by Henri Gascars (c.1635-1701), showing James Butler, 1st Duke of Ormonde and René Mezendier (NGI 4198) which was recorded in the Duchess of Ormonde's dressing room in 1717, and *St Ambrose* (NGI 1912), after Claude Vignon (1593-1670), said to have been purchased at the 1st Marchioness of Ormonde's sale in 1860, though not listed .[4]

At the beginning of the eighteenth century the popular taste among the newly established post-Boyne gentry was for portraits which suggested dignity, loyalty and permanence. Bishop Berkeley observed how 'Portraiture is all that's thought of, and he that's happy in taking a likeness may thrive, while a Master may perish'. His episcopal palace at Cloyne had 'some heads' by van Dyck and Kneller and a picture of St Mary Magdalene believed to be by Rubens.[5] (The practice of making bold attributions to country house pictures was already common.) He condemned the general apathy towards the arts in Ireland, in a letter to Sir John Perceval later 1st Earl of Egmont, dated 22 September 1709, commiserating with him over the fact that his collection of 'statues, medals' etc.' acquired in Italy had been lost. Of Perceval's neighbours, he wrote: 'To feed their eyes with the sight of rusty medals and antique statues would (if I mistake not) seem to them something odd and insipid. The finest collection is not worth a groat where there is no one to admire and set a value on it, and our country seems to me the place in the world which is least furnished with virtuosi'.[6]

In *The Querist*, published in 1735, Berkeley suggested the desirability of starting an academy for design and asked 'whether when a room was once prepared…the annual expense of such an academy need stand the public in above two hundred pounds a year?'[7]

Others had similar ideas. A defining moment in combating 'barbarism and Gothick Ignorance' in Ireland was the creation of the Dublin Society in 1731 by a group of well intentioned gentlemen for 'the improvement of Husbandry, Manufacture and other useful Arts.' Nearly twenty years later their ideas were extended to the 'politer arts' when the Dublin Society Drawing Schools were founded with the help of two Society members, Thomas Prior and a clergyman from County Fermanagh, Samuel Madden, who became known as 'Premium Madden'. In his *Reflections and Resolutions*, published in 1738, Madden had laid out proposals for 'encouraging by Proper Premiums those politer Arts which are in a manner strangers to our country, I mean sculpture, painting and architecture'.

In the Minutes of the Dublin Society for 18 May 1746 occurs the entry: 'Since a good spirit shows itself for drawing and designing which is the groundwork of painting and so useful in manufactures, it is intended to erect a little academy or school of drawing and painting, from whence some geniuses may arise to the benefit and honour of this Kingdom; and it is hoped that gentlemen of taste will encourage and support such a useful design'.[8] From this resolution derived the Drawing Schools in which almost every significant Irish painter of the eighteenth century would participate. They were developed from the art school started by the artist named Robert West, who had studied in Paris with François Boucher and was reputed to have been a superb draughtsman. The Minutes of the Dublin Society for 8 November 1750 relate that after it held a formal meeting as usual in the Parliament House, the members 'adjourned to the Academy for Drawing in Shaw's Court in Dame Street'. The next meeting of the Society on 15 November took place 'in the Academy for Drawing in Shaw's Court'. According to *Faulkner's Dublin Journal* of November 1750, West's 'Academy for Drawing and Design' located in Shaw's Court taught 'drawing from the round and also from life…The Academy was yesterday visited by several members of the Society who expressed great satisfaction on seeing the several drawing Performances of the Pupils which hang up in the room'.[9]

There were three Drawing Schools, 'one for the human figure, one for landscape and ornament, and one for architecture'.[10] The Schools, among the earliest such institutions in Europe, were, in the words of

Walter Strickland, 'for over a hundred years…the centre of art teaching in Ireland and where almost every Irish artist received his training'. A small collection of drawings by contemporary artists assisted the pupils of the Schools, some of which were transferred to the NGI in 1966 from the National Museum. They include two landscapes (NGI 3822 and 3823) by Jean-Antoine Watteau (1684-1721), two studies (NGI 3837 and 3838) by Claude Vignon (1593-1670) and a male nude (NGI 3930) by Anton Raphael Mengs (1728-79).

But the Dublin Society had no gallery of its own to display the work of the Schools, and nothing remotely suitable existed. In his *Recollections,* John O'Keeffe described how the Society was compelled to use the House of Lords as a place to judge the School paintings when the all important premiums first proposed by Madden, were awarded. Once a year students' work was pinned on the walls of the lofty chamber 'from the life, from the round, or from a bust or statue. Children used to pluck off the large scarlet tassels and bobbins from the benches and pelt them at each other'.[11]

The need for a gallery in Ireland to display a permanent collection of art was expressed in 1767 by the Reverend Thomas Campbell, who lamented how 'we have no publick statues, no publick galleries of pictures, no academies for either painting or sculpture, nor will the great allow their pieces to be copied. How different abroad! You can never go into the Vatican or Medicean palace, the Farnese or Luxemburg gallery, but you will see a scaffold raised and an artist at work'. He concluded: 'there should be, at least in the capital, one great collection of master-pieces both of painting and sculpture, where there might be constant access under certain regulations. Here the Publick might view and form its eye; here the student might occupy his hand'.[12]

Less than twenty years later a national gallery was planned by one of Ireland's most colourful Lords Lieutenant. Charles Manners, 4th Duke of Rutland, arrived in Dublin in 1784 bringing his gold and silver plate and his own pictures to hang in the Viceregal Lodge. A miniature of the Duke of Rutland as Lord Lieutenant (NGI 2657) by Horace Hone was bequeathed to the NGI by Miss Eleanor Hone in 1912. In his three short years in Ireland he spent money prodigiously, giving away at one of his balls a thousand pounds (about €60,000 today) to the Dublin poor. In the course of his duties he met the leading personalities of the day, including the 1st Earl of Charlemont. When Charlemont was elected President of the newly formed Royal Irish Academy, Rutland's influence ensured that the Academy received a royal charter.

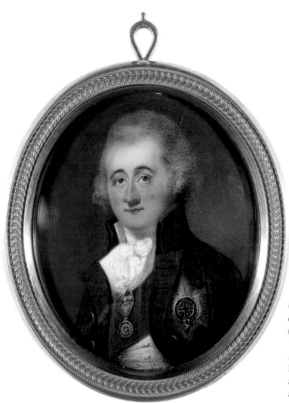

Charles Manners, 4th Duke of Rutland (1754-87), 1805 enamel on copper miniature by Horace Hone (1754-56-1825/27), bequeathed 1912 (NGI 2657).

David's Dying Charge to Solomon, 1643 by Ferdinand Bol (1616-80), presented 1854 (NGI 47). The first and still the largest Dutch painting to be acquired.

Rutland was aware that the time was appropriate for a public gallery in a city with handsome new Georgian streets and squares, aspiring to compete with the rest of Europe in culture. Such galleries had already been established in Dresden and St Petersburg. In Rome the Vatican showed its great artistic accumulation to the public, while in Paris the Academy for Sculpture had been founded back in 1648. In England the Ashmolean at Oxford had opened its doors in 1683, and more recently John Wilkes was promoting the idea of founding a National Gallery in London and had gained the support of Joshua Reynolds.

Rutland's ideas were for an Academy of Painting in Ireland which would include not only an academy for artists to study painting, but a gallery furnished with pictures by Old Masters. The project went as far as the nomination of a Keeper, a Flemish artist named Peter de Gree (1751-89) who had been employed by Joshua Reynolds as an agent for purchasing pictures both for himself and Rutland. In 1785, when de Gree planned to come to Ireland, Reynolds wrote to Rutland: 'I promised to recommend him to your Grace's protection which I can with a very safe conscience, not only as a very ingenious artist, but as a young man of very pleasing manners'.[13]

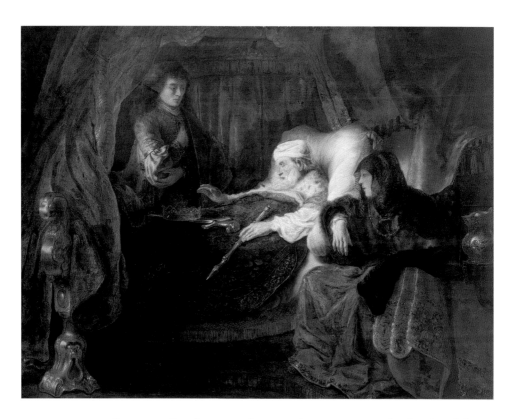

But on 24 October 1787, after an exhausting tour of Ireland with hosts outrivalling themselves in providing entertainment for him, the thirty-three-year-old Duke died of a fever. It is at least possible that, amid the subsequent confusion, the painting by Ferdinand Bol of unknown provenance, *David's Dying Charge to Solomon* (NGI 47), given to the Irish Institution for the National Gallery by a subsequent Lord Lieutenant, the 3rd Earl of Saint Germans, as an impetus for the collection, might have been one of Rutland's paintings that were left behind in Ireland. It had been taken down from the walls of the Viceregal Lodge where it had hung for many years. How it came to the Lodge remains a mystery. A report in *The Freeman's Journal*, however, believed that the Bol was unclaimed 'during the civil discords which prevailed in this country many years ago' when 'the gentry sent their plate, pictures and other valuables to Dublin Castle for safekeeping'.[14]

A similar mystery surrounded another large painting, Pieter Boel's (1622-74) *Noah's Ark* (NGI 42), then thought by Melchior de Hondecoeter and equally donated by Saint Germans. The depiction of the Flood showed a melancholy aspect of the story, the creatures that were left behind to perish, including a dog, an ostrich and a peacock, symbol of

vanity. Precious objects scattered in the foreground alluded to man's vainglorious folly.[15]

After Rutland's death, the Speaker of the Irish House of Commons, John Foster, took up his ideas, making them more complicated. He proposed to unite under one roof an Academy of Arts, a Museum for Mechanical Works, a Repository for Manufactures, and a National Gallery. This unwieldy plan was abandoned, and Dublin would have to wait seven decades for its national gallery.

Deprived of his appointment by Rutland's death, de Gree stayed on in Ireland and made a living decorating various town and country houses with imitation bas-reliefs in oil *grisaille* (a painting executed in monochrome). One of *putti* was acquired by the La Touche family and displayed at their hunting lodge at Luggala in County Wicklow. Luggala was subsequently bought by the 7th Viscount Powerscourt, who would play an important role in the history of the NGI as a Governor, and de Gree's picture, which came with the property, was displayed at Powerscourt House. It entered the NGI in 1943 (NGI 1106) through the Friends of the National Collections of Ireland.

Private collections in big houses were enriched by their owners' visits to the continent. A few were outstanding. In 1781, James Gandon wrote in his now lost diary that there were 'four collections of pictures of consequence; these were the Duke of Leinster's, the Earl of Farnham's, the Earl of Charlemont's and Lord Londonderry's'.[16] Other collectors boasted of possessing paintings by famous artists whose attribution was often a matter of wishful thinking. When Daniel Beaufort visited Castle Bernard in County Cork he recorded in his journal 'a fine large Teniers… a middling Titian…an ugly Claude Lorrain and an abominable Titian' (ms in Trinity College Dublin library). Only a trickle of paintings and pieces of sculpture bought by wealthy Irishmen on the Grand Tour to decorate their great houses would find their way into the NGI, together with the artistic contents of one big house – Russborough.

More modest private collectors continued to acquire family portraits, together with Old Master paintings and a few landscapes from Irish painters who had emerged from the Society Schools. But outside these circles in general in the late eighteenth century there was little interest in painting. In 1796 Anthony Pasquin wrote, 'I must lament that the gentlemen of Ireland do not sufficiently evince that kind disposition towards the fine Arts which is indispensably necessary to their establishment. When I was in that generous nation, I walked through every province and have to regret that I saw but few instances of a supreme taste'.[17]

Irish artists would have a long struggle for recognition. James Gandon reported that he could only find one print shop in Dublin and considered that there were few 'painters of eminence'. The Englishman Dr Richard Twiss wrote in his travel book how at an exhibition of pictures in Dublin by Irish artists 'excepting those (chiefly landscape) by Mr Roberts and Mr Ashford, all the rest were detestable'.[18] But the jaundiced views of Twiss annoyed Irish people so much that a chamber pot with his portrait on the bottom became a popular household artefact.

In the eighteenth century the low regard in which artists were held meant that the majority of artists entering the Society's Schools came from a working class background. George Barret (1728/32-82) was the son of a draper; Hugh Douglas Hamilton (1740-1808), the son of a peruke maker, and James Barry (1741-1806), the most remarkable artist to come out of the Schools, the son of a Cork bricklayer. Since there was so little encouragement for them at home, many like Barry and Hamilton took the boat and established their reputations in England and on the continent.

Lord Charlemont set up an Academy for British and Irish artists abroad. Barry was among the artists who, through the influence of the Dublin Society and the patronage of Edmund Burke, was able to travel to Italy and see at first hand the classical art that inflamed his imagination. Hamilton lived in Italy for twelve years, but returned to Ireland where he worked as a portrait painter.

An exception to the dismal lack of recognition of artists was the experience of landscape painters. At the Schools the premiums awarded for landscape were more substantial, and encouraged a radical change in its presentation. Map-like representations gave place to idealised views and encouraged commissions from those who wished to have their landed possessions recorded in a new way, as attested by many commissioned landscapes and views of demesnes in the NGI by painters like George Barret, the two Roberts and, in the next century, James Arthur O'Connor.

In 1764 the Society of Artists in Ireland was founded, holding annual exhibitions from 1765 to 1780 in a room in the building in William Street which is now the Dublin Civic Museum. Here the public could come and buy. Catalogues reveal how exhibits were displayed under separate heads: Pictures; Sculptures; Models; Architecture or Designs of Architecture. The Society of Artists considered adding a permanent picture gallery to their premises in William Street, yet another early attempt at founding a gallery for the country. However, the artists

involved quarrelled among themselves, and their Society collapsed after its last exhibition in William Street in May 1780.

For the next twenty years no public exhibition of painting took place in Dublin until 1800 when a newly constituted Society of the Artists of Ireland, under the patronage of the Lord Lieutenant, the 4th Duke of Richmond, held an exhibition at Allen's the print sellers in Dame Street. Then, for a glorious two years, in 1801 and 1802 the Society was able to exhibit in the spacious premises of the vacated Parliament House. A report on the exhibition of 1801 described how 'the exhibition of last years was little better than a closet, the present a palace. You may pass thro' a magnificent colonnade and hall into a complex of noble apartments, arched ceilings and lighting at top; the walls hung with green cloth show both the paintings and the superb frames which surround them to the greatest advantage. The first room is appropriated to miniatures, sketches, drawings, elevations, the second room to the paintings; the catalogue contains in the whole 200 pieces'.[19] Two paintings mentioned in this account by an anonymous diarist are in the NGI, a view of Charleville Forest demesne (NGI 4045) by William Ashford (1746-1824) and a portrait of Lieutenant Richard Mansergh St George (NGI 4585) by Hugh Douglas Hamilton (1740-1808).

After two years the Parliament House became unavailable and the Artists had to return to Allen's and its closet. For a time the Dublin Society came to their rescue. In 1796 it had moved into new premises in Hawkins Street which not only accommodated the Drawing Schools, but also a large Exhibition Room, said to be one of the finest in Europe, where the Society of the Artists of Ireland were able to hold three exhibitions. But again there were divisions and confusion, compounded in 1815 when the Dublin Society abandoned Hawkins Street and the Exhibition Room and transferred to Leinster House. The Schools continued until 1849 when they were converted into a School of Design under the Board of Trade, which, under the auspices of the Government became the Metropolitan School of Art in 1877.

Meanwhile there were other attempts to promote art in Ireland. In 1813 the Royal Irish Institution had been formed, with the aim of 'stimulating native talent by furnishing models to assist the labours of Irish artists and by rewarding the authors of superior merit'. A section of Irish artists opposed its stated aims, but eight years later its example led to the foundation of the Hibernian Academy which received its Royal Charter in 1823. From 1826 onward it would hold annual exhibitions. William Ashford was its first President briefly until his death; Thomas James

Mulvany (1779-1845) who became the Keeper of the RHA Schools, was the father of George Francis Mulvany (1809-69) the first Director of the NGI.

George Francis Mulvany succeeded his father as Keeper of the RHA and later became Secretary of the Royal Irish Art Union. The RIAU, founded in 1840 by Stewart Blacker, a young barrister from County Armagh, took its lead from similar societies in England and elsewhere. Art Unions had originated in Switzerland, and there were others in various German principalities.

The RIAU not only held exhibitions and offered prizes, but promoted a popular use of cheap reproductions so that 'anyone could be ennobled by art and anyone could develop taste'. Among the earliest works of art to be engraved for this widespread distribution was the watercolour now in the NGI, *The Aran Fisherman's Drowned Child* (NGI 6048) by Frederic Burton (1816-1900).

Blacker was enthusiastic about the idea of a permanent collection of art, and in 1843 proposed that ten per cent of the RIAU's annual funds should be set aside for the purpose. During the Famine he organised a loan exhibition of Old Masters, the proceeds of which, amounting to £500, went to relief. Among the 228 paintings on display were three from the Earl of Milltown's collection at Russborough House, including *The Holy Family* (NGI 925) by Nicolas Poussin (1594-1665), all of which would later come to the NGI with the Milltown Gift in 1902. But the decline of the RIAU coincided with the Famine; by 1853 it had almost ceased to exist and in 1859 its dwindling assets were donated to the burgeoning NGI, while Blacker withdrew from public life.

When the architect Francis Johnston succeeded William Ashford as President of the Royal Hibernian Academy, he offered to provide an Academy House with exhibition rooms, schools of life drawing concentrating on portraiture and history painting, and apartments for the Keeper. He donated for these purposes the huge sum of £14,000 (nearly half of what the NGI would eventually cost). These premises in Abbey Street would survive until 1916, when they were destroyed during the Easter Rising.

In 1847 George Mulvany published a pamphlet in which he advocated: 'in Dublin, seeing the growing taste, the establishment of a National Gallery of paintings and a conjoint museum of sculpture is merely a matter of time.'[20] As Keeper of the RHA, Mulvany had observed Johnston's generosity at first hand. 'Surely it is not too much to hope that one day a man may yet come forward to emulate the example of Francis Johnston who has so liberally endowed the professors of Art; and

thus lay the foundations of a national collection of art'.

He acknowledged that the time was not right. 'It may be said with famine stalking through the land, desolation and death piling corpses on our shore, society almost shaken to its centre, and each man asking his neighbour – what is next? – how can any sane man expect attention to abstract ideas of Fine Arts and plans for Schools of Design?

'Simply because the Arts are among the highest elements of regeneration. Art-knowledge is essential. Broken in fortune, but not in spirit, as we nationally may be, we should remember that, as citizens of the state, we hold our places only in sacred trust for our successors; that we must work if we would advance; and that the generation which lays the foundation of ultimate prosperity is perhaps even more to be honoured than the happier generation which reaps the profit in enjoyment.'

In Mulvany's impassioned manifesto there was an element of prophecy. A few years later, while the effects of famine still lingered, Johnston's munificence would be followed by that of another benefactor, William Dargan.

1 Anne Crookshank and the Knight of Glin, *The Painters of Ireland c.1660-1920* (London 1978) p. 19

2 Rev. Alexander B Grosart, *The Lismore Papers*, vol. 1, p. 161 & vol. 2, p. 30. Quoted in Crookshank and Glin (as n. 1) p. 19

3 NGI Annual Report 1996: 'Richard Boyle, 1st Earl of Cork, presented by Patrick Reginald Boyle, 13th Earl of Cork and Orrery, in fulfilment of the intended bequest by his uncle, the 12th Earl'.

4 Jane Fenlon, *The Ormonde Picture Collection* (Dublin 2001) p. 15

5 Charles Smith, *The Antient and Present State of the County and City of Cork* (Dublin 1750) p. 147

6 Quoted in Anne Crookshank and the Knight of Glin, *Irish Portraits 1660-1860* exh. cat. NPG, London and NGI (1969) p. 14

7 *ibid.*

8 Quoted in W G Strickland, *A Dictionary of Irish Artists* (Dublin 1913) vol. II, p. 580

9 Quoted in John Turpin, *A School of Art in Dublin since the Eighteenth Century – A History of the National College of Art and Design*, (Dublin 1995) p. 8

10 John Dowling Herbert, *Irish Varieties for the Last Fifty Years* (London 1836) p. 36

11 John O'Keeffe, *Recollections of the Life of John O'Keeffe written by himself* (London 1826) vol. 1, p. 12

12 Thomas Campbell, *An Essay on perfecting the Fine Arts in Great Britain and Ireland* (Dublin 1767)

13 Rutland Papers, quoted in Strickland (as n. 8) vol. 1, p. 269

14 *Freeman's Journal*, 17 Feb. 1864

15 David Oldfield, *Later Flemish Paintings in the NGI* (Dublin 1992) p. 3

16 Quoted in James Gandon Jr. and Thomas James Mulvany, *The Life of James Gandon* (Dublin 1846) p. 49

17 Anthony Pasquin (John Williams), *An Authentic History of the Professors of Painting, Sculpture and Architecture who have practised in Ireland* (London 1796) p. 54

18 Richard Twiss, *A Tour in Ireland 1775* (London 1776) p. 58

19 Anonymous Diarist, 3 June 1801. Quoted in Fintan Cullen (ed.), *Sources in Irish Art* (Cork 2000) p. 238

20 George Francis Mulvany, *Thoughts and Facts concerning the Fine Arts in Ireland and the Schools of Design* (Dublin 1847)

FIXING A SITE ON LEINSTER LAWN

In November 1853 a sub-committee of the Irish Institution, which had been formed to promote the idea of a National Gallery of Ireland, reported that it had considered four possible sites. Space was needed to accommodate a building at least three hundred feet long and sixty feet wide; there should be room for expansion and the site should be accessible to the public.

A site on Park Street, now Lincoln Place, was available, but adjacent houses would have prevented any future development. A location on Clonmel Street, south of St Stephen's Green, off Harcourt Street, was considered too far away to be easily accessed by an essentially walking public. A third site was an empty building in College Street (demolished in 1866 to make way for a bank) formerly occupied by the Royal Irish Institution. This was convenient for the public, and could be used for a gallery straight away, but there would be little possibility of enlarging it in the future.

'The only other site which your Committee deemed necessary to report on is one which, if procurable on any reasonable terms, would, in the opinion of the Committee, be at once the most convenient and the most appropriate for the proposed Buildings, bearing in mind that they are destined to become a National Gallery. That site is Leinster Lawn, Merrion Square'.[1] A building on the north side of the Lawn would be linked architecturally and aesthetically with Leinster House, the head-quarters of the Royal Dublin Society, and with the Natural History Museum which the RDS proposed to build.

Leinster House had been the town house of James Fitzgerald, the 20th Earl of Kildare, later the 1st Duke of Leinster.[2] In 1744 he had purchased for a thousand pounds from Viscount Molesworth a piece of land off Coote Street (now Kildare Street) at what was then the edge of Dublin. When it was pointed out to him that this was a remote unfashionable place, he famously replied, 'Wherever I go, fashion will

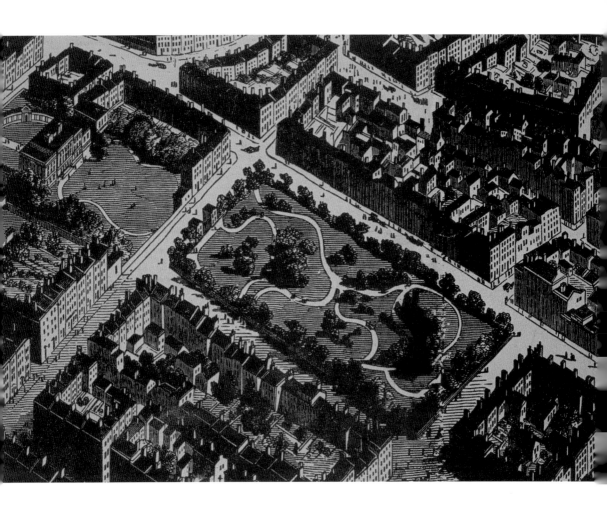

Detail of *Aerial view of Dublin from the South-East,*
published by the Illustrated London News, 1846
wood engraving by Smyth (19th century),
acquired 1908/14 (NGI 11878). Leinster Lawn
(top left) is shown before the Natural History
Museum and National Gallery of Ireland
were built.

follow'. He employed Richard Castle, the leading architect in Ireland, to build a large country house in town. Since he did not consider the site large enough, he leased another plot of land to the east from his neighbour, Viscount Fitzwilliam of Merrion. This area, measuring a little more than six acres, became known as Leinster Lawn.

When the Duke died in 1773 Leinster House was unfinished. His son, William Robert, the 2nd Duke, set about completing it, moving in around 1775 with his bride, Emilia Olivia St George, who had inherited a collection of pictures from her father. These were housed in a gallery designed by James Wyatt, which is now the Seanad (Senate Chamber) of the Dáil. According to James Malton, who described them in 1795, they included 'a student drawing from a Bust by Rembrandt; the Rape of Europa by Claude Lorrain…two capital Pictures of Rubens and his two Wives by van Dyck'.[3] These particular works of art never made the journey across the lawn to the NGI, but in 1878, the 4th Duke presented the Gallery with one item noted by Malton: 'In a Bow in the middle of one side, is a fine marble Statue, an Adonis executed by Poncet'. François-Marie Poncet (1736-97) was a Frenchman who specialised in imitating ancient statuary, and *Adonis*, carrying an arrow in his right hand (NGI 8135), was commissioned for the Duchess by her mother during a visit to Rome in 1784.

The second Duke, who was Colonel of the first Regiment of Volunteers, liked to drill his troops on the Lawn. In July of 1773 the Duke had his son, the Marquess of Kildare, baptised there. The font was placed in a specially erected pavilion, while Grenadiers and the Light Infantry of the Dublin Regiment presented arms. In 1783 Thomas Milton described the 'large lawn on which Volunteers under His Grace's command frequently performed their exercises', and they appear in the accompanying engraving, after a drawing by John James Barralet (c.1747-1815) together with a group of bystanders (NGI 11615).

On Merrion Square, facing the ha-ha at the edge of the Lawn, a fountain to the memory of the Duke of Rutland was erected in 1792 by his widow and friends. A reclining figure of a naiad pouring water from her urn into a shell which formed a reservoir was surrounded with urns and medallions and an inscription reading: 'To the memory of Charles Manners, Duke of Rutland, whose heart was as susceptible of the wants of his fellow creatures as his purse was open to relieve them, this fountain for the poor is dedicated'.

An aquatint (NGI 11643), again after Barralet, shows women carrying away tubs and buckets of water, while a small boy carries more in a large

black kettle. Unfortunately the fountain was vandalised soon after it was erected and a placard appeared on the breast of the disfigured naiad:

'A warning for the public weal
My hapless figure shows
My virgin charms I scarce unveil
When lo: I lost my nose!'

The naiad has gone, but a handsome fragment of the fountain still stands opposite the NGI, an appropriate memorial to the grandee who pioneered the idea of bringing a gallery to Dublin.

After the Act of Union in 1800 numerous wealthy and aristocratic people, deprived of their parliament and the social season which revolved around it, abandoned Dublin. Among them, the 3rd Duke of Leinster, who had been baptised on Leinster Lawn, left Leinster House and went to London, where a residence on Carlton Terrace was considered more convenient for entertainment.

The Duke's sister visited the Dublin town house in 1812: '…it was with sad and solemn steps that we traversed the grass-grown court… Although in the midst of a populous city, we might here have quoted "the long grass whistling in the wind" for since the union with England our family residence in town had been quite neglected and was now more like a convent than a nobleman's hotel'.[3]

In 1814 the Duke decided to dispose of Leinster House altogether and sell it to the Dublin Society. Providentially for the future of the arts in Ireland, the Society acquired the property for a down payment of £10,000 and a yearly rent of £600. The *Freeman's Journal* of 10 December 1814 considered that house and premises had been obtained for 'much below their real value, His Grace having made a very considerable concession to an institution established for such great national objects as the Dublin Society'. Perhaps His Grace was also relieved to get his run-down property off his hands.

Nearly forty years later, in June 1852, the Dublin Society, which, since 1821, when George IV visited Dublin and became its patron, called itself the Royal Dublin Society, was approached by the railway magnate, William Dargan. Dargan offered to finance a spectacular exhibition on Leinster Lawn which would imitate the Great Exhibition in London which had taken place the year before. A similar small exhibition was about to take place in Cork, but this one in Dublin would be on a far grander scale.

Dargan was born in Carlow in 1799, the son of a tenant farmer. By 1852 he had built Ireland's first railway linking Dublin and Kingstown (now Dun Laoghaire) and had covered the rest of the country with six hundred miles of railway line. He became very rich and turned to philanthropy. The Famine's haunting images never left him, and the building of railways through some of the most desolate areas of the country gave him the impetus to promote industry and enterprise.

Following the acceptance of his proposal by the RDS, an area of six and a half acres, now covered by the National Gallery, the Natural History Museum, a lawn, car park and offices, was quickly transformed. The Sligo-born architect, John Benson, influenced by Joseph Paxton's Crystal Palace in London, produced something equally exhilarating, a cluster of glass domes with a frontage of three hundred feet to Merrion Square. The specially made fluted or roughened glass needed eight tons of putty to put it in place. The Great Hall, larger than Paxton's, was described as 'the finest apartment ever built'.

The Dublin Industrial Exhibition was opened on 12 May 1853 by the Lord Lieutenant, the 3rd Earl of Saint Germans. As he and his Countess passed up the centre of the aisle in the Great Hall, a thousand vocalists, accompanied by a full orchestra, sang *God Save the Queen*.

The hero of the hour was not the Lord Lieutenant, nor any of the Knights of St Patrick present in their regalia, nor the municipal officials, but plain honest, modest Mr Dargan. The author of the Exhibition's catalogue, John Sproule, described how 'the Chairman then formally introduced Mr Dargan to His Excellency. This was the signal for the most cordial demonstration on the part of the assembled thousands that has ever been witnessed. The position of Mr Dargan at that moment was one that even a sovereign might envy; surrounded by the wealth and intelligence of his native land, in the Temple dedicated to Industry, erected solely at his expense, all joining the enthusiastic acclamations of respect, which were again and again repeated'.[4]

More than three months later, on Tuesday 30 August, Queen Victoria, who was on a state visit to Ireland, called into the Exhibition with Prince Albert and her sons, the Prince of Wales and Prince Alfred. Later during the afternoon, the royal party drove in slashing rain up to Dargan's residence, Mount Anville, where the engineer and his wife took them to the top of the tower that dominated the house to admire the view of Dublin. The *Illustrated London News* was fulsome about the visit, 'the first that had been paid by a British sovereign to a commoner in modern times…The manner of Her Majesty was exceedingly gracious and

courteous'.[5] Dargan has again been honoured today with the naming after him of the spectacular *Luas* (tram) bridge in nearby Dundrum.

Queen Victoria loved exhibitions and thoroughly enjoyed this one. She returned on Wednesday, Thursday and Friday, inspecting specimens from industrial schools, buying a picture and a toilet mirror composed of oxidised silver and gold. The Gallery possesses detailed watercolours (NGI 2452, 2453 and 7009) by James Mahony (1810-79) of these visits. The earliest shows the Tuesday reception; the royal family is being greeted by the Lord Lieutenant, while Dargan waits for an introduction. Relevant to the future of the National Gallery of Ireland is the painting showing the Wednesday visit. Prince Albert is plainly attired in a black coat, the princes are dressed in tartan, while the Queen, in the *Illustrated London News'* words is wearing 'a printed blue barege robe, a Canton white shawl and a white creelisse bonnet'. They are all standing in the huge barrel-shaped Painting and Sculpture Hall where Mahony's delicate pen depicts many of the statues and a considerable portion of the 1,023 paintings on display.

Dargan wished to draw attention to railways and their benefits to industry, particularly in relation to Ireland. But he went further, insisting that unlike the Great Exhibition in London, here in Dublin almost one third of the area should be devoted to a display of the fine arts. The decision must have seemed quixotic. The great mass of the population of Ireland was still suffering the after effects of the Famine and looking for food to put in their mouths. Surely an emphasis on agriculture and industrial development was more relevant in a country slowly recovering from disaster than wall-to-wall paintings arranged right up to the curve of Benson's roof?

But Dargan shared the Victorian conviction that art fulfilled an important social need. This was what Mulvany had implied in his pamphlet six years before, and Sproule concurred. 'Art is one of the highest elements of civilisation...the deepest instinct of man's nature is the pursuit of that which is beyond him and above him'. Sproule's high moral tone reflected the fact that many of the paintings on display were of a religious nature. 'The religious subjects selected for delineation by the painters of Italy are, of course, chiefly those connected with the peculiar dogmas and worship of the Church of Rome, the forms and details of which are so full of suggestions to the poetic and imaginative faculty of man'.

He condemned one aspect of the Exhibition. 'The general visitor, gifted with some degree of taste and discrimination, shrinks with no

little displeasure from the stare of glaring portraits of Sir Something Somebody or a Lady Nothing. …of the modern portraits we shall say nothing, save that since Van Dyck's time they have sunk lower and lower in the scale of works of art, till at the present day it is rare to find one in any way deserving the name'. He could not have liked the portraits on display by the future Director of the NGI, George Francis Mulvany – one of Thomas Moore (NGI 1097), another a huge lumpen representation of the lawyer, Sir Michael O'Loghlen resplendent in bag wig and legal robes (NGI 932), both now in the NGI.

Sproule was also dismayed at the paucity of paintings by Irish artists. Landscapes by George Barret and James Arthur O'Connor, 'small but able pictures of sweet and lovely scenes only made us regret the want of grandeur'. The Irish picture that really aroused his enthusiasm was the watercolour of *Gougane Barra Lake* (NGI 6028) by George Petrie (1789-1866). 'The lake is black as ink, the black clouds and black rocks of the mountains filling the greater part of the picture, but at the far end shines the bright green island'.

Sproule sneered at Irishmen like Daniel Maclise and James Arthur O'Connor for living in England, who, 'transferring their allegiance to a strange soil...soon forget the purer inspiration of their youth at home'. This was an opinion which would be echoed over the years; as late as 1975, Father Cyril Barrett was condemning Frederic Burton for abandoning Irish themes by going abroad.[6]

The list of lenders to the Exhibition included the King of Prussia and the Lord Chancellor of Ireland, Maziere Brady, who would have a vitally important role in the founding of the NGI. Many Irish peers lent their paintings, the usual questionable Old Masters, Dutch cabinet pictures and works by Italian artists gathered on the Grand Tour. Works of art on display then in the Painting and Sculpture Hall which can be seen today in the NGI include John Hogan's statue of *Hibernia* with her arm around the bust of Lord Cloncurry (on loan from UCD, NGI 14688), (visible in Mahony's watercolour, NGI 7009), Joshua Reynolds' small caricatures of Joseph Leeson and friends (NGI 735-37), which belonged to the Earl of Milltown, and *The Dublin Volunteers on College Green, 4th November 1779* (NGI 125) by Francis Wheatley (1747-1801), then belonging to the 5th Duke of Leinster.

The vindication of Dargan's intention to make art the most prominent aspect of his Exhibition was the popularity of the Painting and Sculpture Hall. The surprise this aroused was expressed in *The Journal of Industrial Progress*: 'It is a remarkable fact that when the Great Exhibition was opened to the working classes at sixpence, they displayed in the

attention to which they daily examined the wonders of Art before them, an amount of reverence as well as good taste… no really high Work of Art graced the Exhibition Halls that did not ever command its circle of attentive admirers, whose earnest and often reverential countenance showed, that while they did not always perfectly understand, they could at least respectfully look up to what was above them and what they felt contained something of the Spiritual, the Divine'.[7]

The Exhibition closed on 31 October 1853 to Haydn's *The Heavens are Telling* and Handel's *Hallelujah Chorus;* once again *God Save the Queen* was heard, played by five massed military bands. Dargan had 'respectfully' refused a title from the Queen– no one today is certain whether it was a knighthood or a baronetcy – but Mr Rooney, the 'active and energetic' secretary of the Exhibition had no hesitation in kneeling in front of the Lord Lieutenant. ' "Rise, Sir Cusack Patrick Rooney…"(a loud and hearty cheer)..'.[8]

1 Report of Sub-Committee and General Committee of the Irish Institution, 17 Nov 1853

2 David J. Griffin and Caroline Pegum, *Leinster House* (Dublin 2000) p. 2 *et seq*

3 Quoted in Renagh Holohan and Jeremy Williams, *The Irish Châteaux: In Search of Descendants of the Wild Geese* (London 1989) p. 175

4 John Sproule introduction to, *Catalogue of the Irish Industrial Exhibition 1853*

5 *Illustrated London News*, 2 Sept. 1853

6 Cyril Barrett, 'Irish Nationalism and Art', in Fintan Cullen (ed.) *Sources in Irish Art* (Cork 2000) p. 279

7 *Journal of Industrial Progress*, Jan. 1854

8 *Illustrated London News*, 7 Nov. 1853

From Dargan Committee to Irish Institution

The sum that Dargan offered the Royal Dublin Society to finance the Dublin Industrial Exhibition was huge – £20,000, about €6 million today. He had asked that it should be refunded to him at five percent interest from the proceeds of the Exhibition. Although by the time the Exhibition closed 1,149,369 visitors had passed through its gates, the receipts were not nearly enough to cover the costs, and Dargan found himself badly out of pocket.

It was the price of popularity, since he was acutely aware that he was a national hero. In late October 1853 he had been 'invited to a public entertainment at the expense of the general body of exhibitors.' A few days later he listened while the Lord Lieutenant proclaimed: '… "I cannot declare the Great Industrial Exhibition of 1853 to be closed without expressing an earnest wish for the health, happiness and prosperity of the man to whom we are all indebted for the instruction we have received from the main productions of art and nature which are contained within these walls." His Excellency concluded by calling for three cheers for Mr Dargan…(Loud and prolonged applause)'.[1]

Earlier in the summer the Dargan Testimonial Committee had been formed to honour Ireland's favourite engineer and philanthropist. At its first meeting on 14 July 1853, huge numbers of people 'of all creeds and classes of the community' attended, and a vast committee was formed whose numbers included peers, noblemen, landowners, the Lord Mayor of Dublin, and 'the Mayors of all the Corporate cities and towns in Ireland.'[2]

A proposal was unanimously adopted to raise a subscription towards the foundation of a 'Dargan Industrial College' 'for the instruction in the practical arts of industry of young men of genius whose humble birth or limited means might offer a barrier to advancement and for the general diffusion of industrial knowledge throughout the land'. There was no mention of art at that crowded enthusiastic meeting. But in the

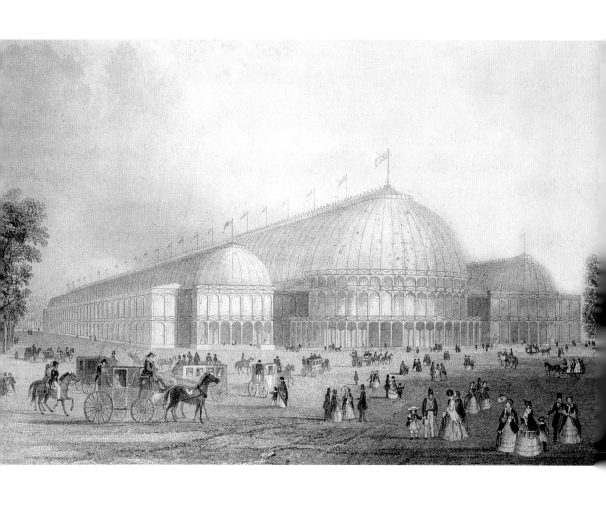

Arrival of the Lord Lieutenant, 3rd Earl of Saint Germans,
at the Dublin Industrial Exhibition on Leinster Lawn, 1853
line engraving, presented 1907 (NGI 11722).

coming months the emphasis shifted as the success of the Exhibition's section devoted to art became apparent.

The overloaded Dargan Testimonial Committee was disorganised. Anyone could join, but subscriptions, anything from a shilling upwards, were slow to come in. By 1 November £5,000 (€1.5m) had been raised. The Dublin correspondent of *The Times*, commented acidly that 'it would appear that the complaint of 'lethargy' still lies against all classes of Irishmen'.[3] In an editorial *The Evening Packet* remonstrated: 'If ever there was an occasion on which steady and well-directed efforts were imperative, it is that of the proposed testimonial to the most illustrious Irishman of the age. The movement to commemorate his character and career commenced with ourselves, and on us will be the disgrace if we do not carry out the object as becomes a nation making a demonstration to commemorate the services of her greatest benefactors'.[4]

While the Dargan Committee struggled, a group of eminent people assembled to form what seemed initially to be yet another organisation to add to the log pile of defunct artistic societies. The name they chose for their new undertaking, the Irish Institution, echoing so many failed assemblages of the past, could not have aroused much enthusiasm. At first this sprinkling of the inevitable peers 'and a few other friends of artistic education in Dublin'[5] must have seemed little different from the copious committees and boards that had proliferated in Dublin over the years.

But the Irish Institution was small and disciplined; it recruited a number of men of outstanding ability who would persevere in the face of immense obstacles. Initially acting more or less in secret with the aim of taking advantage of the success of the Industrial Exhibition to promote a permanent exhibition of the fine arts in Ireland, it would make use of the Dargan Committee to spearhead plans and raise money with the object of building a National Gallery.

Among the founding members was David Richard Pigot (1797-1863), Chief Baron of the Exchequer, and his son, John Pigot (1822-71), a prominent lawyer, whose legal mind would attack many of the problems that were in the way of achievement. The Lord Chancellor of Ireland, Maziere Brady, would play a vital role, while the involvement of the young 6th Viscount Powerscourt and Lord Talbot de Malahide provided a link with the Royal Dublin Society whose co-operation would be essential.

The Irish Institution first met in David Pigot's house for informal discussions based on a detailed memorandum put together by John Pigot which set out in detail the necessary steps towards the establishment of a National Gallery.[6]

Much ground work took place before a formal meeting was held on 1 November 1853 at Charlemont House. Lord Charlemont was elected president in his absence and eight vice-presidents were also chosen. George Mulvany and J Calvert Stronge were appointed secretaries. Those who attended assented to 'the promotion of Art in Ireland by the formation of a permanent Exhibition in Dublin and eventually of an Irish National Gallery'. Events proceeded rapidly. Three days later, on 4 November, a statement was issued to the public announcing the objects of the newly formed Irish Institution. Almost immediately two hundred and twenty subscribers (annual cost one guinea, ten shillings and six-pence for ladies) were recruited who would be entitled to free access to any exhibitions held by the Institution. Committees were formed and split like amoebae. A finance sub-committee, headed by Lord Talbot de Malahide and Mulvany, recommended that money for a National Gallery should be raised by shares of £25 each, and suggested optimisti-cally that £5,000 would be enough to build it.

On 17 November a sub-committee and general committee reported on their preferred site for a National Gallery – 'Leinster Lawn, Merrion Square, a part of the site of the Great Exhibition building'.

There were immediate problems which, it was considered, could easily be overcome. Leinster Lawn was now owned by Sidney Herbert, MP, stepbrother and heir to the 12th Earl of Pembroke; Herbert leased the land to the RDS. Having tolerated the spread of the Industrial Exhibition over his land, he would be no obstacle. 'Your Committee have been informed that the Right Honourable Sidney Herbert…would not be unwilling to allow a portion of it to be occupied by a public building of an ornamental architectural character, provided there should remain a sufficiently ample Lawn or open space opposite the Dublin Society House'.[7]

Yet another committee was formed, the building sub-committee, whose fifteen members, headed by Lord Talbot de Malahide included George Mulvany, the artist Frederic Burton, and the Under Secretary to Ireland, Thomas Askew Larcom. The Committee met on 3 December and decided to send a deputation to the Royal Dublin Society, 'relative to erecting a building along the north side of Leinster Lawn and at right angles with the house, for the purpose of establishing a National Gallery'. The results were most satisfactory. The RDS would raise no objection. 'This Committee have heard with much satisfaction the report made to them of the manner in which the deputation of their body has been received by the Council of the R.D. Society and feel bound

to express their approbation of the liberal terms on which the Council... have stated their proposal for the adoption of the Society'.[8]

At this stage the Dargan Committee had to be included in the enterprise, persuaded literally by peer pressure that paintings and art should reflect Dargan's achievements rather than industry. On 9 January 1854, without consultation with the Irish Institution, it announced to the public that the best way of using the £5,000 at its disposal was to erect 'a suitable building for the reception and exhibition of works of fine arts, and their applications to Industry, to be called The Dargan Institute'. There would be difficulties later when the intentions of the Dargan Committee and the Irish Institution were at odds, but the main principle had been established – that art, rather than industry, should reflect Dargan's achievements. Plans for training intelligent working class boys were thrown to the winds. The opinions of Dargan himself, who was one of three vice-presidents of the first committee of the Irish Institution, are not recorded, but he must have been consulted.

The Irish Institution's further objective was to promote the public's interest in art, raise money and find paintings for a national collection. It was decided that annual exhibitions would be held. Through the good offices of the Royal Hibernian Academy, which offered storage facilities for any paintings acquired, and also allowed the use of its gallery, the first exhibition of the Irish Institution was arranged to take place in 1854.

The catalogue of this first loan exhibition described the objectives of the Irish Institution 'established 1st November, 1853 for the promotion of Arts in Ireland by the formation of a permanent exhibition in Dublin, and eventually of an Irish National Gallery'. This first exhibition of four was the easiest to plan, since those who had lent their pictures to the Industrial Exhibition, which had closed in November, were asked to leave them available for another show. A gratifying number of lenders agreed. The King of the Belgians let his paintings stay on, the Duke of Leinster's *Volunteers* by Wheatley were again on show, and the Lord Lieutenant's pictures made another appearance. Lord Charlemont, as President of the Irish Institution, lent thirteen of his paintings, including William Hogarth's *Gate of Calais* (Tate Britain) and *The Musical Concert* by Gerrit van Honthorst (1590-1656), then attributed to Caravaggio, which would enter the NGI nearly a century and a half later (NGI 4693).

The exhibition opened to the public at the end of January 1854 in the premises of the RHA in Abbey Street, and closed on 4 May. Mulvany, as secretary in charge of the sub-committee responsible for its organization, reported that 'it was deemed advisable to ascertain and fix the

lowest possible rate. For the first three weeks the charge was one penny on the first two days of the week and sixpence on the other four'.[9] A uniform payment of four pence was later demanded, with a penny for the evening showing.

In many ways the exhibition was a trial for the way the future national gallery would be run. The system of reserving the premises for students for copying on Fridays and Saturdays, and only allowing the public in on those days if they paid a shilling, was an idea of Mulvany's which he later used when the NGI opened. He was pleased to report that 'no less than forty-nine persons have been admitted as students or have availed themselves of their privilege as artists to copy in the gallery. Your Sub-Committee feels great pleasure in being able to state that many copies of great merit have been made'.[10]

The number of visitors was over twelve thousand, which was unsatisfactory. Mulvany considered that it was 'explained by first, the novelty of its object; secondly by the peculiarly inclement weather for a month or six weeks after its opening; and thirdly from…an impression that the exhibition contained only works with which the public had become familiar in the Great Exhibition of 1853'. This, wrote Mulvany firmly, was erroneous, although an examination of catalogues of both exhibitions shows how much they did overlap. Many members of the patient viewing public would have declined to trudge through wind and rain or take stuffy horse omnibuses whose floors were laid with straw to the corner of Sackville (now O'Connell) Street that led down to the classic fronted premises of the RHA in Abbey Street. But twelve thousand did so, and on sixty evenings a proportion of them came to pay a penny and see the pictures by gaslight. Towards spring, as the days grew long, the gaslight was discontinued.[11]

In following years three more of these exhibitions were held during the years of the 1850s, when the actual construction of the NGI was in doubt. In 1858, a memorial to the government requesting money for the gallery pointed out: 'that the humbler classes would be interested as well as benefited by such an institution is evinced by the circumstances that during the past two years in an inconvenient building out of reach of the mass of the population…several thousands of all classes have visited the exhibition at a graduated scale of payment'.[12]

After the closing of the first exhibition, by June 1854, an assortment of works of art had been acquired by the Irish Institution for the proposed gallery. Mulvany reported: 'towards the ultimate object, the National Gallery, some advance has been made.' The first painting was a modern

A Landscape with Fishermen, late 1750s by George Barret (1728/30-84). The first Irish picture acquired, presented 1854 (NGI 1909).

picture by two obscure Flemish artists, Victor Genisson (1805-60) and Florent Willems (1823-1905) of the interior of the Sint Pauluskerk in Antwerp (NGI 168). It had been won as a prize in the Irish Art Union by the 2nd Earl of Charlemont and passed on by him. The second, presented by Mr Thomas Berry, was *A Landscape with Fishermen* (NGI 1909) by the Irish artist, George Barret (1728/32-84), possibly one of those noticed by Sproule at the Industrial Exhibition.

William Anthony of London gave the Institution a painting of St Jerome copied from Guido Reni (NGI 1334), 'condition poor...a poor derivative..early nineteenth century in fabric.[13] Bartholomew Watkins, also of London, but formerly of Dublin (who, Strickland tells us, was a dealer and uncle of the landscape painter, Bartholomew Watkins[14]) presented a more interesting painting, then given to Ribera, now to the Neapolitan School, showing St Sebastian struck with an arrow (NGI 1377).

Mrs Carmichael of Rutland Square presented 'two marble statues of merit and value',[15] nineteenth-century Italian copies by Vanelli of ancient

statues, the *Crouching Venus* (NGI 8186) and the *Boy taking a Thorn from his Foot,* or *Lo Spinario* (NGI 8085). Unfortunately a large piece was missing from the base of the *Spinario*, and Mrs Carmichael would not find it for ten years. On 8 December 1863 the Registrar of the NGI, Mr Killingly, wrote to the donor 'to acknowledge the receipt of the communication of this date, enclosing the portion unfortunately taken off one of the Marble Statues which Mrs Carmichael has kindly given to this Institution'.[16] Today the *Spinario* is located between the Beit Wing and the Millennium Wing, and those passing him can see exactly where the piece has been stuck back on.

The picture fund raised by donations stood at £200. More was promised, plaster casts from Lord Cloncurry and a painting from Lord Talbot de Malahide yet to be named. (It never came).

More encouragingly, the paintings which had hung in the Viceregal Lodge, *Noah's Ark* by Pieter Boel and *David's Dying Charge to Solomon* by Ferdinand Bol, had been given by the Lord Lieutenant to the Institution for the Gallery when it came into being. A start had been made.

1 *Illustrated London News*, 6 Nov. 1853
2 'The Donation of Trust 29.3.1859'. See Catherine de Courcy , *The Foundation of the* NGI (Dublin 1985) p. 97
3 *The Times*, 22 Oct. 1853
4 *Evening Packet*, Nov. 1853, p. 13
5 Irish Institution Minutes, 1 Nov. 1853
6 de Courcy (as n. 2) pp. 3-7
7 Report of the Sub-committee and General Committee of the Irish Institution, 17 Nov. 1853
8 Report of the Building Sub-Committee of the Irish Institution, 8 Dec 1853
9 Report of the Sub-committee of the Irish Institution, 20 May 1854 (G F Mulvany)
10 *ibid.*
11 *ibid.*
12 Memorial by Members of the Irish Institution, Subscribers to the Dargan Fund and others interested in the progress of the Fine Arts in Ireland to the Lords Commissioners of Her Majesty's Treasury, June 1858
13 Michael Wynne, *Later Italian Paintings in the* NGI (Dublin 1986) p. 105
14 WG Strickland, *A Dictionary of Irish Artists* (Dublin 1913) vol. II, p. 504
15 Report of the Sub-committee to the General Committee of the Irish Institution, 20 June 1854
16 Damp Press Book. Henry Killingly to Mrs Carmichael, 8 Dec 1863

CHAPTER FIVE

THE PARLIAMENTARY BILL
AND MARSH'S LIBRARY SAGA

The heady optimism engendered by those first steps towards the formation of the National Gallery was increased by the decision of the Dargan Committee to hand over to the Irish Institution the £5,000 it had gathered by subscription. This was considered enough money for a 'plain' building to be constructed.

For a year after the Industrial Exhibition closed, the structure of wood, steel and glass which had been its premises was preserved as a winter garden before it was dismantled. The RDS needed part of the west side of Leinster Lawn for an important development of its own. By coincidence, the Society was about to build an enlarged Natural History Museum for its ever growing collection of geological and zoological specimens, mammals, birds, fishes, molluscs and giant Irish deer which were crammed into an inadequate museum in Leinster House.[1]

Having met amicably with the deputation from the Irish Institution, the general committee of the RDS assembled on 12 January 1854 to consider a plan for two parallel and symmetrical buildings stemming from Leinster House, the Museum to the south and the National Gallery to the north. This must have been discussed with the Irish Institution a month earlier, although there is nothing about it in the records.

Unlike the Irish Institution, the RDS had obtained public funding for its project, which meant that the Board of Works became involved in the Museum's construction. The Board's chairman was Richard Griffith (1784-1878), soon to be knighted, the brilliant Dublin-born geologist and civil engineer who had compiled the great Geological Map of Ireland and supervised the scheme known as 'Griffith's Valuation' which regulated property values and fixed taxation. He was closely associated with the RDS since he had been its Professor of Geology.

The concept of two similar buildings, Museum and Gallery, gracefully leading from Leinster House, both serving the public, appealed to members of a Society whose purpose was to foster the arts and sciences.

*Sir Richard Griffith (1784-1878), Geologist and Chairman
of the Board of Works, c.1854* by Stephen Catterson
Smith the Elder (1806-72), purchased 2003
(NGI 4722).

Again there is no documentary proof, but the idea was probably submitted by Griffith, and prompted by Frederick Clarendon, the official architect of the Board of Works, who was already working on designs for the Museum building.[2]

The general committee of the RDS 'read a Report from the committee appointed to consider the subject of the erection on the Lawn of the Society of the proposed Museum of Natural History and National Gallery accompanied by a ground plan of the same'.[3] The conclusions of this meeting must have been submitted to the Irish Institution, since each body went ahead with its individual legal and technical arrangements to advance these two buildings.

The Irish Institution required an Act of Parliament to establish the Gallery legally and to ensure that the site would be leased from the Herbert Estate in perpetuity, instead of only a hundred and eighty years which was the present arrangement. A Parliamentary Bill would have to be drawn up. The task of drafting such a bill would fall to John Pigot, assisted by his father, David Pigot.

Among those outside the Irish Institution who took a consistent interest in every stage of the proceedings were the Chief Secretary for Ireland, Sir John Young, and the Under Secretary, Colonel Thomas Askew Larcom.

Thomas Larcom (1801-79), another man of genius like Richard Griffith, was an engineer who is chiefly remembered for his work on the Irish Ordnance Survey which lasted from 1828 until 1845, and employed men of such calibre as John O'Donovan, George Petrie and Eugene O'Curry. By 1853, after a spell as deputy chairman of the Board of Works, Larcom occupied the most important position in Ireland. His superior, Sir John Young, spent most of his term of office living in London, leaving Larcom as Under Secretary to do much of Ireland's administrative work. In the midst of all his duties Larcom found time to direct the shaping of the National Gallery.[4]

At the Irish Institution both Pigots, father and son, and those in their confidence, were determined to keep their plans known to as few people as possible. There was debate at every stage about who should be let into the secret proceedings, and even some question as to whether the secretaries of the Irish Institution and the Lord Chancellor, Maziere Brady, would be taken into their confidence. David Pigot wrote to Larcom in June 1854: 'Do you see any objection to John Pigot speaking confidentially about the proposed plan to Mulvany and Stronge and to the Chancellor?…I think there may be an advantage in taking Mulvany

and Stronge into council – and their discretion may be fully relied on'.[5]

The 'proposed plan' was Griffith's inspiration. It was to transfer the contents of Marsh's Library in St Patrick's Close to the new National Gallery and to sell off the delightful little building beside the Cathedral. To most of those involved this seemed an eminently sensible idea.

Marsh's Library, established by Archbishop Narcissus Marsh in 1701 and built to the design of Sir William Robinson, the architect of the Royal Hospital at Kilmainham, is the earliest public library in Ireland. In the 1850s the building was in decay. The roof leaked, and it stood in the middle of a slum, beside a dilapidated St Patrick's Cathedral, away from the reach of most 'graduates and gentlemen' for whom its books were intended. Many of the books were missing. Nearby was a pharmaceutical factory which constantly threatened to set fire to it. The Treasury thought so little of it that it had recently refused a small grant to repair the roof.[6]

Interior of Marsh's Library, Dublin (©HLA).
The special character of the library, with its outstanding book collection from the 16th to 18th centuries and readers' cages, would have undoubtedly been lost had it been resited in the Gallery. The linking of art galleries and libraries is found in many 19th century civic collections.

So there was some justification for the general assent to this mongrel scheme and in July 1854 Griffith made a formal proposal to the Irish Institution.[7] Among those who approved the amalgamation of Gallery and Library was Maziere Brady, who, in addition to being prominent in the Irish Institution, and soon to become a Governor of the National Gallery, was also a Governor of Marsh's Library.

Letters in the NGI archives reveal that the Lord Lieutenant approved, Lord Talbot de Malahide fully concurred, while Young observed 'it is a pity to see such a Library as Marsh's in so dangerous a house, liable to fire, almost inaccessible, starving from poverty and in neglected solitude.'[8]

The transfer of the old library would encourage government funding. Young wrote that 'the Ld Lt has sanctioned by promise of 500 in aid of the plan of amalgamation and perhaps we could coax something more out of the Treasury – for so good an object'.[9] Larcom replied: 'I think the Govt might fairly step forward and find £5000 which L Talbot mentioned to the L.L. to join with the £5000 Dargan money for the erection and furnishing of a suitable building – Books below, Pictures above.'[10]

In the same letter Larcom considered the position of the RDS. 'At first sight there is an anomaly in bringing the library into such close proximity with the Royal Dublin Society and not combining the library with theirs. But they are a different class of books and Marsh's are open to the Public absolutely, whereas the Dublin Society Library is only open to Members. One is Public and the other Private Property'.

David Pigot wrote to Larcom of the importance of 'a good miscellaneous library accessible to the public at large' and proposed that the RDS might even like to incorporate its own library with the books transferred from St Patrick's Close. But he thought that the RDS was far more likely to object to the proposal altogether. Among members of the Irish Institution there was a schoolboy distrust of the RDS and a reluctance to have it involved in any of its affairs.

In mid-July 1854 John Pigot suggested a worst case scenario to his father, David Pigot: 'If, however, the RDS makes any serious attempt to control us or even to get so much as the shadow of a share in our concerns then certainly I should for one go to the length of preferring to give up that site' – on Leinster Lawn – 'altogether. And as the Dargan Testimonial people have all along had quite an equal suspicion of the RDS there would be no difficulty from them. I imagine even at the last moment if we are resolved to build elsewhere an arrangement which even as things are now has its supporters among us'.

In a later letter that same month, young Pigot commended Larcom's

forceful involvement. 'I am not in the least surprised at what Col Larcom suggests of probable difficulties to be expected on the side of the Dublin Society. But it is impossible that this branch of difficulty can be in better hands than his; for he will not yield anything without real effort and he will then yield just so much as and no more than is proper.'

The letters between members of the Irish Institution, the Chief Secretary, the Under Secretary and others involved in the progress of the National Gallery were collected by one of Larcom's secretaries and are preserved in two letter books in the NGI library. Involving the drawing up of the Bill for the establishment of the Gallery, the ironing out of the lease of Sidney Herbert's land and the fate of Marsh's Library, the correspondence gives a vivid idea of a coterie of intelligent minds pushing forward disinterested aims. It was unfortunate that things could go very wrong and that in due course some of the ablest men in Ireland would be described as 'a committee of gentlemen' who 'muddled and meddled'.[11]

Habits of secrecy continued, and ideas were shared very gradually. In July David Pigot was writing to Larcom that 'it would be very desirable that your views should…be mentioned to some of the members' – of the Irish Institution – 'I would mention Lord Meath; Stronge; Mulvany and perhaps my son (who though he does not like to have his name in print, takes a very active role in something about details) as persons to whom your views might be relayed and usefully disclosed…Of course the Chancellor will be apprised of whatever is suggested'.

By mid-July 1854 Larcom could send his superior, Sir John Young, a summary of the proposals that had been so cautiously broached to interested parties.

'After much consultation I think something like this will be the best arrangement for the Library and Gallery:

'A short Act reciting that it is desirable to remove Marsh's Library to a more convenient site, and to establish a National Gallery in Dublin…It would work in this way: The Board of Trustees could receive the Dargan money, the £5000 from the Trustees and the funds now possessed on which may be subscribed again to the Irish Institution, then Mr Herbert's land which it is thought the clause can be so passed as to enable him to sell; erect upon it the buildings, remove to it the Library and the Pictures etc. so the thing wd be in existence.

'Then for the working. There is a Librarian of Marsh's and he is provided with apartments. That body has a small fund which pays him £200 a year and leaves about £10 a year over. The Sale of the house' – Marsh's – 'might increase this fund which would give him some house allowance,

or purchase a small house, and there is one long empty in Merrion Square, the corner house looking east to both Square and Lawn. This provides for the Library'. (The ineffectual librarian of Marsh's, Mr Craddock, was wooed to the plan of transfer when he learned of the possibility of being housed in fashionable Merrion Square.)

Larcom continued: 'For the Gallery it would be necessary to have a Keeper or Sec., or officer of that class, perhaps an artist...and a porter or two. This, if the Gallery is to be open to the Public free, as the Library is, and I strongly recommend that it be so, the need met by some small government grant annually. If otherwise, entrance subscriptions, sale of Catalogues would probably suffice...'

'D.C.' (Dublin Castle). '7.o'clock. Dear Colonel Larcom, I got a friend to draw the proposal bill to enable Sidney Herbert to lease the Leinster Lawn and got Dr. Steel to insert the proper descriptions. You had left the Castle before I could get it finished and hope it will answer. Yours faithfully, John Lentaigne.'

Lentaigne, another energetic mind let into secrets, was a legal functionary involved in many aspects of public life. He had been on the Executive Committee and the Fine Arts Committee of the Industrial Exhibition, and was now a prominent member of both the Irish Institution and the Dargan Committee.[12] (That a number of influential gentlemen were associated with both bodies was an invaluable aid to agreement.)

Lentaigne's draft of the leasing bill is preserved, full of blots and crossings out:

'Whereas the Royal Dublin Society for promoting husbandry and other useful Arts in Ireland in virtue of a tenancy from year to year from the right Hon Sidney Herbert MP holds a certain piece of land in the city of Dublin known by the name of Leinster Lawn...'

Larcom worked tirelessly. David Pigot wrote to him on 20 July 1854: 'Your mode of doing things reminds me again and again of our ever lamented Drummond.' (This referred to the Under Secretary for Ireland, Thomas Drummond, who achieved a good deal before he died in office in 1840.) 'Everything you have done in these months appears to be right'.[13]

The Bill for the Establishment of the National Gallery of Ireland drafted by the Pigots, father and son, Lentaigne, Larcom and Young, with the advice, if not actual participation, of the Lord Chancellor, Maziere Brady, and numerous others, was put together in a hurry. The Parliamentary session at Westminster would end in August 1854 and those

concerned were anxious that the Bill should go through before a new session; any delay would give time and opportunity for members of the RDS and possibly some reactionary members of Marsh's Library to voice objections.

At a joint meeting of delegations of the Dargan Committee and the Irish Institution on 28 June, the Dargan Committee had accepted the proposals for the amalgamation of National Gallery and Marsh's Library. On 24 July, when the Bill was actually going through Parliament, the Committee resolved: 'That we have received with much satisfaction the communication made to this Committee by Lieutenant Colonel Larcom explaining the plan and views of the Government and their desire to cooperate with this Committee in the erection of a suitable edifice for the formation of a National Gallery…and other public purposes: and we fully approve of the proposed arrangements for that purpose.'

One burning consideration at the heart of the Dargan Committee was ignored: a preamble to the Bill by Maziere Brady mentioning Dargan's name was omitted. Lord Canning, the Prime Minister, wrote to Young: 'The National Gallery Bill will be read a third time on Thursday. I have not put in the words about W. Dargan in the preamble but I suppose you can do this in the Commons'.

Troublesome amendments would placate the RDS. The President of the RDS would become an *ex-officio* member of the Board of the National Gallery. Young introduced a clause which allowed the RDS to lease the entire Lawn from Herbert; after that, the Board of Trade and Navigation would give the Gallery its land and fix the rent. This condition introduced the Board of Trade and Navigation into the affairs of the National Gallery, something that Larcom had deplored. But this Board would be the means by which government funds would be obtained.

On 20 July, Canning introduced the Bill in the House of Lords for its first reading. A few days later John Pigot could write to his father, 'The Post and Packet of last night state in the Party Proceedings of Wednesday that Sir J. Young had introduced the Bill' (into the Commons).[14]

A small indication of the haste in which the Bill was drafted is in a plaintive communication from one of the secretaries of the Irish Institution. 'My dear Col Larcom, I hear from London that in the list of names proposed to be inserted in the Bill for the new Natl Gallery my name is printed *James* Calvert Stronge. It should be *John* Calvert Stronge. If the correction has not been made will you have it set to rights'.

The correction was made and Dargan's name was included in the preamble when the Act was passed in Parliament on 10 August : 'to provide

for the Establishment of a National Gallery for Paintings, Sculpture and the Fine Arts, for the Care of a Public Library and the Erection of a Public Museum in Dublin'.

Saunders News Letter wrote lyrically on the day before the Act was passed: 'Before a very great while elapses the beautiful and convenient site of the late exhibition will be occupied appropriately by its offspring, a temple for the cultivation of the abundant taste and genius of our public… Marsh's Library, at present buried in cobwebs and obscurity under the shadow of old St Patrick's, will be removed to the new building.'

The Act appointed five Building Trustees, including Griffith and Larcom, and named the seventeen members of the first Board of Governors and Guardians of the National Gallery of Ireland. There were five *ex-officio* members: the President of the Royal Dublin Society (Lord Carlisle, the Lord Lieutenant), its Senior Vice-President (Joseph Jackson), the Presidents of the Royal Hibernian Academy (Stephen Catterson Smith) and Royal Irish Academy (Thomas Larcom), with the Chairman of the Board of Works (Richard Griffith). The other twelve members of the Board were eligible to serve for five years. They included the first pair of artists, resident in Ireland, nominated by the RHA (George Petrie and George Francis Mulvany), government appointees (including Maziere Brady) donors who were elected, figures associated with the Irish Institution and members of the nobility. While elected members ended in 1871, otherwise the structure of the Board remains the same today, with ten members now selected by the government. It elects its own Chairman and can amend the Bye Laws.

Over the years this formula of providing a Board of seventeen professionals, collectors, business people and artists, has proved more or less satisfactory. Their considerable powers ranged from approving every purchase for the Gallery to the appointment of its Directors. Their relationship with their Director has always been of the greatest importance; sometimes they have given him great freedom to make decisions, at others they have restricted his wishes, causing much frustration.

In 1932 Thomas Bodkin summed up their position: 'distinguished peers, privy councillors, theologians, agriculturists, chancery lawyers, colonial administrators, chemists and Masters of Fox Hounds have brought unprejudiced minds and good business capabilities to the taste of raising our national collection to its present state of beauty and importance'.[15] (Although it must be said that in 1916 Bodkin told Lady Gregory that none of the Trustees knew anything about painting[16] and later, during controversy over the appointment of Lucius O'Callaghan,

Bodkin wrote: 'This Board was once, I am told, described by one of our former colleagues as the worst public Board on which he has ever sat'.[17])

The Irish Institution, many of whose active members were now on the Board of the budding National Gallery, continued under the direction of Mulvany to hold loan exhibitions until 1860 when it disbanded.

The Royal Dublin Society was empowered to lease a portion of Leinster Lawn to the Gallery in the name of the Building Trustees, and to build its Museum, which it would do promptly. After the laying of the foundation stone in March 1856 by Lord Carlisle, the Natural History Museum was completed in fifteen months at a cost of £10,000. It would open its doors sensibly on 31 August 1857 without any orchestras or choruses or lengthy speeches, but with a lecture by the great Scottish missionary, David Livingstone, on recent African discoveries.[18]

The surviving interior of the 'Dead Zoo' with its crowded displays of stuffed creatures, an exuberant demonstration of Victorian method, has no bearing on the story of the National Gallery. But when the Gallery was eventually completed, its exterior, a long barrack of cut stone, finely dressed granite and moulded Portland stone with blank niches set in its sides, would duplicate Clarendon's austere design of the Natural History Museum. Not everyone approved; one critic thought the Museum 'an ugly blank wall', another 'a moping staring cold strip of granite'.[19]

The National Gallery of Ireland, ostensibly an identical building, would not open until 1864, seven years after the Natural History Museum, and it would cost nearly three times as much.

In 1854 there was no indication of the difficulties that lay ahead. The plans seemed straightforward. The Trustees of Marsh's Library would remain independent. Not one of the intelligent gentlemen involved with the plans foresaw that the inclusion of the Library in the NGI and the problems of allowing space for both would cause problems of design.

One absent voice in all the long and secretive negotiations was that of the general public. Twelve years later, when the NGI was at last nearing completion, a letter in the *Irish Times* in 1862 expressed the absurdity of the concept of combining a gallery and a library. 'A library of old fossil divinity attached to a collection of pictures, statues and other works of fine art! Since, as we read in Virgil, the Latin king punished his subjects by tying living men to dead bodies, we have never heard such an extraordinary combination...It is positively ruinous to the gallery and it is equally to the library'. However, at the time this letter was published, Benjamin Lee Guinness was coming to the rescue of Archbishop Marsh's Library when he included it in his generous plan to restore St Patrick's Cathedral.

But a decade earlier, the plan of uniting gallery and library nearly shipwrecked the whole enterprise.

The newly appointed Board of Governors and Guardians of the National Gallery rested for a few months after the Bill was passed before calling its first meeting on Saturday 13 January 1855, in the premises of the Royal Hibernian Academy in Abbey Street. Present were: the Lord Chancellor in the Chair, the Earl of Meath, Lord Talbot de Malahide, Sir George Hodson, Bart, Richard Griffith LlD, J Calvert Stronge, Robert Callwell, John Pigot and George F. Mulvany.[20] George Petrie, whose attendance would be intermittent, was absent. So was William Dargan, who had been elected to the Board, but never attended a meeting. The Board resolved that a Minute Book should be purchased, which would be kept in immaculate copperplate by the Secretary, Mr Henry Killingly.

More important was a formal action by the Chairman of the Board of Works: 'A plan for the proposed National Gallery and the Museum of the Royal Dublin Society was laid upon the Table by Dr Griffith'.[21]

1 CE O'Riordan, *The Natural History Museum Dublin* (Dublin 1983) pp. 11 *et seq.*
2 Catherine de Courcy, *The Foundation of the NGI* (Dublin 1985) p. 15
3 Proceedings of the Royal Dublin Society, 12 Jan. 1854
4 de Courcy (as n. 2) p. 17
5 David Pigot to Larcom, 12 June 1854. Letters quoted in this chapter are from the first Letter Book in the NGI archive
6 Sir John Young to Thomas Larcom, 29 June 1854
7 Memorandum upon the Establishment of a National Gallery in Dublin in the same Building with a Public Library, 11 July 1854
8 Sir John Young to Larcom, 29 June 1854
9 *ibid.*
10 Larcom to Young, 3 July 1854
11 WG Murray, Paper read to the Royal Institute of Architects of Ireland, March 1864.
12 de Courcy (as n. 2) p. 95
13 David Pigot to Larcom, 20 July 1854
14 John Pigot to David Pigot, undated
15 Thomas Bodkin, *Hugh Lane and his Pictures* (Dublin 1932) p. 43
16 Lady Gregory, *Journals* (ed. Daniel J Murray) vol. 1 (Gerrards Cross 1978) p. 6
17 Bodkin ms Trinity College Dublin 6961-88
18 O'Riordan (as n. 1) p. 20
19 *The Warder*, July 1856
20 Minutes of NGI Board, 13 Jan. 1855
21 *ibid.*

CHAPTER SIX

BATTLE OF FIVE ARCHITECTS

At that first meeting of the Board of Governors and Guardians of the National Gallery of Ireland, a memorial to the Treasury was composed requesting a further £6,000 in addition to the £5,000 supplied by the Dargan Fund. It was recognised that the Gallery 'including as it does the removal of a large free library to a more convenient part of the city' would cost more than the Natural History Museum because it would be forty-two feet longer. Although the buildings were parallel to each other, they were not at right angles to Leinster House. Taking into account this discrepancy, 'it is estimated that it may be completed for the sum of eleven thousand pounds, including all the fittings necessary for the purpose to which it is to be applied'.[1] The estimate, all too optimistic, was Griffith's.

The memorial was favourably received by the Treasury and the Minutes of 4 June 1855 record that Larcom had written that day to the Lord Chancellor: 'I am desired by the Lord Lieutenant to acquaint your Lordship for the information of the Governors and Guardians of the National Gallery that their Lordships will propose a grant of £3,000 in the present session of Parliament for the erection of the proposed building and a Second Grant of equal amount in that of next year'.

George Mulvany was chosen as designer of the interior of the new Gallery. The decision to appoint Mulvany, the Honorary Secretary of the Board as well as of the Irish Institution, was probably one of expediency, a means of cutting costs. There may have been an idea among the Building Trustees on the Board that he would informally consult his brother, an architect of great ability, John Skipton Mulvany (1812-71). His designs included the Royal St George Yacht Club at Kingstown (now Dun Laoghaire) and Broadstone Railway Terminus, which Maurice Craig has described as 'the last building in Dublin to partake of the sublime'.[2]

There is no evidence that George Francis Mulvany sought his brother's advice about his designs, some of which are preserved in the

*Transverse section through the hall and staircase
of the proposed NGI, 24 March 1856 ink and wash
drawing by George Francis Mulvany (1809-69),
transferred from the National Museum of
Ireland, 1980 (NGI 18098)*

NGI. On the ground floor would be a sculpture hall and library and above this two picture galleries. An elaborate vestibule with columns supporting a balcony which would lead to the picture gallery protruding to the north would contravene the slender design of Clarendon's Museum.

On 5 November 1855, 'Mr Mulvany submitted a series of plans for the internal arrangement of the National Gallery as approved in committee'. It was resolved 'that the Board approves generally of the Plans laid on the Table by Messrs Mulvany, Stronge and Pigot' (members of the Building Committee) 'and that Lord Talbot de Malahide, Mr Mulvany, Mr Stronge and Mr Pigot be appointed a Committee of the Board to communicate with the Board of Works and with the Building Trustees, and to carry out in conjunction with them all arrangements requiring the sanction of this Board respecting the execution'.[3]

The plans were then shown to the governors of Marsh's Library, who, on Easter Monday 1856, also resolved 'that the Trustees approve generally of the plans now submitted and of the arrangement proposed for the accommodation of the Library and of the removal of the Library to the proposed Building when completed'. Yet another committee would be set up 'to see to the security of the Books from damp'.[4]

The Dargan Committee, headed by Lord Talbot de Malahide, also approved. It seemed that building could begin immediately and the Gallery would be completed a little after the Museum, which was already under construction.[5]

Most of those to whom Mulvany's plans were shown were not qualified to judge them. But when Griffith, who was an engineer, studied them, he realised that something was wrong. He showed them to Jacob Owen (1778-1870), the chief architect of the Board of Works, who was horrified. Owen found himself 'greatly embarrassed'[6] when on 4 March 1856 he sent Griffith a devastating report detailing Mulvany's deficiencies.

'For the purpose of the Exhibition of pictures etc. I have no doubt but the rooms are well adapted, but the drawings which I have seen are so unfinished and shew so manifest a want of experience in the treatment of many important practical points that I venture to hope Mr Mulvany has already discovered the difficulties with which the task is surrounded and will be induced to abandon the office he has undertaken in so liberal a spirit'.

Mulvany had vague but lofty ideas about the roof of the building. 'As a sanction for his plans...Mr Mulvany referred to the roof of the Cash Office in the Bank of Ireland which I inspected with him, but this is a construction so costly and injudicious as to preclude its adoption as a

precedent'. Owen concluded that the details of the plans 'are so imper-
fect that no prudent Builder would undertake a contract on a document
so defective in necessary information, or if he did it would open a door
to extra claims that would be found very embarrassing'.[7]

On 5 March 1856 Griffith sent the report to Larcom in panic. 'My dear
Larcom, In regard to the National Gallery we are still in a very unfinished
state. I think the general design and arrangements are good. Mr Owen
objects much to the construction of the Roof and the general fittings (?)
throughout'.[8]

Owen was the first to point out that the 'inequality of the site is a
matter of importance and appears to be such as to render a basement
storey indispensable'. He considered the matter of expense and con-
cluded that a building erected according to Mulvany's specifications,
including heating, ventilating and library fittings, would cost £22,000.
Griffith, who had put forward the original estimate of £11,000 to the
Treasury, commented to Larcom that Owen's new rough estimate was
'startling'. Only a month before, Mulvany had shown the Board a letter
from the contractors, Messrs Cockburn and Son of New Brunswick
Street, 'giving a probable estimate for the proposed National Gallery
according to the plans submitted for the sum of Twelve Thousand
pounds'.[9] Griffith concluded his covering letter to Larcom, 'of course
you will not mention Owen's report to anyone but the Chancellor, as it
would cause a blow-up if made public'.

He himself moved cautiously. At the next Board meeting he kept
silent on Owen's conclusions but 'brought up a Plan for the roof of the
Picture Gallery designed by Mr Clarendon in order to avoid expense'.[10]
This was not followed up, nor were the shortcomings of Mulvany's
plans discussed openly, although Mulvany must have been made aware
that they would have to be radically amended. It was then decided, most
probably by Griffith, to put them in the hands of the most prominent
architect in Ireland.

Charles Lanyon (1813-89), an Englishman based in Belfast, had been
employed as County Surveyor for Antrim. During his career he designed
roads, bridges, viaducts court houses, churches, banks, country houses,
fever hospitals, lunatic asylums and other public and private buildings.
Queen's University, Belfast, in Tudor Revivalist style is one of his achieve-
ments, but he was equally at home turning out classical, neo-Palladian,
Jacobean, Early English and Decorated Gothic structures. Recently he had
completed the Campanile in the Front Square of Trinity College in Dublin.
He was, co-incidentally, married to Jacob Owen's daughter, Elizabeth.[11]

He must have been contacted quickly. By 9 July he was writing to Griffith: 'We are preparing the sketches for the National Gallery but the more I think of it the more I am persuaded that the Entrance should be at the end'. Griffith sent this note on to Larcom. 'I fear we shall have great difficulty in changing the general features of the design, by entering from the Merrion Square end, but we shall see when the designs and sketches are forwarded'.[12]

These were presented to the Board just over a week later on 17 July by Lanyon's partner, William Lynn (1829-1915). Griffith instructed Lynn to show them to Larcom, sending him to Dublin Castle accompanied by a worried note. 'My dear Larcom, Mr Lynn, Mr Lanyon's Partner has brought up two designs for the National Gallery both of which have merit, but neither can be adopted without considerable modification... they are both far too expensive'.[13] Both plans involved enlarging the proposed building.

On 24 July Lanyon himself came down from Belfast and 'submitted a Plan for the proposed National Gallery and Public Library with an approach from Merrion Square'.[14] The Board took nearly a month to make up its mind, and there was disagreement among the Governors over the merit of the design. Griffith reported to Larcom: 'I regret to find the Chancellor clings to the central entrance which I think very objectionable in many respects, at the last meeting he had adopted the Merrion Square entrance. A petty feeling of jealousy is acting among us and he may have been influenced but I know him to be a just and right minded man and will act to the best of his judgement'.[15]

Lanyon was instructed to make changes; he brought the plans with the Merrion Square entrance included to a tense meeting of the Board held at the Chief Secretary's office, Dublin Castle, on 21 August. John Pigot, who was a Building Trustee, refused to attend, sending a letter 'entirely disapproving of the Plan submitted by Mr Lanyon and suggesting the adhesion to the plans already adopted'.[16] (These, of course, were Mulvany's.)

'After much dissension', during which doubters like the Lord Chancellor must have been persuaded, 'the general principle of the latter (ie Lanyon's plans) was adopted'. The Minutes continue: 'The Lord Chancellor, Colonel Larcom, Dr Griffith and Mr Mulvany were requested to act as a Committee to obtain matured plans from Mr Lanyon to be brought before the Building Trustees'.

The bold decision taken by the Board at this time was reinforced by the fact that the Dargan Committee, which had previously been hesitating

about giving its promised £5,000 to the Irish Institution, had finally been persuaded to accept that the new 'Temple of the Arts', as it was later described by the *Mail*,[17] would be called the National Gallery of Ireland and not the Dargan Institute. After a debate that had lasted almost two years, a compromise had been reached. The Governors and Guardians insisted on the name 'National Gallery of Ireland', which had been confirmed by Act of Parliament, but allowed that 'the great Hall', the principal feature of the intended Building, be called the Dargan Hall'.[18]

For years afterwards there were people who regretted the decision. Among the most recent has been James White, who suggested that if the Gallery had been called after Dargan it might have got wider recognition and not been seen for many years as a second rate imitation of the institution in Trafalgar Square in London.[19]

Dargan would also be acknowledged by the portrait painted by Stephen Catterson Smith RHA, a 'bust or statue' (originally planned to be inside the building), and by an inscription which 'should be placed on a Tablet outside the Building in a suitable and appropriate situation', as was done.

The Dargan Committee handed over the £5,000 and agreed to Lanyon's modified plans. The Board of Marsh's Library also agreed. Lanyon and Lynn set to work. From Belfast Lanyon wrote to Griffith on 2 September: 'We hope to be able to send you on Wednesday or Thursday some tracings showing the arrangement of the staircase and hall. We are very anxious to make the Hall very effective, but do not think it is desirable to make the staircase a too important feature, thereby sacrificing the utility of the Hall'. Previously Lanyon had deplored Mulvany's plans for a large 'vestibule'.[20]

'We think the building of the End next Merrion Square…will be an advantage in completely concealing the rere of the building, and at the same time affording an opportunity for gaining increased accommodation, without any very general addition expense..making it quite subservient to the main building. This enables us to put the Board Room etc into this rere wing and thus throw the whole half of the front building into the Sculpture Hall which may be made a very fair room, but a good height by descending stone steps between the columns... Then the space over the Board Room makes an excellent watercolour gallery and this connected with the front gallery as shown completes a circuit from the grand entrance hall'.[21] On 9 September Lynn sent down the tracings, a 'Plan coloured red' and a 'Blue plan' together with new ideas and alternatives, including the acquisition of No 88 Merrion Square.

Griffith was alone among the Governors in recognising that Lanyon's proposed alterations to Mulvany's design were far too ambitious and costly. Increasingly alarmed, he consulted the contractors, Cockburn and Son, who were building the Natural History Museum. They estimated Lanyon's plans would cost £27,000, or £6000 more than those of Mulvany.

In an undated letter in October Griffith complained to Larcom: 'I have cautioned and recautioned Lanyon regarding expense in his plans, but he said to carry out the entrance from the centre and make a handsome Hall and staircase suited to the entrance to a building two hundred and fifty feet long, little less that would be suitable could be done'.[22] Griffith concluded with his own ideas: 'at the present time the design should be limited to an oblong building without any project for a staircase behind and…the entire of the rere…should consist of good masonry'. He desperately wanted to reduce costs so that 'the building might be erected and a sufficient portion completed for say £12,000 or £12,800'.

On Christmas Eve 1856, at a special Board meeting held at Dublin Castle, 'Dr Griffith undertook to have further calculations made as to the cost of the proposed building substituting a temporary staircase at the rere for the proposed permanent structure.' A sketch of this staircase had been sent to Larcom; Catherine de Courcy has commented that this 'could not have been much more than a ladder.'[23]

When Griffith's amendments to Lanyon's plans were finally considered at a Board meeting on 9 February 1857, they were accepted by a Board which was still ignorant about costs. It was resolved: 'That the plan now presented to this meeting by the Building Trustees be adopted as those according to which the National Gallery shall be erected so far as the Building is represented thereon, with the temporary staircase shewn in the Plan'.[24]

A special meeting was called in Larcom's office in Dublin Castle on 18 March 'for the purpose of opening several tenders received from parties willing to undertake the erection of the National Gallery according to the approved design of Mr Charles Lanyon..modified by him with a view to reduce the expense as far as is compatible with the objects prposed'. Griffith must have known what to expect when the envelopes were opened. Of the submissions of six contractors, the lowest, from Cockburn and Son, was £19,464.

The conclusion of the meeting was melancholy. Griffith signed the report on behalf of the Building Trustees which was read to the Board on 20 April, declaring that they 'are of opinion that before entering into any Contract it will be necessary that an additional sum of about £12,000

should be provided so as to insure the completion of a building to suit the combined purposes for which it is intended'.[25]

Lanyon had no problem in explaining why the Gallery and Library should cost so much more than the Museum across the Lawn, now well on its way to completion. From Belfast on 28 March he wrote to Griffith:

'On comparing the dimensions of the two Buildings, the cubical contents stand thus, viz as 807,000 to 592,000 cubic feet. Taking the cost of the Museum Building at £11,000, the relative cost of the National Gallery should be £15,000, or £3,400 more than the former'.

He listed and justified additional expense: extra foundations, lining walls hollow brick, inside plastering, extra length of main cornice, and cost of internal cut stone work. He concluded: 'Having considered …what reductions could be made…I do not see what can be taken off without very seriously affecting the character of the building except the following, viz:

'Lining of Sculpture Gallery and Library with hollow brickwork – £650

'Substituting plain screed wall between Picture Gallery and Staircase – £338.' That made the total savings £988, which would bring Cockburn's tender down to £18,476. But £5000 extra would be needed for 'furnishing the fittings of Library and for improving staircase, building board room, erected heating apparatus etc.'

Lanyon's letter concluded brusquely: 'Funds in hands of Trustees say £11,000. Required to complete say £12,500. I am, dear Sir, Yours faithfully, Charles Lanyon'.[26]

In desperation the Board turned to the Treasury for more money. On 20 April the Lord Chancellor signed a memorial asking for a further grant 'of at least £12,000'. Naturally there was no mention of Lanyon's extravagant designs. Instead blame was apportioned to the difficult site, the extra foundation works necessary, and the central hall of entrance with its wretched 'suitable staircase'. In addition there were on the Museum of Natural History 'expensive additions of a decorative character' – the sculptural panels depicting Neptune, a dolphin, a serpent, a crocodile, Minerva, an orang-utan and other motifs which, they declared, they would have to match.

The Board was kept waiting for months. Discouragement was compounded when Larcom received an interim report (NGI Archive) from one Mr G Lewis, a Treasury official who suggested that the Gallery was too ambitious altogether, that all Dublin needed was a small plain building, and that there was no need for the amalgamation with Marsh's Library.

In June 1857, Griffith went to London for a series of dispiriting interviews with James Wilson, Secretary of the Treasury. From the plush interior of the Athenaeum he reported ruefully back to Larcom on 6 June that 'Wilson says, and no doubt says truly, that a detailed plan and estimate by a competent architect should have been obtained before any application was made'. The Treasury was particularly displeased, because by this date Mulvany, as will be subsequently related, had already asked it for a large sum of money to buy paintings. Wilson, wrote Griffith, 'said further when are you to procure pictures to cover your walls, if the building was completed?, The Treasury cannot undertake to furnish and support provincial galleries'.

Griffith concluded: 'I think I have made some impression in regard to the necessity of the case and I must leave him time to chew the cud...This is a disheartening communication but I hope for the best…'[27]

When Griffith saw Wilson again on 10 June, he told him that the 'Lord Chancellor says he will engage, if the money to be now granted for the Gallery building, that no application for a grant of pictures will be made. He looked doubtful, as much as to say I do not believe you. I then said do not hesitate as we must have sufficient money to build the Gallery and are confined to a position by an Act of Parliament...on leaving I said make up your mind to ask for the money for we must have it and you will gain credit with us all, he laughed but did not say he would…'[28]

Griffith then 'waited on' Lord Palmerston, who 'expressed himself in a friendly manner', but said, 'in the present transfer of Parliament it would be impossible to carry grants for local establishments'. Griffith told him of his dealings with Wilson, 'at which he laughed and said he was difficult to move…his Lordship…did not pledge himself to move on it'.[29]

The formal reply from the Treasury to the Board came two months later in a letter dated 26 August 1857 and signed by Wilson. 'I am commanded by the Lords Commissioners of Her Majesty's Treasury that, as the grant of £6,000 for that institution was made on the distinct understanding that it would be final, my Lords regret that they have not felt themselves warranted in applying to Parliament for a further grant'.

In vain the Board appealed 'very respectfully'; Wilson replied: 'my Lords regret…' In vain Larcom recruited the Lord Lieutenant to the cause. The Treasury was unmoved.

The project was stalled for many months amid disagreement, acrimony and objections to the design of the building. In autumn 1857 the Irish Institution, which had gone side by side but separately from the Board of the Gallery since August 1854, began organising a memorial of

its own in support for further funding. This met with discouragement, as various peers who were approached refused to sign. Moreover there were new objections from the RDS, to Lanyon's design for the building.

Nearly a year had passed since the Board had approached the Treasury for extra funding when over in London, in February 1858, Palmerston's Whigs were defeated. An unstable Conservative government headed by Lord Derby came into office.

Suddenly it seemed possible that the new government might prove more flexible in funding Dublin's unbuilt National Gallery. The memorial organised by the Irish Institution became important as it arranged for the most important of its members to go to London and plead the cause. On 24 June 1858, 'a very numerous and influential deputation waited upon the Chancellor of the Exchequer…for the purpose of bringing under his notice the establishment of a National Gallery of Art in Dublin in connection with the Dargan Fund'.[30]

The Chancellor was Benjamin Disraeli. The deputation, headed by Lord Talbot de Malahide, included twenty-six Irish MPs who represented twenty-six valuable Parliamentary votes for Lord Derby.

The Packet explained the situation succinctly in an editorial. 'Especially as respected Ireland, the Whigs were insensible to every claim of ours for the slightest advantage. They scoffed at us; they did not care a jot for our welfare; they took no interest whatever in our affairs. Being independent of Irish votes, or conceiving themselves so, they had not the remotest notion of perplexing themselves with our business....The existing cabinet, we are happy to say...have an active sympathy with provincial interests and are particularly anxious to serve Ireland....it is with extreme satisfaction we can announce that the honour of establishing a National Gallery of the Fine Arts in Ireland has been reserved for the Conservative Cabinet'. *The Packet* reported the interview in detail. 'After Lord Talbot de Malahide had stated at length the claims of Ireland for Parliamentary assistance in raising her National Gallery, and after other members of the deputation had enforced their views, the Chancellor of the Exchequer at once replied congratulating the noblemen and gentlemen present on the happy change that had taken place in Ireland…Formerly Irish gentlemen came to London to exhibit an endless chain of grievances; now they sought the advancement of their country in commerce, in manufacture and in art...He (the Chancellor)…would propose such a sum in the estimates as would accomplish the object desired, namely, the erection of a building in Dublin in every way suitable for a National Gallery of Art. Of course the deputation withdrew highly satisfied'.[31]

An editorial in the *Freeman's Journal* commented on how 'great favours, accompanied by rudeness in the giver, lose half their value, while small favours, gracefully conferred, are enhanced beyond their intrinsic importance. The reception of the Irish deputation by the Chancellor of the Exchequer...was an illustration of a small favour gratefully accepted because gracefully conferred...Mr Disraeli is one of those men who know how to improve a situation by "unbought courtesies" which are often overlooked by statesmen'.[32]

The delegation was extremely fortunate with its window of opportunity, since in less than a year Lord Derby's government would fall, Irish votes would become unimportant, and the courteous Mr Disraeli would no longer be in a position to dispense his largesse.

There was now enough money to carry out Lanyon's designs. But objections to them continued. In February 1858, David Pigot complained that they were 'deficient and objectionable both in point of taste and convenience...the plan of the entrance is extremely mean...the position of the proposed staircase particularly ill-judged, both with reference to the general management of the buildings as a matter of taste, and to the approach to the galleries of painting as a matter of convenience'. Pigot was overruled. and Lanyon's new plans were adopted by the Board at the same meeting.[33]

It may be that Pigot made a private complaint to Sir Henry Cole, Secretary to the Department of Science and Art, which since 1857 was responsible for museums and galleries in Great Britain. For whatever reason, perhaps further unease at Lanyon's potential for extravagance, in May 1858 Cole called on one of his own architects with a reputation for cost cutting to look into the plans for the Gallery.

Captain Francis Fowke of the Royal Engineers, a native of County Tyrone, was commissioned to write a report (copy in NGI Archive) which was sent to Lord Salisbury the Prime Minister on 22 September 1858.

Fowke was one of those wayward geniuses thrown up by the Victorian age, an engineer, architect and inventor. In 1857 he had been working on the South Kensington Museum where he had completed the Sheepshank Gallery in under a year, introducing the most modern developments of gas lighting, fireproof flooring and overhead lighting. These were elements that he would repeat in the National Gallery of Ireland, creating one of the most technically advanced museums in the world.

In his report to Lord Salisbury, Fowke condemned Lanyon's grand hall and contentious staircase. 'It has been introduced simply for the sake of

forming what the Architect termed a feature'. His simple solution was to incorporate the double staircase into the Sculpture Gallery. Outside, Fowke would keep the dimensions of the new building almost the same as the Museum building, disguising the difference in a way that would be barely noticeable. The lower ground floor would have storage space for pictures and rooms for the resident porter. In the sculpture gallery Lanyon's elaborate pilasters would be replaced with freestanding Corinthian columns containing an entablature concealing the ventilation system. The hall would be lit by six gas burners of sixty lights each. The main picture gallery upstairs, to be known as the Queen's Gallery, would have no windows but overhead natural lighting, what Fowke called 'horizontal light'. After dark it could be lit by two thousand gas jets suspended from a massive rectangular frame.

Fowke's ideas were accepted with relief and some satisfaction; Mulvany went so far as to suggest that they were similar to his own designs. No objections were raised by the Board of Governors, the Royal Dublin Society, the Dargan Committee or Marsh's Library, all of whose members were presumably weary of the whole project. Lanyon was dismissed with a payment of £600 for work done. There is no need to be sorry for him. His practice would continue to flourish and he would be knighted in 1868.

Messrs Cockburn and Son were contracted for the building. Mr Balfe of the Royal Horticultural Society was asked to supply marquees, and a silver trowel was procured and engraved. On 29 January 1859, the first stone of the National Gallery on Leinster Lawn was laid by the 13th Earl of Eglinton, who was Lord Lieutenant during Lord Derby's brief administration. A written record of His Excellency's 'gracious participation in the work of this day' in the shape of a glass globe containing a circular copper plate was deposited in a cavity of the stone.[34]

The work Fowke did on the Gallery is to be seen in the 194 detailed drawings and plans by him and his chief draughtsman Henry Snell, which were transferred to the NGI from the National Museum in 1980.[35] They cover many aspects of his designs, including the ornamental work on the entrance gate, details of elevation, iron stanchions for the sculpture hall, the tiled paving, the roof ventilation and water pipe casing.[36]

Contrary to the assumed estimates in his report, Fowke's changes did not come cheap, and when the building was completed and sums totted up, his plans actually proved to be more expensive than those of Lanyon. To the annoyance of the Treasury, by the end of 1864 the building had cost £22,483, and additional parliamentary grants for 'internal fittings

etc.' brought up the cost to £24,396. With the £5,000 from the Dargan Committee, the total cost of the Gallery was nearly £30,000 .

However, the Board of Governors and Guardians of the NGI had reason to be satisfied. Since Fowke had taken charge, the cost of the building was no longer their responsibility. They had their Gallery at last.

There is no form of commemoration to Fowke in Dublin. Before he died at the age of forty-two, the year after the NGI was inaugurated, he had invented a military engine made to limber up like a field gun, and the folding camera on the concertina principle which was in use for many years, well into the twentieth century. He had also designed the Royal Albert Hall.[37]

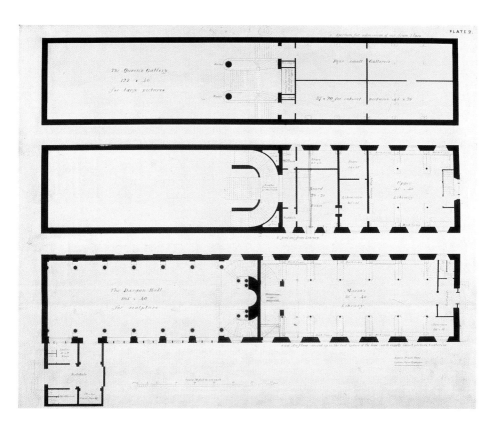

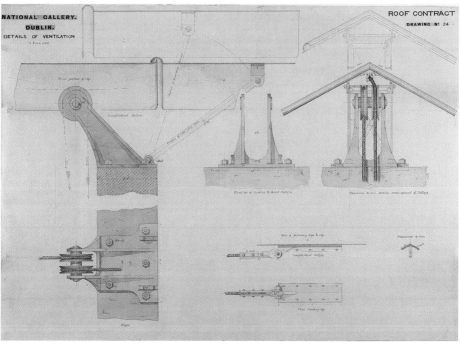

1 Minutes of NGI Board, 13 Jan. 1855
2 Maurice Craig, *Dublin 1660-1860* (Dublin 1952)
 p. 300
3 Minutes, 5 Nov. 1855
4 Minutes, 7 April 1856
5 Catherine de Courcy, *The Foundation of the NGI*
 (Dublin 1985) p. 32
6 Jacob Owen to Richard Griffith, 4 March
 1856. Letters quoted in this chapter are from
 the first Letter Book in the NGI archive.
7 *ibid.*
8 Griffith to Larcom, 5 March 1856
9 Minutes, 4 Feb. 1856
10 Minutes, 28 May 1856
11 Paul Larmour, 'Sir Charles Lanyon',
 The GPA Irish Arts Review (1989-90) pp. 200-06
12 Griffith to Larcom, 9 July 1856
13 Griffith to Larcom, 17 July 1856
14 Minutes, 24 July 1856
15 Griffith to Larcom, 14 Aug.1856
16 Minutes, 21 Aug. 1856
17 *The Mail*, 5 Dec. 1863
18 Minutes, 23 June 1856
19 James White, *The National Gallery of Ireland*
 (London 1968) p. 7
20 Lanyon to Griffith, 2 Sept. 1856, quoted in de
 Courcy (as n. 5) p. 37
21 Lanyon to Griffith, 2 Sept. 1856
22 Griffith to Larcom, undated, quoted in de
 Courcy (as n. 5) p. 38
23 *ibid.*
24 Minutes, 9 Feb. 1857
25 Minutes, 18 March 1857
26 Lanyon to Griffith, 28 March 1857
27 Griffith to Larcom, 6 June 1857
28 Griffith to Larcom, 10 June 1857
29 Griffith to Larcom, 27 June 1857
30 *Daily Express*, 24 June 1858
31 *The Packet*, 24 June 1858
32 *Freeman's Journal*, 25 June 1858
33 Minutes, 6 Feb. 1858
34 Minutes, 22 Jan. 1859. Address to His
 Excellency Archibald William, Earl of
 Eglinton and Winton
35 Minutes, 8 Feb. 1980
36 *NGI Illustrated Summary Catalogue of Drawings,
 Watercolours and Miniatures* (Dublin 1983)
 pp. 146-70
37 *DNB* vol. VII, p. 521

CHAPTER SEVEN

INITIAL ACQUISITIONS AND ADUCCI PICTURES

In 1854 the Irish Institution had received an important gift for the proposed new National Gallery. Captain George Archibald Taylor, who died in that year, bequeathed his collection of watercolours to be used by his executors 'in such a manner as they may deem fit for the encouragement of Irish art'. He also left £2,000 to be invested for the promotion of Irish art and industry. This would be used to fund the Taylor Scholarship and art prizes promoted by the RDS with which the Directors and Governors of the NGI are still associated.[1]

Taylor's wistful portrait in uniform (NGI 521), attributed to Thomas Jones (1823-93), came into the NGI in 1901.[2] Little is known about him apart from his taste; his eighty watercolours, from an original one hundred and five, are by contemporary English and Irish artists. They include two of James Mahony's detailed views of the Irish Industrial Exhibition of 1853, and a remarkable panorama of Dublin which the artist painted in the same year, having climbed the spire of St George's church in Hardwicke Place (NGI 2450). In the distance the glass dome of the Exhibition can be seen. Many remember it hanging in the front hall when James White was Director.

Taylor's watercolours were exhibited for the first time in the Irish Institution's second exhibition held in 1854. But much more was wanted. Few European galleries had been established with such meagre resources. The Prado, the Louvre and the Hermitage received magnificent paintings from the royal collections, while the National Gallery in London started with the Angerstein Collection bought in 1824 for £57,000 by Lord Liverpool's government. Although Dublin could not begin to expect such bounty, the projected NGI suffered from the outset by being regarded as a provincial gallery of the British Isles. With regard to gifts it did far less well than the new Scottish National Gallery at Edinburgh. Considering how many owners of big Irish collections had displayed their paintings in the Irish exhibition of 1853 and at other venues, the NGI

Sir Maziere Brady (1796–1871), Lord Chancellor of Ireland. Posthumous portrait, c.1872 by Thomas Jones (1823–93), presented 1874 (NGI 132).

singularly lacked generous donors.

Paintings were gathered painfully slowly. In 1855 the Irish Institution was given on behalf of the NGI a donation of five pictures[3] by Mr Robert Clouston of Dublin; only one is of interest, a Flemish farmhouse scene with figures enjoying a meal (NGI 340) by David Ryckaert III (1612-61).[4] The Institution also made its first purchase, a portrait of a Burgher by Philips Koninck (NGI 329) for £42 from the dealer, Bartholomew Watkins, who had presented the *St Sebastian* (NGI 1377) a year earlier. It was later catalogued by Walter Armstrong as being in the style of Salomon Koninck and today thought 'not of very good quality'.[5] In 1857 John Calvert Stronge presented a little classical scene of Greek deities (NGI 341) then attributed to the Utrecht artist Johannes van Haansbergen (1642-1705). Much of it had been painted over; when it was cleaned more than a century later a sultry naked nymph crowning a satyr appeared out of the gloom.[6]

James White has been critical of the lack of support for the NGI in Ireland in comparison to the lavish gifts made to galleries elsewhere. 'Not a single first-rate picture was received as a gift during the ten years between the first Act of Parliament and the opening of the Gallery in 1864'.[7] He omits the vigorous *Death of Milo of Croton* (NGI 167) then thought to be by Jacques-Louis David (1748-1825) and now given to Jean-Jacques Bachelier (1724-1806), presented in 1856 by Sir Arthur Guinness. It is true that during that decade and for many years following the opening, the NGI had only two substantial benefactors, the Lord Chancellor, Maziere Brady and William Dargan.

In 1854 John Pigot had turned his attention to an obvious source of pictures. In a letter to his father[8] he noted that the National Gallery in London had recently acquired an accumulation of paintings, the Krüger collection, amounting to a surplus. He wondered if the NGI might ask for some of these paintings 'even if it consisted of the transfer to us of but half a dozen good pictures out of the 60.' He was aware that Mulvany had the same idea. 'Mulvany did write to Kevins the Keeper of the English Gallery upon the subject of the Trustees lending us a portion of the scores of pictures presented to and purchased for that Institution… Kevins long afterwards wrote that the Trustees had no legal powers to do so. This is technically true because that power is in the Treasury'.

An approach must have been made to the Treasury through the Lord Lieutenant, since a letter survives from William Gladstone, then the Chancellor of the Exchequer, to Lord Saint Germans. 'August 30 1854 … it is, I think, improbable that there will be any of the Krüger pictures rejected as candidates for the New Gallery here, which would be

desirable to put into a Sub Gallery in Dublin… we are very far from that stage…which would place at our disposal good pictures to send to Dublin or Edinburgh as being surplus here'.[9]

A bold memorial sent to the Treasury on 31 July 1856, asking for £10,000 for works of art, met with rejection. The Governors then wrote an address to the public 'for donations of Works of Art towards the National Gallery'. They did not mind second-rate paintings. 'Many…painters whose names, though less familiar to the public than those of their great instructors, are still recorded with high approval in the history of art — true and genuine specimens are not infrequently to be obtained'. It was pointed out that big pictures 'suitable to the spacious walls of a large Public gallery will at times, be more easy to purchase than the smaller specimens which are eagerly sought after for the decoration of the Drawing room and the Cabinet; and fine examples of the varied excellences of the modern and living schools of paintings will not be difficult of acquisition if any adequate means shall be available for the purpose'.[10]

The results of this address were disappointing. Very few worthwhile pictures were donated during the next three years. In 1857, the young 7th Viscount Powerscourt gave a huge *Last Supper* (NGI 4001) in poor condition, as by Tintoretto, while Thomas Berry added to his gifts with a copy of Rubens' *Descent from the Cross* (NGI 1941) in 1859. Nor were monetary contributions generous. The Duke of Devonshire gave £50, but on the whole the great and the good were not open-handed. The Minutes in January 1857 record Lord Palmerston's donation of £20. 'The Earl of Egmont enclosed a cheque for £10 and from Viscount Southwell a cheque for £5 and from Colonel W.B.R. Smith £1 towards the same fund. At the same time there were letters from the Duke of Manchester and Sir Harry Fitzherbert 'declining to subscribe to the Gallery.'

Over the years contributions dribbled in, seldom for more than £10, while a surprising number of parsimonious noblemen sent £5. The Lord Lieutenant, Benjamin Lee Guinness and the Lord Primate were generous with donations of £100 each. In 1861 the Queen, possibly remembering her visits to the Exhibition of 1853, also gave £100. Prince Albert and the Prince of Wales gave £50 each. The Venerable Archdeacon of Glendalough gave three guineas, William Malone Esq. one guinea. By the opening of the Gallery in January 1864 the total amount donated by private individuals, bar one, was £1,253. 10s. This was £3. 10s. more than the contribution by Maziere Brady, which enabled the Gallery to have enough paintings to cover its walls.

The beginning of the pivotal events concerning the acquisition of thirty-nine 'Roman pictures' for the NGI is recorded in the Minutes of the eighth Board Meeting of the Governors and Guardians which took place at the premises of the Royal Hibernian Academy on 3 December 1855: 'Read a letter from Signor Aducci offering his gallery of pictures for sale'.

Signor Aducci was a Roman picture-dealer. A trade card from 'Mr Alexander Aducci' (NGI 11550) describes him as 'painter and dealer' and gives his address as No 22 Palazzo Mignanelli, near the Piazza di Spagna. According to the card, he was offering for sale 'ancient pictures acquired by him at the sale of Cardinal Fesch's Gallery'.

Cardinal Joseph Fesch (1763-1839) had been an obsessive collector who acquired thousands of paintings with the aim of building up a collection which would illustrate the history of art.[11] He was a churchman from Corsica whose half-sister, Letizia, happened to be Napoleon's mother. In 1796 Fesch profited through the family connection when Napoleon appointed him Commissioner of Supplies to the army in Italy. This gave him unique opportunities of acquiring paintings; his first came from the Grand Duke of Tuscany, anxious to appease the advancing French army. The best pictures encountered by the conquerors were shipped off to the Louvre; the rest were divided between officers and Fesch had the lion's share.[12]

After Napoleon's downfall Fesch went to Rome, bringing with him a vast number of his paintings. Some were hung in his Palazzo Falconieri, others were in the palazzo belonging to Letizia Bonaparte, while many were piled up in a dozen rented rooms.

When he died his immense collection was dispersed. Many pictures were masterpieces, but others were indifferent copies. The best found their way to museums and collectors around Europe, while a selection was made for the Cardinal Fesch Museum in his birthplace, Ajaccio, where they may be seen today. Other pictures were sold directly to dealers or sold off in lots of fifty or a hundred a day by size.[13]

Aducci seems to have attended the first of the auctions of Fesch's pictures in 1845, since a number of the pictures that he offered the NGI are listed in the catalogue of that sale: those by Giovanni Lanfranco (1582-1647), (NGI 67 & 72), Giulio Cesare Procaccini (1574-1625), (NGI 1820) and Pier Francesco Mola (1612-66), (NGI 1893).

At the meeting on 3 December 1855 the Board showed a guarded interest in Aducci's communication. 'Ordered that the Secretary do write to Signor Aducci to inform him that the Board are not in a position

to entertain the proposal to purchase a Gallery but would be happy to have a catalogue and list of prices of the pictures'.[14]

There would have been no question of the Board being able to buy the pictures Aducci offered without the intervention and generosity of the Lord Chancellor, Maziere Brady. The second son of Francis Tempest Brady, a gold and silver thread manufacturer,[15] Maziere Brady (1796-1871) had many interests outside his successful legal career. He collected pictures, three of which are in the NGI, two landscapes (NGI 271 & 272) by Louis de Vadder (1605-55) and the eye-catching *Paroquets* (NGI 161), the only recorded work by a mysterious Irish artist named Edward Murphy (1796-1841) who killed himself at the age of forty-five.[16]

A friend of the Lord Chancellor was Mrs Anna Brownell Jameson (1794-1860) daughter of an Irish miniature painter who had been brought up in England.[17] She was a prolific writer, and among her books were several which popularised European art. In 1848 Mrs Jameson came to Ireland and stayed with Brady and his family at his house, Hazlebrook, outside Dublin. While she was there, *The Poetry of Sacred and Legendary Art*, the book by which she is remembered was published. In the second volume she mentioned specifically one of Brady's pictures, *Irene and her Attendants coming to remove the body of Saint Sebastian*, attributed to Adam Elsheimer which would be exhibited in the 1858 and 1859 Irish Institution shows.[18]

While she was in Ireland 'making the hospitable mansion of the Chancellor her temporary home', Mrs Jameson toured the country, visiting Birr Castle where she saw the telescope and 'the great Maria' Edgeworth who was in her eighties. In Limerick she saw 'the departure of troops of half-starved emigrants from their desperate families; I have not yet recovered from the spectacle'.[19]

Mrs Jameson was in London when the Board's correspondence with Aducci began. Earlier, in 1846, she had travelled to Italy accompanied by her niece, Louisa Gerardine Bate, called Gerardine or 'Geddie'. On the way in Paris they encountered a friend, Elizabeth Barrett, who was eloping with Robert Browning. They journeyed together as far as Pisa, and Mrs Jameson and her niece went on to Rome. Here the sixteen-year old Gerardine fell in love with a redheaded Scotsman named Robert Macpherson, who dominated the English artistic colony that hovered in the area around the Spanish Steps.[20]

Mrs Jameson was horrified; she disliked Macpherson not only for his bumptious personality and the fact that he was twice as old as her niece, but also because he was a failed artist and a Roman Catholic convert.

Elizabeth Barrett described the ensuing row: 'Poor Geddie had completed her offences by falling in live with a bad artist! (converted from protestantism!) a poor man! with a red beard!!! whatever Geddie could mean by it was what Mrs Jameson in her agony couldn't divine'.[21]

The novelist Mrs Oliphant, who lived in Rome, was kinder about Macpherson. 'There was very little that was like a fortune-hunter in his careless hot-headed humours, noisy Bohemian ways...He was full of generosities and kindness, full of humour and whim and fun, quarrelling hotly and making up again; a big bearded, vehement, noisy man...[22]

Eventually Mrs Jameson came round to the marriage. 'I was against the union at first; but what seemed a sudden rash fancy on both sides became respectable for its constancy. I am glad now that I yielded'.

Macpherson was an artist who had abandoned painting for photography. His beautiful architectural photographs of Rome, its environment and its antiquities, now place him among the most important of pioneer photographers. Unfortunately since his technique was painstaking and his photographs were more expensive than those of his rivals, they sold badly, and picture dealing became a secondary means of earning money. His poverty may well have affected his honesty. He suffered from chronic malaria, and later would take to drink; when he died in 1872 he would leave his wife and four children destitute. Gerardine, crippled with arthritis, died in poverty in 1878.[23]

In 1856 Mrs Jameson was aware that Macpherson was already in financial difficulties and would have had every inclination to link her niece's husband with her friend the Lord Chancellor, Maziere Brady, in his efforts to acquire pictures for the National Gallery of Ireland.

At the twenty-second meeting of the Board, on 15 September 1856, Brady made his first remarkable offer. He 'stated the substance of certain communications which he has had with Mrs Jameson and with Robert Macpherson Esq. of Rome...and submitted the propriety of the immediate acquisition of a selection of Pictures (thirteen in number) from the Collection of Signor Aducci of which pencil drawings have been sent to the Governors, and which are recommended by Mr Macpherson as being very desirable for the commencement of a public Gallery'.[24] Head Curator and Keeper of the Collection, Sergio Benedetti, believes that Aducci drew these himself.[25] One might have expected Macpherson to photograph the paintings, but his subject-matter was exclusively architectural. The Board made a leap of faith in accepting the promise of these careful little scribbles and the word of Mrs Jameson's niece's wild husband. It was aided by Brady's enthusiasm and generosity: 'the Lord

Chancellor having offered to advance the requisite sum for effecting the
purchase and securing the transmission of the pictures to Ireland with
all other attendant charges, without interest until the Governors shall be
enabled out of any funds at their disposal for such purposes to repay
these advances'. The paintings would be collateral.

The Governors knew, and the Lord Chancellor knew, that there was
no guarantee of repayment; moreover, at this stage there was not even
the prospect of a gallery in which could be hung these fifteen huge
Baroque paintings, the majority of them religious. The Governors were
also aware that the pictures offered by Aducci, all dated to the seven-
teenth century, were unfashionable. The Pre-Raphaelites thought Roman
art of the seventeenth century 'insincere'. The period, according to one
contemporary art critic, was one 'when art in Italy after a rapid decline
had sunk into the grave, and only its ghost, resuscitated by the Eclectics,
remained to speak of its departed glories and to warn others by its fate'.[26]
John Ruskin had condemned Italian paintings of this period. At least,
such widely held opinion meant that the pictures would come cheap.

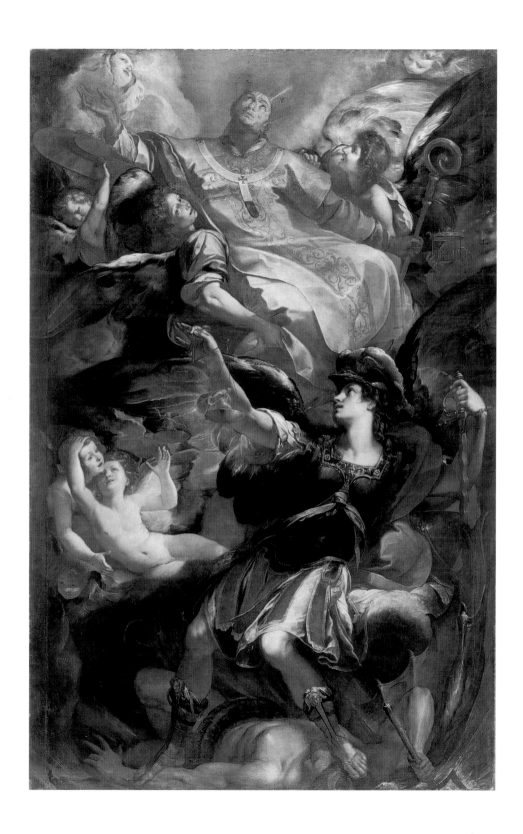

Michael Wynne has pointed out the apparent lack of discussion at the Board meeting; 'the tone of these minutes suggests that there was a general eagerness to avail of the Lord Chancellor's generous action, and an implicit trust in his artistic judgement'.[27] The Board resolved 'that the Lord Chancellor be requested and authorised to complete the purchase of these pictures accordingly'.

The Minutes contain a 'List of the Paintings referred to in the foregoing Resolution: No 1, The Nativity, Rondani; 2, Crucifixion, Anibale Caracci; 3, St Joseph's Dream, Francesco Mola; 4, Apotheosis of St Carlo Borromeo, Giuglio Cesare Procaccini; 5, The Virgin glorified, Palma Giovane; 6, St Pancrazio, Placido Costanzi; 7, Christ curing one possessed by the devil, Coypel; 8, The calling of the Sons of Zebedee, Bon Boulogne; 9, Assumption of the Virgin, Poerson; 10, St Jerome in the Desert, Michael Angelo; 11, The Last Supper, Lanfranco; 12, The miracle of the loaves and fishes, Lanfranco; 13, Scourging of Cupid, Prudhon...'[28]

Three massive altarpieces would be the first French pictures to come into the Gallery: *The Call of the Sons of Zebedee* (NGI 1889), now attributed to Arnould de Vuez (1644-1720), *Christ Healing One Possessed* (NGI 113) by Antoine-Charles Coypel (1694-1752) and *The Assumption of the Virgin* (NGI 1896) by Charles-François Poerson (1609-67), while *The Nativity* (NGI 1918) is signed by Francesco Pascucci (active 1787-1803), *Christ on the Cross* is by Carracci's pupil, Antonio Panico (c.1575-c.1620) the erstwhile 'St Pancrazio' (NGI 1911) is by an artist of the Roman School and *The Scourging of Cupid* (NGI 1739) was painted by Ignaz Stern (1680-1748).

Two months later at the Board meeting of 3 November 1856, the Lord Chancellor was able to say that the pictures had been bought, plus three more, through Macpherson's agency, for the sum of £1,700, 'including the duty payable to the Papal Government on exportation'. The three additional pictures were a landscape (NGI 1977) attributed to Giovanni Battista Viola (1576-1662), a full-length imaginary portrait of Count Alberto Alberti in armour (NGI 1925) by Venetian artist Andrea Celesti (1637-1712) and an expulsion of Adam and Eve, which never turned up in Dublin.

With the Board's permission Brady was prepared to do more. In his first Director's report Mulvany would describe how 'the funds available for purchase having been thus expended, the Lord Chancellor acting in the same liberal spirit which enabled the Board to obtain the collection from Italy, determined to advance further sums of money for such purchases as might seem eminently desirable, trusting to the further resources of the Gallery for repayment'.[29]

Brady would buy five paintings belonging to Macpherson and 'some

others that gentleman had selected at Rome and which he recommended in the warmest manner as worthy of a place in such a Gallery and which he had acquired on the most advantageous terms.'

The total amount payable for all these pictures, Aducci's and Macpherson's, thirty-nine in all, would be £3,333, 'including Mr Macpherson's own commission on the purchases made from other persons'. The Lord Chancellor had already advanced £1,000 for the original pictures which were 'packed and shipped on their way'. He would now advance the rest of the money.

In summing up the Aducci selection of pictures delivered to the Gallery, Michael Wynne concluded 'there is only one inferior work'.[30] This is the burly St Jerome (NGI 1892) which was attributed to Michelangelo, no less. In his first catalogue Mulvany amended this to 'after Michael Angelo (or after his design, most probably.)' The *Freeman's Journal* was convinced it was genuine, although 'the figure presents the appearance of an anatomical painting for the purpose of showing an exaggerated development of the muscles'.[31] Following cleaning in 2001, it emerged as a fine work by Bartolommeo Passarotti (1529-92), who studied Michelangelo's work and signed his canvas with a sparrow (*passerotto*) device.

The Board was not to know that Macpherson had a genuine Michelangelo in his possession which had also come from the Fesch collection. He had seen it among the stock of a dealer covered with smoke, dust and varnish.

'What is that dark panel there?'

'O that' replied the dealer 'is good for nothing'.[32]

He bought it as a job lot and took it home; when he cleaned it with soap and water, he recognised Michelangelo's hand. He had acquired the unfinished *Entombment of Christ* which he kept, calling it 'Gerardine's fortune'[33], meaning to dispose of it for his wife's benefit. However, when he sold it in 1868 to the National Gallery in London, he was paid only £2,000 which went nowhere in solving his financial problems.

The episode cannot be considered a lost opportunity for the Governors of the NGI; even with Brady's generosity they would not have afforded £2,000. But there were other missed chances. Macpherson eliminated eleven of the pictures submitted by Aducci and substituted his own choices. Considering the quality of Aducci's paintings that finally came to the Gallery, and others that Macpherson turned down which are now in other art galleries, this was most unfortunate.

The paintings that Macpherson supplied to the NGI on his own

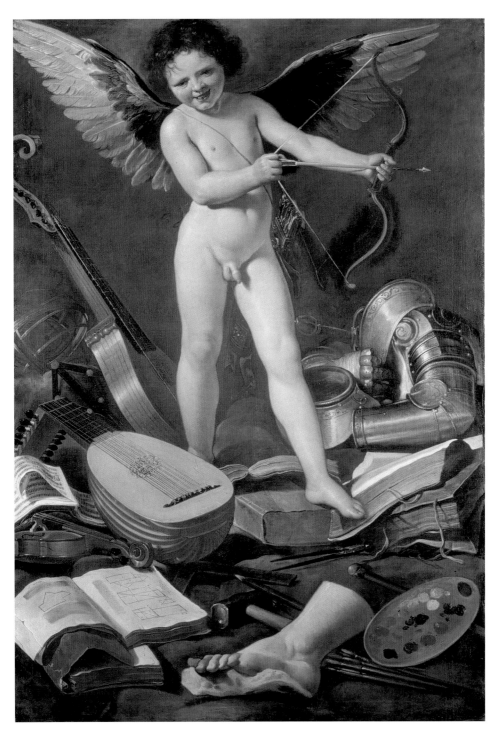

Victorious Love, c.1625 by Rutilio Manetti
(1571–1639), purchased 1856 (NGI 1235).

account, and those obtained from other dealers varied enormously in quality. For £300[34] he picked out four fine pictures from the Monte de Pietà, the official pawnbroker to the Vatican, the so-called *Timoclea before Alexander* (NGI 94) by Pietro della Vecchia (1603-78), *Penelope bringing the bow of Odysseus to her Suitors* (NGI 87) by Padovanino (1588-1648), *St Philip Benizzi* (NGI 364) correctly reattributed by Walter Armstrong from Francia to Marco Palmezzano (1458-1539) and perhaps the most striking of the four, *Victorious Love* (NGI 1235). This was sold as by Caravaggio and derives from a Caravaggio of the same subject in Berlin, Cupid conquering man's achievements, from Virgil's observations on 'Omnia vincit amor'. It is now given to the most important Sienese painter of the seventeenth century, Rutilio Manetti (1571-1639).[35]

Macpherson sent other good Baroque paintings to Dublin, *Europa and the Bull* (NGI 181) by Carlo Maratti (1625-1713), a vast picture whose original home is unknown, *Landscape with the Baptism of Christ* (NGI 196) by Salvator Rosa (1615-73) and *The Visit of the Queen of Sheba to Solomon* (NGI 197) by Leandro Bassano (1557-1622). But most of his other choices, which included a number of poor copies, were sadly inferior. Six of the twenty-three disappeared in the 19th century and one from Aducci never arrived.

It is regrettable, if understandable, considering his financial problems, that he bought from other dealers or chose from his own stock at the expense of Aducci. There was one particular lost opportunity arising from his efforts to promote his own pictures. Early in the seventeenth century the Roman artist, Giovanni Lanfranco (1582-1647) had decorated the Blessed Sacrament Chapel of St Paul's-without-the-Walls in Rome with eight oil paintings and three frescoes. Fesch had owned six of the paintings and according to Aducci in his accompanying notes, during 'la prima invasione Francese...Il detto Emminentissimo' thought so highly of them that he took them to Paris where they stayed until 1814, when the Cardinal returned to Rome, bringing them with him. The Board of the NGI purchased the two most important, *The Last Supper* (NGI 67) and *The Miracle of the Loaves and Fishes* (NGI 72), (in which the fishes, having no Eucharistic connection, are omitted), but the four others, which had been offered by Aducci, with accompanying pencil sketches, were rejected by Macpherson.

The Minutes of 7 December 1861 include a summary of costs of 'the Roman pictures':

'16 Pictures bought from Signor Aducci – £1,700
11 do. Signor Merghetti – £726.17, 10d

4 do. Signor Agostini – £300
2 do. do. £27.19 – 2d.
Total: £2754. 17s.
Mr Macpherson's Commission at 10 per cent – £275
5 Pictures bought from Mr Macpherson – £310'
Sundry charges' of £125. 16s. covered cases, carriage, shipping,
insurance, freight, and 'expenses at Liverpool'.

When the pictures arrived, more than half of them were exhibited in
the gallery of the Irish Institution at 81 Lower Baggot Street.[36] The
Lanfrancos, over seven feet high and fourteen feet wide, were too big to
hang, and had to wait until 1859 to be shown to the public when, at the
last of the Irish Institution exhibitions, they were displayed in the more
spacious premises of the Royal Hibernian Academy in Abbey Street.[37]

Mulvany would hang these first paintings on the walls of the National
Gallery. However, in due course many were removed, 'thinned out', in
Thomas Bodkin's words. They were sent into store, where they remained
for decades. Bodkin, who became Director of the NGI in 1927, was an
opinionated follower of fashion in art. In his 1932 catalogue he wrote how
the Governors and Guardians 'took upon themselves most of the
important business of procuring pictures to adorn the empty walls of
the new building. They went about this work with regrettable haste,
showing more enthusiasm than discretion. The first pictures purchased
for the Gallery were remarkable for their area rather than their authen-
ticity... They would form interesting material for an essay on the taste of
the time'.[38]

Bodkin would be proved spectacularly wrong. Even in 1856, dull and
dirty as the huge pictures must have seemed, the Board could be proud
of its bulk buy. 'Magnificent', Mulvany would write in his first catalogue,
although it took a century to prove him right.

On 5 June 1862 the House of Commons granted the NGI £2,500. 'Sir R.
Peel assured the House...that it was not intended to initiate a series of
such votes for the National Gallery, that the Vote was exceptional and
would be asked for that year only. 'The chief object of the Vote was to pay
for some pictures procured by the Lord Chancellor of Ireland from Italy
and sold by him to the Gallery at much below their market value'.

The Board was now in the position to repay the Lord Chancellor
most of his money. But he would take only £2000, which meant that
after deductions he had made a donation of £1,149. 7s. 8d. to the budding
Gallery.

Other pictures were borrowed on long loan. In November 1856, after the Treasury declined to consider the Memorial asking for £10,000 to purchase works of art, the Lords Commissioners evidently gave some thought to providing some pictures for the Dublin Gallery. The Board learned that, 'while they regret to have been obliged to give an unfavourable reply to your application for a grant of money for the purchase of pictures, they are prepared to consider how far they can place at your disposal a number of Pictures belonging to the National Gallery, but are not now required for that Collection. If it appeared to my Lords that they would be valuable to the Dublin Gallery they would be prepared to entertain favourably the sanction of authorising the Trustees to place them in the Gallery of Dublin'.[39]

The paintings on offer were the precisely the sort that John Pigot had deplored when he wrote to his father in the heady days two years earlier when it seemed that those involved in the creation of the NGI would have money and choice. 'Certainly I do not mean that we should accept, much less ask for, the refuse of the English selections. I think we ought not to accept inferior work, and I think we should be far from craving any'.[40]

John Pigot had emphasised that, although it was desirable to borrow pictures ('good pictures lent for five or ten years would be at first almost as useful to us as if given for ever') they should not be 'inferior' or 'injured.' But needs must, and in spite of the promise of the Roman pictures, more paintings had to be found.

Mulvany went to London in January 1857 where he met Sir Charles Eastlake, the Director of the National Gallery, who gave him a choice of pictures from three sources: the Krüger collection of Westphalian paintings which Pigot had noted two years before and Gladstone had declared unavailable, eight Italian paintings purchased in Venice in 1853 and various unwanted pictures donated to the London Gallery.

In his report back to the Board, Mulvany wrote that 'it must be admitted that these works are to be regarded under the unfavourable aspect of rejected works, having been purchased for the National Gallery of London and having been ultimately judged unsuitable to that Collection; and naturally none of very striking interest or importance can be expected from them'.[41]

Nevertheless, he picked out what he considered the best. It was difficult to be enthusiastic: 'St Dorothea and St Margaret; notwithstanding the peculiarity of the School and the feebleness of execution these companion pictures are not deficient in a certain grace and sentiment'. In 1914

Hugh Lane found and hung this pair, long relegated to the vaults, when he was rearranging the Gallery.[42] Another from this batch of German pictures belonging to the Krüger collection was 'Female portrait, Flemish costume…supposed to be by the younger Holbein. It has at least a genuine character which may render it acceptable'.[43]

The Italian paintings were also indifferent. 'Jacopo Bassano, The Departure of Abraham; in good preservation and fair, though not important specimen of the School'. 'Palma Vecchio. This was originally a very sweet Portrait but the panel has been split, the face and neck painted upon. The hand holding the curtain feeble'.[44]

Mulvany reported: 'Under the third category, "Pictures presented or bequeathed to the Nation", one only has been as yet offered; it is forcibly and well painted and suitable as Gallery Picture…The following is the description in Sir C.L. Eastlake's list: 'half figures life size; painter's name as yet unknown…Presented by Robert Goff Esq.' Ironically, Robert Goff came from County Wexford.

In 1862 more pictures were offered on loan by the National Gallery because space was needed for putting up pictures from the Turner collection. Mulvany chose nine, again with reservations. 'Perseus and Andromeda…far from faultless and too much painted up...Holy Family by Jordaens..suffered from overcleaning'. Of *The Building of the Tower of Babel* by Leandro Bassano he wrote, 'I was not much disposed to take, but it is, at least genuine, and has some of the Venetian tone of colour'.[45]

One painting in this second batch of rejects attributed to Nicolas Poussin, *Phineus and his Followers turned to Stone by the Gorgon*, was another that would catch Lane's eye. In April 1914, just after he had been appointed Director, he wrote to Lady Gregory: 'I have discovered a good picture by N. Poussin at the Castle which had been lent by the NG some years ago, so that I have demanded its return!'[46] In due course it was returned to London where Thomas MacGreevy came across it in the cellars of the National Gallery just before the Second World War[47]. It is now considered only 'French School, circa 1660'.

1 *NGI Illustrated Summary Catalogue of Drawings, Watercolours and Miniatures* (Dublin 1983) p. ix

2 Director's Report 1901: 'Portrait, small half-length of Capt. George Archibald Taylor of Dublin…presented by Miss Bagot, Dublin'.

3 *NGI Illustrated Summary Catalogue* (Dublin 1981) p. 349

4 David Oldfield, *Later Flemish Paintings in the NGI* (Dublin 1992) p. 121

5 Homan Potterton, *Dutch 17th and 18th century paintings in the NGI* (Dublin 1986) p. 79

6 Information from Andrew O'Connor. See also Potterton (as n. 5) p. 197

7 James White, *The National Gallery of Ireland* (London 1968) p. 20

8 John Pigot to David Pigot, 5 Aug. 1854. Letters quoted in this chapter are from the first Letter Book in the NGI archive

9 Gladstone to Lord Saint Germans, 30 Aug. 1854

10 Minutes of NGI Board, 23 Oct. 1856

11 Catherine Whistler, 'The Later Italian Paintings in the NGI' (review of Michael Wynne's 1986 catalogue), *Irish Arts Review*, vol. 4, no. 1, Spring 1987, pp. 66–68

12 Dorothy Carrington, 'Fesch – A Grand Collector', *Apollo*, vol. 86. Nov. 1967, pp. 346–57

13 *ibid.*

14 Minutes, 3 Dec. 1855

15 *DNB*, vol. 11, p. 1099

16 WG Strickland, *A Dictionary of Irish Artists* (Dublin 1913) vol. 11, p. 159

17 *Memoirs of the Life of Anna Jameson, Author of 'Sacred and Legendary Art' etc. by her niece Gerardine Macpherson* (London 1878)

18 The Irish Institution, *Catalogues of the Exhibition of Ancient and Modern Paintings*, (Dublin 1858 and 1859)

19 Macpherson (as n. 17)

20 Alistair Crawford, 'Robert Macpherson 1814-72, the foremost photographer of Rome', *Papers of the British School at Rome*, vol. LXVII (1999) pp. 353-402

21 Quoted *ibid.* p. 359

22 *ibid.*

23 Crawford *passim*

24 Minutes, 15 Sept. 1856

25 In conversation with the author Jan. 2002

26 *Illustrated London News*, 23 Dec. 1854

27 Michael Wynne 'Fesch Paintings in the NGI', *Gazette des Beaux-Arts*, vol. 89, Jan. 1977, p. 6

28 Minutes, 15 Sept. 1856

29 Director's Report 1862

30 Michael Wynne, *Later Italian Paintings in the NGI* (Dublin 1986), p. x

31 *Freeman's Journal*, 2 Feb. 1864

32 (as n. 17) Postscript to *Memoirs of the Life of Anna Jameson*, p. xi

33 *ibid.*, p. xii

34 Wynne (as n. 27), p. 2

35 Sergio Benedetti, *Caravaggio and his Followers in the NGI* (Dublin 1992) p. 40

36 Wynne (as n. 27), p. 2

37 The Irish Institution, *Catalogue of the Exhibition of Ancient and Modern Paintings* (Dublin 1859)

38 Thomas Bodkin, *The National Gallery of Ireland. Catalogue of Oil Pictures in the General Collection* (Dublin 1932) p.viii

39 Minutes, 1 Dec. 1856

40 John Pigot to David Pigot, 5 Aug. 1854

41 Minutes, 21 Jan.1857. Special Meeting - Report of Mr Mulvany on 'certain pictures not required by the National Gallery of London'

42 *Catalogue of paintings in the National Gallery of Ireland* (Dublin 1914) Appendix, pp. 510-11

43 Minutes, as n. 41

44 *ibid.*

45 Minutes, 6 Sept. 1862

46 Lady Gregory, *Hugh Lane's Life and Achievement*, (London 1921) p. 202

47 NGI Administration, Box 30. MacGreevy to Robert Ark, 2 Feb. 1958

CHAPTER EIGHT

PREPARATIONS FOR THE OPENING

On 4 October 1862 the Governors and Guardians held their first meeting in the new Board Room of the National Gallery which was nearing completion. They sat around a 'large and massive circular table of solid oak...so constructed as to form two semi circles; the chairs being of the same material and upholstered in crimson en suite'.[1]

Previous meetings had been held in different locations: the Royal Hibernian Academy, the office of the Art Union of Ireland in Grafton Street, or the Irish Institution House in Lower Baggot Street.[2] A month earlier, on 6 September 1862 in Grafton Street, the Board had appointed the Gallery's first Director. George Francis Mulvany's new role had been signalled a year previously when he had been appointed 'Honorary Curator of the Gallery' and had been given fifty guineas 'in consideration of the trouble to him in the approaching arrangement of the Gallery.' The Board was only too aware of how his dabbling in architecture had had unfortunate consequences for the Gallery. But he was forgiven, and he rewarded them with his energy and devotion to his position.

On 17 October 1861 Mulvany had reported the minutes of the meeting of the Committee of Management and Finance of which he was an energetic member. 'The Committee are all agreed...that the Director of the Gallery should not only be a gentleman of ability and character but also an artist of experience and reputation in his Profession...They cannot name any less sum than £300 a year to be offered to the honourable acceptance of any gentleman so qualified and they have therefore adopted that figure in their desire to name the very lowest in the estimate they have given'.[3]

Three hundred pounds a year was what the Director would be paid initially, and it was not considered much; the reports of the Civil Service Estimates qualify the amount with the word 'only.' By comparison, the salary of the Director of the National Gallery of London was £1,000 annually.

Self-Portrait of George Francis Mulvany (1809-69), first Director (1862-69), 1840s, presented 1930 (NGI 926).

Mulvany had been closely associated with the Gallery's progress. He was present at the first meeting of the Irish Institution and was secretary of the finance sub-committee. He was included in the deputation that successfully approached the Royal Dublin Society for permission to build the Gallery on Leinster Lawn. He was also on the sub-committee that chose pictures for the six exhibitions of the Irish Institution that took place during the 1850s. His uncle, John George (1766-1838), was primarily a landscape painter,[4] best known for one view of the town of Kilmallock, County Limerick (NGI 991). His brother, John Skipton (1813-71), was a successful architect, another, William Thomas (1806-85), became the leading industrialist in the Ruhr, setting up mining companies and building canals. His father, Thomas James Mulvany (1779-1845), a prolific and varied painter,[5] was Keeper of the Royal Hibernian Academy and also author of a number of articles on Irish artists published in *The Citizen*.

Born in 1809, Mulvany attended the Royal Hibernian Academy Schools, presumably because of his father's position there. After a spell in Italy, he became a full Member of the RHA by 1835 and succeeded his father as Keeper in 1845. By then he had been involved for some years with the Royal Irish Art Union, and it was unsurprising that subsequently he should be prominent in the Irish Institution.

His duties as Secretary to the Irish Institution and later as Director of the National Gallery did not prevent him from producing a steady stream of paintings like *The Peasant's Grave*, or *St Patrick Baptising the King of Munster*, as well as portraits of many important Irishmen of the period, including one of Thomas Moore (NGI 1097). Although *The Misses La Touche in Venice* (NGI 4495) has some charm, he has been described as a 'run-of-the-mill portrait painter'.[6]

In 1862 Mulvany not only had to organise the minutiae of setting up and running the Gallery, but continue the search for paintings to hang on the walls. At a time before paintings could be properly reproduced, he did not hesitate to buy copies. 'Of some...of the greatest names in the history of art it may be impossible to obtain an example, save through the princely bounty of some munificent donor. Thus Raffaele, Correggio, Titian may for years be only known to the Irish public through the imperfect means of description, copying and engraving'.[7]

At first he bought locally in Dublin and occasionally in London, looking for bargains. In June 1860, when he was over in London on business with the National Gallery, 'he had not deemed it advisable to make any purchases of pictures in the sales which had taken place during his stay on account of the limited amount of the funds in the

Gallery'. Instead he bought 'engraved imitations of Raffaele; Drawings... 31 in number for £1. 12s'. In the same year he bargained with Mr W. Baschet of Waterford for a copy of a cartoon of Raphael's School of Athens 'originally the property of Madame Laetitia Bonaparte Wyse' (a relation of Cardinal Fesch.).[8]

He secured over seventy paintings for the Gallery, of varying quality, many copies, others in poor condition with layers of overripe varnish, general wear and tear and crude restoration work. In addition to much dross, however, he managed to make a number of varied purchases with the very limited funds at his disposal. He acquired a depiction of *Aesop* (NGI 1988) in 1857 for £13 from an unknown Dublin source, as by Caravaggio, which subsequently dropped to Luca Giordano and at present Follower of Ribera. A *bozzetto* by a Neapolitan artist, Giacinto Diano (1731-1804) (NGI 351), was bought at an auction about November 1859 with two other pictures for £35. Like so many early acquisitions when art history was in its infancy, this interesting picture has changed its title and attribution. When purchased it was called *Elijah Invoking by Prayer the Sacred Fire from Heaven* by Paul de Vos. In subsequent catalogues it was attributed to Tiepolo and Castiglione. Only in 1956 was it recognised as a sketch by Diano for a fresco for the ceiling of the sacristy of Sant'Agostino al Zecca in Naples and its subject deduced as *The Dedication of the Temple at Jerusalem*. Also in 1859 Mulvany purchased locally from Thomas Walker, the Gallery's first Spanish painting, *The Liberation of St Peter* (NGI 31) by José Antolínez (1635-75) for £40 together with a full-size copy of Titian's *St Peter Martyr* (NGI 1942).

Another good painting acquired at this time, *Susanna and the Elders* (NGI 1938) by Giovanni Pellegrini (1675-1741), belonged to Lord Harberton and seems to have come into the Gallery by accident, having, perhaps, been left behind at the Royal Hibernian Academy after Harberton sent his collection to be exhibited there in 1859.[9]

At the Board meeting of 6 May 1861 'Mr Mulvany submitted for approval a Painting, which, with the sanction of the Lord Chancellor, he had purchased for £215. 5s. at the sale of the late Mr Uzelli at Christie's and Manson's Auction in London...The Work is by Zenobio de Machiavelli, painted about 1473...The Virgin, Infant Christ and Saints, a composition of Six Figures'. Machiavelli's (1418-79) Florentine Virgin, wearing her scarlet slippers (NGI 108), has been an enduring favourite among Gallery visitors.

Mulvany's next significant purchase, for £32, was at 'a Gentleman's sale' in Bristol in October 1862. *Scenes from the Life of a Saint*, from the School

of Lucas van Leyden and now given to the Master of St Crispin and Crispinian (active in Brabant c.1480-c.1510),[10] was the first indication of his interest in early German and Netherlandish pictures. The following year, before the official opening of the Gallery, he made some hectic buys, fortified by a further loan from the Lord Chancellor. 'The Funds available for purchase having been expended, the Lord Chancellor, acting in the same liberal spirit which enabled the Board to obtain the Collection from Italy, determined to advance further sums of money... I have been enabled to attend some important Sales and to secure Works of especial interest and value in a National Collection'.[11]

An acquisition for £7. 10s. was one of the NGI's first German pictures (NGI 16), then thought by Hans Schäuffelein (1480-c.1510), today by the Cologne artist Anton Woensam (active 1517-c.41), whose woodcuts outnumber his pictures by ten to one. Its unusual subject, *Joseph and Mary Being Refused Admittance to the Inn,* makes it a rarity.[12] The cheapness was partly due to its poor condition, but also was a result of the prevailing fashion of regarding such paintings as undesirable 'primitives'. Mulvany would acquire a number of German and early Netherlandish paintings that did not conform to contemporary taste. A critic in the *Illustrated London News* explained that 'Italian art...began in the early part of the fourteenth century to reject the hard lifeless types and figures of Byzantine art and to adopt nature herself as a model. In Germany, for centuries...the same weak and debased models, modified by a rude gothicism of character and detail, continued to be followed for many ages after that period'.

In June 1863, 'at the sale of the late Rev Walter Davenport Bromley's Pictures in London', Mulvany bid for an imposing altarpiece (NGI 117) by Marco Palmezzano (1458-1539), whose charm is rather lessened by the staring eyes displayed by the martyr St Lucy on top of the little cup she carries. Like the pictures supplied by Aducci, this painting came from the immense collection of Cardinal Fesch and has been described as 'one of the best Palmezzanos in existence'.[13]

In the following week Mulvany bought an important and massive painting by Jacob Jordaens (1593-1678), *The Veneration of the Eucharist* (NGI 46) for a bargain £84, whose complex significance continues to intrigue art historians.[14] A few months later he bought, for 65 guineas, a *Vanitas* fruit-piece (NGI 11) by Jan Davidsz. de Heem (1606-83/4), with green grapes, overripe pomegranate, butterflies, skull, snake and other symbols combining in a sumptuous allegory of life, death and resurrection, that is equally enjoyable as a bravura example of still-life painting.

Vanitas Fruit-piece, 1633 by Jan Davidsz. de Heem
(1606–83/4), purchased 1863 (NGI 11).

In addition to acquiring paintings, Mulvany was also intensely occupied by plaster casts which had long been considered aids for aspiring artists, as well as a means for educating the public. Bishop Berkeley had recommended 'models in plaister of Paris' for his proposed Academy, and Robert West's school in Shaw's Court was 'furnished with several fine Modells in Plaster imported from Paris'.[15] By the nineteenth century there was a general conviction throughout Europe that the great sculpture of ancient civilisation should be available to all by means of plaster reproductions.

Since the early nineteenth century Cork had possessed a superb collection of casts which had inspired the sculptor John Hogan. They had been made in Rome under the supervision of Antonio Canova, and presented by Pope Pius VII to the Prince Regent of England who, in turn, gave them to the city of Cork. There was nothing similar in Dublin until Mulvany ordered for the NGI casts from Signor Domenico Brucciani in London, who travelled all over Europe obtaining reproductions of ancient masterpieces and supplied them to museums all over the British Isles.

In August 1860 a memorial was sent to the Treasury for a grant: 'That it is intended to occupy with sculpture the principal saloon and the ground floor...a collection of casts as will not only educate and please by the exhibition of the most perfect models of form, but will illustrate the history and progress of sculptural art'.[16]

Such was the current emphasis on this simple means of educating the masses, that, unusually, the Treasury agreed without protest to fund the purchase of casts at a cost of £262. 19s. 6d. There was the usual caveat: 'their Lordships...desire...to add that in sanctioning the cost of these casts...they in no respect commit themselves on the general question of any additional grant towards the Gallery or to anything beyond this particular gift'.[17]

The Treasury would not pay for frames (whose costs were met out of funds provided by the Ancient Art Society)[18] nor for packing (£115. 4s) nor transport (£40)[19] There is a letter in the NGI files addressed to Messrs Malcomson, Proprietors of London and Dublin Steamships, asking if they would reduce the cost of freight.

At the Board meeting of 6 July 1861 Mulvany reported that sixteen cases of casts had been received from the British Museum and from the Arundel Society. By 5 October sixteen extra cases had arrived, and they were all kept in storage until the following June, when Messrs Cockburn and Son undertook to complete the interior of the Sculpture Hall.

In February 1862 the Building Committee 'examined the Frames placed for the Metopes and Frieze of the Parthenon on the Walls of the Sculpture Hall and approved of their position'. Some were considered 'very deficient in sharpness and accuracy apparently in consequence of the moulds being worn and old' and Mulvany had to request replacements from Signor Brucciani.

In November 1862 Lord Cloncurry sent a consignment of seven from Rome, but the condition of many of these Roman reproductions was even worse. Mulvany wrote to Brucciani: 'I suppose I could get good casts in London of the parts wanted, such as the right arm of the Venus of the Capital, the hands of the Venus de Medici, the right hand of the Apollo Belvedere and left arm of the Antinous of the Capital'.[20]

At the Gallery opening, there were one hundred and six on display and the Address to the Lord Lieutenant, recorded in the Minutes of 14 January 1864, specially mentioned 'the Collection of Casts from the Antique which form an important feature of the Irish National Gallery and one distinct from either that of London or Edinburgh…' Over the years more were obtained, such as sixteen from Continental museums 1864-66, including a group from the Louvre and apparently four casts taken from the Trajan Column in Rome (of which there is no trace). In 1875 Lord Talbot de Malahide sent from Rome 'two casts from female busts lately discovered in the excavations now in progress there'.[21] The collection remained in the Sculpture Hall for over eighty years, creating a special atmosphere. In 1932 a visitor found that 'if it is a very warm day, the cool great hall of sculpture, pervaded with the dignity of unchallenging antiquity, is reminiscent of the great cool galleries of Europe'.[22]

A self-portrait by Richard Thomas Moynan (1856-1906) painted in 1887 (*Taking Measurements: the artist copying a cast in the hall in the National Gallery of Ireland*, NGI 4562) gives some idea of the hanging friezes and statues in the front hall vestibule leading to the Sculpture Hall. The ones he depicts are all Greek, although Assyrian and Egyptian friezes could be also found there in the rere.

The pillared Sculpture Hall, lit by gas lamps, was in the charge of the Second Porter, 'Caretaker of the Casts'.[23] The first appointed (without residence) in December 1863 was an Italian immigrant Louis Pedreschi, who would remain on the NGI staff for forty years. He was paid extra for washing the statuary with 'spirits of wine' when the Gallery was closed for a month for its annual cleaning. In April 1875, as the result of a decision by the second Director, Henry Doyle, Pedreschi was paid twelve

*Taking Measurements: the artist copying a cast in the hall
of the National Gallery of Ireland*, 1887 by Richard
Thomas Moynan (1856-1906), purchased 1989
(NGI 4562). The cast being studied is a lion from
Halicarnassus; behind Moynan are a Caryatid
from the Erechtheum and bas-reliefs from the
Parthenon, Xanthos and Eleucis.

shillings for 'Making leaves for Statues'. In July and August of that year two further entries of the Finance Committee accounts read: 'L Pedreschi – Making Vine leaves – 12s' and: 'L Pedreschi – fig leaves 4s.'. The introduction to the 1868 catalogue describes the application of Professor WK Sullivan's silicatization process. This coating of silicate and aluminate of potash avoided painting the casts and was intended to preserve their sharpness and accuracy. It was repeated in 1872.

The composition of the staff of the new Gallery was pondered by the Finance Committee which consisted of the Director and two members of the Board. The original annual estimate of £700 for wages was reduced to £500 by the Treasury. A letter read out at the Board meeting of 7 March 1863 declared that it was not prepared to sanction the two offices of Director and Registrar. 'Their Lordships are of opinion that the Director with a Salary of £300 a year should perform the duties of both offices, finding, out of his salary for himself, any Clerical assistance which possibly may be occasionally required'. This meant that for the first years of his appointment Mulvany had to pay his Registrar, Henry Killingly, £78 out of his already meagre salary.

John Moore, Head Porter, and Ellen Moore, wife of the Head Porter and Housemaid, earning £40 and £25 a year respectively (rising in 1866 to £52 and £30 after Sunday opening had been formalised) had uncomfortable rooms in the basement. On 14 July 1863 the Minutes of the Finance Committee complained: 'the Head Porter's apartments not being provided with sufficient light and air, alterations recommended'.

The Head Porter's duties were laid out on 24 December 1863: 'He is to have charge of the House, the safety of the property, the attendance at the Entrance door and the delivery of all Letters. During the hours of being open to the Public he shall be stationed at the Entrance Hall, see that all persons entering shall pass the registering stiles, and take charge of all umbrellas and sticks. He shall also have charge of the Sale of Catalogues'.

The Housemaid, Ellen Moore, 'shall have charge of the entire cleaning and dusting of the Galleries, the Board Room and Ladies' Waiting Room…In these rooms she shall light the fires when occupied and see to the scrupulous cleaning of the Furniture and she shall at all times be in attendance in the Ladies Waiting Room when required…She shall have the assistance of a Charwoman for the washing the Galleries and all other heavy housework'. Charwomen had no regular position, but were appointed by John Moore, their pay being entered in the Registrar's Account Book and the Minutes of the Finance Committee

*Photo of the Sculpture Hall looking towards the
entrance,* c.1890, attributed to Robert French
(1841-1917), (Lawrence Collection, ©National
Photographic Archive). The room contained
over 90 casts from Antique Greek and Roman
sculpture. The seated attendant has been
identified by his descendants as Louis
Pedreschi, who looked after the casts.
The windows on the opposite side from
Leinster Lawn were filled in during the 1950s.

PAGES 102-3: *Photo of the Sculpture Hall looking towards
the stairs,* c.1900 (©National Photographic
Archive). Recorded after removal of the
gas lighting.

under 'sundry women'. Uniforms were provided for the Porters every year, and greatcoats every third year.[24]

An assistant Gate Porter was appointed just before the opening of the Gallery. He had to be no more than forty years old and had to pass a medical examination. 'Ordered that John Spelman who has acted as gardener at the Gallery for the past two years be appointed Assistant Porter at £35 a year'.

When poor Spelman died of cholera two years later, the Treasury showed itself at its most unpleasant. 'With reference to your letter... applying for the grant of pecuniary assistance for his Widow and Children, I am desired by the Lords Commissioners of Her Majesty's Treasury to inform you that it would not be consistent with the rules of the Service to make payment of Salary for any period subsequent to the day of death...The Director was authorised to appropriate a sum of five pounds out of the fund derived from the Sale of Catalogues to the benefit of Spelman's family'.[25]

It was agreed that names of distinguished artists to balance the frieze on the Natural History Museum would be inscribed under the roof on the outside of the Gallery. 'Phidias, Raphael, M.Angelo, Da Vinci, Titian, Correggio, Van Eyck, Rembrandt, Rubens, Murillo, Velasquez, Zurbaran...'[26] They survived expansion and can be seen on their decorative plaques. In due course the Gallery would be able to show examples of the work of most of these great men.

The Board suffered an alarm after the decision was reached that Marsh's Library should stay where it was beside St Patrick's Cathedral, when it appeared that the big room on the ground floor reserved for its books might be put to other uses than providing walls for hanging pictures. The RDS thought that the space could be filled with specimens from the Irish Geological Collection. From his office in the Gallery Killingly, the Registrar, wrote to Mulvany in London: 'We have had several parties here yesterday and today measuring the Library part of the Building. It would seem that...the government will convert it to Geological or other purpose than art if they can legally do so'.[27] The Board protested in a memorandum, giving 'their most decided objection'.[28]

The proposal to use the vacant room for purposes other than art dragged on until Marsh's Library formally, in June 1865, renounced their desire to move to Merrion Square. The National Gallery Bill had to be amended, and a clause was suggested that the space might be used for 'the advancement of the Fine Arts of Science and Literature as may from time to time be directed by the Lords Commissioners of Her Majesty's

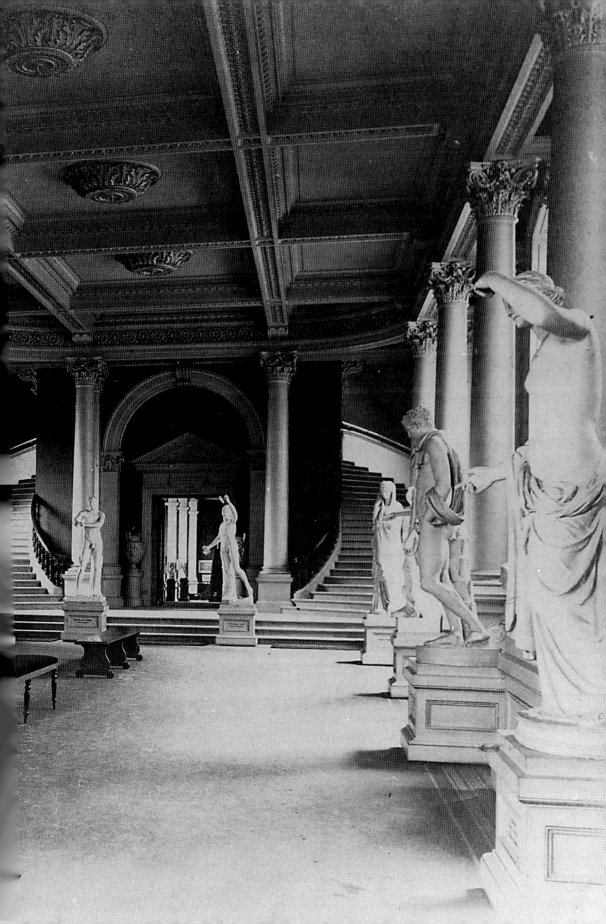

Treasury'. Mulvany was sent over to London, and had an interview with Mr Peel, the Secretary of the Treasury. He was able to report back to the Board: 'Mr Peel agreed to have cut the words "Science and Literature", assuring me at the same time that the Treasury had no intention of allocating the space in question to any purpose save that of art and that it would be available to the National Gallery of Ireland, according as the Board might require it'.[29] For years, because of lack of funds, the big room originally assigned to Marsh's Library was unfinished and unplastered.

On 2 April 1863 the Board learned that the Dargan statue, cast in bronze by Elkington and Co., was expected in Dublin within a week. Fowke's gas lighting was put to the test in December 1863. 'The gas having been fully lighted in the large Gallery, several tests were applied to try its effect upon the flat glass ceiling. No perceptible increase of temperature was experienced in feeling the glass, while the Thermometer registered about 85 degrees between the flat glass ceiling and the roof...The effect of the lighting was deemed most satisfactory'.[30]

The catalogue was completed only three days before the opening. The frontispiece had an engraving of a muse crowned with laurel and the motto, *Ars emollit mores*, Art Refines Custom. Mulvany's Introduction, on the subjects of 'Ancient Masters, Schools of Paintings and Modern Schools',[31] would be reprinted for many years to come. He informed the visitor that this catalogue was 'arranged on the model of that of the Louvre which has been constantly used throughout the present compilation. Alphabetically according to the NAMES OF PAINTERS. After the short memoir of each Painter will be found the title and particulars of the picture or pictures by or attributed to him. The dimensions of pictures given in this Catalogue are those of the canvas exclusive of frames'.[32]

There was the question of Sunday opening. In 1863 a group of gentlemen had written to the Board declaring 'that it would be both politic and philanthropic to afford the mercantile artisan and labouring classes generally (comprising as they do the large majority of the Citizens) an opportunity of benefiting by the instructing and refining influences to be conveyed through the Works of Art exhibited in the Gallery, on the only day at their disposal, namely the Sunday'.

The idea was a novelty, although the Botanic Gardens at Glasnevin opened on Sundays. In England the only public institution to open on the Sabbath was Hampton Court. Throughout 1863 letters with lists of gentlemen and Irish MPs bombarded the Board, which hesitated — a

number of its members had Sabbatarian leanings – but finally agreed. Sunday openings would make for special arrangements and the payment of two shillings and sixpence extra to the porters in attendance.

At a special meeting of the Board on Thursday 28 January 1864, it was ordered:

'That a Board be placed inside the Entrance Gate:
National Gallery of Ireland
Open to the Public, subject to the Regulations of the Board, on Mondays, Tuesdays, Wednesdays and Thursdays from noon to dusk or 6 pm and on Sundays from 2 p.m. to dusk or 5 p.m.
Admission free,
Fridays and Saturdays reserved for artists and students.
Admission to the Public on these days Six-pence.
Donors and Subscribers free.
1st February 1864.
By order George F. Mulvany R.H.A. Director'.

The Board also ordered a notice to be hung up in the Entrance Hall among the plaster representations of Egypt and Nineveh.

'The Gallery is open to the Public subject to the following Regulations:
No Children can be admitted under the age of five years.
Visitors of the Operative Classes are expected not to present themselves in their ordinary work attire.
Visitors are strictly enjoined not to touch any object exhibited and not to deface or injure any portion of the Building or its contents.
Umbrellas and Sticks are to be deposited with the Porter at the Entrance, In case of any infraction of these Regulations of the Board, the officials in care of the Gallery have orders to remove the offender from the premises.
The Board also reserves the right to refuse admission to ill conducted and suspicious characters.
By order, George F. Mulvany, R.H.A. Director.'

At last, on the afternoon of Saturday 30 January 1864, the Board, which at that time consisted of 'The Lord Chancellor, the Earl of Meath, Lord Talbot de Malahide, Sir George Hodson, Sir Richard Griffith, Bart. LlD,

Major Genl Sir Thos A. Larcom, KCB, the Very Rev. Dean Grace, SFTCD, William Brocas, RHA, Robert Callwell Esq, Michael Angelo Hayes, PRHA', together with the Director, George F Mulvany, RHA, the Registrar, Mr T Henry Killingly, and 'a very numerous assemblage of invited guests'[33] awaited the arrival of the Lord Lieutenant.

1 *Irish Times,* 27 Jan. 1864
2 Minutes of NGI Board, *passim*
3 Minutes, 17 Oct. 1861
4 Anne Crookshank and the Knight of Glin, *Ireland's Painters, 1600-1940* (New Haven & London 2002) p. 206
5 *ibid.*
6 *ibid.* p. 208
7 Address to the Public for Donations or Works of Art towards the National Gallery - quoted in Minutes, 6 Oct. 1856
8 Minutes, 4 June 1860
9 Michael Wynne, *Later Italian Paintings in the NGI,* (Dublin 1986) p. 92
10 Christiaan Vogelaar, *Netherlandish 15th and 16th century Paintings in the NGI* (Dublin 1987) p. 4
11 Director's Report 1863
12 David Oldfield, *German Paintings in the NGI* (Dublin 1987) p. 84
13 Ellen Duncan ,'The National Gallery of Ireland', *The Burlington Magazine,* vol. x. (Oct 1906-March 1907) p. 7
14 David Oldfield, *Later Flemish Paintings in the NGI* (Dublin 1992) p. 74
15 *Faulkner's Dublin Journal* (Nov. 1750), quoted in John Turpin, *A School of Art in Dublin since the Eighteenth Century* (Dublin 1995) p. 8

16 Minutes, 4 Aug. 1860
17 *ibid.*
18 Director's Report 1863
19 Minutes, 1 June 1861
20 Damp Press Book. Mulvany to Brucciani, 24 Feb. 1863
21 Minutes *passim*
22 Irene Hough, 'A Visit to our National Gallery', *The Irish Monthly,* Nov. 1932
23 Report of the Finance Committee, 24 Dec. 1863
24 Finance Committee Minutes, 24 Dec. 1863
25 Finance Committee Minutes, 30 Oct. 1866
26 Minutes, 16 Oct. 1890
27 Killingly to Mulvany, 19 June 1863
28 Minutes, 16 July 1863
29 Minutes, 14 June 1865
30 Finance Committee Minutes, 24 Dec. 1863
31 GF Mulvany, *Catalogue of Works of Art in the NGI* (Dublin 1864)
32 *ibid.*
33 *Illustrated London News,* 13 Feb. 1864

DEVELOPMENTS DURING THE 1860s

The new Gallery was well received. The *Freeman's Journal* thought the double staircase was the finest in Dublin, apart from that at the Mater Hospital. The reporter for the *Irish Times* praised the 'great sculpture hall...elegantly arranged, beautifully proportioned and admirably adapted to its purpose'. The staircase was 'truly grand', while the Queen's Gallery had the writer gasping. 'We have been in many galleries, but we know of none that presents such a pleasing *coup d'oeil* on entering'. His eye was 'imperceptibly carried from the dense shaded tiled floor along the gorgeous ranges of fine pictures to the lantern which lights the entire, and which is supported by a range of bronze consoliers'. He noted the 'ranges of very large and luxuriously upholstered double ottomans with leaning back, entirely covered in the richest maroon utrecht velvet' on which 'the public could recline while examining the paintings'.[1] (The financial accounts indicate that Mrs Moore, the wife of the Head Porter, was regularly paid two shillings and six pence extra for washing 'sofa covers' in addition to regular washing, for which she was paid six shillings and six pence every three months.)[2] Altogether there was reason to praise the 'Committee of Management and the able and courteous Director' for 'tasteful arrangement'.[3]

The paintings also came in for approval. In another article the reporter recommended the pictures that 'strike us most forcibly'; they included the de Heem fruit piece (NGI 11) and two Fesch pictures, bought from Signor Aducci in Rome in 1856: *Adoration of the Shepherds* (NGI 1918), by the neo-classical artist Francesco Pascucci (active 1787-1803), and *Christ on the Cross* (NGI 89) now given to Antonio Panico (c.1575-1620).[4]

The reporter for the *Freeman's Journal* also praised this picture: 'How faithfully true to nature, but still rising above it, the artist gives it a power and a soul which true genius alone could invest it with!' He disliked Carlo Maratti's *Europa and the Bull* (NGI 81). 'The white bull into which Jupiter transformed himself and on which Europa sits, is by no means a good

specimen of animal painting, particularly if we are to judge him by the bulls of the present time'.[5] However, he concluded that the National Gallery of Ireland 'already…has been recognised by the public as a place for intellectual instruction, recreation and enjoyment'. Amid the general praise there was one dissenter, architect William George Murray, who, in March 1864, read a paper to the Royal Institute of Architects of Ireland. Murray did not like Fowke's designs at all. He condemned the meanness of the entrance and vestibule, the unsatisfactory arrangement of the Sculpture Hall, 'the intensely ugly, awkward and dangerous grand staircase' and the picture galleries. 'One's feeling is that all is the work of an amateur at his wit's end to carry out some ghost of an idea which he has in his head and perpetually inventing for himself ways of doing things which have been done before a thousand times better'. He mentioned the cost, which remains puzzling, although the term 'over budget' was not in use in Victorian times. 'The cost of the building on the other side of Leinster Lawn…was about £11,000. What is there in the unfinished National Gallery to account for the extra £18,000?'

He concluded: 'I do not say or wish it to be supposed for one moment that any of the parties concerned have pocketed any of the funds…' and went on to denounce the amateur attempts of gentlemen headed by the Lord Chancellor 'to procure for the citizens of Dublin a bad building… from which architecture is excluded and barely half finished at a monstrous cost, and they now ask our thanks as men who have done well for the country. We are saddled with an unfinished monster that can never be removed and will perpetually stand in the way of any future improvement both by its being there, existing in ugliness, and also by its having exhausted the fountains of generosity by which it might be replaced'. Not surprisingly Murray's paper was followed by 'lengthy discussion'.[6] Fowke's reaction to this attack is not known.

But there had been enough praise for Murray's opinions to be ignored by those directly associated with the Gallery. The public initially welcomed the new institution. In the first three weeks 17,453 people passed through the turnstiles. They came on weekdays, on Sunday afternoons and in the evening. On 25 May the NGI was opened at night for the first time, admittance one penny. 'That the evening opening promises to be popular there can be little doubt, from the fact that before the hour of opening last night, the people were to be seen sauntering in front of the Gallery awaiting the opening of the gates'. In the Queen's Gallery 'an oblong frame elevated far above the pictures in the arch of the ceiling' contained two hundred gas jets 'which when in full blaze cast down a

flood of light so strong and equally distributed, yet so modified as to its intensity by the distance which it falls, that one would almost fancy that night were day within the walls'.[7] The opening of the Gallery by gaslight was done intermittently; it would cease, and then be resumed in 1868.

Lady Gregory remembered how her husband took her to the Gallery 'some Sunday long ago, soon after my marriage, that I might see the people coming in, and that many of them were working men with their wives and children'. Sir William Gregory had been fighting for Sunday opening in England and was 'proud that it had been accepted in Ireland long before London museums and galleries had unlocked their Sabbath door'.[8]

But it did not take long for gentlemen to object to the 'operative classes'.

'*Irish Times*…23 Feb. 1864. To the Editor: Sir, On Sunday I visited the National Gallery and felt greatly pleased at seeing the proprietary nature with which the lower orders conducted themselves. Nevertheless there is a class of visitor which it would be desirable to exclude…I mean young boys and children, of whom there were many and who, not being under the supervision of grown people, amused themselves tramping on the ornamental grass in front of the building and touching the statuary in the sculpture department. May I suggest that, as the place was so thronged that at times it was difficult to get in, a red rope or moveable standards should be placed at a sufficient distance from the statuary to prevent it being too nearly approached by the people, as also down the middle of the long room so as to direct the people in one continuous stream through the building, passing up the right hand staircase and down the left'.

'*Freeman's Journal,* 9 March 1864. To the Editor: Sir…Now there are many persons, who, in consequence of having to attend to business during the week days, are unable to see the Gallery except on Sunday…imagine their astonishment to find a set of ragged urchins wherever they go, and quite doing away with any pleasure they might derive from their visit. I regret to say such was the case on last Sunday…and while no liberal-minded person could be so selfish as to wish to exclude the artisan or tradesman, who, however humble, can be respectable, I must say it is very ill-advised of those in charge of that institution to allow such parties into it as I saw there on Sunday, else indeed we will shortly see no respectable person there'.

('If the poor youths alluded to misconduct themselves they ought to be turned out; but if not, the fact of being young and not dressed in

purple and gold, constitutes no ground for exclusion - Ed.')

The matter of Sunday crowding was not considered important enough for Mulvany to bring it up at the Board meetings. The Governors were more interested in numbers, and initially they were buoyant. During the first ten months 167,698 visitors were recorded; the annual attendance for the next three years was 89,943, 109,605 and 128,680.[9]

In December 1863, the 2nd Earl of Charlemont died, and in March 1864, Mervyn Wingfield, 7th Viscount Powerscourt, succeeded him on the Board of Governors and Guardians. He collected paintings and some years later, in 1877, bought one ascribed to Gabriel Metsu, *Young Woman with a Water Pitcher,* which turned out to be by Johannes Vermeer. Unfortunately there was no question of this coming to the impoverished NGI. In 1887 when an extension was needed for Powerscourt House, the painting was sold to the American banker, Henry G. Marquand, who presented it to the Metropolitan Museum of Art in New York.

Lord Powerscourt offered some paintings to the NGI which were less distinguished. They included an explicit *Venus and Cupid* (NGI 77) by the Florentine painter Michele Tosini (1503-77) presented in 1864, the year that he not only joined the Board, but also got married. Possibly his bride objected to its erotic content. However as Governor and Guardian for almost forty years, he would give invaluable service to the Board, and his influence as friend and adviser to both Mulvany and his successor, Henry Doyle, would be most important to the Gallery.

At the same meeting in March 1864, Mulvany announced that the patriot William Smith O'Brien, having returned from exile in 1858 and recently died in Wales, had bequeathed to the new Gallery a painting (NGI 166) by Joseph Haverty (1794-1864), a version of his melancholy and iconic *The Blind Piper,* in which the Limerick piper Pádraig Ó Brien plays a lament for Ireland while an innocent little girl listens.[10] Although the *Piper* was one of the most popular paintings in the Gallery, Mulvany did not build on the small collection of Irish pictures. Instead, he made new attempts to widen the scope of the collection, hanging paintings haphazardly as acquisitions were made, rather than by Schools.[11]

His Gallery was for 'Old Masters' and Irish artists were not among them. In 1860 Richard Rothwell (1800-68) had written to him asking for his *Calisto* to be acquired by the NGI. 'I show this picture…as one for delicacy, for beauty of colour, drawing and richness of background, as equal to anything which we poor modernisers can exhibit, and I should like it to take its place in the National Gallery and for that reason I sent it to Dublin'.[12] Mulvany turned him down, and the Gallery would not

The Blind Piper (Pádraig Ó Brien), c.1844 by Joseph
Patrick Haverty (1794-1864), presented 1863
(NGI 166).

receive *Calisto* (NGI 506) until it was purchased from a London dealer in 1901.

The Director's Report for the year ending 1864 stated that Mulvany had travelled in London and Paris in the months of April, May and June 1864. Later, 'in connection with, and furtherance of, the interests of the Gallery, I made a journey on the Continent in the months of September, October and November, visiting the most important cities in Germany, Italy and Spain'. These were buying sprees, during which he was growing more confident; there were fewer copies or paintings in poor condition and more in the way of pictures which are still important to the NGI. On 7 May at Christie's, Mulvany bought *The Doge Wedding the Adriatic* (NGI 92) by Francesco Guardi (1712-60) for nineteen guineas, an unusual subject for him, copied by his son. In the same month in Paris he acquired two Dutch paintings: *Prince Maurits and Prince Frederik Hendrik going to the Chase* (NGI 8) by Pieter de Molijn (1595-1661), a tiny panel crowded with figures, for thirty guineas and the lovely *Garland of Flowers* (NGI 50), long accepted as by the prolific Jan van Huysum and now attributed to Jacob Xavery (1736-after 1774), which cost seventy-seven guineas.

On his visit to Rome Mulvany purchased for £100, with seven other pictures, the all too realistic *Beheading of St John the Baptist* (NGI 366), another subject then thought to be by Caravaggio, now given to Mattia Preti (1613-99). For £75 he bought the splendid portrait of fifteen-year old *Prince Alessandro Farnese* (NGI 17), only identified in 1993 as by Sofonisba Anguissola (c.1538-1625) from Cremona, one of few women artists of the Renaissance. She often worked for the Spanish Court, explaining the former misidentification of the artist as Alonso Sánchez Coello. In the same year another bargain was acquired, *St Diego of Alcala* (NGI 479) by Francisco de Zurbarán (1598-1664), costing a mere £5. Subsequently thought a copy, as unseen in stores, it was accepted as autograph in 1959 when shown by Thomas MacGreevy to a Spanish scholar.[13] A fine copy, attributed to Raphael Mengs, of Raphael's *Transfiguration* (NGI 120), bought for £21, turns out to have been painted in Rome by the English artist and dealer, James Durno (1745-95). Valued at £1,000, he sold it to the Earl Bishop of Derry.[14] It has alternated, with the Panico *Christ on the Cross* (NGI 89), in hanging above the main staircase.

At the Watkins Brett sale at Christie's in April 1864, Mulvany bought for £3. 15s. an abraded copy of van Dyck's *Frans Francken II* (NGI 1994), with a portrait of Sebastian Vrancx, which disappeared from the Gallery after 1875.[15] More significantly, realising the importance of drawings and watercolours, he obtained four small drawings (NGI 2063, 2234, 3247 & 3287)

attributed to Federico Zuccaro (c.1540-1609) and a portrait head in black and red chalk and ink by Lucas Vorsterman (1595-1675) of Thomas Howard, Earl of Arundel (NGI 2096). He kept watch for an opportunity to acquire more drawings and was rewarded two years later. Henry Wellesley, the illegitimate son of Richard Colley Wellesley (and therefore of Irish descent) was Curator of the Bodleian Library and the University Galleries which formed the nucleus of the Ashmolean in Oxford. After his death, his collection of drawings was dispersed in a huge sale at Sotheby's in the summer of 1866 where Mulvany made some superb purchases. They included a young man in profile (NGI 2233) by Antonio del Pollaiuolo (1431/2-98), *Head of a Girl* by Lorenzo di Credi (1459-1537), *A Standing Philosopher* by Raphael (1483-1520) and a striking portrait of Francesco Gonzaga (NGI 2019), one of a handful of drawings that can be attributed to Andrea Mantegna (1431-1506). In addition, a charming purchase was 'A. Dürer. A rabbit, highly finished. £11,11/- Contemporary copy' (NGI 2095).[16]

Two important gifts by Hodder Westropp and the Irish artist, Frederic Burton (1816-1900), during Mulvany's lifetime further ensured that the NGI's collection of drawings and watercolours had a fine start. The drawings donated by Burton, which had belonged to Sir Thomas Lawrence, included two outstanding studies (NGI 2239 & 2240) by Francesco Primataccio (1504-70) relating to lost paintings.[17]

At the end of 1864 the Gallery received an anonymous donation of £2,000. Only in 1867 on the demise of the donor could Mulvany reveal his name.

'To the Editor of the *Daily Express*…I now for the first time feel at liberty, by reason of the recent death of Mr. Dargan, to make public a fact which the unostentatious nature of the man forbade hitherto to make known but to a very few, that he desired to supradd (sic) to the indirect results of his public spirit to which the Gallery owes its origin substantial aid in the formation of its collections…It was his intention, frequently expressed to me, had health and prosperity been spared to him, to have considerably increased his donation, one already amply sufficient to entitle him to the gratitude of his fellow countrymen'.[18]

Dargan had continued to show a consistent interest in art, and from Mulvany's letter it is clear that he was a good friend of the first Director. When he died on 7 February 1867, most of his fortune had been spent on good causes. His obituary in the *Illustrated London News* traced the tragedy of his declining years – the fall from the horse, the collapse of his enterprises. 'Broken in spirit and constitution, he had not power of resistance,

Head of a Girl, by Lorenzo di Credi (1459-1537),
silverpoint drawing, purchased Rev. Dr Henry
Wellesley sale 1866 (NGI 2069). A typically
graceful study by this Florentine artist, from
the second purchase of Old Master drawings.

and sank under the cares and afflictions which fell upon his later years'. But at the end of his life, when his finances were in disarray, he found money to give to the Gallery.

In 1865 the Treasury agreed to pay the salary of the Registrar, Thomas Henry Killingly, giving Mulvany £300 a year for himself, a sum which was raised to £400 at the end of 1866. But the generous travelling expenses that had been a means of making up the smallness of his stipend were no longer paid. Instead, it was agreed that he should have a guinea a night when he was away from home on Gallery business, and be repaid his exact cab and train fares. In 1867 his salary was raised again, to £500 a year. Having moved several times in Dublin, in 1866 he settled with his family in 18 Herbert Place, a short walk from the Gallery door.[19]

On 2 June 1865 he wrote to 'C Bianconi Esq. My dear Sir, Mr. M.Angelo Hayes communicated yesterday to the Governors and Guardians of the National Gallery of Ireland your kind intention to present a painting of *Christ at Emmaus*, which work the Governors accept with pleasure…

'If you will be kind enough to have it packed and forwarded by train, I will be happy to take charge of it; or if there be any difficulty about a packing case I can send one down if you will let me have the exterior dimensions of the frame of the picture'.[20]

Dargan had displaced Bianconi's long cars with his trains, but the Italian entrepreneur, now happily settled on his estate in County Tipperary, bore no grudge towards the Gallery which his rival had helped create. His gift *The Supper at Emmaus* (NGI 57) by Jacob Jordaens (1593-1678), was a lot more substantial than that of most other donors. 'The rustic realism of the figures, as shown by their bare feet, plain garments and rugged faces, and the humble setting, are typical features of Jordaens' work… The strong contrast of light and shade on the disciple in front, the softer transitions of light on the disciple at the rear, and the fully-lit features of Christ enhance the narrative excitement of the sudden recognition of Christ'.[21]

Squeezing money out of the Treasury invariably provoked trouble and frustration. Although my Lords gradually came to the conclusion that if they allowed a picture gallery to be built in Ireland at considerable public expense, it must have enough funds to function properly, every penny was conceded grudgingly. The vote of £2,500 in 1862 intended to repay the Lord Chancellor had been considered a once-only gesture. When in April 1864 Mulvany wrote requesting a grant, the reply was a refusal full of grumbles about the Gallery's building costs. Not until March 1865 did my Lords 'feel warranted in proposing to Parliament a vote of £2,500 voted for the same purpose in 1862'.[22]

With the earlier vote, the figures were juggled so that they made up the money donated by the Dargan Fund; but this meant that the whole building had been erected at public expense. The Treasury therefore considered it necessary that the fabric of the Gallery should be vested in the Board of Works, a decision that proved fortunate for the Governors, when in 1868 a piece of glass from a pane in the flat glass ceiling of the Queen's Gallery fell onto the Rev Mr O'Neill, parish priest of Blackwater, Co Wexford, and his brother John.[23]

John O'Neill was quite badly hurt. 'As to the Reverend Mr O'Neill,' wrote his solicitor, 'besides the external injuries received by him, he has sustained so great a shock to his system, that he is now suffering from a recurrence of a severe and painful disease, from which he was perfectly free at the time of accident'.[24] Claim and blame were shuffled between the Board of the NGI and the Board of Works until in November 1869 the suffering O'Neills were compensated with £150, which did not come out of the NGI's estimates, but direct from the Treasury.[25]

In March 1866 an annual grant of £1,000 was conceded for the buying of pictures, provided an equivalent sum was raised by public subscription. But since it was soon clear that the public would not give anything like the necessary sum annually, the Treasury eventually conceded that 'pictures given to the Gallery should be valued and counted as money subscriptions'. In these circumstances, Lord Powerscourt's Bolognese School copy of Raphael's *St Cecilia* (NGI 70), donated in 1866 as painted by Domenichino, was accepted by the Treasury as being worth 'at least a sum of three hundred pounds'.

The condition that the equivalent of each year's purchase grant should be made up by an equal sum from financial donations or the value of donated pictures was gradually forgotten. Up until July 1869 the pictures presented were valued at £3,785 and the money gifts, apart from the Dargan Fund, amounted to £6,570[26] (£4,000 of which came from the Lord Chancellor and William Dargan). Soon the money was given annually without conditions; the £1,000 a year grant, with variants, and omissions during the First World War, would continue until 1938.

Each year the Board presented the Treasury with estimates for the following twelve months, covering every aspect of expense – 'Wages, Charwomen, Water Rent, Liveries for Porters, Director's Travelling Expenses, Fittings and Pedestals, Floor Cloths, Oil for Tiles and other sundries', as well as 'the Purchase of Works of Art – £1,000'. The most trivial item was closely questioned. 'My Lords…observe that in last year's Estimate provision was made for six servants at £192, whereas in the

present Estimate five servants are estimated at £228. A full explanation…
is required…'[27]

The NGI's difficulties over money and the contrast with London was appreciated by a wider public. The *Freeman's Journal* sermonised in March 1866: 'When it is considered what has been done with very limited means, and we find that very interesting and important works obtained by purchase have not cost more than £10,000, while for one picture recently added to the London National Gallery, a small, but no doubt most valuable work, a sum of £9,000 was paid, we look confidently forward to seeing the National Gallery of Ireland by means of more liberal policies gradually acquiring a still richer treasure of works of art…'

In March 1866, at the sale of the Comte Raynal de Choiseul Praslin in Paris, Mulvany bought for £46. 12s. 5d. a partial copy of *St Luke drawing the Virgin* (NGI 4) as by 'Dirk van Haarlem', now given to a follower of Rogier van der Weyden (1399/1400-64), possibly even Jan Gossaert (c.1478-1532). Another acquisition at the same sale, costing £360, was the *Rest on the Flight into Egypt with the Infant St John* (NGI 98). Bought as 'School of D. Ghirlandaio', clarified as his son Ridolpho Ghirlandaio in the 1867 catalogue, it is now recognized as a principal work by Francesco Granacci (1469-1543), the friend of Michelangelo, whose influence can be seen in the sculptural pose of the figures, although the Virgin's leg is oddly connected to her body.

Lord Powerscourt was with the Director at Christie's when he obtained the wistful *Portrait of a Gentleman and his Two Children* (NGI 105) by the Bergamese portrait painter, Giovanni Battista Moroni (c.1520/25-78). In Dublin Mulvany purchased from artist, William Brocas, *Head of a Wild Boar* (NGI 43) by Jan Fyt (1611-61), which had been exhibited at the Irish Institution in 1854. This was probably a study for a picture in the Alte Pinakothek, Munich, of a wild boar hunt, which was further based on a painting by Rubens.[28]

As a portrait painter himself, Mulvany had a personal interest in buying portraits for the Gallery. The portrait of a young man (NGI 372) by Georg Pencz (1500-50) was purchased in Paris for £41, one of many continental purchases whose exact provenance was not stated. In 1866, Mulvany obtained two other noteworthy sixteenth century German portraits, the *Count of Montfort and Rothenfels* (NGI 6) by Bernhard Strigel (c.1460-1528) bought in Paris for £160, and, at the Henry Farrer sale at Christie's, as Hans Asper, *Katherina Knoblauch* (NGI 21), bedecked in gold and jewels, by Conrad Faber (1500-52/3), whose *oeuvre* of forty-one portraits was only established from 1909. She was knocked down for twenty-three

Rest on the Flight into Egypt with the Infant St John, c.1494
by Francesco Granacci (1469-1543), purchased
1866 (NGI 98).

guineas, the pendant of her husband later entering the Art Institute of Chicago. Nearly twenty years later Doyle would buy her brother, Heinrich (NGI 243), also by Faber.[29]

In the same year Mulvany purchased for £100 from an unknown source in London the first of eleven pictures in the NGI by the Spaniard, Bartolomé Esteban Murillo (1618-82). This was a portrait of Josua van Belle (NGI 30), a shipping merchant from Rotterdam who lived for a time in Seville, where Murillo painted the portly Dutchman as a prince, in the manner of Rubens and van Dyck, standing on a terrace with a balustrade and a draped scarlet curtain as a backdrop.[30]

After he returned to Holland from Spain, van Belle lived in his home town, where he accumulated a celebrated collection of paintings. These were disposed of by his son in a sale which took place on 6 September 1730, although this particular family portrait was not included. However, another painting in that sale, Lot 92, was *A Lady Writing a Letter, with her Maid* (NGI 4535) by Johannes Vermeer (1632-75)[31] which, after many changes of ownership, would come into the NGI in 1987 as the most dazzling item of the gift of Sir Alfred and Lady Beit.

In addition to the running of the Gallery and the journeys in search of purchases, Mulvany was responsible for the restoration and preservation of the new acquisitions. A cement 'lining table' for carrying out repairs was one of the Gallery's early requisites.[32] In his Director's Report for 1868 Mulvany described how 'the portrait of the Daughter of the Doge Mocenigo' (NGI 1085) 'by Paolo Veronese' (a generous attribution for this work, which had been presented by Joseph F Duckett in 1868) 'has been much painted upon. On closer investigation I found that an entirely new face had been painted over the original, which, along with other repairs, I carefully restored'.

He also described how a picture attributed to Giovanni Bellini 'is not yet completely restored. I found it in very bad condition, covered with varnish and old repairs and I have devoted much time myself to its careful restoration'. This was the painting which Mulvany had bought from M. Auguiot in Paris in 1867 for £1350 (£800 in cash and £550 to be paid over ten months). The Treasury helped to fund the purchase although the money had to be repaid the following year. It is a double portrait of two Venetian men (NGI 100) and had been in the Fesch collection, then later belonged to the French history painter, Paul Delaroche, best known for his highly charged *The Execution of Lady Jane Grey*, in the London National Gallery. Although the Bellini has been recently cleaned, identifying the artist continues to be a mystery. It is now assumed that the portrait on the

right is by Vincenzo Catena (c.1480-1531), while the head on the left is by an unknown contemporary.

For his restoration work Mulvany received an extra £40 in addition to his salary.[33] For many years pictures were also sent to the firm of Treacy in Heytesbury Street. The account books show regular payments: 'May 8 1865 - John Treacy Repairing Pictures – £3.'; 'October 12 1867 – John Treacy Repairing several pictures – £24'. In 1908, the head of the firm, another John Treacy, wrote to the Director at the time, Sir Walter Armstrong, about *Christ on the Cross* (NGI 89) by Antonio Maria Panico. 'Sir, the large painting of the Crucifixion was much repaired when Mr Mulvany, the first Director of the Gallery bought it. We lined and cleaned it for him shortly after the Gallery was opened, and during Mr Doyle's time, the late Director, it got 12 or 15 coats of varnish which now has (sic) got discoloured'.

Restoration was still a casual practice in the mid-nineteenth century, although the 'infamous' methods condemned by Mr Jeanron, the Director of the Louvre, had been abandoned – the 'wash-and-daub' process carried out by men hired at the rate of ten francs a day, which had destroyed many important pictures. The discipline of attribution was equally haphazard, often more a matter of inspired guesswork and optimism. It was not surprising that, as Mulvany grew more confident and had more money to spend, he should make mistakes.

Every collection of Old Masters should have a painting by Peter Paul Rubens (1577-1640) and Mulvany acquired one from Monsieur Nieuwenhuys in Paris for £720, most of the Treasury Grant for 1868. *The Annunciation* had a good provenance, since it had once been in the House of Orange collection at Huis ten Bosch in The Hague, but modern research suggests that it came from Rubens' huge workshop where pupils and assistants worked up the great artist's ideas, with perhaps a slight retouching to suggest that a picture came, literally, from the master's own hand. David Oldfield concludes that 'the workmanship is...not up to Rubens' standards'.[34]

When Mulvany acquired them for the NGI, however, the 'Rubens' and the 'Bellini', both unquestioned and expensive, gave pleasure to the Board, to the Director and to the citizens of Dublin. So did the *Head of a White Bull* (NGI 56) by an imitator of Paulus Potter, also expensive at £500, bought as genuine in 1868, the last year of Mulvany's life, now condemned for 'an overriding silliness'.[35] Mulvany's last year as Director also brought in a Luca Giordano (1634-1705), *St Sebastian tended by St Irene* (NGI 79), as by Caravaggio, which was presented by the 3rd Duke of Leinster.

Soon there began to develop a more serious problem for the Gallery. After the initial euphoria and interest, the number of visitors plummeted. Attendance at the NGI reached a high-water mark of 138,680 people in 1867, a figure that would not be attained again for nearly a century. Admissions would dwindle throughout the next decade to a more or less stable figure of around 90,000, and then go down again until the empty galleries echoed.

An article in the *Freeman's Journal* in March 1868 must have made disturbing reading for the Director and his Board.

'It is much to be regretted that this valuable institution has not been consistently favoured with our public countenance. Its inauguration was hailed with ardour by many prominent citizens, and for some time subsequent to that event, popular sympathy and support was not grudgingly afforded'. The *Journal* went on: 'There can be no doubt that the day time of our poorer people is too occupied to allow of visits to the fine arts, and the Gallery up to the present time has been closed at nights. This has to some extent been remedied and the splendid brilliantly lighted halls are now open gratis from eight to ten o'clock in the evening'. There were many inducements for a visit. 'The halls (statuary and painting) are comfortably heated, fitted up with easy couches, well lighted, and altogether very cheerful…There are attendants, civil and intelligent, ready to afford any general explanation…We have no hesitation in recommending our toiling friends to try a visit on some Saturday evening'.[36]

However: '…the first symptoms of decline were rapidly followed by an almost entire absence of visitors; and during the four weeks on which free admission was to be had you may see an enthusiastic young lady here and there sketching in the solitary hall'.[37] For the next century the image of the Gallery's empty rooms would cause repeated comment and derision.

The Minutes of 4 February 1869 note that the Director was 'dangerously ill'. He died three days later of 'paralysis' at his house in Herbert Place. He was sixty. He may have had a stroke brought on by overwork and the endless journeys in smoky trains, enduring rough crossings of the Irish Sea and the English Channel. His successor, whose lifestyle was similarly frenetic, would die in similar circumstances.

Through her brother-in-law, the grieving Mrs Mulvany formally acknowledged the letter of appreciation sent to her by the Board with 'her heartfelt thanks for the expression of their sentiments and tribute to the memory of her beloved husband… emanating, as it does, from those

who had the best opportunity of knowing and valuing his labours and his worth'.[38]

Walter Strickland would sum up Mulvany's Directorship with faint praise: 'Of much sound sense and ability and of pleasing manners, he was, considering the limited powers accorded to him by the Board of Directors, undoubtedly successful as a director. He possessed good judgement, and, for the time, no inconsiderable knowledge of art'.[39] This assessment, coloured by dislike of many of the pictures chosen in the NGI's early years, is grudging. But Mulvany's achievements were substantial. Not only did he buy beautiful paintings for very little money, but the Gallery's very existence owed much to the exertions of its first Director.

1 *Irish Times*, 27 Jan. 1864
2 Minutes of NGI Finance Committee, 'incidental expenses'
3 *Irish Times*, 27 Jan. 1864
4 *Irish Times*, 19 Feb. 1864
5 *Freeman's Journal*, 17 Feb. 1864
6 *Irish Times*, 9 March 1864
7 *Daily Express*, 25 May 1864
8 Lady Gregory, *Hugh Lane's Life and Achievement* (London 1921) p 196
9 Homan Potterton introduction to *Illustrated Summary Catalogue of Paintings in the NGI* (Dublin 1981) p. xviii
10 Minutes of NGI Board, 3 March 1864
11 Potterton (as n. 9)
12 Quoted in WG Strickland, *A Dictionary of Irish Artists* (Dublin 1913) vol. II, p. 311
13 Notes in NGI Archive, quoted in Rosemarie Mulcahy, *Spanish Paintings in the NGI* (Dublin 1988) p. 87, n. 2 and n. 3
14 Nicola Figgis,' Raphael's "Transfiguration": Some Irish Grand Tour Associations', *Irish Arts Review Yearbook* (1998) pp. 52-56
15 David Oldfield, *Later Flemish Paintings in the NGI* (Dublin 1992) p. 34
16 Minutes, 2 Aug. 1866
17 Homan Potterton introduction to *Illustrated Summary Catalogue of Drawings, Watercolours and Miniatures* (Dublin 1983) pp. x, xi and xii.
18 *Daily Express*, 20 Feb. 1867
19 *Thom's Directory 1866*
20 Damp Press Book. Mulvany to Charles Bianconi, 2 June 1865
21 Oldfield (as n. 15) pp. 80-81
22 Minutes, 22 March 1865
23 Minutes of Special Meeting, 8 Oct. 1868
24 *ibid*. Letter from Arthur Cullen, Solicitor
25 Minutes, 18 Nov. 1869
26 NGI Estimates
27 Minutes, 1 Feb.1866. Letter from Treasury
28 Oldfield (as n. 15) p. 58
29 David Oldfield, *German Paintings in the NGI* (Dublin 1987) pp. 19-23
30 Rosemarie Mulcahy, *Spanish Paintings in the NGI* (Dublin 1988) p. 55
31 Arthur K. Wheelock jr. (ed.), *Johannes Vermeer*, exh. in Washington and The Hague 1995-96, p. 188
32 Minutes, 15 July 1862
33 Thomas Henry Killingly, Account Book, 30 Nov. 1867
34 Oldfield (as n. 15) p. 107
35 Homan Potterton, *Dutch Paintings in the NGI* (Dublin 1986) p. 117
36 *Freeman's Journal*, 13 March 1868
37 *ibid*.
38 Minutes, 4 March 1869. Thomas Mulvany to the Board.
39 Strickland (as n. 12) vol. II, p.153

CHAPTER TEN

EVERYDAY BUSINESS AND THE LOSS OF THE FIRST REGISTRAR

When Mulvany was appointed in 1862, there had been no open contest for Director. Now, in March 1869 the position was advertised in Dublin's four daily newspapers. Six artists, five of whom were members of the Royal Hibernian Academy, put their names forward.

Michael Angelo Hayes (1820-77) whose detailed watercolour of Sackville (today O'Connell) Street (NGI 2980) is in the Gallery, was a member of the Board of Governors and Guardians and resigned in order to make himself eligible for the post. But perhaps his quarrel with the RHA in 1856, when he refused to recognise George Petrie as a member of the Academy, was remembered.

Stephen Catterson Smith (1806-72), an Englishman who had settled in Dublin in 1845 at the age of thirty-nine, went further, resigning his position as President of the RHA which had given him an *ex-officio* seat on the Board of the NGI, but also made him ineligible for the Directorship. He was a popular portrait painter whose subjects included various Lord Lieutenants, 'Balloo', an Indian servant of Lt General Hart of Kilderry, and the 1862 full-length portrait of William Dargan beside a table, presented by the Dargan Testimonial Committee,[1] from which a more portable bust-size fragment was later cut out (NGI 141).

Both Hayes and Catterson Smith were unsuccessful, and nothing more was heard about them in any official capacity, since they did not get their old positions back. Eight years later they were both dead, and by turning them down the Board had saved itself another election. Poor Catterson Smith was hanging pictures for the International Exhibition in Earlsfort Terrace; 'he was seized with apoplexy and died about eight o'clock in the evening on the drawing-room sofa in his house, No 42 Stephen's Green'.[2]

Three other artists were also passed over for the Directorship. James Richard Marquis (1853-85), Thomas Bridgford (1812-78), born in Lancashire but brought to Dublin as a child and Patrick Vincent Duffy (1832-1909) who

Photo of Henry Doyle (1827-92), second Director
(1869-92), c.1870 (NGI Archive).

emphasised his nationality: 'I am, besides, an Irishman devoted to and
dependent on Art'.[3]

The successful applicant was another artist, an outsider who lived in
London. The Minutes for 22 March 1869 noted: 'It was resolved that Mr
Henry E Doyle be appointed to that office...he having six votes, being
the majority of the Governors present.' Nine Governors eligible to vote
were at the meeting. As Thomas Bodkin pointed out,' a new and glorious
era was opened in the Gallery's history'.[4]

This was not apparent at the time. *The Irish Times,* which had been
tipped off as to the way the Governors were thinking, deplored any idea
of 'an importation from London'. A week before the election an editorial
observed that 'An Irish artist...should certainly be placed over the
National Gallery'. The fact that three of the applicants for the position
had their origins across the water did not enter the argument; at least
they lived in Ireland, and belonged to the Royal Hibernian Academy.
Until 1872 Henry Doyle was not even an Associate, and the *Irish Times*
suspected worse – that he was an Englishman. 'A "gentleman from
London" may command many influential friends. We hear it deplored on
all sides that the arts in Ireland are at a very low ebb, but it is difficult to
understand how they could prosper as we desire they should, if appoint-

ments are given to Englishmen who cannot be expected to entertain a very large desire for Irish success'.[5] Over the years similar arguments would recur.

'We have Irish artists, but no Irish, no national art', Thomas Davis had declared in 1843.[6] After Davis's death the question of the state of Irish art also continued to be a sensitive one. It surfaced in 1864, the year the Gallery opened, when the new Lord Lieutenant, Lord Wodehouse, was called upon to distribute medals to artists at the Royal Dublin Society. Standards were low, and most of the medals, according to the London *Times*, ever ready to have fun at Irish expense, were distributed to 'some young ladies for works of modest pretension, and, as it appears, still more moderate execution'. Lord Wodehouse was frank. 'His Excellency was most courteous in his style, but the real purport of his remarks was that the exhibitors had better throw their compositions in the fire, their medals into the Liffey and their efforts into another track altogether as far as art was considered'. 'Moreover', proclaimed *The Times*, asserting that 'art is not in the Irish people', '...what natural and early training is there for art even at Dublin, and what chance is there for a people if it have not natural and early training? There is no collection of pictures and sculptures or other works of art that a man can walk into any hour that he pleases'.[7]

The Times had gone too far, and Mulvany wrote a dignified letter stating there was indeed a National Gallery in Dublin, adding that he had sent a catalogue to Lord Wodehouse. He also pointed out proudly that the NGI was 'the first institution of its kind in the three kingdoms which has opened its doors for the benefit of the working class on Sundays after the hours of divine service'. Another correspondent who announced 'I am not an Irishman, but I hope you will allow me this opportunity of raising for a moment a shillelagh in defence of art in Ireland' praised 'the best lighted picture gallery that has ever been built, where a man can walk in almost when he pleases, even on a Sunday afternoon'.

In November 1867 Mulvany had to answer a critic nearer home. The Lord Mayor of Dublin resented money being spent on the arts, and told the Chief Secretary, Lord Mayo: 'if your Lordship goes down to what is called our National Gallery, you will not find in it one single painting by an eminent master, or one that would enlighten the eyes of the humblest person who goes to study art'. Again Mulvany refuted an outrageous statement. 'We have work by Murillo, Velasquez, Rubens, van Dyck, Ferdinand Bol, Govaert Flinck, Jordaens...'[8]

But where was Irish art in Ireland?

After Mulvany's death, six days after the post for his successor was advertised, an anonymous correspondent wrote a long letter to *The Irish Times* entitled 'A Plea for Irish Art'. It reiterated familiar arguments:

'We…have a National Gallery which, with few exceptions, contains no Irish pictures and is singularly deficient in modern works. It is only National at present in as far as its valuables are national property. What is wanted is a collection of first class works by Irish artists exclusively, which would always be open in some public hall in Dublin so that their beauties and peculiarities should be easily seen by the public as well as our young artists who would work more enthusiastically and express their native poetic feelings more freely when they saw that such were honoured and welcomed by the nation. When it is recollected that Ireland has produced such artists as Barry, Danby, Mulready, Foley and Hogan, it is clear that a great artistic future is possible to it'.[9]

Henry Edward Doyle (1827-92), would, as Director, become acutely aware of the absence of Irish art in the Gallery and promote the artists whom Mulvany had ignored. He was a member of yet another Irish artistic dynasty. In the space of three generations this Doyle family obtained five separate entries in the Dictionary of National Biography.[10]

John Doyle (1797-1868), Henry's father, who studied art at the Dublin Society Schools, went to London in 1821, where he became a political cartoonist. His eldest son, the illustrator Charles Altamont Doyle (1832-93), was father of Arthur Conan Doyle, the creator of Sherlock Holmes. Another son, Richard (1824-83), known as Dicky, friend of Dickens and Thackeray, was the best known artist of the clan; he drew and painted flowers and fairies and designed the cover of *Punch* which was used until 1956.

Henry Doyle, John Doyle's second son, was also an artist and, unlike the rest of his family, born in Dublin where he received his initial art training. He also drew for *Punch*, before switching to its rival, the comic magazine, *Fun*. He became a friend of the future Cardinal Wiseman, and through his patronage was appointed Commissioner for the Papal States in the London Exhibition of 1862.[11] He then spent some years in Ireland where he decorated the apse of the Dominican convent chapel at Cabra, North Dublin. During this period he married Jane Ball, the daughter of the Justice of Common Pleas in Ireland.[12]

Never outstanding as an artist, Doyle had numerous friends on both sides of the Irish Sea and has been to date the longest serving NGI Director at twenty-three years. Lady Gregory observed that 'he had much charm of manner, though he was more staid in appearance than

his brilliant brother "Dicky".'[13] Strickland wrote that Doyle 'by his tact, his good nature and his easy and pleasant manners made friends wherever he went and was well known and popular in London society'.[14] Lord Powerscourt remembered that 'he was one of my greatest friends and a delightful companion'.[15]

He had been closely associated with the Dublin International Exhibition of 1865. Aimed at surpassing Dargan's Industrial Exhibition of 1853, this was located at Earlsfort Terrace in a similar huge 'winter palace'. Doyle was put in charge of the Old Masters lent for the occasion, which were located in the Eastern Court in a room 94 feet in length. 'Some doubts were displayed as to whether Mr Doyle had displayed good taste in using light and neutral tints for the purpose of decoration…The results have proved that he was perfectly right'.[16]

Mulvany was with Doyle as the paintings and sculpture were being arranged. 'The task of unpacking and arranging the Exhibition was still going on up to the hour of opening on Tuesday… Mr Henry Doyle was busy hanging his pictures and arranging his marbles, receiving able assistance with the former from Mr Mulvany and with the latter from Lord Southwell'.[17] (Southwell would be elected to the Board of the NGI in August 1869.) When the Prince of Wales opened the Exhibition and returned for a second visit, it was Doyle who showed him around, pointing out masterpieces such as Hogarth's *The Gate of Calais* lent by the Earl of Charlemont which His Royal Highness 'especially admired'.[18]

Many of the Governors had personal experience of the abilities of the gregarious Henry Doyle when they came to consider him for Director. In his report at his first Board meeting, he indicated other friends such as Mr Boxall, the Director, and Mr Wornum, the Keeper, of the National Gallery in London, 'with both of whom I had a previous acquaintance and was warmly congratulated upon my appointment by both'. With the aid of Lord Overstone and Mr Gregory (later Sir William), 'the only Trustees I happen to know', and a word from John Ruskin, he immediately arranged for a loan of Turner drawings for the NGI.[19] This was a success, and soon he thought of keeping one of the smaller galleries especially for loans – an idea that did not work out, although he obtained one loan of twelve pictures from Lord Spencer's collection at Althorp during the time of Spencer's term as Lord Lieutenant.[20]

Three months after his appointment, in June 1869, Doyle went to Paris accompanied by Lord Powerscourt, who would recall how 'many a pleasant trip we had visiting foreign galleries and hunting for pictures, both on the Continent and at Christie's and elsewhere'.[21] On this occasion

Private View of the 1888 Old Masters Exhibition at the Royal Academy, London, 1889, by Henry Jamyn Brooks (1865-1925), (courtesy of the National Portrait Gallery, London). This large canvas (152.4 x 406.4 cm) contains sixty-five figures, fifty-nine identifiable, including Sir Frederic Burton (left group in profile), John Ruskin and Sir William Agnew.

Detail with Sir Richard Wallace, the Countess of Jersey and Sir Frederick Leighton in front of Henry Doyle (left; holding catalogue beside Sir John Robinson) and 7th Viscount Powerscourt (right, with beard)

they attended a sale of paintings belonging to two Russian grandees, Prince Alexander Koucheleff and Prince Alexander Besborodko, who had been Grand Chancellor of the Russian Empire. With Powerscourt's approval Doyle bought two paintings with strongly religious themes. The syrupy *Madonna Dolorosa* (NGI 83) by Sassoferrato (1609-85) has turned out to be a copy. The second picture, bought for £400, with grudging aid from the Treasury contracted by Lord Powerscourt, was a version of *The Infant St John Playing with a Lamb* (NGI 33) by Murillo (1617-82). It was dirty and covered with layers of yellow varnish which were not cleaned off until 1986, when the quality of the painting was revealed, removing all doubts as to its attribution.

Two more pictures acquired in 1869 were mentioned in the Minutes of 3 December. 'An old Flemish Picture attributed to Van der Goes purchased in London for £30 was submitted to the Board and its purchase approved'. This was the left wing of a triptych owned by a Waterford family named O'Shea, of whom nothing is known. *Christ bidding farewell to the Virgin* (NGI 13) is now given to Gerard David (1484-1523), the Bruges Master strongly influenced by van Eyck. Doyle was following Mulvany's preferences in purchasing this early Flemish masterpiece.

The other painting bought at this time is of a small boy, *Master John Crewe* (NGI 159), and cost £15. 'A picture by Martin Cregan RHA, formerly President of the Royal Hibernian Academy, a Copy of a Picture by Sir Joshua Reynolds which has since been destroyed, was submitted for purchase to the Board by the Director who stated that one of the objects that it would be well to keep in view in the future was the formation of a collection of the works of native artists of eminence and that he thought this picture worthy to form part of such a Collection'.[22] These were Doyle's first recorded thoughts on collecting Irish pictures.

He and his wife moved to Ireland and settled in Bray. From 1871-74 the Doyles lived at 4 Newcourt Road, one of the new villas springing up south of the town; in 1874 they moved to a larger house called Rahan on Kilbride Road.[23] William Dargan had been closely involved with Bray, losing much of his fortune trying to turn it into 'the Brighton of Ireland'. From the elegant little station puffing trains took passengers on the hour-long journey into Dublin. A familiar sight there was the tall bearded figure of Henry Doyle commuting to Westland Row. It was only a few minutes walk to Merrion Square, past Dargan's statue and into the vestibule with its Assyrian reliefs.

Doyle went elsewhere frequently – at least once a month, often twice, to London, where he had a *pied à terre*, and regularly to the Continent. For

a time the guinea a day that the Director could collect when he was away from home, together with his travelling expenses, was recorded in detail in the minutes of the Finance Committee. For example, in February 1876 his return ticket to London cost £5. 4s. 9d. He spent twelve days there, from the 4th to the 15th, and claimed twelve guineas. Carriage hire in Dublin for two months came to 9s.6d. In March he went to the Continent, to Paris and Avignon. In April he returned to Paris:

'Paris 13 days, 1 April to 13 — £13. 13s.
Paris Carriage Hire — £1. 4s. 4d
Paris Rail to Brussels — £1. 13s.
Brussels 5 days, 14 to 18 — £5. 5s.
Brussels Rail to Calais —14s. 10d.
London 3 days, 19 to 21 — £3. 3s
Carriage hire — 15s.
Dublin Carriage hire — 2s. 6d. Total £26. 19s.'[24]

These itemised travelling expenses, continuing for some years before they were simplified, give an idea of a restless lifestyle, catching mail boats, visiting the Continent and staying for days in London principally to attend sales at Christie's.

The reason for noting Doyle's movements in such detail, and the implementation of a voucher system for payments, was undoubtedly pressure from the Treasury following the events that blighted the early years of his directorship — the humiliation and dismissal of the first Registrar of the Gallery, Thomas Henry Killingly.

The Registrar's duties were described in the Bye Laws as 'clerk and assistant to the Director and keeps the accounts'. Killingly, who had worked for the Irish Institution since it was founded in 1853, saw to mundane matters at the Gallery while the Director was away. He was responsible for laying out the expenditure in the Estimates, which included such items as £50 for fuel and gas and £29 for incidentals like 'dusting, washing, etc.' In addition to the prices paid for paintings, and salaries, his account book lists the bills that were his responsibility to pay: 'December 31 1863. To Patrick Cullen — Coal £12. 18s; May 31st 1865. To W. Galbraith, Hibernian Gas Co, Gas £34. 12s. 2d. Others include 'Printing, Stationery and Postage, Porters' Uniforms, Caps, Clay and other materials for Garden and Ironmongery'. With regard to paintings, he recorded bills for framing and glazing as well as accounts for 'Works of Art purchased'.

He kept the Minutes. He wrote letters to the Board of Works about the roof leaking ('permanent injury will be sustained by the building and its

contents if the roof is not made staunch') to the Hibernian Gas Company about gas leaking, ('You will oblige me by sending one of your men to stop leakage which is most perceptible in the glass pipe at the rear of the Board Room') and to members of the public about mislaid umbrellas.

The Bye Laws stated that he had to be constantly present at the Gallery when it was open to the public. For all this he was initially paid £78 out of Mulvany's pocket. Only in 1865 was his salary paid out of public funds and raised to £120 a year, then to £150 in 1867.

Killingly and Mulvany had an amiable working relationship. Favours seem to have been exchanged; in 1864 and 1865 Killingly's son, Alfred, was employed at the Gallery on Sunday afternoons, earning £5. 10s. for each year, and on one occasion in 1866 being paid £2. 2s. for 'writing 50 labels for pictures'.[25]

That Killingly and Mulvany were friends is evident from the personal note that Killingly added to the formal condolence addressed to Mrs Mulvany by the Governors. 'Madam…you will permit me to add my own heartfelt sorrow for the loss yourself and family have sustained in the death of Mr Mulvany, from whom I ever experienced during the fifteen years we were officially connected unvarying courtesy, consideration and kindness, the recollection of which I will ever cherish with gratitude'.[26]

When Mulvany was away on Gallery business the Registrar had sent him regular informal letters. On 20 July 1863 Killingly was writing to Mulvany in London. 'I received your letter of yesterday this morning and have attended to your instructions respecting Mrs Mulvany… The Paragraph about the Picture you bought appeared in the D.Express and I. Times but not in the Freeman or News, although I sent it to them'. The next day he described how 'Moore and Louis' (porters) 'are daily occupied in matters that require attention. I have had O'Brien's wife washing out the large gallery, but it presents, notwithstanding the best exertion on her part, but an indifferent appearance'.[27]

A letter written after the Gallery opened at the end of April 1864 indicates a casual attitude towards money.

'I have sent the Letters received to Mrs Mulvany but none of them are of any immediate moment…The attendance at the Gallery this week was but 5,112 persons; Catalogues sold 164; Umbrella receipts £1. 19s. 11d. Total receipts £5. 19s. Total since you left home £16. 9s. from which I paid sundry incidental expenses – £9. 3s. 9d. – and having given Mrs Mulvany £17 and £2 leaves a balance in my favour of £11. 14s. 9d. for which you can send me a cheque….

'I will of course hand Mrs Mulvany any money she requires. I have lodged the cheque you alluded to to your credit and will lodge Mr Holmes'...wishing you a safe return in good health, I remain, Dear Sir, Yours very truly, Henry Killingly'.[28]

The Finance Committee had their account book written up by Killingly, who transferred entries from his own separate account book, which survives in the NGI archives. One entry occurring only in this account book under incidental expenses for 1864 lists 'T.Killingly, Sundry Accounts for Miscellaneous Expenses £45. 2s. 8d' which are unexplained. Unlike other annotated accounts, Killingly's book was not marked in pencil by the inspectors who examined the confusion of Mulvany's last years; probably they did not see it. It was abandoned after Killingly's suspension in 1871.

Trouble came to light slowly after Mulvany's death. On 1 April 1869 the Minutes recorded: 'read a letter from Mrs Mulvany stating she had lodged a sum of £89. 5s. 10d. to the credit of the Treasurers of the National Gallery in the Bank of Ireland, being the amount of the annual Government Grant in the hands of the late Director at the time of his decease'. There is a pencilled star beside Mrs Mulvany's name, one of numerous pencilled underlinings and comments that occur in the account book and the Minutes.

In November the Treasury appointed Mr CL Ryan to look into the discrepancies that had been observed. The questions Ryan asks and Killingly's confused answers make painful reading.[29]

'Query 3. The April order is signed "Maziere Brady for Director" as are also the Schedules of Orders. In the May order is signed "Maziere Brady, Governor" Explanation is requested'.

'This difference in the mode of signing the orders was simply an over-sight on the part of Sir Maziere Brady'.

'Query 4. In a letter dated Sept. 6 the accountant requested that the accounts for June and July might be returned to him for correction. The accounts were sent on September 7, since which time they have not been seen in this Department'.

'These corrected accounts are now transmitted. Much delay was occasioned in making them strictly conformable with the new mode of keeping the public accounts, owing to a misconception on my part. Henry Killingly, Registrar'.

'Query 21...The only pass Book transmitted for Examination in this Department is that containing an account of sums paid to Charwomen. It is requested that the other Pass Books may be sent...'

'…The second Pass Book had to be signed by several parties, one of whom was absent for several weeks in the country. He will be in Dublin next week and the Book will be forwarded'.

Killingly must have thought that his explanations had been accepted, since in November 1870 he had asked for a raise from £150 to £200 which the Treasury refused. Meanwhile the infinitely slow progress of his downfall continued. An entry in the Finance Committee's Minute Book of 'April 1871 – Travelling Expenses of Registrar, £10. 5s. 5d.' suggests that Killingly went twice to London to face the Treasury in person. Early in 1871 he was suspended and on 4 May a sub-commitee was formed 'to investigate the charges brought by the Treasury against the Director and Registrar'. The Finance Committee, consisting of Sir George Hodson, John Calvert Stronge and the Director, tried to sort out matters.

'Thursday Nov 16th 1871. A paper was read from Mr Killingly giving a detailed account of the various items of expenditure which were included under the heading of 'Extra Attendance' and which together amount to the sum of £4. 8s queried by the Audit Office. He was called before the Committee and gave additional verbal explanation'.[30]

The report of the Finance Committee concluded that 'Mr Killingly has laid himself open to grave reprehension for great negligence and irregularity in the discharge of his official duties'. However 'no single instance of misappropriation or dishonesty can be laid to Mr Killingly's charge'.[31]

The Governors did their best to defend their Registrar. Through a letter sent in Doyle's name as Director, they admitted that the account system had been 'somewhat lax' and 'not such as could have met the requirements of a public department supported by a Parliamentary grant'. They heaped much of the blame on the careless behaviour of the Lord Chancellor and Robert Callwell, both former members of the Finance Committee, and both conveniently dead. They pointed out that none of the financial irregularities that had been discovered benefitted Mr Killingly in any way. On one occasion a miscalculation brought about a suggestion of forgery; fortunately, 'by the merest chance' Mrs Mulvany searched and found Mulvany's 'private pocketbook' with an entry confirming that Mr Killingly had done nothing criminal. They assured the Treasury that 'similar irregularities could not occur again' and begged that their Registrar should not be subject to 'a punishment so severe as dismissal, involving utter ruin.'[32]

In vain. On 3 October 1872 a special meeting of the Board was called. A letter from the Treasury was read out 'signifying on the part of their

Lordships their intention of declining to place upon their estimate of expenses for the National Gallery a sum for the Registrar's salary if Mr Killingly should continue to hold the office'. There was nothing further to be done.

'Resolved: That the Board of Governors and Guardians, while stating that nothing has occurred to alter the opinion at which they had arrived on the case of Mr Killingly…feel that the letter of the Lords of Her Majesty's Treasury dated the 23rd ult…leaves them no alternative but to record the dismissal of Mr Killingly from the office of Registrar, and he is hereby dismissed accordingly'.[33] Through the intervention of the Lord Lieutenant, the Treasury was persuaded to pay Killingly the arrears of his salary between his suspension and the date of his dismissal.[34]

A mature and experienced man was selected as the new Registrar. Mr Philip Kennedy was sixty-five years old when he was appointed, and in twenty years time his age would present difficulties.

1 WG Strickland, *A Dictionary of Irish Artists*, (Dublin 1913) vol. II, pp. 363-82

2 *ibid.* p. 364

3 NGI Administrative Box 2. Applications for post of Director, 1869

4 Thomas Bodkin, *NGI Catalogue of Oil Pictures in the General Collection* (Dublin 1932) p. vii

5 *Irish Times*, 15 March 1869

6 Thomas Davis, *The Nation*, 29 July 1843. Quoted in Fintan Cullen (ed.), *Sources in Irish Art* (Cork 2000) p. 70

7 *The Times*, 28 Dec.1864

8 *Daily Express*, 6 Nov. 1867

9 *Irish Times*, 10 Feb. 1869

10 Rodney Engen et al, *Richard Doyle and his Family*, exh. cat. V & A, London, 1983-84, p. 9

11 Strickland 1913 (as n. 1) vol. I, p.295

12 *ibid.*

13 Lady Gregory, *Hugh Lane's Life and Achievement* (London 1921) p. 197

14 Strickland (as n. 1) vol. I, p. 295

15 Lord Powerscourt, *A Description and History of Powerscourt* (London 1903) p. 112

16 *Irish Times*, 10 May 1865

17 *Illustrated London News*, 16 May 1865

18 *Irish Times*, 11 May 1865

19 *ibid.*

20 Minutes of NGI Board, 18 Nov. 1869

21 Powerscourt (as n. 15)

22 Minutes, 3 Dec. 1869

23 *Thom's Directory*, 1871 and 1874

24 Minutes, Finance Committee. May 1863-13 June 1889

25 NGI Archives – Henry Killingly – Account Book

26 Minutes, 4 March 1869

27 Damp Press Book. Killingly to Mulvany, 20 and 21 July 1863

28 *ibid.* Killingly to Mulvany, undated, but end April 1864

29 *ibid.*

30 Minutes, Finance Committee, 16 Nov. 1871

31 *ibid.* 30 Nov. 1871

32 NGI Administrative Box 2. Draft letter to Treasury from Henry Doyle to TH Burke, 5 June 1872

33 Minutes of special meeting, 3 Oct. 1872

34 Minutes, 21 Nov. 1872

CHAPTER ELEVEN

THE INDISPENSABLE
LORD POWERSCOURT

At the Board meeting of 3 February 1870, Henry Doyle reported that in his first year: '…total attendance was 117,942, being on 179 week days when the Gallery was open without charge, 79,987; on 47 Sundays from 2 till 5 o'clock p.m. 28,200; on 88 student days at the charge of 6d, 943; and on 13 evenings when the Gallery was lighted with gas, 8,812'. '8 Ladies and 12 Gentlemen' were admitted as students. Four pictures were purchased…'

He concluded by notifying the Board of a forthcoming sale in Paris which he wished to attend. This was the collection of Prince Demidoff, one of whose highlights was Titian's *The Supper at Emmaus* (NGI 84). Most authorities believe that the composition is by Titian and part of its execution is by his studio[1] It cost £520 and, with a portrait of Miss Boaden (NGI 160) by George Harlow (1787-1819), was the only purchase during 1870.

Membership of the Board was changing. By 1871 Maziere Brady, John Pigot and Robert Callwell, involved with the progress of the Gallery since its inception, had all died. Brady was generous in his will, leaving the Gallery a further donation of £700. From his collection Doyle bought *Paroquets* (NGI 161) by Edward Murphy (c.1796-1841), the second painting by an Irish artist that he acquired for the Gallery.

The system of voting new members on to the Board had been abandoned because of the lack of qualified voters, and in the Minutes of 2 November 1871 it was recorded that 'the appointment to any vacancy or vacancies rests with His Excellency the Lord Lieutenant'. They tended to favour members of the landed gentry who expressed an interest in art. In the early 1870s these included the 3rd Earl of Portarlington, who would give the Gallery good drawings of seafaring subjects by the Van de Veldes and two paintings, a windblown seascape (NGI 228) by Abraham Storck (1644-1708) and a version of the popular Williamite battle scene, *William of Orange at the Siege of Namur* (NGI 145) by Jan Wyck (c.1640-1702). Sir John Crampton, a retired diplomat and a competent amateur artist, would sit on the Board beside his neighbours from around Bray: the Director, Sir

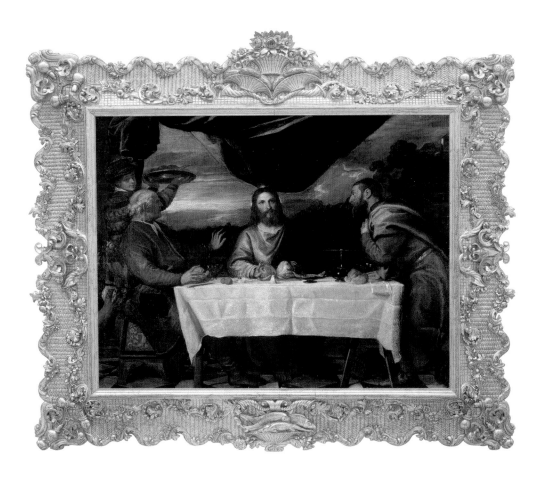

The Supper at Emmaus, c.1545, by Titian (c.1480/85-1576) and Studio, purchased 1870 (NGI 84), in montage with former trophy frame, c.1836, by Vincenzo Bolci of Florence. Described as 'remarkable', though 'very florid and not in the best taste' by Henry Doyle in the 1882 catalogue (a unique reference to a frame), it was sent to the stores and restored in public view during 1999.

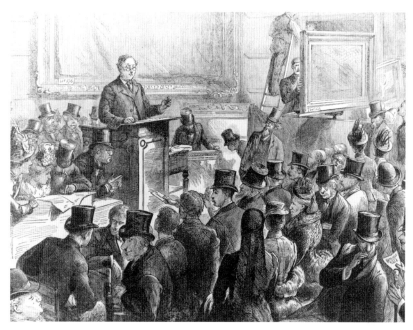

An auction at Christie's, from The Graphic,
10 September 1887 (NGI Archive). Henry Doyle
and Lord Powerscourt are shown in top hats,
to the left, behind the auctioneer.

George Hodson, who had exhibited landscapes and figure drawings in
the RHA, and had been among the first Governors of the NGI, and Lord
Powerscourt, who enthusiastically joined with Doyle in searching for
paintings.

'We hunted in couples after those pictures', Powerscourt wrote,[2] their
main hunting field being Christie's. A drawing of the auction house in
The Graphic for 10 September 1887 shows the top-hatted figures of Doyle
and Powerscourt standing together behind the auctioneer.

'I may say that I was the only one of the Governors who accompanied
Henry Doyle in search of pictures for the Gallery, and he used to say that
it strengthened his hand when he could go about accompanied by
myself as one of the Board to approve and share the responsibility of the
purchases'.[3] Surely Powerscourt was beside the Director at Christie's
in March 1880, when Doyle bought two paintings by George Barret
(1728/32 -84) of *Powerscourt Waterfall* (NGI 174) and *A View near Avoca* (NGI 175) for
twenty-two guineas and thirteen guineas respectively.[4] 'It was also an
extreme pleasure to me and a work which was of the greatest possible
interest, and when we secured some prize…I was as much overjoyed at
our success as he was'.[5]

In 1874 Powerscourt bid for a painting for the Gallery on his own 'in the absence of the director through indisposition'.[6] *Members of the Sheridan Family* (NGI 139) was painted by Sir Edwin Landseer (1802-73) in 1847 and acquired at a disposal sale after the artist's death. Normally a Landseer was far too expensive for the NGI to consider (his *Otter Hunt* made 5,700 guineas in 1877), but this only cost 170 guineas because it had not been completed. The main sitter, Charles Kinnaird Sheridan, pictured languishing with tuberculosis, died at the age of thirty in 1847. Like most of Landseer's late portraits, the painting was unfinished by the time Landseer himself died.[7] As a result, it has an Impressionistic touch which to many eyes is more attractive than his highly finished deer, horses, Scotsmen and dogs (although even here a King Charles spaniel lies in the foreground.) The French critic T Durer, who visited the NGI in 1882, admired it especially; 'incomplete though it is, seems to us to be a specimen of painting as powerful and expressive as any of the same painter to be found in the National Gallery in London'.[8]

The majority of Doyle's purchases for the NGI were made at Christie's. Regularly he received catalogues from King Street 'With Messrs Christie, Manson and Woods' respectful compliments'. By the week they offered items from collections that were 'very extensive', 'choice', 'highly important', 'a valuable assemblage', 'very extensive and valuable', 'splendid', 'modern', 'capital', 'choice', 'very choice' or 'beautiful'.[9] The paintings could be viewed two days before; the important sales were held on Saturdays. These were always occasions; Thomas H Woods, who had become a partner in the firm in 1859, insisted on the presence of all the partners at a Saturday sale.[10]

'Of all the art exhibitions in London', *The Times* wrote in 1875, 'the most agreeable is that which is always open throughout the spring and summer months in King Street, St James. With a constantly changing programme and its prices ranging from a guinea to ten thousand, it is almost as complete a mirror of the wealth, taste and fashion of the period as our own advertisements'.[11]

The £10,000 mark was reached in 1876 when Gainsborough's *Portrait of the Duchess of Devonshire* was the first work of art to sell for such a large sum. With £1,000 a year to spend, Doyle was at the guinea end of prices. He could not afford to buy contemporary English paintings like E Long's *The Babylonian Marriage Market*, knocked down for 6,000 guineas. He had to compete with such regulars at Christie's as William Agnew, whose firm had been buying for rich clients, including the National Gallery in London, since the late 1850s. At the outset of Doyle's directorship Agnew

had paid £2,560 for Turner's *Venice; the Dogana*, and two years later he would pay 5,000 guineas for *Walton Bridges* by the same artist.[12]

Doyle often bid on impulse when other formidable buyers were inattentive; the image comes to mind of a jackal snatching titbits from feasting lions. Homan Potterton has concluded from a study of his catalogues that 'on more than one occasion he probably made a spur of the moment decision and secured for the Gallery an important picture at a bargain price'.[13] It was through attendance at Christie's that he bought half a dozen of the Gallery's masterpieces.

In June 1871 he paid 105 guineas for *Head of an Old Man* (NGI 48), acquired as a Rembrandt. Much loved up to the 1970s, it came to be dismissed as a nineteenth-century forgery, but dendochronology and recent cleaning revealed it as 'a fine and typical example of a work very close to Rembrandt'[14], though only by a Follower.

In the same month Doyle bought Giovanni Paolo Panini's highly detailed *Preparations to Celebrate the Birth of the Dauphin of France in the Piazza Navona* (NGI 95). Panini (1691-1765) made two almost identical versions of the paintings, one of which is in the Louvre, while the other belonged to Cardinal de Polignac, who appears in the picture and who had arranged the festivities. Doyle wrote: 'the picture was the property of Lord Ashburton, who told me that it was purchased by his father from the Polignac family, but, upon succeeding to the title, finding that with a few other pictures, for want of space in his houses, he sent them to Christie's to be sold, this one with a reserve price of only £500. There it was knocked down to me at...£650'.[15]

In 1871 *St Francis of Assisi* (NGI 51) was acquired for 100 guineas as a Rubens, although probably Rubens only painted the face. In 1895 Walter Armstrong would buy a companion picture of *St Dominic* (NGI 427).[16] In spite of the paucity of his budget, Doyle did not hesitate to pay relatively high prices, like the 420 guineas which secured *A Wooded Landscape* (NGI 37) by Jacob van Ruisdael (1628/9-82), which had once belonged to William Beckford of Fonthill.

The Visit of the Queen of Sheba to King Solomon (NGI 76) costing £100, by the prominent woman artist, Lavinia Fontana (1552-1614), had belonged to Prince Napoleon in the Palais Royal in Paris, and, though large, was one of the few works saved from a fire in 1872. In the same year the Director bought a sorrowful *St Jerome in the Wilderness* (NGI 1) by the Spaniard, Luis de Morales (c.1520-86) and a portrait by the Austrian Wolfgang Huber (1490-1553) of *Anthony Hundertpfundt* standing in front of a brick wall (NGI 15). (The portrait of his wife, also with her back to the wall, is in Philadelphia). The

study by William Hogarth of *George II and his Family* (NGI 126), acquired in 1874 for £120, would catch the attention of Whistler, George Moore and George Bernard Shaw. Doyle would also buy a Hogarth portrait of Benjamin Hoadly (NGI 398) in 1891 whose pendant wife was acquired in 1998 by the York City Art Gallery. His interest in Hogarth was reflected in the numerous books on the artist in his library.[17] Hogarth was less appreciated and therefore cheaper than Gainsborough, Reynolds or other British painters.

Doyle's talent for picking out a bargain was demonstrated by his purchase for £75 of Rubens' *The Tribute Money* (NGI 38), a gorgeous painting which had been bought in 1618 by Sir Dudley Carleton, English ambassador in The Hague, directly from Rubens. It is included on a list by the artist as *originale de mia mano*.[18]

In 1871 Doyle made a strong declaration that Irish paintings would be important in the Gallery by purchasing *The Opening of the Sixth Seal* (NGI 62) by Francis Danby (1793-1861). Danby was born in Wexford and had attended the Dublin Schools, although he lived most of his life in England. The smouldering panorama of the Apocalypse, complete with fiery volcano, flash of lightning and humans awaiting judgement on the slippery rocks, was executed in 1828 at a time when social uncertainties encouraged an obsession with doom. When it was exhibited at the Royal Academy a critic noted 'the crowd constantly collected on one side of the room' before the picture. Like the Ruisdael (NGI 37) bought the following year, it had belonged to William Beckford and hung at Fonthill. By the time Doyle came across it, doom had gone out of fashion and he bought it for £100.[19] Today the picture still attracts attention, and enquiries continue to come in, even from abroad, from people who may remember it from childhood.

Doyle obtained other Irish paintings, including pictures by James Arthur O'Connor (c.1792-1841). In 1872 and 1873, *Moonlight* (NGI 158) and *A View of the Glen of the Dargle* (NGI 163) were bought cheaply at £20 and £10 respectively. *The Poachers* (NGI 18), generally considered O'Connor's best moonlight piece, was bought from Viscount Powerscourt in 1879 for £26. *Merry Christmas in the Baron's Hall* (NGI 156) by Daniel Maclise (1806-70), who had recently died, cost £300 in 1872. Probably for personal reasons Doyle bought two paintings of Capri (NGI 153 & 155) by a friend, Michael Brennan (1839-71), a young artist who had died in Italy, and had previously worked on *Fun*,[20] the satirical magazine to which Doyle had contributed. These pictures, together with, among others *The Opening of the Sixth Seal* and Murphy's *Paroquets*, variously 'newly framed', 'cleaned, 'varnished and glazed'[21] were hung together in a 'Modern Gallery'. 'A step of some

importance to the Gallery and to the public has been taken during the year in the setting apart of one of the smaller Galleries for a collection exclusively of Modern paintings, especially those of Irish artists, which tho' very limited in number at present, includes some pictures of the first class, which it is hoped may form the nucleus of what may become a fair and complete representation of our native schools'.[22]

The young Bernard Shaw had been familiar in the early 1870s with the NGI as Mulvany had hung it, the place where 'I learned to recognise Old Masters at sight'. He spent hours in the Gallery's largely deserted rooms, dragging with him his friend, Matthew Edward McNulty, whom he had met at the Dublin Commercial School. The two schoolboys would go from picture to picture until they became familiar with every work, studying the style of the dark old Flemish and Italian painters on the walls. It was an experience that Shaw never forgot and referred to on numerous occasions during his lifetime; on his death it would pay huge dividends to the NGI.[23]

The Gallery familiar to Shaw was about to change. In 1875 Doyle set about rearranging the pictures. A decade had passed since the opening, and the walls needed repainting, which gave him the opportunity for a radical rehanging. The time had also come for a new catalogue. Mulvany's original catalogue had been reprinted in 1867 and 1868 with an amended list of donations (niggardly, apart from Dargan and Brady) and supplements of works of art acquired in the meantime.

An edition of Mulvany's catalogue belonging to Doyle, which he annotated and amended with many crossings out, is in the NGI. It indicates sweeping alterations. Many of the old pictures that came into the Gallery in the early years, donations by Robert Clouston and others to the Irish Institution, unworthy paintings bought from Robert Macpherson, and Mulvany's copies, were sent into store. Looking for space, Doyle took down several of the Cardinal Fesch pictures, the Poerson, Procaccini, Pascucci and *St Jerome* 'after Michelangelo'. He banished other pictures highly thought of today, *The Liberation of St Peter* (NGI 31) by Antolínez, *St Diego of Alcala* (NGI 479) by Zurbarán and Matteo Preti's *Beheading of St John the Baptist* (NGI 366). Also removed were two paintings acquired from Macpherson *St Philip Benizzi* (NGI 364) by Marco Palmezzano and Rutilio Manetti's *Victorious Love* (NGI 1235). It is possible that Doyle disliked the latter because of its pagan message and the Amorino's sturdy nudity, partly concealed by an ill-fitting piece of drapery removed in 1967-68.[24] He took down *Portrait of a Man* (NGI 1373) by Georg Pencz which was not restored to the catalogues until 1971, perhaps because the priapic

nature of the statue the sitter is holding.

In addition to his 'Modern Gallery' and another of the smaller galleries turned into the forerunner of the National Historical and Portrait Gallery, he reserved a third gallery into a room for drawings, engravings, a set of chromo-lithographs of famous paintings produced by the Arundel Society and 'Autotypes' – reproductions of Michelangelo's frescoes in the Sistine Chapel and the statues of the Medici tomb. In the Sculpture Hall the casts in the care of Luigi Pedreschi were rearranged.

The new Registrar, Philip W. Kennedy, proved satisfactory and hard working.[25] He kept the accounts and the members of the Finance Committee regularly examined them.[26] Statuary was washed, and so were sofa covers; soap and soda bought; the porters were regularly given new uniforms and hats; the Director received his travel allowance and guinea a day for crossing over and back to London and over again to France, Belgium and Italy. (The Director of the National Gallery in London also had to receive sanction from the Treasury to travel abroad.)[27] Mrs Moore was given three shillings and sixpence worth of buttermilk for washing the floor. Two feather dusters cost eighteen shillings. Paintings were bought, framed, restored, insured, cleaned, covered with plate glass and given gold tablets. The Director, the Registrar, and the rest of the staff were issued with their salaries according to the voucher system. The postman was presented with a Christmas Box of half a crown; the Head Porter in charge of the Entrance Door and the Sale of Catalogues received three shillings every Sunday, sixpence more than the other porters.

Correspondence had to be dealt with. 'Office of Public Works…Sir, the 2cwt of bogwood referred to in your letter of the 11th inst represents means of lighting 448 fires; the three rooms referred to, if they had been lighted every day would only (including Sundays) give 171 fires requiring under 3/4 of a cwt. Furthermore it does not appear necessary to have a second fire in the Porter's office…As regards the size of the bogwood, it is the business of the person who lights the fires to break it up'.[28]

Kennedy worked without reward. In 1883 Doyle asked for a salary increase for himself and the Registrar. '..My Lords are pleased, in consideration of his length of service and the meritorious manner in which he has discharged his duties, to approve of Mr Doyle's salary as Director being raised to £600 a year as a purely personal arrangement, the ordinary salary remaining at £500.

'My Lords are not prepared to increase the salary of £150 now enjoyed by the Registrar'.[29] Kennedy tried again in 1886, but again was unsuccessful.

He never received his raise.

There was the occasional excitement. On a night in June 1872 the recently erected statue of the late Prince Consort in the middle of Leinster Lawn was damaged by Fenians. Mr Bantry White, the treasurer of the RDS, who was living in Leinster House, went outside and found a gate open which should have been locked. It was the responsibility of the Gallery. Together with Mr Maunsell, a Vice-President of the Society, and the night watchman, he approached the caretaker's window in the basement of the Gallery where 'I could hear persons talking and laughing and also see parties walking about the apartment.

'....In about 6 or 7 minutes afterwards a young man came up to the door and asked what we wanted, saying in a most impudent manner that we had no right to disturb them as they had friends with them, whereupon Mr Maunsell asked him whether he had not heard or felt anything. He said that they had and were just coming up to look'.

'I found several pieces of what appeared to be two tin canisters, a portion of a newspaper and several small pieces of the Statue itself; also a long piece of fuse - all near the pedestal'.[30]

Amazingly *Prince Albert* by John Foley, which has been described as 'the finest official statue to survive the change of regime'[31] (although WB Yeats referred to its 'mask of preposterous benevolence') is still on Leinster Lawn, resited and recently cleaned by the Office of Public Works, in its unobtrusive site beside the Natural History Museum.

In 1874, after the porter Simon Leigh had died after taking a fit, Joseph Burton was appointed in his place. In order to have a Civil Service Certificate, poor Burton had to know how to read and write and do simple arithmetic. He failed his examination in arithmetic, and then, soon afterwards, in October 1875, also died, after a short illness. John Dunne who replaced him, also had difficulties passing the examination; presumably he did, as the Finance Minutes indicate that he continued to receive a salary.

On 15 August 1878, when the Gallery was lit by gas in connection with the Conversazione given to the British Association for the Advancement of Science by the RDS, a small fire was discovered in one of the flues in the Sculpture Hall due to gas overheating. '…it was discovered and extinguished by the employees of the Gallery with the greatest rapidity and before the arrival of the Fire Brigade with the assistance of four men who happened to be present. It was resolved that the approval of the Board be conveyed to the former for their exertions on the occasion'.[32]

Meanwhile Doyle was augmenting the Dutch school with a number

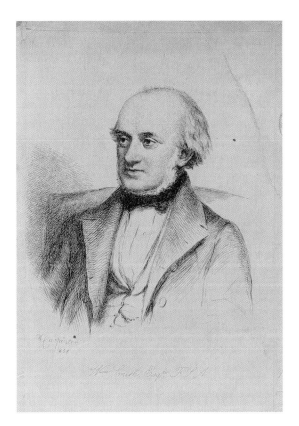

William Smith (1808-76), Printseller and Watercolour collector, c.1858 etching after Margaret Sarah Carpenter (1793-1872), engraved by William Carpenter (c.1818-99), acquired 1913/14 (NGI 11339). 128 English watercolours came to the NGI from Smith, forming a core group.

of bargains – Dirck Wijntrack's (before 1625-78) *Rabbits at the Mouth of a Burrow* (NGI 29) at £28, *The Artist's Brothers* (NGI 180) by Jan Salomonsz de Braij (c.1627-97), then thought to be unknown children by Jacob de Braij and Dirck Maes' (1656-1717) *William III hunting at Het Loo*, which each cost only £10. In 1879 he opted for the humorous *Village School* (NGI 226) by Jan Steen (1625/6-79) for £420, a high price for an accomplished work, where an unexpected donation of £100 from Dr Michael Barry of Brighton made up the sum due.

Doyle may have been worried by the paucity of 'modern' British pictures in the Gallery, when in 1877 he took advantage of the instalment system which Mulvany had used. *The Temple of Neptune at Paestum* (NGI 220) by the Scottish artist David Roberts (1796-1864), bought for £210 in two instalments, was followed by a disappointing purchase, a huge dull failure by another Scot, David Wilkie (1785-1841), *Napoleon and Pope Pius VII at Fontainebleau in 1813* (NGI 240), which cost a massive £2,000. Although three members of the Board, including Powerscourt, agreed that this was a significant acquisition, it resulted in a scolding from the Treasury: '…my

Lords...are of position that you should never incur any liability (when it can possibly be avoided) in excess of the sum voted by Parliament for the year without obtaining the sanction of this Board'.[33] The debt to Agnew's, noted in the Finance Minutes, was paid off slowly, £700 in December 1878, £500 on 6 November 1879, and £500 in September 1881.

Pecuniary donations might have been meagre, but during the 1870s the Gallery received a number of important gifts of works of art. They included a group of English watercolours of the eightenth and nineteenth centuries given in 1872 by William Smith (1808-76) who had retired from business as a print seller and helped to establish the National Portrait Gallery in London. He moved in similar art circles to Doyle and had been encouraged to first lend some of his watercolours, however had no other Irish connection. Four years later, on Smith's death, the gift was augmented by a further bequest.

In 1872 Mr John Heugh gave the gallery a sun-filled painting of a milkmaid and a cow (NGI 49) by Aelbert Cuyp (1620-91) which, after a lot of debate, is now again considered autograph. The Board formally thanked the donor, a decent man, who replied that the letter 'goes far beyond the merit of my small gift. If in any way I may have encouraged others to give, it will be a great reward for a small act...I believe in art as one of God's gifts and part therefore of God's truth, worthy of every encouragement that can give it as they have opportunity'.

Other donated paintings during the 1870s included a Pompeo Batoni (1708-87) of *Pope Pius VI* (NGI 109) from Robert Tighe, a curious source, since his family were strong Methodists; from the 4th Marquess of Ely a large portrait group of his ancestors (NGI 200) by Angelica Kauffman (1740-1807), begun during her triumphal visit to Ireland in 1771 and *The Dublin Hellfire Club* (NGI 134) by the English artist James Worsdale (c.1692-1767), presented by John Wardell in 1878. 'It is a group of men sitting solemnly together, looking as unlike a blasphemous crew as can be conceived'.[34] Although in bad condition, 'The painting is interesting as the earliest surviving picture in Ireland showing an interior with figures drinking and smoking, including provincial furniture such as a wine cooler with carved masks on its sides'.[35] In the same year the 4th Duke of Leinster, a member of the Board, presented the statue of *Adonis* (NGI 8135 by François-Marie Poncet (1736-97) formerly in Leinster House, though, this sensual nude only first appears in the 1898 catalogue, exhibited by Walter Armstrong on the main stair landing.

In July 1879 Doyle received a letter from Hertford House, Manchester Square, London. 'My dear Mr Doyle, It has long been my wish to become

the purchaser of Daniel Maclise's picture, *The Marriage of Strongbow*, with a view of presenting it to the National Gallery of Ireland as I have always felt that this masterly painting of our great Irish artist ought to find a permanent home on Irish soil...Believe me, Yours very truly, Richard Wallace'.[36]

Sir Richard Wallace, the illegitimate son of the 4th Marquess of Hertford, had inherited his father's art collection, which would later be given to the English nation by his widow as the Wallace Collection. He owned property in Ireland and took a conscientious interest in Irish affairs. In January 1879 he was appointed a member of the Board of the NGI and presented a forgettable portrait (NGI 221) formerly attributed to

The Marriage of Strongbow and Aoife, detail of the marriage ceremony c.1854 by Daniel Maclise (1806-70), Sir Richard Wallace (Governor and Guardian) gift 1879 (NGI 205).

Velázquez (1599-1660), but six months later he gave the Maclise.

The Marriage of Strongbow and Aoife (NGI 205) was first shown at the Royal Academy in 1854. The artist had taken years to present in writhing detail the destruction of Gaelic civilisation, symbolised by a forced marriage. Richard de Clare, Earl of Pembroke, known as Strongbow, a victorious wreath round his helmet, his booted foot on a broken cross, the sacrificial bride with her train of bridesmaids, as every prominent wedding should have, the grieving bard clutching his broken harp, the lamenting, the dead and dying wearing their carefully researched Celtic and Romanesque accessories, are assembled in the second painting of nationalistic significance to come into the Gallery, following on Haverty's *The Blind Piper*. Both these paintings were gifts and both were enduringly popular.

1 Raymond Keaveney introduction to *European Masterpieces from the NGI*, exh. Australia and NGI 1994-5, p. 26
2 Lord Powerscourt, *A Description and History of Powerscourt* (London 1903) p. 113
3 *ibid.*
4 Minutes of the NGI Board, 8 April 1880
5 Powerscourt (as n. 2) *ibid.*
6 Minutes, 23 July 1874
7 Richard Ormond in *Sir Edwin Landseer* (London 1961), exh. cat. Tate Gallery, London, pp. 130, 131
8 T. Durer, 'Une visite aux Galeries Nationales d'Irlande et d'Ecosse', *Gazette des Beaux-Arts*, 1882
9 Catalogues in NGI Library
10 Percy Colson, *A Story of Christie's* (London 1950)
11 *ibid.* p. 28
12 Geoffrey Agnew, *Agnew's 1817-1967* (London 1967) p. 26
13 Homan Potterton introduction to *NGI Illustrated Summary of Paintings* (Dublin 1981) p. xix
14 Andrew O'Connor and Niamh McGuinne, *The Deeper Picture* (Dublin 1998) p. 77
15 Catalogue of the Collection 1868, annotated by Doyle, in NGI Library
16 David Oldfield, *Later Flemish Paintings in the NGI* (Dublin 1992) pp. 101-4

17 John W Sullivan, 'The Recherché Library of the late Henry E, Doyle Esq, CB, RHA. Sold 22 Feb 1892 and the following five days'. Auction cat. No 8 D'Olier Street, Dublin, (Dublin City Library)
18 Oldfield (as n. 16) p. 97
19 Minutes, 4 April 1872. Pencil insertion
20 Anne Crookshank and the Knight of Glin, *Ireland's Painters 1600-1940* (New Haven and London 2002) p. 247
21 Director's Report 1872
22 *ibid.*
23 Michael Holroyd, *Bernard Shaw* (Harmondsworth 1990) vol. 1, p. 37
24 O'Connor and McGuinne (as n. 14) p. 11
25 Director's Report, 1894
26 Finance Committee Minute Book, 1863-89
27 Minutes, 6 April 1882
28 Damp Press Book, 17 Oct. 1877
29 Minutes. Letter from Treasury to Board 11 Jan. 1883
30 Report of the Treasurer and Housekeeper of the RDS on the Attempt to Blow up Prince Albert's Statue, 18 June 1872
31 Jeremy Williams, *A Companion Guide to Architecture in Ireland* (Dublin 1992) p. 42
32 Minutes, 29 Aug. 1878
33 Minutes, March 1878
34 DA Chart, *The Story of Dublin* (London 1907 & 1932) Section IX
35 Crookshank and Glin (as n. 20) p. 48
36 Minutes, 6 Nov. 1879 Letter from Sir Richard Wallace 24 July 1879

The Marriage of Strongbow and Aoife, detail of the defeated Irish harper c.1854 by Daniel Maclise (1806-70), Sir Richard Wallace (Governor and Guardian) gift 1879 (NGI 205).

CHAPTER TWELVE

OPENING A NATIONAL PORTRAIT GALLERY

In 1882 a Monsieur T. Durer visited the National Gallery of Ireland and described his impressions in an article which appeared in the *Gazette des Beaux Arts*.[1] He admitted, 'when I discovered the whole of one side of the great Dublin gallery covered with Italian pictures and recalled that the collection only dates from 1854, at first I felt a certain unease and asked myself what I was about to see. And lo and behold! the ensemble is satisfying and exceeds expectations'.

He conceded that the basis of the collection was composed of painters of the second rank, but was able to pick out many choice examples (*de bons morceaux*). Among the Italian paintings he mentioned the Panini and the Lavinia Fontana. He praised the Flemish and Dutch pictures ('a very respectable collection'), noted 'two or three Spaniards', 'some primitive Germans' and the English pictures ('outstanding'). On Irish painters he commented: 'I cannot say that I discovered here any true masters endowed with any great originality. I feel that whatever can exist among Irish painters is dominated by the influence of the London Schools'. However, he praised James Arthur O'Connor, whose landscapes, 'although of a timid technique, are full of a true feeling for nature'.

M. Durer continued: 'when we realise that in Ireland we find ourselves at the end of Europe in a country where in order to obtain *objets d'art* one has to go a long way in search of them, we ask how it has been possible in such a short space of time to gather together such a collection of pictures with the sole help of some subscriptions, a certain number of donations and an annual sum of a thousand pounds sterling from the public purse. It is because the Dublin gallery has had the good fortune to come upon an outstanding director in M. Henry Doyle...Have you ever met a director who was at the same time an artist and a connoisseur, a passionate collector collecting for his museum, that is to say, always at the chase, following the sales, going in search of discoveries in galleries,

mounting the stairs of people whom he has heard have a picture? A director of this sort I had never met before meeting M. Doyle...Since [he] came to his post in 1869 he has found means to buy for his museum around seventy pictures...almost all of the best authentic choice, if put up for sale again would probably fetch three or four times what they cost...We know what one has to pay today in London for English masters – and lo! M. Doyle with the help of the little budget at his disposal has known how to bring into his gallery the great full length portrait of Reynolds which is a canvas of the quality we would be happy to see in the Louvre'. This was the *Earl of Bellamont* dressed in pink and white satin and lace and towering feathered hat (NGI 216) by Joshua Reynolds (1723-92) which Doyle had bought at Christie's in 1875 for £550.

Unfairly, many of the pictures M. Durer selected for attention – among them the Machiavelli, the Moroni, and several of the 'primitive Germans' – had been acquired by Mulvany. It was Dublin's luck that Mulvany, like Doyle, was an 'outstanding...and passionate collector'.

In November 1880 Doyle's merits as a Director had been recognised in a letter which 'was ordered to be inserted in the Minutes.'

'Hawarden Castle, Chester. Dear Mr Doyle, I have never heard of you as a solicitor for honours, but I have not forgotten you as the energetic and effective head of a public establishment and I have to propose to you with the sanction of Her Majesty, that you should receive a Companionship of the Bath…W.E.Gladstone'.[2]

Until the end of the century a CB was generally given to Directors of minor galleries like the NGI. Doyle's successor, Walter Armstrong, would receive a knighthood, but in the 1880s, Dublin, as usual, had to take second place to London, where the Irishman, Frederic Burton, was knighted in 1884.

As Director of the National Gallery, Burton had £10,000 a year for paintings, and much more if a particular purchase was approved by the

Charles Coote, 1st Earl of Bellamont (1738–1800), 1773-74
by Joshua Reynolds (1723-92), purchased 1875
(NGI 216). The disreputable and vain Irish Peer is
shown in one of the most flamboyant costume
pieces by Reynolds.

Treasury. Like Doyle, he had to answer to my Lords. While Doyle searched for his bargains, Burton was in a position to spend – some considered overspend – and acquire great paintings for London. For Leonardo's *Virgin of the Rocks* he paid £9,000 in 1880, which was considered a bargain, but other paintings cost far more.[3]

Later Lady Gregory claimed that the Trustees of the National Gallery, including her husband, 'looked on [Doyle] with favour as a desirable successor to Sir Frederic Burton, then growing old. But he died suddenly in 1892…'[4] Meanwhile, Doyle and Burton were amicable rivals, although Burton with his huge budget had little to fear from Doyle. They would have encountered one another at the Hamilton Palace Sale, one of the most theatrical auctions ever staged by Christie's.

In 1882 the Duke of Hamilton, disliking the coal mines and factories that disfigured the landscape around his ancestral seat, decided to sell up. His pictures were outstanding, and Doyle determined to buy something worthwhile.

Lord Powerscourt went in person to the Secretary of the Treasury, Mr Courtney, requesting an extra grant 'to take better advantage of the opportunity thus afforded'. For once, the Treasury sympathised: '…my Lords are prepared under the circumstances to ask Parliament to increase your purchase grant for 1882-83 from £1,000 to £2,000'.[5]

Armed with his increased funds, Doyle attended Christie's where Burton was about to spend ten times as much. Two Frenchmen were also present, both assumed to be bidding for the Louvre. The onlookers behaved 'like supporters at a football match'.[6] Purchases by Burton were greeted by 'rounds of loud and enthusiastic applause' while 'ominous silence' followed successes by the Frenchmen. (It transpired they had nothing to do with the Louvre.) Burton bought fourteen pictures for £21,319[7] for the National Gallery.

Doyle had to be a lot more circumspect. He came away well under budget with five pictures, one a masterpiece. (My Lords deducted £500 from subsequent grants.)[8] *The Resurrection* (NGI 178) by Bonifazio di Pitati (1487-1553), now attributed to fellow Venetian Antonio Palma (c.1510-75), cost £231; a *Madonna and Child with Saints* (NGI 212) by Giovanni Lo Spagna (c.1450-1528) £212. A portrait was 'attributed to Leonardo da Vinci', probably because of the row of spiny hills in the distance and a mysterious 'V' in the inscription (but Doyle did not expect a Leonardo for £212). It was identified in 1905 as by Alessandro Oliverio (active 1532-44), who worked for a time in Venice. Armstrong noted *The Burlington Magazine* article in his annotated 1898 Gallery catalogue (NGI Library).

One masterpiece, the sombre and splendid *Lamentation over the Dead Christ* by Nicolas Poussin (1594-1665), costing £512, had been bought in Rome the previous century by Sir William Hamilton and is still considered a highlight of the NGI's collection.

In the first years of the 1880s, purchases by Doyle also included two views, in mint condition, of Dresden (NGI 181 & 182) by Bernardo Bellotto (1721-80), the nephew of Canaletto; a large marine piece, *The Arrival of the Kattendijk at the Texel, 1702* (NGI 173) by Ludolf Bakhuizen (1631-1708), and an early Thomas Gainsborough (1727-88), the light-permeated *View of Suffolk* (NGI 191), sold at Christie's for a bargain £32. 10s. He went wrong, although he never knew it, with Frans Hals' *Fisherboy* (c.1580-1666), purchased for £400, about whose authenticity there has since been much discussion: 'in places crudely painted and lacking in the brio which one associates with the master'.[9]

In 1883 at the artist's sale following his death, he purchased a moody portrait drawing (NGI 2259) by Dante Gabriel Rossetti (1828-82) of Jane Burden (later Mrs William Morris), the embodiment of pre-Raphaelite beauty with her long columned neck, huge dark eyes, luscious mouth and long wavy hair. This was the NGI's sole venture into pre-Raphaelite art. In the same year, on 2 June, Doyle made his greatest impulse buy at the Stourhead Heirlooms sale.

'Sir...I have to report to you for the information of the Lords Commissioners...that at a recent sale at Christie and Manson's, taking advantage of an unexpected opportunity, I succeeded in obtaining for the Gallery an undoubted picture by Rembrandt for the sum of £514 and to do so it was necessary to forestall the grant for next year to the extent of £360...'[10]

As usual, Powerscourt was at Christie's that day. 'Henry Doyle...was waiting for a portrait of a Lord Lieutenant of Ireland, Lord Northington, by Sir Joshua Reynolds, but before that came up there was put upon the easel a small landscape by Rembrandt, *The Flight into Egypt*. Mr Agnew, as well as others, was attending the sale, but his attention happened to be called off at that moment, and the picture hung at something about 400 guineas. I said to Doyle, "Never mind the Lord Lieutenant; don't let that Rembrandt go at that price!" He made a bid, and the little gem was knocked down to us. There was a piece of luck! Agnew came back and

Detail of *The Lamentation over the Dead Christ*, 1657/60
by Nicolas Poussin (1594-1665), purchased
Hamilton Palace sale, 1882 (NGI 214).

Landscape with the Rest on the Flight into Egypt, 1647 by
Rembrandt (1606-69), purchased Christie's, 1883
(NGI 215).

said, "What has become of the Rembrandt? I said, "We have got it for the
National Gallery of Ireland". "Oh!" he said, "if it has gone to the nation I
do not mind." [11]

Doyle's successor, Sir Walter Armstrong, was told that the Berlin
Museum wanted the picture and had given a commission for its pur-
chase at considerably more than double what it actually cost. 'The agent'
(presumably Agnew) 'bungled and Ireland triumphed...' [12]

In the same article, which appeared in 1890, two years before he became
Director of the NGI, Armstrong wrote: 'In its way it is one of the most
perfect Rembrandts in existence. Very seldom did the master put so
much delicate but spirited work onto so narrow a surface, and never
did he more subtly illustrate the rich mysteries of chiaroscuro'. [13] The
composition of *Landscape with the Rest on the Flight into Egypt* (NGI 215) was
identified and copied by Turner, who saw it at Stourhead. It is derived
from a picture by Adam Elsheimer, subsequently engraved by Hendrick
Goudt; [14] a copy of this engraving which Rembrandt used as his source
was obtained by the Gallery in 2001 (NGI 20903).

Powerscourt gives an idea of the cut and thrust of Christie's, and it is easy to imagine the two gentlemen from Ireland scrutinising their catalogues as each new picture made its appearance. Among the competition were Sir Charles Tennant, a wealthy Glaswegian, Lord Normanton, a constant bidder, and fellow Irishman Sir William Gregory in his role as Trustee for the National Gallery in London. 'At most important sales Mr Agnew would be on the lookout on behalf of a wealthy client'.[15] By the late 1880s American millionaires had come on the scene, 'determined to buy the best things that come into the market', according to Sir William Gregory.

Against the odds Doyle continued to bid for noteworthy pictures at Christie's sales – in 1885 Canaletto's (1697-1768) *St Mark's Square* (NGI 286) for 170 guineas and the moving *Ecce Homo* (NGI 75) by Titian (c.1485/90-1576) bought for as little as £70. 10s. In the same year the *Portrait of a Child* (NGI 263) (possibly related to Prince Maurice of Orange) by Paulus Moreelse (1571-1638) cost just five guineas.

Doyle's liking for religious subjects was again demonstrated in 1886 when he bought a painting of *The Immaculate Conception* (NGI 273) as by Jan de Valdés Leal at the W. Graham sale in April 1886 for 42 guineas. In 1928 the painting was re-attributed to Zurbarán and traces of a signature were found during cleaning in 1981.[16] *Sts Cosmas and Damian and their Brothers surviving the Stake* (NGI 242) by the early Renaissance master Fra Angelico (active 1417-55), which Doyle also obtained at the Graham sale, for £73. 10s, was another example of his alertness and good luck. The little panel was part of a predella or lower register of an altarpiece illustrating the lives of the saints and their three brothers commissioned by Cosimo de Medici and painted for the High Altar of the Convent of San Marco in Florence. Other panels are in Munich, Paris and Washington. The altarpiece had been later broken and this was an inducement for Thomas Bodkin, a future Director, to plead for them to be reunited to tell their story of martyrdom.[17]

Another Christie's sale, rivalling Hamilton Palace, was the Blenheim Palace sale in 1885. 'Sensational', *The Times* described the event, which took six days. With the decline of agriculture in the 1870s and 1880s, and the reduction of rents, many noble families needed cash to support their lifestyles. The Settled Land Act of 1882 allowed for the sale of land and chattels which had previously been held in trust. As a result, more contents of great houses were coming on the market.

Before the Blenheim Palace sale Burton, now Sir Frederic, had bargained on behalf of the National Gallery in London with the Duke of

Marlborough (and the Treasury) for eleven pictures. The most expensive was Raphael's *Ansidei Madonna* which cost the British nation £70,000, the highest price ever paid for a picture at that time.[18]

By contrast, in addition to three copies of pictures by David Teniers II (1610-90) for his *Theatrum Pictorium* (NGI 288, 289 & 290), Doyle bought, for twenty-one guineas, a *St Jerome* (NGI 277) by Willem Key (c.1510-68), then attributed to Giorgio Vasari, which had been in Blenheim since the time of the first Duke, and an outstanding oil study of a youth as St Sebastian (NGI 275) by Anthony van Dyck (1599-1641), which had hung in Blenheim's Third State Room.[19]

One of the main functions of the Gallery's paintings and the assembly of plaster and marble in the Sculpture Hall was to enable students to copy works of art. In his Director's Report for 1873 Doyle wrote: '…arrangements are…made to afford the greatest possible facility to students…to take advantage of the opportunity for copying and studying excellent models in the various branches of Ancient and Modern art which is the chief object of the Institution to afford them'. He pointed out to the Treasury that 'this is the only institution in Ireland which affords the Art Student an opportunity of seeing and copying pictures, this country being…singularly destitute of accessible private collections'.[20]

For all the talk of educating and instructing, there were never many students, 'twenty-six ladies and nine gentlemen in 1870'; '21 female and 9 male students' in 1873; 'eleven altogether' in 1874. 'Ladies' made up the majority; women from middle class homes were taking to art as a genteel pastime. Among requests to draw which are preserved in the archives, only one student is recognisable as a future artist of distinction. 'Miss Underwood will be greatly obliged for two tickets to studying the Gallery for Miss Alma Barton and Miss Rose Barton', (1856-1929).[21] Another artist known to have copied in the NGI, although no communication survives in the archives, was Roderic O'Conor (1860-1940), who believed in the theory of furthering knowledge of art through close study of the works of other artists.[22]

The National Portrait Gallery came into existence very slowly. As early as 1872 Doyle decided to create it on the lines of the one in London. In that year he had taken part in the Dublin Exhibition of Arts, Industries and Manufactures held in the Exhibition Palace in Earlsfort Terrace. Such exhibitions seem to have occurred almost as regularly as Christmas pantomimes; this one included an exhibition of paintings arranged as 'Ancient Masters' and 'Modern Masters' (including *Good morrow Paddy, where*

are you going wid the Pigs? by Erskine Nicol). There was also a successful 'Loan Museum' of 630 portraits and engravings of 'Irish Worthies' run by Doyle, as Honorary Secretary of the Portrait Committee.

The popularity of this portrait exhibition led directly to Doyle's idea of creating a permanent Irish National Portrait Gallery. In forwarding the estimates of expenses for 1873-74 to the Treasury, he asked for an extra sum of £2,000 to purchase portraits. My Lords refused, saying that there was a perfectly good portrait gallery in London 'where eminent Irishmen are represented indiscriminately with Englishmen and Scotsmen'.[23]

Doyle appealed, making two points. First, the portrait collection in London was inaccessible to most Irish people 'who can never visit the Metropolis' while 'those of the more educated class' who found themselves in London would not have time to 'avail themselves of the advantages of such a Gallery which are not to be gained by a hasty passage through its rooms'. Secondly, many eminent personages connected with Ireland were not considered sufficiently important for London. He cited as an example the portrait of Lord Northington (NGI 217) by Joshua Reynolds (1723-92), which he had ironically passed over in favour of the Rembrandt. Having been turned down by the National Portrait Gallery in London, Doyle bought it in 1884 from H Graves and Co.[24]

He decided to go ahead with his Dublin portrait gallery, without funding. ('My Lords…continue…to be of the opinion that local and not imperial liberality is the proper source from which such collections should be created and maintained.') In his report to the Board for 1873 he pointed out how members of the Board 'have approved in principle the foundation of a National Portrait Gallery which, tho' as yet it has received no pecuniary encouragement from the Treasury, yet may become a very important and interesting adjunct to the Gallery'.[25]

Eight years passed before Doyle's plans for the portrait gallery were realised, as the space originally intended for Marsh's Library remained unfinished and without designation; it still did not officially belong to the NGI. There had been an idea to adapt it for more casts, a collection of reproductions of works by John Foley which the sculptor had bequeathed to the RDS. However, these were broken up, and the space continued to be empty; the Director and Board regularly put the estimate for its completion into the annual estimates, but the Treasury repeatedly turned it down.

Portraits that had been accumulated in the meantime were hung elsewhere in the 'Intermediate Gallery.' Not until April 1881 was a sum designated for the Portrait Gallery, after a series of consultations between

Doyle, Colonel M'Kerlie, President of the Board of Works, and therefore a Governor of the NGI, and the Lord Lieutenant, Lord Frederick Cavendish, who put his backing to the project.[26] This must have been one of the few official assignments carried out by Lord Frederick before he was murdered on 7 May in Phoenix Park.

In November 1881 the Director forwarded the Estimate for 1882-83 to the Treasury, stating that the new Gallery would be completed in the course of the next year. But only in the Minutes 31 July 1884 was it reported that 'the Governors inspected the new Historical and Portrait Gallery which the Director reported had been opened to the public on the 23rd of June and expressed their approval of all its arrangements'.

According to Doyle's report for 1884 the collection placed in it comprised forty-eight oil paintings, six watercolours, nineteen drawings, twenty line engravings, fifty-five mezzotints and six marble busts. A special catalogue costing a penny was issued; unfortunately no copy survives in the archives.

The 'Historical and Portrait Gallery' would prove a popular innovation, although today there is little interest in images of the Marquess of Thomond (NGI 131), or the poet Thomas Dermody (NGI 138) or John Dicksee's glum Henry Lawrence (NGI 135) killed in the Siege of Lucknow. Occasionally Irish portraiture and quality combined, as in the portrait of Edmund Burke (NGI 128) by James Barry (1741-1806) commissioned by Burke's friend, Dr Brocklesby, and bought in 1875, or that of multi-talented Samuel Lover (NGI 142) by James Harwood (1797-1868), purchased as far back as 1872. Other worthy portraits were those submitted to the Board in April 1885: 'A Portrait group of Edmund Burke and Charles Fox attributed to Zoffany' (NGI 258) now given to Thomas Hickey, for £950, 'also a small full-length portrait of Mr Christopher Nugent' (NGI 261), 'an Irish Gentleman who became General in the service of the Venetian Republic, by Pietro Longhi from Mr Freeman for £15',[27] now thought to be by Venetian Bartolomeo Nazari (1699-1758).

In an interview he gave to the *Evening Telegraph* at the end of 1891, Doyle talked proudly of this new Gallery (containing the Yeats Museum since 1999): 'The…design of the hall was my own, and I chose plain Grecian pillars, square in form and without ornament, as being the most suitable for the purpose contemplated. I think you will agree that the hall has a decidedly classical simplicity and an air of light and space about it'.[28]

The 1885 NGI Catalogue lists the portraits 'of eminent Irishmen and Irish women…also of statesmen and others who were politically or socially connected with Ireland, or whose lives serve in any way to

illustrate her history or throw light on her social or literary or artistic records'. Engravings were in a separate room.

Over the years donations for the Portrait Gallery had poured in – engravings of Lord Chancellor Plunket (NGI 10109), Chief Baron Wandesford (NGI 10235); oil portraits of John Cornelius O'Callaghan (NGI 313) and Peter Purcell (NGI 308), founder of the Royal Agricultural Society of Ireland; a small marble bust of Daniel O'Connell by John Jones (NGI 8111). The impression gained is that people found it easier to empty their spare rooms and attics rather than donate money. Occasionally something worthwhile would be given, like the miniature by Horace Hone of the architect James Gandon (NGI 2156) presented by Nathaniel Hone the Younger, or the portrait in oil of Lord Edward Fitzgerald (NGI 195) by Hugh Douglas Hamilton presented by the 4th Duke of Leinster in 1884. In 1891 the 5th Duke gave the much-exhibited *The Dublin Volunteers on College Green 4th November 1779* (NGI 125) by Francis Wheatley (1747-1801). The Leinster family gave steadily to the Gallery, but on one occasion in 1879 the 4th Duke offered for sale at £50 a subject by Jusepe de Ribera (1591-1652) for the under-represented Spanish School (although most of Ribera's working life was spent in Italy). This was bought as St Jerome, but is now recognised as *St Onuphrius* (NGI 219), a desert father who lived in the wilderness for sixty years.

Doyle gave his Portrait Gallery one of his own pictures, 'a portrait from life in water colour dated 1858 of His Eminence Cardinal Wiseman' (NGI 2080). Unlike Burton, he continued drawing and painting after his appointment as Director. His portraits of Robert Emmet (NGI 2081) and John Ruskin (NGI 2383) are in the NGI together with other drawings by him whose provenance is unknown. He may well have presented them himself, as he did two works by his father, John Doyle, the caricaturist 'HB'. In 1886 he also purchased for the Gallery a collection of water-colours by his brother, Richard Doyle, who had died three years before.

In 1887 he introduced autograph writings of eminent people, after a collection of twenty, including autographs by Grattan and O'Connell, were presented by Richard Green Esq (not now to be found) and a letter from Thomas Moore was included with his portrait (NGI 257) painted in Rome by John Jackson (1778-1831). In the same year Sir Edward Guinness gave £1,000 'to enable the Board to obtain a selection of Mezzotint Portraits at the sale of the Chaloner Smith collection'[29] after the Treasury had declined as usual. John Chaloner Smith (1827-95) was an Irish collector of mezzotints, who published a four-volume complete catalogue of *British Mezzotinto Portraits*, 1878-84. Doyle purchased 200 from

Lady Mary Bingham (d.1814), wife of future Earl of Lucan, mezzotint after Angelica Kauffman (1740-1807), engraved by James Watson (c.1740-90), purchased 2nd Chaloner Smith sale, 1888 (NGI 10392).

the first sale in 1887 for £674; 78 at the second sale in 1888 for £289. 4s and 19 were bought by Armstrong at the third sale in 1896 for £18. 1s. 3d, the sitters 'almost all having some connection with Ireland.' There were numerous kings, queens, lords lieutenant, 'authors, artists, actors, actresses etc.'.[30] Apart from the sitters, many of the engravers were celebrated Irish practitioners, such as James MacArdell, John Brooks, Nathaniel Hone and James Watson. Some of the 'choicest' were displayed on 'three solid screens erected down the centre of the Historical and Portrait Gallery'.[31] A sketch of the Queen's Gallery accompanying the 1891 *Evening Telegraph* interview shows Antonio Panico's *Christ on the Cross* (NGI 89) hanging in the same place where it is now, and paintings piled high up the walls. The place had become overcrowded; Doyle told the interviewer, that he had removed 'a hundred or so' pictures 'to make room for more valuable things.' He was asked: 'What was the arrangement you adopted, Mr Doyle with regard to this Foreign Gallery?' 'Well, a very simple one. I placed the works of the Flemish school, originals and copies, on the left hand from the staircase; and those of the Italian school on the right'.

In the small gallery opposite the Irish pictures were five paintings by Joseph Mallord William Turner (1775-1851). Doyle commented that: 'I was surprised that I was allowed to have them so easily. They were part of the Vernon collection and were given to this gallery as a perpetual loan. The executors did not seem to attach as much importance to them as I did and I found little difficulty in securing them for this gallery when the collection was distributed'.

These Turners came to the Gallery in 1884. In the Minutes of 31 July: 'The Director reported that five pictures by Turner selected by him with the assistance of Lord Powerscourt...had been received and have been cleaned and restored etc. by Mr John Tracey under the direction of the Director...' Considering the price of Turners on the open market, Doyle must have felt great satisfaction.

They were among a selection distributed to provincial galleries under the conditions of the National Gallery Loan Act which came to the Gallery in July 1884. Powerscourt wrote how 'we went by appointment to Trafalgar Square to meet Sir Frederick (sic) Burton at the National Gallery, and I said that he would probably consider that his native land and city should have the first choice in the distribution, to which he agreed…This is the way in which we Irishmen do little jobs for ourselves, or rather for our country. We are rather celebrated for doing jobs, but I think this was a harmless one!'[32]

In addition to the Turners, Doyle picked out four other pictures of the 'modern' British School, under-represented at the NGI: *The Dialogue at Waterloo* — a large Landseer; *A Music Party* by William Etty (1787-1849); William Mulready's (1786-1863) *The Young Brother* and a David Wilkie (1785-1841), the *Peep-o'-Day Boys' Cabin, in the West of Ireland.* They would remain in the NGI until the late 1920s, when they were returned to London; the Wilkie was exhibited in 2002 in a retrospective, to critical acclaim.

Doyle continued to gather Old Masters, concentrating on the Dutch School. Among paintings acquired in the late years of his directorship were *Head of an Old Man* (NGI 254) by Govert Flinck (1615-60), *Cornelis de Graeff with his Wife and Sons arriving at Soestdijk* (NGI 287) by Jacob van Ruisdael (1628/9-82) and Thomas de Keyser 1596/7-1667), and another double, of *Ladies and Cavaliers* (NGI 119) by Dirck van Delen (1605-71) and Dirck Hals (1591-1656), the younger brother of Frans. In June 1889 he attended a further huge sale, the paintings of Hubert Galton of Hadzor where he acquired the graceful *A Lady Playing a Lute* (NGI 150) by Jan Mytens (c.1614-70) at 40 guineas. He also bought for 96 guineas *A Man in a Large Brimmed Hat* (NGI 107). It was already re-attributed from Rembrandt to Gerbrand van den

Eeckhout. The signature of Willem Drost (active 1652-80) only appeared when the picture was cleaned in 1982 and it has since become a key work for linking other paintings to him. In July 1891 Doyle attended the Cavendish Bentinck sale at Christie's and acquired his last masterpiece for the Gallery, a *bozzetto*, or sketch, by Giovanni Battista Tiepolo (1696-1770) of an *Allegory of the Immaculate Conception and of Redemption*.

The year before, 1890, there had occured the excitement of the Danseart 'Rembrandt.' Powerscourt tells the tale. He and Doyle were in Brussels when an acquaintance, John Lumley, told them: '"There is a prize here, belonging to a gentleman... a beautiful portrait by Rembrandt." The next morning we...were received by Mr Danseart and asked him if he had a portrait by Rembrandt and if it was for sale. "Yes" he said "but there has been an American gentleman here this morning and he has offered me 800 guineas for it."...he took us into this bedroom, where there was a lovely portrait of a young man in a high-crowned hat in the most perfect condition. We endeavoured to conceal our excitement and Doyle said, "I will give you 850 guineas for it". The owner said, "I think I will accept that."...John Lumley was delighted, and said, "Well you have got a bargain, and no mistake!"'[33]

Beware of bargain Rembrandts. The young man (NGI 319), claimed by the unreliable M.Danseart to be the likeness of Louis van der Linden, held his own as a Rembrandt until the 1980s, when a series of scholars demoted the portrait to Govert Flinck (1615-60) and, according to one, not even a good Flinck.[34] Nor is he Louis van der Linden.

In 1891 Doyle acquired *The Toy Seller* by William Mulready (1786 -1863), a painter who was born in Ennis, County Clare, although he had lived most of his life in London. He paid £304; it had been sold in 1863 after the artist's death for around £1,200, and in the circumstances he felt satisfied. The *Evening Telegraph* reporter asked: 'You lately made a purchase of a fine work by Mulready, I believe, Mr Doyle?'

'Yes, there it is beside the door. It is...on a much larger scale than the artist usually painted. That is the reason I picked it up so cheaply.'

'I do not admire the picture as much as I have some other works of Mulready, Mr Doyle. It shows a negro trying to sell a toy to a fair young mother and child, and the contrast between the black and white races is presented in a very startling way, and in my view, in defiance of, not to say, canons of art, but one's natural perceptions of harmony, or what may legitimately be allowed in the presentation of contrasts. Then the flesh-painting of the white figures is very pink and unreal, and I think the hands of the woman are too large and masculine looking'.

'The flesh painting is peculiar to Mulready's style, and does seem rather pink, but the head and bust of the negro shows great power of treatment. It is a fine study'.

Evidently Doyle stopped short at calling his interviewer a racist. The journalist found him 'a model director. He is the pink of urbanity and courtesy, and is a thousand times better than any guidebook, however unconventional and gossipy. He takes pride in his work, and throws himself into it with a subdued gentlemanly sort of enthusiasm that cannot fail to impress the observer - the same sort of pride that a sea-captain takes in a handsome and gallant ship which feels his touch and answers to a call whenever it is made upon her'.

Two months later Doyle was dead.

In the last month of his life, he attended the sale of the Miss James collection where he acquired a sketch in pencil, chalk and watercolour of a vase of flowers (NGI 2167) by Jan van Huysum (1682-1749). He also bought four drawings by Jean-Antoine Watteau (1684-1721) two of which, *The Back of a Seated Lady*, in red chalk (NGI 2299) and *Boy tuning a violin*, in black and red chalk (NGI 2301), are perhaps the most beautiful drawings in the Gallery.

He died on 17 February 1892 at his London lodging in South Street. He was fifty-five. The *Freeman's Journal* copied a notice from the *Pall Mall Gazette*. '…Mr Henry Doyle, the accomplished Director of the National Gallery of Ireland, died in London suddenly the day before yesterday of disease of the heart. Mr Doyle had come to London for the purpose of consulting his doctor, but had no idea that his state was so serious…'

Immediately after his death his immense library was put up for auction in a sale that lasted for five days. From the number of books and the catalogues of libraries in his possession it is evident that, in addition to his preoccupation with art, he was a serious book collector who was also interested in coins, possessing many numismatic books and journals. In addition to the usual range of nineteenth-century writers, the indispensible art books, numerous volumes on Irish subjects, including *Dublin Street Ballads* and O'Donovan's *Annals of the Four Masters,* he had a quantity of travel books, three dubious volumes (*Rosy Tales! for all True Lovers of the Birch - Privately Printed*), comic books by his brother, Richard Doyle, and *The Hunting of the Snark*. Poignantly one item in the catalogue is Stokes' *Diseases of the Heart and Aorta*.[35]

Walter Armstrong summed up his predecessor's achievement in his first Director's Report. 'The year in question will ever be signalised in the annals of the National Gallery of Ireland by the lamented death of Mr Henry Doyle, CB, who for twenty-three years fulfilled the duties of

Director with extraordinary success. During his incumbency of the post some two hundred and thirty-nine oil pictures, to say nothing of drawings, engravings, and other works of art, were added to the collection, with the result that it has become, perhaps, the best gallery in existence in proportion to the means at its disposal'.

1 T. Durer, 'Une Visite aux Galeries Nationales d'Irlande et d'Ecosse', *Gazette des Beaux Arts* (1882) (translated by Gillian Somerville-Large)
2 Minutes of the NGI Board, 11 Nov. 1880
3 Homan Potterton, 'A Director with Discrimination', *Country Life* (9 May 1974) pp. 1140-41
4 Lady Gregory, *Hugh Lane's Life and Achievement* (London 1921) p. 106
5 Minutes, 24 Aug. 1880
6 Potterton (as n. 3)
7 *ibid.*
8 Minutes, Jan. 1883
9 Homan Potterton, *Dutch 17th and 18th century Paintings in the NGI* (Dublin 1986) p. 55
10 Letter read into Minutes, 26 July 1883
11 Lord Powerscourt, *A Description and History of Powerscourt* (London 1903) p.113
12 W. Armstrong, 'The National Gallery of Ireland – II', *Magazine of Art* (1890) p. 286. Quoted in Potterton (as n. 9) p. 124
13 *ibid.*
14 *ibid.*
15 Percy Colson, *The Story of Christie's* (London 1950) p. 57
16 Rosemarie Mulcahy, *Spanish Paintings in the NGI* (Dublin 1988) pp. 89-91
17 Thomas Bodkin, *Dismembered Masterpieces* (London 1945) p. 20
18 Potterton (as n. 3)
19 David Oldfield, *Later Flemish Paintings in the NGI* (Dublin 1992) p .28
20 Minutes, 12 Dec. 1874
21 NGI Administrative Box 8
22 Paula Murphy, *Roderic O'Conor 1860-1940* (Dublin 1992) p. 10
23 Minutes, 13 Feb. 1873
24 Minutes, 29 May 1873
25 Minutes, 3 July 1873
26 Minutes, 21 April 1881
27 Minutes, April 1885
28 *Evening Telegraph*, 8 Dec. 1891
29 Director's Report 1887
30 *ibid.*
31 *ibid.*
32 Powerscourt (as n. 11) p. 114
33 *ibid.* p. 112
34 Potterton (as n. 9) p. 46
35 John W. Sullivan 'The Recherché Library of the late Henry E, Doyle Esq, CB RHA. Sold 22 Feb 1892 and the following five days', Auction cat., No 8 D'Olier Street (Dublin City Library)

CHAPTER THIRTEEN

RUNNING AFFAIRS IN THE 1890S

Among the applicants to succeed Doyle was Sir Thomas Newenham Deane, who with his son, Thomas Manly Deane, had submitted tentative plans for the enlargement of the Gallery, and Stephen Catterson Smith the Younger, whose father had applied unsuccessfully to be Director in 1899. Another applicant was the Hon. Frederick Lawless, an amateur art critic, who would subsequently be appointed to the Board and serve for more than thirty years. Among the unlikely candidates was Donal Sampson, who enclosed a testimonial from Lord Arundell of Wardour. 'Lord Arundell..considers that Mr D. Sampson, having ceased to receive any rents from a large property in the county Clare principally through the action of recent legislation, has a claim to indirect compensation from the Government.'[1]

The outstanding candidate was Walter Armstrong. Born in 1850, a graduate of Exeter College in Oxford, Armstrong had studied art for twenty-five years. He had published books on art and articles, including two papers on the National Gallery of Ireland in *The Magazine of Art*. He had demonstrated his knowledge and taste in advising the collector Samuel Joseph on assembling an outstanding collection of Dutch pictures. In 1892, the year Armstrong was appointed, Joseph would present the NGI with a genre picture of carousing peasants, *A Merrymaking* (NGI 324) by Cornelis Dusart (1660-1704).

Armstrong presented testimonials from Sir Frederic Burton, Sir Frederick Leighton, President of the Royal Academy, Dr Wilhelm Bode, Director of the Kaiser Friedrich Museum in Berlin ('You know Art and you have the feeling of the artistic point in a picture.'), DF Lippmann, Director of the Royal Museum, Berlin ('I can think of none more highly qualified than Mr Armstrong') and Abraham Bredius, Director of the Mauritshuis in The Hague. ('I declare with pleasure that among the very few real connoisseurs of our old Dutch School in England, you are one of the best')[2]

Sir Walter Armstrong (1850-1915), third Director
(1892-1914), 1896 by Walter Osborne (1859-1903),
presented 1959 (NGI 1389).

On 24 March 1892, ten members of the Board assembled to elect a new Director. They included the 5th Duke of Leinster in the Chair, Lord Powerscourt, Thomas Jones, the President of the RHA, and the sculptor Thomas Farrell. A majority voted for Walter Armstrong.[3]

Armstrong, whose hard task was to succeed the highly popular and successful Doyle, had one considerable handicap – he was an Englishman. In his application Frederick Lawless had enclosed a testimonial from Sir Bernard Burke, Ulster King of Arms, which pointed out that 'he has in addition one qualification which I value highly, he is an Irishman by birth.' From the Athenaeum, Lord Ross wrote to Lord Powerscourt: 'I think there can be no doubt that W.A. is the best man we have before us. Of course, as usual, there is a widespread wish to see an Irishman appointed but we can't help that unless proper qualifications are shown.'[4] Armstrong's lack of Irish credentials was immediately attacked by the *Irish Times*: '…his special experience…does not…disentitle us from asking whether it is possible that no Irish amateur or collector was a candidate for the office… What we have is another valuable Irish place, to which our lovers and students of art might well aspire, going across the Channel where there is no great disposition shown to give Irishmen a chance when candidates for places are in the public gift.'[5]

According to his contract Armstrong had to live in Dublin. He brought his family over and chose to live north of the city near Howth, as far away on the Dublin coastline as could be from Doyle's house in Bray.[6]

He faced immediate problems. Attendance at the Gallery was continuing to fall and would do so throughout the decade, from 90,413 in 1892 to 72,117 in 1900.[7] The building was now totally inadequate for the ever growing Collection, and the Treasury refused to consider any enlargement. The attendants were demanding a rise in pay. The Registrar, who was eighty-four years old, was showing signs of decline, the most obvious being the shaky handwriting, blots and crossings out that appeared in the Minute Book.

In 1882 T Durer had described the NGI as 'un batiment isolé.' The reporter from the *Evening Telegraph* who interviewed Doyle in 1891 wrote how 'one would really wish for his sake that the National Gallery were a more popular place than it seems to be…On week days its fine halls are comparatively empty; it is only on Sundays that they present any real appearance of life…It is badly located. Merrion-square is on the outskirts of the city, so to speak; and the gallery was planted there out of respect to the memory of William Dargan and the Exhibition which he got up there at his own expense in 1853.'[8]

In 1907, DA Chart described the approach to the National Gallery in the days when people could go from Kildare Street to Merrion Square. (It does not really seem too far to walk.) 'Passing from the Museum across the front of Leinster House, a small wicket gate gives access to Leinster Lawn and the National Gallery...In the immediate foreground is the old private garden and shrubbery, now treated as city park under the name of Leinster Lawn. Beyond is Merrion Square, a grassy hollow encircled with trees...It has, especially when viewed from the upper windows of Leinster House, a curious appearance, as of lawn and woodland rolling away to a remote distance, where houses begin to reappear among the trees.'[9]

The overcrowded conditions for the collection and the general drabness were not incentives for viewers to make the journey to the out-of-the-way Gallery. Nor were the dark Old Masters which had to be 'skyed' to the ceiling, the screens that Doyle had placed in the main gallery to take some of the accumulation of pictures, or the much touted Irish Portrait Gallery filled with figures of beribboned viceroys, generals, archbishops and patriots. In the year that Armstrong became Director an article in the *Daily Express* reported that so serious was the lack of space, that pictures were stored in the Director's office.[10]

Throughout the 1890s Armstrong and the Board sent urgent requests for an extension to the Gallery. The one accompanying the Director's Report for 1893 elicited the reproach from Treasury Chambers: 'the

*Sign advertising the NGI and the National Portrait
Gallery, late 19th century (NGI Archive).*

Board of Governors must remember that the claim is only one out of many and my Lords are bound to give preference to the most pressing or important.'[11] At the end of 1894, 'the Governors and Guardians feel obliged to refer to their resolution forwarded on 3rd November 1892 and repeated on 2nd November 1893, where they impressed upon H.M. Treasury the necessity for an immediate increase in the Gallery Buildings.' On 14 November 1895 a communication was 'addressed to the Lords Commissioners of H.M. Treasury asking their consideration of the great inconvenience caused...by the inadequacy of the existing accommodation for works of art in the National Gallery, Dublin.' In 1896 a similar resolution accompanied the Director's Report for 1895. The Treasury was unmoved.

A memorandum from Sir Richard Sankey, head of the Board of Works, in May 1894, put forward some of the problems the Gallery faced:

'Heating arrangements.

Boiler lit at 12 o'clock, gallery not warm until 3 o'clock or so. A porter attends fire, which occupies him about 20 minutes every hour, consequently there is no one during these periods to look after the Gallery for which he is responsible..

State of Roof

During rain the water comes in in some twenty different places'

The annual estimates for 1895-96 gives some indication of the patchy make-do-and mend methods of keeping the NGI in order:

'Painting of small galleries.

Repair front door

Hose for fire mains

Whitewashing.

Repairing roof.

Lawn needs manure etc.

Board Room Clock.

Two doz bentwood chairs.

Board room writing table

Complete the renewal of roof blinds...'[12]

It was not surprising that when Burton retired from the position of Director of the National Gallery in London in 1894, Armstrong put his name forward as candidate for his successor.[13]

At the first Board meeting he attended on 16 June 1892, a petition had been read from the attendants of the Gallery. 'We...beg with great respect to bring before your Honourable Board an appeal for an increase of our respective salaries in which there has been no alteration for the last

twenty-five years.' One of the new Director's first tasks was to enquire into the relative wages of other attendants at other institutions. He discovered that by comparison the staff at the National Gallery was underpaid, and wrote to the Treasury on 7 January 1893.

The Treasury moved slowly. Not until September 1894 was a reply received, one of the earliest communications in the archives to be typewritten.[14] 'Their Lordships … are of opinion that…a fair case can be made out for an improvement in the wages of the present staff of Porters in your Department.' They granted 'the following scale of wages to take effect as from the 1st April last:

Dunne, Pedreschi, Forde 24/- a week.

Cleary 23/- rising to 24/- after 10 years service,

Boyle 20/- rising by 1/- per week per year to 24/-.'

This evidently satisfied the attendants; positions at the National Gallery were privileged and eagerly sought after. In the same letter the Treasury recommended that in future, salaried members of the staff should be 'pensioners from the Army Navy or Police,' as happened elsewhere.

Cleary only had his raise a short time. On 8 August 1895 'The Director announced that, subject to the approval of the Board, he had been obliged to dismiss Denis Cleary…for being under the influence of drink.'[15]

A pathetic note is preserved in the NGI archives, addressed to the Registrar. 'I hope you will kindly pardon me the offence I have committed in not answering any of your letters before this as I have not been in a fit state to do so and trusting in your generosity to speak favourable on my behalf to the director for committing such a gross offence. I remain, Sir, your obedient servt., D. Cleary.

P.S. I am ashamed to go to Gallery. D.C.'

Together with the note is a memorandum: 'Denis Cleary Appointed by the Board 21st January 1889…Wages £52 per annum: increased in Sept 1894 to £59. 16s. Dismissed – 1st August 1895. Length of Service 9 years, 6 months, 10 days'.[16]

On 29 March 1894 a letter from the Registrar, Philip W. Kennedy, to the Director was read into the Minutes: 'Sir, I beg to inform you that on the 30 April next, I propose to retire from the post of Registrar to the National Gallery of Ireland, an office I have now filled since November 1872. In placing my resignation in your hands, I may perhaps be allowed to point out that during 21 years of my service I have received no increase of pay and have never had any vacation with the exception of one week during

the summer of 1885.' The Board may have heaved a collective sigh of relief as they passed a resolution of regret. The guilt they felt is expressed in another resolution carried unanimously. 'That the Superannuation Statement of Mr P. W. Kennedy…be forwarded at once to the secretary of H.M. Treasury with a recommendation that looking to his great age (85 years) and to the facts that during his 21 years of service he has received only one week's leave of absence and has never received any remuneration for extra service (Sunday attendance)… some substantial increase may be awarded by their Lordships to the pension he has earned…'

The Treasury replied that there was a hitch. It seemed that Mr Kennedy had not obtained a Civil Service Certificate on his appointment to the Gallery in 1872. However, a way out of this difficulty was offered. 'If…it can be made to appear…that it was through inadvertence on the part of the Governors and Guardians that Mr Kennedy was appointed without a Civil Service Certificate, my Lords will be prepared to exercise in his favour their powers under Section 2 of the Superannuation Act 1884.'

The Board hastened to resolve that they felt confident that 'it was through inadvertence on the part of the Governors and Guardians of that time'. Lord Powerscourt, the only member of the Board who had been present when Kennedy was elected, 'said he had no doubt whatever that if the necessity of such a certificate…had been known, steps would have been taken to obtain it.'[17] These statements my Lords accepted. 'The Director read a letter dated 30 August 1894…from the Treasury granting to Mr Kennedy…a retiring allowance of £52. 10s. per annum in addition to the pension of £35 awarded in 1857.' Kennedy left the administrative affairs of the Gallery in confusion, and his successor spent a good deal of time getting them back in order. He had to clear off 'arrears of work caused by the incapacity of Mr Kennedy during the latter years of his life to keep pace with the growth of the institution.'[18]

Unsurprisingly, the Board passed a unanimous resolution 'that the Civil Service Commissioners be recommended to fix the limits of age for appointment to the Registrarship of the National Gallery, Ireland as from 25 to 45 years.'[19]

Armstrong had worked with the tired old man for nearly two years, and knew that without an efficient Registrar[20] the work of the Gallery would be wholly his responsibility. It may be asked why, after Kennedy's experience at the post, anyone should wish to take the position, but there was no shortage of candidates. The names of six were put to the vote and 'a clear majority' chose yet another Englishman.

The choice was inspired. Walter George Strickland was familiar with Ireland, having spent time in the west, with his uncle, agent to Viscount Dillon.[21] At the time of his appointment he was forty-four, just within the new limits of age set by the Civil Service Commissioners. He found the work congenial; he certainly did not do it for the money, £200 a year. That he had private means is suggested by his residence, Newtownpark House, Blackrock, a substantial Georgian mansion. In 1902 Armstrong tried to get him a raise: 'the duties of the said officer have increased so rapidly that practically the whole of his time is now required by the Gallery and his office has quite outgrown that of mere clerk and accountant which was sufficient in the early years of this institution.'[22] The Treasury refused, but Strickland carried on.

He and Armstrong not only took up the challenge of their respective positions in the NGI, but found time to pursue their own interests. Armstrong's books on art appeared steadily: *Orchardson* (1895), *Velázquez* (1896), *Reynolds* (1900), *Raeburn* (1901), *Turner* (1902), *Gainsborough* (1904), *The Peel Collection and the Dutch School* (1904,) *Lawrence* (1913).[23] Strickland embarked on his massive *A Dictionary of Irish Artists*, which would be published in 1913. Since many of the sources that he used have been destroyed – the files of the RHA in the 1916 Rising and the records in the Four Courts fire of 1922 – the *Dictionary* continues to be an essential source for art historians.

Battling with overcrowding, Armstrong accelerated the process begun by Doyle of arranging the pictures according to different schools. The Raphael cartoons were taken down, and paintings lowered, which, according to the *Daily Express*, 'had perforce been hung so high before that they were scarcely visible.'

Naturally Armstrong was familiar with Christie's. The Gallery has his catalogue for the Beckett-Denison sale of 1885 where he notes the Conrad Faber (catalogued as a Holbein) and Canaletto, bought by Doyle for the NGI. In the close art world of London and Dublin, it was inevitable that Doyle and Armstrong were acquainted. In 1891 Armstrong had sold to the NGI for £30 a painting by the Utrecht artist, Jacob Duck (1600-67) showing a woman asleep beside a military drum on which are coins and jewels (NGI 335). Women asleep had lewd implications in Dutch painting and Duck painted several more obvious pictures of women of easy virtue, but this lady's role is not overemphasised; in such a charming picture specifics could be ignored by a prudish Director like Doyle.[24]

In June 1892, three months after he was elected, Armstrong attended Mrs S Morton's sale at Christie's and bought for 45 guineas *The Castle of Montfoort near Utrecht* (NGI 328) by Anthony Jansz. van der Croos (1606/7-after

1661). This was in the spirit of Doyle. In the same year he spent 40 guineas on an over-cleaned portrait of a woman (NGI 371) by Hans Suess von Kulmbach (c.1480-1522) and in 1893, 35 guineas on a landscape with cattle (NGI 345) by Willem Romeyn (c.1624-after 1694). But he soon eschewed the hurly burly of the auction house. He did not have Lord Powerscourt as a companion and with Doyle's death the heady days of London auctions were over.

During Armstrong's long Directorship fewer than a dozen paintings came from Christie's. He preferred to buy from independent dealers. They included Anthony, Horace Buttery (also a restorer), Lawrie and Co, Shepherd Bros, Sedelmeyer in Paris, Langton Douglas (who would be a future Director of the NGI) and the ubiquitous Agnew's. Another source of pictures was the elderly Martin Colnaghi, with whom Hugh Lane began his career, who shared with Armstrong a scholarly enthusiasm for Flemish and Dutch pictures of the sixteenth and seventeenth centuries.

In 1898 the Treasury queried Armstrong's travels. 'Their Lordship's attention has been attracted to the relatively large sum (£150) included under Subhead C for your travelling expenses…' He pointed out the disadvantages of living far away from the European art market. 'The only way in which so small a purchase fund can be made to yield anything like a satisfactory return is by taking the promptest advantage of every opportunity which offers, which involves frequent journeys to England and the continent. The present Director has found it impossible to do the work of the Gallery properly without bearing, himself, very serious expenses for journeys. For instance, he has travelled several times to Paris, twice to Holland, twice to Berlin and once to Russia, on the services of the Gallery at his own expense.'[25]

Two years after his appointment the *Daily Express* observed that he was 'intelligently following' in Doyle's footsteps and commented that 'the Director…is not unduly partial to any one school. Early and late Italian art, the Flemish and our native schools are alike to Mr Armstrong. He cannot, indeed, afford to buy modern pictures. That is a luxury reserved for English galleries…As for the policy of appointing a really capable man as director of an art gallery, and leaving him to do his best with definite resources, the example of Dublin is quite enough to show that it is the only sensible course to pursue.'[26]

Armstrong's early purchases of Dutch paintings for the Gallery included, for £75, a Pieter de Hooch (1629-84) with off-duty soldiers, *Players at Tric-trac* (NGI 322). Cards on the floor indicate licentiousness and there is

a good deal of drinking and smoking. *A breakfast-piece* by Pieter Claesz. (1597-1661) was acquired in 1893 for £40, and in the same year the intriguing *Interior with Figures* (NGI 327), by Nicolas de Gyselaer (1583-before 1659) for £20. *Vertumnus and Pomona* (NGI 347) by Nicolaes Maes (1632-92) was bought from the Paris dealer, Bourgeois, in 1894 for £120. The Gallery also acquired, as the work of Gerrit van Honthorst, *The Arrest of Christ* (NGI 425), presented in 1894 by Sir George Donaldson, in memory of his Irish mother. It is actually by Matthias Stom (c.1600- after 1650), a Caravaggist artist working in Naples and Sicily.

Others schools were not neglected. In 1893 he bought *Harnham Ridge from Archdeacon Fisher's House, Salisbury* (NGI 376) by John Constable (1776-1837) from Agnew's for £125 and from the sister of deceased Bartholomew Colles Watkins (1833-91), who had been on the Board, a Connemara landscape (NGI 388) for £50. The Minutes read that it was purchased 'in pursuance of wishes expressed at the meeting held on the 3rd November 1892'. Two years later he obtained for five guineas from Mrs Snow in Waterford two pencil portraits (NGI 2116 & 3211) by Gainsborough (1727-88) drawn when the artist was sixteen ('fecit 1743-4'). He was proud of them, and mentioned them in his subsequent book on the artist. Armstrong ventured back to Christie's in 1894 for a Romney, *Titania, Puck and the Changeling* (NGI 381) which cost £215.

He also purchased in Dublin in 1894 for £10 from Mr O'Hea part of a Spanish altarpiece (NGI 354) which is as notable for its curious provenance as for its subject – St James is having his throat cut. This had been bought by a cork merchant, Mr Grieve Christie, and was said to have been shipped from Spain to Dublin in one of Mr Christie's cargoes with three other panels from the same altarpiece. Two were acquired by Dr (later Sir) Thornley Stoker, a member of the Board of the NGI, a successful surgeon and brother of the writer Bram Stoker. The other panels went missing until two (NGI 4025 & 4026) were discovered many years later in 1971 by James White in the Richmond Hospital, Dublin, where Stoker probably deposited them. They were purchased for the NGI. A fourth panel, sold by Mr O'Hea to a Dr Joseph Kenny in 1894, is still missing, known only through a photograph. The altarpiece was considered Italian until 1972 and is now given to two Masters of the Valencian School.[27]

In 1896 Armstrong bought two of the most outstanding pictures in the NGI. A description of the first from the Director's Report reads: 'Judith with the head of Holofernes stands at the door of a tent and is placing the head of Holofernes in a bag held by an old negress… Through the opening of the tent is seen the end of a bed with the sole of one foot of

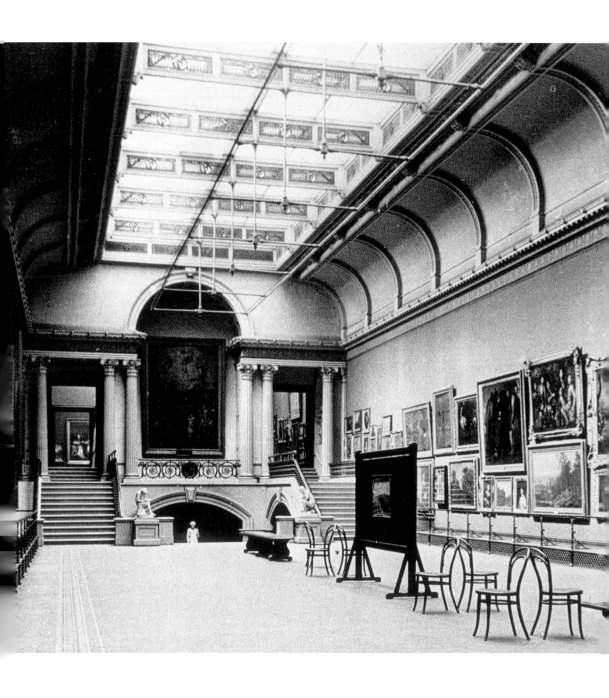

The Queen's Gallery, c.1900 slide by Ephraim McDowel Cosgrave (©Royal Society of Antiquaries of Ireland). The earliest interior view of the picture galleries was made by a historian of Dublin and friend of Registrar, Walter Strickland. The north wall is hung with Dutch and Flemish paintings, the south wall is hung with Italian paintings and there are Northern, British (Wilkie) and Irish paintings in the upper rooms. Note the gas burners hanging below the glazed ceiling.

Portrait of a Musician, late 1480s by Filippino Lippi
(c.1457-1504), purchased 1897 as by Sandro
Botticelli (NGI 470).

Holofernes. On the left a pole with a long pennon twisted about it. Background of feigned marble.' Andrea Mantegna (1431-1506) painted *Judith with the Head of Holofernes* (NGI 442) in *grisaille*; a matching picture of *Samson and Delilah* is in the National Gallery in London, and they may be two of a series illustrating the deeds of courageous women. The painting cost £1,200, well over the year's budget, but the NGI was helped by a donation by Lord Ardilaun.

The second painting cost £20. In March 1893, a year after his appointment, Armstrong had presented the Gallery with *The Robing of Esther* (NGI 380) by William de Poorter (1608-after 1648) who may have been a pupil of Rembrandt. Now in 1896 he bought another picture ascribed to the same artist: 'Willem de Poorter 17th century Dutch School. Interior with Figures. On panel 8 in. h. 10 in. w. Purchased from H. Buttery, London. Hung in Small Dutch Gallery and numbered 439.'[28] But this strange little painting, not much larger than a big postcard, was better than a de Poorter. The group of men playing some sort of a rough game, perhaps *La Main Chaude*, or Hot Cockles by candlelight, tantalised and puzzled the experts who examined it. Could it be a Rembrandt? In his 1904 catalogue Armstrong, who had first called it *Playing La Main Chaude*, described it as 'greatly superior to the average work of de Poorter'.

In October 2001, Professor Ernst van de Wetering, the sole remaining member of the Rembrandt Research Project in Amsterdam, which examines and assesses Rembrandts in galleries and collections around the world, took the unusual step of going the other way – confirming that here indeed was a work by Rembrandt, dating from around 1628 when he was in his early twenties. It was painted in the same period, with similar shabby candlelit rooms and leaping shadows, as his early *Christ at Emmaus* and *The Artist in his Studio* (which, before it ended up in the Museum of Fine Arts, Boston, would pass through the hands of Robert Langton Douglas).

Other pictures acquired during Armstrong's bumper years include *Portrait of a Musician* (NGI 470), purchased in 1897 for £1,500, which has been attributed to a gamut of artists from Florence, Ferrara and Lucca, including Botticelli and Cosimo Tura. It is now generally accepted as a fine example of Filippino Lippi (c.1457-1504).[29] The following year saw a small interior scene (NGI 468) possibly by Judith Leyster (1609-60) come to the Gallery for £30, and *Les Tours de Cartes* (NGI 478) by Jean-Baptiste Chardin (1699-1779), the only surviving version of various 'Card Tricks' which Chardin painted, bought from Colnaghi for £750.

Another painting from Colnaghi's, also purchased in 1898, for £150 was the delightful, if ridiculous, *Pretiose Recognised* (NGI 476) by Godfried

Schalcken (1634-1706). The subject of a lost daughter identified by a mole on her left breast is taken from a short story by Cervantes called *La Gitanilla*. Described in an 1818 Christie's catalogue as 'an exquisite bijou', this painting was once in the collection formed before 1723 by Phillippe, Duc d'Orléans, Regent of France, and hung in the Palais-Royal in Paris.[30]

Armstrong also enriched the NGI prints and drawings collection when in 1896 he bought a small group of superb drawings by Dutch masters from F Muller and Co in Amsterdam. They included work by Gerbrand van den Eeckhout (1621-74), Jan van Goyen (1596-1656) and three historical compositions by Jacob van der Ulft (1627-89), one of which was *The Persecutions in Ireland* (NGI 3248). This gesture was never again repeated.[31]

Little is known about Armstrong's private life. He had five children and liked golf and photography.[32] However, there are details about two of his friendships. One is with the Irish artist, Walter Osborne (1859-1903). In 1895 they made a trip to France and Spain, touring galleries in Paris and Madrid, and visiting Toledo. 'We two Philistines'[33] seemed to have had boyish fun, while Armstrong's knowledge of Spanish painting enthused Osborne. The NGI acquired in 1966 some affectionate pencil sketches of Armstrong by Osborne drawn during this journey – one shows Armstrong asleep in a train (NGI 3802), another wearing a squashed hat in a cafe in Madrid, puffing away at a cigar under his walrus moustache (NGI 3804). A cigar is included in Osborne's formal portrait of Armstrong (NGI 1389) whose flesh tones elicited the curious comment from Armstrong's friend, Whistler: 'It has a skin! It has a skin!' This is inscribed 'To My Friend, Walter Armstrong.' In return Armstrong asked Osborne for a self-portrait (NGI 555).

When Osborne died in 1903 at the age of forty-four, his mourners included Nathaniel Hone, for whom his death 'is like a nightmare to me still'[34] and George Moore, who considered Dublin a duller place to live in. Armstrong wrote to Sarah Purser on how he had arranged 'to go through such things as Walter O had left behind him with the intention…to buy some for the National Gallery.'[35] He bought two oils, including *The Lustre Jug* (NGI 553), various drawings, and three watercolours, including two charming scenes with children, *The Dolls' School* (NGI 2535) and *The House Builders* (NGI 2536).

Armstrong had known James Abbott McNeill Whistler (1834-1903) in London before he came to Ireland. At the end of the artist's life, in the summer of 1900, Whistler spent a week or so in a house called 'Craigie' in Sutton which Armstrong probably obtained for him, since it was not far from Ceanchor House, where he lived. But 'Craigie' was on the wrong

side of Dublin Bay and the weather was wretched.

Armstrong described how Whistler 'excited the curiosity of the natives by...papering up the windows on the north side of the house for half their height with brown paper. He came to dinner with me one night stipulating that he should be allowed to depart at 9:30 as he was such an early goer to bed. We dined accordingly at 7, and his Jehu, with the only closed fly the northern half of Dublin could supply, was punctually at the door at the hour named. There he had to wait for three hours, for it was not until 12:30 that the delightful flow of Whistler's eloquence came to an end and that he extracted himself from the deep armchair which had been his pulpit for four hours and a half...I spent an hour or two with him in the Irish National Gallery. I found him there, lying on the handrail before a sketch by Hogarth (*George II and his family*) and declaring it was the most beautiful picture in the world...He soon grew tired of Sutton and Ireland and when I called at Craigie a few days after the dinner he had flown...'[36]

In October 1898 Armstrong inserted a memorandum into the Minutes: '..A new Edition of the Catalogue of the Gallery has been completed and is now in the Printer's hands... The Catalogue includes all works exhibited in the Gallery up to date...

1 Catalogue of Pictures. This has been carefully revised and corrected and in great part re-written; and all works acquired since 1890, the date of the last catalogue have been included.
2 Catalogue of Drawings...The whole of the drawings have now been catalogued alphabetically under artists' names and numbered.
3 Portrait Gallery...A full catalogue has been compiled.
4 Sculpture...this...has been revised and somewhat curtailed...

The additions...necessitated by the growth of the Collection have considerably increased its bulk, from 188 pages in that of 1890 to 361 in 1898. It is hoped, however, that the price, 6d, will remain the same.'[37]

He must have felt pleased with the scholarly update of his predecessors' efforts. From the 188 pages of Doyle's 1890 catalogue it had swollen to 361. The Preface states there were now '464 pictures, 348 original drawings, watercolours &c., 280 engraved portraits, 16 busts and statues in bronze and marble', including a fuller account of those which could not be hung because of lack of space. Along with numerous re-attributions, the painting collection was renumbered (some of the forgotten larger paintings in the basement only received a number when they re-emerged in

1967) and there was the first proper list of sculpture, apart from the cast collection. Another edition was published in 1904 after the NGI had been enlarged.

Altogether he had good reason to feel satisfied. Those first years of his Directorship were the most enjoyable, not to say carefree. He was knighted in 1899 (his friend, Osborne, refused a similar honour). Two years earlier the promise of Lady Milltown's donation of the contents of Russborough House had finally persuaded the Treasury to find the money to enlarge the Gallery. But the Milltown Collection would create friction throughout the next decade.

1 NGI Administrative Box 2. Applications for position of Director
2 *ibid.* Application by Walter Armstrong.
3 Minutes of the NGI Board, 19 March 1892
4 Admin. Box 2. Lord Ross to Lord Powerscourt, 23 March 1892
5 *Irish Times,* 25 March 1892
6 *Thom's Directory 1892*
7 Director's Reports
8 *Evening Telegraph,* 7 Dec. 1891
9 DA Chart, *The Story of Dublin* (London 1932) section xi
10 *Daily Express,* 2 Dec. 1892
11 Admin. Box 2. Treasury Chambers to Armstrong, 1 October 1894
12 Admin. Box 2
13 'An Artistic Causerie', *The Graphic,* 5 August 1893
14 Admin. Box 2. Francis Mowatt to Armstrong, 19 Sept. 1894
15 Minutes, 8 Aug.1895
16 Admin. Box 2
17 Minutes, 2 Aug. 1894
18 Minutes, 6 March 1902
19 Minutes, 2 Aug. 1894
20 Minutes, 19 April 1894
21 Theo Snoddy introduction to W G Strickland, *A Dictionary of Irish Artists* (London 1913, reprinted Shannon 1969), p. v
22 Minutes, 6 March 1902
23 Homan Potterton introduction to *NGI Illustrated Summary Catalogue* (Dublin 1981) p. xxii
24 Homan Potterton, *Dutch 17th and 18th century paintings in the NGI* (Dublin 1986) p. 36
25 Minutes, 3 Feb. 1898
26 *Daily Express,* 4 April 1894
27 Rosemarie Mulachy, *Spanish Paintings in the NGI* (Dublin 1988) pp. 67-75
28 Director's Report 1896
29 *Master European Paintings from the NGI* exh. USA & Dublin 1992-93, p. 80
30 Potterton 1986 (as n. 24) p. 141
31 *Master European Drawings from the Collection of the NGI* exh. Dublin 1983, preface by Raymond Keaveney
32 Denys Sutton, 'Sir Walter Armstrong', *Apollo,* (Feb. 1982) p. 75
33 National Library of Ireland. Purser ms 12021. Armstrong to Purser, 3 Dec. 1895
34 Nathaniel Hone to Purser, quoted John O'Grady, *Sarah Purser* (Dublin 1996) p. 105
35 NLI. Purser ms 12021. Armstrong to Purser, 16 May 1903
36 E R Pennell and J Pennell *The Life of James McNeill Whistler* (London & Philadelphia 1908) vol. 2, pp. 258-59
37 Minutes, 13 Oct. 1898

THE MILLTOWN GIFT

In October 1897 the Board of the National Gallery of Ireland received a letter, marked Private, on black-edged writing paper, from Blessington, County. Wicklow.

'Dear Sirs,

Being desirous of keeping together, as one collection, in memory of my husband the sixth Earl of Milltown, the Pictures, Prints, Works of Art and Antique Furniture on view at Russborough, I am writing to know whether the Directors of the National Gallery Dublin would… be disposed to accept an immediate gift of the articles above referred to, making some arrangement that would be binding upon them, by which the pictures and articles…may be exhibited as one separate collection, to be known as the Collection of Edward Nugent, sixth Earl of Milltown. I should be happy to show, or to allow any one deputed by you to see, the Collection at Russborough. I shall be at Home on Thursday next, the 21st instant. There is a tram that leaves Terenure at twenty minutes past eight o'clock and another at eleven o'clock a.m. which will take you to Featherbed Lane, where I will have a man waiting to open the gate for you.'[1]

The writer was Geraldine, Countess of Milltown, widow of the 6th Earl. Lord Powerscourt accompanied Armstrong on that autumn day out to one of the great Palladian houses of Ireland.[2] They would have strolled through the rooms, including the Saloon whose ceiling is decorated with plaster work by the Lafranchini brothers, inspecting the paintings and furniture which the Countess proposed to donate to the NGI in memory of her beloved husband.

Armstrong was used to going to country houses in Ireland and Great Britain to view works of art.[3] He was evidently pleased with what he saw at Russborough and made friends with Lady Milltown.[4] He reported back to the Board and on 11 November wrote to her: 'it was unanimously resolved that the gift offered by your Ladyship…should be accepted

Edward Nugent Leeson, 6th Earl of Milltown (1835-90),
against Russborough, 1875 by Francis Grant (1810-78),
Milltown Gift 1902 (NGI 1036). The last Earl,
whose widow was to present the entire
contents of Russborough to the Gallery,
in one of many portraits of the Irish landed
gentry painted by Scottish-born President
of the Royal Academy.

under the conditions laid down in your letter to myself dated Monday 18th October 1897.' From the Board warmest and most grateful thanks were conveyed for her Ladyship's munificence.

Russborough was richly furnished. The house, with its great granite front and curved colonnades, had been designed by Richard Castle (who had been responsible for Leinster House) and built with the collaboration of Francis Bindon. In his *Views of the Seats of Noblemen and Gentlemen of the United Kingdom* JP Neale noted in 1826 how 'this Seat, placed amongst a superb amphitheatre of the Wicklow mountains, about fifteen miles from Dublin, has always been considered one of the most splendid architectural specimens in Ireland.'[5] Neale added a list of the principal pictures in the house, some 145, with additionally 14 pastels, watercolours and reliefs, which turned out to be most useful, as it proved to be their earliest inventory; no Leeson papers have come to light mentioning their provenance.

The house was built in the 1740s for Joseph Leeson (1711-83), whose ancestor had been a humble sergeant in Charles I's time. Thanks to a brewery behind his house on St Stephen's Green, and various unscrupulous land deals, Leeson's father became one of the richest men in Dublin, and at his death young Joseph inherited £50,000 and an income of £6,000 a year.

'The son of a brewer created a P(ee)r
Wine makes Lo(or)ds, I've been told,
and pray why should not beer?'

So Laetitia Pilkington wrote in 1748 when it was rumoured that Joseph Leeson might be ennobled.[6] He had leased out his brewery, since he proposed to become a gentleman untainted by commerce, but he had to wait until 1763 before he became the first Earl of Milltown. By then he had his house and estate at Russborough in the county of Wicklow.

He went on two Grand Tours in Italy where he collected for Russborough. The first visit took place in 1744 when he stayed for many months in Rome. Here he purchased landscapes in gouache (NGI 7400-07) from Giovanni Battista Busiri (1698-1757) and two Roman views and two *capricci* (NGI 725-28), all signed and dated 1740 by Giovanni Paolo Panini (1691-1765), most likely bought directly from the artist. He became one of the first English or Irish milords, if not the first, to sit for the portraitist Pompeo Batoni (1708-87), wearing a green silk fur-lined *robe de chambre* and fur hat (NGI 701).[7] Pastels by the Venetian Rosalba Carriera (1675-1758) of *The Seasons* and two goddesses (NGI 3844-49) were probably bought at this time and placed in ornate gilt rococo frames on his return.[8]

Leeson's second tour in 1750, when he was accompanied by his son Joseph and his nephew Joseph Henry, resulted in more Batoni portraits, including the *Presumed Portrait of the Marchese Caterina Gabrielli as Diana* (NGI 703), and another of his son wearing the same fur-lined robe (NGI 702). The, then unknown, painter, Joshua Reynolds, was commissioned to make a number of caricatures of Leeson and his associates. The best known of these, the *Parody of the 'School of Athens'* (NGI 734), was for his nephew Joseph Henry and brought into the Milltown Collection by the widow of the 4th Earl who acquired it at a Foster's sale in 1870, together with his pair of views of Tivoli (NGI 746-47) by the British painter, Richard Wilson (1713-83).

The collection at Russborough also contained a number of rare seventeenth-century Florentine pictures, which are of great interest to art scholars. They include *Moses Defending Jethro's Daughters at the Well* (NGI 1683) by Cesare Dandini (1595-1658), *Medoro and Angelica* (NGI 1747) by Lorenzo Lippi (1606-65) and three paintings by Felice Ficherelli (1605-60): a *Sacrifice of Isaac* (NGI 1070), luscious *St Mary Magdalen* (NGI 1707), and that unedifying and puzzlingly popular subject, *Lot and his Daughters* (NGI 1746). It is thought that they were bought through the efforts of one of Leeson's agents, Dr Tyrrell, living in Florence, who combined his medical work with marketing wine and cheese.

In addition to the Italian pictures, which included much that was second rate or copied, there were examples from the English, French, Dutch and Flemish schools. A number of pieces of sculpture were significant, including two statuettes of Antique fauns by Bartolomeo Cavaceppi (?1716-99), who worked as restorer in addition to making original pieces, two subjects (NGI 8242-43) copied in Florence by Giovanni Battista Piamontini (active 1725-?62) and three Roman cinerary urns (NGI 8279, 8288 & 8299). Copies of Classical sculpture by Bartolomeo Solari (1709-c.56) were acquired for the colonnades at Russborough.

The Irish School was represented by sixteen real and imaginary Italianate landscapes by the young George Barret commissioned by Joseph Leeson in the 1740s as tall narrow panels and overdoors. Three derive from the paintings by Giovanni Battista Busiri (1698-1757), featuring the Colosseum, Roman Forum and the Temple of Vesta at Tivoli.[9]

Neale's list of 1826 includes twenty-five paintings by French artists, the most outstanding being Poussin's *Holy Family with St Anne, St Elizabeth and the young St John* (NGI 925). This was painted in 1649 for Jean Pointel, a silk merchant and friend of the artist, and vanished after 1665 until recorded hanging in the Saloon at Russborough.

The 2nd Earl of Milltown, also Joseph (1730-1801), added considerably to the artefacts of the house. He died unmarried in 1801, and was succeeded by his brother, Brice (1735-1807), who spent much of his time repairing Russborough after it was damaged in the 1798 rebellion, not by the rebels, but by the forces of the Crown.

The 4th Earl, another Joseph (1799-1866), according to Neale 'not only added to the Collection of Pictures, but has brought from Italy some very fine bronzes.' These were four bronzes of the Labours of Hercules (NGI 8121, 8123-25) from the workshop of Ferdinando Tacca (1619-86). Unfortunately the 4th Earl was a compulsive gambler. He also had an illegitimate family in Italy, known as the Fitzleesons.[10] His neighbour Elizabeth Smith noted the behaviour of Lord and Lady Milltown in her diary: '26 October 1845. Lord Milltown has won £1,500. That and her share of a Kilkenny property varying from £80 to £120 a year and some small legacy left him lately by an Aunt is the extent of their means; all else is under sequestration owing to his folly, which, were it not hereditary would be incomprehensible.' '...17 February 1850. More of Lord Milltown's plate gone to be sold.' However, most of the contents of Russborough remained in the house, presumably because they were entailed.

The 5th Earl, Joseph Henry, died unmarried in 1871; in the same year his brother, Edward Nugent, succeeded to the Earldom and married Lady Geraldine Evelyn Stanhope, daughter of the 5th Earl of Harrington. The 6th Earl died in 1890, and his brother, the 7th Earl, in the following year leaving no direct heirs. Seven years later Geraldine, widow of the 6th Earl, wrote her letter to the Board. The paintings, and much else, including books, bookcases, pier glass mirrors, and ornate Irish side tables of deepest Honduras mahogany, were promised to the National Gallery of Ireland.

It is possible that she was inspired by the Wallace Collection, where Lady Wallace, a widow, like herself, had recently filled her house in Manchester Square in London with a mixture of pictures, furniture and porcelain and offered it to the public in memory of her husband. The idea of combining furniture and pictures in a picture gallery was shared by Lady Fitzgerald of No 29 Merrion Square who in 1896 bequeathed the NGI a French escritoire, an Italian cabinet, a mirror and a table, together with five modest pictures (NGI 444-8).[11]

Armstrong acted swiftly. The usual letter to the Treasury, written on 19 November 1897, accompanying the estimates for 1898 and pleading for extra accommodation for the Gallery, included new material: 'The Countess of Milltown...has offered to the Gallery as a free gift the whole

of the works of art at Russborough House, Wicklow… The collection includes about 180 pictures, about 30 pieces of antique and other sculpture, an excellent reference library of books…and a number of pieces of decorated furniture and objects of art…The value of the whole may be estimated at £40,000.

'…The Board of Governors and Guardians had Lady Milltown's offer before them at a meeting held on Tuesday the 11th instant, and accepted it unanimously, subject to their being put in a position to fulfil its conditions.

'…These conditions are that a separate room or rooms be assigned to the collection in the Gallery buildings, and that it be named the Milltown Collection.[12]

The letter went on to emphasise 'that Lady Milltown's offer supplies a further and imperative necessity for that extension of the Gallery building which they have felt it their duty for some years past to urge on the Government.' The Treasury stirred. Armstrong received a letter stating that 'should Lady Milltown's gift be actually made, they [the Lords Commissioners] will be prepared to provide the necessary accommodation.'[13]

The Board of Works was contacted and Sir Thomas Newenham Deane's old plans for a Gallery extension, first made in 1892, were submitted to them. After he died in 1899, the extension was completed by his son, Sir Thomas Manly Deane. Armstrong stipulated changes from the original plans, 'making the various entrances from one Gallery to another of a larger and more dignified character…cutting off the angles of the several rooms, thus changing their shape from square to octagonal.'[14] The flooring was to be improved and the walls of the area between the old building and the new were to be covered with white tiles or glass tiles to increase light. 'These plans…have been laid before the Lords of the Treasury and they have been informed that the estimate for the work is £20,250…'[15] A major decorative feature was the enfilade of doorcases carved in walnut by Carlo Cambi of Siena (1847-c.1900), who had worked with Deane on the National Museum of Ireland.

Building work started in March 1900 and the extension was finished exactly three years later. Everything was straightforward; there were none of the nightmare delays that had occurred in the Gallery's early days. The cost of the work, exclusive of clerk of works' salary and architect's fees, came in under budget at £18,906. 10s.[16] One small glitch was the date '1902' laid in mosaic at the entrance from the new portico.

On 11 August 1902 Armstrong was writing to the Board of Works

*Exterior of the NGI after building of the entrance portico
and Milltown Wing, c.1903* (©National
Photographic Archive).
The upper panels on the 1864 wing are inscribed
with the names of Greek painter Apelles and
sculptor Phidias above the Dargan Memorial
Tablet at ground level.

requesting electric light for the old buildings. 'As to the currents required, the whole of the lamps specified will never be turned on simultaneously so that a provision of electricity sufficient to enable one fifth of the power to be seen at one time will be enough.' The Board of Works replied that the offices and underground premises, the long basement store rooms, the old boiler room, old store room and porter's dwelling house would continue to be lit by gas.[17] Fowke's original building was repainted, regrettably using similar paint and distemper, instead of the more expensive Tynecastle canvas as the Director desired. The Gallery staff, without any outside help, took down and rearranged the pictures under Armstrong's direction.[18]

The Assyrian, Egyptian and Greek and Roman casts were removed when the front hall or vestibule was rebuilt. The suite of rooms on the ground floor, was entirely taken up with the portrait gallery. The Raphael Cartoons were hung up once again 'at the end of the great Italian room where they can be properly seen for the first time.'[19] The old portrait gallery was devoted to 'portrait prints', together with *The Marriage of Strongbow and Eva* and *The Volunteers on College Green*.[20]

There was a generous basement floor for storage, the gentlemen's lavatory, 'workshops' for the restoration of pictures and the heating boiler. The ladies' lavatory was situated beside the new entrance hall. The statues were cleaned and rearranged. The complete building consisted of twenty-three galleries, the smallest of which could comfortably display twenty average-sized pictures in a straight line. The big Queen's Gallery upstairs was devoted to the Italian school. The other old rooms at the head of the stairs contained the French, Spanish and English Schools, one room again being devoted to the Turner oils on loan, while the old room behind the stairs, where the Board Room had been, was now devoted to watercolours. The new top-lit rooms on the upper floor had four rooms reserved for the Milltown Collection including the Milltown library; the others displayed the Flemish, German and Dutch pictures. On the same floor was the Director's room; the top floor had other administrative offices.

The total Gallery, old and new buildings combined, could now show something like seven hundred pictures.[21] No picture was 'skyed'. 'An ideal Gallery...' trumpeted the *Freeman's Journal*. 'In these charming rooms, which are large enough, yet not too large, lofty, well lit, and aesthetically pleasing, one feels that the pictures which the connoisseurship of half a century had carefully selected are for the first time worthily displayed. We have now in Ireland an Art Gallery which any

city in Europe might well be proud of.' The *Irish Times* equally praised 'a new building of magnificent proportions and beauty added to what was the worst Art Gallery in the United Kingdom' now transformed into 'one of the best-equipped, most neatly designed and elegantly fitted Public Galleries in the Kingdom.' The Treasury sanctioned seven additional members of staff, ex-service men, except for John Walsh who had been a policeman.[22] There was just one drawback; the four rooms reserved for the Milltown Collection were empty.

The Lord Lieutenant postponed his formal visit to the Gallery and the new extension, which was opened without ceremony on 16 March 1903. When, on 16 June 1904, Armstrong delivered his Report for 1903, he had to announce: 'The collection presented by the Countess of Milltown and formally made over to the Governors and Guardians by Indenture of 30th July 1902 has not as yet been received in the Gallery, although the rooms designed for its reception have been completed.'

What had gone wrong? Lady Milltown had been on cordial terms with Armstrong until May 1900. Two months earlier she determined to sell a picture by Ingres, 'a first rate female portrait'[23] and contribute a painting of her own choice to the Memorial. Armstrong suggested that she should buy a Gainsborough. She wrote to him on 9 March 1900:

'Dear Sir Walter… On my arrival in London I went to Mr Agnew and saw..the Gainsborough. It was a good picture, but I did not like the Horse, and after…seeing no end of pictures Mr Johnson brought out a beautiful Sir J. Reynolds of Lord Buckingham's Family. The only thing that staggered me was the price, £15,000, but he knocked off £1,000 and I have satisfied the Ingres for £1,050 so that leaves £12,050 to be paid in a month…you must say I have nobly fulfilled my promise to the Gallery… G. Milltown.'[24]

The large family group she selected was of the Temple family (NGI 773). The Earl was twice Lord Lieutenant of Ireland and later became the Marquess of Buckingham, while the Countess was a Nugent, distantly connected to the late Lord Milltown. Together with their son and a black servant they are posed in front of the Borghese Vase, a suitable reference to the landscaped gardens inherited at Stowe in Buckinghamshire, where this painting hung in the Family Room.

A month later on Armstrong received another communication, the last one in the archives addressed to him personally .

'Dear Sir Walter, A friend has just sent me the Evening Telegraph of Saturday April 14th and he directs my attention to a paragraph stating that my three 'Watteaus' are 'Paters'. As there has never been any

Fête Champêtre – Dance, 1730s, by Jean-Baptiste
Pater (1695-1736), Milltown Gift 1902 (NGI 730).
Lady Milltown and Walter Armstrong dis-
agreed over its artist in one of many disputes
which soured relations between them.

question about the genuiness of these three works of art I shall feel much
obliged if you will sincerely contradict this misstatement in the Daily
Telegraph. Yours very truly, G. Milltown, Russborough, May 4th 1900.'[25]

On a visit to London Armstrong had been indiscreet, talking to the art
correspondent, Claude Phillips, who quoted him at length in the *Daily
Telegraph* without giving his actual words. Phillips' article was reprinted in
Dublin's *Evening Telegraph*. Of the Milltown Collection he had written:
'Three fine Paters have hitherto borne the name of Watteau, which was
so freely applied in the last century to the whole school of the painters of
'Fêtes Galantes.' Sir Walter Armstrong will no doubt restore them to the
lesser master whose attractive art was but a faint echo of that of the
exquisite painter of Valenciennes.' The paintings (NGI 729-31), now given
to Jean-Baptiste Pater (1695-1736), had been listed as Watteaus by Neale,
and two of them had been shown as by that artist at the Irish Institution
exhibition of 1854.

Phillips had also mentioned the painting by Ingres. On 21 May the first
of many letters from the Countess's solicitor, W.A. Lanphier of Naas, to

the Chief Secretary's Office in Dublin Castle declared that 'the connection of the 'Ingres' with the memorial was only known to Lady Milltown, Miss Kelly of Russborough, the housekeeper, and Sir Walter Armstrong.' Lanphier added that 'the Countess of Milltown…is extremely annoyed at the very unbecoming manner in which these works of art have been referred to.'[26]

Armstrong arranged for the *Evening Telegraph* to publish a formal acknowledgement that the offending paragraph contained the opinions 'of the writer alone'. But the friendship between Armstrong and Lady Milltown was shattered forever. Having had no satisfactory response from Armstrong, Lady Milltown declined to have further correspondence with him. She never forgave him for demoting her Paters and there is no evidence that she communicated with him directly again.

A conciliatory letter of 9 August from the Chief Secretary's Office to Lanphier, who by now was handling all the Countess's correspondence, acknowledging the 'unfortunate and much to be regretted incident', added, 'I am directed by the Lord Lieutenant and by the Trustees to request that you will convey to the Countess of Milltown that they, on behalf the people of Ireland, highly appreciate and value her munificent gift; that in proof of this a large sum of money has been provided for the erection of suitable buildings for the reception of the collection.'

Lord Powerscourt, as the oldest member of the Board of Governors, wrote directly to Lady Milltown, reminding her that the Treasury had advanced the funds for building, and 'might possibly appropriate the new buildings to some other use, which I, and as well as others, should consider as a National Misfortune.' The reply was a curt note: 'Dear Lord Powerscourt, I have received your kind letter. I have forwarded it to my solicitor. Yours very truly, G. Milltown.'

Henceforth Mr Lanphier of Naas was Lady Milltown's mouthpiece, and the intermediary who received letters from Lanphier and Armstrong and the Board was the office of Sir Patrick Coll, the Chief Crown Solicitor.

Meanwhile her chief tactic in relation to the National Gallery was delay. The extension to the Gallery had been well on its way to completion before she signed the Deed of Gift for the Collection on 30 July 1902 and 'made over to the National Gallery of Ireland the collection of Pictures, Sculpture, Books, Silver, Decorative Furniture and other Works of Art at Russborough, Co Wicklow: the said collection to be known as the Milltown Collection and to be kept and exhibited separately from the rest of the Gallery collection.'[27]

The second Schedule of the Deed of Gift contained the Countess's conditions with the fatal clause, 'including any future addition or additions.' (In the event 20 pictures in the NGI are not on the original inventory and 13 listed did not arrive.) A plan showed the six rooms to contain the Collection 'coloured pink'.

In February 1903, a month before the opening, Lady Milltown was informed that the rooms for the Milltown Memorial were completed. She ignored this notification. On 5 April, the Registrar, Strickland, stated that 'Lady Milltown's solicitor writes to me to say that he expects to receive definite instructions from Lady Milltown in a few days with regard to having delivery effected of the Collection.'

At the end of May, Lady Milltown directed that packing and removal should be done by Mr Pierce of Messrs Sibthorpe and Son of Molesworth Street. Armstrong objected to this, writing to Strickland on 10 June: 'Of course, we will not divide our responsibility for the things at Russborough, they are now the property of the nation, and we cannot delegate our responsibility.' But three days later Mr Holmes from Dublin Castle wrote to him: 'I want to enlist your good offices with the Trustees of the National Gallery to induce them not to stand on their high horse (I speak of them in their collective capacity and so assume that they have but one steed between them!) in their relations with Lady Milltown.' Her Ladyship's requirements were backed by the Chief Crown Solicitor and Armstrong had to yield. Mr Pierce of Sibthorpes would supervise the packing.

But when? At the end of October 1903 the Lord Lieutenant, Lord Cadogan, asked Armstrong about the delivery of the gift and was informed that there was still no sign of the collection coming to the Gallery. Six months later, writing to the Treasury on 23 March 1904, Armstrong informed the Secretary he had been told 'the collection is to be delivered to the Gallery in May and arrangements are now in progress for its reception.' But May passed, and so did the summer of 1904.

On 8 October Armstrong received a letter from the Chief Secretary's Office informing him 'that her Ladyship, having failed to deliver the Collection, notwithstanding repeated applications, the Executive Government have felt it their unpleasant duty to cause a writ...to be issued against her Ladyship...to compel her to carry the gift into effect.' The writ seemed to be effective, since Mr MacDonnell at the Chief Secretary's Office could write to Armstrong on 14 November that 'the Countess of Milltown has now expressed her willingness to deliver the collection in May next.'

But there was further tension when a paragraph appeared in the *Irish Times* on 29 December 1904 hinting that some of the rooms designated for the Milltown Collection were to be put to other temporary use – to display some of the pictures of the Forbes Collection assembled by Hugh Lane. Lanphier wrote to Sir Patrick Coll on behalf of the Countess: '…It is to be deeply regretted that the Director of the National Gallery should evince such lamentable want of tact…as he has from first to last displayed…The fruit of your good offices is withered through the folly of a subordinate official in the employment of the Trustees…'

JB Dougherty at the Chief Secretary's Office, now the chief intermediary, wrote testily to Armstrong on behalf of Coll : '…it is undesirable in the last degree that a new subject of controversy should now be raised…' The Board passed a resolution stating that 'the Governors and Guardians of the National Gallery of Ireland beg leave to inform the Lord Lieutenant that each and every room…coloured pink in the map attached to the original Deed…is now and always has been empty and partitioned off from the rest of the Gallery and that the Governors and Guardians have no intention of putting these rooms to any use whatever, save to that for which they are reserved.'[28]

That problem resolved, on 3 February 1905 Armstrong laid before the Board a 'draft of a scheme for the removal of the Milltown Collection from Russborough House to Dublin.' This would be aided by the willingness of the Victoria and Albert Museum to lend 'two of their specially constructed travelling vans, together with a foreman whose experience had been acquired by daily employment on such transfers.'

It has to be said that many donors of gifts to galleries behave in a dictatorial way; they are the benefactors, and they do not expect their wishes to be thwarted. Lady Milltown now prolonged the transfer further by sending her surveyor, Mr Inglis, to look at the rooms in National Gallery. He reported back, and Mr Lanphier passed on the news to Dougherty, who in turn passed it on to Armstrong, that there was not enough wall space, the bookcases were too small, the glass cases for silver and smaller treasures were 'wholly unfitted', that her Ladyship wanted to know 'what provision has been made for the suspension of the chandeliers… and lastly she wants the pictures numbered.' A resolution from the Board stated that all Lady Milltown's wishes would be carried out once the Collection was delivered.

Cajolery and flattery were tried. At the beginning of July 1905, Sir Thornley Stoker, a Board member, visited Russborough at Lady Milltown's invitation and inspected the collection. He had been deeply

impressed by its high quality and especially mentioned portraits of the school of Holbein and Zuccaro...Chippendale chairs and the smaller *objets d'art* contained in the vitrines as desirable acquisitions for the Gallery. This statement was crossed out of the Minutes and initialled by Dr JP Mahaffy, subsequently Vice-Provost of Trinity College, who for many years was an influential and opinionated member of the Board. After a resolution praising the Countess's generosity, Mahaffy and two other Board members, RS Longworth-Dames and Lt Col Hutcheson Poë, went to Russborough and had an 'audience' with Lady Milltown. At her Ladyship's suggestion, Mr Inglis and Mr Lanphier then attended a Board meeting on 12 August, where Mr Inglis raised his objections to leaking skylights, corner cupboards, book cases, and the dado rail whose height would continue to be a contested problem (Lady Milltown wished it to be the same as at Russborough).

On 4 November Dougherty wrote to Armstrong from the Chief Secretary's Office that 'no further correspondence should be carried out between the Board and Mr Lanphier.' Strickland wrote to Lanphier the next day: 'any further communications you have to make on the question of the Countess of Milltown's gift be addressed to the Under Secretary at Dublin Castle.' Two weeks later a Draft Consent bound the Countess of Milltown to hand over the Collection. A copy, heavily amended by Mr Lanphier in red ink, was delivered to the Board, although the matter had gone to law a year before. Among the new clauses Lanphier inserted were: 'The Plaintiffs undertake to afford to the Countess of Milltown or any person authorised by her in writing free access...to the rooms set apart for the reception of the Milltown Memorial during the installation of the Memorial therein and to prevent intrusion upon her during her visits by any person save those whom she may desire to see.'

At last, almost exactly three years after the extension to the Gallery was completed, horse-drawn vans wended their way through Blessington towards Dublin. On 19 March 1906 'the Director informed the Board that the delivery of the Milltown pictures and other objects had commenced…'[29] Meanwhile Lanphier was writing to Dublin Castle that 'her Ladyship wishes the pictures of her grandfather and grandmother and of her father and her brother, Algernon Gayleard Stanhope, to be exhibited with the other family portraits in a room set apart...' Armstrong loathed these pompous portraits, two (NGI 1036, 1322) by the Scottish artist, Francis Grant (1810-78), which he stated were 'not to be hung as examples of Art.'[30] They do reflect the Victorian period and the

6th Earl's portrait stood out when loaned to the first retrospective of Grant's work, held by the Scottish National Portrait Gallery in 2003.

On 23 April, Armstrong reported that 'the whole of the pictures, furniture and books specified in the schedule to the Deed of Gift...had arrived and that the silver was to be delivered in the following week.' When he examined the delivery, he found that it included 'a large number of pictures, pieces of furniture and other objects...added to the gift by Lady Milltown...during the period between the summer of 1899 when Lady Milltown ceased to permit the Gallery authorities to visit Russborough and the execution of the Deed of Gift in 1902.' He had originally selected seventy-two pictures, while the Buckingham family by Reynolds, bought by Lady Milltown, made seventy-three. However, Sibthorpes had now delivered a total of two hundred and nine.

'In addition to the general undesirability of these additional pictures from an artistic standpoint, they have been rendered more fully unacceptable by some process of cleaning, renovating of frames. etc. Many of the backs have been painted yellow for some reason not easy to divine.' The Ingres, sold by Lady Milltown, was to be regretted, and so was a drawing by William Blake (*A Woman Peeling Apples and Angels*) which was on the original list with the Deed of 1902, but subsequently disappeared and is not recorded in his work.

Although much of the silver was 'of a kind as to justify...exhibition either for artist merit or archaeological value' it included seventy-five plates of identical pattern. Armstrong was already familiar with the library, for which a special room had been reserved. The 1902 deed listed its contents – a typical country house collection of books with some standard works, very few art books and a lot of periodicals, including twenty-nine volumes of *The Gentleman's Magazine* and forty volumes of the *Sporting Magazine* and *New Sporting Magazine*.

'As to the furniture', the report continued, 'Lady Milltown...has included in her gift an immense number of objects which were not accepted, which were even specifically rejected by us.' They included eyeglasses, cameos, sealing-wax, a favourite horse's hoof mounted in silver as an inkwell and a Dispensation to Joseph, 1st Earl of Milltown from Pope Benedict XIV. 'Her Ladyship, moreover, has surrendered much of the furniture in a condition quite different to what it was when the selection was made. Many things have been regilded, others have been lacquered or varnished, or even painted, apparently with Aspinall's Enamel. Large quantities of the most ordinary furniture have been included, which it would be absurd to place in the Gallery.'[31]

Armstrong made an attempt to return some of the unwanted items to Russborough. However in January 1907 the office of the Chief Crown Solicitor gave an opinion that nothing could be returned to Lady Milltown unless she consented to have it back. Everything had to be catalogued and exhibited, although the Governors could arrange them in a room by themselves.

Meanwhile a new stream of letters via the Under Secretary's Office from Lanphier, backed by Lady Milltown and Mr Inglis, arrived on Armstrong's desk. '...Mr Inglis complains of the haphazard placing of the furniture and the hurtful contrast between colour coverings and that of the walls which have altogether defeated the intentions of Lady Milltown...' 'Lady Milltown is unable to accept the explanation offered... of the Board's inconsistent and contradictory decisions as to the dado rail and radiators...'.

In August 1907 Lady Milltown visited the Gallery and found little to her liking. The dado rails and glass cases came in for more criticism. The furniture stood in front of pictures. The portraits of Lords Harrington and Milltown were in the library instead of the exhibition rooms. 'Lady Milltown is of opinion that the officers of the National Gallery have mismanaged the Collection from the very start...'

After further exchanges, on 20 January 1908, 'it was resolved that a deputation consisting of Dr Mahaffy, Sir Thornley Stoker, Mr Waldron, Mr Longworth Dames, and the Registrar, Mr Strickland, should meet Lady Milltown at the Gallery on a day to be fixed by mutual agreement.' (The Director was not invited to attend.). After this entry in the Minutes of 22 January 1908, there were no more immediate communications from Lanphier or mention of the Collection in the Minutes – so presumably the meeting went well.

Nothing more was heard from Lanphier or Lady Milltown for three years until the summer 1912 when Lanphier wrote that her Ladyship desired to give more silver to the Gallery; after discussion, the Board agreed to squeeze in a few more pieces. But this decision prompted a new surge of letters. 'Where is the St Patrick Star belonging to the sixth Earl of Milltown exhibited? I would ask you to remember her Ladyship's rights under the Deed of Gift which must not be infringed.' 'I cannot trace any letter or communication, formal or informal, from you informing Lady Milltown that you wished to alter the arrangements of certain items of the Collection...'

As late as October 1913 Lanphier was writing: 'I am instructed by the Countess of Milltown to inform you that I visited the new building of the National Gallery on Friday the 17th instant and inspected the rooms utilised for the exhibition of the above, when I observed that some items of furniture particularly associated with the memory of the sixth Earl of Milltown...had been removed therefrom, and I was informed by one of the attendants that the library was locked and that the public were not admitted thereto...'

It was almost the last word. Less than three months later, on 5 January 1914, Lady Milltown died. In the same year Armstrong retired, and the new Director felt free to do what he liked with the Milltown Collection.

Today the rooms that were reserved for the Milltown Memorial contain Italian, Dutch and Flemish paintings, the majority of the silver is on long-term loan to the National Museum of Ireland and those books with more elaborate bindings are in the Oireachtas Library. The replica Star of the Grand Master of the Knights of St Patrick, inlaid with diamonds, rubies and emeralds survives (NGI 12068). Some of the furniture and Irish century mirrors of the 1750s attributed to Houghton and Kelly are hung in the NGI's adjunct at No 90 Merrion Square and the old Board Room.[32] The best pictures of the Collection hang among their appropriate schools, including the Batonis, Poussin, Reynolds and Paters which cost Armstrong Lady Milltown's friendship. Sculpture, a pair of Florentine cabinets (NGI 12060-1) with ivory and pietra dura insets (returned to that city for restoration) and one of the cinerary urns are to be seen in the new Classical Sculpture and Decorative Arts link to the Millennium Wing. In 1991 the NGI held an exhibition which illustrated the variety and beauty of the *objets d'art* presented by the Countess.

There is no notice in the Gallery such as the Countess composed: 'This collection of Art, the contents of Russborough, is dedicated to the memory of the Right Honourable Edward Nugent Leeson, 6th Earl of Milltown K.P.C... by his widow, the Lady Geraldine Evelyn, Countess of Milltown...in the assured belief that his memory as a patriotic Irishman will be always revered by his compatriots, to whom these works of art will testify to his unalterable desire to benefit his beloved native country...'[33]

However, it is appropriate that the portion of the Gallery added in the early years of the twentieth century is known as the Milltown Wing.

1 NGI Milltown Correspondence, 16 Oct. 1897

2 Lord Powerscourt, *A Description and History of Powerscourt* (London 1903) p. 115

3 NGI 1890 catalogue annotated by Walter Armstrong with details of country houses he visited (NGI Library)

4 Milltown Correspondence, Lady Milltown to Armstrong, 9 March 1900

5 JP Neale *Views of the Seats of Noblemen and Gentlemen in the United Kingdom.* (London 1826) 2nd series, vol. 3, not paginated

6 Laetitia Pilkington, quoted in Sergio Benedetti, *The Milltowns- A Family Reunion* (Dublin 1997) p. 7

7 Michael Wynne, *Later Italian Paintings in the NGI* (Dublin 1986) p. xii

8 Benedetti (as n. 6) *passim.*

9 Nicola Figgis and Brendan Rooney, *Irish Paintings in the NGI* (Dublin 2001) vol. 1, pp. 40 *et seq.*

10 Elizabeth (Grant) Smith, *The Highland Lady in Ireland. Journals 1840-50* (ed. Patricia Pelly & Andrew Todd), (Edinburgh 1991) p. 173 (28 May 1843)

11 Minutes of NGI Board, 6 August 1896

12 *ibid.* Letter to HM Treasury, 19 Nov. 1897

13 *ibid.* Letter from Treasury Chambers, 8 Dec. 1897

14 *ibid.* Board of Works to Armstrong, 12 Oct. 1898

15 *ibid.*

16 *The British Architect*, 3 April 1903

17 NGI Administrative Box 2

18 Director's Report 1902

19 Ellen Duncan, 'The National Gallery of Ireland', *The Burlington Magazine*, vol. x (Oct. 1906-07) p. 11

20 *Freeman's Journal*, 9 March 1903

21 James White, *The National Gallery of Ireland* (London 1968) p. 11

22 Director's Report 1902

23 Claude Phillips in *Evening Telegraph*, 14 April 1900

24 NGI Milltown Correspondence. Lady Milltown to Armstrong, 9 March 1900

25 *ibid.* 4 May 1900

26 Further letters in this chapter are from the Milltown Correspondence in the NGI

27 Director's Report 1902

28 Minutes, 13 Jan. 1905

29 Minutes, 19 March 1906

30 Minutes, 23 May 1906

31 *ibid.*

32 Benedetti (as n. 3) p. viii

33 Draft consent binding the Countess of Milltown to hand over the Collection, 18 Nov. 1905

BEQUESTS AND BARGAINS

The beginning of the twentieth century brought two notable bequests, from Henry Vaughan and from Sir Henry Page Turner Barron.

The Turner Bequest was made by Henry Vaughan (1809-99). After he inherited a fortune from his father, a wealthy Southwark hat manufacturer, Vaughan accumulated an important collection of paintings and watercolours. In 1900, after his death, he bequeathed his treasures to various public institutions; they included a collection of watercolours by Joseph Mallord William Turner (1775-1851) which were divided between the Victoria and Albert Museum, the British Museum, and the National Galleries of Scotland and Ireland. Dublin received thirty-one works, which cover all phases of Turner's development as a painter of watercolours.[1] *The West Gate, Canterbury* (NGI 2408) painted about 1793, is in the eighteenth-century tradition; others in the selection given to the NGI include a view of sunset over Petworth Park, Sussex, the home of Turner's patron, Lord Egremont, part of a series made in 1827 (NGI 2430), and later works painted during his travels in France, Switzerland, Germany and Italy.

Vaughan had taken immense care to buy watercolours that had not faded, and while in his possession they were carefully shielded from exposure to daylight at a time when the effects of light on watercolour were not fully understood. Under the terms of his will the pictures in the NGI are only to be exhibited during January when sunlight is at its weakest. They first went on exhibition in the January gloom of 1901[2] and, with additional gifts, now total thirty-five.

Armstrong observed in his 1902 book on Turner how 'during the other eleven months they have to be kept in a closed cabinet and only taken out when wanted, as you would take down a book in a library…' He added, 'The result will be, most likely, that a century hence Turner as a colourist will only survive in things which once formed part of the Vaughan collection, unless those drawings which are still uninjured are

The Doge's Palace and Piazzetta, Venice, c.1840
watercolour by Joseph Mallord William
Turner (1775-1851), Henry Vaughan Bequest
1900 (NGI 2423).

put out of reach of harm while there is yet time.' A century has passed, and the Vaughan pictures in the NGI are as pristine as they were when Armstrong removed them from their specially designed cabinet, with viewing easel, to examine them.

Under the heading 'His Art at its Best', he described one of the NGI Turner watercolours in detail, *The Doge's Palace and Piazzetta, Venice* (NGI 2423). 'In this Venice…the Doge's Palace is a rosy purple, the Zecca is pale violet, the sea is green, the sky is yellow…It is an exquisite pattern of colour, held together by prismatic truth, but the sense it conveys of a beam of white light laid open and analysed. The black gondola and a few other buttress touches give substance to the vision, and prevent it from suggesting the rainbow's evanescence.'[3]

At the same Board meeting during which Armstrong announced that the Turner drawings had arrived at the Gallery, he also informed the Board 'that the late Sir Henry Barron, Bart., had by will devised to the Gallery the right of selecting ten pictures from among those which might be in his possession at his death.'[4]

Sir Henry Page Turner Barron (1824-1900) of Belmont Park in Waterford was a wealthy Catholic landowner who went into the diplomatic service. He collected paintings, particularly those of the Dutch school. He had already given the NGI four pictures, including, in 1878, Cignani's *St Cecilia and Angels* (NGI 183) later identified as by Jacopo Vignali (1592-1664) and in 1898 the *Portrait of a Lady* (NGI 204) by Nicolaes Maes (1634-93), in which the sitter, erroneously thought by Sir Henry to be Charles II's mistress, the Duchess of Portsmouth, because her name is inscribed on the reverse, leans against a fountain to emphasise her purity.

Now Armstrong was able to make a selection that comprised the most important gift of Dutch pictures to the NGI before the Beit Collection. Among the ten paintings were *A Banquet Piece* (NGI 514) by Willem Claesz. Heda (1593/4-1680/2); a farmyard assembly called simply *Poultry* (NGI 509) by Melchior de Hondecoeter (1636-95); Salomon van Ruysdael's (c.1600-70) *The Halt* (NGI 507) and *The Sleeping Shepherdess* (NGI 511) by Jan Baptist Weenix (1621-61). The most spectacular picture was the richly detailed *Christ in the House of Martha and Mary* (NGI 513), a collaboration between Rubens (1577-1640), who painted the figures, and Jan Brueghel II (1601-78) who painted the landscape and still-life. In 1993 the NGI was able to buy a fragment showing fish and game (NGI 4590), which had been removed by a previous owner to make the composition square.[5]

In the same fruitful year, 1901, the Gallery received a bequest of two pictures painted in Brittany by the underrated County Down artist, Helen

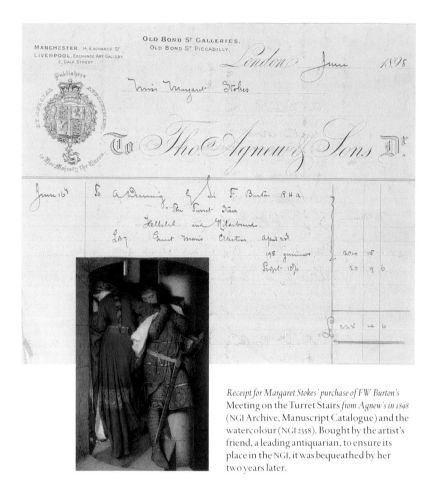

Receipt for Margaret Stokes' purchase of F W Burton's
Meeting on the Turret Stairs *from Agnew's in 1898*
(NGI Archive, Manuscript Catalogue) and the
watercolour (NGI 2358). Bought by the artist's
friend, a leading antiquarian, to ensure its
place in the NGI, it was bequeathed by her
two years later.

Mabel Trevor (1831-1900). According to DA Chart, *The Fisherman's Mother*
(NGI 500) 'depicted an aged, but not broken woman of the poorer class,
her face corrugated with wrinkles, but her eyes showing an undimmed
interest in life.'[6]

In March 1900 Sir Frederic Burton died, six years after his retirement
from the National Gallery in London. After his appointment in 1874
he never painted again. He did not lose touch with his Irish roots; he
joined the Board of the Abbey Theatre, and commented to his friend,
Lady Gregory: 'my best joys have been connected with Ireland.'[7] He
bequeathed to the NGI a *Flagellation of Christ* (NGI 494) from the Studio of
Luca Signorelli (c.1441-1523) related to a panel in the Brera, Milan.[8]

Nine months after Burton's death the NGI put on an exhibition of his
work which 'proved of great interest to the public, as evinced by the large
numbers who visited the Gallery, estimated at 8,000.'[9] A special catalogue,
costing one penny, listing the 104 pictures covering his artistic career,[10]

was so popular that the entire stock of 800 was sold at the door. At a time when so many Irish paintings were annexed as 'British school', Burton's drawings and watercolours were seen as being particularly Irish.

Among the drawings exhibited, seventy-five were loaned by his executors, while the rest were from private sources, with the 'famous head of George Eliot' from the National Portrait Gallery, London. Twenty-six examples and an album were purchased from the executors in 1901. In 1900, Margaret Stokes, daughter of Dr Stokes, antiquarian and friend of Petrie and Burton had bequeathed a collection of sketches by Petrie and a number of works by Burton. They included his marvellous *The Meeting on the Turret Stairs* (NGI 2358), a portrayal of doomed romance in the pre-Raphaelite style which is one of the Gallery's most popular pictures, although, being a watercolour, may not be often displayed.

More works by Burton came to the NGI in 1904 on the death of Miss Annie Callwell, who, with her father, Robert Callwell, had also been a friend of Petrie and Burton. One was a touching watercolour portrait of herself as a young girl (NGI 6030), her plainness given distinction by Burton's skill. Another was *The Aran Fisherman's Drowned Child* (NGI 6048), painted in 1841, which had been engraved in 1843 by the Royal Irish Art Union, and became one of its most popular prints. Marie Bourke suggests that Burton may have witnessed some similar tragedy when he was in the West of Ireland.[11]

Miss Callwell also bequeathed five watercolours by George Petrie including *Gougane Barra Lake with the Hermitage of St Finbarr* (NGI 6028), inscribed 'To my friend, R. Callwell by Geo. Petrie R.H.A.' Her will was a nightmare, as she had not left enough money to meet her debts. There were three hundred shares of £25 each in the National Assurance Company of Ireland, which had not been fully paid for. Her solicitor informed the Board: 'We are instructed that there is reason to apprehend a call at an early date in respect of these shares and that the assets of the deceased other than the pictures are insufficient to meet the total liability.' To the benefit of the NGI, the difficulties were sorted out.

On 24 March 1904 the Director informed the Board that Lord Powerscourt, who was seventy, had offered his portrait to be hung in the Board Room. *Mervyn Wingfield, 7th Viscount Powerscourt* (NGI 561) had been painted by Ireland's most prominent portrait painter since Osborne's death, Sarah Purser (1848-1943), who later told Thomas MacGreevy that the portrait was the 'dead spit' of the subject. 'Mr Lawless moved and Sir Thornley Stoker seconded...cordial thanks...with the hope that many years might lapse before the portrait became eligible for transference from the

Board room to the Gallery.' But only two months later the Director announced: 'I have to record the death in the month of June of Viscount Powerscourt KP, who for nearly forty years was a member of the Board of Governors and Guardians of the Gallery.'[12]

In 1905 and 1908 the Director's taste for Spanish paintings bore fruit in the purchase of two pictures from the same source (the Marqués de la Vega Inclán) by Francisco de Goya (1746-1828). *Lady in a Black Mantilla* (NGI 572), 'an excellent example of the remarkable freedom and economy of brushwork that Goya achieved in his late paintings'[13] was purchased for £600. An early portrait of a man wearing an embroidered cravat, *'El Conde del Tajo'* (NGI 600), (or possibly someone masquerading as such, given the title is not to be found in directories of the Spanish nobility) cost £975. Some doubts have been expressed about the authenticity of these paintings, particularly *El Conde*, but Rosemarie Mulcahy believes that they are both worthy of Goya and catalogues them as such.[14]

Paintings selected for the Dutch school include *The Riding School* (NGI 544) by Karel Dujardin (c.1622-78) with its beautiful Arab horse, bought in 1903 for £100. This painting, by an artist influenced by Poussin, had long been well known, and it appears to be his last picture. *Interior of St Laurenskerk, Rotterdam* (NGI 558) by Anthonie de Lorme (c.1610-73) was acquired in the same year and represents the emergence of luminous church interiors in Dutch art. In 1909 Armstrong bought for £120 a polished double portrait (NGI 497) *Jeronimus Tonneman and his son Jeronimus (The Dilettanti)* by Cornelis Troost (1696-1750). A year after the picture was done, the younger Tonneman, shown playing the flute in the height of refinement, stabbed his mistress with a pair of scissors and fled Holland as a midshipman on a voyage to the East Indies.[15]

For the Flemish school Armstrong divided a husband and wife in 1910, buying for the large sum of £1,000 the portrait of the wife of Nicolas de Hellincx (NGI 606) by Frans Pourbus the Younger (1569-1622), a stiff clothes horse in elaborate clothes and jewellery, fingering her skull-headed rosary. The portrait of her husband went to the Museum voor Schone Kunsten in Antwerp.

His chief contribution to the Italian school during these later years was a small panel picture bought for £250 as by Lorentino d'Arezzo, but later recognised as a devotional painting by Paolo Uccello (1397-1475) painted between 1435 and 1438 (NGI 603).[16] Originally the Virgin was draped in a black nun's veil; when she was cleaned she presented quite a different figure. Sergio Benedetti describes the painting as 'a composition of extraordinary modernity. The Virgin stands between a classical architectural

background and an imaginary window, suggested by the picture frame, holding a plump Child who is playfully lunging forward...The Virgin's hair is gathered in the fashionable Florentine style of the time...Only the two foreshortened haloes above the figures tell us that we are looking at a religious painting.'[17]

Naturally Armstrong obtained British paintings to which he had devoted years of scholarship. *The Chibouk* (NGI 537) by Richard Parkes Bonington (1801-28), acquired in 1902, depicting a Turk holding a long chibouk or pipe in his hand, is the Gallery's only example of the work of the young genius who died at the age of twenty-seven. A number of portraits were purchased, including William Burton-Conygham (NGI 562) by Gilbert Stuart (1755-1828), General Wade (NGI 560) by the then unknown James Latham (1696-1747), as by Hogarth. A full-length Thomas Gainsborough of fiery Irish actor, James Quin (NGI 565), whose paint condition has long been unstable too, was purchased in 1904 from Lawrie and Co for £750. Francis Wheatley's (1747-1801) splendid *Mr and Mrs Richardson* (NGI 617), posed against a garden pavilion, was acquired as by Benjamin Wilson from Knoedler in 1910 for £600.

In 1907, according to DA Chart 'the pictures by Irish painters or on Irish subjects are mostly hung in the section reserved for the British School.'[18] Armstrong chose to hang a painting by Nathaniel Hone just beyond the room full of Turners. Among paintings of the Irish school which came in during the latter part of his Directorship was *The Royal Charter School, Clontarf, Co. Dublin* (NGI 577) by William Ashford (1746-1824), costing £21 and showing a jaunting car passing a handsome building (which disappeared in the nineteenth century) overlooking the choppy waters of Dublin Bay. When Sir Thornley Stoker died in 1910 Armstrong purchased at his posthumous sale for £16, the ugly *Allegorical Portrait* (NGI 619) by Pieter Aertsz., now attributed to Pieter Huys (?1519-?81) and, for 10 guineas, a fine *View of Leixlip Castle* (NGI 615), thought then another William Ashford and now more convincingly catalogued as by Joseph Tudor (active 1739-59), who painted another view of Leixlip, at Castletown. A delicate Mulready, *Bathers Surprised* (NGI 611), cost £69 in 1910; another Osborne oil, *A Cottage Garden, Uffington* (NGI 635) dominated by lilies, was bought in 1912 for £25.

The drawings and watercolours in the Gallery, superbly enhanced by the Turners and Burtons, were augmented by Armstrong's purchases in a way that has shaped the Collection of Master Drawings as it stands to this day.[19] They include works by Jordaens (NGI 2597), Fra Bartolommeo (NGI 2444), Vaillant (NGI 2435), a disputed Dürer study of St Catherine (NGI 2336), and two sheets now only attributed to Rubens including *A Dragon's*

Head (NGI 2606) related to apocalyptic paintings in the Alte Pinakothek, Munich.[20] In 1912 another bequest, small but important, from Miss Eleanor Hone added a red chalk drawing by Guercino (NGI 2658) to two others (NGI 2603 & 2631), re-evaluated by Sir Denis Mahon as autograph. In the same year Armstrong purchased a rare Thomas Lawrence life class nude (NGI 2674) and a peasant scene by Adriaen van Ostade (NGI 2675).[21] After Armstrong's retirement the purchase of Old Master drawings slowed down, and instead of multiple purchases at great sales, they were acquired in single or small groups of drawings. The emphasis would shift to Irish portraits and topography, studies and engravings related to works already in the collection, with greater reliance on donations and bequests.

In addition to pictures whose sitters or subjects were co-incidentally of interest for Irish history, Armstrong was just as keen to expand 'The National, Historical and Portrait Gallery' as Doyle had been. Small groups of engraved portraits were bought regularly for a few pounds from Mr JV McAlpine and other sources; in February 1906, Strickland presented 4 portraits and 29 views of Dublin and his friend, Dublin historian, Ephraim McDowel Cosgrave, 41 engraved views of Dublin in December 1907. A gift of a different class was the magnificent portrait of the Fenian, John O'Leary (NGI 595) by John Butler Yeats (1839-1922), presented by the National Literary Society in 1908 and one of three oil paintings of him by Yeats now in the collection.

In his Director's Report for 1910, Armstrong records spending £155 on representations of Gerald Griffin, novelist (NGI 609); Eliza O'Neill, actress (NGI 604); Kitty Clive, actress (NGI 642); Spranger Barry, actor (NGI 1815); JP Kemble as the 'Count of Narbonne' (NGI 2639); James Barry, artist (NGI 614); Dean Swift (NGI 177); a miniature of Edmund Burke by Nathaniel Hone, in gold frame (NGI 7315); engravings of Lord Boyle and Lady Boyle (NGI 10362 & 10436); two lithograph portraits of Sir William Wilde which cost ten shillings (NGI 10684-85), and mezzotint of the Earl Bishop of Bristol (NGI 10209), from JV McAlpine, at a price of two pounds. His enthusiasm is shown by the research he carried out on Wheatley's painting of *The Volunteers on College Green, 4th November 1779* (NGI 125), based on the partial key and list of regiments (NGI Archive) and to be found in the 1904 NGI Catalogue.

The series of seven galleries in the new rooms of Deane's extension contained these historical portraits ranged in chronological order, so that each room represented an era. 'The flowing curls of one century give place to the round faces and wigs of another, merging finally in the familiar lineaments of the last century.'[22] According to Ellen Duncan,

'the remarkable collection of about 700 Irish portraits...form not the least interesting section of the gallery in Merrion Square.'[23] Photographs show the portraits hung interspersed with death masks. DA Chart enjoyed them, 'amid the bright colour and life of the oil paintings, one sometimes encounters suddenly a white and rigid face that tells mutely, yet eloquently, of death and the mystery that lies beyond. It is the death-mask of some noted leader of revolt who died on the scaffold or in gaol. During the brief interval between execution and burial, the features of the departed were sometimes preserved for posterity in this gruesome manner.'

As the Minutes in Armstrong's time show, death masks were acquired of Robert Emmet (NGI 8130), Wolfe Tone (NGI 8128), John Mitchel (NGI 8133), George Petrie (NGI 8154) and John Philpot Curran (NGI 8132). The curious practice of acquiring death masks would continue; in 1926 one of John Butler Yeats (NGI 8194) was presented by sculptor, Edmond Quinn, who carried it out and one of George Bernard Shaw (NGI 8254) was given by the Trustees of the British Museum as recently as 1981. They pleased the public and may have made the Gallery less similar to what George Moore described as 'the most perfect image of the Sahara that I know. Now and then one sees a human being hurry by like a Bedouin on the horizon.'[24]

Attendances were still low. The number of students attending to draw from casts was also declining, as methods of art teaching were changing. In 1911 'it was suggested by the Director that in future the charge of six-pence payable for admission to the gallery on Thursdays and Fridays by those who are not students should be abolished…and that students should be permitted to copy at any time when the Gallery is open.'[25]

A visitor who would, in the distant future, transform the Gallery, was spotted by George Russell (AE), who wrote to John Quinn on 1 October 1908: 'I had a very interesting accidental meeting with Bernard Shaw the day before yesterday. He talked for twenty-five minutes, neither of us knowing who the other person was. I found a stranger in the National Gallery who asked me a question about some picture and we got into an animated conversation. I thought the elderly gentleman a very intelligent person. I only learned the same night that it was Shaw, who was passing through Dublin, not having been there for thirty-five years. He saw my portrait in the Municipal Gallery and told Jack Yeats, whom he met by accident there, that he had been speaking to a gentleman like the portrait while he was in the National Gallery. He was very amusing in his conversation; talked of Whistler a good deal, said that Whistler was frightfully stupid…'[26] The picture Shaw was enquiring about, and in

which Whistler had shown such passionate interest, was Hogarth's portrait group of *George II and his family* (NGI 126).[27] Perhaps Armstrong, recognising a distinguished visitor, was present and mentioned Whistler's name. The encounters demonstrate what a small city Dublin was and how Shaw's interest in art never lessened.

In 1910 Mrs Joseph, widow of Armstrong's patron, lent to the Gallery the Vermeer which Armstrong had advised Joseph to buy, 'The Soldier and the Laughing Girl', which attracted many visitors.' This was as near to a Vermeer that the National Gallery and the public would see for seven decades – *The Officer and the Laughing Girl* went to New York and is now in the Frick Museum.

Year by year there was the work of cleaning, restoring and glazing. In his report for 1900 Armstrong noted 'as it has been found after patient experiments that it is impossible, owing to the heating arrangements and the atmospheric conditions, to keep the surfaces of the pictures in presentable condition without the protection of glass, the glasses which have been removed have been replaced and the work of putting the whole collection under glass resumed.' The heating furnaces threw up a mist of coal dust and would continue to do so for years to come.

The assistance of Walter Strickland as Registrar was essential to the smooth running of the NGI. Among other relevant business he recorded each change of staff. 'Henry Fullerton, late Commissioned Boatman, Coast Guard. Date of Birth 6th March 1863. Service, 20 Years. Pensioned, 1st April 1901. Amount of pension £25. 17s. Has 3 Good Conduct Badges and Good Conduct Medal and Gratuity.' By the end of the Boer Wars in 1902 all the attendants had been on the Services payroll before they acquired coveted positions at the NGI.

The Registrar also had to sift through the numerous letters from members of the public desirous of disposing of their possessions. These cluttered up the administration boxes for many years; today's procedure whereby the owner can bring a picture to the Gallery's Picture Clinic to be assessed has eased that particular responsibility of Registrar and Director.

'…I have two pictures after the style of Claude Lorraine which I have no use for. May I venture to send them on to you with a view of purchase?…my husband being dead, and my means limited, I find I must part with many little things I have…'

'…Having a couple of very pretty pictures to dispose of same, I am

*Photo of National Historical and Portrait Gallery
rooms from* National Portrait Gallery *booklet,*
c.1921 (NGI Library). The first room of writers
includes portrayals of Lady Morgan, William
Carleton and George Petrie and the dado rail,
insisted on by Lady Milltown on both floors
of the wing, is still in place.

thinking of asking if you do anything in that way in the Art Museum
there. One picture is 'Ecce Homo' very nicely got up, all needlework in
Berlin Wool and raised beadwork reaching the borders. Richly framed in
mahogany. I won't attempt to further describe this beautiful piece of art
until I hear from you...'[28]

Armstrong preferred to observe beautiful pieces of art in sumptuous
surroundings. An annotated 1890 catalogue with interleaves describing
his visits to big houses to view pictures was presented to the National
Gallery in 1935. He went to Carton ('in the Ante Room, five Cuyps, two
v.g. ...J.Weenix, Angry swan and dogs...Claude, Europa, bad state but
genuine'), Castletown ('visited with Duke of Leinster 14.10.1892') and else-
where. There are few dates in his notes, some of which were enlarged
later, and only the occasional estimates: 'Gosford Castle, Armagh: Prayer

Room – Gheeraerdt David? Good female portrait spoilt pro tem by restoration – £100; Man with hand on a classic bust (a repainted Wissing?) – £20; Jervas (School of) child with lance – £20' and 'Kilcooley Abbey (T.B.Ponsonby.) Gainsborough P of a Lady, bad state – after careful cleaning etc. could turn out to be a very good Gainsborough worth £2000 to £2500' and 'Bellevue, Wicklow – Two early examples of Velasquez not attractive – (one now in Berlin Museum the other chez Ld Iveagh.')[29]

Few, if any, of the pictures that Armstrong saw and noted would come to the National Gallery; their owners declined to donate them and the steady disposal of paintings from the big houses of Ireland was ignored by future Directors, apart from Hugh Lane. For the present the NGI was absorbed in dealing with the affairs of one big house. Since Armstrong was *persona non grata* with Lady Milltown, members of the Board had added responsibility in dealing with her demands and listening to unctuous letters from Mr Lanphier read out at Board meetings.

On 12 July 1907 'the Director laid before the Board a Warrant... appointing Elizabeth, Lady Butler, a Governor and Guardian of the Gallery'[30] – the first woman member of the Board. Born Elizabeth Thompson, Lady Butler had made a name for herself painting crowded battle scenes, notably *The Roll Call after Balaclava,* and *Scotland for Ever,* depicting the charge of the Scots Greys at Waterloo. An Englishwoman, she was married to Sir William Butler, an Irish general in the British army who had nationalistic leanings. She shared his opinions, and painted her poignant *An Eviction in Ireland* while staying in Wicklow. According to her 1909 autobiography it was done on the spot in the wind and rain at Glendalough. 'I found the ruins of the cabin smouldering, the ground quite hot under my feet and I set up my easel there.' Thomas Bodkin was offered this painting by Lady Butler's daughter, but showed no interest.[31] It is now in the Department of Irish Folklore, University College, Dublin, purchased for 35 guineas.[32] Her other important Irish picture, *Listed for the Connaught Rangers* (Bury Art Gallery and Museum), was auctioned in Manchester in 1921; Robert Langton Douglas, then Director of the NGI asked for a catalogue, but took no further action.[33] The NGI has no example of her work, not even of her lively sketch books. Her appointment to the Board was more or less honorary; being profoundly deaf,[34] she seldom attended a meeting and resigned in 1912.[35] By contrast, the next woman member of the Board, Sarah Purser, would be an active and important participant.

Armstrong's Directorship was at a time when in both literature and the arts the pace of change had quickened. No longer did Irish artists go

blindly to England to better their careers. Members of the loosely termed 'Antwerp School' went to Belgium, and those on the fringe of the Barbizon school, painters like Roderic O'Conor (1861-1940) and Joseph Malachy Kavanagh (1856-1918) made their way to France. Sarah Purser studied in Paris; Nathaniel Hone The Younger spent time in France before returning to Ireland around 1875. Soon William Orpen and John Lavery, who worked mostly in England, would become prominent.

For the art world of Dublin this was an exciting time after the stagnant nature of preceding years. In March 1883 the *Freeman's Journal* had reviewed a current RHA Exhibition: 'There is an almost absolute absence of any picture by an Irish artist requiring imaginative treatment. Respectable dullness is the prevailing characteristic.'[36] But this was about to change.

In 1898 Sarah Purser, together with other interested people, including George Russell (AE), helped to arrange a loan exhibition of modern art. Together with Strickland, Armstrong was on the committee of the Art Loan Exhibition which opened in April 1899 with eighty-eight pictures, including eight Corots, a Courbet, two Degas, a Manet, a Monet, two Puvis de Chavannes and six Whistlers. Among the contributors was George Moore, who had a small collection of Impressionist pictures in Ely Place, and Edward Martyn, whom Moore had persuaded to buy two Degas pastels and a Monet during a trip to Paris (later bequeathed to the NGI). Whether the Art Loan Exhibition changed Irish opinion of modern art is doubtful. But it was a start. However, Armstrong made no move towards buying examples of the paintings on display.

From the purchases Armstrong made while he was Director, apart from those of his friend, Osborne, it is clear that he did not believe that the National Gallery was the true place for contemporary art, Irish or otherwise. He showed little more interest in the Irish School than had Mulvany half a century before. Nor, during his Directorship did he try to provide his Gallery with examples of work by lately deceased French-men with advanced ideas on art, or even by his friend Whistler, who had died in 1903. (Other directors were equally cautious; DS McColl, who was Keeper at the Tate at the same time as Armstrong, made no attempt to buy Impressionists for his Gallery.)[37] Enthused by Lane, Armstrong believed that 'modern' pictures should go elsewhere, to a modern art gallery in Dublin. His association with modern art increased when he was elected president of the United Arts Club in 1911, just as Mrs Ellen Duncan organised an exhibition there of Post-Impressionist works condemned by AE ('A student of the diseases which affect old civilisations would find the Post-Impressionists an interesting pathological study…')[38]

Christ in the House of Martha and Mary, 1628 by Jan
Brueghel II (1601-78) and Peter Paul Rubens
(1577-1640), Sir Henry Page Turner Barron
Bequest 1901 (NGI 513), with separated fragment
purchased 1993 (NGI 4590).

Armstrong transformed the national collection by correct cata-
loguing and attribution. He ran the Gallery smoothly, putting the
pictures on a proper scholastic footing. His approach to purchasing was
deliberate, very unlike Doyle's inspired guesswork. His predilection was
for Dutch paintings, and he acquired a number of masterpieces from
artists of the second rank, like Godfried Schalcken and Cornelis Troost.
Possibly the old gibe, which has a ring of George Moore, was invented
around this time: the NGI was 'a collection of first-class paintings by
second class masters and second class paintings by first-class masters.'

His personal choice from the collection of Sir Henry Page Barron
greatly enriched the Dutch collection. He knew that the picture he had
bought in 1896 as by Willem de Poorter (NGI 439) had special qualities. One
of his last acts as Director was to revise the catalogue which was pub-
lished after his retirement. Under Rembrandt, with illustration, is the
entry: '*A Dutch Interior* 7 ¾ in. H. 10 in. W. Panel. Interior of a dark room,
lighted only by a single lamp or candle on a table to the right. Several fig-
ures of men, apparently playing at the game of *La Main Chaude*.'[39] It would

Jeronimus Tonneman and his son Jeronimus
(The Dilettanti), 1736 by Cornelis Troost (1697–
1750), purchased 1909 (NGI 497). Although the
NGI possesses only a few 18th century Dutch
paintings, this is acknowledged as one of the
Troost's finest pictures, showing the idealised
home of a rich Amsterdam merchant and his
waistrel son.

be over eighty years before he was proved right. He was a Rembrandt man. 'In one picture by the Dutchman there is more concentration, more force, more passion than in all the Italian works put together.'[40]

Outside the Dutch school he bought two of the most important paintings in the Gallery, Mantegna's *Judith and Holofernes* and the little panel which would prove to be by Paolo Uccello. Through his careful choices the Gallery obtained two Goyas, a beautiful Chardin and a number of important English paintings. He transformed the collection of drawings and watercolours with astute purchases, and saw into the Gallery a number of important donations.

He retired early in 1914 at the age of sixty-three, having been a full-time Director for twenty-two years, many of which had not been easy. He returned to live in England; perhaps he was never truly at home in Ireland. In April 1914 he was granted a pension of £183. 6s. 8d per annum.[41]

1 Homan Potterton introduction to *NGI Illustrated Summary Catalogue of Drawings, Watercolours and Miniatures,* (Dublin 1983) p. xvi
2 Minutes of the NGI Board, 21 Feb. 1901
3 Walter Armstrong, *Turner* (London 1902) pp. 139, 282
4 Minutes, 29 Nov. 1900
5 Minutes, 9 July 1993
6 DA Chart, *The Story of Dublin* (London 1932) Section xi
7 Lady Gregory, 'Sir Frederic Burton', *The Leader*, Dublin. Quoted in Marie Bourke, *The Aran Fisherman's Drowned Child* (Dublin 1987) p. 35
8 Director's Report 1900
9 Minutes, 21 Feb. 1901
10 *ibid.*
11 Bourke (as n. 7) p. 33
12 Minutes, 16 June 1904
13 Rosemarie Mulcahy, *Spanish Paintings in the NGI* (Dublin 1988) p. 22
14 *ibid.* pp. 18, 22
15 Homan Potterton, *Dutch 17th and 18th Century Paintings in the NGI* (Dublin 1986) p. 156
16 Sergio Benedetti, 'Renaissance Masterpiece', *Irish Arts Review* (Winter 2002) p. 55
17 *ibid.*
18 Chart (as n. 6)
19 Potterton (as n. 1) p. xv
20 *ibid.* p. xvi
21 *ibid.* p. xviii
22 Chart (as n. 6)
23 Ellen Duncan, 'The National Gallery of Ireland', *The Burlington Magazine*, vol. x (Oct. 1906–07) p. 23
24 George Moore, Lecture to the RHA, December 1904
25 Minutes, 7 Aug. 1912
26 Adrian Frazier, *George Moore 1852–1933* (New Haven & London 2000) p. 350
27 Irene Hough, 'A Visit to our National Gallery', *The Irish Monthly* (Nov. 1932)
28 NGI Admin. Box 2
29 Interleaved catalogue presented by Mr Fintan Murphy. Minutes, 5 June 1935
30 Minutes, 12 July 1907
31 TCD Bodkin ms 6951–2195. Alec Martin to Thomas Bodkin
32 *Folk Tradition in Irish Art, An Exhibition of Paintings from the collection of The Department of Irish Folklore, University College Dublin*, exh. Newman House, Dublin 1993, no. 10
33 NGI Admin. Box 7. Letter from Capes Dunn and Co., Auctioneers, 28 July 1921
34 Author's personal information
35 Minutes, 11 Dec. 1912
36 Quoted in John O'Grady, *The Life and Work of Sarah Purser* (Dublin 1996) p. 153
37 Francis Spalding, *The Tate — A History* (London 1988) p. 31
38 *Irish Times,* 29 March 1912
39 Walter Armstrong, *Catalogue of Pictures and other works of art in the NGI* (Dublin 1914) p. 134
40 Walter Armstrong, *Art in Great Britain and Ireland* (London 1909) p. 130
41 Minutes, 24 April 1914

CHAPTER SIXTEEN

MODERN ART FOR DUBLIN

Walter Armstrong's Director's Report for 1902 included the entry: 'Oil Picture, Portrait of a Lady by George Jamesone. Presented by H.P. Lane, Esq.' This work (NGI 534) by a minor Scottish artist (c.1590-1644) was the first of many gifts to the NGI by Hugh Lane. The following year, on 1 September 1903, a warrant was issued from Dublin Castle appointing Hugh P. Lane, Esquire, to the seat on the Board vacated by the decease of the late Viscount de Vesci.[1]

Lady Gregory claimed that one of the Governors resigned rather 'than sit with a man who deals in pictures.' No indication of such a move is in the Minutes. But the subject was a touchy one; for much of his career Lane was condemned more for being a dealer than for any rumours gleefully taken up by George Moore. In *Vale*, the third volume of Moore's unreliable memoir, *Hail and Farewell*, he makes his neighbour, Sir Thornley Stoker, describe Lane as 'a London picture-dealer who had come to Ireland to see what he could pick up.'[2] Stoker had died by the time *Vale* was written, and Moore did not hesitate to use the dead man as buffer and mouthpiece during his outrageous telling of the tale of Lane dressing in Lady Gregory's clothes.

Buying and selling pictures for profit was not a respectable occupation. However, many in the Irish society that Lane frequented considered him more a gentleman than someone in trade. As artist Henry Tonks recalled, 'a picture dealer he certainly was, but never in romance or real life has there been such a dealer before.'[3]

Armstrong gave Lane constant support. It would be hard to imagine a greater contrast in personality between the staid, golf-playing, family man and Lane with his restless energy, who starved himself to save money to buy paintings. Armstrong was a scholar, while books held no interest for Lane. His library at Lindsey House, sold off after his death, included *Chambers' Encyclopaedia*, *Collins' Peerage of England*, Horace Walpole's *Letters*, and *House and Gardens* by his friend, architect, Edwin Lutyens, who

designed the garden. Almost all the rest, including Strickland's *A Dictionary of Irish Artists*, concerned painting. He had folios of reproductions of works by Cézanne, Gauguin and van Gogh, perhaps an indication of where his self-education might lead him beyond the Impressionists.[4] 'Nothing but press cuttings,' he told his South African friend, Joseph Solomon, when asked about his reading habits.[5]

In *Vale,* Moore summed up Lady Gregory's huge influence on Lane by making him say, 'I am Lady Gregory's nephew, and must be doing something for Ireland.'[6] His mother was her elder sister, who made a disastrous marriage with a divinity student named James Lane. Lady Gregory recalled the day when the family from their lofty seat at Roxborough learned about Adelaide's determination to marry beneath her. 'It was as if there had been a death in the house…Who is he? He may be the son of an *attorney,* we whispered in horror. So he was…'[7]

Hugh Lane, the third son of this painful union, was born on 9 November 1875 in Douglas, outside Cork. Robert O'Byrne, in his biography, has pointed out the irony of his drowning almost within sight of his birthplace. He spent most of his childhood in Redruth, Cornwall, where his father had a parish. But he came to Ireland on holiday, staying in various family houses. Lady Gregory considered that 'those visits were to Hugh a great romance and excitement; he loved to look at pictures and ornaments, finger family jewels and the like.'[8] She also mentioned 'nursery dreams of a wonderful gallery of pictures.'

In his eighteenth year, in a family that was impoverished after his parents' separation, the question came up 'What shall we do about Hugh?' Sir William Gregory had died by this time; during his lifetime he had been closely involved with the National Gallery in London to which he left a number of pictures (nothing for the Gallery in his native Ireland.) Through her late husband's contacts, Lady Gregory gained a position for her nephew for twenty shillings a week, so in 1893, the year Armstrong

Sir Hugh Lane (1875-1915), fourth Director (1914-15), 1905 pencil drawing by John Butler Yeats (1839-1922), 1919 gift (NGI 2866). In a few strokes, Yeats captures the elegance and sense of purpose of his sitter, who gave him a major commission of painting portraits of contemporaries.

became Director of the NGI, Lane entered the Marlborough Gallery in Pall Mall, run by Martin Colnaghi, a connection of the firm of Colnaghi that operated until recently in London.[9] His mother wrote: 'In a few years Hugh will be making his thousands.'[10]

Although Colnaghi, who was in his seventies, did not get on with his precocious eighteen-year-old apprentice, grumbling at his bad handwriting,[11] Lane learned a good deal about dealing and restoration from him. In her biography of her nephew Lady Gregory relayed accounts of his successful efforts to clean up dirty pictures, such as the transformation of the painting bought as by Sir Thomas Lawrence into George Romney's portrait of Mrs Edward Taylor. 'I cannot be mistaken in those Romney eyes.' *Mrs Taylor* is now in the NGI, as a result of the Lane Bequest (NGI 789). Henry Tonks wrote of Lane how 'repainting he seemed to be always able to see through, and the happiest moments of his life were when he was superintending or actually doing himself the removal of paint.'[12]

Lane left the Marlborough, and after a spell as partner in another gallery, set up on his own in 1898 in a ground floor front room at No 2, Pall Mall Place. He worked with courage, intuition, luck, and something

more; Tonks considered that 'he certainly had an extraordinary power, which seemed like a natural gift of detecting a good picture. No doubt his unusual memory helped...'[13] His lack of academic experience, only partially alleviated by earnest trips to galleries abroad, meant that he had to rely largely on instinct; this was not initially a problem, although basic ignorance about paintings would cloud many of his attributions.

By the age of twenty-one Lane was said to have a fortune of £23,000. Lady Gregory remembered 'telling Sir Frederic Burton, the gentle director of the Trafalgar Square National Gallery, of one of Hugh's early rapid dealings, and his answer, 'I have never in all my life been able to have the same courage in my own opinion as that young man.'[14] Soon Lane was able to tell his aunt, 'it would be a very poor year in which I could not make ten thousand pounds.'[15]

In his obituary of Lane, the art critic C Lewis Hind mentioned 'his extraordinary faculty for discerning the greatness of a work of art, whatever condition of dirt, decay or repainting the picture might be in.'[16] Stephen Gwynn wrote how 'his flair for recognising the work of any given painter, allied with the surest instinct for beauty, quickly brought him a fortune and enabled him to indulge a princely generosity'.[17]

Others were unconvinced. The painter Charles Ricketts called him 'an uneducated flunkey'.[18] In 1934, reviewing Thomas Bodkin's hagiography, *Hugh Lane and his Pictures*, Clive Bell considered that Lane 'was a typical "gentleman dealer" with…a dealer's flair and a dealer's taste. He seems to have acquired…a few masterpieces (e.g. *Les Parapluies*, *Le Duc d'Orleans*), a fair number of second-rate works by modern masters, many showy but inferior pieces by good or great painters...a quantity of bad…more or less contemporary stuff by painters of the kind in which dealers delight (e.g. Diaz, Mancini…Stevens) and a sprinkling of palpable frauds.' (The NGI is without examples of Mancini, but the Frenchman Narcisse-Virgile Diaz de la Peña (1807-76) and Belgian Alfred Stevens (1826-1906) are both represented by gifts from Sir Alfred Chester Beatty). Bell added: 'What he bought he sold brilliantly or bestowed judiciously.'[19]

Lane became a legend among those who were even peripherally involved with fine art. In 1919 when Robert Langton Douglas went to inspect some pictures for sale, he reported: 'of course the old British lady told me the usual lies about Lane. Every owner of a dud picture tells you that Lane offered a million for it. But we know Lane better.'[20]

In October 1901, when he was already a wealthy man, Lane visited an exhibition in Dublin which Sarah Purser had put up at her own expense showing paintings by the landscape artist Nathaniel Hone the Younger

(1831-1917), and the portrait painter John Butler Yeats (1839-1922). The exhibition, held at the Royal Society of Antiquaries on St Stephen's Green for just two weeks, had a profound effect on him. According to Bodkin, 'the little show proved to be the spark which fired Lane's imagination with the idea of working for Ireland.'

Not only did he buy pictures from both artists, but he also encouraged the elderly Yeats to paint a series of portraits of prominent Irishmen for a future National Portrait Gallery. A studio was rented on St Stephens Green and Lane contracted to pay £10 per portrait – a frustrating item of business, since the unreliable old artist, not only did not deliver, but cajoled money off his patron for years.

Next, Lane organised a winter exhibition of Old Masters from Irish country houses which was held in the Royal Hibernian Academy premises in Abbey Street in order to help the Academy's miserable finances. He persuaded owners to lend paintings and arranged a military band to play at the show together with 'At Home' tea parties. By the time the exhibition closed on 5 February 1903 more than 80,000 people had paid a shilling to see the possessions of the landed gentry, and at the state ball in Dublin Castle on St Patrick's Day the dress code was based on Old Master paintings.[21]

The enterprise did not go altogether smoothly. Walter Osborne and WG Strickland, who were on the exhibition committee, resigned because they thought a suspect Reynolds was a copy and Lane had to bring on art experts from London to confirm the attribution. His motives were questioned. Lady Gregory quotes Yeats hearing from 'a Dublin painter, who afterwards became, and still is, his most devoted and unselfish and able supporter' declaring 'he knows that there are many good pictures in Irish country houses, he wants to find out where they are that he may buy them at a low price and trade for them in England.'[22] It has to be said that in future a good many pictures from Irish country houses would pass through Lane's hands.

His uncertainties about his role as gentleman dealer resulted in two ambitions – to obtain an official position as a director of a gallery, preferably one in Ireland, and to create a gallery of modern art for Dublin. While the show at the RHA was on, he wrote to his friend John Caroline at Christie's describing 'how I am trying to wake up those sleepy Irish painters to do great things...I gave up "dealing" some time ago, and hope sooner or later to get some appointment which will be more congenial work.'[23] But he found that he could never give up "dealing".

However, he went a small step towards official recognition by being appointed to the Board of the NGI at the age of twenty-eight. He was

prominent at the first Board meeting he attended, in March 1904, seconding a motion dealing with Miss Callwell's complicated legacy. He also 'applied to the Board for its hypothetical consent to a loan of pictures to an exhibition of the work of Irish artists proposed to be held in the Guildhall, London, during the coming season.' The Board promised three, but in the event sent four, *The Opening of the Sixth Seal* by Francis Danby and *The Last Gleam of Sunset* by his son, James Francis Danby, *The Poachers* by James Arthur O'Connor, and *Interior of a Breton Cottage* by Helen Mabel Trevor.[24] None of these could be considered *avant-garde*. Lane politely referred to the National Gallery in his Prefatory Notice to his catalogue. 'We have in the Dublin National Gallery a collection of the works of the Old Masters which it would be hard to match in the United Kingdom outside London.'

The Exhibition of Works by Irish Painters, which took place in May 1904, showed 465 pictures. They included nine by John Butler Yeats, seven by his son Jack, and numerous examples of work by Osborne, John Lavery and Frederic Burton. Thirteen paintings were by Lane's new friend and distant cousin, William Orpen, with whom he would travel to Paris later in 1904 and discover Impressionism. In the introduction to the catalogue Lane put forward the idea that would obsess him. 'A gallery of Irish and modern art in Dublin would create a standard of taste and a feeling of the relative importance of painters.'[25]

In the early years of his appointment Lane was a regular attender at Board meetings of the NGI. He made further gifts: on 31 March 1904 he offered *Self-Portrait as a Fisherman* (NGI 566) by John Hoppner (1758-1810) and in September a watercolour of a young lady in a ruff (NGI 2555) by Adam Buck (1759-1833). In December 1907 he presented the Gallery with two Flemish genre scenes, *The Stolen Pancake* (NGI 589) by Jan Joseph Horemans (1682-1759) and *Interior with Five Figures* (NGI 590) by Jan Baptiste Lambrechts (1680-after 1731). Neither is very attractive, perhaps they were surplus to his requirements.

The showing of the Staats Forbes collection in the RHA at the end of 1904 marked Lane's first attempt to create a permanent collection of modern art for Dublin. James Staats Forbes was a Scottish railway engineer, who at the time of his death owned 4,000 pictures which were to be disposed of. Lane arranged for a selection of 160 to come to Dublin, where, it was hoped, philanthropic buyers would raise enough money for his proposed modern gallery. They were put on show at the RHA on 21 November 1904. 'A wonderful exhibition it was, organised by Lane, who rushed about Dublin from one end to the other, begging of everyone to come to his exhibition, gathering up ladies into groups, giving them all

something to do...He discovered a young gentleman who sang comic songs very well; for the sake of Art he was asked to sing.'[26]

A month after the opening, on 22 December, at Lane's request, Armstrong lectured at the RHA on 'Pictures and Picture Galleries', giving full support to the establishment of a modern art gallery in Dublin. The day before, a letter had appeared in the Irish Times signed 'Viator'; WB Yeats writing to Lady Gregory described him as 'an anonimous person' (sic)[27] but it was probably written by Lt Colonel Plunkett, Director of the National Museum. The letter declared that 'there is not one picture of first-rate importance' in the exhibition, and the whole collection would not fetch £3,000 if sold at auction.

Armstrong came to Lane's defence; on 23 December, next to a report on his lecture, the Irish Times published a letter from the artist Dermod O'Brien, announcing that 'the Director of our National Gallery [Sir Walter Armstrong] considers the sum required for these Forbes' pictures as very reasonable and has kindly offered to make a careful valuation for the use and assistance of the committee in view of the executors allowing a further revision to be made.'[28]

A section of the Dublin public was not prepared to admire Courbet, Millet, Fantin-Latour or Whistler, who were among the artists represented. A report on the show in the Evening Herald on 2 January 1905 talked of 'false sentimentalism and realism often of a grossly sensual kind.'[29] Sir Thomas Drew, the President of the RHA, maintained that the exhibition contained 'pictures which would not in any respect be acceptable...in a pleasing or popular gallery.'

Halfway through the exhibition's run, Lane was told to take his modern French pictures away from the RHA to make way for the Decorators' Guild of Great Britain. It was not the fault of the RHA, which had warned Lane that it had been long contracted to hold a show organised by the Decorators' Guild, but Lane's supporters considered that the 'paper hangers' (Yeats' phrase) should give way to Staats Forbes.

The Board of the NGI stepped in. Lane had arranged with the Staats Forbes executors to retain 82 of the pictures out of the original 160. He attended the Board meeting of 13 January 1905 and 'suggested that the Board should permit the exhibition in the Gallery of a selection of 80 pictures and drawings from the Forbes Collection recently exhibited in the galleries of the Royal Hibernian Academy.'[30] The Board was accommodating. 'It was agreed that the selection in question should be afforded such publicity in the National Gallery building until March 31st 1905 as may be possible without disturbing the existing collection, on the

understanding that the Governors and Guardians are in no way responsible for the expenses or risks of housing and exhibiting the said pictures.'[31]

Possibly the Governors and Armstrong were less than enthusiastic since the national collection had only recently been rehung in the newly enlarged Gallery. For whatever reason, Lane changed his mind and decided to show his pictures in the Rotunda of the National Museum of Ireland, whose Director, Plunkett, loathed them. The exhibition, which was topped up by Edward Martyn's Impressionists and a Pissarro lent by Durand-Ruel, purchased by Lane for his new gallery, was reopened in the National Museum on 18 January 1905. Plunkett had done his best to be unhelpful, leaving large display cases against many walls where pictures could be shown.[32] He had told Lady Gregory as he escorted her to the Guildhall procession in London two years before, 'I hope never to see a picture hung in Dublin until the artist has been dead a hundred years.'[33]

Lane's social efforts brought in support, not only his from friends, but also from the highest in the land, the Chief Secretary and the Lord Lieutenant, Lord Dudley, whose wife was one of Lane's most enthusiastic admirers. The Dudleys persuaded the visiting Prince of Wales to buy two Constables and two Corots for the proposed gallery. Lane's friend, Lord Mayo, had wished to buy one of the Corots, *Peasants by a Lake*, but agreed to purchase and donate another picture.

Unfortunately the Prince's choice turned out not to be by Corot, but by an obscure Hungarian artist named Giza Meszoly and Lane's reputation as a judge of painting was once again questioned.[34] Armstrong was dragged into the dispute by his mischievous enemy, George Moore. Previously, while the exhibition was in the RHA, Moore had followed Armstrong in giving a lecture, his subject being Impressionist paintings. He spoke in the RHA on 8 December 1904, when Armstrong was in the audience. During his talk he condemned the listening Director for refusing to buy for £10 some years before a Manet that would now cost £1,000. (There is no evidence of this in NGI documents.) He added that a young man wandering into the NGI's 'dull and commonplace' collection would say to himself, 'if this is painting, painting is depressing work, and I would prefer to be a clerk in a brewery.'[35]

Later Moore attacked Armstrong again. The authenticity of the Corot/Meszoly painting had been debated for months by the time he gave an interview to a reporter of the Dublin *Evening Mail* and, declaring that Forbes had admitted that the painting was not authentic, adding that 'all galleries are full of forgeries.'[36]

When Lane's many friends called upon Moore to retract, he gave a

second interview in which he chose to transfer the blame for choosing the dubious Corot from Lane to Armstrong. There may have been some basis in his assertion, since Lady Gregory wrote that Armstrong, as Lane's loyal friend, threatened to resign, presumably from the Exhibition Committee, over the affair.[37] Moore added cruelly that Armstrong had a taste for acquiring high-priced fakes and there were plenty in the National Gallery.

Two months later, when he was a witness to the Committee of Inquiry into the Work Carried on by the Royal Hibernian Academy and the Metropolitan School of Art, Moore returned to the attack . 'True, that the pictures that are bought for the National Gallery are generally worthless. Sometimes the pictures are ridiculous forgeries…They are nearly always without artistic merit…How can I expect Sir Walter Armstrong to give much attention to his Gallery? No one goes there, except when it rains. Ireland is given over to officials, graziers and priests.'[38] Armstrong had to endure Moore's abuse at a time when he was struggling with the problems of the Milltown Collection. Moore was no friend of Lane or his supporters either.

Lane's struggles with the authenticity of the Corot and his efforts to establish his new Modern Gallery were outside the interests of the NGI. By January 1905 he had collected enough money to buy 160 of the Staats Forbes paintings. On 24 March Dublin Corporation agreed an income of £500 a year 'for the maintenance of a Municipal Gallery of Modern Art and for the reception of the valuable pictures which had been presented to the State.' Two years later a temporary gallery was established by renting No 17, Harcourt Street, once the home of the hanging judge, Lord Clonmel. Three hundred paintings had been assembled, including the portraits of contemporary Irishmen which Lane had managed to obtain from John Butler Yeats and William Orpen. In addition: 'I have also deposited here my collection of pictures by Continental artists, and intend to present the most of them, provided that the promised permanent building is erected on a suitable site within a few years. This collection includes a selection of the Forbes and Durand-Ruel pictures, bought by me after the Royal Hibernian Academy winter exhibition, and some important examples of Manet, Renoir, Mancini, etc., which I have purchased to make this gallery widely representative of the greatest painters of the twentieth century.'[39]

While Armstrong had offered Lane his full support, it must have been irritating for the Director with his meagre £1,000 grant-in-aid to observe the enormous sums that Lane was able to raise for buying paintings. The NGI Board hesitated to become involved with the new Gallery. On 10

December 1907, at a meeting attended by Hugh Lane, 'the question of nominating representatives of the Board of the National Gallery to serve on the Governing Body of the Municipal Art Gallery was discussed. It was…resolved that the Governors and Guardians of the National Gallery Ireland, while sympathising with the movement for the establishment of a Modern Art Gallery in Dublin, and with the generous efforts made to that end by Mr Hugh Lane, do not as yet feel themselves sufficiently well informed as to the present state of the affairs of the Modern Gallery and the arrangements for its control to take the responsibilities of nominating representatives on its Governing Body.'[40]

A month later, in January 1908, the Municipal Council of the City of Dublin asked the NGI Board for two nominees to the governing committee of the proposed Municipal Gallery of Modern Art. After a vote, the Board declared itself unable to fulfil this request as 'beyond the scope of their functions as defined in the Act of Parliament appointing them.' It added 'as there are members of this Board deeply interested in the success of the Municipal Art Gallery, these members would be happy to help the Library Committee if that Committee should think fit to invite them to co-operate in their individual capacity.'[41] No further evidence of interest in the concerns of the new Gallery by the NGI is in the Minutes.

Lane had always been clear in his ideas about the twin roles of the National Gallery of Ireland and his Municipal Art Gallery. In his preface to the catalogue of the Municipal Gallery, published in 1908, he wrote: 'I hope that this Gallery will always fulfil the object for which it was intended, and by ceding to the National Gallery those pictures which, having stood the test of time, are no longer modern, make room for good examples of the movements of the day. The National Gallery can encourage this desire on my part by depositing in the gallery the few modern pictures which it has recently acquired.'[42] In the event, in spite of future efforts of co-operation, the paintings in both galleries stayed *in situ*.

On 10 February 1908, Dublin Corporation unanimously elected Lane an Honorary Freeman of the City, while in June 1909, he was knighted 'for his services to art'. The knighthood eased snide accusations of his being a dealer.

His place in society was reasonably secure, and his friends included owners of big houses who would find him a convenient conduit for the disposal of their paintings. On the Board of the NGI Lord Mayo was a loyal supporter; another was Lt Col William Hutcheson Poë, whose gardens at his estate, Heywood, now in County Laois, were designed by their mutual friend, the architect Edwin Lutyens. Lane would call upon

The Vere Foster Family, 1907 by William Orpen
(1878-1931), purchased 1951 (NGI 1199). Intended to
demonstrate the status of a wealthy landed
family, this full-size group portrait has come
to be seen as a symbol of their passing.

Lutyens to create grandiose designs for his proposed permanent Municipal Gallery.

Many pictures displayed on the walls of his rich friends' houses would ultimately be for sale. At his huge house at Ballyfin in County Laois Sir Algernon Coote, the premier baronet of Ireland, had a fine art collection; a number of his paintings were on show at the Old Masters exhibition at the RHA in 1902. Later he sold a Lancret to Lane, which Moore mentioned in *Vale* as an example of Lane's sharp practice, and early in 1915, a portrait of a little girl, *The Capuchin Doll* (NGI 803) after Jean-Baptiste Greuze (1725-1805) for which Lane paid £800, believing it to be autograph. It would come to the NGI with the Lane Bequest.[43]

Lane could show his dealer's instincts about buying paintings from big houses cheaply. In January 1915 he acquired from the Croker family of Ballynagarde, County Limerick for just £42 the sumptuous *Banquet Piece* (NGI 811) by Frans Snyders (1579-1657). The produce of Antwerp's market place is painted in detail: figs, quinces, grapes, plums, apricots, apples, peaches, oranges, melons and white currants. A squirrel, a scarlet lobster on a pewter dish, roses, a gilt cup and a parakeet add variety.[44] Like the 'Greuze' the picture remained unsold and came into the NGI as part of the Lane Bequest, valued at even less than Lane paid for it — £35.[45]

Poussin's *Acis and Galatea* (NGI 814) also part of the Bequest in 1918, was bought from Captain John Leslie of Glaslough in 1914 for a modest £315. It is said to have inspired WB Yeats' *News for the Delphic Oracle* and certainly it appears that 'nymphs and satyrs copulate in the foam.' According to Anita Leslie, her aunt, Leonie Leslie, had taught her four sons 'to walk, on a drawing-room sofa above which hung a splendid Poussin...in which debauched cherubs are lowering a red canopy over the amorous couple, while sunburned satyrs carry off white-thighed Baccantes with obvious intent...Each of Leonie's children in turn peered up at this scene, asking, 'But what are they all doing?" 'My grandmother could think of no better reply than "Having a lovely picnic, dear." '[46]

Lane's association with the eccentric Vere Foster family led to two pictures coming into the NGI. In the summer of 1907 he obtained a commission for William Orpen (an artist admired by Armstrong)[47] to paint a supercilious family group, father carrying a gun, mother and two daughters, one dressed as a boy, the other in frills. Dogs were included, together with a lot of feathers and dead birds, and a donkey, since Lady Vere Foster loved donkeys. The weather was bad, and from time to time the donkey was led into the drawing room of Glyde Court to be painted.[48]

In order to pay for the picture the Vere Fosters were forced to sell Lane

a painting by Sir Thomas Lawrence of an ancestor, *Lady Elizabeth Foster*, later Duchess of Devonshire, while arranging for a copy of the painting to be hung on the walls of Glyde Court.[49] The Lawrence (NGI 788) became part of the Lane Bequest, while many years later, in 1951, the Vere Foster group (NGI 1199) was bought for the Gallery by Thomas MacGreevy from Mrs Dorothy May, the little girl on the right.

During his first years on the Board of the NGI, Lane had presented the Gallery with six pictures, advised on the purchase of others, and, in December 1907, arranged for a loan of three of his pictures – 'a male Portrait by Titian, a female Portrait by Goya and a decorative picture by some unidentified master of the Spanish school.'[50] The Titian was *Portrait of a Man in a Red Cap* which would play a part in the last months of his life. In November 1908 he was reappointed to the Board, but his attendance became increasingly infrequent; between March 1910 and April 1913 he attended no Board meetings.

The controversies concerning the Municipal Gallery involved Dublin Corporation, Lord Ardilaun, William Martin Murphy, Lutyens and others, but not Armstrong or the Governors and Guardians of the NGI. They were not consulted on questions of site and architect and the eventual loan of Impressionists to the National Gallery in London, which were transferred to London in the summer of 1913 after Lane grew exasperated with Dublin Corporation.

He had made his first will in August 1898, when still a young man, bequeathing to the National Gallery in London a work by Aelbert Cuyp and a landscape by Richard Wilson. In April 1905, with his new found enthusiasm for Ireland, a second will left the best of his Old Master paintings to the NGI, while most of the remainder of his legacy would go to fund to purchase pictures for his Gallery of Modern Art.[51]

His third will, the one that would provide the National Gallery of Ireland with its single largest bequest, was drawn up on 11 October 1913.[52] The thirty-nine modern pictures, later the subject of bitter dispute, 'lent by me to the London National Gallery…I bequeath to found a collection of Modern Continental Art in London.' For the rest:

'I bequeath the remainder of my property to the National Gallery of Ireland (instead of to the Dublin Modern Art Gallery which I considered so important for the founding of an Irish School of painting) to be invested and the income to be spent on buying pictures of deceased painters of established merit. I hope that this alteration from the Modern Gallery to the National Gallery will be remembered by the Dublin Municipality and others as an example of this want of public

spirit in the year 1913, and for the folly of such bodies assuming to decide on questions of Art instead of relying on expert opinion.'

This third will was made at a time when Lane was canvassing energetically to become the NGI's new Director. Although he had the NGI much in mind, and had no intention of abandoning Ireland if he could get the position, his words make it clear that he was motivated by anger at his rejection by Dublin. A reviewer of Bodkin's account of the controversy wrote: 'his will of 11 October 1913 appears to have been made in a fit of temper…If this is not the mood of "I'll show them" we have never met it.'[53]

1 Minutes of NGI Board, Jan. 1904
2 George Moore, *Hail and Farewell*, (London 1911-14) vol. 3, p. 525
3 Sir Henry Tonks, Obituary of Sir Hugh Lane, *The Burlington Magazine* vol. 27 (June 1915)
4 'Catalogue of Valuable Books Chiefly of the Fine Arts. The Property of Sir Hugh Lane, deceased', 26 November 1917
5 Robert O'Byrne, *Hugh Lane 1875-1915* (Dublin 2000) p. 27
6 Moore (as n. 2)
7 Lady Gregory, *Hugh Lane's Life and Achievement* (London 1921) p. 4
8 *ibid*. p. 9
9 O'Byrne (as n. 5) p. 14
10 Gregory (as n. 7) p. 11
11 *ibid*.
12 Tonks (as n. 3)
13 *ibid*.
14 Gregory (as n. 7) p. 5
15 *ibid*. p. 28
16 *Daily Chronicle*, 20 May 1915. Quoted O'Byrne (as n. 5) p. 215
17 *DNB* 1912-21 vol., p. 319
18 Quoted in Roy Foster, *W.B. Yeats. A Life*, vol. 2 (Oxford 2003) p. 18
19 Clive Bell, *New Statesman and Nation* (21 April 1934)
20 TCD Bodkin ms 6961-39. Douglas to Bodkin, 4 Feb.1919
21 O'Byrne (as n. 5) p. 44
22 Gregory (as n. 7) p. 44
23 *ibid*.
24 Minutes 24 March 1904. 'Catalogue of the Exhibition of Works by Irish Painters..' by A.G.Temple F.S.A., Director of the Art Gallery of the Corporation of London
25 *ibid*. p.x. Introduction by Hugh Lane
26 Moore (as n. 2) p. 97
27 *Collected Letters of W B Yeats* (ed. John Kelly and Ronald Schuchard), (Oxford 1994), vol. 3, p. 689
28 *Irish Times*, 23 Dec. 1904
29 Quoted O'Byrne (as n. 5) p. 65
30 Minutes, 13 Jan. 1905
31 *ibid*.
32 O'Byrne (as n. 5) p. 67
33 Gregory (as n. 7) p. 49
34 O'Byrne (as n. 5) p. 69
35 Adrian Frazier, *George Moore 1852-1933* (New Haven & London 2000) p. 339
36 *Evening Mail*, 3 Aug. 1905
37 Gregory (as n. 7) p. 68
38 Parliamentary Papers XXI Cd 3256 (1906). Report of the Committee of Inquiry into the Work Carried on by the Royal Hibernian Academy and the Metropolitan School of Art Dublin. p. 512
39 Catalogue of the Municipal Gallery of Modern Art, Dublin (January 1908) Prefatory Notice.
40 Minutes, 10 Dec. 1907
41 Minutes, 22 Jan. 1908
42 Catalogue (as n. 39)
43 Robert O'Byrne, *Hugh Lane's Legacy at the NGI* exh. NGI, 2000 pp. 8 & 16
44 David Oldfield, *Later Flemish Paintings in the NGI.* (Dublin 1992) pp. 130-32
45 NGI Admin. Box 4 .Pictures belonging to Sir Hugh Lane's Estate that it is now proposed to exclude from the Sale, in order that they may be taken over by the Governors of the National Gallery of Ireland (Annotated by Douglas)
46 Anita Leslie, *The Gilt and the Gingerbread* (London 1981) p. 17
47 Denys Sutton, 'Sir Walter Armstrong, Museum Director and Pioneer Art Historian', *Apollo* (Feb. 1982) p. 75
48 Mark Bence-Jones, *Twilight of the Ascendancy* (London 1987) p. 116
49 O'Byrne (as n. 43) p. 9
50 Minutes, 10 Dec. 1907
51 O'Byrne (as n. 5) pp. 58-59
52 Thomas Bodkin, *Hugh Lane and his Pictures*, (Dublin 1932) p. 39
53 *Times Literary Supplement*, 10 April 1934

A WHIRLWIND YEAR

A significant item was entered in the Minutes of the meeting of the Board of the National Gallery of Ireland on 3 December 1913:

'A letter from the Director [Walter Armstrong] to the Governors and Guardians intimating that his resignation of the post of Director would become effectual on the 31st March next was read. It was resolved that the forthcoming vacancy should be advertised in the leading newspapers and that candidates should be invited to send in their applications to the Registrar on or before the 1st of February prox.'

Although Armstrong had not reached the statutory retiring age of sixty-five, he had been working for the Gallery for twenty-two years. He was tiring. The prospect of more confrontation with Lady Milltown may have dismayed him, although she would die a month later. During his last two years as Director he acquired little of interest for the Gallery. In his final Director's Report for 1913 his main addition to the collection is *A View of Bray Head* (NGI 647) by Samuel Frederick Brocas (c.1792-1847) bought for £20.

In August 1913 Sir Hugh Lane had presented the NGI with five paintings, all portraits: *The Artist's Mother* (NGI 648) by William Collins (1788-1847), *The Artist's Sister* (NGI 651) by David Wilkie, *A Lady* (NGI 649) by John Linnell (1792-1882), *A Lady* (NGI 652), artist unknown, and *Jean-Jacques Dessont* (NGI 650) by JP Horstok (1745-1825).[1]

Before he announced his impending retirement, Armstrong's intention was well known, and Lane passionately wished that his third attempt to acquire an official position should succeed. He had applied for the Directorship of the Walker Gallery in Liverpool, and in 1907 had made an attempt to succeed Col Plunkett as Curator of the National Museum in Dublin. When he applied for the Museum post, 'he at once began buying precious gifts for it.'[2] He had not been chosen; a 'safe' man, another Plunkett, Count Plunkett, got the job. Count Plunkett's son, Joseph Mary, would be executed after the Rising in 1916.

During 1913, in the midst of his troubles with Dublin Corporation, Lane canvassed cautiously for the Directorship of the NGI. In February he consented to judge the Taylor Prize. He resumed attending Board meetings and chaired the meeting on 6 August 1913 when he presented the Gallery with his portraits.

In spite of these gestures, he refused to declare himself officially as a candidate when the time came for Armstrong to retire. There were other contenders for the Directorship, including the Registrar, Walter Strickland, who had just published his monumental *A Dictionary of Irish Artists*, and who knew more about the running of the Gallery than any other possible applicant for the job. Another was Dermod O'Brien, who had been appointed President of the RHA in 1912 and was therefore an *ex-officio* member of the Board. After Lane's death O'Brien showed Lady Gregory a letter Lane had written to him in April 1914:

'The Directorship of the Dublin National Gallery used to be the great longing of my life, it is only serious ill-health and perhaps the realising of how little interest is taken in art in Dublin that makes me dread a fresh task. Still, I would like to leave my mark there, and as old pictures are the only things in the world that I know anything about, I feel that in two or three years (if I live so long) I may be able to do some little good. Of course I would spend the salary on the collection – probably a great deal more – and though I feel bound to add to the Modern Gallery, collecting old pictures is my real pleasure in life.'[3]

Lane's friendship with O'Brien did not prevent jealousy; at the end of July he was complaining to Lady Gregory: 'I hear that Dermod O'Brien has been working at all the Governors of the National Gallery and that he will probably be appointed Director – very deceitful of him. But I won't compete.'[4] But soon after, O'Brien decided against applying for the post. Lane was still doubtful, writing to him in late October, 'I wish I could feel any pleasure in the prospect of getting the job, but I feel

very thoroughly discouraged with my native country and the gross misunderstanding of everything one tries to do for it.'[5]

Another friend was Sarah Purser, to whom he confided on 6 December 1913: 'If the Directorship of the Nat Gal were offered to me I would undertake to make it my first interest in life and that nothing wd tempt me to sacrifice its interests. I would come to Dublin as often as it was necessary but living there would make it impossible to pick up bargains or to get things given.' He also informed her that 'the only thing that could be said for my living there would be that I should spend my salary in the country, but as I intend and am ready to undertake to spend the salary on pictures for the gallery I think that this objection falls through.'[6]

A month later, in January 1914, Sarah Purser was appointed to the Board. The Lord Lieutenant, Lord Aberdeen, wrote: 'Your membership will, I am sure, be widely recognised as eminently fitting. You will succeed to a place previously occupied by one of your distinguished sisters in art, Lady Butler.'[7]

Before Lane left on his first visit to America, in December 1913, leaving his bewildered supporters to work on his behalf, he had to go some way towards declaring himself. He was coy with Purser. 'I do not want to apply for the post as I have nothing to gain by getting it and much to give.' However, on the advice of Armstrong, who supported him as his successor, he contacted Dr Mahaffy, soon to be Provost of Trinity College, who regularly acted as Chairman of the NGI Board. 'I will not formally apply for the post as I do not wish to run the risk of a refusal. If you yourself feel that I am the best man for the job, I know that your influence with the Board will carry more weight than any others.'[8] He also asked Lady Gregory to write to Mahaffy. 'Tell him that if I am appointed to the National Gallery I will make it my adopted child.'[9]

Mahaffy, another ally of Lane, wrote to Dermod O'Brien on 16 January 1914: 'I have in my pocket a note from H. Lane, saying he will accept the post if offered to him, under condition that he will be allowed to reside in London (the centre of art buying) and come over when required. He also proposes to hand over the £500 salary to increase our purchases...This last I told him the Govs could not consider. That is his own affair and very generous it is. But I hold that the statement is a genuine application and will rule it so, if I am in the Chair.'[10]

While Lane was in America, his supporters canvassed hard. Lady Gregory could write to him in January 1914: 'I have been working about the National Gallery, and as far as I can ascertain a good majority of the

Trustees are safe for Hugh Lane.'[11] However, she was pessimistic, 'for there were still men in Dublin who believed in some hidden covetousness and some who twitted him with his trade.'[12]

When the time came, there were only two candidates to be considered, Lane and Strickland, whose scholarship and dependability theoretically made him the more qualified. But Strickland lacked Lane's social connections, was hopeless at lobbying, and some members of the Board, including O'Brien, actively disliked him.

There was argument at the Board meeting of 4 February when Mahaffy, as Chairman, read out formal applications from Lane and Strickland. A member of the Board, probably the artist, JM Kavanagh, pointed out that Lane was not eligible because he was still a member of the Board and had not taken the trouble to resign. Lady Gregory was told that the member, whose name she got wrong, wished to snub Mahaffy,[13] who acted swiftly, and adjourned the meeting until 25 February. By then, Lane had returned, and, following urgent prompting, had resigned from the Board.

On 25 February both applications were read out. 'After some discussion these two names were put to the vote, when it appeared that Sir Hugh Lane had the majority of votes.'[14] He was elected by ten votes to five.

Lady Gregory was ecstatic. She wrote to Yeats: 'I awoke this morning more happy and satisfied than for a long time – almost radiant…It seems as if that barren tide may have turned, and that the worst hour is over. There is one of our 'best men' employed anyhow.'[15]

Lane himself was nervous. Three days after his appointment he wrote to Thomas Bodkin: 'I hope to become enthusiastic over my new job as soon as I get started and anyway will do my best for as long as I am on the job for the Gallery.'[16] To his aunt he confided 'I am feeling very depressed at my new responsibilities, but I am sure that once I get started it will become absorbing.'[17]

He was determined to remain in London, 'the bargain centre of the world (in pictures)' as he had told Mahaffy.[18] Lady Gregory observed: 'would Joseph have had the means so to enrich his brethren if he had remained in hunger-stricken Canaan?'[19] He arranged for his appointment to be part-time, so that he could commute to Ireland whenever necessary from his imposing seventeenth-century mansion, Lindsey House in Chelsea, where his sister, Ruth Shine, kept house for him, and looked after Tiger the Persian cat and Tinko the Pekinese, a present from his friend, Sir Alec Martin, who worked in Christie's.

His decision, confirmed by amendments to the Bye Laws adopted at a

special meeting on 27 March, promoted unease at the Treasury, who wrote to the Board on 11 April 'enquiring whether by the terms of his appointment Sir Hugh Lane is required to devote his whole time to the public service.' The Board replied that, as they had appointed Lane to the post of Director according to the new regulations in the Bye Laws, 'in the opinion of the Governors and Guardians no other condition as to hours of attendance should be imposed on the Director. Any such limitations would…militate against the interests of the Gallery, as the nature of the work devolving on him is such as can only be satisfactorily carried out by giving him considerable freedom of action in the performance of his official duties.'[20]

At Lane's suggestion it was decided to send the customary begging letter to the Treasury asking for more money all round. The salaries of the Director and Registrar should be increased, and money for purchase of pictures should be increased. 'The sum of £1000…was fixed when pictures were, on the average, worth about one tenth of their present market value. The collection is…poor…in works by the leading masters …The presence of even one famous picture would make a great difference to the reputation of the Dublin Gallery and would attract visitors from all over Europe.'[21]

The letter pointed out that the Collection which had cost about £50,000 was now worth £250,000. The salary put forward for the Director was £800. But Lane and the Board must have known that there was little or no chance that the Treasury, already uneasy about Lane's demands, would countenance these suggested increases. Eventually my Lords agreed that Lane should be paid £500 per annum without a pension. However, 'they are of the opinion…that a salary of this amount is very high for an office only given part-time service.'[22] They would not consider raising the salary of any other Gallery official who found he had more work because of Lane's part-time status. They were unimpressed by the information that Lane had promised to use this salary, and his travel allowance of £150, for the purchase of pictures.

Lane informed Maurice Headlam, the Treasury Remembrancer at Dublin Castle, that 'he had no use for a pension.'[23] His position was not unique, as Headlam explained to one of the Governors, W F Bailey. 'Lane and the Governors need have no worry about the former's status. He is a Civil Servant, but not a pensionable Civil Servant...he is in exactly the same position as Holroyd of the National Gallery in London and other distinguished people'. Headlam added:'His successor may not wish to "take private practice" and may wish to have a pension.'[24] But a

precedent had been set, and for the next half century money would be saved by the Treasury, and later the Department of Finance in the Free State government, by making the post of Director of the NGI part-time.

The first Board meeting Lane attended as Director, on 1 April 1914, went quietly. At the next, on 22 April, he set out to dazzle the Governors. 'The Director offered to the Gallery as a gift the following three pictures, viz: 'The Vision of St Francis' by El Greco; 'Portrait of a Lady' by Paul Veronese; 'Decorative group' by GB Piazzetta. These were shown to the Board, and in accepting them the Governors expressed to Sir Hugh Lane their warm thanks and gratitude for his generosity in making such a valuable and important gift.'[25]

The portrait (NGI 657) by Paolo Veronese (1528-88) enhanced the Venetian pictures in the Gallery. The decorative group, *A Pastoral Outing* (NGI 656), with a lady holding a Chinese umbrella, a cowherd and a cow looking in from the right of the canvas, is now catalogued as Studio of Piazzetta. *St Francis Receiving the Stigmata* (NGI 658) by El Greco (1541-1614), in which the saint in ecstasy stands beside a skull, symbol of mortality, was an important addition to the Gallery's meagre Spanish School. 'A painting with a certain hallucinatory power as he accepts the physical suffering of the stigmata…The saint is framed by almost abstract clouds in a deep blue sky.'[26] The clouds were revealed by cleaning in 1985. Wilson Steer and others regarded St Francis as 'a wonderful likeness' of Lane. The painting had been acquired by Lane in 1912 for £700, at a time when the artist's genius was not fully appreciated. It was a year during which Lane spent £29,000 on pictures, many of which would eventually enter the Gallery. The huge sum contrasted with the NGI's annual £1,000 grant-in-aid.

Subsequently Lane made staggered gifts to the NGI from his personal collection. At the meeting on 3 June he presented a fine portrait of a man (NGI 673), now given to Annibale Carracci (1560-1609), two still-life paintings (NGI 670 & 671) by François Desportes (1661-1743) and a Gainsborough (NGI 668), *The Return from Shooting*. On 24 June he wrote to Bodkin: 'I shall not give all the things I intend at next Wednesday's meeting but will just give a couple of good things…'[27] He hesitated, since he had just received 'a very rude letter' from the Treasury about his salary, considered excessive. 'I was going to give an important Gainsborough landscape and some good pictures to fill important gaps in the collection at next week's meeting, but I feel rather angry at the moment.'[28] However, on 1 July a Gainsborough profile of *Rev. Humphry Gainsborough* (NGI 675) was given, together with a Romney, and other pictures. *Jael and Sisera* (NGI 667) now given to Pedro Núñez del Valle (early 1590s-c.1657)

St Francis receiving the Stigmata, 1590/95 by El Greco
(1541–1614), Lane Gift 1914 (NGI 658)

was entered in the Minutes for 1 June as a purchase, but elsewhere was listed as another of Lane's gifts and confirmed as such by Bodkin.[29] In December Lane presented a small portrait of the artist's mother by William Henry Hunt (NGI 683), at the same time lending the Gallery some of the most important pictures unsold and on his hands: his Claude Lorrain, a Tintoretto, a Chardin, and three paintings ascribed to Poussin.

One gets the impression that the members of the Board were struck dumb by such generosity. Certainly Lane did not think the members of the Board grateful enough in expressing their thanks. After the June presentation he wrote with his usual touch of paranoia to his sister, Ruth Shine, that the Board 'said polite things, but I think inquire that they can't be genuine as I am giving them!'[30] But he went on giving. Among the paintings donated by him was *The Weigh-House at the Buttermarket, Amsterdam* (NGI 681) by Johannes Hubert Prins (1757-1806) which he bought at the end of May 1914 and in October asked Sarah Purser to present to the Gallery in her name. Over his lifetime he presented the NGI with twenty-four paintings.

Armstrong's last Director's Report in 1913 had stated: 'The repainting and decoration of the Galley which had been begun the previous year was completed during the summer and autumn, the galleries in the old building being decorated in harmony with those in the new.' Lane did not like the colour scheme, Armstrong's choice, but since there was no question of getting further funds from official sources, he began some limited redecoration on his own responsibility immediately after his appointment. The Minutes of 29 April record 'a letter from the Board of Works asking for a requisition from the Board of the National Gallery approving the repainting of the smaller rooms at the National Gallery (at the Director's expense).' The Board agreed – why would it not? Lane told WB Yeats that he thought of asking Lutyens over 'to see how the building could be improved'[31], an idea which might well have inspired controversy.

He always kept Lindsey House full of fresh flowers, and had instructed Mrs Duncan, the Director of the Municipal Gallery in Harcourt Street to do the same. When John Butler Yeats was painting portraits for him, the artist resented Lane putting roses in the bowls in the studio.[32] Although there is no mention of flowers in the NGI papers, most certainly they were there. A caretaker at the Municipal Gallery remembered how 'with flowers...he was wonderful. He would put them in so quick, and they would look just as if they were growing in the bowl.'[33]

He combed the cellars together with his friend Thomas Bodkin, who

described how 'I… spent four or five days going through them all [the pictures] in the company of the late Sir Hugh Lane. My experience is…that there is nothing of real value in our cellars, but on the contrary, a vast amount of rubbish.'[34] The Lanfrancos and other pictures bought through Robert Macpherson lay undisturbed.

An examination of the catalogue produced by Lane in 1914, much of which had been written by Armstrong, makes it clear that he brought out of store a number of pictures that caught his fancy. Among them were a portrait, then thought by van Dyck, purchased in Paris in 1866, the two early German pictures of women Saints that Mulvany had selected from the Krüger collection, and *Dinner at a Farmhouse* (NGI 340) by David Ryckaert III (1612-61) presented by Robert Clouston to the Irish Institution back in 1855. Possibly he elected to display as a curiosity the gloomy *Interior of the Sint-Pauluskerk, Antwerp* (NGI 168) by Victor Genisson and Willems Florent, the NGI's very first picture, presented in 1853. He chose another nineteenth-century continental picture, perhaps to make a pair, Herman Dyck's *The Last of the Brotherhood* (NGI 169), presented in 1865.

Upstairs the Raphael cartoons were back. To make room for Lane's gifts and loans, other pictures had to be sent down, including one he himself had given to the Gallery in 1907, the *Interior of a Kitchen*, by Jan Horemans. He reduced the Hugh Douglas Hamiltons (oils and pastels) on display from eleven to nine and the Walter Osbornes from seven to three.[35]

Visiting the National Gallery eight years after his death, Lady Gregory found 'the men there so civil and kind, remembering Hugh.'[36] The caretaker of Lane's Municipal Gallery in Harcourt Street described Lane's methods there, and no doubt it was the same at the NGI. 'He worked harder than any of us. He would be moving pictures and hanging and shifting them; he never would ask any one to do what he would not do himself. He never spared himself, and if he went out for lunch or his dinner, he wouldn't take as long at it as you'd be drinking a cup of tea.'[37] Even working part time, he accommodated Mahaffy by taking some of the portraits in the Provost's House to the NGI, putting on an overall, rolling up his sleeves and cleaning some of them himself.[38] Before his death they were exhibited on screens in the Sculpture Hall.[39]

The dispute over the Milltown pictures solved itself suddenly by the death of Lady Milltown early in 1914. In his 1932 catalogue of paintings, Bodkin stated that it was Lane who dismantled the four rooms devoted to the Milltown Memorial. He claimed that 'an arrangement was made between the parties interested which permitted this collection to be merged into the general collection, with inestimable aesthetic advantage

to the whole.'[40] There is no correspondence suggesting that permission was sought to break up the collection, nor any mention of this action in the Minutes and it is tempting to speculate that Lane went ahead with the task with his usual gusto without consultation, very soon after Lady Milltown died. But who was there now to complain? Not the amiable Lord Turton, nephew of the 7th Earl, who had inherited Russborough.

Lord Turton (entered in the Minutes as Mr Turton), wrote to the Board asking if he could borrow back any of the Milltown collection ('pictures and other articles') not needed in the Gallery for use at Russborough. The Board was eager to comply, especially as he would deal with the transfer and insurance at his own expense. He showed his appreciation by lending the NGI a picture which would come absolutely into the Gallery on the death of himself and his wife, if none of the articles left had been previously recalled. This was the engaging *Mrs Congreve with her Children* (NGI 676) by Philip Reinagle (1749-1833), in which mother and children are assembled in a room on whose walls can be seen another portrait by Reinagle of the children's father and another brother, and a portrait by Godfrey Kneller of a distant member of the family, the Irish-born dramatist, William Congreve. Over the years the Gallery has been able to acquire these paintings together with two others visible in Mrs Congreve's drawing room.[41]

Lane wanted a uniform. Headlam declared that Lane 'may wear any uniform to which the Director of the National Gallery is entitled – if any exists.'[42] The Director designed his own to look vaguely consular with a gold braid, a sword, bright buttons, white gloves and a billycock hat; the effect is more naval, and suggests an officer of HMS Pinafore (photo in NGI Archive). He was never to wear it on an official occasion.

The outbreak of war in August 1914 brought changes to the Gallery almost at once. By 3 October the War Office in London wrote asking if any of the ex-soldiers employed at the Gallery would re-enlist. Strickland replied that out of eight ex-soldiers employed in the NGI two had already re-joined the colours and three were physically unfit.[43] By April 1916 four attendants had rejoined, three to the Royal Irish Fusiliers and the fourth to the Royal Navy as Petty Officer.[44] Two months later the Gallery agreed to store furniture removed from Dublin Castle, which was being converted into a hospital.

In January 1915 the Treasury announced that, in view of wartime needs, the grant-in-aid would be suspended. Lane pleaded that 'during this year unexampled opportunities will present themselves for the purchase of important works at low prices, as many collections will be

forced on the market owing to the effects of the war, and in the sale-rooms our grant of £1,000 will have a purchasing value which may never occur again.'[45] The Treasury was unmoved, even by the Board's suggestion that it should borrow on the security of a future grant from the Treasury at some date unknown. My Lords were 'sorry to disappoint the Gallery, particularly as they are so exceptionally well qualified to take advantage of the present opportunity, but they must put down their misfortune to the hazards of war.'

The fall in prices for paintings that resulted from the uncertainties of war brought great difficulties for Lane as a dealer. His problems had begun some months beforehand when the fortunes of his client, Arthur Grenfell, collapsed. Lane had sold him many pictures, including Titian's *Portrait of a Man in a Red Cap* , for which he had paid £2,205 in 1907 and had sold to Grenfell for £30,000. Now, hearing of Grenfell's, difficulties, he felt an obligation to buy the pictures back.

'I am dreading the Grenfell sale', he wrote to Bodkin on 24 June 1914, 'the worst season on record and the dealers against my things.' He bought back the Titian for a low £13,650, but the other purchases, including Lawrence's *Lady Elizabeth Foster* (NGI 788), once owned by the Fosters of Glyde Court, which had cost him £5,880, Ferdinand Bol's *Portrait of a Lady* (NGI 810), and a landscape by Gainsborough (NGI 796) totalled £31,000.[46] After the war Grenfell recovered his fortune.

When Lady Gregory learned how much money Lane owed she was appalled. He was amused when he saw her despair. 'Don't worry, it will be all right. You've got it rather out of proportion. Think of a charwoman trying to raise thirty shillings and you'll get the idea.'[47]

At the beginning of 1915, heavily in debt, he planned reluctantly to go to America in the hope of finding new clients. He also had a commission from the dealer Joseph Duveen to inspect and value some paintings which had been damaged by a fire while crossing the Atlantic.

He was due to sail in February 1914. He came over to Dublin at the beginning of the month, and wrote out a codicil to his October 1913 will on the official note paper of the NGI, stamped with the lion and the unicorn and the imperial crown between them. He signed each page and dated the document '3rd February, 1915.'

'This is a codicil to my last will to the effect that the group of pictures now at the London National Gallery which I had bequeathed to that Institution, I now bequeath to the city of Dublin, providing that a suitable building is provided for them within five years of my death.' He appointed Lady Gregory as his sole trustee, a burden she would find terrible.

He stated: 'I also wish that the pictures now on loan at this [National Gallery of Ireland] Gallery remain as my gift.' These were: *Juno confiding Io to Argus* (NGI 763) by Claude Lorrain (1600/04-82), three Poussins, one dubious, *The Young Governess* (NGI 813) by Jean-Baptiste Chardin (1699-1779) and *Diana and Endymion* (NGI 1768) by Jacopo Tintoretto (1518-94), or rather his School.

He put the codicil in a sealed envelope addressed to his sister, Mrs Ruth Shine, who was the custodian of his will, and locked it in his desk at the National Gallery.[48] (Terence de Vere White, who died in 1994 after many years as a member of the Board of the Gallery, wrote that 'Lane's unwitnessed codicil, which would not pass the title in a flitch of bacon, has added a chapter to the list of Irish grievances.')[49]

Lane's departure to America was put off for two months because of 'a bad feverish cough' according to his sister's diary.[50] Consequently he was able to return to Dublin for his last Board meeting of the NGI on 7 April. Plenty of business would be entered in the Minute Book. Lane made his final gift, *The Virgin of the Rosary* (NGI 760) by the Spanish artist, Sebastian de Llanos y Valdés (c.1605-77). On his suggestion, it was agreed to lend the new Lord Lieutenant, Lord French, some pictures for the Viceregal Lodge, while an offer was made for the use of rooms in the National Gallery building to the Lord Lieutenant, who would receive an address of welcome from the Board.

Strickland would reach the age of sixty-five in June, and was due to retire; the Board unanimously decided to ask the Treasury to postpone his retirement for two years. Poignantly 'it was resolved that Sir Hugh Lane be appointed as Judge on behalf of the Gallery in the Taylor competition for 1916 and in the event of his being unable to act that Miss Purser be nominated to replace him at the adjudication.'[51]

That evening Lane had dinner with Lady Gregory and the next afternoon he conducted her and WB Yeats around the Gallery. 'He took us through the rooms to show me all he had done and all he had given in those thirteen months. He was proud of his work and well pleased...His life's desire had been accomplished; he had charge of a great Gallery already enriched by his bounty. I said to him as he gave us tea in the Director's room, with its look of dignity, its mahogany bookcases, and its books "I am glad to see you in your right setting at last."'[52]

The codicil was lying in his desk as the teacups chinked. Lady Gregory stated that 'Yeats being with us we had no intimate talk.'[53] But aunt and nephew might have talked at dinner the night before. In an acrimonious correspondence during the 1940s, Maurice Headlam, writing to Bodkin,

found it difficult to believe that Lane told her nothing about his intentions. Bodkin took this to mean that Headlam was accusing Lady Gregory of deceit. Although Headlam (who remembered Lane's fury at Dublin Corporation, but was unreliable about dates) apologised, he enquired 'But why did he not inform his beloved aunt?' Bodkin replied, with reason, that his experience as a Charity Commissioner left him with the knowledge that most wills and codicils are undisclosed to beneficiaries.[54] However, Lane probably did tell Lady Gregory about his change of heart towards Ireland.

He is known to have had forebodings about crossing the Atlantic in wartime conditions, but when he toured the Gallery with Lady Gregory he was full of enthusiasm and plans. 'I like to remember him there in authority, in love with his work, in harmony with all that was about him.'[55]

In 1930 she wrote in her diary: 'In my catalogue of the Dublin National Gallery is written "To Aunt Augusta from the Director! April 8 1915." and I have written under it "Hugh gave me this as I said goodbye to him at the door of the National Gallery the last time I ever saw him."'[56]

He returned to London on 10 April and at Euston Station met Alec Martin of Christie's, who travelled with him to Liverpool. On 11 April Lane talked on the telephone to Mrs Henriette Hind, the American wife of the art critic C Lewis Hind, who had been acting as his intermediary. She told him she had found a buyer, Henry Clay Frick, who would pay £50,000 for his Titian and also buy his Holbein, *Thomas Cromwell*, which Lane had bought the previous year in Dublin for £38,000 from the Earl of Caledon. The prices now offered were reasonable. Many years later Martin told Bodkin, 'The sale of the Red Cap and the Holbein was negotiated on the telephone from the Hotel in Liverpool on the morning he sailed, and although he only just got his money back, it did ease the pressure and he was able to travel without undue financial strain. Had the sale been earlier I don't think he would ever have gone to America.'[57]

In New York, Lane, reported as being in good spirits, completed his business satisfactorily and embarked for Ireland on 1 May 1915, on the Cunard Line's *Lusitania*, a British-registered vessel and therefore vulnerable to attacks from German submarines.

1 Minutes of NGI Board, 6 Aug. 1913
2 Lady Gregory, *Hugh Lane's Life and Achievement* (London 1921) p. 83
3 *ibid.* p. 199
4 Quoted in Robert O'Byrne, *Hugh Lane 1875–1915* (Dublin 2000) p. 198
5 *ibid.*
6 NGI Admin. Box 4. Lane to Purser 6 Dec. 1913
7 Quoted John O'Grady, *The Life and Work of Sarah Purser* (Dublin 1996) p. 115
8 Quoted in O'Byrne (as n. 4) p. 199
9 Gregory (as n. 2) p. 200
10 NGI Admin. Box 4. Mahaffy to O'Brien, 16 Jan. 1914
11 Gregory (as n.2) p. 200
12 *ibid.* p. 201
13 *ibid.*
14 Minutes, 25 Feb. 1914
15 Gregory (as n. 2) p. 201
16 TCD Bodkin ms. 6968-19
17 Gregory (as n. 2) p. 202
18 NLI, Lane Papers ms 13,071. Lane to Mahaffy, 1 Dec. 1913
19 Gregory (as n. 2) p. 88
20 Minutes, 22 April 1914
21 Minutes, 3 June 1914, quoting Letter to the Treasury, 4 May 1914
22 Minutes, 3 June 1914
23 NGI Admin. Box 4. Headlam to Bailey, 7 July 1914
24 *ibid.* Headlam to Bailey, 14 July 1914
25 Director's Report 1914
26 Adrian Le Harivel in *European Masterpieces from the NGI*, exh. Canberra and Adelaide, 1994-5, p. 14
27 TCD Bodkin ms 6968-20. Lane to Bodkin, 24 June 1914
28 Gregory (as n. 2) p. 203
29 TCD Bodkin ms 6968-81. Bodkin's statement attacking Robert Langton Douglas (undated)
30 Kermode papers. Lane to Ruth Shine, 5 June 1914. Quoted O'Byrne (as n. 4) p. 202
31 Gregory (as n. 2) p. 203
32 Hilary Pyle, *Yeats - Portrait of an Artistic Family* (London 1997) p. 116
33 Gregory (as n. 2) p. 139
34 TCD Bodkin ms (as n. 29)
35 NGI Catalogues, 1908 and 1914
36 Lady Gregory, *Journals* (ed. Daniel J. Murphy) (Gerrards Cross 1978 & 87) vol. 1 (11 March 1923)
37 Gregory (as n. 2) p. 139
38 *ibid.* p. 204
39 Director's Report 1915
40 Thomas Bodkin, introduction to *NGI Catalogue of Oil Paintings in the General Collection* (Dublin 1932) p. viii
41 Minutes, 1 July 1914
42 NGI Admin. Box 4. Headlam to Bailey, 7 July 1914
43 *ibid.* Estimates 1915-16
44 Director's Report 1915
45 Minutes, 20 January 1915
46 O'Byrne (as n. 4) p. 207
47 Gregory (as n. 2) p. 213
48 Thomas Bodkin, *Hugh Lane and his Pictures* (Dublin 1932) pp. 45, 46
49 Terence de Vere White, *A Fretful Midge* (London 1957) p. 7
50 Quoted O'Byrne (as n. 4) p. 209
51 Minutes, 7 April 1914
52 Gregory (as n. 2) p. 211
53 *ibid.*
54 TCD Bodkin ms 6963-358 *et seq.*
55 Gregory (as n. 2) p. 211
56 Gregory (as n. 35) vol. 2 (16 July 1930)
57 TCD Bodkin ms 6951-2174. Martin to Bodkin, 24 Oct. 1932

CHAPTER EIGHTEEN

EVENTS TO THE EASTER RISING

The *Lusitania* was struck by a torpedo on the afternoon of 7 May 1915 and sank, in less than twenty minutes, off the coast of Cork, with the loss of 1,200 lives. Lane was last seen 'pale, but quite calm' without a lifebelt, walking towards the bow of the ship in search of friends he had made aboard ship, a wealthy American couple named Pearson. He was heard saying, 'This is a sad end for us all.'[1] His body was never found.

Grief over his death was widespread; people burst into tears in the street.[2] Walter Armstrong wrote to Sarah Purser: 'Poor Lane. What a cruel fate it was that led him on that trip. I was nearly on it myself & it would have been a good thing if the fate had been mine instead of his for a man of 65 is wanted by very few people in such a world as we have now.'[3] On 18 May the Board held a special meeting when the members recorded 'their deep grief at the loss of Sir Hugh Lane, to whose generosity, enthusiasm and knowledge the Gallery owes so much.'[4]

The composition of the Board had changed over the years; at present, there were only two grandees, Lord Mayo (another friend of Lane) and Lord Rathdonnell, President of the RDS, who took little interest in the NGI and seldom attended meetings. Neither peer was present at the meeting, but 'desired that their names might be associated with the resolution on the loss of Sir Hugh Lane.'[5]

Dermod O'Brien (1865-1945) portrait painter, and President of the RHA, was prominent in Irish cultural life. Jack Yeats would write a spoof obituary about him:

Here lies
Dermod O'Brien,
But don't
Be cryin'
For in his winding sheetings
He'll still preside at meetings[6]

Sarah Purser, rival to O'Brien as Dublin's foremost portrait painter,

seldom missed a Board meeting throughout her long life. She was deeply grieved by Lane's death. When Thomas MacGreevy met her in the NGI, she was crying 'Oh, my poor Lane, my poor Lane.'[7]

Aileen Bodkin, Thomas Bodkin's wife, mentions three further members at this difficult time. 'Mr Jonathan Hogg of 'Hogg's Teas' was a charming old Quaker widower… a courtly old gentleman who met us in his garden, secateurs in hand, while we waited for dinner à trois of a summer's evening…' The NGI has a sketch by John Butler Yeats dated 1886 of the young Jonathan Hogg as a member of the Contemporary Club (NGI 7363).[8] 'Laurence (Larkie) Waldron was a stock-broker…the centre of a Johnsonian circle that gathered at weekends in his house in Killiney.' Waldron was fat, also known as 'Tubby.' 'Mr F. Lawless was the Hon Freddie Lawless and brother of Lord Cloncurry and the more memorable Hon Emily Lawless, whose books one really ought to get around to reading…'[9]

Other Board members included Sir George Stevenson, Chairman of the Office of Public Works (formerly the Board of Works); the scholar, William Bailey, who recently had worked as a Land Commissioner; Sir Thomas Manly Deane, the architect of the new wing for the NGI; the artist JM Kavanagh and Richard Caulfield Orpen, architect and brother of William Orpen. Sir Howard Grubb was a scientist and astronomical instrument maker as well as Vice-President of the RDS. Major Sir Neville Wilkinson, Ulster King of Arms, had worked for years making a dolls' house, Titania's Palace; in Who's Who he listed his recreation as 'tinycraft.'

As usual, Dr Mahaffy, Provost of Trinity, took the Chair at the meeting on 18 May; the Dublin Figaro, a gossip-journal, had described him in 1892 as 'a tall, heavily built man with reddish hair, sanguine complexion, overhanging brows and grey eyes…like a brace of surgeon's knives.' The Minutes reported: 'it was considered that, seeing the many difficulties that surround the Governors owing to the unexpected loss of Sir Hugh Lane, it was expedient to supply promptly his place. The Board therefore

unanimously resolved to appoint the Registrar, Mr W.G. Strickland as Director until the term of his office expires – and the Chairman was requested to notify the appointment to the Treasury and ask their sanction.'[10]

The bland words, written into the Minute Book by Strickland, concealed a simmering altercation. Mahaffy wanted Strickland to succeed Lane as Director. He made the proposal, a move that seemed logical, and it was natural that Strickland now felt he deserved the Directorship, having been passed over on the previous occasion. All the Gallery records point to his long exemplary service. Lane had fought not only for an increase in the Registrar's salary and pension rights, but for his extension of service after the date of his retirement fell due. The letter to the Treasury, written at Lane's instigation on 4 May 1914, requesting further funding, had pointed out how 'the present Registrar has devoted himself more especially to everything connected with this Portrait and Historical section of the Gallery, and its satisfactory condition is largely due to his industry and knowledge of Irish Biography and Portraiture. In support of this we can point to his recent Dictionary of Irish Painters...a large and important work.'[11] Strickland put a notice in the press on 21 May, stating that he had been appointed Director, while Mahaffy notified the Treasury.

But the Registrar had enemies. The hurried vote in agreement to Mahaffy's proposal was misunderstood, and after the meeting was concluded, several members of the Board expressed their indignation. Lord Mayo (who was not present) told Bailey, 'I suppose it does not matter much under existing circumstances whether Strickland is Director or not as he cannot buy pictures, and has only to see that the Gallery is kept clean etc, but the way it was carried out I most strongly object to...The whole matter is most disagreeable.'[12] Dermod O'Brien was furious, sending Bailey a 'long indignant letter', and another at the end of the month to Bodkin. 'I was quite ready to recommend to the Treasury that he should be paid something extra for his added responsibilities pending the election of a Director for which there seemed no immediate hurry, but I did not want him to have the satisfaction of calling himself Director nor of his having at his disposal the travelling allowance that the Director gets.'[13] O'Brien wrote to Mahaffy protesting at 'the extraordinary way in which the Registrar seems to be conducting the secretarial work'[14] and the announcement in the papers that he had been appointed Director.

Bailey also wrote to Mahaffy inferring that he and other members of the Board had been deceived. The words 'arrangements for the Gallery', written into the Minutes, did not specify an election. 'In Sir Hugh Lane's case, as we all remember, his qualifications were scrutinised with anxious

care and solicitude, while the appointment of Mr Strickland, as announced in today's papers, would appear to have been made without any adequate examination of the claims of candidates and no proper notice of the intention to appoint a Director was given...I did not take this to mean that the very important duty of selecting a Director to replace Sir Hugh Lane was to be submitted to the meeting. Indeed I understood the phrase 'arrangements for the Gallery' referred to matters connected with the arrangement of pictures'.[15]

Bailey concluded that Strickland's appointment was invalid. Meanwhile he had 'a savage fight' with Waldron, a 'strong Stricklandite', which he reported to Purser: 'He...makes the point also made by the Provost that, as there is no money to buy pictures this year, it doesn't matter who we appoint. I suggested that on this line a charwoman would do and would be cheaper.'[16] He wrote to O'Brien: 'I think that we should now start afresh – and hold that the proceedings at the last meeting were merely recommendatory – they cannot be conclusive as no proper notice was given.'[17]

When the Board met on 2 June, Richard Orpen formally objected to the Minutes of the previous meeting, 'on the ground that they did not correctly record the proceedings.' He contended that no vote was taken, nor resolution adopted appointing a Director. The only decision arrived at by the Governors and Guardians was that the Chairman (Mahaffy) should be authorised to communicate with the Treasury asking that, 'if, for the present, the post of Director be allowed to remain unfilled, Mr Strickland the Registrar be given an increased salary...'

Mahaffy's manoeuvrings were lost and Strickland's enemies emerged triumphant when a letter from the Treasury dated 21 May was read out. My Lords refused to have him appointed to the 'substantive post' of Director, but agreed that he should stay on the extra year until his office expired when he was sixty-five. He would be paid an extra £100 for his added responsibilities in addition to his Registrar's salary of £250. They also concurred with the suggestion made at the 18 May meeting by Mahaffy, that an assistant or 'clerk' should be appointed at a salary of £150 per annum to help fill the vacancy made by Strickland's new duties.[18]

The appointment of a new Director was therefore postponed until June 1916, the date of Strickland's retirement; amid a sulphurous atmosphere, after threatening to resign, he was persuaded to carry on for another year without a formal appointment as Director.

Meanwhile, in almost indecent haste after Lane's death, canvassing had begun for the Director's position. Before the end of May 1915, Sarah

Purser was approached by Robbie Ross and William Orpen's cousin, EL Alabaster. Prompted by Lady Gregory, WB Yeats lobbied Sarah Purser and Bailey to consider Robert Gregory.[19]

At the same time Thomas Bodkin (1887-1961), a particular friend of Lane, put his own name forward three weeks after the *Lusitania* went down. Educated at Belvedere College and Clongowes Wood, Bodkin had been practising law since 1911. But his true interest was in art, as he explained in a letter to Dermod O'Brien dated 29 May 1915.

'...I am thinking of going for Lane's place at the National Gallery. The Bar is promising me something but the Gallery would be work which would always make me most happy and the position would quite fill my ambition.' He admitted that his qualifications for the post in comparison with 'poor Lane's' seemed 'pitifully poor' but stressed that he had visited every gallery and important exhibition in London and Paris over the last ten years, often as a result of his 'constant association' with Lane. 'I have some reason to know that as far back as 1913 he put on record his wish that I should be associated with his plans for a Municipal Gallery in the event of his death.'[20]

O'Brien gave lukewarm support. He told Bodkin that he had written to Bailey suggesting that he 'might be a good person to fill the post when a proper election came on.' He added 'I believe that you would do quite well and in a short time make a most valuable director.'[21] Before the end of May, when the Treasury decreed the appointment of the new Director should be postponed, Bodkin had contacted Bailey, Purser, Orpen and Waldron.[22] He also sought support from Sir Alec Martin, Lane's friend at Christie's, who replied with some embarrassment: 'you quite appreciate that, as I have only met you once, it is a little difficult'.[23] (But Martin and Bodkin would become lifelong friends).

The search for the codicil to Lane's will continued. Since he had become more affable towards Ireland, and had told friends he planned to make another will, there were widespread rumours that he had changed his mind about the final destination of his 'modern' pictures. Bodkin mentioned the possibility of a codicil to O'Brien. Within three days of his death WB Yeats was trying to reach his spirit through automatic writing.[24] Staying in London in Lindsey House, Lady Gregory may have remembered the last tea party held in the Director's office. She had an idea; Yeats liked to think it was 'revealed' to her by 'Lane's spirit.'[25] She told Ruth Shine, who wrote to Mr Duncan, husband of the Director of the Municipal Gallery, who took the letter to Strickland who forced open the Director's desk and found the sealed envelope addressed to Mrs Shine.

Throughout June Yeats continued trying to discover the whereabouts of any new will by spiritual methods 'recorded at great and apparently credulous length, including harrowing cinematic impressions of the last moments on board the doomed ship.'[26] The fate of the pictures greedily retained by the National Gallery in London was no direct business of the NGI Board, but the old will was the legal one, and Lane's huge bequest to the NGI would have to be dealt with. For the present, another row among the Governors and Guardians was about to erupt. This was over the appointment of an 'assistant or clerk' to train under Strickland 'and eventually, if found suitable, to be made Registrar.'

A Committee of five Board members, Mahaffy, Waldron, Stevenson, Bailey and O'Brien, was appointed to examine applications. The post was advertised, and because it was wartime, was made open to both men and women. About 120 people replied, almost evenly divided between the sexes.[27] Sarah Purser received a huge amount of correspondence from those applying for the position and their supporters; in particular, she was being nudged by Thomas Bodkin to back another candidate, his friend, the writer, James Stephens.

James Stephens (1882-1950) had been brought up in grim circumstances in Lord Meath's Protestant School for boys, but by now he had achieved some success as a novelist and poet. In 1912 he published *The Crock of Gold*, a prose fantasy which brought fame, including the prestigious Colignac prize, received from the hands of Yeats, but no fortune. From Paris, where he was living with his family, he wrote to Bodkin on 16 June 1915: 'if that Clerkship can be gotten for me I'll take it and be glad, for at this moment affairs are going for me in miserly fashion. No one will buy my stuff.'[28] Maurice Headlam wrote in his *Irish Reminiscences*: 'It was represented to me that he had nothing to live on but his writings and that did not bring him in enough to keep body and soul together.'[29]

Purser hesitated in her support of the whimsical author, writing to Bodkin: 'Putting friendship aside, do you really think Stephens wd. be good? Wd you entrust (for instance) keeping the place clean & looking after sanitation, managing servants etc. etc. to him? He was, I am sure, perhaps very attentive at his office, here he wd be his own master & you at least wd never have the heart to chuck him out. On the other hand he wd add lustre to the Gallery & help to make it a centre but I expect Mr S. won't hear of it...'[30]

'Mr S.' was Strickland. The understanding between Purser and Bodkin was that she would support Bodkin as candidate for Director after Strickland's departure; meanwhile he assured her over Stephens: 'if he

and I were there together, he would do his work properly or there would be trouble. No one would try to chuck him more heartily than his friend myself…'

On 7 July the committee appointed to oversee the appointment of the clerkship submitted the names of five 'ladies'. 'They did not think any of the men candidates suitable for the post, except that a minority of the Committee thought, and strongly pressed, that the name of Mr James Stephens should be submitted to the Governors...'[31] The minority consisted of Bailey and O'Brien.

From Paris Stephens had sent a reference from his former employers, the solicitors Messrs McCready, and a very brief letter of application. '…I am an Irish author and have published several books in prose and verse and have been engaged a good deal in critical work. Previous to entering literature I had a long training in clerical business.' Sir George Stevenson considered this 'a scanty compliance with the requirements of the advertisement.'[32]

In fact Stephens had something more than 'lustre' to contribute to the NGI. Before going to Paris he had held down two jobs as clerk in solicitors' offices. He told Aileen Bodkin how he got the first. He had answered an advertisement for a post requiring shorthand, of which he was wholly ignorant; his prospective employer put him to the test by dictating a series of letters before going out of his office for a drink. Stephens, who had only written down names and addresses, got others in the office to compose suitable letters, which the employer signed without inspecting. He was offered the job, which he managed to retain while he took shorthand lessons.[33]

Of the six candidates Miss Duncan, twenty years a school teacher, received four votes, including those of Mahaffy and Stevenson. (But someone pencilled in the report the words 'Too old'.)[34] None of the 'ladies' was interviewed by the Board, before Stephens was voted to the post by seven votes to four.

From Paris Stephens wrote to Bodkin on 9 July '…That's great news. Me voila content and it certainly was a wise idea of yours. …I hope to the lord you will get the other job when it falls in. I wish you had it now. AE mentioned it in his letter as being practically certain that next year you would be there waving the sceptre and the crown…'[35]

Stevenson wrote a furious letter of protest about Stephens' election, which was entered into the Minutes. Mahaffy went further, immediately resigned from the Board and next day sent a letter to the *Irish Times*. '…I think it right to say that after what was done there at the last meeting,

and still more how it was done, I will have nothing further to do with that Board.'[36] Stephens commented: 'that resigning of his governorship & writing to the papers is a curious, childish petulance for a learned gentleman, qu'il soit damné & the back of my hand to him.'[37]

He wrote to Bodkin on 15 July: '…"Here's a pretty mess, Here's a how de do!" 'You've got to advise me and by your advice I will go. Examinons le position. A director implacably hostile to me, & having under his thumb thirteen subordinates each of whom by a nod and beck & wreathed smile can be enlisted in the same hostility. Mais quelle boite! …Do you see me drawing my meagre screw at the end of one lunar month? But here is the graveman…your position! If I go in will those other baulked senators nourish hatred against you & pickle your rod & proclaim bans and excommunications against you? They may. If they are Mahaffyish they will & next year will be more important than this one is. When I wrote the application I wanted the job; myself & destitution were bowing to each other; but since then things have changed. In a week I will get a decent advance royalty for my now completed manuscript… So I enclose you a billet which…I think you had better forward to the gods…'[38]

The 'billet' stated: 'I regret that circumstances oblige me to withdraw my application for the position of Clerk to the National Gallery'. Bodkin never forwarded it, and after further anxious delay and hesitations on the part of Strickland, it was resolved at the Board meeting on 21 July 'that Mr Stephens be informed that he has been appointed temporary clerk or assistant for one year at a salary of £150 per annum…' So Stephens borrowed £15 from Bodkin and moved his family back to Dublin to a top floor flat in a house in Fitzwilliam Place.

By 20 August Stephens could write to Bodkin: '…The job is going along peacefully so far; I have not yet set foot in the Gallery or seen one of the pictures; and am waiting with interest to see will permission ever be accorded to me to step out of the Clerk's office.' (This was on the third floor, reached by its own staircase.)

Stephens' health was poor; in January 1917 he had debilitating influenza followed by a series of operations. Nevertheless, in times of great difficulty he proved to be an efficient clerk and later Registrar.

Strickland's year as acting Director was a dreary one. No pictures were bought and there were few bequests. Mrs Pemberton of Worcestershire gave a portrait by Henry Munns (1832-98) of white-bearded, long-haired Francis Danby (NGI 770). Another donation was a prosaic portrait by Walter Osborne of Edward Dowden, the recently deceased Shakespearean scholar and Professor of Literature in TCD (NGI 774). The

The Temptation of Adam, 1767-70 by James Barry
(1741-1806), Royal Society of Arts Gift 1915
(NGI 762).

most interesting acquisition, presented by the Royal Society of Arts, was *The Temptation of Adam and Eve* (NGI 762) by James Barry in which a worried looking Adam, posed following John Milton's description in *Paradise Lost* ('amaz'd, astonished…blank while horror chill ran through his veins') listens to Eve.

On Christmas Eve 1915 the Treasury wrote, proposing that the NGI should be closed for the duration of the war. French galleries were closed, and so was the National Portrait Gallery in London. Expense on heat, light and wages, not to mention policing, would be saved. The Board met on 5 January 1916, and directed Strickland to write a strong protest answering each of the Treasury's reasons for closure. The Gallery employed no police except one on Sunday, who could be dispensed with. Since it closed at dusk, no artificial light was used beyond that in the caretaker's room. There could be no saving on heating without injuring the pictures. A Director would have to be retained even if the Gallery was closed, so would a skeleton staff of five; any saving would amount to about £200.[39]

The Treasury accepted the arguments and nothing further was advanced about closure. However, My Lords had another idea. Could not savings be made by having Strickland stay on for another year, continuing with his Registrar's salary and the extra £100 which had already been conceded to him? The Board replied, through Strickland – the letter must have been humiliating for him to have to write – asking 'whether it is open to them to proceed with the appointment of a new Director from June next, should a candidate be found who, in addition to being a suitable person, will be willing to discharge the duties of the position at the reduced salary proposed by H.M. Treasury during the war'.[40]

At the end of March 1916, an advertisement was inserted in *The Times, The Morning Post, The Burlington Magazine, The Irish Times, Dublin Evening Mail, The Freeman's Journal* and *The Daily Independent*:

'The office of resident Director of the National Gallery of Ireland, to which a salary of £500 a year and travelling expenses up to a maximum of £150 was attached before the war, will be vacant in June next. The Treasury has reduced the remuneration for such office of Director to £350 per annum and travelling expenses up to a maximum of £100, both reductions to continue during the war.'

April came. On the evening of Easter Saturday Stephens visited Bodkin, who taught him *The Lark in the Clear Air* ('the loveliest air extant and wonderfully well worded') on an instrument Stephens called a 'dulcimer.' On Easter Sunday Strickland was away in London and Stephens was at the Gallery.

Both Bodkin and Stephens wrote accounts of Easter Week 1916. Bodkin's was complicated by the presence of his fiancée, Aileen Cox, who was visiting from England and had expected to go to the theatre on the evening of Easter Monday. (The Gallery has a delightful portrait of her (NGI 4575) by the English artist, Gerald Brockhurst (1890-1978), presented in 1991 by Mrs Elizabeth Jameson, the sitter's daughter. When Langton Douglas saw it displayed at a London show, he told Bodkin 'there were few portraits better than hers as pictures, and none more attractive.')[41]

On the Thursday after Easter Monday, according to a member of Bodkin's household, 'Tom brought home a lot of bread. He joined the Red+ and went off to the Castle tonight at about 7 pm... Friday – Tom came home. He had a terrible time out all night with the ambulance, the Sinn Feins fired on them even when they had Sinn Fein wounded.'[42] Bodkin's Red Cross armband is preserved with his papers.

Easter Monday was a Bank Holiday, Strickland was still absent, but the Gallery was open and Stephens was at work with his 'dulcimer'. 'After transacting what business was necessary, I bent myself to the notes above and below the stave...' (While he was Registrar, he had time on his hands to write poetry, quarrel with George Bernard Shaw and conduct literary business in Gallery time; a letter about his poems from the editor, Edward Marsh, is in the NGI files.) 'Peace was in the building, and if any of the attendants had knowledge or rumour of war they did not mention it to me.'

At midday he went home to Fitzwilliam Place, noting people standing on the corner of Merrion Row looking towards St Stephens Green. At lunch he was told of a great deal of rifle firing and concluded that 'the Military recruits or Volunteer detachments were practising...' Returning towards the NGI he saw the same crowds at Merrion Row and addressed 'a sleepy, rough-looking man about 40 years of age, with a blunt red moustache, and the distant eyes which one sees in sailors...

'"Don't you know?" said he. And then he saw that I did not know. "The Sinn Feiners have seized the City this morning." '

Later: 'I returned to my office, and decided that I would close it for the day. The men were very relieved when I ordered the gong to be sounded. There were some people in the place and they were soon put out. The outer doors were locked, and the great door, but I kept the men on duty until the evening. We were the last public institution open; all the others had been closed for hours.'

Bodkin would observe: '…when the Rebellion of 1916 broke out, Mr Stephens, who was present in the Gallery at the time, had the public excluded and closed the Gallery. Had he not done this, it is most probable that the Rebels had occupied the Gallery, which commanded the street along which the troops advanced from Kingstown to the city. Had they done so the Collection would have undoubtedly suffered irreparable damage.'[43]

From his third floor office Stephens could hear the shooting from St Stephens Green. 'At five o'clock I left. I met Miss P (Purser); all of whose rumours coincided with those I had gathered. She was in exceedingly good humour and interested.' Later the same day he saw a man shot by the Volunteers at St Stephens Green as he tried to prevent his lorry being commandeered for use as a barricade. 'There was a hole in the top of his head and one does not know how ugly blood can be until it has clotted the hair.'[44]

The Gallery being closed on his own responsibility, Stephens spent the rest of the week touring the city on foot. His vivid observations were collected in his book, *The Insurrection in Dublin*, published later in the year.

In 1982 Dr Brendan O'Brien gave the Gallery a watercolour (NGI 18486) painted at the end of Easter Week by Edmond Delrenne (20th cent.), showing O'Connell Street in ruins. Delrenne, a Belgian refugee offered hospitality by Dermod O'Brien, was standing in a doorway when a man beside him was killed by a stray bullet.[45]

Apart from sympathy conveyed by the Governors to the Royal Hibernian Academy over the destruction of their premises in Abbey Street 'during the late rebellion'[46] there is no other mention of the 1916 Rising to be found in the Minutes.

1 Lady Gregory, *Hugh Lane's Life and Achievement* (London 1921) pp. 216-17

2 NLI ms 10,929. WF Bailey to Lady Gregory, 25 May 1915

3 NLI Purser ms 10,201. Armstrong to Purser, 25 May 1915

4 Minutes of NGI Board, 18 May 1915

5 *ibid.*

6 TCD Bodkin ms 6944-1380

7 Elizabeth Coxhead, *Daughters of Erin* (London 1965) p. 155.

8 Hilary Pyle, *Yeats — Portrait of an Artistic Family* (London 1997) p.70

9 TCD Bodkin ms 6968-22

10 Minutes, 18 May 1915

11 Minutes, 14 May 1914

12 NGI Admin. Box 4. Mayo to Bailey, 28 May 1915

13 TCD Bodkin ms 6944-976

14 NGI Admin. Box 4. O'Brien to Mahaffy, 1 June 1915

15 *ibid.* Bailey to Mahaffy, 21 May 1915

16 NLI Purser ms 10,201. Bailey to Purser, 29 May 1915

17 NGI Admin. Box 4. Bailey to O'Brien, 29 May 1915

18 Minutes, 2 June 1915, quoting Letter from the Treasury dated 29 May 1915

19 Roy Foster, *W.B. Yeats — A Life* (Oxford 2003) vol. 2, p. 21

20 NGI Admin. Box 4. Bodkin to O'Brien, 29 May 1915

21 TCD Bodkin ms 694-976. O'Brien to Bodkin, 31 May 1915

22 NGI Admin. Box 4

23 TCD Bodkin ms 6951-2102. Martin to Bodkin, 17 July 1915

24 Foster (as n. 19) p. 19

25 *ibid.* p. 20

26 *ibid.*

27 Minutes, 21 July 1915. Stevenson to Strickland

28 TCD Bodkin ms 1613. Aileen Bodkin, typescript of 'A Really Nice Man'; Stephens to Bodkin, 16 June 1915

29 Maurice Headlam, *Irish Reminiscences* (London 1947) p. 66

30 NLI Purser ms. Purser to Bodkin, 20 June 1915

31 Minutes, Report of committee as to candidates for the clerkship

32 Minutes, 21 July 1915. Stevenson to Strickland

33 TCD Bodkin ms 1613. Aileen Bodkin, typescript of 'A Really Nice Man'

34 NGI Admin. Box 4

35 Richard T Finneran (ed.), *Letters of James Stephens* (London 1974) p. 167. Stephens to Bodkin, 16 June 1915

36 Mahaffy to *Irish Times*, 8 July 1916

37 Finneran (as n. 35) Stephens to Bodkin, 16 July 1915

38 *ibid.* 15 July 1915

39 Minutes, 5 Jan. 1916

40 Minutes, 26 Jan. 1916

41 TCD Bodkin ms. Langton Douglas to Bodkin, 16 Nov. 1918

42 *ibid.* 7031-18. Account by member of Bodkin household, annotated 'by Emma'

43 TCD Bodkin ms 6961-53

44 James Stephens, *The Insurrection in Dublin* (Dublin 1916)

45 Minutes, 11 June 1982

46 Minutes, 24 May 1916

CHAPTER NINETEEN

THE GALLERY AT WAR

In spite of the reduced salary of £350 per annum, thirty-five candidates replied to the advertisement for part-time Director. Among them was the art historian, Maurice Brockwell, a friend of Lane and Armstrong, and Norman Forbes Robertson, an art dealer, another friend of Lane who had plentiful testimonials, including one from Winston Churchill.

Thomas Bodkin continued to canvas members of the Board. Bailey wrote to Sarah Purser in January 1916: 'AE and others say that Bodkin would make a very good Director. What think you?'[1] Bodkin had confided his ambition to become Director to Stephens, whose wish was 'to be with you among the daubs.'[2] When Stephens and Bodkin met on the evening of Easter Saturday 1916, they had discussed Bodkin's aspirations; Stephens, according to Bodkin 'was most honestly hopeful of my getting the Gallery and most optimistic, though without reason or cause, about my chances.'[3] But Bodkin hesitated, because by then he knew there was a very strong candidate indeed. This was Robert Langton Douglas, scholar and art dealer.

Later Bodkin would claim that he stood down for Douglas. 'Shortly before the date fixed for the election of a Director the late Provost Mahaffy paid me a visit and showed me a letter from Captain (then Mr) Langton Douglas…stating that he intended to apply for the post…I knew of his deservedly great reputation as a critic of certain periods of Italian art, and…I concluded that he would be an eminently suitable person to be appointed Director, notwithstanding the fact that he was a professional dealer on a large scale. I accordingly wrote to the Board withdrawing my candidature.'[4] This extract is from a letter written from Bodkin to the Board in June 1923, which detailed Douglas's misdemeanours, but since it contains inaccuracies, his withdrawal may have been less gracious than he implied.

His account to WB Yeats of Douglas's appointment glossed over the fact that he had sought the position very soon after the *Lusitania* tragedy.

He told Yeats that Douglas 'owed his appointment largely to the efforts made on his behalf by you and Lady Gregory…I had lodged an application for the post. I only did so after a year had elapsed from the death of Sir Hugh Lane and under pressure of a number of Governors who thought I was a fitting person to be appointed; and I withdrew my name the moment Captain Douglas was mentioned.'[5]

Purser sought the best advice. 'I don't think you can do better than Langton Douglas for the Gallery', Walter Armstrong considered. 'He knows a lot, and judging by the things he has bought and the house I have seen him in, he has good taste.'[6] Alec Martin wrote to Ruth Shine, in a letter forwarded to Purser: 'I want to be fair to Bodkin… but of course there is no comparison between him and Douglas.'[7]

Douglas's letter of application, sent on 18 April 1916, included details of his many publications, including his study of Fra Angelico and his *History of Siena*. He added: 'I wish to carry on, as far as my powers permit, the work of Sir Hugh Lane, and to hold the office in the same condition as he held it.' This implied that, like Lane, he would work as a part-time Director and also carry on as a dealer. He mentioned his successes: 'I need only refer to twelve now well-known Rembrandts – of which seven were discovered by me; Giovanni Bellini's *St Francis of the Desert* which I also rediscovered; Roger van der Weyden's great triptych, now in the Louvre, and his portrait of Lionello d'Este; two Holbein portraits and three examples of Velasquez.'

He added: 'If I am appointed I shall suffer pecuniarily. But I would gladly sacrifice a considerable portion of my present income in order to continue the work of the late Director; as it has always been my ambition to devote myself some day to the work of developing and enriching a great public collection.'[8]

He also told the Board: 'I have good private means; and I am not seeking an income.'[9] This was not true. He needed all the money he could earn to support an ex-wife, a mistress and children. He loved children and fathered 'fifteen or so'.[10] In February 1919, congratulating Bodkin on the birth of a daughter, he wrote: 'I think you are a lucky man. I always like to have babies in my house; and it pains me to think that my youngest daughter is nearly seven.'[11]

His very youngest daughter, Dr Claire Douglas (born in 1933, and briefly married to JD Salinger) described her father as 'a sensualist, a spendthrift and an obstinate, angry and untactful man.'[12] His second wife wrote to Bodkin in 1934 when another row appeared to be looming: 'you will understand that I mean no disloyalty when I say that he is a veritable

Robert Langton Douglas (1864-1951), fifth Director
(1916-23), in Captain's uniform, c.1916 (NGI Archive).

genius at antagonising his friends.'[13] His enemies included Bernard Berenson, Roger Fry – and Lane. Ruth Shine wrote to Purser: 'he was not a friend of Hugh's, I do not think they were in sympathy.'[14]

And yet he had charisma and charm. Among his numerous friends was Paul Verlaine, who gave him an inscribed copy of his poem *Sagesse*. His Irish friends included AE and George Moore; he was an intimate companion of William Orpen[15] and on good terms with WB Yeats, who in 1923 would 'greatly regret Douglas's resignation'.[16] The warm relationship he developed with James Stephens would be at the expense of Thomas Bodkin. After the harsh quarrels, Aileen Bodkin could still describe Douglas as 'personally a great dear.'[17]

Douglas and Lane had something else in common besides being dealers; both were sons of clergymen. Douglas's father had attended Trinity College, Dublin, his only connection with Ireland. Born in 1864, like his father Douglas took holy orders, and served for a time as chaplain in Italy. His decision to leave the church, compounded by his marriage difficulties, was also due to his increased interest in art, particularly early Italian Renaissance and Sienese painting. He read German, French and Italian. Aileen Bodkin described him as 'a really scholarly art-historian – far greater in that particular respect (i.e. profound scholarship as opposed to natural flair to the power of genius) than his predecessor, Hugh Lane.'[18]

In 1904 he became a dealer. 'I found I could not educate my sons and fulfil my obligations with what I was able to earn by writing and lecturing.'[19] Among his clients were JP Morgan, John G Johnson who enriched the Philadelphia Museum of Art with paintings bought through Douglas, and the Metropolitan Museum of Art, New York. He attended the same auctions and cultivated the same wealthy clients as Lane.

He had had previous dealings with the NGI. In 1906 he sold Armstrong a portrait (NGI 576) by Adriaen Thomasz. Key (c.1544-after 1589) which had belonged to Lord Powerscourt. Three years later he sold the Gallery the *Virgin and Child* (NGI 603) which would be recognised as by Paolo Uccello.[20]

The Minutes of the meeting on 24 May 1916 record the Governors' interview with Douglas prior to his appointment. He agreed 'to be on the same terms as those under which Sir Hugh Lane was appointed, that is, without pension on the termination of his appointment, and on the temporarily reduced salary; also that he should have a residence in or near Dublin.' (He never did; like Lane, he continued to live in London.) He withdrew, and the Board voted unanimously that he should take up the Directorship from 3 June 1916.

At the same meeting the complications arising from Lane's will and the codicil were discussed. A letter from the Treasury Solicitor was read out, requesting the views of the Governors on Sir Hugh Lane's legacy. Douglas was asked to draw up a report in which he picked out forty-one of the best of Lane's Old Masters, reporting back at the next meeting on 7 June 1916.

This was the first meeting to be recorded in Stephens' handwriting, as Strickland had kept the Minutes up to the time of his departure. The Governors passed a somewhat lukewarm resolution, placing on record 'their sense of the services rendered to the Gallery by Mr Strickland.'

At this stage the Governors resolved to claim the portrait of Lane by the American artist John Singer Sargent (1856-1925), all the pictures lent to the Belfast Art Gallery, and all the paintings lent to the National Gallery in London. They considered they had a right to them as residual legatees. The paintings chosen by Douglas at the Board's request were to be excluded from the sale of Lane's effects and absorbed into the NGI collection, and a resolution to this effect was passed on 7 June 1916.

The decision to apply to the courts for retention of forty-one of Lane's pictures was the first matter to divide the Board and the new Director. Douglas wished to follow Lane's wishes to the letter and sell all the paintings in Lindsey House, buying others which would be of his own choosing. In a letter to Dermod O'Brien he put forward arguments about Lane's stated wish to dispose of the pictures. He complained that 'we are

not carrying out Sir Hugh Lane's solemnly expressed wishes' and quoted Lane's various testaments: 'It was obviously the intention of Sir Hugh Lane, when he signed his will in October 1913, and also when he wrote, with his own hand, the codicil of his Will on 3 February 1915, that all his pictures by Old Masters which are at Lindsey House should be sold. The last paragraph of his Will contains these words, "I bequeath the remainder of my property to the National Gallery of Ireland, to be invested, and the income to be spent in buying pictures of deceased painters of established merit."'

Having made the moral point ignored by the Board, Douglas proceeded to compromise, proposing to retain a number of the pictures. '(1) Pictures in a reasonably good state which are valued at more than a thousand pounds each, and which are by masters who would otherwise not be represented in the Gallery; as well as (2) pictures of special interest for Ireland, and (3) genuine pictures of good quality of the early Italian and French schools, which are by masters whose works rarely come into the market.'

In Douglas's opinion, the National Gallery of Ireland required paintings to fill up the gaps in the different schools, and not just what he considered dealer's stock ('for the most part pictures bought to sell on foreign markets.') He concluded that 'in a Gallery like ours, where so many important masters are wholly unrepresented, a wise Director would not, in any case, recommend the retention of average works by masters already represented.' After the war there would be 'great opportunities of buying cheaply good pictures by important masters who are not represented in any way in our Gallery.'[21]

The argument was lost at the next Board meeting.[22] 'Proposed by Mr Bodkin, seconded by Miss Purser, that the Resolution of 7th June 1916 directing the exclusion of 41 pictures from the sale of Sir Hugh Lane's effects be reaffirmed.' Two months later the Chief Crown Solicitors affirmed that there was no legal reason why these pictures should not be retained.[23] It might be argued that London's determination to keep the Lane pictures in spite of Lane's 1915 codicil was ethically no worse than the Board blatantly ignoring the provisions of his earlier will.

There was a further theoretical reason for retaining the pictures. Bodkin (by now a member of the Board) put forward the possibility that money realised from their sale might be deemed a trust fund, which meant that only the income could be used for future purchases, and curtailing the power of the Board to use the money as it might wish.

The author and publisher, Grant Richards, an executor of Lane's will, had declared that 'it is quite certain that the Gallery could never buy

such good pictures again with the money they would have at their disposal.'[24] Douglas wrote to the Chief Crown Solicitor contradicting this statement, sending a copy to Bodkin, accompanied by a letter, dated 7 November 1917, which was tactless, considering Bodkin's admiration for Lane. 'That is a silly statement of Grant Richards...it can be so easily disproved. I have only to give a list with prices of the pictures that I have bought in the last year. No one admires Sir Hugh Lane's gifts more than I do...But I cannot admit that he was pre-eminent as a discoverer and purchaser of Old Masters for I know well that (1) I bought in the ten years preceding his death far more important examples of Old Masters than he did and (2) I bought them at relatively lower prices.'[25]

Douglas felt that the NGI was relatively strong in the English and Dutch schools, while other schools were weak, if not absent altogether. Lane had made a habit of having numerous eighteenth-century English portraits in his stock, since they were popular among the *arrivistes* who made up much of his clientele.[26] Among the forty-one paintings were four Gainsboroughs, including the lovely *Mrs Horton* (NGI 795) which meant that the Gallery would have nine paintings by the artist, including the two that Lane had presented in 1914. The Romney of *Mrs Edward Taylor* (NGI 789) which Lane had cleaned himself, had been bought in February 1913 and remained unsold at his death, although it was the sort of portrait that his clients liked. Among other paintings from the selection of forty-one, those by Rembrandt, Greuze, Stubbs, Bordone, Constable and Poussin have failed more recent scrutiny.

Douglas's ideas were ruthless. He would have sold Lawrence's statuesque *Lady Elizabeth Foster* (NGI 788), bought back from Arthur Grenfell. He would also have disposed of the Frans Snyders *Banquet Piece* (NGI 811), Hogarth's *Mackinen Children* (NGI 791), and *Juno Confiding Io to the Care of Argus* (NGI 763) by Claude Lorrain. (In 1981 this painting would be complemented by another beautiful Claude Lorrain, *Hagar and the Angel*, which Lady Dunsany presented to the Gallery on a long term loan, NGI 14683) He considered the painting of *A Boy Standing on a Terrace* (NGI 809) by van Dyck 'a very poor picture that does not at all represent the Master'.[27] Nor did he like Titian's portrait of *Count Baldassare Castiglione*, the author of *Il Cortegiano*, the Renaissance handbook on good manners (NGI 782): 'so little of the original picture remains, and there is so much repaint upon it, that it has scarcely the character of a genuine work.'[28] Lane had bought it

Detail of *Juno confiding Io to the Care of Argus*, 1660 by Claude Lorrain (1604/05-82), Lane Bequest 1918 (NGI 763).

from Colnaghi in London in November 1913 for £11,000 and it had taken its place on the famous easel at Lindsey House where guests enthused over it.[29] But Douglas, who had sold the picture to Lord Mansfield before Lane acquired it, wrote to Purser: 'When I first saw it, the whole of Castiglione's clothes had gone for ever. The background, too, had been tampered with. Only on the face, and in the landscape background, did the original surface remain, and here there were some spots.'[30] This was the result of harsh cleaning in the past.

Purser ignored him, and called in experts, who were all in favour of the retention of the picture. They included Charles Ricketts, who had written a critical biography of Titian; Douglas unwisely claimed his 'argument is simply tosh.' Moreover, Alec Martin forwarded a letter to Purser from Robert Ross, who suggested that 'if the Titian is sold, the incident would alienate a great many English people who sympathise and are at present ready to support the Dublin claim to the French collection of Lane.'[31] So Douglas was overruled, and with some reservations the Titian is accepted as by the master.[32]

For the period of the war, with no grant-in-aid and nothing yet from the Lane Bequest, there was no money for buying paintings. In a letter to Bodkin dated 30 March 1918, Douglas lamented: 'I could have wept with rage at the Colthart sale and the Blake sale when I saw our rivals, with pockets full of money…bidding as they liked…"Another picture for Canada!" "Another picture for Melbourne!"'[33] By the time this letter was written, Bodkin and Douglas had fallen out.

From the start, Bodkin's resentment over Douglas's appointment was obvious to many people. In October 1916 Lady Gregory, who, together with Yeats, disliked Bodkin, wrote in her journal how 'T.Bodkin…who wanted to be made Director of the Dublin National Gallery (quite incompetent), has a good many stones in his sling. He had brought one of the N.G. (Dublin) trustees, fat Mr Waldron who, when he saw the Titian portrait of Baldassare, asked if it was by Lancret (he, Bodkin, told me none of the Trustees know anything at all about pictures) and he spent his time telling Waldron little spiteful things about Langton Douglas, the new Director, an unpopular man, but a real expert.'[34]

After Douglas's resignation in 1923, Yeats reproached Bodkin. 'I think I ought to be entirely candid. I have something against you…that having been Douglas's rival for the post of Director, and being his possible successor, you spoke against him (I am not thinking of anything said at any meeting of the Board, of which I know little or nothing)…Perhaps twice or thrice I have spoken of my dislike for this action of yours, and I think

that upon each occasion I said that I did not think your action was in any way calculated.'[35]

Bodkin and Douglas had started out on good terms. Douglas had gone out of his way to assist Bodkin when William Bailey died suddenly in April 1917. In the same week, with his customary promptness, Bodkin was writing to Douglas: 'You may have heard that poor Bailey has just died and so created a vacancy on the Board… I would very much like to be nominated to succeed him. Waldron would, I know, support my candidacy strongly; and I fancy all the other Governors would be favourably disposed. Lane's reference to me in his codicil ought to carry some weight.'[36]

Douglas replied immediately: 'I wrote before I received your letter to the secretary of the Lord Lieutenant and to two members of the Board, saying that you were the best man for the position.' Two weeks later he told Bodkin: 'I have written to Mr Dale a long, and, I hope, persuasive, letter, demonstrating how important it is that you should be appointed to the Board rather than some official political and social personage who knows little about art and is not very keen about the development of the Gallery and art education in Ireland.'[37] Bodkin was appointed and put to work as liaison between the Crown Solicitor, Attorney General, Lady Gregory and Mrs Shine concerning the retention of the forty-one pictures.

Bodkin must have been aware the Director's burgeoning friendship with James Stephens. Because of Douglas's frequent absences, Stephens' role as clerk, and later as Registrar, was as essential to the smooth running of the Gallery as Strickland's had been while Lane was away. The correspondence between Douglas and Stephens indicates not only how much Douglas relied on Stephens, but more than that, common ground and true affection between the two men.

When in Dublin, Douglas stayed at the Shelbourne Hotel, where he entertained lavishly. 'Wednesday night. Shelbourne Hotel. My dear Stephens… I am very grateful to you for your very active and sympathetic help in this hustling worrying fortnight…I do not expect that that you will care to get out of bed so early and please do not do so unless you feel that you want to get out of bed. But if you are up and about please call here at eight and come with me to the boat.'

'…17 October 1917. My dear Douglas…I am glad you are pleased with the Joyce book or booklet. It is published now ten or twelve years and some of the lyrics in it are, I think very beautiful. But his vein is thin… Yours very truly J.S.'

'16 February 1918…I wrote to you yesterday acknowledging the Chinese poems. I was very glad to get them and they are, as you say, great. Good luck to you and yrs. Seamas has the mumps.'

'18 November 1918. My dear Douglas, We have just received a basket of grapes with your card enclosed. Each grape as big as a cathedral bell and of a sweetness such as grape never had before. You are a brick and we both tender you our thanks and our profoundest salaams. Yours always, J.S.'[38]

Only a few years before, Stephens had been writing to Bodkin thanking him in similar style for gifts received. For the present Stephens continued his long friendship with Bodkin. In October 1916 Lady Gregory visited Stephens in Fitzwilliam Place, who was giving a reading of his 'Tain' stories. She recalled AE's description: 'quite like a little gnome, wetting his fingers at his mouth to turn each page, his face lighting up with the glory of the page.' Present was 'T Bodkin and a young man "who had been in the Post Office" (at the Rising). I asked him if he had shed blood or had his been shed, and he said his had not been shed.'[39]

In the same month Stephens gave Douglas a copy of *The Insurrection in Dublin* which he inscribed: 'To Langton Douglas from James Stephens, October 10 1916.' Douglas replied, 'Your book arrived today and I have already read it through. I could not lay it down…Today I went to Lindsey House, to confer with Lady Gregory, Mrs Shine and Yeats about the Lane pictures that are claimed by the British National Gallery. We shall have to fight for them. I wish that the Trustees of that National Gallery, who are adhering so strictly to what they conceive to be their legal rights, would read page 77 of your last book.'[40]

On page 77 of *The Insurrection in Dublin* Stephens had written: 'The fault lies with England – we are a little country and you, a huge country, have persistently beaten us – no nation has forgiven its enemies as we have for-given you, time after time down the miserable generations, the continuity of our forgiveness only equalled by the continuity of your ill treatment.'

Douglas was too much of a patriotic Englishman to agree fully with Stephens' Republican ideals. A letter to Bodkin in early 1918 supported conscription. 'Ireland's honour demands that she should conscript her-self…If Ireland does not help England to the uttermost in the struggle – however much she disapproves of England's policy in other matters – then Ireland is acting like a cad. I, as a Nationalist, am disgusted at the…illogical attitude of the Nationalist part. It is as unreasonable as the action of the Unionist who…has nothing to offer Ireland save force and injustice.'[41]

He had three sons fighting the Germans, one of whom was killed. Another eventually became Air-Marshal Sholto Douglas; in July 1918, his father told Bodkin, 'he recently attacked a Hun aerodrome flying very low. He has been given the Croix de Guerre with palms.'[42]

Douglas himself was a volunteer soldier. When the war broke out in 1914 he was over fifty. He dyed his hair, gave his age as forty and enlisted. It was not necessary then for a private to produce a birth certificate. He joined the Royal Fusiliers and marched with his comrades singing 'Tipperary.' Later he was given a commission, served in France and obtained a post at the War Office.[43] For the rest of his long life he would call himself Captain.

His army service did not prevent him from continuing his business as a dealer. Nor did he see that it would interfere with his appointment as Director of the National Gallery of Ireland. In his letter of application (NGI Archive) he wrote of his position at the War Office: 'My special work there is now nearly finished; and, if I should be appointed to the Directorship, I can either have indefinite leave without pay, or, if it is necessary, I can relinquish my commission.'

The Board, however, soon discovered that his country needed him. In October 1916 the Governors were called upon to resolve 'that, in view of the request of the War Office, the Director be permitted to take up duties at the War Office in addition to those which he is discharging as Director of the National Gallery of Ireland for a period limited to three months from the 15th October 1916.'[44]

Two months later Douglas was writing to the Board: 'My commanding officer at the War Office is anxious that I should continue to work with him for another three months at least…I am sure…that every member of the Board will agree that, if I can do a good job in the army, I ought to do it. Men of my age are especially wanted at the War Office when the younger men there are, very rightly, being sent overseas.'[45]

Although he relinquished his commission in July 1917, he continued to work at the War Office. Throughout the rest of the war he was absent from Dublin for much of the time, and Stephens had to do much of the running of the Gallery. A letter from Stephens to Bodkin in October 1917 gives a flavour of Douglas's brief visits. 'Gallery. October 25 1917…The Director (RLD) is staying such a short time and has to fly around so much during that stay that he wants to meet me tonight to go into Gallery business.'[46] Douglas thought it sufficient to arrive in Dublin a few days before a Board meeting, see what there was to be done, attend the meeting and then go back to London to his work at the War Office, as well as his dealing.[47]

When Stephens was ill, the daily running of the Gallery fell on others. In February 1917, when he had influenza and underwent a series of operations, Sarah Purser took over; Douglas wrote to her: 'it is very good of you to help us in this way. You will find Teskey [the chief attendant] invaluable.'[48]

Later Bodkin would be in charge, as he explained in a letter to the Treasury at the end of 1920. 'Mr Stephens, the Registrar of the National Gallery, has been very ill for the last week or two, and has just undergone a severe operation. The Director of the Gallery is at present abroad. At his request I am attending as far as I can to the affairs of the Gallery... As soon as Mr Stephens was allowed to see visitors I brought him your letter...Mr Stephens asks me to say that (1) Treasury authority for meeting the excess on Subhead A from savings on Subhead D and war bonus vote has never been sought...(2) The saving affected under Subhead D was due to rigid economy...(3) The Paymaster General has been instructed to pay the £2. 2s. 9d. Exchequer Extra Receipts...'

The affairs of the Gallery could be tedious. Bodkin would have had to file a letter from the Exchequer and Audit department three weeks later. 'By an oversight the amount received from 'Lavatories' in 1918-19 was treated as £1. 5s. 5d. instead of £1. 5s. 6d. Will you therefore please note that the amount of £1. 5s. 6d. should be shewn as due to be paid into the Exchequer in respect of 1918-19.'[49]

Douglas's absences became increasingly annoying, as illness ('I deeply regret that owing to an attack of bronchitis and sore throat, I am unable to attend the meeting of the Board. I enclose a medical certificate'[50]) or, once, toothache, were used as excuses. Twice, he agreed to represent the Board as judge of the Taylor art scholarship and twice he announced at the last moment that he would be unable to be present. The Board had justification in amending Bye Law 9 in October 1919: 'The Director shall reside in Ireland for at least 120 days in each year which need not run concurrently. He shall not absent himself from the Gallery for a longer period than three months at a time without the express permission of the Board.'[51]

Perhaps such absences may be blamed for the NGI overlooking two important dispersal sales of big houses. The contents of Killua House, auctioned on 2 June 1920, included '200 oil paintings of the highest importance, embracing examples by esteemed Masters of the early Flemish, Italian and Dutch schools.' In November the contents of Charleville Castle were sold off; they included a set of five views of the demesne by William Ashford, sold for £18.[52] They had been on view at the 1801 Exhibition of the Society of Artists at Parliament House where a viewer

observed: 'There is here abundant scope for an exertion of the artist's genius in the delineation of foliage. The articulation is perfect, and the colouring so beautifully rich, and various, that I could with pleasure have spent hours in viewing them.'[53] One of the five, *The River in the Demesne at Charleville* (NGI 4045) was eventually acquired by the NGI in 1972 for a considerably greater sum (£2,500).

According to Denys Sutton, Douglas did spend some time in Dublin with his family; his children remembered staying at seaside resorts close to Dublin and that he sat for his portrait to Patrick Tuohy (private collection). In 1959 this portrait was offered for purchase by Miss B Tuohy, but declined,[54] possibly an indication of lingering resentment by a later Board for an unpopular Director.

If the anecdote told by Denys Sutton is true, the Board had reason to feel irritated. After a good lunch in Jammets, Stephens and Douglas repaired to a room above a shop where Stephens endeavoured to teach the Director the violin. Time passed, and they forgot about the Board meeting they both should have been attending.

In 1923 Bodkin wrote an undated memorandum addressed to the Board, listing Douglas's faults as a Director – his neglect in writing any catalogue, providing postcards for the public to buy, or writing newspaper articles about acquisitions. Nor did he glaze important pictures.[55] (Glass continued to be an important protection from the coal fumes rising from the basement furnace.) He made no effort in arranging for lectures. Bodkin wrote: 'I myself volunteered to deliver on Saturday afternoons a course of popular lectures in the Gallery…the Director shelved the proposition. Possibly his reason for doing so was a disbelief in my competence, though I have been honoured with invitations to lecture on art by almost all the learned societies in Ireland.'[56]

Douglas had written to the Chairman of the Board in February 1917, saying that, like Lane, he wished to give his salary as Director to the Gallery[57] but there is no evidence that he ever got around to doing so. His picture dealing, like that of Lane's, suffered because of the war. He wrote to Bodkin, contrasting his position with Lane's: 'In one respect I am at a great disadvantage at present. I have to sell my 'finds' quickly, as I am not a bachelor and I have several relations wholly or partly dependent on me.' It was imprudent of him to mention in the same letter that he had bought 'a beautiful and important example of Giovanni Bellini for less than £400.'[58] He also boasted about this 'Bellini' to the Chief Crown Solicitor. As Bodkin would point out, this picture was never offered to the NGI.[59]

During his Directorship Douglas's personal gifts to the Gallery were meagre – a dull portrait of the poet Thomas Moore (NGI 775) by Martin Archer Shee and James Arthur O'Connor's *View of the Devil's Glen* (NGI 825), one of 'four charming O'Connors' bought early in 1918, which remained unsold until he presented it to the NGI in 1919. In a letter to Stephens on 31 October 1917, he wrote 'I bought a fine picture by Lawless at the Colthart sale yesterday. I had to give a good deal for it! Serving Ireland is like serving God.' He wanted to present the NGI with this 'unusual example of Irish Pre-Raphaelitism'[60] – *The Sick Call* (NGI 864), depicting a priest carried in a boat to administer to a dying man, by a gifted Irish painter who died young (Matthew Lawless 1837-64) – but he never felt that he was in a position to do so. For a time he lent it to the Gallery, and after he resigned his Directorship he sold it, through Lucius O'Callaghan, to the NGI for £250 in 1925.[61] *An Actor between the Muses of Tragedy and Comedy* (NGI 862) and portrait of two little girls, probably his nieces (NGI 863) by Thomas Hickey (1741-1834) went through a similar progression – lent to the Gallery by Douglas in 1917 then sold in 1925, for £220 and £100.

The Board was made extremely uneasy by Douglas's policy of selling to the NGI pictures which he owned himself. Such behaviour contrasted badly with Lane's great generosity. In his memorandum Bodkin detailed the contrasting fates of two pictures from the collection of Sir John Robinson. One was *Jael and Sisera* (NGI 667) by Pedro Núñez del Valle (early 1590s-c.1657) bought by Lane, as by Jacinto de Espinosa, after an auction in 1913 for £40 and presented to the NGI in June 1914. The other was a panel of the *Virgin and Child with St Anne* (NGI 818) by Alejo Fernández (c.1475-1543), bought at the same time by Douglas; in the following four years he would be unable to sell it to any of his clients. Bodkin wrote that it was in 'poor condition.' In 1918 Douglas sold it to the Gallery; the sum mentioned in the Director's Report is for £1,000, but the cheque stubs which were used for money for the newly released Lane Fund reveal that he was paid £1,231.[62] This was a huge amount, although, according to Denys Sutton, he treasured the painting, and considered he was quite fair to let the NGI have it at cost price. (Robinson had claimed wildly that *Jael and Sisera* was by Velázquez and the Alejo Fernández is today considered by a follower, which does not say much for the taste and knowledge of the Keeper of Pictures at the Victoria and Albert.)[63]

Over the years Douglas would lose the confidence of the majority of Governors and Guardians. Arguments over his behaviour have clouded his achievement in dealing with the huge problems presented by Lane's complicated legacy.

1 NLI Purser correspondence. Quoted in
 John O'Grady *The Life and Work of Sarah Purser*
 (Dublin 1996) p. 125

2 TCD Bodkin ms 1613. Aileen Bodkin,
 typescript of 'A Really Nice Man'.
 Stephens to Bodkin, 16 June 1915

3 TCD Bodkin ms 7013-9. Bodkin's account of
 Easter Week

4 TCD Bodkin ms 6961-81. Bodkin's
 memorandum on Douglas's
 misdemeanours, undated but June 1923

5 TCD Bodkin ms 7130-1. Bodkin to Yeats,
 early July 1923

6 NLI Purser correspondence 10201.
 Armstrong to Purser, 24 May 1915

7 NLI Purser correspondence. Quoted
 O'Grady (as n. 1)

8 NGI Admin. Box 4. Letter of application
 from Robert Langton Douglas, 18 April 1916

9 *ibid.*

10 Margaret A Salinger, *Dream Catcher -
 A Memoir* (New York 2000) p. 11

11 TCD Bodkin ms 6961-38. Douglas to Bodkin,
 1 Feb 1919

12 Claire Douglas, letter to *The New York Review
 of Books*, 16 July 1987

13 TCD Bodkin ms 6961-116. Jean Douglas to
 Bodkin, undated 1935

14 Quoted O'Grady (as n. 1) p. 125

15 Denys Sutton, 'Robert Langton Douglas',
 Apollo (June 1979) p. 157

16 TCD Bodkin ms 1731-2. Yeats to Bodkin,
 7 July 1925

17 Bodkin (as n. 2)

18 *ibid.*

19 Sutton (as n. 15) p. 103

20 Director's Reports 1906 and 1909

21 NGI Admin. Box 4. Douglas to O'Brien,
 24 June 1917

22 Minutes of NGI Board, 2 July 1917

23 Minutes, 3 October 1917. Letter from Chief
 Crown Solicitors, 19 Sept. 1917

24 Douglas to Chief Crown Solicitor.
 Quoted Sutton (as n. 15) p. 159

25 TCD Bodkin ms 6961-7. Douglas to Bodkin,
 2 Nov. 1917

26 Robert O'Byrne, *Hugh Lane's Legacy at the NGI*
 exh. NGI 2000, p. 9

27 NGI Admin. Box 4. Pictures belonging to Sir
 Hugh Lane's Estate that it is now proposed
 to exclude from the Sale, in order that they
 may be taken over by the Governors of the
 National Gallery of Ireland (Annotated by
 Douglas)

28 *ibid.* Douglas to O'Brien, 24 June 1917

29 Lady Gregory, *Hugh Lane's Life and Achievement*
 (London 1921) p. 175

30 NLI Purser correspondence 10201.
 Douglas to Purser, 15 Aug. 1917

31 Quoted O'Grady (as n. 1) pp. 128-29

32 Raymond Keaveney in *European Masterpieces
 from the NGI*, exh. Australia and NGI 1994-5
 p. 24 cites relevant literature

33 TCD Bodkin ms 6961-16. Douglas to Bodkin,
 30 March 1918

34 Lady Gregory, *Journals* (ed. Daniel J.
 Murphy), (Gerrards Cross 1978) vol. 1, p. 6

35 TCD Bodkin ms 1733-2. WB Yeats to Bodkin,
 14 July 1923

36 NGI Admin. Box 4. 17 April 1917

37 TCD Bodkin ms 6961-24

38 NGI Admin. Box 4. Correspondence
 between Douglas and Stephens

39 Gregory (as n. 34) p. 53

40 NGI Admin. Box 4. Douglas to Stephens,
 12 Oct. 1916

41 TCD Bodkin ms 6961-19

42 TCD Bodkin ms 6961-24

43 Sutton (as n. 15) p. 146

44 Minutes, 4 October 1916

45 NGI Admin. Box 4. 5 Feb. 1917

46 TCD Bodkin ms 1613

47 Sutton (as n. 15) p. 160

48 NLI Purser correspondence 10201.
 Douglas to Purser, 23 Feb. 1917

49 NGI Admin. Box 4

50 *ibid.* Douglas to Chairman of Board of
 Governors, 5 Feb. 1917

51 Minutes, 22 Oct. 1919

52 Cynthia O'Connor, 'The Dispersal of the
 Country House Collections of Ireland',
 Bulletin of the Irish Georgian Society, vol. 35 (1992)
 pp. 38-47

53 Anonymous diarist. Quoted Fintan Cullen
 (ed.) *Sources in Irish Art* (Cork 2000) p. 241

54 Minutes, 2 Dec. 1959

55 TCD ms 6961-81. Bodkin's memorandum on
 Douglas's misdemeanours

56 *ibid.*

57 NGI Admin. Box 4. Douglas to Chairman of
 Board of Governors, 5 Feb. 1917

58 *ibid.*

59 Bodkin ms (as n. 55)

60 Sutton (as n. 15) p. 162

61 Director's Report 1925

62 NGI Admin. Box 4. Cheque stubs from the
 Lane Fund made out to Robert Langton
 Douglas

63 Rosemarie Mulcahy, *Spanish Paintings in the
 NGI* (Dublin 1988) pp. 56-60 (Núñez) &
 7-8 (Fernández)

CHAPTER TWENTY

HUGH LANE'S LEGACY

Among the difficulties arising from Lane's legacy were squabbles with the Municipal Gallery and its Director, Mrs Ellen Duncan, who had been appointed by Lane. It was agreed that the NGI should lend the portrait of Lane by his friend, the American artist, John Singer Sargent (1856-1925) to the Municipal Gallery for twenty years, but the latter institution has kept it. On Mrs Duncan's insistence, a number of pieces of sculpture by Maillol, Rodin and others were excluded from any sale of Lane's works of art and deposited with her on loan. Advised by Sir Alec Martin, she also claimed a number of pictures and drawings. A conciliatory letter to Douglas expressed the hope that 'whatever the issue, it won't affect our friendly feeling... I feel quite sure that our aims are the same *au fond* and wish for nothing more than that the two galleries should work together happily.'

Writing from Harcourt Street, she added: 'I don't know whether I told you that this Gallery is rather a popular place of resort. We have, I think, a good many more visitors than the National Gallery, partly because we are in a more central thoroughfare, but chiefly I think because many people like and understand modern pictures better than Old Masters.'[1] Her put-down is enhanced by remembering that the NGI's location had been mooted yards away off Harcourt Street.

In addition to the sculpture, she got sixty-five pictures for the Municipal Gallery, also excluded from the sale of the Lane estate. They included landscapes by Corot and Boudin, a Daumier and paintings by William Orpen, Augustus John and Wilson Steer, works that would have found a place in the NGI alongside any Old Master.

Another problem for Douglas and the Board arose from a commit-ment made by Lane before his death. In April 1915, Christie's had held an art auction in aid of the Red Cross, during which Lane pledged to pay £10,000 for a portrait to be painted by Sargent. While he was in New York, Lane tried unsuccessfully to find another benefactor to take on this colossal commission. However, since he had sold the Red Cap Titian, he

Woodrow Wilson (1856-1924), President of the United States, 1917 by John Singer Sargent (1856-1925), commissioned as part of the Lane Bequest (NGI 817).

was in funds, and before he boarded the *Lusitania* he sent a telegram affirming that he would keep his promise.

After his death the NGI Governors were reluctant to honour 'Sir Hugh Lane's alleged debt' but, having taken legal advice, discovered that they would indeed have to pay the £10,000 to the Red Cross. They set about finding a sitter for Sargent; at least they would have one of his paintings.[2] John Quinn told Lady Gregory that Lane had been considering Queen Mary or Princess Patricia of Connaught. But on Sarah Purser's advice it was decided that the American president, Woodrow Wilson should be chosen, and Douglas, a friend of Sargent, thought the idea 'excellent.'

The Red Cross was paid, the portrait was painted, and after being shown at various American museums, was put on show in the Gallery early in 1919 (NGI 817). It was a disappointment. Douglas wrote to Sarah Purser:'that man is a typical, nonconformist parvenu.'[3] Lady Gregory thought it 'a waste of £10,000…a commonplace man sitting, as Gogarty says, 'like a dentist' (I should say a doctor) ready to put his hand to the telephone.' Gogarty said that Sargent 'ought to have been commissioned to paint James Stephens' and Lady Gregory replied: 'It would have been worth the £10,000 to see Mahaffy's face had that been proposed at the National Gallery Board…'[4]

Although the matter of the paintings seized by the National Gallery in London did not affect the NGI directly, Douglas strongly supported their return to Ireland. He sent a message to the public meeting at the Mansion House in Dublin on 29 January 1918, protesting at the behaviour of the London National Gallery, which united a spectrum of opinion ranging from Michael Collins to Lord Powerscourt: 'Ireland's moral right to them is incontestable. I have discussed this question with many English members of Parliament and with English connoisseurs and men of letters; with but one or two exceptions they are all of the opinion that England ought to return these pictures to Lane's native country.'[5]

The 'one or two exceptions' included Sir Alec Martin, who in his affidavit declaring his opinion on Lane's wishes, affirmed 'personally I should have seen the pictures placed in London rather than in Dublin.' There was a general feeling in London, where people tended to be anti-Irish because of the political situation, that a philistine provincial capital like Dublin had been rewarded quite enough by Lane's legacy to the NGI.

Douglas may have disagreed with the retention of the forty-one Lane pictures for the NGI which he (and Lane) had wanted to be sold, but once he had been overruled by the Board, he took advice and drew up a list with an estimate of their value. Because of the depressed state of the art

Portrait of a Young Woman with a Glove, c.1632 by
Rembrandt (1606-69) and Studio, Lane Bequest
1918 (NGI 808). Subject of one of the longest
debates over an attribution to Rembrandt,
there is a 1903 letter from Wilhelm Bode to
Lane expressing astonishment that it should
have been doubted (NGI Archive).

market the total value of the pictures was put at £55,148, less than half of what they had cost Lane. The *Portrait of Cardinal Antonio Ciocchi del Monte* (NGI 783) by Sebastiano del Piombo (1485-1547) for which Lane had paid £9,500 in December 1912 was now valued at £1,500; the Goya, *Woman in a Grey Shawl* (NGI 784), was reduced to £3,000, about half what Lane had paid for it. The disputed Titian of *Baldassare Castiglione* (NGI 782) which had been bought for £11,000 in November 1913 was now estimated at £5,500.[6]

The most expensive picture by far, at £15,000, was *Portrait of a Young Woman with a Glove* (NGI 808) by Rembrandt, which Lane had bought sometime between 1909 and 1913, paying £25,000, according to Lady Gregory. It is now given to Rembrandt and unknown assistant. Lane had included it in a collection of Dutch and Flemish paintings purchased from him by Max Michaelis, the diamond millionaire, who presented it as a gift to the Union of South Africa. However, when it was exhibited in London before its departure for South Africa, its authenticity was questioned, and Lane offered to take it back in return for other pictures. It remained unsold in Lindsey House until it entered the NGI.[7]

Not until April 1918 was legal permission to retain the pictures granted to the Gallery. Douglas planned their first public exhibition with care, writing to Bodkin on 10 March 1918: 'I want to make a stir with the Lane pictures and to encourage or to shame some wealthy Irishman to do likewise.'[8] Three weeks later he wrote: ' I wish, as Director, to make this exhibition of the greatest service to the Gallery. I want to say to Irishmen with money: "Go thou and do likewise. As Lane has done so can you do, according to your wealth and opportunities..." '[9]

The Gallery was closed for 'five or six weeks'[10] for cleaning and hanging. A thousand invitations were issued. In his preface to the accompanying catalogue (NGI Library), Douglas paid tribute to Lane's discrimination and generosity, but declared his personal opinion of the forty-one pictures.

'The present collection consists…of sixty-two pictures, of which twenty-one were given to the Gallery by Lane and forty-one are selected from the works Lane happened to own when death suddenly overtook him. These forty-one pictures then, were not selected for the Gallery by Sir Hugh Lane, nor did they form the carefully selected cabinet of a private collector who was also a great connoisseur...Nearly all of these pictures had been offered for sale by him, and had he lived would have been offered for sale again. Had he survived he would probably have given to the Gallery even greater and rarer works than these. Nevertheless…this collection must be regarded as one of the most splendid gifts that a patriotic

citizen of fine taste has ever made to the National Gallery of his country.'

The exhibition was opened on 6 July 1918 in the presence the new Lord Lieutenant, Lord French, who had overseen the suppression of the 1916 Rising, and was not the most popular man in Ireland. Dermod O'Brien had written to Douglas:

'An invitation will have to be sent to His Ex. but can we do that without having previously presented him with an address of welcome?… Are we to do so when there is such a strong feeling that French is only here as military governor?…If His Ex. were to come would the Lord Mayor and his merry men put in an appearance? Or the Dublin MPs?…' But everything went smoothly, after Douglas decided that there would not be an official 'reopening.' So Lord French got a 'loyal and hearty welcome' from O'Brien who was able to 'fire off my stunt on Lane and his gifts' before asking 'His Ex. to declare the show formally opened.'[11]

The following month Lady Gregory 'went to the National Gallery to see Hugh's bequest…I stayed there a long time, looking sadly at the Goya and at the Rembrandt I used to look at so often when I came in late and tired to Lindsey House, there was such sunshine in the face – and the Titian courtier and the rest.' Of Lane's portrait by Sargent, which was on display among his pictures, she noted: 'the eyes seemed to follow me, seemed to reproach me for not having carried out what he had trusted me to do.'[12]

A claim by the Income Tax commissioners against Lane's estate amounted to £10,000. Writing to Lane's solicitors, Bird & Bird, on 15 December 1916, Douglas had conveyed the Board's wish to contest this. The letter is revealing in demonstrating one dealer's interpretation of the actions of another, by stating truthfully that Lane 'lost money in the last three years of his life.'

'…A dealer often sells at a loss pictures which have been in his stock many years. Sir Hugh Lane himself not infrequently sold a picture at a loss when he missed his market with it, or when, in a moment of enthusiasm, he had given more for a picture than it was really worth. Private dealers, who have no shop, and have only a small and special clientele, must do this…'

Douglas concluded that Lane should be regarded as a public benefactor. 'The Board do not regard Sir Hugh Lane as a dealer in the ordinary sense of the word, as he bought and sold pictures merely with the object of helping Public Institutions.'[13]

However, little more than a month later, having made further enquiries, Douglas had to advise the Board to acquiesce to the Tax Commissioners.'…It transpires that Sir Hugh Lane had not paid income

tax for many years, and that, whilst he had some heavy losses, he had also made very great profits.'[14]

Lane's affairs had been wound up at last. In May 1917 the freehold of Lindsey House was sold for £9,500. The sale was followed by the auction of his possessions – his library, with various books bought for the NGI, his jewellery and furniture. Paintings which the NGI had rejected were also disposed of, including a de Hooch, Hogarth's *Street Scene*, Gainsborough's *Admiral Vernon*, four portraits each by Lely and van Dyck and three by Kneller. Although prices were low, the total amassed £27,000,[15] and created the substantial Lane Fund for the Gallery, whose income of between £1,000 and £3,000 annually would henceforth be used for buying pictures. To date, more than sixty paintings have been bought from money supplied in this way, and, given the meagreness of the annual government grant-in-aid which continued to be £1,000 a year, Lane's generosity provided an essential means of acquiring works of art until the establishment of the Shaw Fund at the end of the 1960s.[16]

From 1917 to 1923 income from the Lane Fund ended up in Douglas's hands. In December 1918 the Board gave approval for the purchase from the Director of the Alejo Fernández panel of the *Holy Family with St Anne* (NGI 818), a sale to which Bodkin would allude disapprovingly in his 1923 memorandum. Douglas also sold to the Gallery a landscape attributed to Guardi (NGI 819) but no longer considered authentic,[17] costing £231. On 2 July 1919 'the picture, *Scenes from the Life of St Augustine* (NGI 823) by the Master of the St Augustine Legend (c.1500), was exhibited by the Director, and on the motion of Col Sir N.R. Wilkinson, seconded by Mr Bodkin, it was resolved to purchase this picture at the price of £2,500 and that the thanks of the Governors and Guardians be offered to the Director for giving this picture to the Gallery at a price less than he paid for it.'[18] Even Bodkin could find no fault with this right-hand panel of a Flemish triptych depicting St Augustine's death. Later the Director was instructed to offer the owner (unspecified) of the centre of the triptych £10,000 for it, but nothing came of this transaction.[19]

Cheque stubs from the Lane Fund, preserved in the NGI files, show regular payments made out to Captain R. Langton Douglas: '"A Horse" by Gericault …Captain R. Langton Douglas – £200' ; ' £836. 17s. 2d. [unspecified]…'; 'June 23rd 1921 – £420 for picture by Simon W. Kick'; 'Hobbema, final payment £64…'; 'A port. of Admiral Ommaney by Benjm West – £353. 4s.…'

In his Director's Report for 1921, Douglas enlarged on this policy of selling his own pictures to his own Gallery. 'It may be explained here that the Director, when he has an opportunity of purchasing a picture which

he considers to be a desirable acquisition for the National Gallery, buys it, if he is able to do so, even though the Gallery may have no funds available for the purchase of pictures. He then holds the picture, at his own risk, and in some cases exhibits it to the Gallery, until such time as the Board has sufficient funds to acquire it, should the members wish to do so. Every picture that the Director offers to the Board is offered at a price lower than the total sum it has cost the Director.'

There is no reason to disbelieve a successful and knowledgeable dealer, who had supplied, and would continue to supply, the world's greatest museums and galleries with great paintings, many of which he had discovered himself. His clients were confident of his knowledge. Back in 1903 Carl Snyder had written of him, 'I have actually found an apparently honest man – Langton Douglas; he is a dealer, though an art critic, and frankly says so. No Berenson business about him.'[20]

Douglas saw no reason why he should not sell to the Gallery of which he was Director suitable paintings at a modest commission, or no commission at all. Denys Sutton considered that 'the Gallery was certainly not overcharged for these pictures.'[21] The St Augustine panel enriched the Netherlandish school. *A Horse* (NGI 828) by Theodore Géricault (1791-1824), considered 'excellent' by Sutton, is not now so highly considered. Douglas sold five early Italian paintings to the Gallery, one of which is particularly significant. *The Assumption of St Mary Magdalene* (NGI 841), painted in the 1380s, is one of the earliest painted examples of that particular subject. The artist, Don Silvestro dei Gherarducci (d.1399), a Benedictine monk in the monastery of Santa Maria degli Angeli in Florence, is considered a very rare master, painting in a style that was half Florentine and half Sienese.[22] This was purchased from the Director for £1,000 in 1922.[23] Other Sienese paintings – on which Douglas was an authority – were the first to come into the Gallery, as Bodkin noted in his 1932 catalogue.

Another important purchase from the Director was the early Roman painting, *The Virgin invoking God to heal the hand of Pope Leo I* (NGI 827), illustrating an episode in the Golden Legend. After celebrating mass the Pope felt aroused by a woman kissing his hand and punished himself by cutting it off; the Virgin intervened and an angel was sent to restore it. Antoniazzo Romano (active 1461-1508) illustrated the miracle with a serene depiction of the Virgin and, beneath her, the angel fitting the hand back onto the arm of the Pope. This cost the Gallery £1,836 in 1920, partly paid out of the Lane Fund, partly from grant-in-aid.[24] Not until 1922 was it decided that 'any money spent out of the Lane Fund be used solely for the

purchase of specific works of art, to be labelled as purchased from the Lane Fund.'[25] However, the policy was not strictly adhered to; the money for expensive pictures such as Perugino's *Pietà* (NGI 942), bought in 1931, and *St Jerome Translating the Gospels* (NGI 1013) by Nicolás Francés, bought in 1939, had to be raised from both available sources.

In spite of the general high quality of the paintings supplied by Douglas, there was a growing suspicion among members of the Board that he was dumping on the NGI pictures that he had been unable to dispose of to his clients. Bodkin declared as much in his 1923 accusatory memorandum. 'I think it more than likely that many of these pictures represent bad bargains by the Director in his capacity as a private dealer which he has been unable to realise.'[26]

Times were hard for the art market, and this may be true. Did the Gallery really need yet another English portrait, *Admiral Ommaney* (NGI 838) by Benjamin West, purchased from the Director in 1922 for £354? Or more Dutch paintings like *An Artist Painting a Model* (NGI 834) by Simon Kick(1603-51) for £420 in 1921 or, in the same year, *The Ferry Boat* (NGI 832) by Meindert Hobbema (1638-1709) sold for £1,000, and considered by Bodkin 'entirely unworthy of the collection'[27]? The Kick was bought without the Board's consent under Bye Law 16, which enabled the Director to buy a picture under the value of £500 on his own initiative. Douglas had kept it for two years before passing it on to the NGI. The Board 'noted' the acquisition without enthusiasm.[28]

Occasionally Douglas made an outside purchase, like the time he was directed by the Board to call upon a Mrs Fitzgerald to inspect *Near St Patrick's Close, and old Dublin street* (NGI 836) by Walter Osborne,[29] bought for £600. But he never asked the Board to consider paintings offered by other dealers. Bodkin claimed the five paintings purchased from other dealers' stock during Douglas's Directorship were all submitted on his own recommendation, not that of Douglas.[30] They were a *Pietà* by Girolamo de Santa Croce (NGI 846), two portraits by John Linnell (NGI 843 & 844), a miniature by Nathaniel Hone (NGI 7316) and a beautiful portrait of an aristocratic Spanish lady (NGI 829), then given to Pantoja de la Cruz, but now to an unknown artist of the Madrid School (c.1620). This last led to an embarrassing episode reported by Bodkin in his memorandum. It is recorded in the Minutes as 'after discussion', words that can mean 'after a blazing row.'

The Dublin dealer, Henry Sinclair, was selling off a number of paintings which had been in Powerscourt House, among which was the Spanish lady. According to Bodkin, Douglas 'vehemently objected' to

The Virgin invoking God to heal the hand of Pope Leo I,
c.1475 by Antoniazzo Romano (active 1461-1508),
purchased 1920 (NGI 827). This is typical of the
quality works by lesser known Italian artists
which Langton Douglas specialised in finding
for the Gallery and collections in America.

Near St Patrick's Close, an old Dublin street, 1887 by
Walter Osborne (1859-1903), purchased 1921
(NGI 836).

buying it, stating that the price was too high and the picture was unworthy. 'It was only when I informed the Board that the Director was himself in private treaty for the purchase of this picture and had offered a price not materially less than that asked…that the Board unanimously decided on its purchase. My statement was, of course, made in the presence of the Director and was not contradicted by him.'[31]

Bodkin also deplored the fact that Douglas kept some of the really good paintings he had acquired for sale to other galleries that would pay him more. In 1923 he would complain to Yeats: 'Mr Dermod O'Brien and myself know of many other pictures which he acquired during his Directorship at prices well within our scope which we had hoped he might have offered to us; for example a Gian Bellini which he bought for £400 in 1917 and the magnificent Tintoretto which he bought this year at the Brownlow sale for £500.'[32]

Dispute over Lane's income tax, Douglas's frequent absences, his picture selling policy and arguments over the long delay in winding up the Lane Estate had contributed to the hostility between Bodkin and Douglas. On 10 April 1919, Douglas wrote to Bodkin, 'It is not to the interest of the Gallery that there should be a clique or cabal, a Board within a Board…Every successful Gallery is best under a united rule…a Director cannot do much without unity and concord.' Two days later he wrote from London: 'the centre of the whole question is not in Dublin, it is here. The Board are treating the whole business in a thoroughly provincial spirit...you are quite mistaken in saying that it was my duty to write to, or to see, the Crown solicitors.'

Bodkin would take no scolding, nor agree with Douglas's contention that there was no point in seeking further counsel's opinion. A draft letter to Douglas in his papers complains: 'I have sufficient intelligence to apprehend that your letter conveys a cryptic charge against myself…In my opinion the delay is mainly to be laid at your door...'[33]

In July 1918 Douglas set about arranging an exhibition of war paintings by his friend Sir William Orpen. The idea received the approval of the Board, but eventually it decided that such an exhibition would be unwise, given the state of Ireland at the time. In September 1918 the Minutes recorded 'a letter from Major WL Armstrong expressing appreciation of the Director's expression of sympathy at the death of Sir Walter Armstrong.' At the end of the year Stephens was promoted from clerk to Registrar with a small increase in salary. It must have been difficult for Stephens to observe the increasingly bad relations between Douglas and Bodkin, both of whom were his friends.

In 1918 the Board received the Hone Bequest, which would cause problems and delays reminiscent of the Milltown Gift. During a long painting career Nathaniel Hone the Younger (1831-1917) had accumulated a huge collection of his oils, drawings and watercolours at his home in north Dublin. He was a rich man with a dislike of publicity, and had done little to promote his art. Sarah Purser had brought him some prominence with her Hone -Yeats exhibition of 1901, but it was only in recent years that his status as an artist had become appreciated.

His widow arranged to leave the Gallery 550 oils and 887 watercolours of landscapes, seascapes, pastures with cattle, and wide open skies. Locations included Egypt and France, where he had been influenced by the Barbizon school. By the terms of her will Magdalen Hone not only provided £1,500 to fund a special room for her husband's paintings, but also suggested selling off those that the NGI did not want to provide extra money.

In 1920 Dermod O'Brien, one of her executors, arranged an exhibition in the NGI. Douglas had reservations, writing to Bodkin: 'O'Brien is still anxious to hang an enormous number of Hones. But to do this will defeat his own aims and the aims of all wise admirers of Hone. Of course, he does not see this.'[34]

Ninety oils and ninety-nine watercolours went on show in the NGI in the summer of 1921, views of Greece, France, Holland, Venice, England and Ireland; there were cows, breakers, sweeping skies, the Norfolk Broads, and the flat meadows of Malahide near his house. Douglas was right; there were too many. There are still too many. Legal problems connected with the legacy took more than twenty-five years to sort out. In 1948 a sub-committee of the Board asked the Minister for Finance to seek financial aid for the building of an extension to house the pictures — by this time Mrs Hone's financial bequest had accrued to £8,000. But this was disallowed. In 1951, 211 oil paintings (mostly sketches) and 336 watercolours were accepted into the Gallery; the rest became the property of the Hone heirs. Only two of Hone's paintings are displayed on the walls of the NGI; the others, oils and watercolours, are in storage.

Political events in Ireland from 1916 to 1922 seem to have had little effect on the affairs of the NGI. On 2 February 1921 the Board noted a 'circular letter', 'a communication from the Under Secretary, Dublin Castle, regarding administrative changes necessitated by the passing into law of the Government of Ireland Act.' On 6 April the Chief Secretary enquired 'as to the future position of the Gallery in view of the passing of the Act'. The answer was easy; the Board affirmed that the collection should stay in Ireland.

Nathaniel Hone the Younger (1831-1917) in Brandon's Paris studio, 44, Rue Notre-Dame de Lorette, 1870 by Edouard Brandon (1831-97), gift to sitter and purchased 1927 (NGI 881).

After the departure of the British administration, the Civil War caused difficulties, briefly noted in the Minutes. On 21 July 1922 a meeting was postponed 'owing to the state of war.' On 4 October 1922 'it was resolved that the Gallery be not re-opened until further notice.' On 6 December 'the Director reported that damage had been done to the building by gunfire and that the matter was being attended to by the Board of Works…The closing of the Gallery was reaffirmed.'

Douglas's absences had continued long after the Armistice. In 1919, when attendance at the War Office could no longer be used as an excuse, the statutory time for residence in Ireland of the Director had been fixed as 120 days per annum, which did not need to run concurrently. Douglas ruffled the Board by saying that they had engaged a Director, not a chambermaid, for the Gallery.[35] In December 1921 he had gained the Board's permission 'to leave Ireland for England and Rome in order that he might see certain collections of pictures, notwithstanding the provisions of Bye Law No 9.' Bodkin dissented, and asked that a detailed written return of the Director's attendance at the Gallery should be produced at the next meeting.[36]

Matters came to a head in early 1923 when Douglas planned a trip to New York, this time without seeking permission from the Board. He knew that, even though the Gallery was closed to the public, such a journey, whose objective was largely related to his dealing activities, would cause trouble. On 20 January he wrote agitatedly to Stephens: 'I am sending you twenty copies of a letter that I am addressing to the Governors…Please address one, in a separate envelope, to each member of the Board. Do not mislay the copies please…Please express to the Board my regret that I cannot be present on February 7. With sincere thanks, R. Langton Douglas. p.s. I am writing myself to two or three members of the Board. Later p.s. I am sending the copy for the Chairman in an envelope addressed to him by me, as it is more courteous to do this.'[37]

The meeting on 7 February 1923, without the presence of the Director, took place in the Board Room above the Gallery empty of visitors. Stephens was also absent, in hospital. Present were Jonathan Hogg, Sarah Purser, Lucius O'Callaghan, N Blair Browne, Henry Tisdall, and Thomas Bodkin. However, the five-year terms of Bodkin and Hogg had expired, and had not yet been renewed by the new government. When he returned from America, Douglas starred their names and made a note at the bottom of the page of Minutes: ' *These are not members of the Board, their terms of office having expired.'

Hogg was in the Chair at this meeting when Douglas's letter to the

Chairman and Governors was formally read out in his absence:

'Dear Sir, I leave Southampton for New York on January 20 and I hope to return in 5 or 6 weeks' time. The chief object of my journey, which is made entirely at my own cost, is to interest Irishmen in America in the National Gallery and the Municipal Gallery. The National Gallery needs money for three objects: first, to buy the house in Merrion Square next to the Gallery; secondly, to form a collection of photographs; thirdly, to buy pictures of schools of painting that are not represented or are inadequately represented in the Gallery…

In the present state of affairs I may not succeed in getting any money for these objects, but if we interest Irishmen in America in our Galleries, we may receive donations and bequests later on…'

The six Board members present at the meeting, who had each received a copy of the letter, passed a unanimous resolution:

'The Board of Governors and Guardians desire to place on record their opinion that it is quite irregular that the Director should absent himself from a Statutory Meeting without authority, and to state that he is not in any way authorised by the Board to collect money for the Gallery in America, and specially for the purchase of a house which has not even been considered by the Board.'[38]

Douglas attended the next meeting, on 6 April 1923. In his 'plummy churchman's voice'[39] he made a long statement defending his action in going to New York 'as my conduct as Director has been *censored by a Resolution*' (crossed out and signed 'RLD' and 'criticised by Members' substituted) of the Board.' He said that he had not only written to every member of the Board, and also the Chairman, but also to 'the President of the Irish Free State' who replied, approving his plans. However, he did not show the 'President's' letter to the Board members. He said he found it impossible to postpone his departure. He pointed out that the Gallery was closed, there was no urgent business, and his absence was merely a technical breach of his duties.

As for the house on Merrion Square, he had mentioned the subject 'for the last five years, in private and in public…and I have never heard one member of this Board object to this proposal. He claimed to have referred to it at Board meetings, although there is nothing in the Minutes to support this statement. He added that Dermod O'Brien also worked hard to secure the house for the Gallery. (Today the ownership of No 88 Merrion Square by the NGI is an essential part of the Gallery complex.)

Douglas had always been obsessed with the idea of finding rich patrons to fund or provide pictures for his Gallery. If he had been more

successful in New York in arousing interest in the NGI, as he claimed he sought to do, perhaps he might have won over the Board. But all he could bring back was one picture, presented by John Quinn, friend of Lady Gregory, and patron of the Yeats family, a painting of the Flemish School (c.1560-70) now identified as *The Meeting of Rebecca and Abraham's Servant at the Well of Nahor* (NGI 845). He blamed his lack of success on American opinion of Irish politics.

The following meeting, on 6 June, was turbulent, as a statement by Dermod O'Brien at the meeting of 4 July made clear. The latter was attended by ten Board members: O'Brien, Sir Philip Hanson, Bodkin, Professor Sydney Young, Mr Blair Browne, HC Tisdall, Lucius O'Callaghan, Sarah Purser, Richard Caulfield Orpen and Sir Neville Wilkinson.

It was unfortunate for Douglas that O'Brien took the chair. The Chairman announced that Hogg and Bodkin had been reappointed to the Board; there was some question of Wilkinson's eligibility and he retired. The Minutes of the meeting of 6 June were called for, and Douglas read out a statement he had made in his own handwriting. 'Only three members of the Board attended: Messrs Dermod O'Brien, N. Blair Browne and L.O'Callaghan. There was, therefore, no quorum. Signed R.Langton Douglas, Director.'

O'Brien then read out a statement as to what had actually happened on 6 June, 'embodying his notes as Chairman'. Members present had been himself, Blair Browne, Lucius O'Callaghan, Hogg and Bodkin. At the opening of the meeting Douglas had contended that it could not be held, on the grounds that there was no quorum, since Hogg and Bodkin were no longer members of the Board. However, Blair Browne and O'Callaghan had hastily proposed and seconded O'Brien to take the Chair. O'Brien immediately ruled that 'in view of the various recommendations he had received on several occasions relative to appointments in the Royal Hibernian Academy and the Board of Visitors to the Museum from the Lord Lieutenant, the Minister of Education and the Minister of Agriculture – all these Boards were expected...to carry on until such time as the government could take up all such cognate questions. He ruled that the Board is properly constituted...the quorum necessary being made up by the inclusion of Mr Bodkin and Mr Hogg. The Minutes of the last meeting were therefore read, confirmed as amended and signed.'

After O'Brien read his statement it was noticed that something was badly wrong with the Minute Book. The Minutes of the 7 February meeting, covering three pages, had been marked with big St Andrew's

crosses in blue ink by Douglas, who had written in the margin: 'These Minutes have been cancelled, as this meeting was no meeting according to the Bye Laws, there having been no quorum. R Langton Douglas, Director.' Moreover, Douglas had also cut out one of the pages. (Even his supporter, Lord Mayo, was horrified when he learned of this.)

'The Board are astonished to find that the Minutes of the Board of the 7th February have not only been crossed out but a page of the Minute Book has also been cut out by the Director, although signed by the Chairman of the meeting at which Minutes were confirmed. The note made by the Director on the Minutes stating that they were 'cancelled' is absolutely unauthorised and untrue and the Registrar is directed to rein-sert the page which was cut out.'[40] This Stephens did very neatly. Bodkin gleefully kept a legal ruling in his papers which stated that Douglas's action was liable to result in imprisonment and hard labour.[41]

Before the 4 July meeting, Douglas's last, there had been an exchange of letters between Douglas and Bodkin. Douglas wrote:

'June 25 1923. Private and confidential.

Dear Mr Bodkin…I desire to say this: I am a 'part time civil servant' and it is obvious that when a man has two jobs and serves two masters the interest of the two masters must sometimes clash. But it has always been the opinion of conscientious members of my own family and especially of those who know me best (such as my late mother) that it is the interests of my business and the interests of my own family that have suffered through this clashing of interests. They know not only the time that I have given to promoting the interests of the Gallery…of the pictures that I have given to the Gallery or have sold to the Gallery under cost price, they know also that I have from time to time locked up a great deal of capital in pictures with the sole idea of lending them to the Gallery or offering them to the Gallery later on – pictures which have, in many cases, no interest for my own private clients. They know, too, that I have foregone opportunities of making large sums of money, because I felt that the Gallery had first claim upon my time. But, above all, they know that I have been anxious about the Gallery and eager to promote its inter-ests and that I have been worried because of (1) decline in trade – I have not been able to devote time to it when I was appointed to the Directorship (2) conflict in Ireland made it impossible to carry out some of my plans in regard to the Gallery as an instrument of education.

'While you have a right to your own opinion on the question whether the interests of the Gallery have or have not suffered in consequence of the clashing of interest, you have no right, because you have some sort of

axe to grind, to go about assiduously circulating, under the cover of privilege, false and malicious statements which are not only untrue, but which can easily be proved to be untrue, as they concern matters of fact. So long as this kind of thing is going on there can be no peace…'

Bodkin's reply, dated 26 June 1923, was headed: 'Not private nor confidential.

'Dear Captain Douglas, …I cannot refrain from attempting to correct some of the extraordinary statements contained in the amazing letter I received from you yesterday morning…I have no axe of any description to grind…my views as to your utility in the Gallery are shared…by the majority of (if not by all) my colleagues on the Board; Lord Mayo, possibly is an exception…you are not truthful when you state that I conduct 'an assiduous campaign of false and malicious statement.' If I did conduct such a campaign the only manly and honourable course for you to adopt would be to issue a writ against me for slander and libel… I am reluctantly driven to believe that the unpleasantness which characterises our relations arises from a fundamental difference of our standards of gentlemanly conduct…you introduce into your controversial statements references to your mother, who must be an elderly lady and can know nothing of the affairs of the National Gallery but what she hears from you…'[42]

Douglas knew he was defeated before he attended the 4 July meeting, when the Board would ask for him to resign, having noted his handiwork in the Minute Book. He came prepared. Before offering his resignation, he 'offered to the Gallery as a gift *A View of Brazil* by Franz Post which was accepted.' No thanks were recorded and only after the following meeting were thanks posted to him.

The Governors present were O'Brien, Sir Philip Hanson, Bodkin, Professor Sydney Young, Blair Browne, Tisdall, Lucius O'Callaghan, Sarah Purser and Richard Caulfield Orpen. 'It was proposed by Mr Dermod O'Brien, seconded by Sir Philip Hanson, and resolved unanimously, that the Director's resignation be accepted and take effect forthwith.'[43] But after the meeting Sarah Purser shook hands with Douglas.

The landscape (NGI 847) by Frans Post (1612-80), with its river, palm trees, oxcart, slaves, sugar plantations, furnace house, crocodile, armadilloes, anteaters, a monkey, a snake, herons and other animals and birds set in a green-blue haze, is a particularly attractive work by this artist, who based a whole painting career on memories of a two-year sojourn in Brazil. (In 1918 Douglas had written to Bodkin, possibly after acquiring this painting: 'I like van der Post very much, but I wish that he had not always painted

the same picture.')[44] The Board's acceptance of the picture was ungracious, but Douglas departed in some style.

1 NGI Administrative Box 4. Ellen Duncan
 to Douglas, 8 July 1916
2 Minutes of NGI Board, 4 April 1917
3 NLI Purser ms 10201. Douglas to Purser,
 15 Jan. 1918
4 Lady Gregory, *Journals* (ed. Daniel J.
 Murphy) (Gerrards Cross 1978) vol. 1, p. 54
 (15 March 1919)
5 'Report of a Public Meeting held at the
 Mansion House, Dublin on the 29th of
 January 1918', Talbot Press, Dublin
6 Robert O'Byrne, *Hugh Lane 1875-1915*
 (Dublin 2000) p. 219
7 Homan Potterton, *Dutch 17th and 18th century
 paintings in the NGI* (Dublin 1986) pp. 124-27
8 TCD Bodkin ms 6961-13. Douglas to Bodkin,
 10 March 1915
9 *ibid.* ms 6961-16. Douglas to Bodkin,
 30 March 1918
10 Minutes, 3 April 1918
11 NGI Admin. Box 4. O'Brien to Douglas,
 21 May 1918
12 Gregory (as n. 4), (8 September 1918)
13 NGI Admin. Box 4. Douglas to Messrs Bird
 & Bird, 15 Dec. 1916
14 *ibid.* Douglas to Chairman of NGI Board,
 5 Feb. 1917
15 Minutes, 13 Feb. 1916
16 O'Byrne (as n. 6) pp. 219-20
17 Michael Wynne, *Later Italian Paintings in the
 NGI* (Dublin 1986) p. 45
18 Director's Reports, 4 December 1918 and
 2 July 1919
19 Minutes, 1 June 1921
20 Archives of American Art, New York.
 Jacacci papers. Quoted in Denys
 Sutton, 'Robert Langton Douglas',
 Apollo, (May 1979) p. 367
21 Denys Sutton, 'Robert Langton Douglas',
 Apollo (June 1979) p. 162
22 Federico Zeri, 'Major and Minor Italian
 artists in Dublin', *Apollo* (Feb.1974) p. 13
23 Director's Report 1922
24 Director's Report 1920
25 Minutes, 5 April 1922
26 TCD Bodkin ms 6961-81. Bodkin
 memorandum on Douglas's
 misdemeanours, June 1923
27 TCD Bodkin ms 7001-1732.
 Bodkin to WB Yeats, 9 July 1923
28 Minutes, 6 July 1921
29 Minutes, 6 April 1921
30 Bodkin (as n. 27)
31 Minutes, 6 April 1921
32 Bodkin (as n. 27)
33 TCD Bodkin ms 6961-41, 44 and 45 Exchanges
 between Bodkin and Douglas
34 TCD Bodkin ms 6961-71
35 *ibid.*
36 Minutes, 7 Dec. 1921
37 NGI Admin. Box 4
38 Minutes, 7 Feb. 1923
39 Margaret A. Salinger, *Dream Catcher -
 A Memoir* (New York 2000) p. 12
40 Minutes, 4 July 1923. Resolution proposed
 by Hogg and seconded by O'Callaghan
41 TCD Bodkin ms 6961-86
42 TCD Bodkin ms 6961-84 and 85
 Letters between Douglas and Bodkin,
 25 & 26 June 1923
43 Minutes, 4 July 1923
44 TCD Bodkin ms 6961-10.
 Douglas to Bodkin, 13 March 1918

CHAPTER TWENTY ONE

ADAPTING TO THE NEW STATE

Following Douglas's resignation on 4 July 1923, Bodkin was in truculent mood. The day after, he wrote a furious letter to WB Yeats recalling past injuries and accusing him of interfering now. 'You wrote to a friend of mine expressing a very unfavourable opinion of my candidature and my knowledge of painting. You said among other things that I had doubted the authenticity of Lane's Red Cap Titian.' The crux of his letter was a report that he had received. 'I venture to write to you to tell you that on Wednesday evening I was informed that you discussed the present situation of the National Gallery and the recent happenings on the Board with a number of members of the Kildare Street Club, some of them Senators, one of them a Governor of the Gallery and others who were unconcerned in any way with its affairs.'[1]

On the evening of the turbulent Board meeting during which Douglas had resigned, Yeats had been talking to a Governor, Lt Col Hutcheson Poë, who, as a supporter of Douglas, had not attended. Yeats told Bodkin: 'I could not have said anything of your action at Wednesday's meeting when speaking to Hutchen Poe (sic) on Wednesday night, for I knew nothing except that Langton Douglas had resigned. I had seen neither Douglas nor Stephens but somebody had telephoned or left a message while I was out...I spoke to Hutcheson Poe upon the situation and upon what led up to it – about which I do know something – but my memory is that I spoke to him alone and that I used careful and considerate words. We then rejoined the other Senators and if we spoke of the matter in their presence (which I do not think) it must have been in a very summary way.'[2]

But someone had told tales to Bodkin, and his dislike of Yeats would continue. His campaign against Douglas also cost him Stephens' friendship. Years later, writing to the *Irish Times* after Bodkin's death, Aileen Bodkin declared 'it was Stephens who withdrew his friendship from, rather than actively quarrelled with, my husband, to the latter's lasting

Rolls Royce 1920 pattern armoured car on patrol in
Merrion Square to quell an expected Blue Shirt Rally,
1923 (©Getty Images/Hulton Archive).

regret.' She enlarged on the estrangement in the typescript she endearingly entitled *A Really Nice Man*, a collection of letters between Bodkin and Stephens.

'The whole thing, I think, was a question of divided loyalties...There were, I think, occasions when TB's sense of public responsibility as a Governor of the Gallery was at variance with the Director's divided interests. Stephens felt his loyalty lay unquestionably with his immediate superior, who was, moreover, extremely and genuinely kind to himself and his family.'[3]

Immediately after Douglas's resignation Stephens took six weeks leave in Paris, a preliminary to his eventual departure. Bodkin's continuing powerful association with the NGI was instrumental in his decision, and after February 1924 there was no further communication between the two. Years later, in May 1941, Bodkin wrote to Stephens trying to heal the breach, but got no reply to his long wistful letter. It included the statement: 'You might be interested to hear that I have seen a good deal of Langton Douglas and his nice little (second) wife and that when I was in Oxford lecturing lately I was told that he was now in America and had joined the Catholic church.'[4]

Remarkably, Bodkin and Douglas made up their differences. Two years after he departed, Douglas was offering paintings to the NGI Board dominated by Bodkin, and he would continue to do so for the next twenty years. As late as 1950, when he had long lived in America, he was trying to interest the Gallery in a picture by Giovanni del Biondo.[5] He would be far more valuable to the NGI as a dealer than he had been in the chaotic years when he was a Director.

By 1928 he was writing to Bodkin: 'My wife and I will be pleased if you will lunch with us...with kindest regards to you and Mrs Bodkin.' In the course of the next decade all sorts of friendly letters were exchanged. One from Douglas to Bodkin, written in July 1934, observed: 'My wife recently read in *Country Life* a poem of yours which she liked very much...' (It was about spring.) 'I think we ought to collect a Merrion Square anthology...even I wrote poetry in Merrion Square.'[6] Stephens, Bodkin and Douglas all found time in the NGI to compose verse.

Throughout 1923, because of the political situation, the Gallery continued to be closed, although it was possible for enterprising members of the public to make a visit. '21st June 1923. Dear Mr Stephens...My mother is now in town at present, and I should like to bring her to see the pictures some afternoon. If I went round by the basement entrance to Nassau Street and mentioned your name perhaps we could get through...'[7]

In the circumstances the Board could go slowly in its search for a new Director. A sub-committee was formed headed by Bodkin, the other members being O'Brien, O'Callaghan and Blair Browne. During the months before a new Director was appointed, it bought several pictures on Bodkin's advice, including a damaged painting of *Four Franciscan Monks* (NGI 849) by Gerard ter Borch (1617-81) for £1,571. 7s. 4d of Lane money. A rare seascape discovered by Bodkin (NGI 850) by the little-known Dutch artist Gerrit Pompe (active 1670-90) was bought in Dublin for £50,[8] while a landscape (NGI 848) by the Irish artist Thomas Sautelle Roberts (1760-1826) cost £15.[9]

On 3 October 1923, Stephens placed advertisements for the Director-ship in leading European papers. The grim conditions of the appoint-ment were stated in a memo from the Ministry of Finance to Sir Philip Hanson: 'No bonus will be paid to the new Director. The job should be regarded as part-time at an inclusive salary of £500 per year. In this con-nection…we think [the tenure of office] should be distinctly understood that it should be terminable at any time after reasonable notice without any claim to compensation.'[10]

This did not suit Bodkin, who had written truthfully to Douglas in his 'not private nor confidential' letter: 'you have repeated over and over again the statement that I seek your post when you must know that it is false.'[11] He told WB Yeats: 'I am not now a candidate for Captain Douglas's position nor have I any present intention of becoming one. For one reason I could not afford to relinquish my present position in the Civil Service.'[12]

But more people than ever applied for the post. Given the salary and conditions of employment, it is not surprising that the range and quality of the applicants were wide.[13] The applications, which included some from France and Germany, were whittled down to two, the editor of *The Burlington Magazine*, Robert Rattray Tatlock, and Lucius O'Callaghan, member of the Royal Hibernian Academy, ex-President of the Royal Institute of Architects of Ireland, and member of the Board of the National Gallery of Ireland.

In his application Tatlock, who had testimonials from leading art experts, protested that he was not another dealer: '…though a very large amount of pictures pass through my hands every year, it would be fatal for me to be even in the most indirect way privately interested in the sale of works of art.'[14] (Lord Mayo had written to Dermod O'Brien: 'I agree that a picture dealer will not do. We have had two of them, and you are quite right, it is time to have a man who will not sell us his 'particulars' but buy for the Gallery and subject the pictures to the Board.'[15])

Tatlock insisted that it was important for him to live in London. 'You have, I believe, nearly £2,500 per annum available for purchases, and to get the best value out of that the Director should know what pictures are for sale in London, Paris and elsewhere.' He was strongly supported by Bodkin. However, other Board members had reservations, including Sarah Purser, who had been told that the editor of *The Burlington Magazine* only wished the Directorship as a stepping stone to higher things. Dermod O'Brien feared that he would fill the Gallery with 'the latest productions of the cubists.'[16] Lt Col Hutcheson Poë wrote to O'Brien: 'I dare say O'Callaghan would fit the appointment as well as, if not better than, any of the others, who might be more 'showy' but without the Gallery's interest at heart.'[17]

O'Callaghan had become a candidate at the last moment. On 24 November he told Bodkin that he had resigned his membership of the Board and applied for the post at 'the urgent solicitations and representations of some members of the Board.'[18] Bodkin was horrified and wrote a furious 'Resolution' stating that O'Callaghan had no capabilities for the position whatsoever, apart from 'nationality, personal charm and a tasteful appreciation of a particular school of painting.' He listed 'young... energetic' Tatlock's lengthy qualifications. Although 'I have the greatest

personal regard and liking for him,' he observed of O'Callaghan, 'He has no reputation as a scholar or as a critic of painting…He has never written a book, an article or compiled a catalogue or lectured in connection with painting. He has no expert knowledge of…the market value of paintings…'

Bodkin concluded that such an elected appointment would be interpreted as the conduct, say, of a Board of Guardians, 'as satirised on the stage of the Abbey Theatre. This country at the present time rings with accusations of jobbery… If the Board appoint Mr O'Callaghan over Mr Tatlock, not even the position and personnel of its members will suffice to protect them against such a charge.'[19] But the majority of Board members considered that, in the political turmoil, it was as well to have an Irishman at the helm, moreover, a well-meaning and modest man. On 5 December 1923, supported by Lord Mayo, Dermod O'Brien and Sarah Purser, O'Callaghan was elected Director of the Gallery by six votes to three.

Bodkin released his 'Resolution' to the press. The *Irish Times* weighed in, taking a markedly different view to those ancient controversies over the appointments of Armstrong and Doyle. 'No tradition can be more precious to any country than the tradition that merit, and merit only, is the touchstone of public service…' The appointment was raised in the Dail. 'President Cosgrave refused to interfere. He said the responsibility rested with the Board of Governors…We hope…that the dispute will not come before the Dail.'[20]

Bowing to the inevitable, Bodkin must have written to O'Callaghan, who sent an uneasy reply on 15 December: 'I was glad to get your letter of the 13th. At first I was a little worried by all the fuss in the papers but I have not only got over that but am now rather enjoying it…I think the publicity will make things easier for me. People will not only not expect too much, but will be relieved if I do moderately well.'[21]

O'Callaghan was a middle-class Dubliner whose sporting interests included rugby football, fishing and even skating. Such breezy activities might have little to do with art, but he also collected Dutch pictures. 'Oculus' of *The Irish Builder*, who had interviewed him in 1922, noted that 'he…has converted his office into a veritable muscum and picture gallery, there being, I gather, no further suitable floor and wall space available in his home.'

Commenting on his subject's 'disarming smile, which would place even a collector of income tax entirely at his ease,' 'Oculus' found him 'at his drawing board enveloped in a smoke cloud, grappling with one of those problems which are continually presenting themselves to every architect.'[22]

O'Callaghan kept up his architecture practice during his Director-ship. His work included banks, churches, libraries, and much of St Finian's Diocesan College in Mullingar. Later, with his partner Louis Giron, he would be responsible for a number of buildings at the new RDS premises in Ballsbridge, after Leinster House was taken over by the new government to house the Dáil.

Two months after his appointment, his first important undertaking was to supervise the reopening of the Gallery, following a letter from the Ministry of Home Affairs stating that there was no longer any military reason why the Gallery should remain closed. Stephens' last surviving letter to Bodkin, dated 8 February 1924, states: 'We are busy, for the Gallery is to reopen either on Monday or Wednesday.'

Before the foundation of the state, the Gallery had dealt directly with the Treasury. Now, under the Ministers and Secretaries Act, 1924, responsi-bility for its running was transferred to the new Department of Finance, whose civil servants, over the next sixty years, would be as difficult to deal with, if not more so, than My Lords had been.

The task of appointing Board members now fell to the Taoiseach. An early government appointment was Chief Justice Hugh Kennedy, signing his name Aodh Macineidigh. Sarah Purser had been good friends with Arthur Griffith and William Cosgrave; now she was joined on the Board by others who were sympathetic to the new government; WB Yeats, who had maintained an interest in the NGI since Lane's Directorship, and Sir John Lavery were both appointed early in 1924.[23] Lavery lived in England and seldom appeared at Board meetings, unlike Sir Alec Martin, who at this stage, crossed the sea regularly to attend. Yeats, who was round the corner, seldom missed a meeting while he lived in Merrion Square.

One preoccupation of the new government was the introduction of Irish, and much correspondence in the archives deals with the subject. Back in June 1922 a letter from Aireacht Airgid (Ministry of Finance) had written:

'A Dhuine Uasail...the Provisional Government desires that, as far as possible, the stationery used by Government Departments be headed distinctly in the Irish language.' Almost a year later the NGI received a list of 'Direction notices' including translations of 'Gentlemen'; 'Ladies Only'; 'Smoking not Allowed'. Letter headings were to be set out in Irish and English.[24] There is a list of translated terms written by Stephens on the opening pages of the then current Minutes. (In 1915 Stephens had joined a class for beginners in Irish in a branch of the Gaelic League in Ely

Place. George Moore's brother, Col Maurice Moore, was in the same class.)

In the Minutes of 6 February 1924 O'Callaghan announced details of the Edward Martyn Bequest, seven pictures in all, including a Corot and the NGI's first Impressionists. Martyn had accompanied his cousin, George Moore, to Paris in 1885 where Moore had taken him to Durand-Ruel's Gallery and persuaded him to buy a sparkling river scene (NGI 852) by Claude Monet (1840-1926) and two pastels by Edgar Degas (1834-1917), one of harlequins (NGI 2741), the other of two ballet dancers (NGI 2740).

The pictures had been in the closed Gallery for some time. Lady Gregory had written in her journal in June 1923: 'In the afternoon Yeats took me for a little walk, and we met Stephens, who brought us into the locked up National Gallery to see Edward Martyn's pictures he has now given to it. I used to ask him for his best three or four for the Municipal Gallery, and these will be probably lent to it.' This was the case; the NGI was not greatly interested in them and for a number of years they were shown in the Municipal Gallery.

At the end of 1924 Callaghan bought, under Bye Law 16, for £350, the graceful *Summer and Spring* (NGI 856) by Bernardo Strozzi (1581-1644),[25] a painting which had been sold to the 6th Viscount Powerscourt in 1836 by Alessandro Aducci, the Roman dealer from whom the Fesch pictures were obtained in 1856. It came from the Dublin dealers Harris and Sinclair, who were selling off a number of pictures from Powerscourt. The Board had already considered two, a sea piece by Charles Brooking, which was declined, and the portrait of the Spanish lady which had caused such argument between Douglas and the Board.

O'Callaghan had the advice, and probably assistance, of Bodkin to aid him; over in London, at Christie's, he could call upon the expertise of Sir Alec Martin, now a Board member. It is difficult to ascertain how many of the pictures bought during his Directorship were his original choice. *The Levite and his Concubine at Gibeah* (NGI 879) by Jan Victors (c.1619-76), a subject treated almost exclusively by painters in the circle of Rembrandt,[26] was certainly bought by him in 1926 under Bye Law 16 for £450; he was an authority on Dutch paintings.

A letter to Martin, dated 17 October 1924, about another picture suggests uncertainties. '…Bodkin spoke to me about the de Koninck landscape… I like the de Koninck and consider it a good example and in fine condition. If you think the price is right, and agree that it is a desirable one for us, I shall ask Agnew to send it over for inspection…but if you are not keen on our getting it, I shan't ask them to send the picture

Argenteuil Basin with a Single Sailboat, popularly
known as *River Scene, Autumn*, 1874 by Claude
Monet (1840-1926), Edward Martyn Bequest 1924
(NGI 852).

here…'[27] Presumably Martin gave an adverse opinion, as nothing more was heard of it. In 1924 Martin gave the Gallery a painting of *Cheyne Walk, Chelsea* (NGI 854) by Charles Deane (active 1815-51) in memory of his friend Hugh Lane. For years to come, his opinions would strongly influence the purchasing policy of the Gallery.

An important painting acquired in O'Callaghan's time was the altarpiece *Assumption of the Virgin with Sts Jerome and Francis* (NGI 861). She is being carried to heaven by six angels hovering above her tomb which is filled with roses and lilies. For long thought by one follower of Fra Angelico, the 'Pseudo-Domenico di Michelino', it is now attributed to another, Zanobi Strozzi (1412-68). It cost £2,000, most of the money coming from the Lane Fund. The engaging *St Isidore* (NGI 1987) today attributed to Juan van der Hamen y Léon (1596-1631) probably came into the Gallery in September 1926 (records referring to its entry are missing). An angel in the background ploughs a field for St Isidore, the patron of Madrid, so that he can take time off to pray, and the sturdy peasant looks upward with a rapt expression.[28]

Douglas had quickly resumed friendly relations with Dublin and with O'Callaghan personally. ('Why do you not come and see me when you visit London?')[29] In 1925 he sold the Gallery three pictures by Irish painters which he had loaned when he was Director— two by Thomas Hickey (NGI 862, 863 & 864).

For the Portrait Gallery the German-born scholar, *Dr Kuno Meyer* (NGI 859) by Augustus John (1878-1961) was acquired and six portraits by John Butler Yeats, including *George Moore, Douglas Hyde* and *WB Yeats*, given by Cornelius Sullivan in memory of his friend John Quinn in 1926. Another portrait, bought in 1927, was of Nathaniel Hone the Younger (NGI 881) by the relatively unknown French artist Edouard Brandon (1831-97). Benedict Nicolson was much struck by it when he saw it in 1968, observing how the artist 'has succeeded in catching the casualness of a Bazille or Degas pose at the astonishingly early date of 1870.'[30]

Among bequests was the modest five guineas sent by the St Patrick's Society Singapore; the Board directed 'that the amount be placed on deposit and held towards the purchase of a work of art that may be named or noted as a gift of the Society.'[31] A watercolour by Leendert de Koningh the Elder (1777-1849) of *Figures and Cattle by a Canal* (NGI 2841) was bought in 1928 in the Society's name. In the same year Mrs Brabazon Coombe presented sixteen watercolours by Hercules Brabazon Brabazon (1821-1906), augmenting the gouache of *Houses on Capri* by the same Anglo-Irish artist, which had been part of the Edward Martyn Bequest in 1924.

Other gifts included six miniatures by Horace Hone, and two more death masks from the collection of the scholar Dr Sigerson, together with a stark portrait drawing of Sigerson after his death (a duplicate was presented by Miss L Gavan Duffy in 1940). *A Meeting of the Ward Hunt*, 1873 (NGI 891) by William Osborne (1823-1901) father of Walter Osborne, was bought from William Jameson in 1927, a rarity, since surprisingly few Irish sporting pictures of this type exist.

The greatest missed opportunity of O'Callaghan's Directorship was the failure to buy James Barry's erotic masterpiece, *Jupiter and Juno on Mount Ida*, in which a buxom Juno is seducing Jupiter so that he may fall asleep and she can help the Greek army unhindered. The owner, Ernest Fletcher, frantic to get rid of it, wrote to the acting Registrar, Brinsley MacNamara: 'I had certainly hoped to have found a resting place for the picture as I cannot accommodate it in my house since it is hardly a suitable subject for domestic decoration...Do you think your Board would feel justified in paying say £10 for it and I would then discharge the costs incurred?'[32] In vain; the Board declined it. Having offered 'my poor Barry' to numerous other galleries, including the Tate,[33] Fletcher managed to find a home for it at the Sheffield Art Gallery.

Other paintings were less interesting. '28 February 1927...As I have in my possession an oil painting (head and bust) of some Irish Statesman which was bought by my parents 54 years ago at the Auction held in the Parish Priest's house after the P.Priest's death, who was himself very old, and as it is in good order and must be a very old picture, will you kindly let me know if it might be of any value.'[34]

Fashions in pictures come and go. A clergyman in County Leitrim who enquired about his Maratti was told: 'Pictures by Carlo Maratti and most of the 17th century Italian painters are of very little value at present. At one time they were in great demand, but recently good examples from celebrated collections have been selling for trifling sums. There is no picture by this artist exhibited at present in the Gallery.'[35] But in the vaults awaiting resurrection lay Maratti's splendid *The Rape of Europa* (NGI 81) bought from Robert Macpherson in 1856.

Stephens continued as Registrar for the best part of 1924. A lively letter to O'Callaghan survives, dated 15 July 1924. 'My dear Director... The sun is shining here, a boiler it is, and the Board of Works is painting our railings... A lovely tango colour they are now. I wish they could stay so, but the workmen tell me they will cover all that grandeur with a coat of timid, leprous grey. I wish you would command me to have a bomb slung at the Dargan statue on our Lawn, that man's frock coat, and

Sir Alec Martin (1884-1971), c.1915 by John Laviers
Wheatley (1892-1955), (courtesy of the National
Portrait Gallery, London).

the general, imbecile complacency of his rear-view comes between me and happiness.'[36]

In February 1925 he went on extended leave for a lecture tour and Brinsley MacNamara was made temporary Registrar. He wrote to Stephens on 10 August: 'I suppose you do not know that I have been acting in your place since February last, but of course in a purely temporary capacity.'[37]

But Stephens resigned on 2 December 1925[38] and MacNamara took his place. Born John Weldon, he had published *The Valley of the Squinting Windows* in 1918, which so enraged his native town of Delvin in Westmeath that the novel was publicly burned. Now, like Stephens, he had time between his duties as Registrar for a literary career, writing plays for the Abbey Theatre and becoming a director there for a short time. He was another lifelong friend of Bodkin.

In his early years as Registrar he had to deal with the changes brought about by the new state. There were strict limits on expenditure and regulations among civil servants. 'The practice that exists in some departments of allowing ten or fifteen minutes grace is to be discontinued and punctual attendance at 9.30 is to be enforced.' At the Gallery the staff arrived at 9.50 for the 10 a.m. opening and received half an hour for lunch. Their day varied according to daylight, as there was a reluctance to use the gas lighting in the building; 'in the late autumn and winter, when the light fails, the Gallery is closed.'[39]

The practice of appointing pensioners from the Forces as attendants continued. 'A Chara, This is to introduce to you Mr R.McDonnell, a demobilised soldier of the National Army who appears suitable for the vacancy which you notified to me. I shall be glad if you will let me know the result of your interview with this applicant. Mise le meas, Eamon Price, Major General, Office in c/o Resettlement.' Scribbled in pen is a note: 'President Cosgrave is interested in this applicant and would be pleased to hear of his being accepted by you for this vacancy.' McDonnell got the job.[40]

In 1923 the Gallery employed one housemaid, one charwoman, a furnaceman, a 'floorman' or cleaner and ten attendants, whose numbers rose to thirteen by 1927. Staff were still kitted out annually with 'Frock Suits (Black Vicuna) ...trousers (Black Vicuna) ...Caps (Black Vicuna), 2 Jacket suits (Dark Tweed), 2 Dungaree Suits, 13 aprons, 5 Overcoats.'[41]

Week by week the Registrar dealt with correspondence that had changed little since Killingly's time: the appointment of a new fur-naceman, his dungarees, gas in the housekeeper's quarters, the failure of

the chimney sweep to arrive, the matter of exemption of pictures from the new import duties on furniture, a request from the Department of External Affairs for the use of the Gallery for a reception. The answer was no; Bye Law 34 forbade it and the Board considered that 'the opening of the Gallery in the manner proposed would leave the Gallery and its contents open to risk of irreparable damage by theft.'[42]

It was MacNamara who replied to the ageing artist, Aloysius O'Kelly (1853-c.1935) who wrote on 5 July 1926: '…I have recently come to Ireland after an absence of many years with the intention of making paintings of the ancient remains of Irish Architecture. I have been over three months in Cashel painting seven pictures of different views of the Rock of Cashel, its Cathedral, Round Tower, etc. I intend shortly going to other places in Ireland where I am likely to find material for pictures. My object in applying to you is to get information how I can show these pictures…

'Many years ago, when resident in London, I frequently exhibited at the Royal Hibernian Academy. In recent years the changes have been so great that I have now no connections in Ireland, and don't know of any art dealers or agencies through whom to reach the public. I don't even know if the Hibernian Academy still exists.'[43] MacNamara told him to get in touch with Richard Caulfield Orpen, secretary of the RHA. But O'Kelly does not seem to have followed this advice; he vanished and died in America.

O'Kelly's artistic career included spells in pictorial journalism, providing drawings of incidents during the Land Wars for the *Illustrated London News*,[44] and a sojourn in Egypt where he painted orientalist pictures. In 1895 he emigrated to America. In 2002 his important early work, *Mass in a Connemara Cabin*, exhibited in the Paris Salon in 1884 and believed to have been destroyed, was discovered in a Catholic presbytery in Edinburgh; it is at present on loan to the NGI (NGI 14780).

The Director and MacNamara dealt positively with a letter to O'Callaghan from Raymond Brooke. 'I want to take a lady, Miss Rose Barton, round the Gallery. She has to go in a light wheel chair…It is a very light chair with rubber tyres and it continually goes to the Tate and the National Gallery in London.'[45] This was the watercolourist (1856-1929).

On 14 February 1924, Sarah Purser founded the Society of the Friends of the National Collections of Ireland, similar to societies already established in London, Paris, Amsterdam and Berlin. Dermod O'Brien and Walter Strickland were among its first vice-presidents, Bodkin was a founder Council member and 112 members at a guinea a head joined 'to secure works of art and objects of historic interest or importance for the

national or public collections of Ireland by purchase, gift or bequest.'[46] The Friends devoted much time to pursuing the return of the Lane pictures, but its true importance was in the distribution of donated pictures. In 1925 the NGI received its first gift through the Friends, an ink and wash drawing of *Silenus and King Midas* (NGI 2750) by Giuseppe Passeri (1654-1714) presented by WB Yeats' friend, the Hon. Mrs Phillimore. Donations now total 52 paintings, 144 works on paper and miniatures, 4 stained glass panels, a sculpture and an embroidery by Lily Yeats.

O'Callaghan found time to assemble a catalogue, which was published virtually unaltered in 1928 after his resignation. The first since Lane's in 1914, it was considered a model of its kind. 'The most satisfying shilling's worth that has yet been offered to the public by a Government Department', enthused the *Irish Independent*. 'Mr O'Callaghan has aimed at giving his readers quality as well as quantity. It would be difficult to better his brief biographical notes on painters…'

On 3 February 1927 O'Callaghan wrote to the Department of Education: 'I beg to inform you that, at a meeting of the Board of Governors held on the 2nd inst., I tendered my resignation of the post of Director as from the 31st of March next. At the unanimous request of the Board, the date was altered to the 30th June 1927 and the Board decided to accept my resignation from that date.'[47]

He gave as his reason for resigning the pressure of his architectural practice. But there is evidence of other reasons. In the introduction to her typescript of *A Really Nice Man*, Mrs Bodkin described O'Callaghan's Directorship as 'a brief and unhappy interregnum that need not be gone into here.'[48]

O'Callaghan was undermined from the start by Bodkin and by the circumstances of his election. An indication of the problems he encountered is the draft of a letter to Alec Martin, written after his resignation, which survives in Administrative Box 8 of the National Gallery archives. Perhaps it was left there deliberately.

'9 February 1927. My dear Alec, I am convinced that the arrangement which has been suggested about Bodkin for the Directorship would be the best thing that could be done in the interests of the Gallery. *In my opinion* [added] he is the only one here that would make a success of it. He is very keen and full of energy and I am sure he will not spare himself. *I am sure many* and *Of course people will say that he pushed me out* [both crossed out] *I do not know what the members of the B* [crossed out] *think the matter has* [crossed out] *is known to all* [crossed out] to many members of the Board. Hanson and Miss Purser are aware of it *but* [crossed out] and I believe approve…I have no

doubt that it will go through (*though there may be a small minority against*) [crossed out]'.[49]

Jonathan Hogg wrote to Bodkin on his appointment in 1927: 'My dear Bodkin, You will have heard that there was no opposition today and I can now congratulate the Gallery on having a Director who will have its interests at heart. This is not saying anything adverse to O'Callaghan, who did all he could and was most pleasant, but many things want to be changed with the changing times.'[50]

1 TCD Bodkin ms 7130. Bodkin to WB Yeats, early July 1923
2 *ibid.* Yeats to Bodkin, 7 July 1923
3 TCD Bodkin ms 7000-1613
4 *ibid.*
5 Minutes, 5 July 1950
6 TCD Bodkin ms 6961-106. Douglas to Bodkin, 2 July 1934
7 NGI Administrative Box 6. 21 July 1923
8 Homan Potterton, *Dutch 17-th and 18th Century Paintings in the NGI* (Dublin 1986) p. 112
9 Minutes, 5 Dec. 1923
10 NGI Admin. Box 6. A Ryan at the Ministry of Finance (Aireacht Airgid) to Sir Philip Hanson, C.B. Board of Works.
11 TCD Bodkin ms 6961-85
12 TCD Bodkin ms 7130-1. Bodkin to Yeats, early June 1923
13 NGI Admin. Box 6. Applications for Directorship, Nov. 1924
14 *ibid.* Tatlock's application for post as Director.
15 *Ibid.* Lord Mayo to O'Brien, 2 Nov.1923
16 TCD Bodkin ms 6961-88. Resolution.
17 NGI Admin. Box 6. Hutcheson Poë to O'Brien, 21 Nov. 1923
18 TCD Bodkin ms 6961-88. Resolution
19 *ibid.*
20 *Irish Times*, 10 Dec. 1923
21 TCD Bodkin ms 6962-1
22 'Oculus', *The Irish Builder and Engineer* (14 Jan.1922) p. 9
23 Minutes, 6 Feb. 1924
24 NGI Admin. Box 6
25 Minutes, 3 Dec. 1924
26 Potterton (as n. 8) p. 170
27 NGI Admin. Box 7. O'Callaghan to Martin, 17 Oct. 1924
28 Rosemarie Mulcahy, *Spanish Paintings in the NGI* (Dublin 1988) pp. 76-78
29 NGI Admin. Box 7. Douglas to O'Callaghan, 15 Dec. 1924
30 Benedict Nicolson, 'The National Gallery of Ireland', *The Burlington Magazine* (Nov. 1968) p. 595
31 Minutes, 2 June 1926
32 NGI Admin. Box 7. Fletcher to O'Callaghan, 8 Dec. 1926
33 *ibid.* Letters about paintings
34 *ibid.*
35 *ibid.*
36 *ibid.* Stephens to O'Callaghan, 15 July 1924
37 *ibid.* MacNamara to Stephens, 10 Aug. 1925
38 Minutes, 2 Dec. 1925
39 NGI Admin. Box 7. Report on Circular 52/23 of 28 Nov. 1923
40 *ibid.*
41 *ibid.* Letter to the Controller of Stores, Aldborough House, 4 Feb. 1927.
42 Minutes, 27 April 1925
43 NGI Administrative Box 7. Aloysius O'Kelly to Registrar, 5 July 1926
44 Anne Crookshank and the Knight of Glin, *Ireland's Painters 1600-1940* (New Haven & London 2002) pp. 258-60
45 NGI Admin. Box 8. Brooke to O'Callaghan, 24 May 1927
46 'First Annual Report of The Friends of the National Collection of Ireland, 1924'. Quoted in *75 years of Giving – The Friends of the National Collections of Ireland* exh. Dublin 1999, p. 11
47 NGI Admin. Box 7
48 TCD Bodkin ms 7000-1613
49 NGI Admin. Box 8. Draft letter from O'Callaghan to Martin, 9 Feb. 1927
50 TCD Bodkin ms 7005-367. Hogg to Bodkin, 27 June 1927

'ONE OF THE GREAT COLLECTIONS'

Like Hugh Lane and Robert Langton Douglas, Thomas Bodkin collected pictures and dealt in them. In 1923 he listed many of those that were in his house in Wilton Terrace to WB Yeats when he asked him to come and look at them. (Yeats declined.)[1] In the memorandum accompanying his application to the Directorship in 1927, he mentioned twenty-nine ('etc.etc.') pictures by Old Masters which he 'had discovered and acquired.'[2] After his death the Archbishop of Birmingham wrote how 'the early maturity of his judgement was made clear when the collection of paintings, purchased in youth with an odd ten pounds now and then, was sold, shortly before he died, for some tens of thousands.'[3] In 1963 his widow, Aileen Bodkin, through the Friends of the National Collections of Ireland, gave two of Bodkin's paintings to the NGI, *A Stormy Landscape* (NGI 1760) by George Barret and an oil sketch by James Barry of *Iachimo in Imogen's Chamber* (NGI 1759). Two more, *Abraham's Sacrifice near Bethel* (NGI 4644) by Sébastien Bourdon (1616-71) and *Saint Mary Magdalen in the Wilderness* (NGI 4645), attributed to Annibale Carracci (1560-1609) entered the Gallery in 1997 through the Sir Denis Mahon promised Bequest.

Back in 1924 Bodkin made a profit on another of his pictures. He had bought for £1,000[4] a painting by Quentin Matsys which, through Alec Martin, he disposed of at a Christie's auction on 18 July 1924 for £3,787. 17s. 6d. after commission was deducted.[5] Unless his arithmetic was wrong, he seems to have had other successes. At a lecture in 1935 he observed: 'With the sale of one picture alone I once, before I became Director, earned fifteen times my annual salary.'[6] In 1927 he was able to apply for the Directorship of the National Gallery for a second time because he felt financially secure. He had just published *The Approach to Painting*, full of common sense about going to a gallery. 'The visitor should provide himself in advance with a catalogue, and, with its help, determine to confine his attention to the work for a strictly limited number of schools or masters for the greater part of the visit.'[7] His friend Arnold Bennett wrote

Thomas Bodkin (1887-1961), seventh Director (1927-35),
1948 by James Sleator (1888-1949), bequeathed
by sitter's daughter 1974 (NGI 4084,
©The Artist's Estate).

The Main Gallery, 1932 by The MacEgan (1856-1939),
(courtesy of Burns Collection, Boston
College, ©The Artist's Estate). The prominent
sculpture of *Sophocles* is by John Donoghue and
the paintings Italian. The sound-absorbing
Minton floor tiles only appear to be concealed
by wooden flooring.

how the book's author 'knows painting from the inside; he understands
the creative processes.'

In his application he stressed his achievements – the articles he had
written for leading art journals, the paintings he had discovered and his
well-attended lectures. In 1917 he had given the Hermione Lectures at
Alexandra College which he developed into *Four Irish Landscape Painters*,
published in 1920.

He mentioned his long association with Lane, who had once written:
'You are indeed a help, but for a few like yourself I would have taken my
pictures from Dublin long ago.' He concluded: 'If appointed Director, I
could obtain valuable help in discharging the duties of office from
numerous friends and acquaintances among the Directors of the great

galleries at home and abroad, experts, collectors and writers on art.' The Board elected him unanimously.[8]

The Minister for Finance had agreed that Bodkin could work part-time as Director, at the same time continuing in the Charitable Donations and Bequests office which he had joined as a secretary in 1917. His salary as Director would be £500 per annum with travelling expenses up to a maximum of £150.[9] He hoped to change these dismal conditions and make the appointment full-time.

He now had the opportunity, for which he had waited for most of his life, of enhancing the role of the NGI both in Ireland and abroad. He was proud of his charge, and when, once again he gave a Hermione Lecture in 1928, he could point out: 'Today our National Gallery boasts one of the great collections of Europe and certainly there is no better collection of its size in the world.' He stated that there was no better collection of Dutch pictures in any gallery outside Holland, except the National Gallery in London. He mentioned values, which always appealed to the public. The Rembrandt *Landscape with the Rest on the Flight into Egypt* (NGI 215) which had cost £500 was now worth £100,000, and when it was lent to the Rijksmuseum in Amsterdam in 1932 it would be insured for as much. The paintings which over the years had cost a total of £22,000 were now worth £2,000,000. In the preface to the NGI catalogue he published in 1932 he estimated the collection consisted of 'nearly eight hundred pictures, of six hundred drawings and water-colours, of many hundred prints and of a few statues and casts.'[10]

During O'Callaghan's time Bodkin had influenced the purchasing policy of the Gallery. As Director he immediately began making purchases of his choice. On 6 June 1927, a week after he became Director, the Minutes recorded 'the offer of picture 'Joseph Selling Corn in Egypt' by Pieter Lastman from Mr Bernard McCoy at the price of £300 was accepted… and the Director empowered to purchase under the terms of Bye-law 16.'[11] Pieter Lastman (1583-1633) was Rembrandt's teacher, and the crowded painting (NGI 890), bought in Belfast, dominated by Joseph wearing a huge turban, full of fussy detail of animals and classic allusions, had been copied by Rembrandt in a pencil sketch now in the Albertina, Vienna.

In October: 'Apotheosis of Jean Jacques Rousseau' submitted for purchase for 143,000 francs (£1,153. 7s. 6d.) It was ordered that the picture be purchased at the price named.'[12] This depiction of worshippers at Rousseau's catafalque in the Tuileries Gardens (NGI 896) by Hubert Robert (1733-1808) paid for out of the Lane Fund, proved popular in France; references throughout the Minutes show frequent French requests for its loan.

'The offer for purchase from Captain Langton Douglas of a picture 'Landscape' by Jan Siberechts at the price of £600 was accepted.'[13] The Flemish painter Jan Siberechts (1622–c.1700) specialised, oddly, in scenes of peasants crossing water with their carts and animals; this example, *The Farm Cart* (NGI 900), is beloved by children because of the urinating horse. Another painting obtained from Douglas in 1934 through Bye Law 16 for a bargain £120, was James Barry's *Self-Portrait as Timanthes* (NGI 971), 'one of Barry's finest and most complex works.'[14]

At the same meeting at which the Siberechts was presented, Bodkin persuaded the Board to change Bye Law 16 which gave the Director leave to purchase a picture up to a value of £500 on his own initiative; the amount was raised to £1,500. As a result of this amendment he bought from Christie's for 720 guineas *St Rufina* (NGI 962) one of seventeen virgin martyrs painted by Francisco de Zurbarán which belonged to King Louis-Philippe.[15] Originally identified as St Justa until its correct name was found after cleaning in 1967, the painting was something that Bodkin dearly wanted, 'an acquisition of very great importance… Zurbaran, more than any other Spanish painter, represents the dignity and piety of Spain at her zenith.'[16] However, Thomas MacGreevy wrote that he 'liked St Justa better for her skirt than her face.'[17]

Aware of the trouble that had been caused in the past by the tempting dual role of director-dealer, and the fact that he himself had indulged in dealing before his appointment, Bodkin made his own position clear at the Board meeting of 4 April 1928. As a test case he offered for the Board's consideration a small picture by Abraham Cornelisz Begeijn which he had bought for himself for £7, knowing it was not needed for the Gallery. What he wanted was the Board to trust him – no more quarrels on the Langton Douglas scale. 'He assured the Board…that he would always buy or submit to the Board any picture of real merit by a master who, in his opinion should be and was not adequately represented in the Gallery…If, however, he was offered in his private capacity a fine picture by a master already represented by a very similar work in the Gallery, he considered himself at full liberty to acquire such a picture for his own collection.' The Board demurred and 'refrained from making any formal ruling on the points raised by the Director.'[18] But after members turned down the Begeijn they let him do what he wanted with regard to works of art for the Gallery. However, he later stated: 'When I entered the Gallery I ceased absolutely to buy pictures for myself. No Director should be allowed uncontrollable liberty to do so. That would put him in a position of intolerable temptation.'[19]

He expected a free hand and did not want to be hampered by committees or by the Board. He succeeded – 'they had never run contrary to my advice' – although he found plenty to criticise in his Board members. The fact that many failed to attend Board meetings meant that often there was less than the necessary quorum of nine members to vote on the acquisition of a painting. Only Sarah Purser could be relied upon to turn up. Sir John Lavery, and even Sir Alec Martin, by now seldom came over from England, while old gentlemen like Jonathan Hogg and Frederick Lawless regarded their presence on the Board as lifelong membership of a club. He concluded: 'My own experience as a Governor before my appointment as Director leads me to the conclusion that Members of the Board have, occasionally, outlived their interest in the Gallery and their utility as Governors and Guardians.'[20]

For the first years of his Directorship he had to tolerate another Governor, WB Yeats, with whom he worked on the Coinage Committee; Yeats, however, did not seek a further five years as Governor after he left his Merrion Sqare house in 1929. In 1935 writing to MacNamara, another of Yeats' enemies, Bodkin commented: 'W.B., as I well know from experience, is a most difficult fellow...though I am always proud to think of him as an Irishman, he has no real understanding of the mentality of our race. He handled the Lane controversy...on just the same provocative lines. Otherwise the Lane pictures might now be in Dublin.'[21] Years after the poet's death he told Alec Martin: 'I always...disliked Yeats – he was a cold-hearted vainglorious impostor in many ways.'[22]

In reply to the Minister of Education, Joseph O'Neill, who was responsible for the running of the NGI, and who had asked for his own nominations for Board members, Bodkin stated firmly that 'I do not feel at liberty to comply with your suggestion that I should nominate persons suitable in my opinion...because, as the Director himself is appointed by the Board, it might seem invidious that he should make formal and official representations as to the Board's constituents.' He did, however, recommend that appointments should be for the statutory period of five years only and not 'virtually life appointments.'[23]

He persuaded the Department of Finance to pay the full amount of the grant-in-aid of £1,000 on the first of April every year rather than dribbling it out in small sums. He had to ask the government to introduce new legislation to allow paintings to be borrowed by other galleries; the change of government in 1922 had meant that there was no law in place permitting this, and the situation was not rectified until 1928 (and then only on Bodkin's insistence) when it received the Royal Assent as was

*North wall of Main Gallery with North Italian and
Venetian paintings in tiered hang of Thomas Bodkin, c.1930
(NGI Archive).*

*Upper room with selected 15th–16th century Venetian
paintings hung on the line by George Furlong, 1935
(NGI Archive). The paintings are by J. Bassano,
Moroni, Sebastiano del Piombo, Venetian
School (then Bordone), Pordenone (then
Lotto), North Italian School (then Follower
of Moroni, so hung as a pendant) and Palma
Vecchio.*

then necessary. Lending pictures has always been an essential function of the Gallery, raising its profile and allowing reciprocal exchange.

An early task was the first rehanging of pictures since Lane's time. Bodkin wrote to Alec Martin in November 1929: 'I have rehung the Gallery almost entirely. It was a frightful job and I am dead beat, but I am longing to show it to you as I trust you will find it much improved… I…am feeling desperately tired, and am worked from morning till night.'[24]

The result pleased critics and the *Irish Times* reported: 'The various schools of painters have been efficiently segregated and placed in separate rooms and in the rearrangement scheme the pictures are given a better display value.'[25] The section devoted to Irish artists was one of the most comprehensive in the Gallery. However, in 1932 Irene Hough considered that the Irish section of the NGI 'in comparison with the Harcourt Street Collection is very poor. Our greatest artists are still alive and cannot therefore be admitted here.'[26]

'Owing to the increasing demands on the wall space at my disposal here,'[27] Bodkin returned to the National Gallery in London a number of pictures that had long been on loan. They included David Wilkie's *The Peep o' Day Boy's Cabin* and an enormous (six feet by thirteen[28]) painting by Landseer, *Dialogue at Waterloo,* where the Duke of Wellington shows his daughter-in-law the devastation of the battle field, loaned back in 1884 and very unfashionable by the 1920s. Sir Augustus Daniel, the Director of the National Gallery, wrote: 'It is sad that I have to receive a large Landseer, but I am comforted by the thought that you are getting rid of it.' There was some press criticism, since the return coincided with Bodkin's intervention in the Lane controversy with the publication of his book, *Hugh Lane and his Pictures* (1932), and was seen as politically motivated, but Sir Augustus quite understood why Bodkin wanted to dispose of a 'large and uninspired' picture.

Bodkin kept the borrowed Turners which Irene Hough saw with pleasure in the summer of 1932. 'And here in the third room is my gorgeous Turner… *Regulus leaving Rome.* Opposite two more Turners, *The Opening of the Walhalla* and *Lake Avernus.*'[29]

One of his innovations was the yearly exhibitions of recent acquisitions to the Gallery which were held following the annual closing for cleaning and rehanging. He made the opening of each exhibition a very formal occasion. A reception would be given at the end of November and invitations were issued to members of the government, including the Governor General and Mrs O'Neill, WT Cosgrave and Mrs Cosgrave,

ministers and the diplomatic corps. Afterwards the élite would be invited to a tea party at his house a short distance away. Aileen Bodkin remembered how 'when the National Gallery was reopened after its annual cleaning all the assembled guests of the Governors and Guardians, government ministers et al came on to Wilton Terrace for tea…our little house used to be crammed to its utmost capacity…In fact on one such occasion I remember…Cosgrave complaining, fractious-facetious-like that he could never get a full meeting of his Cabinet together except in our house…' She recalled the dress sword of the Governor General's ADC lying on the hall table beside Compton Mackenzie's shepherd's crook – Mackenzie being over for the Tailteann games.[30]

For another big Dublin occasion, the Eucharistic Congress in June 1932, the Gallery made special efforts. Before 1914 the Gallery, depending on the evening light, closed at 6pm in the summer, but wartime restrictions brought in a 5pm closing which was adhered to for many years. An exception was made for the Congress and the Gallery was kept open in the summer evening light until 8pm to provide for the great number of visitors in town. Four thousand people visited the NGI during the week, but after 5 pm the attendance diminished rapidly, until after 7 pm no visitors came. At the request of the Office of Public Works, on 22 and 26 May the gas lighting of the Gallery 'in the offices fronting on the public thoroughfares' was on from 10p.m. to 4 am.[31]

Bodkin went out of his way to encourage visitors. He lectured frequently ('How our schools might make use of our galleries') and regularly took groups on tours around the paintings. He was a sympathetic guide. In 1928 Gale Ogle, secretary of the Parents' National Educational Union, wrote to him: 'We wish to thank you for your extreme kindness in showing us the National Gallery on Sunday…it was such fun having the doors unlocked and going up the long winding stairs and then more doors, till finally the pictures themselves were charmed magic casements…We would also thank you for your courtesy and thoughtfulness in providing chocolates for our enjoyment.'[32] In 1929, after he had shown John Steegman, Director of the National Portrait Gallery in London, round the Gallery, Steegman wrote: 'I was immensely impressed by the collection; I have seldom seen one so full of plums!'[33]

Frederick Lawless, promoted to 5th Baron Cloncurry, and Jonathan Hogg, two of the oldest Board members, both died in 1929. Lawless had presented the Gallery with a Batoni copy (NGI 909), a cut-down painting by John Singer Sargent, *The Bead Stringers of Venice* (NGI 921) and *The Young Sophocles leading the Chorus of Victory after the Battle of Salamis* (NGI 8037) by

the American sculptor John Donoghue (1853-1903). Hogg's bequest consisted of two works by James MacNeill Whistler, which he had acquired at the exhibition of the Dublin Sketching Club in 1884 in Leinster Hall, Molesworth Street. Whistler had sent over twenty-five of his works, including the portraits of his mother and of Thomas Carlyle, to a show which caused a furore. According to Booth Pearsall, who acted as agent for Whistler, 'the whole of Dublin was convulsed and many went to Molesworth Street to see the exhibition who rarely went to see anything of the kind.' Resolutions were passed 'that never again should such pictures be exhibited.'

Among visitors to Leinster Hall had been the young Jonathan Hogg, who was less of a philistine. Pearsall wrote: 'an offer was made by a friend to purchase *The Mother* and the *Carlyle* which seemed to promise well, but came to nothing.'[34] Alas! This 'friend' was Hogg. At least he was persuaded to buy two watercolours, *Sunrise: gold and grey* (NGI 2916) signed with Whistler's butterfly device (for which the artist sent him a receipt) and the shining *Nocturne in Grey and Gold, Piccadilly* (NGI 2915) and he left both to the NGI in 1930.

Another donation from a Board member during Bodkin's Directorship was a selection of paintings from the old warrior, Lt Col Sir William Hutcheson Poë, whose army career in various Imperial wars had seen a leg amputated. He had sat on the Board for years, and in 1931 presented the NGI with several pictures including a game-piece (NGI 947) by Jan Weenix (1642-1719) in which the landscape of a château is dominated by the corpse of a brown hare.

His wife, Lady Hutcheson Poë, bequeathed two paintings by William Orpen (1878-1931) *The Dead Ptarmigan* (NGI 945), one of the artist's most self-indulgent self-portraits, and *The Wash House* (NGI 946). She preferred to leave them to the NGI rather than the Municipal Gallery still in Harcourt Street, which she considered insecure and impermanent.[35] (Irene Hough condemned 'this site of dingy dignity.')[36] By then Orpen's reputation had crashed, and after he died in 1932 Bodkin was able to acquire for very little money three of his most accomplished pictures: *A Portuguese Lady* (NGI 955) for £108, *Looking out to Sea* (NGI 956) for £225 and the ravishing nude, *Sunlight* (NGI 957) for £100.

Two years later, in 1934, Langton Douglas, who admired his friend Orpen's work, sold the NGI *The Knacker's Yard* (NGI 970) for £400. The regular trickle of pictures Douglas sold the Gallery included the delightful *Portrait of the Artist painting a Lady's Portrait* (NGI 952) by Pietro Longhi (1702-85).'As the National Gallery of Ireland...does not possess a work by

Pietro Longhi, I would like to show you one of the finest works of Longhi which I have recently bought from a great English family. ...It is in an excellent state and not expensive.'[37] He was paid £450 .

George Moore's collection of French paintings never came to the Gallery he despised. The NGI had to be content with the bequest in 1933 of a dull portrait of his ancestor, another George Moore (NGI 960), by the English artist, Thomas Wyatt (1773-1840). A more attractive gift was a portrait by the Irish artist Thomas Frye (1710-62) of Sir Charles Kemeys-Tynte (NGI 927) presented by Gordon Hannen, a director of Christie's, at the instigation of Sir Alec Martin, a painting that was enhanced by cleaning in the mid-1960s. A gift of similar value was a still-life, the only known example (NGI 961) by Christiaen Jansz. Dusart (1618-82/83), bequeathed in 1933 by Dr Travers Smith.

In 1930 old Miss Emily Drummond left the NGI a portrait of Edmund Burke and another of her father, Thomas Drummond, who had been Under Secretary for Ireland '...but I declare that should the Irish Free State cease to function as part of the British Empire and an independent Republic be established in that country...I give and bequeath the two said portraits to the Scottish National Portrait Gallery of Edinburgh.' In 1948 both portraits had to be dispatched to Scotland.

With the Lane Fund Bodkin purchased a dignified portrait of an unknown Frenchman (NGI 920) by Jean-Baptiste Perronneau (1715-83) from Agnew in London at a cost of £2,000. Trawling around the Dublin streets, he visited the shop of Henry Naylor, where Sir Thornley Stoker had looked for paintings, and bought a number of bargains including *The O'Connell Centenary Celebrations* (NGI 893) by Charles Russell (1852-1910) for £20, a *Landscape with horse and donkeys* (NGI 935) by Thomas Sautelle Roberts for £12. 10s. (until recently thought by his elder brother, Thomas) and a *Coast Scene* (NGI 1951) by Edwin Hayes (1819 -1904) purchased in 1932 for £8. Far more importantly, in 1928 he tracked down in Louis Wine's antique shop in Grafton Street the *Peasant Wedding* (NGI 911) which had been discovered in an Irish country house, and is one of the best of many versions of the subject by Pieter Brueghel the Younger (c.1564-c.1637). It was an impressive and unexpected find which Bodkin personally acquired for the Gallery for £1,200 under the increased terms of Bye Law 16.

In spite of the tight restrictions imposed by the Department of Finance, he was far from being confined to Dublin. Diaries record travels that must have been as demanding as those of Henry Doyle half a century earlier: 27-30 Jan. 1928 - London Burlington, Christie, Lady Lavery, Tate; 29 - 7 Feb - Germany (lectures) ; ...May 1st 1929 - Porter 1/- sleeper 7/6;

May 4th Paris 6 - 22 - Spain 23 - 28 - Paris 27 - 30 London; Sept 2 -London - N.Gallery, Buttery, Agnew...[38]

He enjoyed what he described as 'dealer crawling and gallery hunting'.[39] There were drawbacks and lost opportunities. In 1931 the depreciation of the pound prevented him travelling to The Hague in search of a Hondecoeter. Lack of funds meant that the purchase of a small El Greco fell through. A letter to MacNamara dated 21 September 1929 complains not only of the difficulty in finding suitable pictures in Brussels, but of being eaten by mosquitoes.

Bodkin's taste was eclectic and he bought examples of paintings from numerous different schools and periods, keeping to his meagre budget and always looking for quality. Purchases included an early Florentine *Virgin and Child with Angels* (NGI 943) by Giovanni del Biondo (active 1356-92), found in Rome in 1931, a landscape (NGI 950) co-painted by Jean Baptiste Corot (1796-1874) and Charles Daubigny (1817-78), bought in 1931 for £63, and Alfred Sisley's *The Canal du Loing at St Mammès* (NGI 966), costing £54. It was not the Sisley he originally sought; a Minute of 1 February 1933 reads: 'The Director submitted an offer for purchase from Messrs Durand Ruel and Co, Paris, of the picture *La Route* by Alfred Sisley at the price of £750. The Director was authorised to negotiate for the purchase of the picture at a lower price.' But later it was found that the 'Alfred Sisley mentioned in the last meeting was no longer available' and the NGI had to settle for another, by chance an exceptional example and costing only £54. Successive Boards showed repeated examples of conservative taste and lack of courage, reinforcing Brian Fallon's opinion that 'modern art did not occur in Ireland'.[40]

Bodkin succeeded in buying a painting by Eugène Delacroix (1798-1863) *Demosthenes by the Seashore* (NGI 964), a late work showing the artist's superb skills as a colourist. The orator, wearing a billowing cloak, leaving his sandals behind a rock, ignoring his two waving companions, preaches to a restless seascape, his arm outstretched under a turbulent sky. Thomas MacGreevy wrote congratulating him 'on beginning the nucleus of a national collection of modern French pictures.' A 'worthy' picture by Sisley or Delacroix was 'something precious to have in Ireland so I rejoice at your news.'[41]

Bodkin considered his 'greatest bargain' to be the *Pietà* (NGI 942) by Pietro Perugino (1446-1523). Like the NGI's *Pretiose Discovered* by Godfried Schalcken, the painting had been in the collection of the executed Phillippe Égalité, Duc d'Orléans, and the head of the Virgin had been damaged (fancifully associated with the Revolutionary mob). It was

The Pietà, c.1495 by Pietro Perugino (1446-1523) purchased 1931 (NGI 942). An earlier version in the Uffizi, Florence, lacks the Flemish-inspired landscape with Calvary.

The Liffey Swim, 1923 by Jack B. Yeats (1871-1957),
presented 1931 (NGI 941, ©Yeats Estate and
DACS, London 2004).

bought at the Orléans sale in the Strand in 1798 by the ancestor of Sir
Christopher Sykes who sold it at Christie's in June 1931. It cost £3,990,
almost all the Lane income for the year. The Board gave Bodkin its fullest
support, and because of the world slump and the recession in the art
market, the price was considered to be low, although the painting was in
poor condition.[42] (Irene Hough heard 'some American accents near me
discuss whether it was worth the three or four thousand paid for it.'[43])

After Lady Gregory died, Bodkin bought at the sale at Coole Park
fifteen drawings, all portraits, at a cost of £29. 18s.[44] Nine were by John
Butler Yeats, commissioned by Gregory in 1898; the sitters were Douglas
Hyde, Standish O'Grady, George Russell, JM Synge, Edward Martyn,
John Eglinton, Frank Fay and John Butler Yeats' sons, Jack B Yeats, and
WB Yeats, painted in Chinese white and charcoal grey. When Gregory
praised this watercolour, the old man replied: 'We artists live by praise; it
is the sign to us that we have expressed ourselves adequately.'[45]

In 1931 *The Liffey Swim* (NGI 941) by Jack B Yeats (1871-1957) was presented to
the Gallery by the Haverty Trust which had acquired it the previous year.
The Trust, founded by the wealthy son of Joseph Patrick Haverty, whose
Blind Piper came into the Gallery in 1864, purchases works of art by painters
of Irish birth who lived in Ireland. Yeats was not born in Ireland, but the

Trust made an exception, since he was the outstanding modern Irish painter. Since the NGI did not hang the works of living artists, the picture had to be lent out to Crawford Municipal Gallery in Cork until Yeats died. He himself was unimpressed by the choice: 'I hoped they would have taken something wilder, but there were some cold feet' (Yeats Archive).

In his 1932 catalogue, Bodkin described the painting prosaically as 'a record of the annual swimming match in the River Liffey seen from Bachelor's Walk on the North bank of the River looking towards O'Connell Bridge. In the late afternoon, crowds of onlookers lean over the parapet watching the competitors.'[46] First exhibited in 1925 at the RHA, it was a break from Yeats' favourite tinkers and wild men of the west, although light years away from the future, described by a friend and member of the Board, Terence de Vere White in his novel, *A Fretful Midge* (p. 116): '... quite suddenly, when over fifty years of age, he began to paint in an expressionist style in which the drawing was implicit, so that he might have greater freedom to express things through colour rather than form...the only thing that is modern in Yeats' paintings is the license he takes to depart from those scientific distinctions.'

As Registrar, MacNamara continued to manage day to day business. ('...I beg to state that the goods received from your Department of the 22nd ultimo include three black lead brushes, but not the particular item, 1 stove brush hard, described in enclosed delivery note.'[47]) Other trivial matters, like the removal of the Civic State Coach, dumped on the Gallery premises, were dealt with by the Director personally. The coach ended up in the Fire Station in Tara Street during Civic Week, and the Gallery refused to take it back.

Bodkin stood out in vain for the eleven attendants, most of them recruited from the Defence Forces, to have some sort of a level of education. Also 'They should be neat with their fingers and not suffer from any physical disability which would make them unfit for the duty of moving most valuable and occasionally heavy pictures.'[48] When the new Free State Government wanted the old frock coats changed to jacket suits, he insisted attendants retained their caps: 'caps give the men the appearance of tidiness and authority.'

An attendant who gave great trouble was John Penrose. In 1924 a letter from a soldier in Marshalsea Barracks complained of 'Pengrave' 'who had a lot of criticism of our present Govt and this goes on daily at lunch hour and it is carried outside... he has also used our President in very low opinion...'

Penrose did far worse five years later, although his crimes are unspecified; a postcard from Bodkin to MacNamara mentions 'Penrose and his women.' His offences took place in the Gallery and other attendants were called as witnesses. MacNamara had to deal with the matter, keeping the court proceedings out of the newspapers. He wrote to Bodkin, who was abroad: '3rd May 1929...Penrose...suggested eloquently that it was a malicious charge engineered by his enemies... and that, in view of the publicity that was likely to be given to the Gallery if we could use our influence to whitewash him somehow...I told him of course that we could do nothing...'

'19 May...two months in Mountjoy for his performance on each occasion...I have not yet sent Penrose formal notice of dismissal. Am I to do this now or wait until your return?'[49]

Soon after he became Director Bodkin was criticised for the lack of bilingual descriptions of pictures. (He neglected learning Irish, which in future would cost him the Directorship of the Arts Council.)[50] In a letter to the *Irish Times* of 18 June 1928 he argued that 'to translate, for example, Baldassare Castiglione by Tiziano Vecellio or Antonio Ciocchi del Monte Sansovino by Sebastiano del Piombo into Irish would call for scholarship of an unusual kind and use it to little purpose.' (Excepting Italian, Spanish and Early Northern works, the labels today are always bilingual.) He considered there were more interesting and pressing things to occupy him. 'We seldom buy anything that is not of quite outstanding importance or of national interest to Ireland.'

By 1934 it would seem that Bodkin had good reason to be satisfied with the hard work he had put into his role as Director. He had bought important pictures. He had made huge efforts to publicise the NGI, arranging pictures and lectures. His championing of Lane and the wretched story of the lost Impressionists took the form of his book, *Hugh Lane and his Pictures,* published in 1932 and generally well reviewed. A limited edition, bound in green morocco with a gilded harp on the spine, commissioned by the government, was followed by a general edition.

He had seen to the publication of two catalogues – one in 1928, the last to list and describe the casts on view, and a second in 1932, one of the last to consist of text only. It was 'the seventeenth issued to the public since the first one appeared in 1864.'[51] The work for both catalogues had been largely done by O'Callaghan ('Mr Bodkin has passed his work without alteration, but with the addition of a list of the most recent acquisitions'),[52] but Bodkin, with the aid of MacNamara, put his stamp on the 1932 edition. 'Every great school of European art is adequately represented,

and the Irishman who desires to gain a good general idea of the trend of pictorial art from the dawn of the Renaissance to modern times is under no necessity to leave his own shores for the purpose.'[53]

Throughout his Directorship, however, Bodkin was frustrated by official indifference, while the Department of Finance, representing an impoverished government, continued to be parsimonious. ('Stationery Office, 27 September 1927 ...I am to inform you that it is not proposed at this stage to purchase a copy of Thom's 1927 Directory. A copy on loan, however, is forwarded herewith and you are requested kindly to return it when you have finished with it. Mise le meas...'[54]). Bodkin was unable to persuade the Department to allow him a regular typist which caused difficulties 'on the occasion when a specially large amount of shorthand typing has to be done at the Gallery' for example, when the new catalogue had to be assembled.

The 1920s and 30s were a time of economic stagnation in a country that was 'inward looking in its affairs.'[55] At the end of his tenure Bodkin wrote: 'The neglect of the Fine Arts in Ireland has troubled thoughtful men and women for generations. With the establishment of the Irish Free State in 1922 many of us hoped that enlightened action would soon be taken by your Government to help us to make up the leeway which sundered us from other civilised states...'[56]

He was unable to achieve his basic aims. The position of Director continued to be part-time and underpaid. When he rehung the pictures after his appointment he did not hesitate to hang them one above the other, and the rearrangement emphasised that once again the Gallery was full – an extension was needed for the expanded collection.

On 3 July 1929, while he was in the process of rehanging, he submitted a memorandum to the Board on what he considered the many inadequacies of the Gallery. The last enlargement to the Gallery was in 1903; with the many additional pictures he considered that 'this state of affairs is not likely to give encouragement to intending benefactors. Serious overcrowding prevented the proper display of pictures and even the condition of the popular Irish Room 'would not, I think be permitted in any other National Gallery of similar importance.'[57]

The memorandum, which was forwarded to the Government, looked ahead prematurely. 'I think the time has...come when the Government should be asked to acquire some or all of the property lying between Clare Street on the North and the Gallery on the South to provide for such extension as may be necessary in the future.'[58] In vain.

His difficulties with the government are reflected his report on the

organisation of the Gallery compiled in 1931. His Director's Reports repeat his frustrations, detailing items such as the need for a press cutting agency, the lack of staff, the overcrowding, the condition of the basement where stored paintings were in danger of deterioration, the miserly salary of the Director and Gallery officials in comparison to those of the National Gallery in England.

Two deputations of Board members, accompanied by Bodkin, approached successive governments seeking improvements in the Gallery's status. The first, in 1931, accomplished nothing, in spite of Bodkin's friendly terms with William Cosgrave and members of his government. The second, in July 1934, consisting of three Board members, Dr Denis Coffey, President of UCD, Dermod O'Brien and the surgeon and art collector, Sir Robert Woods, accompanied by Bodkin, met with Thomas Derrig, an anti-Treaty politician and Gaelic enthusiast, now Minister for Education in de Valera's government. (De Valera had toured the Gallery with Bodkin in December 1932, nine months after his first electoral victory.)

It was plain there was little in common between Derrig and Bodkin, and the hour-long meeting was unpleasant. The Minister brought up matters relating to the status of the Gallery which were rebutted by the deputation members. There was the fact, disputed by the Department of Finance, that 'the Parliamentary Grant to the National Gallery was at present approximately £1,000 less than it was under the regime of the British Government. Official figures show that the last Grant made under the British Government for the year 1921-22 was £5,145. The Grant voted this year by the Oireachtas was £3,875.'[59]

The lack of facilities and staff was reiterated, including the resolution that the Gallery would have to be closed to the public if the Registrar was absent through illness or other cause while the Director was unavoidably away. Bodkin was closely questioned by the Minister.

'In reply to various questions from the Minister, the Director described in detail the duties which he was called upon to discharge in connection with the preservation, arrangement, reconditioning, cataloguing and purchase of pictures; the reception of visitors and correspondence with foreign scholars; attendance at committees in his official capacity...the necessity of keeping abreast of the study of art and the condition of international art markets'[60] and much more. How argumentative the meeting became is not clear in the bland report, but it seems that Bodkin, prone to making enemies, had made another.

The Minister reserved judgement, and nothing more was heard from him by the time Bodkin submitted his resignation on 14 November 1934. Probably he was pressurised to leave. Anne Kelly considers: 'It is hard to resist coming to the conclusion that he was forced to resign and that no concessions would be granted to the Gallery while he remained as Director.'[61] After he resigned he told Sir Alec Martin that he had been informed that Derrig was prepared to make the job of a future Director permanent with a proper salary and bonus. 'If my resignation has really produced this happy result I have done something for the cause of Ireland by going into exile.'[62]

It had not. Successive governments liked the Directorship to be part-time because it saved money. Lane's insistence that he should have time to do other things like dealing set a precedent that would last for almost half a century.

Bodkin had wanted the job more than anything else, but ultimately he considered the eight years of his Directorship an unhappy ordeal, as he made clear in his letter of resignation read to the Board in December 1934. He had accepted a post across the Irish sea; he would make a success of it, and leave his enemies behind. Abandoning his Directorship, he told the Board, was a 'bitter experience'. 'It is with poignant regret that I leave my country, my many good friends here and our great Gallery in which I have always had an abiding interest, but, I feel, in accepting the flattering invitation of the University of Birmingham to become the Professor of Fine Arts and Director of the Barber Institute, I shall be able to use such talent as I may have to better advantage than I could ever have done under existing circumstances in the National Gallery of Ireland.'[63]

In March 1937 he wrote to MacNamara '…I am quite acclimatised to Birmingham; though I still suffer from occasional black fits of homesickness. They, however, can generally be dissipated by the purchase and perusal of one of the Irish papers.'[64]

1 TCD Bodkin ms 1733 2. 14 July 1923
2 NGI Administrative Box 8. Memorandum to accompany the application of Thomas Bodkin for the post of Director of the National Gallery of Ireland
3 The Archbishop of Birmingham in *Alive to God's Beauty*, exh. Birmingham, June 1962
4 As n. 2
5 TCD Bodkin ms 6951-2113. Receipt from Christie's
6 Thomas Bodkin, 'The Importance of Art in Ireland', Lecture at inauguration of Purser-Griffith Scholarship, Dublin, 24 June 1935.
7 Thomas Bodkin, *The Approach to Painting* (London 1950) p. 15
8 Minutes of NGI Board, 1 June 1927
9 NGI Admin. Box 8
10 Thomas Bodkin, NGI Catalogue (Dublin 1932) p. ix
11 Minutes, 6 July 1927
12 Minutes, 13 Oct. 1927
13 Minutes, 25 Jan. 1928
14 Nicola Figgis and Brendan Rooney, *Irish Paintings in the NGI* (Dublin 2001) p. 80
15 Minutes, 5 July 1933
16 NGI Admin. Box 14. Report on Acquisitions for 1933
17 TCD Bodkin Archive 6962-29. MacGreevy to Bodkin, 12 Dec. 1934
18 Minutes, 4 April 1928
19 Bodkin (as n. 6)
20 NGI Admin. Box 10. Bodkin to O'Neill, 10 June 1929
21 TCD Bodkin ms 6962-213. Bodkin to MacNamara, undated but Oct. 1935
22 TCD Bodkin ms 6951-2260. Bodkin to Martin, 16 March 1943
23 As n. 20
24 NGI Admin. Box 8. Bodkin to Martin, 'November 1929'
25 *Irish Times* 1 Dec. 1929
26 Irene Hough, 'A Visit to our National Gallery', *The Irish Monthly* (November 1932)
27 NGI Admin. Box 14. Bodkin to Daniel, 15 Nov. 1932
28 Director's Report 1932
29 Hough (as n. 26)
30 TCD Bodkin ms 1613-274
31 NGI Admin. Box 13. Eucharistic Congress, 1932, Illumination of Buildings
32 TCD Bodkin ms 6963-274
33 NGI Admin. Box 17. Steegman to Bodkin, 4 April 1929
34 ER and J Pennell, *The Life of James NacNeill Whistler* (London & Philadelphia 1908) vol. 2, pp. 35-36
35 TCD Bodkin ms 6962-172. Hutcheson Poë to Bodkin, 21 Sept. 1931.
36 Hough (as n. 26)
37 TCD Bodkin ms 6961-91. Douglas to Bodkin, 8 March 1932
38 TCD Bodkin ms 7023. Bodkin's Diaries for 1928 and 1929
39 NGI Admin. Box 10. Bodkin to MacNamara, 21 Sept. 1929
40 Brian Fallon, *Irish Art 1830-1990* (Dublin 1994) p. 110
41 NGI Admin. Box 16. MacGreevy to Bodkin, 10 March 1934
42 Minutes, 1 July 1936. Report by Sebastien Isepp on condition of pictures in NGI
43 Hough (as n. 26)
44 Minutes, 15 July 1932
45 Quoted in Hilary Pyle, *Yeats-Portrait of an Artistic Family* (London 1997) p. 88
46 Bodkin (as n. 10) p. 145
47 NGI Admin. Box 8. Registrar to Department of Posts and Telegraphs (stores) 30 May 1927
48 NGI Admin. Box 12. Bodkin to Secretary, Department of Industry and Commerce, 17 Aug. 1931
49 TCD Bodkin ms 6962-138, 139, 140. MacNamara to Bodkin, May 1929
50 Anne Kelly, 'Thomas Bodkin at the NGI', *Irish Arts Review Yearbook* (1991-92) p. 180, n. 15
51 NGI Catalogue 1928. Note
52 *Irish Times*, 28 July 1928
53 Bodkin (as n. 10) p. x
54 NGI Admin. Box 8. 27 Sept. 1927
55 Brian P Kennedy, *Irish Painting* (Dublin 1993) p. 28
56 Bodkin (as n. 6)
57 Minutes, 3 July 1929
58 *ibid.*
59 Director's Report 1935
60 Minutes, 3 Oct. 1934
61 Kelly (as n. 50) p. 177
62 NGI Admin. Box 14. Bodkin to Martin, 15 Dec. 1934
63 Minutes, 19 Dec. 1934
64 NGI Admin. Box 17. Bodkin to MacNamara, 8 March 1937

CHAPTER TWENTY THREE

OPTIMISM AND DESPAIR

At Thomas Bodkin's suggestion, Brinsley MacNamara was made acting Director in March 1935, as Bodkin departed for Birmingham.[1] During his three months in charge MacNamara proposed the purchase of a number of expensive pictures, including a Filippino Lippi (5,000 guineas), a Boucher (5,000 guineas) and a Murillo (£1,000) which were all rejected by the Board.

Lucius O'Callaghan, who had continued to sit on the Board during Bodkin's Directorship, pondered whether to try again for the vacant Directorship. He had protested to Bodkin ('My dear Tommy') that 'unfortunately I have neither the ability nor, so far as lecturing and publicity work goes, the energy to follow in your footsteps.'[2] Nevertheless, with the support of Sir Alec Martin and Sir John Purser Griffith he put out feelers, but the majority of the Board would not have him again.

Among formal candidates were Thomas MacGreevy and the historian, Nikolaus Pevsner, who obtained a reference from Bodkin, 'but I only recommend him in the event of a suitable Irishman not coming forward.' (This letter in the Bodkin archive is annotated by Mrs Bodkin in her usual red ink: 'As if there were one!')[3] Bodkin changed his mind about Pevsner when he learned 'that he was not much liked during his lectureship at the Courtauld Institute.'[4]

George Furlong was elected on 3 July 1935, beating the inevitable British scholar, Dr Whitehead, by a single vote. Furlong was Irish – after Langton Douglas all Directors of the NGI have been Irish. A bachelor, at thirty-seven he was the youngest Director yet appointed and the most qualified since Walter Armstrong.

Educated at Clongowes Wood and University College, Dublin, Furlong undertook graduate studies at Grenoble, Munich and Vienna, where he gained his doctorate in 1928. Fluent in French and German, in 1930 he became Assistant Keeper at the National Gallery in London. His supporters included Kenneth Clark and Sir Robert Witte, a Trustee of

George Furlong (1898–1987), eighth Director (1935–50),
1935 by Frances Kelly (1908–2002), presented 1988
(NGI 4547, ©The Artist's Estate).

the National Gallery who gave him a warm recommendation. 'I consider that his knowledge and taste are excellent and that he is capable of quickly seizing the essential characteristics of any pictures with which he has to deal. He is cultivated and intelligent in a wide sense...he combines sound knowledge, good taste and a practical head for affairs.'[5]

Bodkin had known Furlong since the 1920s and now told MacNamara patronisingly: 'He is a gentlemanly lad and his experience in the National Gallery in London will have shown him how things should be done.' He wrote to Furlong: 'Congratulations and my best wishes for a happy and triumphant career as Director of our great National Gallery... I am glad the post has gone to an Irishman.' On this letter Mrs Bodkin scribbled in her red pen in the 1960s: 'Blimey! See Brinsley MacNamara on him'[6]; sadly there would be a falling out.

According to Terence de Vere White, Furlong was assumed incorrectly to belong to the family of Furlongs whose horse, Reynoldstown had recently won the Grand National.[7] The Directorship began unfortunately when he was laid up in the Elphin Nursing Home with a poisoned foot on the day following his arrival in the Gallery on 1 October. Mrs Con Curran remarked: 'he cannot have properly shaken the dust of England from his feet before leaving'.[8]

He recovered quickly and began doing what new Directors usually sought to do – transform the Gallery. For the first time since the early days of the 1903 extension, pictures were hung on the line. 'In the rearranging,' wrote the reporter of the *Irish Times*, 'he had several objects in view; to have every picture on a level with the eye; and to have each picture isolated...the biggish spaces between each picture serve to isolate the picture so that one can see a picture without bits of an adjoining picture demanding notice at the same time. Dr Furlong told me that all the modern galleries are hung in that uncrowded way.' The novelty drew a record 600 people into the Gallery one Sunday afternoon.

Paintings were moved around; early Irish paintings of the seventeenth, eighteenth and nineteenth centuries were brought down from the second floor to a room off the Portrait Gallery. The second floor was devoted to Italian pictures, their number increased from 89 to 116. The walls were repainted, the Italian rooms a brick red, the Dutch room grey and the Irish room 'an unusual shade which tones beautifully with the gilt frames. Over a ground of light beige there is a dusting of gold.'

The Board Room, Director's and Registrar's rooms, and waiting room for distinguished visitors were furnished with pieces from the Milltown Collection brought up from the basement, one 'so dirty that Dr Furlong

did not know either its value or the wood of which it was composed. Now many Italian tables, Chippendale and other *meubles* are revealed under his vigilance and the Gallery has greatly benefited.'[9]

The new Director next turned his attention to the restoration of paintings. Bodkin had considered no one in Dublin sufficiently qualified for the task, and told the Earl of Rosse, 'I personally would not entrust an important picture for treatment to any of the Irish cleaners. Please don't quote this opinion of mine.'[10]

Furlong had trained as a guide in the Kunsthistorisches Museum, Vienna, and arranged for the chief restorer there, Sebastien Isepp, to come to Dublin. Herr Isepp considered 'the greater part of the pictures are in relatively good condition, with the exception of twenty or thirty.' He reconditioned some and made a report on others. The big Palmezzano (NGI 117) suffered from blisters, crusts and retouching; the Gerard David had 'numerous blisters, which are becoming quite loose and very dangerous.' Other pictures were dirty, with dark grey varnish impossible to see through, or needed reconditioning, retouching and varnishing. In most cases he considered these faults could be remedied in Dublin, and several, including Palmezzano's *St Philip Benizzi* (NGI 364), and the huge Reynolds given by Lady Milltown (NGI 733), were treated locally.

The Perugino *Pietà* purchased by Bodkin (NGI 942) was another matter. 'This magnificent picture is spoiled through early restoration, particularly through unnecessary overpainting, darkening, retouching, cracks in the paint and dangerous blisters. It is obviously not very well preserved and has a number of false patches, but through a thorough restoration, which might take a whole year, it should recover its original beauty.'[11] The painting was dispatched to Vienna, and after Herr Isepp had completed his work, was lent for a period to the Kunsthistoriches Museum.[12]

Furlong's first purchase for the Gallery, announced at the Board Meeting for 5 February 1936, reflecting his own scholarship, was of two Austrian primitives obtained from Vienna for £664. 1s. 7d. – a small panel of the Salzburg School c.1430 of *Christ on the Cross* (NGI 979) and the *Apostles Bidding Farewell* (NGI 978) by a master of the Styrian School, 1494. At the same meeting he announced the offer of the stunning *David and Goliath* by Orazio Gentileschi (1563-1639) from the English dealer, Tomás Harris, who wrote that it had been discovered in a small sweet shop in Limehouse, London. Looking at its size (185 x 136 cm) the viewer may wonder at the dimensions of that sweet shop. The National Gallery in London hoped to buy the painting, believing it to be by Caravaggio, but lost interest when

David and Goliath, c.1605–07 by Orazio Gentileschi
(1565–1647), purchased 1936 (NGI 980).

'Le Corsage Noir', The Black Bodice, 1878 by Berthe
Morisot (1841–95), purchased 1936 (NGI 984).

the correct artist was identified; Furlong was able to knock down the price from £2,000 to £1,400.[13]

In June 1936 'the Director drew the Board's attention to a picture 'Le Corsage Noir' by Berthe Morisot for sale by Messrs Knoedler and Co at the price of £1,250.'[14] The painting was bought (NGI 984), using the Lane Fund. Subsequently the Board would prove reluctant to augment the Gallery's meagre collection of late nineteenth and early twentieth century paintings, turning down a Gauguin and a Modigliani suggested by Furlong. In December 1938 it allowed Furlong to purchase a 'Monet' snowscene for £425 (NGI 1009) which turned out to be one of his rare mistakes. In 1943 a genuine Monet was offered the Gallery for £2,000, which the dealer, Arthur Tooth, considered 'one of the finest Impressionist pictures in this country and justified good price'; this was declined.

In 1937 the grant-in-aid was raised from £1,000 to £2,000 annually, the first increase since 1866. With increased funding Furlong bought brilliantly. *The Shepherdess Spako with the Infant Cyrus* (NGI 994) by Giovanni Benedetto Castiglione (c.1610-65), considered one of the 'finest and most beautiful works'[15] by the artist, cost £378 at Christie's. *The Flight into Egypt* (NGI 1000), linked to the shadowy Jan de Beer (c.1475-c.1527) and derived from a woodcut by Albrecht Dürer, cost £300. From Colnaghi for £170 Furlong obtained *Party Feasting in a Garden* (NGI 993) where a number of glum-looking young people are assembled in colourful surroundings, unhappy because they know that ultimately they will perish. This was identified in 1964 by the art historian Anne Crookshank as the work of Giovanni Battista Passeri (c.1610-79), his only known signed painting.[16] *Man Singing by Candlelight* (NGI 1005) by the Flemish artist Adam de Coster (c.1586-1643) with its dramatic Caravaggesque effect of lighting, was bought for £80 from the Waterford Furniture Stores.

Other notable paintings acquired include the *Adoration of the Magi* (NGI 997) by Jan van Scorel (1495-1562) bought for £413, *The Massacre of the Innocents* (NGI 1020) by Giuseppe Crespi (1665-1747) which cost a mere £40, and *The Return from the Palio* by Giovanni Maria Butteri (1540-1606) acquired for £670 from Langton Douglas.

Also from Douglas, acting on behalf of Mrs Otto Kahn, came the important Franco-Spanish masterpiece, *St Jerome translating the Bible* (NGI 1013) by Nicolás Francés (c.1400-68). Having beaten Mrs Kahn down from the £6,000 she demanded, Douglas wrote to Furlong: 'This is a picture which I wish to get for your Gallery as it is one of the masterpieces of its school and period.'[17] It is reminiscent of an illuminated manuscript and appropriately it was purchased by a medievalist; Furlong's doctorate was

on Old English book illustrations of the tenth and eleventh centuries. With £2,800 from the Lane Fund and the rest from grant-in-aid, he persuaded the Board to part with £4,200 in June 1939.

Less than a year later, in February 1940, the Board learned that 'in view of the grave need for economy in all State Departments' the provision of £2,000 a year grant-in-aid would be reduced once again to the original £1,000.[18]

That year Pierce Higgins presented the NGI with the explicit *Jupiter and Ganymede* (NGI 1046) by Nicolaes van Helt-Stockard (1614-69). A few years earlier the painting had been offered to the Board for £200[19] but it was turned down by a scandalised Board member, who said that on no account could such a subject be shown in the Gallery. According to Furlong: 'I reminded Mr Justice Murnaghan of this. He said the probable reason was that there is a 'lot of that sort of thing' going on in Ireland. It is very prevalent in Cork particularly and even in Dublin. He said the judges get nauseated by the frequency of these cases...I am having the...picture hung in the Gallery.'[20] He made no further comment.

Furlong had inherited familiar depressing problems. One was attendance; in 1936 only 39,336 visitors came to the Gallery. In an article written in 1940 he admitted that the average daily attendance at the National Gallery was 120. The Hone Bequest was unresolved, the Gallery understaffed and the staff were treated miserably. A memo from the Registrar reiterating that half an hour was allowed for their lunch added: 'The above attendants and floormen are requested to state whether they desire to spend the half hour outside or inside...it must be clearly understood that should an attendant elect to spend the half hour allowed inside the Gallery, he cannot be permitted at the same time to spend half an hour, or part of it, outside the Gallery.'[21]

When Furlong was told that no money was available for an extension – nothing new – he decided to make more room by changing the Sculpture Hall. The plaster casts, so lovingly collected by Mulvany a century before, would be stored downstairs in a room not open to the public, but with access to students. They would be kept in chronological order, the Greek sculptures separated from those of Greco-Roman origin and it was suggested that the Parthenon Frieze should be lent to University College Dublin. Some were loaned to Castletown by James White, a few were placed out in the wind and rain beside the restaurant which came with the 1968 extension, others were broken. At least they were spared the indignity of those at the National College of Art and Design, which students deliberately smashed in protest at having to copy them.

In the Sculpture Hall the concrete floor was removed, four feet dug away, and replaced by an oak surface. Instead of the statuary, paintings of the Irish school, cleaned and given a mastic varnish treatment, their frames washed with soap and water, were mounted down the room on large paper-covered stands. The ceiling was repainted in five shades of cream paint, revealing the plaster work; half of the frosted glass was removed from the side windows, giving far more light.[22] These changes took place at a time when the most important pictures in the NGI had been removed.

As early as 1937 Furlong received a letter from the secretary of the Office of Public Works (formerly the Board of Works) 'on the question of the protection of works of Art in time of War or civil disorder.' An airy letter from the Director of the National Museum was quoted, which suggested 'the most valuable material could be carried away to an underground shelter in St Stephen's Green...Should the danger not be considered as a very imminent risk...then I should say that a good shelter in the Dublin Mountains and two or three lorries...might be sufficient safeguarding against a catastrophe...'[23]

In 1938 Furlong attended the Museums Association Air Raid Precautions Meeting in London. A year later the Department of Education claimed authority 'to direct the removal of property from one place to another for its safety. This authority would not be available, however, until the emergency has actually arisen and it is desirable to have arrangements completed beforehand.'

Such arrangements were discussed in full at a Board meeting on 15 February 1939. Furlong made 'a selection of pictures to be saved in case of emergency...The list is not of pictures strictly in order of merit but of the most important pictures in each school – Italian, Flemish, Dutch, French, English, Spanish and Irish. In all 123 pictures have been selected.' Cases were prepared with batons cut to size, together with packing materials, screws and labels.

Furlong wrote in his diary in the summer of 1940: 'An attendant in the Gallery, Niland, attended an ARP meeting yesterday. It seems nothing has been done since last September. They have no fire fighting supplies... the same applies to stirrup pumps and hose pumps...according to Niland the NG is one of the best equipped departments – we have at least some fire fighting appliances. Arranged with him for a suitable ARP shelter in the basement.'[24] William Niland, chief attendant at the Gallery, took a fire fighting course and received a second class certificate. The NGI files contain references to badges for ARP officers, identity cards, armlets,

keys and who was entitled to them, and space for air raid shelters. Beds, mattresses, pillowcases, blankets, and eighteen sheets (personal issue) were supplied by the Department of Defence for those fire-fighters on night duty. A system of warning bells was suggested; perhaps the gong used to clear visitors from the Gallery might be used?[25]

The Department of Education planned to send the paintings selected by Furlong to Tourmakeady in County Mayo, a location even more remote than the Welsh coal mines where the treasures of the English National Gallery were stored during the war. However the Department changed its mind. Furlong observed: 'It seems that West of the Shannon, which was always considered safe, is now considered to be highly dangerous: a complete volte face in military opinion.'[26] The Minister for Education wrote that the taking down of pictures off the Gallery walls 'should be done as unobtrusively as possible and in such a manner as to cause the minimum of dislocation to the normal routine of the Gallery.'[27] Furlong's retort that such an act by definition was impossible went unheard. Years after his retirement he remained apoplectic over the Minister's obtuseness.[28]

Furlong's diary for 11 July 1940 records: 'the pictures — twenty-four cases containing the best ones — are to be moved to the Bank of Ireland next week. This and the general situation has caused a certain amount of hysteria.'

He recommended that since the pictures required light and air and needed to be available for inspection, they should not remain in their cases, but be hung. He was ignored and the paintings remained unpacked in the vaults of the Bank of Ireland for over a year, when the Board became filled with panic. 'It was realised that the pictures were deteriorating and would continue further to deteriorate.'[29] With the authorisation of the Department of Education, Furlong obtained permission to take some back; when he showed them to the Board their condition was considered 'not quite satisfactory.' He was told to remove other pictures that remained in the Bank out of their cases in rotation, so that they could be exposed to light and air.

Meanwhile, on the Department's instructions, the Board considered other places to which the paintings might be taken, suggesting three Anglo-Irish houses, 'Adare Manor (Co Limerick) the property of Lord Dunraven; Castle Forbes (Co Longford) the property of Lord Granard; Pakenham Hall (Co Westmeath) the property of Lord Longford.'[30] Furlong wrote to the Department: 'all these houses would be safe from a military point of view and the houses large enough to contain many

pictures, provided that any of the owners would be willing to lend them for this purpose.'

The Department hesitated, although at the end of 1941 it allowed the Director to bring back all the paintings in the Bank of Ireland to the Gallery, where they remained still stored in their cases, but with the lids off. Not until April 1942 did it approach the Gallery with its former idea – the paintings could be stored in the Preparatory College of Tourmakeady in County Mayo. Together with Mr Murray, Assistant Secretary of the Department, Furlong went down by slow turf-burning train, inspected the College, and found it suitable.[31]

Lorries were provided by the Great Southern Railways with a special allowance for petrol; the cost of the journey was £125. 10s. Considerably more pictures were sent west than had been stored in the bank – 224 in 132 packing cases. Some got a case to themselves, like the Mantegna, the Perugino, Rembrandt's *Rest on the Flight into Egypt* and *La Main Chaude* – always considered special. Others shared a case, like the three Goyas and the El Greco.[32]

Niland, and another attendant, Thomas O'Leary, accompanied the paintings and hung them up in the Preparatory College before Niland returned to Dublin. Although Furlong had pressed for two attendants to stay in the west, only O'Leary remained behind. 'A man of sterling character', who had worked in the NGI for twelve years, O'Leary was separated from his wife and supported 'an aged mother' who was in charge of his two daughters. 'We considered him the most trustworthy man for this responsibility, and because his family circumstances would permit him better than those of any of the other attendants to go to Tourmakeady.'[33]

O'Leary came to hate cold isolated Tourmakeady at the foot of the Partry Mountains where people spoke Irish. He wrote piteous letters to MacNamara.

'Colaiste Muire, Tourmakeady. 2nd 4.43. Dear Mr MacNamara, I wish to make an application for an increase on the £1.0.0 which I was allowed when I first came down here and at that time I didn't know how things stood here...Where I am staying is anything but comfortable and I had to make big sacrifices here during last winter. If I wanted to write on this subject I could write for two hours. I was waiting thinking the war might come to an end but no sign so far...' In January 1944 he got an extra three shillings a week as 'additional emergency bonus...'

'18.2.43 ...would you please put a case before Dr Furlong for me for a pair of those ARP boots and an overcoat. The weather is dreadful here,

plenty of snow and I have a mile to walk to the College…I cannot get a pair of boots here no matter what I will pay, all paper...' MacNamara had to tell him that the boots he asked for were only for ARP purposes.

'24.4.44…I will hang on to see if the end will ever come...'

'19.12.44…Would you make arrangements to give me a change out of this place in March...I thought that I would be able to stick it to the end but I am very much afraid that I won't. My nerves won't allow me. This is an awful place and miles from every place, then I have to stay a mile and a half from the College, up in the mountains. No place to go and no one to speak to. I never before had such an experience. If a fire did start in the College at night time, it would be all burned before anyone could get to the College, because you could not cycle in the night from where I am. It's a lane and a bad one...'

Gallantly he continued to 'hang on'. On 1 January 1945, he wrote, 'I would like to fight it to the end. I came with the pictures and I would like to go back with them.'

There was some worry from the local Chief Superintendent of the Garda Siochana about the safety of the paintings in their remote western location. Thirty years before the Beit robberies Furlong wrote reassuringly: 'When the Attendant, Thomas O'Leary is absent, they are not, in my opinion, in danger of robbery…it would…be difficult, if not impossible to sell any of them or to take them out of the country.'

One break in O'Leary's ordeal was a visit from Robert Figgis, secretary to the Friends of the National Collections of Ireland, who, in 1944 drove down to Mayo, using scarce petrol, to borrow the NGI's seven French Impressionist paintings for an Exhibition of Modern French Art at the National College of Art. He could not find enough petrol to take them back to Mayo, so after the exhibition they were returned to the NGI.

For O'Leary liberation only came in a letter from MacNamara dated 19 May 1945. 'I know you will be glad to hear the good news. The pictures are to be brought back at last. The transfer is to begin next week. Messrs Niland and Wallace are going down on Tuesday next to do the packing…and I have to ask that you yourself will try to have as many of the smaller cases as you can made ready before they start work on the larger ones...'[34]

Scribbled on the list of 224 paintings, in MacNamara's hand writing, are the words: 'All returned from Tourmakeady in good order, slight blistering on a few of the canvases.' The Gallery's best were rehung, and those inferior pictures which had been displayed for three years in their place were sent down again to the cellars. O'Leary resumed his post in Dublin as attendant.

Judging by his diary for the year 1940, Furlong was as depressed by the years of the Emergency (as the Second World War was called in Ireland) as his subordinate in Mayo. He was deeply distressed by Ireland's neutrality. As a young man in Austria and Germany he had seen the effects of Nazism, and had witnessed from a tram[35] Hitler's abortive putsch in Munich in 1923. In 1936 he assisted the Jewish Viennese art historian Otto Pächt in escaping from Austria by issuing him an invitation to Ireland.

He kept in his files newspaper cuttings that troubled him – the Report of the Royal Commission on Population banned in Ireland, the Chairman of the Clare County Board of the Gaelic Athletic Association objecting to foreign games in the National Army. He retained a copy of a letter by Pamela Hinkson, daughter of Kathleen Tynan, to Cardinal Macrory, Primate of Ireland, condemning the Primate's pronouncements that 'this war was sent by God to punish a wicked world' and 'Ireland was spared because it was free from sins of materialism.' In his diary he recorded how his friend, David Haldane Porter, tore up the *Irish Times* in a railway carriage and threw it out of the window as a gesture of disgust after reading that the Irish Government had reaffirmed its neutrality. 'Nobody took any notice of him, he said.'[36]

Politics came into Board meetings. When the British Council wanted to continue to borrow Orpen's *The Dead Ptarmigan*, which had been on show in its pavilion at the World Fair, that institution was bitterly attacked by Joseph Connolly, chairman of the Office of Public Works, who declared that it indulged in anti-Irish propaganda in America. 'He resented very much obliging the British Council and said the Gallery should have nothing to do with it.'[37] Such detail did not appear in the Minutes, only the fact that the motion to continue to lend was defeated 'on a show of hands.'[38] Later, on Connolly's suggestion, the British War Loan investments of the Lane Fund (about £24,000) were exchanged for Irish Government securities. Meanwhile Furlong and Connolly quarrelled openly about the delay in redecorating the Sculpture Hall. Another enemy was John Burke, also on the Board, who went to the Minister of Education complaining about the rehanging of the Irish pictures in the Sculpture Hall. Burke wanted Judge Murnaghan to join him in a protest. 'M. declined...I gave him instances of Burke behaviour. No trustee has ever degraded the dignity of the Gallery like he has.'[39]

On 28 June 1940 Furlong wrote: 'I find the continuous war discussion very futile. If we cannot do anything positive to help I think one ought to employ one's energy in some inoffensive cultural direction.' The following year he found something 'positive' by allowing himself to be

recruited by John Betjeman as a 'whisperer' for the Special Operations Executive (SOE) which was responsible for part of the chaotic British espionage undertakings in Ireland during the Emergency. (The Directors of the National Museum and the National Library were also involved in clandestine activities.) The role of a 'whisperer' was to disseminate propaganda at social gatherings, and Furlong was to be given selected pieces of information on his frequent visits to London. How successful he was in this role has not been discovered.[40]

Extracts from his surviving diary, written in 1940 and covering less than a year, reveal how much he hated Dublin. 'Oliver St John Gogarty is still in America and cannot get back now...Lucky man.' 'Awoke feeling very depressed and determined at all costs to get out of this place come what may.' 'Each day I scan the columns of *The Times* for some job in London...what is certain is that I shall never be contented living here. I can form no contacts here. It is impossible. Meanwhile the years fly by.' 'I am here now almost five years and so far I have not found one person who speaks the same language and that I ever want to see again.' 'Constantia Maxwell [Professor of History in Trinity College]...finds Dublin very boring and dull...' 'The Pearsalls...agreed with me on the petit bourgeois character of Dublin and the lack of any intellectual interest...' '...lack of culture and interest in culture which one meets on all sides...' 'Went to Jules to have a manicure and haircut. Got the usual bad service. It is miserable how low Dublin standards are.'[41]

His depression is puzzling, since so much of his life seems to have been colourful. He made frequent visits to London. Elegant in his appearance, at his modern, pastel-hued flat at 42 Upper Mount Street, which he kept filled with flowers,[42] he entertained people to tea, a porter from the Gallery acting as butler.[43] His friends included Frank McDermott, Sir John Mahaffy, the British ambassador, Lady Fingal, Brenda Gogarty, Joseph Hone, who asked him to read the manuscript of his biography of WB Yeats, and Lennox Robinson, who invited him to Sorrento Cottage to meet TS Eliot.

He regularly attended Sarah Purser's 'days of wrath' at Mespil Road and describes how he helped her down the steep curved stone steps at the NGI that led from the Board Room after a Board meeting which she was attending at the age of ninety-four. She died in September 1943, having been on the Board for twenty-seven years. One of her ideas which benefited the NGI was the founding of the Purser-Griffith scholarship in 1934 to train Irish art scholars. So far two Directors have taken it, Homan Potterton and Raymond Keaveney.

In 1939 Furlong had written in *The Contemporary Art World* how 'visitors to Dublin are pleasantly surprised at the extent of the lively artistic activity which they can find in the capital...at least five galleries where one can see exhibitions continually of contemporary works...the habit of buying pictures is widespread in Dublin...visitors to private houses...are frequently surprised at the number of small collections of the leading French painters of today that they find hanging side by side with their Irish contemporaries.'

Much of his unhappiness was related to the Gallery. Attendance figures slumped to 24,273 in 1941 – he had no gift for publicity like Kenneth Clark, Director of the National Gallery in London, who had arranged inspiring wartime concerts. The Board blocked the purchase of many pictures proposed by Furlong. Apart from Burke and Connolly, who were his direct enemies, other Governors, including the playgoer, Joseph Holloway, Lord Longford, the elderly Dermod O'Brien, the artists Seán Keating, and Jack Yeats, appointed in 1938, would prove increasingly cautious.

In 1940 he had visited Evie Hone in her stained glass studio at Marlay. 'Her work is really good. She does most of her work at home now and has deserted the Tower of Glass as she got tired of Miss Purser's abuse.' He was on the Board of the Friends of the National Collections of Ireland and associated with Mainie Jellett and Evie Hone on the committee of the first Exhibition of Living Art held in September 1943, which has been considered 'probably...the most consequential art exhibition to have been held in Ireland during the first half of the century.'[44] Evie Hone was also a Board member, appointed in 1943; since she had a limp from childhood polio, she had to be aided when negotiating the steps to the Board Room.[45]

In spite of reduced funds and the caution of his Board, Furlong continued to acquire good pictures. In 1940 he bought from Langton Douglas for £800 a Rimini School panel depicting *The Crucifixion* and *Noli me Tangere* (NGI 1022), now given to The Master of Verrucchio (active 1330s). (This was the last painting Douglas sold to the Gallery.) In 1941 under Bye Law 16 he purchased *James Joyce* (NGI 1051) by Jacques-Emile Blanche (1861-1942) for 140 guineas. The following year the very mannered *St John the Baptist* (NGI 1088) by Alessandro Allori (1535-1607) cost £60 and the important *Archimedes and King Hieron of Syracuse* (NGI 1099) by Sebastiano Ricci £320. Paintings purchased in 1943 included *Greenwich Pier* (NGI 1105) by James Tissot (1836-1902) for 135 guineas, and a fine copy by Tiepolo of Veronese's *Christ in the House of Simeon the Pharisee* (NGI 1111) for £1,200. *The Calling of St Matthew* (NGI 1115) at present considered workshop of Marinus van Reymerswaele (c.1495-1567),

bought for £1000, again demonstrated Furlong's taste for the unusual. Marinus specialised in painting tax-collectors, lawyers, moneylenders and bankers; here, St Matthew, whose role as tax-gatherer, invoices piled above him, is ridiculed, meets the eyes of Jesus standing in the crowd below and is converted.[46] Although Furlong showed little enthusiasm for Irish pictures, he acquired Walter Osborne's Impressionist *In a Dublin Park, light and shade* (NGI 1121) in 1944 for £200; he also bought *Lady Sarah and the Hon. Jeffry Amherst* (NGI 1135) by Robert Fagan (1761-1816) for £160.

In April 1945, Furlong persuaded the Board to let him buy for £5,000 from his favourite supplier, MF Drey, a sensitive study of a frail old man, *Portrait of a Venetian Senator* (NGI 1122) by Jacopo Tintoretto (1518-94). The portrait is believed to date to the 1570s, when the artist himself was growing old, in a period when he painted a number of other elderly sitters.[47] The purchase created difficulties, since only £3,000 was available from the grant-in-aid and Lane Fund combined, and £2,000 had to be borrowed from the Bank of Ireland, 'to be repaid out of dividends on the Lane Fund investments as they come in.'[48] The investments coming in from month to month soon paid off the overdraft, but the Board disliked the arrangement, which was not repeated.

Among gifts which came into the NGI in the late 1940s were a *Procession to Calvary* (NGI 1141) by the School of Jacopo Bassano from Sir Alec and Lady Martin, through the FNCI; a watercolour by Rose Barton, *Going to the Levée at Dublin Castle* (NGI 2989), and *The Entry of George IV into Dublin, 17th August 1821* (NGI 1148) by William Turner de Lond (active 1767-1826), a picture despised by Thomas MacGreevy because of its Imperialist subject.[49] Three paintings by Jack B Yeats – *Morning in a City* (NGI 1050), presented by the Haverty Trust in 1941; *Men of Destiny* (NGI 1134), presented by the Jack B Yeats National Loan Exhibition committee in 1945; and *Above the Fair* (NGI 1147), presented in 1947 'with a group of Irish citizens' by Father Senan Moynihan OFM. Cap., known always as Father Senan, editor of *The Capuchin Annual* – formed a core to the NGI's collection of the painter's works.

Until the late 1940s most of the Gallery was lit by gas; Furlong supervised the new installation of electricity which was completed in 1948. In 1986 Jim Geiran, who became resident attendant in 1948, at a salary of £243. 16s. a year (he brought up seven children in the basement flat) gave a series of interviews on his retirement which convey the NGI's atmosphere at the time he took up his position – the gas lamps in use before the new electricity came, the closure of the Gallery at dusk, the twelve attendants, the one lift, hand-propelled by ropes, and the infrequent visitors whom he marked down one by one as they came in. He remem-

bered Jack Yeats giving his daughter colouring books and the professional staff of two, Furlong and MacNamara.[50]

He did not reveal if he had observed how much Furlong and MacNamara disliked each other. Their letters in the archives are cold, and MacNamara addressed Furlong as 'Dear Director', never by his Christian name. Homan Potterton related that MacNamara was, 'according to George, "the rudest man he ever met". MacNamara's sin was that he did not stand up when the Director came into the room.'[51]

In a letter to Bodkin dated 9 July 1947 (annotated in red by Mrs Bodkin 'NB') MacNamara laid out his resentment: '…I must unburden myself to you now. It is about Furlong. He…is scarcely ever present here… Even the faint interest that he had in this place is now completely gone… Last week I arranged with him…to take a fortnight of my annual leave… Although he was back from London only about a week, he had to go there again for this week only…As he went out on Friday evening last, he left a message for the doorkeeper that he would not be back until the 21st which I know means about the 28th or the 31st, when he will stroll in for his salary and be away again. Again no holiday for me.

'The position has become intolerable for me…it would help me greatly to know if there is any immediate prospect of his getting an appointment in England…The general air of insolence that he has assumed would seem to suggest that he is confident of something…I am quite sure that when he goes it will be the slinking out of a cad in the matter of his performance on Friday evening, and therefore one does not expect him to give any notice of his resignation from the Directorship here!'[52]

The quarrel continued when MacNamara remarked to Furlong how smoothly things were run when Bodkin was in charge. 'I was quite sure you had spoken well of me to him when he was coming here. His answer, 'Oh, Bodkin may have told you that he had spoken well of you to me, but I can assure you that what he did say about you was something altogether different…this statement could not possibly be true.' (Annotated: 'Indeed it certainly could not').[53]

In May 1948 the Tate Gallery called in all loans of paintings by Turner, and Furlong was asked for those that had hung in the NGI since 1884 to be returned. After *The Golden Bough, Regulus, The Opening of the Walhalla*, and *Venice, Santa Maria della Salute* were sent back to London, John Rothenstein, Director of the Tate, wrote to Furlong complaining that 'their condition is unusually bad even for an artist whose works have, in many other instances, deteriorated so deplorably. In particular, all four pictures

appear to have undergone some form of cleaning which has left a skin of varnish so uneven that while the impasto and whites are clogged with dissolved varnish, other parts of the pictures have been cleaned down to the paint-film. Their condition suggests that the cleaning took place some years ago...We have also noticed that the 'Regulus' has been severely torn...'[54] Rothenstein assured Furlong that the damage was old, and not done during his Directorship. Perhaps John Treacy, who treated the pictures under Doyle's instructions in 1884, may take the blame. The date that the fifth Turner painting in the NGI, *Richmond Bridge,* went back to London is uncertain, although Bodkin probably returned it in the 1920s.

The Opening of the Walhalla, cleaned and sparkling, is currently on display in the Clore Wing of Tate Britain. Norman Reid, the Assistant Keeper of the Tate, had suggested to Furlong that 'the loans will normally be either renewed or varied at a later date.'[55] But Furlong did not follow up this implied promise, nor did MacGreevy. After the treatment of the loan paintings, the Tate may have been reluctant to arrange a further loan. The matter was not brought up at Board meetings and there is no further correspondence in the NGI files. So, although the NGI is lucky to have the Vaughan Bequest, it no longer displays any oil painting by Turner.

At a Board meeting on 7 December 1949, Furlong proposed the purchase of a Murillo for £8,000. The Gallery already had two Murillos, and in future would acquire more. However, *The Pool of Bethesda* is a masterpiece. The Board asked Alec Martin to try and beat down Agnew's to 'say £6,000.' Agnew's stayed firm, and at the next meeting, on 1 February 1950, Furlong, knowing there was no hope of the Board sanctioning the purchase, produced his already-prepared resignation letter, which told them he was leaving 'for private reasons.'[56]

After his departure, the Murillo was bought by the National Gallery in London, and Martin felt he had to justify his hesitation over the purchase of the painting in a long letter to the Board.[57] His caution would have benefited the Gallery when the Shaw money started pouring in, but his health deteriorated, and although he remained a member of the Board until his death in 1971, he ceased to give his advice when the first purchases were made using the Shaw Fund in the late 1960s.

Furlong retired to London, where he spent the rest of his long life with his partner, Rex Britcher. Homan Potterton remembered how 'his home in South Kensington was an Aladdin's cave of beautiful objects... he was a keen supporter of the Byron Society, the London chapter of the Irish Georgian Society...and other societies; and he never missed Glyndebourne.'[58] In 1967 he was in Ireland, attending the Wexford Festival.[59] He died in his ninetieth year in 1987.

In many ways he was an indifferent Director, and his gradual loss of interest in Gallery affairs was deplorable. He took no pleasure in administration and did little to encourage visitors. Anne Crookshank remembered having her *viva voce* examination for the Diploma in the History of European Painting with Furlong in 1948. 'It took place in the Gallery...quite uninterrupted...by any other person, for a whole hour. The only noise was the creaking of our bentwood chairs and our nervous voices, for no visitors appeared at all.'[60]

But Furlong's taste was sound, and the NGI is singularly fortunate in his purchases of a series of captivating pictures, many at bargain prices, over his fourteen-year tenure. The importance of his selections for his poverty-stricken gallery is highlighted by an observation he made in 1939. 'It is curious to note that...there are no art patrons in Ireland who contribute anything to the galleries. Wealthy Irishmen, though perhaps very generous in other directions, seem to take no interest in their galleries. There are no bequests or funds here like one finds in London and Edinburgh. Since the death of Sir Hugh Lane in 1915 there has been no patron of the National Collection to take his place. This aspect of citizenship, never very much cultivated before his day, seems to have completely died out since.'[61]

Potterton wrote that Furlong did not 'realise to the full what an outstanding contribution he had made to the National Gallery of Ireland.'

1 Minutes of Special Meeting of the
 NGI Board, 6 March 1935

2 TCD Bodkin ms 6962-2. O'Callaghan
 to Bodkin, 9 Dec. 1934

3 *ibid*. 6962-197. Bodkin to MacNamara,
 9 May 1935

4 *ibid*. 6962-200. 11 May 1935

5 NGI Administrative Box 16. Robert Witte,
 14 May 1935

6 TCD Bodkin ms 6962-207. Bodkin to
 Furlong, 5 July 1935

7 Terence de Vere White, *A Fretful Midge*
 (London 1957) p. 124. Quoted by Homan
 Potterton ,Obituary of George Furlong,
 Irish Times, 25 March 1987

8 UCD Archives IEUDADA KA53.
 Furlong's Diary, 4 Aug. 1940

9 *Irish Times*, 21 March 1936

10 NGI Administrative Box 13. Bodkin to Earl
 of Rosse, 25 Oct. 1932

11 Minutes, 1 July 1936. Report by Sebastien
 Isepp on condition of pictures in NGI

12 Minutes, 5 Feb 1936

13 Michael Wynne, *Later Italian Paintings in the
 NGI* (Dublin 1986) pp. 37-39 and Minutes,
 5 Feb. 1936

14 Minutes, 3 June 1936

15 Wynne (as n. 13) p. 19

16 Anne Crookshank, 'Two Signatures of
 Giovanni Battista Passeri', *The Burlington
 Magazine*, vol. 106 (1964) p. 179

17 Rosemarie Mulcahy, *Spanish Paintings in the
 NGI* (Dublin 1988) p. 16

18 Minutes, 7 Feb. 1940

19 Minutes, 1 April 1936

20 UCD Archives (as n. 8) 2 Oct. 1940

21 NGI Administrative Box 16. MacNamara
 'to all Attendants' 21 Aug. 1936

22 UCD Archives IEUCDADA KA53 .
 Newspaper report

23 NGI Admin.Box 16. Secretary of OPW
 to Furlong, 15 July 1937

24 UCD Archives (as n. 8) 26 June 1940

25 NGI Admin. Box 19

26 UCD Archives (as n. 8) 27 June 1940

27 Minutes, 5 July 1940

28 Homan Potterton, Obituary of Dr George
 Furlong, *Irish Times*, 25 March 1987

29 Minutes, 1 Oct. 1941

30 Minutes, 2 July 1941

31 NGI Administrative Box 20. Furlong to
 Secretary, Department of Education,
 10 April 1942

32 *ibid*. List of pictures packed for safety

33 *ibid*. Furlong to TJ Morris, Department of
 Finance, 27 April 1943

34 *ibid*. O'Leary – MacNamara correspondence

35 NGI Administrative Box 16.Obituary of
 George Furlong, *Daily Telegraph*, 11 May 1987

36 UCD Archives (as n. 8) 5 July 1940

37 *ibid*. 3 July 1940

38 Minutes, 3 June 1940

39 UCD Archives (as n. 8) 2 Oct. 1940

40 Eunan O'Halpin, 'Toys' and 'Whispers'
 in '16-land: SOE and Ireland 1940-42',
 Intelligence and National Security, vol. 15,
 no 4 (Winter 2000) pp. 12, 13

41 UCD Archives (as n. 8)

42 UCD Archives IEUCDADA KA53. Newspaper
 report, 30 April 1941

43 Potterton (as n. 28)

44 S B Kennedy, *Irish Art and Modernism*
 (Belfast 1991) p.119

45 ' The Master of the National Gallery', inter-
 view with Jim Geiran, *Image* (Dec. 1986)

46 Christiaan Vogelaar, *Netherlandish 15th and 16th
 Century Paintings in the NGI* (Dublin 1987)
 pp. 2-4

47 Raymond Keaveney in *European Masterpieces
 from the NGI*, exh. Australia and NGI 1994, p. 32

48 Minutes, 6 June 1945

49 TCD Bodkin ms 6962-36. MacGreevy
 to Bodkin, 23 Feb. 1955

50 Interviews with Jim Geiran, Nov./Dec. 1986:
 'The Man who lives in the Gallery' *Evening
 Press*; 'The Master of the National Gallery',
 Image; 'Life in Aladdin's Cave',
 Sunday Independent

51 Potterton (as n. 28)

52 TCD Bodkin ms 6962-235. MacNamara to
 Bodkin, 9 July 1947

53 *ibid*. 15 July 1947

54 NGI Admin. Box 22. Rothenstein to
 Furlong, 30 July 1948

55 *ibid*. Reid to Furlong 7 May 1948

56 Minutes, 3 Feb. 1950

57 Minutes, 15 Feb. 1950

58 NGI Admin. Box 40. White to Furlong,
 reserving rooms at the Talbot Hotel
 Wexford. 15 June 1967

59 Potterton (as n. 28)

60 Anne Crookshank, 'In My View -
 The National Gallery of Ireland',
 Apollo (Sept. 1992) p. 166

61 George Furlong, *The Contemporary Art World*
 (London 1939) article in Furlong papers
 (as n. 8)

CHAPTER TWENTY FOUR

CHESTER BEATTY
AND GREAT EXPECTATIONS

Thomas Bodkin wrote to Brinsley MacNamara: 'The Ministry will never get a first class Director at the salary it offers and I am greatly afraid that someone like MacGreevy will be foisted on you. Alec Martin and Jack Yeats will, of course, back MacGreevy who would, I think be even worse than Furlong.'[1] Once again MacNamara had filled in as temporary Director until 7 June 1950, when, by nine votes to two on a show of hands, Thomas MacGreevy was declared the new Director of the National Gallery of Ireland (part-time).

MacGreevy was born in Tarbert, County Kerry, in 1893, the fifth of seven children of a policeman and a primary school teacher. In 1909 he was appointed to a post with the Irish Land Commission in Dublin. Transferred to London, he worked first for the Charity Commissioners of England and Wales (interesting that two Directors of the NGI worked in this field), and then in the Intelligence Division in the Admiralty.

On St Patrick's Day 1917, he enlisted as a gunner, and on 10 May 1917 was gazetted a second Lieutenant in the Royal Field Artillery. On 2 October 1918, he was wounded at Comine.[2] In spite of his brave army record, he retained bitter feelings towards the Crown, reflected in his much-anthologised poem *Aodh Ruadh O Domhnaill* ('my Innisfree') with its line on hanged heroes buried with non-commissioned officers' bored maledictions.

After his demobilisation on 22 January 1919, with the aid of a grant for demobilised officers, he took an arts course in Trinity College 'designed for persons intending to pursue the Profession of Journalism'[3], gaining a Moderatorship in History and Political Science. He studied French and German under Dr Rudmose-Browne. After working with the Carnegie Trust and *The Connoisseur*, in 1927 he was appointed as the Trinity College Lecturer at the École Normale Superieure in Paris. This was only a stop-gap; in a few months he was replaced by 'S. B. Beckett'.[4] However, for two years he continued in another role at the École Normale, and altogether

lived in France for seven years, a period during which he wrote the bulk of his poetry. In 1933 he returned to London, joining the staff of *The Studio*, and lecturing in the National Gallery. The Second World War brought his return to Dublin where he became art critic for *The Irish Times*, and a regular contributor to *The Capuchin Annual*.[5]

Perhaps because he had no formal art training, his art preferences were capricious. His diatribe against English and Dutch painting in an article, ostensibly defending criticism aimed at two paintings by Mainie Jellett exhibited at the Dublin Painting Exhibition in 1923, reflected some of his opinions. 'Think of the artist that Gainsborough would have been if he had lived in France or Italy...Gainsborough wasted time, energy and space covering acres of good canvas with meaningless paint... The curious inability of the Englishman ever to be more than half an artist... We are not interested in dead Dutch boors and dead English gentlemen... They tell us nothing about art...'He would never refer to 'Georgian' architecture in Ireland, preferring 'Irish Classical'. He gave a crisp comment on the College of Science in Merrion Street, built in 1911: 'architectural Kiplingism in Ireland.'[6]

In 1934, condemning the English as 'cultural imperialists', he stressed to Bodkin the superiority of the European continent: 'the mainland is better for the things of the mind and for the arts than the islands ever have been'.[7] Fluent in French, he was an ardent Francophile. Brian Fallon has considered that 'it was not only admiration for French culture, French political structures and French thought which inclined the Irish intelligentsia towards Francophilia. France offered, in effect, an alternative to English domination, or at least a corrective to it.'[8]

In his later years MacGreevy liked to be called Chevalier, having received the Cross of Chevalier of the Legion of Honour in 1948, before he became Director. His friend, Jack Yeats, and his successor, James White, were also made Chevaliers, and so was Bodkin, to whom MacGreevy sent 'congratulations...on your translation to the rank of Officer in the Legion of Honour, our Legion of Honour by God's grace.'[9]

In 1923 his advocacy of Jack Yeats' paintings ('the Cézanne of our time'[10]) led to a public quarrel with Bodkin, who had written in the *Irish Statesman* on Nathaniel Hone: 'No Irish painter, living or dead, has equalled, much less surpassed, the purely aesthetic quality of his art.' MacGreevy responded in a letter championing 'the genius of a living Irish painter... No Hone that I have ever seen could, I think, equal, much less surpass, the aesthetic quality, the impressive design, the massive movement, the fine colour of *Morning After Rain* in the last Jack Yeats exhibition.' He compared Yeats to Bonnard and Brueghel. In reply Bodkin attacked 'the self-constituted and super-sensitive champion of Mr Yeats.'[11]

MacGreevy had been interested in obtaining a Directorship in an Irish art institution for many years. In 1921, with references from Lady Gregory, AE, Lennox Robinson, Dermod O'Brien and Seán Keating, he tried unsuccessfully to obtain the Curatorship of Lane's Municipal Art Gallery. in Harcourt Street.[12] The post would have paid three pounds a week.

In 1927, following O'Callaghan's resignation, with the support of his friends, WB Yeats, who was still on the Board, and Mrs Yeats, he considered applying for the NGI Directorship. Mrs Yeats wrote to him in Paris on 27 February: '...if the Board decides they want a whole time man Bodkin will not be elected and our name will go up. But this is terribly private. There seems to be an inclination to have a whole time man, and most of the Board seem to dislike B. personally, but on the other hand they seem, some of them, to think he might be a good man. Several have seen W. but W. unfortunately has been suffering from nerves...He would, I need hardly say, prefer you.'[13]

On 12 March MacGreevy wrote to MacNamara asking for 'particulars, forms of application, etc., in case I should want to apply . . .'[14] But Bodkin, after resigning from his position on the Board, had been elected unanimously in June 1927.

MacGreevy applied formally in 1935. 'I have studied the history of art over a great part of France. I have visited Italy eight or nine times and there is practically no important work of art in town or village between Naples and the Alps that I do not know at first hand. I have also travelled extensively in Spain, Austria, Germany and Switzerland. I may justifiably claim to have a most comprehensive and intimate knowledge of the contents of the most important galleries of Western Europe.' If this wasn't enough, 'I learned Irish as a boy and have no doubt that if it were desired to conduct the business of the National Gallery in Irish I should be able to do so in a few months.'[15]

But again he was unsuccessful. Furlong got the position, and MacGreevy had to wait until 7 June 7 1950 to be elected Director at the age of fifty-seven. Problems had not gone away. Attendances were still low, and falling; 40,664 people visited the Gallery in 1950 compared to 43,298 the year before. His first fussy Annual Report focussed on his lack of free time. 'It would be absurd for the Director to pretend that the strain of the first six months during which he has held office has not been considerable . . . In theory the post of the Director is a half-time post. But not only has he a full-time duty at the Gallery, but he finds it possible to keep abreast of correspondence only by working at it at home, at night, and not occasionally, but practically every night, and more often than not by coming into the Gallery to work on Sunday afternoons as well as on weekdays.'[16]

He began in the usual way with a rehanging of the paintings. MacNamara wrote to Bodkin in December 1950: 'The collection is being turned upside down and inside out...you may scarcely be able to recognise the Gallery as the same place when next you call.' Bodkin visited the Gallery in March 1952. 'Cher ami et colleague', he wrote to MacGreevy (red exclamation marks by Mrs Bodkin), 'it was an extreme pleasure to see you the other day and to survey the splendid work you have done in the NGI . . . Thanks to you its long eclipse has now ended. I am astonished at all you have done for it in the face of the difficulties of which I had for so long personal experience.'[17] By December MacGreevy could tell him: 'Your Gallery has at last its redecoration completed. The Irish Room and Hall this autumn. The re-hanging is nearly finished; you will be glad to know I managed to find place for a few more Hones.'[18]

The rehanging was at the expense of the Portrait Gallery, in which MacGreevy had no interest. As late as 1962 Henry Mangan, Chairman of the Office of Public Works and a member of the Board, who had long been obsessed with creating a separate National Portrait Gallery, was writing an angry memo on the state of Irish portraiture in the NGI. In 'Inner room No 1 the late James McNeill, Governor General of the Irish Free State' was jammed into a corner close to a side door; on the other side was Strongbow. The portraits, some in double lines, were huddled together on the walls and sides of several projecting partitions. In a smaller, equally crowded room, Cromwell, King William, Swift, and George Bernard Shaw, shared space with bronze busts of Kevin O'Higgins, Arthur Griffith, Michael Collins, Austin Stack and Cathal Brugha, ranged on windowsills.[19]

During the first years of his Directorship MacGreevy was closely advised by Monsignor Shine, lecturer in philosophy, socialite, art collector and art dealer since the 1920s.[20] MacGreevy had given Shine's name as referee in his application. Many paintings that he acquired had religious themes and a number were actually purchased from Shine, including a *Virgin and Child* by the Workshop of Lucas Cranach the Elder (as autograph) for £600 and the *Descent from the Cross* (NGI 1282) now given to Giovanni Balducci (d.1603), for £210. In those early days MacGreevy liked to buy pictures cheaply, although *The Holy Family* (NGI 1232) offered by Shine, now attributed to the School of Fra Bartolomeo (1472-1517), cost £3,000. Another of the Monsignor's friends, the Taoiseach, John A Costello, used this painting for his 1952 Christmas card.[21] After Shine died in 1961, he left his collection to his housekeeper, Miss Kate Farrelly, from whom MacGreevy bought the Flemish School *Descent from the Cross* (as School of Liège) for £250 (NGI 1641), *The Mystic Marriage of St Catherine* (NGI 1638) by Benedetto Veli (1564-1639) for £350, and an *Annunciation* sketch (NGI 1640), by Venetian Carlo Carlone (1686-1775), for £50.

Writing about MacGreevy, Homan Potterton has concluded: 'it cannot be said that the purchases he made at this time are among the most important pictures in the collection.'[22] However, when he was not following the advice of his mentor, the new Director did buy some good pictures in those early years: the Bruges School *Annunciation* (NGI 1223), as Pieter Pourbus (though still a fine work) purchased in 1951; *Horace Hone Sketching* (NGI 1297) by Nathaniel Hone, purchased a year later for £200, and a portrait of Susan Mitchell (NGI 1298) by John Butler Yeats for £25. In 1951 he paid a visit to Glyde Court in County Louth, where Mrs Dorothy Vere May, the youngest child in the portrait group of *The Vere Foster Family* (NGI 1199)

sold it to him for £450. This was the painting for which Hugh Lane had obtained the commission for William Orpen in 1907. Mrs May also sold him for £800 (as genuine) a copy of Rubens' *Hippopotamus Hunt* (NGI 1198) which fell on top of her dog as she was crossing Butt Bridge in her car on her way to deliver it; his paw went through it. The restorer, James Gorry, was able to repair the damage.[23]

In 1956 MacGreevy made a mistake when he paid £2,500 for *L'Occupation Selon l'âge* (NGI 1321) attributed incorrectly to Watteau. He submitted the painting to the Board on 1 February, when it was declined, on Alec Martin's advice. He persisted in believing it to be at least partially by Watteau, and eventually the Board let him buy it. Bodkin, a Board member who was absent when the decision was made, was furious. 'Had I known of the proposal to purchase the picture...attributed to Watteau I should have certainly lodged a strong objection...for I don't think that any outstanding critic of French painting accepts that attribution...'[24]

MacGreevy's tendency to upgrade by persistence was most evident in his insistence that *The Holy Family with St John* (NGI 98) by Francesco Granacci, a colleague of Michelangelo, was actually by the great master. In the introduction to his unillustrated 1956 *Catalogue of Pictures of the Italian Schools* he wrote: 'It is I who placed the Michelangelo label on the *Holy Family with St John*. The attribution goes back nearly forty years to the day when Adolfo Venturi...seeing the picture labelled *School of Ghirlandaio* most pertinently demanded "But who in the school of Ghirlandaio, except the young Michelangelo was capable of producing such a work?"[25]

Among the Director's most adventurous purchases before the Shaw Bequest were two beautiful early Flemish paintings belonging to the Duke of Devonshire by the Master of the Youth of St Romold (active c.1490). St Romold was a Scottish Saint who is reputed to have died a martyr's death in the town of Malines (now in Belgium) around AD775, and twenty-nine or more pictures depicting his life hung in his cathedral there. Seven of these, illustrating his youth, were identified as the work of one particular artist; two were reputedly pillaged by the English and in due course ended up at Chatsworth, to be sold off at Christie's in June 1958, where MacGreevy bought them, for £4,200 and £1,320,[26] using the Lane Fund. One intriguingly shows *The Enthronement of St Romold as Bishop of Dublin* (NGI 1380), an event that history does not record. Most of the other paintings are still in the cathedral.[27]

In February 1951 'The Director submitted an offer...of a companion picture to the Gallery's *Mrs Congreve and her Children* (NGI 1676) by Philip Reinagle. The offer was declined.' This is the picture of *Captain William*

Congreve with his Son (NGI 1213) which is visible on the back wall of Mrs Congreve's drawing room in the painting presented by Sir Edward Turton back in 1914. Fortunately, since the pictures are among the most popular in the Gallery, the Board changed its mind at the next meeting and it was agreed to offer the vendor, Mrs A V Brown, her asking price of £140.[28]

In 1951, soon after he became Director, MacGreevy brought out an illustrated book, consisting of 133 black and white photographs of the Gallery's most prominent pictures. Most of the preparation had been carried out by Furlong. This was reissued in 1963, with 50 additional pictures acquired during MacGreevy's Directorship. Both editions were paid for out of a fund rising from the income of a gift of $12,000 in 1947 by Mrs Magawley Banon of Jacksonville, Florida, in memory of her husband, Edward Magawley Banon. The fund has continued to pay for various publications for over half a century.

No full catalogue had been published by the NGI since Bodkin's time. In a letter dated 2 April 1960, Bodkin reproached him over 'the urgent desirability of producing a proper catalogue of the Gallery. No Gallery of similar importance to ours is without a full catalogue…I am at a complete loss to understand the failure to produce anything of the kind during the past ten years or so, notwithstanding the fact that the Gallery has now a typing assistant, which was not the case during my period of office.'[29] Eventually a concise catalogue of oil paintings alone appeared in 1963, at the end of MacGreevy's Directorship.

Besides the immense Chester Beatty gift, MacGreevy received a number of other important bequests and gifts. In 1952 Mrs May Botterell presented two paintings by William Leech (1881-1968) *A Convent Garden, Brittany* (NGI 1245) and *The Sunshade* (NGI 1246).[30] In 1959, through the Friends of the National Collections of Ireland, Sir Alec Martin gave *An Indian Lady* (NGI 1390) by Thomas Hickey one of four portraits he would present in this manner. Evie Hone died in 1955, leaving the NGI a group of paintings which included two of the most important of the Gallery's infrequent acquisitions of modern art – collages (NGI 1313 & 1314) by Juan Gris (1887-1927) and Pablo Picasso (1881-1973). A later legacy by Richard Best in 1959 brought in good Irish pictures including Sarah Purser's (1848-1943) attractive *Le Petit Déjeuner* (NGI 1424) and three early paintings by Jack Yeats (NGI 1406-09). In 1960 another bequest through the FNCI, from Mrs J Egan, gave the Gallery one of its most popular Yeats paintings, depicting three jockeys, *Before the Start* (NGI 1549).

In 1954 the NGI possessed five paintings by Yeats, all donations or bequests. However, the Board's strict policy of only buying the works of

A Convent Garden, Brittany, c.1913 by William John
Leech (1881-1968), presented 1952 (NGI 1245,
©The Artist's Estate).The outstanding canvas
from Leech's early period in France.

dead artists resulted in one of its greatest missed opportunities. Jack B
Yeats had ceased to attend Board meetings after July 1953, but was still
very much alive on 11 January 1954, when a special meeting was called, and
the Board learned that the government was prepared 'to contribute a
sum of £2,000 towards the purchase of three pictures by Jack B Yeats
offered for purchase by the Dawson Gallery at the inclusive price of
£2,700...' The paintings in question were Yeats' early masterpieces,
Bachelor's Walk – in Memory, Communication with Prisoners (Kilmainham) and *The
Funeral of Harry Boland.* In 1941 they had been bought from the Dublin
dealer, Victor Waddington, by Father Senan, who had been a Board
member and had died recently; they had hung in his offices as part of a
'Capuchin collection'.[31] Father Cyril Barrett considered that 'it is arguable
that these were the finest things that nationalistic art has produced in
Ireland.'[32]

Most regrettably the Board stuck to the rules. 'After a discussion the
Board, while appreciating the Government's offer, did not feel disposed
to take part in the purchase of these pictures at the prices asked for
them.' They only had to find £700, but made no effort to circumvent the
situation, perhaps by a rich Governor buying at least one of these paint-
ings and contributing it to the Gallery. Although MacGreevy was aware
of their importance, having written on them in *The Capuchin Annual* in 1943,
he does not seem to have pressed the matter. Two are now in the Niland
Gallery in Sligo; the third, *Bachelor's Walk- in Memory,* imbued with tender-
ness, dignity and grace, was purchased by Mrs Randal Plunkett. In April
1957, soon after Yeats' death, MacGreevy fruitlessly brought up the
subject with Éamon de Valera. 'If at all possible Mrs Plunkett should be
persuaded to surrender the ownership of *Bachelor's Walk – In Memory,*
which is one of the most moving and beautiful pictures by the artist ever
painted.'[33] Sadly, its whereabouts are unknown after it was stolen from
the hall of Dunsany Castle. There is no doubt that if the NGI had
acquired these pictures, they would have been by far the most popular of
Yeats' pictures in its possession.

A year after his appointment, MacGreevy wrote a memorandum on
the National Gallery 'submitted for the President's consideration.' Many
of the recommendations it contained were old ones, derived from
Bodkin's *Report on the Arts.* The most important was to make the
Directorship full time. The Minister of Education had agreed in principle
by July 1953,[34] but two years later nothing had been done. MacGreevy
wrote a querulous note to the Department in August 1955: '...for five
years I have put everything else to one side. I was known as a writer and I

Sir Alfred Chester Beatty (1875-1968), 1954 drawing by Seán O'Sullivan (1906-64), purchased 1963 (NGI 3567, ©The Artist's Estate)

The Gleaners, 1854 by Jules Breton (1827-1906), Alfred Chester Beatty Gift 1950 (NGI 4213).

am no longer, to all intents and purposes, a writer – and have given all my time, in season and out of season, to the National Gallery and its problems.'[35] Not for another year was he made a full-time Director,[36] the first since Walter Armstrong.

Two major events in the Gallery's history took place during MacGreevy's Directorship, the gift of Sir Alfred Chester Beatty, which he was able to announce at his first Board meeting, and the bequest of George Bernard Shaw.

In August 1949, Furlong had received a letter from Leo McCauley of the Department of External Affairs, informing him of an offer by 'Mr Alfred Chester Beatty... who is about to take up residence in Ireland, to the National Gallery of a collection of pictures of the French Barbizon School.' McCauley added as a footnote: 'I enclose the biographical note on Mr Chester Beatty from the current edition of *Who's Who*,'[37] an indication of how little was known generally about the millionaire mining engineer.

Born in America, with two Irish grandparents, having made his money exploiting the copper belt in Northern Rhodesia (now Zambia), Sir Alfred Chester Beatty (1875-1968) began his wide-ranging interest in art by collecting Chinese snuff bottles. After the victory of the Labour Party in

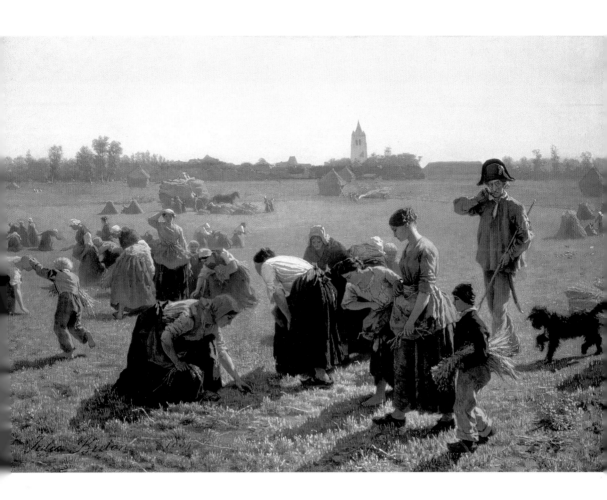

1945 in the English General Election, worried about taxation, Beatty moved from England to Ireland. As a token of appreciation of his encouragement to make this decision by the Taoiseach of the day, John A Costello, he made this gift of paintings.

Furlong had departed by the time the paintings came to the Gallery in the summer of 1950, and it was MacGreevy who received them and arranged a formal presentation on 5 September, attended by the Taoiseach.[38] There were ninety-three paintings of the Barbizon and nineteenth-century continental schools, omitting the Impressionists. Artists represented included Charles Daubigny (1817-78), Johan Jongkind (1819-91), Constantin Troyon (1810-65), Jules Breton (1827-1906), whose *The Gleaners* (NGI 4213) is considered his masterpiece, and specialists in Orientalist subjects like Eugène Fromentin (1820-60), who painted Arab horsemen, and historical painter Ernest Meissonier (1815-91) whose *Group of Cavalry*

in the Snow (NGI 4263), with its meticulous detail, is popular with Gallery visitors. There was a subject from *Faust* (NGI 4280) by James Tissot (1836-1902) and a large riverscape (NGI 4212) by Eugène Boudin (1824-98). Such paintings reflected the millionaire's personal taste. 'I cannot help feeling more and more that some of the eccentric painters like Picasso and that group will not live and although the Barbizon School...will never retain its old position...they were the only great artists who existed in the 19th century...'[39]

In addition to this huge donation, during the early 1950s Beatty made a series of individual gifts to the Gallery, amounting to 48 more paintings, 253 drawings and miniatures, and six sculptures.[40] Among them were two Italian fourteenth-century pictures and 185 miniatures presented in 1951, and a pencil drawing by Picasso of two dancers of Diaghilev's Ballet Russe (NGI 3271), and a damaged *Still-life* by Pieter Claesz (1597/8-1661), (NGI 1285), presented in 1953 and restored to its former beauty in 2001. In 1954 he presented a second Tissot (NGI 1275), together with the striking *A Girl Asleep* (NGI 1294) by English artist Dod Procter (1891-1972).

Regularly the Board thanked their new benefactor for a stream of items – a Roman *Apollo* (NGI 8033), an Epstein head (NGI 8074), twelve ornamental chairs which were found to be too fragile and were returned to him for use in his Library. Two show cases were also returned at Beatty's request: 'in view of his continuing generous gifts to the Gallery the Board has inclined always to meet his wishes.'[41]

Beatty's second wife, Edith, had amassed a superb collection of Impressionist paintings, bought with a cheque for £100,000 which her husband had given her in 1928. She had died intestate, which made the future of her pictures uncertain, given a number of complicated tax problems. Beatty wanted her collection to be declared of national importance in both England and Ireland, so that it could be exempt from death duties. He also had plans about a number of paintings he himself owned.

He wrote to MacGreevy in November 1952: 'Fortunately there are some pictures which belong to me personally and I am hoping to give some, if not all, of them to Dublin. There is a very fine Renoir landscape, a very fine picture of a girl sewing which was bought from Durand Ruel in Paris 25 years ago at a very high price, a superb Courbet...a Degas pastel of a woman bathing, a Van Gogh of a wheat field and a very fine Utrillo... I also have a superb Pissarro and a superb Monet.' He concluded that this collection was 'simply staggering.'[42] It was a fiction that he did not appreciate Impressionists, or at least their monetary worth.

MacGreevy had a gift for making friends. They included WB Yeats

and Mrs Yeats, Samuel Beckett, James Joyce, for whom he transcribed portions of *Finnegan's Wake*,[43] Alec Martin, ('I have a great liking for him and think he will be a good Director')[44] and Jack Yeats, whose presence on the Board had also helped ensure his appointment. Now he earned the friendship of the millionare philanthropist.Throughout the 1950s he received a series of affectionate letters signed, 'your old friend CB.' Beatty had a running joke, calling himself and MacGreevy 'M&B' after the pre-penicillin antibiotics. He gave him presents – £50 at Christmas, claret, his hotel expenses when he visited him in Nice.

In the early years of this correspondence Beatty made great promises. 'I want to fix up a small collection of some of the pictures that are missing in the National Gallery and have a room in memory of my wife…I want to include some of the pictures from my wife's collection, which will make a nice show and fill a very big gap which you have there.'[45] 'I think the National Gallery…needs examples of Seurat, van Gogh, Degas, Renoir and Courbet and I hope to be able to fill in some of these gaps in the coming year.'[46] 'I want to do everything I can to build up the Gallery, and if I offer anything which is not of the proper quality I hope you will be perfectly frank and turn it down immediately.'[47]

In September 1954 Beatty offered twenty-two pictures, including two Monets, two Renoirs, a van Gogh and a Degas pastel, for a loan exhibition. He wrote to MacGreevy: 'As you know, it is my hope to be in a position to give or bequeath to the National Gallery of Ireland a representative selection of pictures from my wife's collection…For the moment I should prefer to keep things elastic. …I hope that most of the pictures in the present loan will ultimately go to the Gallery as a memorial to my wife. As an earnest of that hope and intention, I herewith offer the Cézanne watercolour of the Montagne Ste Victoire [NGI 3300] as a gift.'[48]

Not one of the marvellous oil paintings he mentioned in his letters to MacGreevy came to the NGI. What went wrong? The Board wrote in a press release that the loan was 'a harbinger of things to come.'[49] But the uncertainty of words like 'elastic', 'harbinger', 'hope and intention', was significant, and the NGI is not the home of a wonderful collection of Impressionists.

The fact that the loan exhibition of a selection of Beatty's best, one of the most dazzling displays of French paintings that Dublin has ever seen, attracted little interest in Ireland, may have contributed to his change of mind. Later, in 1956, eight more were offered on loan to the NGI. But these were withdrawn in May 1957, and in June 1959 he wrote to MacGreevy: '…I am sorry that I cannot keep on the loan indefinitely but I have got

rid of certain pictures myself, to take advantage of the present market, and must have some to take their place. I am sorry I have not got an unlimited number because if I had a big collection left, I would be glad to give the Gallery some Impressionists in addition to the Cézanne water-colour I gave them.'[50]

He arranged to sell his wife's paintings to British provincial galleries in order to escape British death duties.[51] At the same time, to raise cash to alleviate his tax problems, he was selling his own pictures, aware of their worth; 'In New York these pictures are simply going up and up like mad.'[52] After 1955 there was no further mention in his letters to MacGreevy of any coming to the NGI.

In 1962, through the Board, MacGreevy made an unsuccessful attempt to qualify the NGI as an institution able to purchase a Beatty painting without incurring tax. 'A van Gogh picture..is Sir Chester Beatty's property. At Mrs Chester Beatty's death it was recognised as of national importance in England...the Director had been instructed to enquire of the Chairman of the Revenue Commissioners whether if the picture were purchased for the National Gallery of Ireland, there was any likeli-hood in the manner of death duties, as had been made in similar purchases by British Galleries. Mr Reamon's letter was read to the meeting. It was to the effect that he could not see any possibility of such a concession being made by the English revenue authorities.'[53] That was the last of van Gogh's *Wheatfield*.

It would be churlish to criticise MacGreevy and the Board, who per-haps could have ignored tax implications and bought the painting at a high price with Shaw money. It would be more churlish to criticise Beatty. The Chester Beatty Library, now in Dublin Castle, which he gave to Ireland, is the best museum of its kind in the world. He commented to MacGreevy on the Metropolitan Museum of New York: 'Their Oriental manuscripts and miniatures cannot compare with Dublin. Their Korans and all these things are simply a joke alongside Dublin.' The collection he donated to the NGI of pre-Impressionist nineteenth-century French paintings is unsurpassed outside France.

Still, it is hard to be really enthusiastic about *The Gleaners* and what Benedict Nicolson described as 'the somewhat dispiriting conglomera-tion of French nineteenth-century official painting and Troyon's herds of cattle'[54] and not to mourn the absence of Courbet's great green forest with stags, now in the Kimball Museum, Texas, Renoir's sewing girl, Degas' woman finishing her bath, and the other wonderful paintings denied to the NGI.

At least the Gallery has value in the Picasso drawing, and as Beatty reminded MacGreevy several times, in the Cézanne watercolour. For MacGreevy it was 'to me the greatest of all Cézanne watercolours. I had known it and coveted it for the National Gallery of Ireland since I first saw it twenty-five years ago before it entered the Chester Beatty Collection.'[55] Bruce Chatwin has written of a similar Cézanne: 'the essence of Mont Saint-Victoire is captured in a few strings of water-colour. What is not appreciated is that this empty space is not empty but full; and to realise this 'fullness' requires the most single-minded discipline. Either the work must be perfect or it is nothing.'[56]

Back in 1944 Bodkin had received one of George Bernard Shaw's post-cards: 'Do you remember our meeting at Plunketts years ago? If so, may I ask you a question? I am making a will leaving my Irish property for certain public purposes which may prove impracticable. In that case it is to go to the National Gallery (your old shop) to which I owe the only real education I ever got as a boy in Eire.

'What I want to know is – is there any special fund for the purchase of pictures as distinct from general establishment charges? If so, I should be inclined to earmark my bequest for it. Would you do so if you were in my place? G Bernard Shaw.'[57]

This postcard was donated to the Gallery by Mrs Bodkin in 1966 after Bodkin's death (NGI Archive), and a copy hung for many years in the entrance hall. Bodkin replied:

'…The National Gallery of Ireland, had, under the British adminis-tration, a fund of £1,000 a year voted by Parliament for the purchase of pictures. It was suspended during the last war, thus enabling the govern-ment to purchase one extra high explosive shell per annum, as I pointed out in a report which irritated the Lords Commissioners of His Majesty's Treasury. The Government of Eire did no better until the year 1938 when they increased the grant for purchase to £2,000. I fancy, but am not sure, that the grant has been suspended again as a measure of war-economy.' Of course he was right.

'But the Gallery has another fund for purchase, derived from invest-ments bequeathed by Sir Hugh Lane. In normal times the income from these produced about £1,500 a year. You would, in my opinion, be doing our country a great service did you decide to supplement these meagre resources...'[58]

Bodkin kept silent about these communications. At the Board meeting of 5 April 1950, 'the Registrar read correspondence between the Director [Furlong] and Mr Bernard Shaw in connection with the life-size Shaw

statue by Prince Troubetzkoy...Although most of Mr Shaw's remarks on the subject were phrased in his usual light-hearted manner, he paid a tribute to the Gallery for a priceless part of his education, in recognition of which he had left to it a third part of his residual estate. He made the suggestion that the statue should be erected on Leinster Lawn in front of the Gallery.'[59] The statue stood in the forecourt of the NGI until it was brought inside in 1997; at present it is in the old sculpture hall, now named in his honour as the Shaw Room.

Shaw's gratitude to the NGI was lifelong. In 1898 he wrote: 'Let me add a word of gratitude to that cherished asylum of my boyhood, the National Gallery of Ireland. I believe I am the only Irishman who has been in it, except the officials. But I knew that it did much more for me than the two confiscated medieval cathedrals so magnificently 'restored' out of the profits of the drink trade.'[60]

He died in 1950 and left £367,233[61] equivalent to around £7m today. The income brought in to the NGI was first noted in the Minutes for 4 December 1957. 'The Gallery had received to date the sum of £10,000 in respect of the Shaw bequest.' After that the money arrived in quantities; 'The Board noted that the total receipts from the Shaw fund from the 1st January 1958 to the 31st March 1959 amounted to £74,199. 17s. 9d.'[62] The Board would be discreet: 'It was...decided that all details relating to the funds accruing from the Shaw Bequest should be treated as confidential and not to be communicated to the press.'[63] By the end of 1959 the total receipts from Shaw's estate amounted to £240,373. 6s. 3d. [64]

Hearing of the Gallery's dramatic good fortune, dealers began to send information about expensive paintings for sale. To begin with, MacGreevy decided to buy two Italian paintings. *Clarice Orsini* (NGI 1385) by Domenico Ghirlandaio (1449-94) cost £7,395, mostly drawn from the Shaw Fund. The other painting, also purchased in 1959, was *Venice, Queen of the Adriatic* (NGI 1384) by Jacopo Tintoretto. The NGI already had three Tintorettos, including the moving *Venetian Senator* acquired in Furlong's time; in his Italian catalogue MacGreevy's only comment on this painting was 'the hand much repainted.' Now he decided to buy this allegorical representation of Venice mentioned by Bernard Berenson in *Italian Pictures of the Renaissance* (1957) and offered by Thomas Agnew for £25,000, reduced to £23,000 on the intervention of Alec Martin. MacGreevy wrote to Beatty: 'The feeling...seemed to be that at least one important picture bearing Shaw's name should be acquired...it was decided that we should hold three-quarters of the amount already in hand from the Shaw Bequest...and to feel free to spend up to one quarter of the amount in

From
Bernard Shaw
Phone & Wire: AYOT SAINT LAWRENCE,
CODICOTE 218. 21/2/1950 WELWYN. HERTS.

*Many thanks for your letter. The
rule is very necessary; for until a man
is dead one cannot be sure that he
will not be hanged.*

*I did not forget Dargan; but he
is virtually out of sight of the Gallery.*

*The rule is in force in the Houses
of Parliament and the National Portrait
Gallery here.*

It will shut up O'R. anyhow.

G. Bernard Shaw

*Postcard from George Bernard Shaw to Thomas
MacGreevy about displaying the bronze of him by
Troubetzkoy in his lifetime, 21 February 1950
(NGI Archive, ©Society of Authors on behalf
of the Bernard Shaw Estate). O'R, referred to
in the last line, is likely to be Patrick O'Reilly,
a Dublin dustman and Chairman of the
Irish Labour Party. He had raised funds for a
commemorative plaque at Shaw's birthplace,
infuriating Shaw with the proposed inscrip-
tion and may have agitated for Shaw's portrait
to be on view at the NGI.*

hand at present on pictures. That, in confidence, leaves us with over eighty thousand in hand from the Shaw bequest, which, with further sums coming in, will be retained for building purposes, pending the decision by the Attorney General on the legal question.'[65] This must have made Beatty feel better about retaining his Impressionists. Earlier he had told MacGreevy: 'I am delighted to hear about the Bernard Shaw money coming in so regularly and in substantial amounts.'[66] Since *Venice* was the first picture bought with Shaw money, it is a pity that it is now demoted to Domenico Tintoretto, Jacopo's less talented son. According to Adrian Le Harivel, it 'is very much something done in the studio.'[67]

Conscious of its new responsibilities, the Board, prompted by Bodkin, 'decided until further order to make no acquisitions save (a) of pictures that have a special national interest (b) of pictures of outstanding aesthetic and historical importance.'[68] It was Bodkin's last good turn for the Gallery, his death occurring soon after. Without him, the Board gave its Director increased leeway; during the Directorships of MacGreevy and White it would be sidelined in a manner that echoed Bodkin's term of office. But Bodkin had more discrimination, knowledge and taste. Bye Law 17 stressed that the Board could only purchase pictures which were submitted to it by the Director...'The Director was in effect a filter through which the pictures offered for sale to the Gallery might pass before being considered for purchase by the Board.'[69]

With infinite opportunities for purchasing paintings of the very highest quality, MacGreevy bought some French pictures using the Shaw Fund, beginning with an *Adoration of the Shepherds* (NGI 1645) acquired in 1961 from Heim in Paris, as by Louis Le Nain (1593-1648) for £7,500. This, like the Tintoretto, suffered the curse of the relatives, as scholars have yet to separate the Le Nain brothers. Two pretty eighteenth-century portraits were purchased at the same time, a pastel by Quentin de La Tour (1704-88) of *LA Thibault-Dubois* (NGI 3315) costing 100,000 francs, whose handling has led to its artist being identified as, in fact, Jean Valade (1710-87), and *Countess Fersen* (NGI 1646) by Jean Nattier (1685-1766) for £7,000.[70]

MacGreevy then turned his attention to Spanish painting. In 1959 he acquired the charming *A Noble Spanish Child in its Cradle* (NGI 1387), once thought to be by Velázquez, but bought with the correct attribution to Juan Carreño de Miranda (1614-85) for £1,600, using grant-in-aid. Three years later he applied Shaw money to the purchase of two Murillos which perfectly convey what has been called the artist's 'southern sweetness and softness', inspiring a cult for his work outside as well as inside Spain. *The Holy Family* (NGI 1719) cost £40,000; an intense *Penitent Magdalen* (NGI 1720), 'one of the finest single-figure compositions that I have come across…magnificently painted',[71] cost £9,000. Would Shaw have considered them 'pictures of outstanding aesthetic…importance?' Probably not; reviewing a show of 'Old Masters at the Academy' in 1890, he wrote: 'you pass a Murillo, with a heavenly-faced infant shepherd Christ…you come to a second Murillo, a Madonna, from the discordant mock Roman colouring of which your very soul recoils, so villainously does it jar after the majestic harmonies of Velazquez.'[72]

Another Spanish picture selected by MacGreevy was the magnificent *Abraham and the Three Angels* (NGI 1721), by Juan Fernández de Navarrete 'El Mudo' (?1538-79). Three Christ-like figures stand before a genuflecting Abraham, illustrating an episode in Genesis. The huge painting, originally commissioned by Philip II for the guest room of the Monastery of the Escorial, was given as war booty by Joseph Bonaparte to Marshal Soult. It remained in France until MacGreevy purchased it in 1962 for £14,000, his outstanding pictorial contribution to the NGI.[73]

He spent Shaw money on two more French pictures, £6,500 on a sketchy François Boucher (1703-70) *A Young Girl in a Park* (NGI 1723), painted at the end of the artist's life when his eyesight was failing, and £8,500 on *Adolphe Marlet* (NGI 1722) by Gustave Courbet (1819-77). In 1963, the last year of his Directorship, he bought Jack Yeats' *Double Jockey Act* (NGI 1737) now that the painter was safely dead; it cost £2,500 'after some argument about price'[74].

Abraham and the three Angels, 1576 by Juan Fernández de Navarrete (?1538-79), purchased with Shaw Fund 1962 (NGI 1721). The Spaniard's training in Venice is evident from the colouring and landscape.

By 1962 benefits from the Shaw estate stood at £419,825. 3s. 5d. MacGreevy had grown cautious and was determined that funds should be diverted to a restoration institute in the Gallery. He turned down a Delacroix, and expressed such ill-considered reservations over an outstanding group of paintings by Gian Antonio Guardi and his brother, Francesco, which had been bought by the Earl of Bantry and identified in Bantry House, that none of them were acquired for the NGI. Two, including *Erminia and the Shepherds*, of which MacGreevy said 'the group of young shepherds seemed to the Director to be flat and unsparkling'[75] are now in the National Gallery of Art in Washington.[76] Instead, at the same meeting when their possible purchase was discussed, he declared: 'If...it were a question of spending very large sums of money from capital the Director insisted that in his view the question of establishing a cleaning institute should have priority over all others.'[77]

Back in 1951 he had brought Helmut Ruhemann, consultant restorer for the National Gallery in London, over to Dublin. Ruhemann's report on the condition of many pictures mentioned 'blistering...varnish disintegrating, cupping...flaking...bad retouching'. It concluded: '...the most urgent need for your Gallery is, of course, to get a restoration workshop'.[78]

In May 1957 the scholar Denis Mahon wrote to MacGreevy about the two neglected Lanfrancos acquired in 1856. 'Your paintings are...of very considerable importance in the history of Baroque painting. It is really a great shame that you have not at your disposal the funds and facilities for relining and cleaning them, since in their present condition they are virtually lost to all of us.' MacGreevy quoted this in a report seeking funding not only for an extension to the Gallery but the establishment of the workshop. He added: 'It would appear that the Lanfrancos were removed from exhibition to store by...Walter Armstrong some time about 1900...Between then and the present time they have been neither exhibited nor catalogued. The surface varnish has darkened, it is not an exaggeration to say blackened, in sixty years of non-exposure to the light...'[79]

The condition of the Lanfrancos, and other paintings 'which under the grime of sixty years are still splendidly preserved',[80] decided MacGreevy to call in Dr Cesare Brandi, Director of the Istituto Centrale del Restauro in Rome, 'to make a report on what equipment, etc., would be necessary for the installation of a restoration and cleaning studio in the Gallery.'[81] Brandi's report on the requirements was thorough – 'marten brushes (camel-hair); spatulae...scalpels...fluorescent light...rooms... for retouching and varnishing...' Nothing came of it immediately, apart

from the restoration of Palmezzano's *Virgin and Child* panel in Rome under Brandi's supervision, but the necessity was recognised and a student, Matthew Moss, was sent to Rome to train as a restorer.

MacGreevy had been in poor health since he took up the Directorship, and his letters have references to fatigue ('Illness and bereavement and work,work, work…')[82] His first heart attack occurred in 1958. Chester Beatty assured him: 'Don't worry about expenses. I want to pay all your expenses in connection with the attack.'[83] While he was indisposed Bodkin suggested MacNamara, the perpetual understudy, as temporary Director. However Dr William O'Sullivan, Keeper of the Arts in the National Museum, was called in to assist, attending Board meetings sitting beside the ailing Director, and taking responsibility for the increasingly complex finances of the Gallery. MacNamara retired in 1960, having served with impressive reliability for thirty-five years; he was succeeded by Patrick Ryan.

MacGreevy suffered a further heart attack in 1962. It was a tribute to his popularity among Board members and government ministers that he was persuaded to stay on until 1963. During his time the Directorship was made full-time. Every room in the Gallery was redecorated, every picture rehung. Lectures were inaugurated on Wednesdays (lunch time) and on Sunday afternoons. He had supervised immensely important donations and bequests.

The restoration premises and the extension of the NGI itself would not come to fruition until James White's Directorship, but MacGreevy set these developments in train, persuading the government of the need to enlarge the Gallery, particularly in view of the new riches brought to it by Beatty and Shaw.

MacGreevy was given a honorary doctorate by the National University of Ireland in 1957, was made Cavaliere Ufficiale al Merito della Repubblica Italiana in 1955, and in 1963 was awarded a Silver Cultural medal. Some of his pompous charm, poetic sensibility and eccentricity is indicated by his account of the return of the Gallery's precious Fra Angelico picture from an exhibition in Rome. 'Before they put it on the truck for the customs shed, they first put in a live greyhound in a cage. Then my case, and then another greyhound in a cage, and only a fortnight before I had been looking at the greyhound of Andrea da Firenze at Santa Maria Novella. So the dogs of God acted as guardians for our Fra Angelico on its journey home.'[84]

1 TCD Bodkin ms 6932-240.
 Bodkin to MacNamara

2 TCD MacGreevy Archive 8140-3.
 Summary of MacGreevy's army
 experience

3 *ibid.* 8141-5. MacGreevy CV

4 *ibid.* 8141-8. Rudmose-Browne to
 MacGreevy 2 May 1927

5 Susan Schreibman, 'Thomas MacGreevy'
 Local Ireland (1 July 1998)

6 TCD MacGreevy Archive 8136. 9 May, 1956

7 NGI Administrative Box 16. MacGreevy to
 Bodkin, 8 Feb.1934

8 Brian Fallon, *An Age of Innocence- Irish Culture
 1930-1960* (Dublin 1998) p. 124

9 TCD Bodkin ms 6962-35.
 MacGreevy to Bodkin, 3 Dec. 1952

10 Thomas MacGreevy, *T.S.Eliot. A Study*
 (London 1931) p. 19

11 *Irish Statesman* (Sept. 1923)

12 TCD MacGreevy Archive 8142-1.
 Application for Curatorship of Municipal
 Gallery

13 *ibid.* 8104. George Yeats to MacGreevy,
 27 Feb. 1927

14 NGI Admin. Box 8. MacGreevy to
 MacNamara, 12 March 1927

15 NGI Admin. Box 16. MacGreevy's
 application for Directorship

16 Director's Report 1950

17 TCD MacGreevy Archive 6962-32.
 Bodkin to MacGreevy, 19 March 1952

18 *ibid.*

19 *ibid.* 6962-37. 17 March 1962. Memo on
 National Portrait Gallery by Henry
 Mangan

20 NGI Archive 196. ESB Centre for the Study
 of Irish Art – Reverend Shine

21 *ibid.*

22 Homan Potterton introduction to *NGI
 Illustrated Summary Catalogue of Paintings*
 (Dublin 1981) p. xxxviii

23 NGI Admin.Box 24. Dorothy May to
 MacGreevy, 4 July and 15 Aug. 1951

24 TCD Bodkin ms 6962 51. Bodkin to Board,
 10 April 1956

25 Thomas MacGreevy, *Catalogue of Pictures of
 the Italian Schools* (Dublin 1956) p. 5

26 Minutes, 1 October 1958 and Christiaan
 Vogelaar, *Netherlandish 15th and 16th century
 Paintings in the NGI* (Dublin 1987) pp. 53-62

27 Vogelaar (as n. 26) pp. 53-62

28 Minutes, 14 Feb. 1951

29 TCD MacGreevy Archive 8148-295.
 Bodkin to MacGreevy, April 1960

30 Minutes, 3 Dec. 1952

31 Bruce Arnold, *Jack Yeats* (New Haven &
 London 1998) p. 320

32 Cyril Barrett, 'Irish Nationalism and Art',
 Studies (Winter 1975) Quoted Fintan Cullen
 (ed.) *Sources in Irish Art* (Cork 2000) p. 276

33 TCD MacGreevy Archive 8148-250.
 Reminder requested by An Taoiseach Mr
 de Valera of subjects that came up when
 he received me on April 15, 1957.

34 Minutes, 1 July 1953

35 NGI Admin. Box 24. MacGreevy to
 Department of Education, 19 Aug. 1955

36 Minutes, 6 April 1955

37 NGI Admin. Box 40. Leo McCauley to
 Furlong, 27 August 1949

38 Minutes, 5 July 1950

39 TCD MacGreevy Archive 8133-15. Beatty to
 MacGreevy, 3 Nov. 1953

40 Brian P Kennedy, 'Sir Alfred Chester Beatty
 and the NGI', *Irish Arts Review*, vol. 4, no 1
 (Spring 1987) pp. 41-54

41 Minutes, 6 April 1955

42 TCD MacGreevy Archive 8133-6.
 Beatty to MacGreevy, 5 Dec. 1952

43 NGI Admin. Box 40. Undated postcard,
 Dalton to MacGreevy

44 TCD Bodkin ms 6951-2271.
 Martin to Bodkin, 27 Nov. 1950

45 TCD MacGreevy Archive 8133-9.
 Beatty to MacGreevy, 11 February 1953

46 *ibid.* 8133-15. Beatty to MacGreevy,
 3 Nov. 1953

47 NGI Archives. Chester Beatty file, 6 Jan 1954

48 *ibid.* 13 September 1954

49 *ibid.*

50 *ibid.* Beatty to MacGreevy, 22 June 1959

51 Kennedy (as n. 40)

52 TCD MacGreevy Archive 8133 48.
 Beatty to MacGreevy, 27 Nov. 1957

53 Minutes, 5 October 1962

54 Benedict Nicolson, 'Dublin Blooms'
 The Burlington Magazine vol. CXXVI, no 972
 (March 1984) p. 131

55 Letter from Thomas MacGreevy,
 Irish Times, 26 Jan. 1959

56 Quoted in Nicolas Shakespeare,
 Bruce Chatwin (London 1999), p. 307

57 TCD Bodkin Archive 6943-349.
 Shaw to Bodkin, 7 March 1944

58 *ibid.* 6963-350. Bodkin to Shaw, 9 March 1944

59 Minutes, 5 April 1950

60 George Bernard Shaw,
 In the days of my youth (London 1898), p. 47

61 Michael Holroyd, *Bernard Shaw –
 The Last Laugh* (London 1991), p. 3

62 Minutes, 3 July 1959

63 Minutes, 4 Feb. 1959

64 NGI Admin. Box 31. Position of Shaw
 Bequest on 31/1/1960

65 NGI Dossier. MacGreevy to Beatty, 8 April 1959

66 TCD MacGreevy Archive 8133 52. Beatty to MacGreevy, 12 March 1958

67 NGI Dossier. Le Harivel to Millar, 30 May 1994

68 Minutes, 1 June 1960

69 Minutes, 1 Feb. 1963

70 Minutes, 7 April 1961

71 Letter from Thomas MacGreevy, *Irish Times*, 30 April 1962

72 George Bernard Shaw, 'Old Masters at the Academy', *The World*, 9 January 1890

73 Rosemarie Mulcahy, *Spanish Paintings in the NGI* (Dublin 1988) pp. 10-14

74 Minutes, 5 April 1963

75 Minutes, 5 July 1963

76 Anne Crookshank and the Knight of Glin, *Ireland's Painters 1600-1940* (New Haven & London 2002) p. 61

77 Minutes, 5 July 1953

78 NGI Admin. Box 24. Report by Ruhemann, 14 July 1951

79 NGI Admin. Box 31. Report by MacGreevy on National Gallery Premises 1959

80 Minutes, 2 December 1959

81 NGI Archives, Report by Dr Brandi

82 TCD Bodkin Archive 6962-35. MacGreevy to Bodkin, 3 Dec. 1952

83 *ibid.* 8133-53. Beatty to MacGreevy, 9 April 1958

84 TCD Bodkin Archive 6962-40. MacGreevy to Bodkin, 22 April 1955

CHAPTER TWENTY FIVE

MORE GIFTS FROM BERNARD SHAW

In 1969, praising James White, who had conducted a transformation of the Gallery in six short years, Seymour Leslie echoed George Moore, by condemning the old days in a generalisation that incorporated the NGI. 'Time was, as our older readers must recall, when most galleries of painting, ill-lit, ill-catalogued (even with glazing on the frames, so that reflection made examination unrewarding) were unattractive dusty repositories, mere cemeteries of Old Masters in their yellowing varnishes. Galleries were only visited in very wet weather or on Sundays (so improving and suitable). In Dublin a heavy shower always brought in wee lads who thumbed the pictures – hence the glazing.' (One of the first tasks of the current chief attendant, Mick O'Shea, when he joined the NGI early in White's Directorship, was to remove the glass from the paintings.)[1]

When the young Shaw moved from room to room absorbing a life-long knowledge of paintings by studying those hung by Mulvany, there were no side attractions, no restaurant or shops, nothing to disturb the Gallery's principal function - the study and enjoyment of art. Leslie felt able to dismiss generations of aspiring artists who came to the Gallery as 'a few awe-struck students, perhaps certainly some spinsters with easels, desperately copying a van Dyck.' In addition, he did not hesitate to describe former Governors as 'senile.'[2]

By 1969 major changes at the NGI gave him confidence to express his opinions. The Gallery had a new wing. Money pouring into the coffers of the Shaw Fund had increased greatly with income coming from the stage and film productions of *My Fair Lady,* the musical based on Shaw's play *Pygmalion.* At the same time numbers of visitors had increased dramatically and the public's growing awareness of art owed much to the efforts of the current Director, James White.

It has been observed that James White 'popularised the visual arts in a country where literature had long come first.'[3] The years when he was

Director have been described as a golden age for the NGI which for so long had been unable to shake off its reputation as a sombre neglected institution with a handful of visitors.

After MacGreevy resigned at the end of September 1963, there was the usual hiatus before a new Director was elected. Initially only nine candidates applied, and a second attempt to attract more suitable people had to be made. With government consent, the post was readvertised at a higher salary – £2,500 for a man, and £2,275 for a woman – and more candidates put forward their names. James White, Director of the Municipal Art Gallery in Parnell Square was a late entrant, who had been approached by two members of the Board. After several ballots, he defeated the art historian, Anne Crookshank, by six votes to five.[4]

Crookshank had been trained at the Courtauld Institute, had worked at the Tate and was Keeper of the Belfast Art Gallery. When, early in February, before White's official appointment, Noel Browne had queried in the Dáil his lack of experience and qualifications in matters of art, the Board was a little perturbed, but not too much. 'The Board…decided that the Minister for Education had replied effectively to Dr Browne.'[5]

White came from a middle-class background, although his father's predilection for horse racing resulted in a somewhat impoverished childhood. At the age of sixteen he joined the John Player tobacco company as a clerk and after thirty years had risen to assistant manager. His background in business, giving him experience in public relations, was combined with an interest in art that had begun while he was still at Belvedere College. The artist, Jack Hanlon, later a priest, was a classmate and a pupil of Mainie Jellett, to whom he brought his friend for painting lessons. Jellett dissuaded White from his ambition to become a painter and pushed him in the direction of art criticism.[6]

Like MacGreevy, he was self-taught, his enthusiasm taking him abroad. 'I know from pre-war experience in continental galleries the horror of

*James White (1913–2004), tenth Director (1964–80), 1981
by Edward McGuire (1932–86), purchased 1981
(NGI 4348, ©The Artist's Estate).*

approaching collections of pictures so cluttered up with indifferent works that one invariably missed treasures of the most absorbing interest.[7] He told Hector Legge that every year he accompanied his rich uncle Phonsie on annual trips to European cities to view art galleries. He became art critic for *The Standard*, and later for the *Irish Press*, at the same time, travelling around Ireland giving lectures on Irish art, while he pursued his business career. Cigarettes were not neglected.

By the 1950s he had become a popular lecturer in art to students in University College and Trinity. In 1949 Mrs George Bernard Shaw left money for the education of Irish girls, and part of this fund was used to finance lectures in art. After his day's work at Players, White travelled around Ireland, setting up his own slide projector and screen, giving lectures to small groups of twelve or fifteen people. Many of them told him that these lectures introduced them to painting, and this experience inspired a missionary aim 'to bring art to the people.'[8]

He was interested in contemporary Irish artists and was one of the first critics to recognise the importance of Louis le Brocquy. He wrote the catalogue to le Brocquy's exhibition at the Venice Biennale in 1956, where the artist received the Premio Acquisto Internazionale, for *A Family*, which came into the Gallery in 2001.

Throughout the 1950s White organised exhibitions intended to involve the Irish people in art. A turning point in his career was the exhibition, *Paintings from Irish Collections*, held in 1957 at the Municipal Gallery of Modern Art. No similar exhibition had taken place since 1904 when Lane had brought together an assembly of pictures from Irish houses. It directed White's interest from modern art to involvement in Old Masters.[9]

In 1960, after thirty years, he switched careers and became Curator of the Dublin Municipal Gallery at a time when that institution seemed moribund. His efforts to restore its fortunes were noticed and on 1 June 1964, at the age of fifty, he took up his appointment as Director of the National Gallery of Ireland.

Naturally he had had many previous contacts with the NGI. He had supported Bodkin in the campaign for the return of the Lane pictures, was acquainted with Furlong, and a friend of MacGreevy, with whom he shared an admiration for Irish artists, particularly Jack Yeats.

In 1945 White had expressed to Furlong some of his views about the link between the public and art when he tried unsuccessfully to gain a commission for a book about the NGI '…I have decided…to approach the work with a view to making the visitor's sojourn in the Gallery a pleasant one by indicating to him the order in which he might view the

pictures and something of the particular quality which he might expect from individual painters or schools. I had also proposed to state boldly certain of the pictures which are outstanding and make our Gallery unique, as I have little regard for the literary art writers who fear to endorse their judgement by example.'[10]

In 1951 MacGreevy had tried to help him. 'The Director submitted a proposal from Mr James White with regard to lectures which he was prepared to give in the Gallery...As the conditions entailed the taking of an admission fee, the Board felt the proposal could not be entertained.'[11] In due course the obstacle was overcome, and White lectured regularly at the NGI. In 1957 when his Impressionists were on loan to the NGI, Chester Beatty told MacGreevy: 'I have received such a nice letter from Mr James White who is doing some lecturing in the Gallery, and he tells me how much interest this loan exhibition has attracted',[12] an observation perhaps arising more from flattery than accuracy.

White maintained that he was 'born lucky' and there is no doubt that arriving at the NGI at a fortuitous time greatly enhanced his opportunities of making it a centre of cultural activity. The Board realised immediately that they had a Director who would get things done. He was only a month in the office when 'Senator Maguire proposed that Mr White should be congratulated on the work he had done since taking up duty as Director of the Gallery...the motion...passed unanimously by the Board.'[13]

White had begun spectacularly, using experience gained at the Municipal Gallery, by combining his initial rehang with an exhibition to coincide with the hundredth anniversary of the NGI's formal opening. The *Centenary Exhibition*, which included 208 paintings from the NGI's collection, together with loans from twelve other European galleries, ran from October to December 1964. There had not been enough time to arrange for ideal loans, since the exhibition had to be assembled hastily to meet the centenary date, but nevertheless, it was an outstanding success. The building of the new extension to the Gallery, probably the most important event of White's Directorship, had taken time. A letter sent to MacGreevy in 1961 by HJ Mundow, chairman of the Office of Public Works, and thus a member of the Board, stated that 'on examining the official file on the extension of the National Gallery, I find that an extension was originally proposed by the Board of the Gallery in 1929. The estimated cost of a two-storey building at the North West Corner of the Gallery and fronting Clare Lane was then £14,000. After thirty-two years the project is still being discussed...'[14]

Early in 1962 the Minister for Finance approved 'an expenditure of £277,000 approximately.'[15] As usually happens, the final cost was considerably more. The design was principally the work of Frank du Berry, an architect in Office of Public Works. There had been a suggestion that space at the Natural History Museum, the National Library, or the Royal Hospital at Kilmainham might have been used as a separate 'Extension or Annexe' for portions of the Gallery.[16] Nothing more dreadful had been proposed for the NGI since the idea of combining it with Marsh's Library back in 1854, and MacGreevy rightly objected. He considered that the unsatisfactory Portrait Gallery might possibly go elsewhere, but even if that were done, there would still be a need for an extension attached to the main building in Merrion Square. Luckily du Berry found the proposed alternative locations totally unsuitable for hanging pictures, a conclusion that would seem obvious. He set off to examine other galleries for ideas – the Birmingham Art Gallery, the Tate, the National Gallery in London, the Courtauld Gallery, and, for good measure, the Building Research Station at Garston and the Ministry of Works Lighting Division in London.

He 'expended four hundred and six hours of unpaid overtime in six months to enable the plans to be completed.'[17] They allowed for a restaurant and ten new exhibition rooms, including a special room for miniatures and two large rooms for drawings. They would increase the hanging space by over fifty per cent.

Building began in late 1964 and was completed four years later. Du Berry's design, incorporating modern lighting, heating by means of ducted warm air, and an intruder alarm system proved popular. The exception to the modern layout was a curving marble staircase, as grandiose as the design by Sir Charles Lanyon which echoed the NGI's original plan a century before. The smooth narrow steps had to be inlaid with strips of roughened graphite to make them less dangerous.

Two years earlier, before the extension was completed, the opening of the new conservation department, on Tuesday 27 September 1966, was another most significant event in the NGI's history. From the time Mulvany had got to work at his cement lining table, conservation at the NGI had been a major problem. Ireland was far behind the rest of Europe; the National Gallery of Norway in Oslo had appointed its first Conservator in 1870.[18]

Within a month of White's appointment he visited the Istituto Centrale del Restauro in Rome and began the process which would transform many paintings. By the end of the year he had arranged for Dr

Selim Augusti of the Museo Capodimonte in Naples to come to Dublin and supervise the purchase of equipment and the layout of rooms. These would include a restoration laboratory, a physico-chemical laboratory and a photographic laboratory. Equipment included a vacuum table, electrically heated spatulas, a binocular prism microscope with a pillar stand, a headband magnifier, and importantly, an x-ray apparatus for radiography, planigraphy and stereo-radiography.[19] They gave a hospital feel to the conservation department.

Much of the correspondence between White and Augusti concerned cost. The price of the Stereo Planigraph x-ray unit for investigating oil paintings alone was £3,677. The Department of Finance would pay for most of the equipment, although 'the Board decided that the balance of the cost of the x-ray machine (approx £4000) should be paid from the Shaw Fund as the Government could not agree to this payment in view of the financial state of the economy.'[20]

After Matthew Moss, the Gallery's first full-time restorer, had completed a four-year training at the Istituto del Restauro in Rome, a programme of restoration was begun.[21] Moss needed supervision; a lot of the paintings were huge, there were very many, and help was needed for an operation on a large scale. In October 1966, it was agreed, through the Italian government, that a team of fifteen Italian restorers from the

*Exterior of Gallery after 1968 extension and building of
disability ramp 1990* (NGI Archive).

*Conservation being carried out at the Gallery by members
of the Istituto Centrale del Restauro, Rome,* 1967-68
(NGI Archive). Paintings by Rubens, Lanfranco,
Gainsborough and Gris (on easel) can be seen.

Istituto would come to Dublin the following summer, and they came again in 1968 and following years. In the summer of 1967 the chief Italian restorers were given £10 per day and accommodation at the Shelbourne Hotel; assistant restorers £6, staying at the Lansdowne Hotel, and senior student restorers £2 and a private guest house.[22]

White reported on the initial relining of a series of vast canvases. 'A new system of steel-frame supports was devised to take the largest pictures and by applying the energies of the whole team to each stage of the series of operations, a remarkable result of a production-line kind was achieved.'[23]

After the relining, the cleaning. Two of the earliest paintings to benefit were the Lanfrancos. Their resurrection has been described by the present Chief Restorer, Andrew O'Connor, who recalled the 'dramatic' results of cleaning them in the summer of 1967, 'dramatic because of the density of the dirt and varnish which obscured them; almost literally they were black and it was not really possible to see what the subjects were, never mind try to identify individual features.' He added: 'the two paintings sparkled as they emerged from their obscurity.'[24]

Virgin and Child, c.1435-40 by Paolo Uccello (1397-1475), before and after cleaning (NGI 603).

Other paintings acquired from Rome in 1856 were transformed, including those by Carlo Maratti, Mattia Preti, Giulio Cesare Procaccini, and Pier Francesco Mola. In two summers, 1967 and 1968, about a hundred and twenty pictures were treated. The Madonna in her panel by Paolo Uccello was stripped of her dark veil and emerged as a blonde with a plait around her head, while Rutilio Manetti's *Victorious Love* was deprived of his loincloth. The paintings by the two Renaissance women artists, Lavinia Fontana and Sofonisba Anguissola, were restored, as was *St Peter denying Christ* by Pensionante del Saraceni, the Flemish *Master of St Crispin and Crispinian* (NGI 360) and Gainsborough's portrait of James Quin.[25]

It was decided (as MacGreevy had wished) that expenses relating to the Italian restorers and the whole conservation programme, should be paid for out of the Shaw Fund.[26] The question arises as to whether the NGI was entitled to use Shaw's money for this purpose. In the early days of the Bequest legal opinion was that his money was solely for purchasing pictures. In 1959 the Chief State Solicitor wrote: 'In my opinion it is a necessary implication of the Bequest that the monies realised may be used only for the authorised objects of the Charity and those objects do not include the provision of buildings in which to house works of art.'[27]

In 1967 when a portrait by the Swedish artist Alexander Roslin (1724-1802) of *Le Marquis de Vaudreuil* (NGI 1824) was acquired for £25,000, the press notice stated that 'it was purchased from the Galerie Heim, Paris, and the Director considers that its price is moderate. The money comes from the Shaw Fund which, in any case, is only permitted for the purchase of pictures.'

Since 1950 over a hundred works have been bought through the Shaw Fund. However, there is nothing specific in his will about spending Shaw's fund exclusively on pictures; it merely declared that one third of the income 'of my Residuary Trust Funds' should be bequeathed 'upon trust for the National Gallery of Ireland.' Opinions, including legal opinions, change, and money from the Shaw Fund would be used for many other purposes than buying paintings. Shaw's intentions might be interpreted from his remark that 'a good Gallery is the best of investments, because people will give you pictures to hang in it which you would not get otherwise, except by buying them in competition with American millionaires.'

A footnote to the work of the Department of Conservation was an exchange between White and Charles Haughey who later, as Taoiseach, would have a part to play in the Gallery's history. 'Dear Charlie, I enclose herewith an estimate for the repairs of your picture from Peru. We

St George and the Dragon, 1400/50 by Novgorod
School (1400/50), purchased with Shaw Fund
1971 (NGI 1857). One of the twenty-three icons
originally collected by Irish-born diplomat,
intelligence officer and scholar, WED Allen.

would be prepared to do the restoration but it would not be completed for about six months…As a matter of interest we consider the picture to be a late copy of early Peruvian work, probably executed in the early 18th century.'[28]

When du Berry's extension was officially opened on 25 September 1968,[29] White organised a number of events. His book on the Gallery was published at this time. He assembled a new room of American paintings, dominated by Sargent's portrait of Woodrow Wilson. Another room featured a collection of 23 icons purchased from WED Allen of Waterford for £80,000, the money coming from the Shaw Fund. Most importantly, the Assistant Director, Dr Michael Wynne, who joined the NGI in 1965 (the appointment marking progress in the Gallery's organisation) arranged an exhibition in which all eight Lanfrancos which had decorated the Chapel in St Paul's-without-the-Walls in Rome were lent from other museums and reunited for the first time in centuries. Other newly cleaned Italian pictures acquired in 1856 dazzled the experts, and the NGI found itself in possession of something remarkable, a collection of Italian *Seicento* paintings which exceeded in quality any outside Italy.

A dissenting voice was the editor of *The Burlington Magazine*, Benedict Nicolson, who criticised the hanging of the Lanfrancos at eye level, rather than raised, as they would have been in their Roman chapel; he considered the only means of appreciating them was by lying on the ground. Nor did he care for the red background on which the Dutch pictures hung, 'a too small and insistent pattern of blobs'. More serious was his contention that the restorers had worked at dangerous speed in order to be in time for the opening of the new wing. 'Italian restorers know what they are about with Italian pictures, but are not accustomed to the special problems raised by the conditions of English eighteenth century portraits and portrait groups…the uneven cleaning of some English paintings of this period leaves a disturbing impression, but political considerations, it appears, made it impossible for them to be entrusted to…English restorers…Politics play a terrifying role in Dublin, and allowance must be made for a few failures at the National Gallery, both in restoration and as regards recent acquisitions on these grounds.'[30] It must be said that Nicolson was writing at a time when he was embroiled in a controversy over one of White's purchases.

The Italian restorers continued their summer visits; a full team of fifteen were in Dublin in 1970. By the time White retired, many of the more important paintings in the NGI had been examined and restored. Some idea of the process may be had from reading notes on one picture,

Bernardo Strozzi's *Summer and Spring*, the painting once owned by Cardinal Fesch which was sold by Aducci to the 6th Viscount Powerscourt and purchased for the NGI from the Powerscourt collection in 1924. The process of restoration reads: 'condition good. Restored Summer 1972 and Spring 1986. Minor spots of paint were found throughout. An old relining had damaged the true rich impasto of this fine painting. An x-radiograph taken in spring 1986 confirmed a major *pentimento*. Spring's left arm and hand were originally raised above her left shoulder. On the back of the old lining canvas, and on the stretcher, are red seals bearing a double 'A' in monogram, undoubtedly the seal of Alessandro Aducci, the Roman dealer.'[31]

A concise catalogue of the Collection by MacGreevy had been published in 1963. This was followed in 1971 by a catalogue assembled by Michael Wynne of all the paintings up to 1970. It was not ideal, providing only the most basic information, while early methods of data processing and computerisation resulted in a text which was not easy on the eye. However, Wynne had, for the first time, assembled an essential list of all the paintings in the possession of the NGI, many of which had come into the collection unrecorded.

By 1970 staff had increased significantly since MacGreevy's time; new posts included assistant director, librarian, cataloguers, restorers, secretary and a permanent typist. New publications were on sale in the Gallery shop, including catalogues accompanying the various exhibitions organised by White – *WB Yeats Centenary*; *Swift and his Age Tercentenary*; *cuimhneachán 1916*; *Irish Portraits 1660-1860*; *the Trinity College Historical Society Centenary*,; *the Church of Ireland Disestablishment Centenary* and, in 1971, two exhibitions marking the centenaries of Jack Yeats and John Millington Synge.

Before the extension was opened attendance figures had leaped, from 68,137 in 1964 to 199,102 in 1968. The new wing had attracted 324,573 by 1969, when White could report that 'the average daily attendance, 892, is ahead of that recorded in other world capitals, taking relative population into account.'[32] Largely as a result of his capacity for publicity, numbers would increase to over half a million by 1977.[33] 'It is absolutely necessary that we use every means possible to remind the public of our existence.' He found his appearances on television 'terribly important...We noted... that the day after I appear on television the attendance would go up by a hundred.'[34]

Concerts, seminars, free lectures and guided tours became features of the Gallery year. The new restaurant in the extension was well patronised, and the Lecture Theatre, showing special art film shows in addition

to lectures, was another feature that attracted visitors. Public lectures for the year 1969 consisted of forty-eight on Sundays at 3 p.m, thirty-five on Wednesdays at 1.15, forty-eight on Thursdays at 7 p.m., thirteen Saturday Tours and a hundred and two Special Lectures.

At the end of 1964 White announced that he was transferring to the NGI the popular Children's Art Holiday first held at Christmas 1962 in the Municipal Gallery. 'The idea was to make children feel that the Gallery was a friendly place where they could enjoy themselves by permitting them to paint pictures in the Gallery under the guidance of well known artists.'[35] An artist, paid for by the Arts Council,[36] painted a picture, and groups of children sitting in the Italian gallery, provided with jam jars, copied him. By 1970 the holiday, which, greatly expanded, continues to be part of the Gallery year, was attended by an average of a thousand children a day.[37]

More controversial was White's wish to open the NGI to other events. Early in 1965 Brian Boydell asked permission to hold a series of concerts in the Gallery, but the idea was considered 'premature.'[38] A year later it was decided that 'Dr Boydell and the Director of Music, Radio Eireann, cannot go ahead until there is a change in the Bye Laws.' In 1966 Bye Law 30 was changed, permitting concerts,[39] and from that time music became an important Gallery tradition. Annual concerts during the winter season, in which musicians like the harpist Catriona Yeats, or Geraldine O'Grady performed, were held by Radio Telefis Eireann.

In August 1965 White wrote to each member of the Board for consent for a large reception for 1,500 guests from various government ministries to be held in the Gallery; this was refused. However, two years later the Royal Astronomical Society, the 14th General Assembly of the Conseil International de la Chasse, and a reception by the Department of Labour to mark the Feast of St Joseph the Worker went ahead, in spite of doubts expressed by the Attorney General about the legality of 'functions'. White persisted, and by the end of 1968, when the new wing of the Gallery was opened, the Attorney General had mellowed. The Chief State Solicitor informed the Board: '...receptions may be held in the Gallery if held by the Governors and Guardians, or under their control and held to help the purpose of the Gallery and be consonant with the functions and duties of the Governors and Guardians.'[40]

But many receptions had little to do with art. 'Functions' held in the Gallery involved such diverse organisations as the Society of St Vincent de Paul, the Society of Chemical Industry in Ireland, the Seventh Viking Congress, the American Dental Society, the Irish Dental Association,

Dublin Port and Docks Board, International Women's Year, the Congress of the European Society for Surgical Research, and the World Congress of Sports Journalists.

In 1956 Bye Law 3 had been changed, allowing the election of a Chairman and Vice-Chairman who would preside throughout their appointment – previous chairmen had been appointed at each meeting.[41] The annual election of Chairman and Vice-Chairman was a formality, going smoothly without controversy, and the officers only changed by death and departure. During the greater part of White's Directorship Chairman and Vice-Chairman were his supporters and friends, Senator Edward McGuire and Terence de Vere White.

In June 1967 the most important Governor since Hugh Lane, who would be a benefactor on an even greater scale, was welcomed as a Governor and Guardian of the NGI.[42] Sir Alfred Beit, who with his wife, Lady Clementine Beit, came to Ireland in 1952, and bought Russborough, once the home of Lady Milltown, would be a conscientious Board member. But some meetings were inconvenient for him. In July, 1968 he complained:

'Dear James, …The National Gallery meeting on the first Friday in July is going to be a perpetual problem to me since it coincides with the semi-finals of the tennis at Wimbledon. This is one of the sports to which I am devoted and I go nearly every day during the fortnight it is in progress. Last year, as a newly elected member of the Board, I abandoned the tennis and came to the July meeting, but regret that this is not possible this year, nor in future years, and I am wondering whether it would be possible to disturb the routine of the meetings to the extent of making the July meeting the second Friday in that month…Yours ever, Alfred.'[43]

White replied that it would be 'a little unwise to ask the Board to change the date of the meeting because of the tennis' and five years would pass before the July meeting was rescheduled to accommodate Sir Alfred. By then the NGI owed him much. In March 1966 James MacAuley mentioned 'murmurs of excitement in the room devoted to Sir Alfred Beit's collection.'[44] The annual winter loan of Beit's paintings, which for the rest of the year hung in Russborough, became a regular feature of the Gallery year, when for a few months the Gallery was truly representative, displaying a Vermeer and a Velázquez.

Before the extension was completed in 1968, there was a question of space, and not all the paintings could find a place. '9th December 1966… I suggest that in view of what you say, you only take a small number of the

pictures this winter, and I would suggest the Vermeer, the two Metsus, the Marriage at Cana by Jan Steen, the Monk by Rubens, the Cornfield by Ruysdael, the Goya and the Lute Player by Franz Hals. As you are aware, the last two are of medium size and all the rest are small. I shall be glad to hear if this would suit you and whether the Gallery would be prepared, as last year, to pay the cost of transport in one direction while I pay for it in the other.'[45] Beit undertook the responsibility for insurance.[46]

On 16 July 1971 the Financial Sub-committee, consisting of McGuire, de Vere White, Dr John Leyden and the Director, recommended a policy for buying paintings. Small purchases of Irish pictures were to be made out of the grant-in-aid. Bargain finds of Old Masters should be considered. Large important but expensive items should not be indulged in. 'The aim in general is to endeavour to achieve an annual income of £10,000 from our combined sources of income...' In theory the Board had to sanction any new purchase proposed by the Director, but his decisions were rarely opposed, and when some were questioned by outsiders, the Board defended him fiercely. In 1966 the Board decided that the Director should write two annual reports, 'the confidential report not to be published'[47], while the money coming in from Shaw's royalties should remain secret.

With the aid of the Shaw Fund White strengthened the Irish school. At his first Board meeting on 5 July 1964 he announced the acquisition of *About to Write a Letter* by Jack Yeats (NGI 1766) for £4,000. A year later Yeats' *Grief* (NGI 1769), sold by Victor Waddington, Yeats' dealer who had moved to Cork Street in London, cost £6,300. In 1966 Nathaniel Hone's satiric *The Conjuror* (NGI 1790), attacking Sir Joshua Reynolds, a painting which would have appealed to Shaw, was bought from Colnaghi for £2,500. Other purchases of Irish paintings bought with the Shaw Fund were two Roderic O'Conors, a fine Nathaniel Grogan (1740-1807) of Cork Harbour (NGI 4074), a scene of Kinsale (NGI 4303), bought as by Grogan, now identified as by John Butts (c.1728-65),[48] a collection of drawings of Irish cities by Francis Place (expensive at £19,000), two William Ashfords and a rare family group which shows an eighteenth-century Irish interior (NGI 4304), thought then by Philip Hussey, but now given to English-born Strickland Lowry (1737-c.85).[49] All these paintings remain important, given the rising interest in Irish painting which would soon make Irish pictures the trophies of millionaires.

Many good Irish paintings were purchased with funds unrelated to Shaw, often costing less than £1,000 using grant-in-aid and the Lane Fund – pictures such as *Peter La Touche* by Robert Hunter (NGI 4034); *Father Matthew Giving the Pledge* by Joseph Patrick Haverty (NGI 4035); the appealing *Children*

Dancing at a Crossroads by Trevor Thomas Fowler (NGI 4122) and Richard Thomas Moynan's less favoured *Death of the Queen* (NGI 4028), which cost £100. In 1967 a fine study in watercolour by Daniel Maclise for *The Marriage of Strongbow and Aoife* (NGI 6315) came into the Gallery from Agnew's in London for a price of £400.[50] In 1970, White acquired for £1,800 four views of Ballinrobe House and Lough Mask by James Arthur O'Connor from Courtney Kenny, a London theatrical personality whose ancestors had owned Ballinrobe House. Six years later, thirty-one portraits from Malahide Castle, County Dublin, were obtained when the Castle ceased to be in the hands of the Talbot family; most of them are on display there as a result of a loan arrangement. They include nine portraits by Garret Morphy (1665-1715/16), the first Irish artist to paint pictures of distinction[51]. Without dipping into Shaw funds, assisted by the FNCI, White bought for £9,000 the exquisite double portrait, *The Ladies Catherine and Charlotte Talbot* (NGI 4184) by the Scottish painter John Michael Wright (1617-1700) who was in Dublin in 1679 when he painted the young daughters of the Earl of Tyrconnell. In 1968, three paintings by Mainie Jellett cost £288. 15s., and two of Paul Henry's most popular paintings, *Launching the Currach* (NGI 1869) and *The Potato Diggers* (NGI 1870) were bought for £500. The best bargain of all were the *Angels* on linen by Harry Clarke (NGI 1878-83 & 4136), thrown out of Haddington Road Church and rescued from a rubbish skip.

Such sums were trivial compared to what was available. White's thinking was on a grand scale; he had the money. *My Fair Lady* was playing and the NGI was rich. Cinderella could go to the Ball.

The first significant painting acquired by White with Shaw money was the early Sienese *Crucifixion* (NGI 1768) by Giovanni di Paolo (c.1403-83) bought in 1964 from Wildenstein in New York for £78,853. Unfortunately the background cross lacked terminals, which were made up by Monsieur Jean Marchig of Geneva.[52] The following year, in 1965, White purchased for £220,000, also from Wildenstein, an Avignon School painting, *The Annunciation* (NGI 1780) later identified as by Jacques Yverni (active 1410-38). White was proud of this purchase, and it has stood the test of time.

In 1968 argument was aroused by the purchase of *The Discovery of St Alexis* (NGI 1867) from Heim in Paris. The price of £95,000 was considered by outside experts to be dubiously low and the attribution to Georges de La Tour, whose paintings are rare, was soon questioned. The acrimonious controversy involved the English art historians, Christopher Wright, Anthony Blunt, and Benedict Nicolson, and the French authority, François-George Pariset, who, according to the persuasive François Heim,

The Ladies Catherine and Charlotte Talbot, 1679 by
John Michael Wright (c.1623–1700), purchased
1976, with other portraits of Irish sitters, from
Malahide Castle (NGI 4184).

'considers all this turmoil as part of a tentative effort by the Anglo-Saxon art historians to take the leadership in the studies on de la Tour to which he has dedicated twenty-five years of his life.'[53] But after the exhibition in the Louvre in September 1972, the painting was acknowledged as not belonging to the *oeuvre* of Georges de La Tour, and its current attribution is to his studio.

Another dubious acquisition from Wildenstein was *Venus and Cupid (Day)* (NGI 4313) by Jean-Honoré Fragonard (1732-1806), one of a series of overdoors depicting the hours of the day, which experts consider a poor example of the artist's work. The decision to buy this picture for the large price of £375,000 was proposed by Terence de Vere White, seconded by Sir Alfred Beit, and unanimously agreed by the Board.[54]

White also decided to embellish the galleries with statuary which he found could be acquired relatively cheaply in contrast to paintings. This resulted in two handsome marble busts purchased in 1967 – of *Cardinal Guido Bentivoglio* (NGI 8030) by François Duquesnoy for £6,000 and of the *Duc de Mercoeur* (NGI 8036), still attributed to French Court sculptor,

Berthélémy Prieur (c.1540-1611), also for £6,000. Eleven years later he paid £80,000 for two beautiful sixteenth-century wooden statues of Our Lady and St John the Evangelist (NGI 8246 & 8247) by Ligier Richier (c. 1500-67)of the Lorraine school.[55]

The two French frescoes (NGI 4170 & 4171), supposed to be from the large apse of the Chapel of St Pierre de Campublic, near Avignon, would be a nightmare. The first reference to them in the Minutes is in April 1974. 'The Director drew the attention of the Board to two painted murals of the 12th or 13th century from France which he had gone to see in Switzerland.' White was enthusiastic, believing that Irish missionaries were involved in their creation, introducing a Celtic element with animal symbols.[56] They were understood to be a link to decorated manuscripts produced in Ireland like the Book of Kells.

White sent the art historian, Dr Françoise Henry, a member of the Board, together with another authority, Dr Eileen Kane from University College, Dublin, to Geneva to inspect them. Dr Henry's strength was scholarship, not attribution. She submitted her report to the Board in December 1975. Although it contained many caveats – for instance she was aware that the Provence area was almost devoid of Romanesque frescoes – and she assumed that the frescoes had been touched up or restored, she concluded that they were unlikely to be fakes. She failed to notice that in one of them, among the twelve apostles was an intruder, St Lawrence with his gridiron.[57] When they were formally offered to the Gallery by the Swiss dealer, Roger Ferrero, for £175,000, it was she who proposed the purchase.[58]

Deterioration in exchange rates put the price of the frescoes up to £182,000. White planned to display them in the old Portrait Gallery which would cost £15,000 to prepare, £10,000 of which would come from the Shaw Fund. There were delays, as the room contained portraits due to go to Malahide. When the room was finally emptied of paintings and the Office of Public Works started work, more money, £5,223. 34s[59] was necessary; the Shaw Fund was dipped into again. Apses were built to take the frescoes, a carpet was ordered to cover the Minton tiles, and finally, in June 1978, the Fresco Room was opened to the public.

Ferrero had supplied other museums with similar frescoes, some in Switzerland, and one going to the Kimball Art Museum in Texas where it was a popular location for weddings. The fact that such a reputable institution owned a similar fresco appeared to confirm that those acquired by the NGI were genuine. But in time they were proved to have been produced in recent years by a craftsman who had set up what was more or

less a cottage industry. Ten years after they were installed in the Fresco Room, the NGI's French frescoes were officially denounced as forgeries.

It must be emphasised that alongside this disaster White had notable successes with his purchases using the Shaw Fund – the hypnotic *El Sueno (Sleep)*, by Goya (NGI 1928), bought in 1969 for £145,000; *The Four Seasons* (NGI 1982) by the brilliant Renaissance French artist Simon Vouet (1590-1649), which cost £24,000 in June 1970, and the accomplished group portrait of *Julie Bonaparte as Queen of Spain, with her daughters Zénaïde and Charlotte* (NGI 4055) by Baron Gérard, a Museum favourite, from Heim in London in 1972 for £40,000.

He also bought from Heim in 1973 for £250,000 another French picture, the extraordinary *The Funeral of Patroclus* (NGI 4060) by Jacques-Louis David (1748-1825) for £250,000, a compressed violent painting (94 x 218 cm) as crowded with figures as *The Marriage of Strongbow and Aoife*. It is a student work that had disappeared only to turn up in 1972, a large grimy canvas found in a Neapolitan collection, the first of a number of rediscoveries to filter into the NGI. White's initiative claimed for the Gallery a picture that replaced another 'David', *The Death of Milo of Croton* (NGI 167), reassigned to Jean-Jacques Bachelier (1724-1806). The scholar Robert Rosenblum, who was associated with both pictures, described the rediscovery in a Neapolitan collection of a painting which encapsulated the story of French art before the Revolution, as 'one of the great Eureka experiences of my life. 'As for me, David, and Dublin, the tale had the best of endings. The false David I had taken away from the collection in 1965 was replaced in 1973 by the real thing.'[60]

White will be remembered with much gratitude as the Director who transformed the Gallery, enticed us in, and enthused and educated us. Homan Potterton has pointed out his ability to get on with everyone. 'He was as acceptable to the aristocratic old guard such as the Rosses, the Dunsanys and the Beits, as he was to entrenched civil servants…He was trusted by politicians and those academics who tried to sneer at him were soon won over by his good humour and practicality. When it came to the man in the street, James had his complete approval. He had an easy bonhomie, loved a saucy joke and had a ready repartee.'[61] Mick O'Shea, Head Attendant at the NGI, remembers him as 'a real gentleman.'[62]

An interviewer found White 'very knowledgeable, self-confident, out-

Detail of *Julie Bonaparte as Queen of Spain, with her daughters Zénaïde and Charlotte*, 1808 by Baron Gérard (1770-1837), purchased with Shaw Fund 1972 (NGI 4055).

spoken and both fluent and entertaining in what he has to say about art…He has an original and lively approach to the problem of putting the public in touch with their own property – the national and civic collections of this country…'[63] He has been described as 'a small, suave, energetic man with a ready wit and a penchant for naughty talk' who 'deployed his considerable gifts of persuasion in interesting political and official circles in art and encouraging them to make funds available for his Gallery.'[64] Like his predecessors, Bodkin and MacGreevy, he was appointed Chevalier of the Legion of Honour.

'We must kill the museum atmosphere in galleries' he said shortly after his appointment. 'Instead we must make them living places.'[65] His strategies for encouraging the public to come to his Gallery were helped by changing attitudes. 'I regard my job as one where I must serve people by providing them with every possible facility and doing my utmost to attract them to the Gallery. As I see it, we have moved to the age of leisure. That is why art galleries are more important than they used to be. They have become a new kind of bridge between man's recreation and amusement and his inner spiritual enjoyment.'[66]

1 Author's interview with Mick O'Shea, NGI
2 Seymour Leslie, 'A Personal History –
 Our National Gallery', *The Irish Tatler &
 Sketch* (Dec. 1969)
3 *Irish Times*, 13 June 2003. Obituary of James
 White
4 Minutes of NGI Board, 10 April 1964
5 Minutes, 7 Feb. 1964
6 Brian P Kennedy, 'James White: A Brief
 Biography' in *Art is my Life – A Tribute to James
 White* (ed. BP Kennedy, Dublin 1992) p. ix
7 NGI Administrative Box 31. White to
 Furlong, 14 Feb. 1945
8 Kennedy (as n. 6) p .x
9 *ibid.*
10 NGI Box (as n. 7)
11 Minutes, 3 Oct. 1951
12 TCD MacGreevy Archive 8133-44.
 Beatty to MacGreevy, 2 April 1957
13 Minutes, 3 July 1964
14 NGI Admin. Box 34. Mundow to
 MacGreevy, 22 Aug. 1961
15 *ibid.* Department of Education to
 MacGreevy, 27 Jan. 1962
16 *ibid.* Frank du Berry. Report on Extension
 of the National Gallery
17 Minutes, 5 Oct. 1962
18 Andrew O'Connor and Niamh McGuinne,
 The Deeper Picture – Conservation at the NGI
 (Dublin 2000) p. 8
19 NGI Admin. Box 38 – Correspondence on
 orders for equipment or Conservation
 Department. 1965
20 Minutes, 3 June 1966
21 *Restored Paintings/Catalogue of Paintings Restored
 in the National Gallery of Ireland to December 1971
 (2nd Edition).* Notes by Marion King to
 MacGreevy. Letter from Moss to
 MacGreevy undated.
22 NGI Admin. 41. Statement of Expenses for
 Visit of Italian Restorers 18.6.1967 to 31.7.1967
23 NGI Admin. Box 44. James White,
 'Restorations in the National Gallery of
 Ireland', 1970
24 O'Connor and McGuinne (as n. 18)
25 White (as n. 21)
26 Minutes, 21 Oct. 1966
27 NGI Admin. Box 41. Extract from Chief
 Solicitor's letter, 13 April 1959
28 NGI Admin. Box 42. White to Haughey,
 25 Jan. 1968
29 Minutes, 4 Oct. 1968
30 Benedict Nicolson, 'The National Gallery
 of Ireland', *The Burlington Magazine*
 (Nov. 1968)

31 Michael Wynne, *Later Italian Paintings in the
 NGI* (Dublin 1986) p. 117
32 Director's Report 1970
33 Homan Potterton introduction to,
 NGI Illustrated Summary Catalogue of Paintings
 (Dublin 1981) p. xxx
34 James White interviewed by Maureen
 Charlton, *Hibernia* (July 1966)
35 Minutes, 4 December 1964
36 *ibid.*
37 *ibid.*
38 Minutes, 5 Feb.1965
39 Minutes, 4 Feb. 1966
40 NGI Admin. Box 42. Chief State Solicitor
 to White, 1 Nov. 1968
41 Minutes, 4 July 1956
42 Minutes, 7 April 1966. Beit appointed;
 2 June 1966, Beit welcomed to Board.
43 NGI Admin.Box 42. Beit to White, 3 July 1968
44 James MacAuley in *Hibernia* (March 1966)
45 NGI Admin. Box 40. Beit to White, 9 Dec.
 1966
46 Minutes, 4 Feb. 1966
47 *ibid.*
48 Nicola Figgis and Brendan Rooney,
 Irish Paintings in the NGI. vol. 1 (Dublin 2001),
 p. 96
49 *ibid.* p. 358
50 Minutes, 1 Dec. 1967
51 Figgis and Rooney (as n. 48) pp. 364-71
52 Minutes, 2 Oct. 1964
53 De la Tour dossier.
 Heim to White, 28 March 1969
54 Minutes, 8 Dec. 1978
55 Minutes, 13 Oct. 1978
56 James White interviews, replayed on
 John Boorman's *Tribute to James White* .
 (RTE compilation 12 July 2003)
57 Ian Baird in *Irish Independent*, 12 Jan. 1987
58 Minutes, 13 Feb. 1976
59 Minutes, 14 Oct. 1977
60 Robert Rosenblum, 'The Fall and Rise of
 Jacques-Louis David in Dublin' in Kennedy
 (ed.), (as n. 6) p. 170
61 Homan Potterton, 'James White
 (1913-2003)', *The Burlington Magazine* (Sept. 2003)
62 Author's interview with Mick O'Shea, NGI
63 Bruce Arnold, 'New Directions in the
 National Gallery of Ireland',
 Hibernia (June 1966)
64 (as n. 3)
65 Arnold (as n. 63)
66 White (as n. 34)

CHAPTER TWENTY SIX

THE SWEENEY BEQUEST
AND BEIT GIFT

At a meeting on 14 September 1979, when five candidates were considered, Homan Potterton was selected to succeed James White as eleventh Director of the National Gallery of Ireland.[1]

Potterton was well qualified, a home-grown product and, at thirty-three, the youngest Director ever in the post. The son of a Meath farmer and auctioneer, he was educated at Kilkenny College and Trinity College, Dublin; later he won the Purser-Griffith Diploma and Prize in the History of Art. After post-graduate studies in Edinburgh, he spent two years in the NGI as 'temporary cataloguer' before moving to London to become an Assistant Keeper at the National Gallery, with special responsibility for the seventeenth and eighteenth century Italian schools. He mounted a 'Painting in Focus' exhibition on Caravaggio's *Supper at Emmaus* in 1975 and a major exhibition of Venetian seventeenth-century painting in 1979.[2] He published widely, but in London he became known particularly for his essential National Gallery Guide Book, translated into five languages. Writing on the NGI collection would be one of his major preoccupations as Director.

Nine months passed between Potterton's appointment and White's departure. On 11 April 1980, 'the Chairman reminded the Board that this was the last meeting that Mr James White, Director, would attend...the present stature of the Gallery reflects the unsparing and expert service Mr White has given as Director.' Potterton took over on 12 June 1980.

With its extensive collection of oil paintings, including a range of significant Old Masters, together with watercolours, prints and sculptures, the NGI had achieved status on an international scale. Potterton declared: 'Every morning when I walk in, it hits me that this really is a magnificent collection of paintings.'[3]

At the same time he immediately became aware that there were fundamental problems relating to the Gallery that the glory of White's

Homan Potterton (b.1946), eleventh Director (1981–88),
in the Director's Office, 1986 by Andrew Festing
(b.1941), (Private Collection, ©The Artist).
The former Director's office above the portico
was designed by Deane and Son, the fireplace
carved by Carlo Cambi. A half-open door leads
to the old Board Room. Here, in a tribute to

Johann Zoffany's *Tribuna* (Royal Collection),
favourite Gallery paintings are shown, though
not to scale. The miniature painter's desk
(NGI 12000) designed for Charles Robertson
(1760-1821) around 1800, is covered with books,
including Potterton's Dutch catalogue.

departure had largely concealed. Thanks to White, attendance figures were robust, but circumstances outside the Gallery's control dictated that there was little money for the most basic needs relating to staff shortages and the fabric of the buildings.

From the moment of his appointment Potterton found that he was restricted by the lack of funds in carrying out his job adequately. The country was undergoing a period of economic depression, and the NGI was an easy target for cuts. Soon Potterton was telling the Board: 'After ten months as Director I now realise that the Gallery's financial position is not just bad (as I expected) but chronic. This means that I am discouraged in attempting to maintain the Gallery's present level of activity...or any of the developments and innovations which are not only desirable, but necessary.'[4]

For most of the period of his Directorship, from 1981 to 1987 (with a break of some months from February to November 1982), the Fine Gael-Labour coalition government was in power, struggling with the disastrous state of the national coffers. Government policy throughout the public sector was to reduce the number of employees in every institution under its control. For the NGI this resulted in different rooms in the Gallery having to be closed regularly when staff was unavailable. Official restrictions as to reappointments meant that two vacant posts of Assistant Keeper remained unfilled, while the attendants, insufficient in numbers, and newly unionised, were constantly dissatisfied.

At his first Board meeting as Director, Potterton had to tackle a letter to the recently elected Chairman, William Finlay, requesting a meeting with representatives of the Board to discuss the status of professional staff in the Gallery.[5] It was decided that the professional and attendant staff should no longer be regarded as civil servants, but employees of the Board. The professional staff demanded that there should be four grades of employment – keeper, deputy keeper, assistant keeper I and assistant keeper II. Claims over their salaries were referred to the Labour Court, while attendant staff sought a nine percent rise following a Labour Court recommendation.[6]

Early in his Directorship Potterton reported: 'With regard to the size of our purchase grant, it is quite simply not enough, and furthermore it highlights the fact that the Government funding of the National Gallery is not enough. The total budget for the National Gallery in 1980 was £404,000 and this included a sum of £327,000 for the salaries of the forty-three people (of whom thirty-three are attendants) who work in the Gallery. The number of professional assistants – only nine – employed in

the Gallery is not enough and the salaries paid to them are not enough.

'All these factors combined during the period 1980-81 have meant that most of my time as Director has been spent, not in pursuit of suitable pictures for the Collection and in the proper cataloguing of them, but instead in negotiations with staff unions and at hearings in the Labour Court.'[7]

Sixteen months after he took office, Potterton was writing to John Kelly, the Minister for Trade, Commerce and Tourism: 'I would like, if I might, to say privately and personally that I am finding the experience of attempting to direct Ireland's National Gallery an increasingly disheartening and disenchanting one. My days are spent in fruitless discussion with the Departments of Education and the Public Service Unions and Shop Stewards. I expected, and can cope with, red tape, but much of what I encounter is, I believe, deliberate and wilful obstruction...It is impossible to implement even the most urgent reforms in areas such as security, nor does it seem likely that improvements (which are certainly desirable) to the general appearance of the building can be implemented.'[8]

In 1984 the Fine Gael government decided to transfer responsibility for Gallery affairs from the Department of Education, which had held it since the foundation of the State, to the Department of the Taoiseach, where it became the responsibility of the newly created Minister of State with responsibility for Arts and Culture – a post held by Ted Nealon until the fall of the government in 1987. (The Arts Minister's mandate now includes Sport and Tourism.) In reporting the new circumstances to the Board, Potterton noted dryly: 'from the record painted by the Minutes it is clear that our sixty-year association with the Department of Education has been disastrous.'[9] But his relationship with the newly composed administration would prove even more unsatisfactory than the old disagreements.

One immediate issue was the result of the Gallery's success and popularity with the public. Potterton deplored the indiscriminate use of its premises for receptions which sometimes got out of hand. At a reception organised by the Convention Bureau of Ireland, attended by 850 guests, one of the wooden jardinières attributed to Andrea Brustolon was damaged. There were several occasions when the restaurant, which had been leased to a caterer, permitted other receptions without the Board's knowledge or permission. On one memorable occasion there was a wedding reception, held without permission, of a member of the catering staff.[10]

Potterton consulted his staff, who agreed 'that to permit the Gallery

to be used for receptions was an abuse of the function and dignity of the Gallery...The administration concerned with receptions in the Gallery places a burden on me and the staff and also exposes us to an amount of abuse.'[11] He brought in guide lines about the suitability of 'functions', particularly those that took place in the picture galleries, and in July 1982 persuaded the Board to adopt a new formula concerning them. 'The Board agreed that, in future, use of the Gallery for any social purposes shall be confined to Restaurant and Lecture Theatre. In addition, only such use as is complementary to the objectives of the Gallery should be allowed.'[12]

Potterton described his first eighteen months in office as 'hair-raising, even shocking.' But in spite of all the unwelcome diversions, he set out to achieve a number of goals. The most important was to initiate a programme for providing the Gallery with a series of fully researched and illustrated catalogues. He had produced National Gallery publications in London to general satisfaction; now in Dublin he had the assistance of a highly competent team, including Dr Michael Wynne, who had been responsible for the computerised list of the Gallery's paintings in 1971. With minimum funding this important undertaking would give international recognition to the NGI's collections. The last comprehensive catalogue of the collection in the Gallery had been published by Bodkin in 1932 with very little assistance and a borrowed typist; the most recent was Wynne's 1971 checklist. Neither of these were complete, since many pictures had never been properly investigated. Research on the items in the Milltown Collection had never been published.

It has been said that 'compiling a catalogue of a collection requires peculiar skills. Such pages probably represent more hours of work than any other form of historical scholarship.'[13] The *Illustrated Summary Catalogue of Paintings* was a priority, and Potterton set a deadline of eighteen months for its publication in July 1981. Not only were the pictures on display inspected, listed and photographed, but also those on indefinite loan and the thousands of works in store. The conservation department had a huge new task. A number had to be surface-cleaned and varnished. Signatures were discovered – of Zurbarán on *The Immaculate Conception*, Eeckhout on *Christ Preaching in the Temple*, William Drost's on *Man Wearing a Large Brimmed Hat.* Jacob van Ruisdael's *A Wooded Landscape* was authenticated. The text of the *Illustrated Summary Catalogue*, incorporating corrections, and new attributions, was the work of Adrian Le Harivel and Dr Michael Wynne, while Potterton contributed an introduction containing a short history of the NGI which has been most useful to the

present author. Sponsorship was found; Allied Irish Banks met the cost of production and gave the Gallery 4,000 copies. The publication was launched by Charles Haughey a month before the Fianna Fail government he led lost a general election on 20 January 1982; at the same time Haughey opened an exhibition entitled *The Best of the Cellar - 300 rarely seen pictures*.

In 1983 the *Illustrated Catalogue of Drawings, Watercolours and Miniatures* appeared, covering 5,000 items. Before this, many of these items were unknown, and were literally recovered from the basement stores. The compiler, Adrian Le Harivel, employed in a temporary studentship; the typescript, photographs and index were the work of volunteers. 'Recording the collection by these catalogues is not a luxury but basic to the administration of the Gallery and it is a sad reflection on the Gallery that such vital work has to be undertaken by volunteers and ill-paid staff.[14] Every drawing and watercolour in the NGI was illustrated, and even if, because of the diminutive scale of the illustrations and their grey monotone, many of them are difficult to see clearly it has enabled further research to be undertaken.

The *Illustrated Summary Catalogue of Prints and Sculpture* followed in 1988. Another massive undertaking by Le Harivel and a team of 'ill-paid' assistants, it recorded nearly 3,000 individual prints, 60 engraved books, and over 300 sculptures. The print collection in the NGI, enriched by numerous eighteenth-century mezzotints by Irish craftsmen, covers a very wide range of subjects, portraits, landscapes, classical subjects, and buildings, created from the seventeenth century to recent times.

Cover of *Illustrated Summary Catalogue of Drawings, Watercolours and Miniatures*, 1983, with *Boy tuning a violin* by Jean-Antoine Watteau (1684-1721) a red chalk drawing, purchased by Henry Doyle in 1890. With the Summary catalogues of Paintings (1981) and Prints and Sculpture (1988), they revealed the scope of the collection for the first time.

Meanwhile a series of text catalogues devoted to different schools in the National Gallery of Ireland were commissioned and published throughout the 1980s – Michael Wynne's *Later Italian Paintings*, David Oldfield's *German Paintings*, Christiaan Vogelaar's *Netherlandish Fifteenth and Sixteenth Century Paintings,* and Rosemarie Mulcahy's *Spanish Paintings,* which appeared in time to include the Goya and Murillos from the Beit collection. In addition, a number of smaller publications were directly aimed at the public, attractive to buyers in the increasingly important Gallery shop. Titles included *Fifty Irish Paintings*, *Fifty French Paintings*, *Fifty Irish Portraits*, and *Music and Painting in the National Gallery of Ireland.* Reproductions of works also greatly increased knowledge of the Collection and there were calendars and diaries.

More catalogues have appeared since then: Oldfield's *Later Flemish Paintings,* published in 1992, and the handsome *Irish Paintings in the NGI, vol.1* by Nicola Figgis and Brendan Rooney, which was published in 2002. The full range is not yet completed, and there is still much work to do; two catalogues on the later Irish collection, the French, Early Italian and English pictures are in the process of being researched. The importance of those that have been published cannot be exaggerated; for the first time in the NGI's history there are authoritative surveys of a number of Schools.

Potterton found time amid his duties to write the first of the text catalogues to be published, *Dutch Seventeenth and Eighteenth Century Paintings in the National Gallery of Ireland,* taking two months extended leave in mid-July 1985 to complete it before publication in July 1986. Potterton wrote in the introduction: 'When I started work on the catalogue six years ago… I foolishly imagined that one Dutch cow in a landscape was the same as the next, and that the task of cataloguing such pictures would be a simple one. Over the years, as I proved to myself the silliness of my misconception, I have acquired some knowledge of Dutch painting in its Golden Age; but only sufficient for me to appreciate how much more there is to know.'[15]

In the light of the availability of the Shaw Fund, there was a natural reluctance by the administration to supply increases of the grant-in-aid. Because the government was aware that the NGI benefited from the Lane and Shaw Funds, the Gallery was allocated less money for its annual purchases than other cultural institutions. While the NGI received £24,000 as grant-in-aid for 1981, the Hugh Lane Municipal Gallery received £30,000 from Dublin Corporation, the National Museum £60,000 for purchases and the National Library £50,000. This might seem fair, when at the NGI the considerable income from the Shaw bequest was augmented

by the £8,000 income from the Lane Fund. But prices of paintings were rising rapidly, there was VAT to pay and there were differences between the Irish punt and sterling which profoundly affected the price of works of art for Irish buyers at auction in London.

At the same time Shaw money was less than it used to be. As Benedict Nicolson observed, 'should the National Gallery have to rely mainly on the rain in Spain?'[16] From his gallery in Bond Street, Julian Agnew wrote to Michael Wynne: 'I will sit down with a cold towel and see if I have any ideas for a really successful followup of My Fair Lady.'[17] Potterton was all too aware that funds from this source were decreasing, after the period he described as 'when... we were swimming.'[18]

With the funds available he realised that a change in purchasing policy was necessary. He made his aims known in a report dated 10 April 1981. No longer was it expedient to let the Shaw Fund accumulate and then spend the capital on one large purchase. 'With present market prices, this may no longer be a satisfactory policy, as the amount available at any one time (i.e. about half a million) is an in-between figure. By this I mean that capital pictures may now cost £1m or more, whereas it is still perfectly possible to acquire very good pictures that are also important for a figure below £250,000.'[19]

The policy laid out that 'wherever possible, acquisitions should be made in the sale room and in the event of a major picture of exceptional value to the Gallery coming on the market that the Director reserves the right to buy it before informing the Board, even if its price exceeds £250,000.'[20] Potterton's intention was to use the Shaw Fund for major acquisitions of international significance, the Lane Fund for exceptional Irish purchases, and the grant-in-aid generally for less important paintings by Irish artists. Like Doyle, a century before, he decided that it was essential to bid at auction as the only way to obtain, if not bargains, paintings at a reduced price.

His first purchase as Director was hardly sensational, a *Portrait of a Lady* (NGI 8249) by the sculptor Edward Foley (1814-74), brother of John Henry Foley. In the same year the NGI acquired *A Girl Reading* (NGI 8250), a life-size marble statue by Patrick MacDowell (1799-1870). He aimed by way of these modest purchases by Irish sculptors to swell the NGI's small sculpture collection, and other nineteenth-century pieces by Irish sculptors would be acquired throughout his Directorship.

A few months later, in November 1980,[21] he bought an important painting with Irish associations: Francis Wheatley's double portrait of the *Marquess and Marchioness of Antrim* (NGI 4339) seated in their phaeton a haughty

The Marquess and Marchioness of Antrim, 1782, an
Irish-period masterpiece by Francis Wheatley
(1747-1801), purchased with the Shaw Fund in
1980 (NGI 4339).

representation of ascendancy privilege. A bold purchase, costing Stg
£110,000 sterling from the Shaw Fund, far more than the estimate and
almost double the price for any previous Wheatley, it was a good buy.

So was *The Duchess of Bolton as a Shepherdess* (NGI 4340) by James Maubert
(1666-1746), the Irish-trained contemporary of Garret Morphy, which cost
Stg£1,800 at Christie's, this time less than half the estimate of £3,000-
£5,000. Potterton noted that 'the discovery of this major painting by an
Irish-trained artist whose work is little known to us is an event of prime
importance for the study of Irish painting.'[22] When its purchase was
ignored by the press, he protested to the *Irish Times*:

'The picture shows a reasonably pretty woman with garlands of
spring flowers, a delightful spaniel dog and a charming lamb. The lady in
the painting lived in Ireland and the artist trained in Ireland...This pur-
chase...was not treated as news by your newspaper — presumably on
account of the fact that your readers would not regard it as such...In the

light of your reporting I feel safe in assuming that the National Gallery is only news when it is closed by the staff in protest against their inadequate salaries; when a member of the public suffers a heart attack in the Gallery; when we lose a picture or have one hopelessly damaged; or when we buy a canvas that some of your readers could describe as a blank.'[23]

Potterton was very much aware of one obvious weakness in the Collection. 'It is difficult...for the visitor to the Gallery to gain any impression as to what happened in art after about 1870, as our Collection is extremely poor in examples of painting later than that time.' At the same time the Hugh Lane Municipal Gallery could at last show half of the Impressionist paintings that had belonged to Lane. It was a pity that the gallery across the river was in a worse state than the NGI. Benedict Nicolson noticed 'its unkempt appearance, poor hanging, virtual absence of literature and some questionable recent acquisitions. All the more severe is the shock of encountering there Renoir's *Les Parapluies*, Manet's *Eva Gonzales* and other Impressionist paintings familiar from the London National Gallery, shuttled from one to the other like children of divorced parents, under the terms of the 1979 settlement of the Hugh Lane bequest.'[24] This had been arranged by James White and his counterpart in London.

Potterton had decided in 1981 to terminate the agreement for an exchange of pictures between the National Gallery and the Municipal Gallery which had never come to anything.[25] Now the masterpieces shown at the Municipal Gallery underlined the poverty of late nineteenth- and twentieth-century art at the NGI. Such paintings as there were did not nearly match the quality of the Lane Impressionists, and they had come into the Gallery more or less by chance – bequeathed by Edward Martyn and Evie Hone, or occasional purchases, such as the Berthe Morisot by Furlong.

Since the NGI could no longer afford significant Impressionists, Potterton made it a priority to extend the collection to include more recent works of art. He signalled a new direction by holding a Raoul Dufy exhibition at the Gallery in October 1980, curated by Raymond Keaveney, and sought help from gallery owners like Julian Agnew for paintings covering the years 1900-1920.[26] However, the new paintings which partially filled a major gap in the NGI were acquired at auction.

Shaw money could still pay for important twentieth-century pictures, even if it could no longer run to a Matisse or a Picasso. In December 1981, Potterton acquired *Stella in a Flowered Hat* (NGI 4355), a richly coloured portrait painted under the influence of the Fauve movement by Kees van

Dongen (1877-1968). More paintings followed, representing key movements in late nineteenth- and early twentieth-century paintings, beginning with *Lady on a Terrace* (NGI 4361) by Paul Signac (1863-1935) bought at Christie's, New York, for $165,000. A bouquet of *Chrysanthemums in a Chinese Vase* (NGI 4459), a rare flower-piece by Camille Pissarro (1830-1903) at $280,000 was also from Christie's, New York.

In 1983 *Women in a Garden* (NGI 4490) by the Franco-German Emile Nolde (1867-1956), cost a daunting £315,000 at Sotheby's. Potterton observed that when it later went on show at the English National Gallery it 'excited much admiration and indeed envy, as London does not possess any oil painting by this important Expressionist artist.'[27] A painting by the powerful Expressionist artist Chaïm Soutine (1893-1943) *Landscape with a Flight of Stairs* (NGI 4485) was bought for £87,000 from the Crane Kalman Gallery, London, in February 1984. Writing in the *Irish Times*, Brian Fallon found it 'magnificent...the van Gogh legacy is obvious, yet van Gogh could never have done this.'[28] To augment this group, Lord Moyne, a tireless Board member, together with Lady Moyne, donated a charming small painting by Pierre Bonnard (1867-1947), *A Boy Eating Cherries* (NGI 4356).

The necessity of buying Irish pictures, even though at this stage they were relatively cheap, was inevitably at the expense of other purchases. Benedict Nicolson noted how 'the problems of a National Gallery that also bears responsibility for collecting and showing the works of its native school are well known and Dublin by no means escapes the mixed blessing of this dual role.'[29] Nevertheless Irish paintings were purchased, one of the earliest being the double portrait of the *Earl Bishop of Derry with his Granddaughter, Lady Caroline Crichton, in the Gardens of the Villa Borghese in Rome* (NGI 4350) acquired in 1981. This hitherto unknown picture, painted around 1790, was bought prior to the sale of Glyde Court, from Mrs Dorothy May. A descendant of the Earl Bishop, she received £23,000 from the Lane Fund for one of the Hugh Douglas Hamilton's most important works.

With the Shaw Fund four views of Lucan House and Demesne by Thomas Roberts (1748-78), a landscape painter under-represented in the NGI, were obtained for £40,000. From the Adare sale in June 1982 came *A Bay Racehorse* (NGI 4363) by the little known Irish primitive Daniel Quigley (active 1760-80) and from America, a rare history picture by Henry Brooke (1738-1806), *The Continence of Scipio* (NGI 4367). *A View of Kilkenny* (NGI 4467), attributed to William Ashford, now given to the English landscape artist, Thomas Mitchell (1735-90), was bought from Christie's for Stg£14,000.

Other portraits included the superb double portrait of *Bishop Clayton*

Stella in a Flowered Hat, c.1907, by Kees van Dongen
(1877-1968), purchased with Shaw Fund 1981 (NGI
4355, ©ADAGP, Paris and DACS, London 2004).

and his wife (NGI 4370) by James Latham (1696-1747), acquired from an insouciant Representative Church Body for a bargain £8,000; another Hugh Douglas Hamilton of the *Cardinal Duke of York* (NGI 4349) from the picture dealer and restorer, James Gorry, and a portrait of *John, Viscount Perceval, 2nd Earl of Egmont* (NGI 4489) by Francis Hayman (1708-76). The Earl was an eccentric who wanted to make himself king of the world's Jews, and colonise St John's, Newfoundland, on feudal lines, defending it with bows and arrows.

Potterton obtained more recent Irish paintings, including *Military Manoeuvres* (NGI 4364) by Richard Thomas Moynan, depicting ragged children playing, bought for £7,000, one of the most popular works in the Gallery, and *The Wounded Poacher* (NGI 448/) and *Jour de Marché, Finistère* (NGI 4513) by Harry Jones Thaddeus (1860-1916) whose reputation was rising rapidly. He acquired twentieth-century portraits by David Hone, Estella Solomons, Patrick Hennessy, and three portraits of former Directors, *Thomas MacGreevy* (NGI 7971) by Seán O'Sullivan, *James White* (NGI 4348) by Edward Maguire, and *George Furlong* (NGI 4547) by Frances Kelly.

In 1981 Potterton bought seven watercolours by the recently discovered Mildred Anne Butler (1858-1941), an event he described as 'the phenomenon of the year…They had remained virtually untouched at her home in County Kilkenny until they were exhibited, prior to their sale.' Hailed as an unknown, her pictures went for very high prices, paid for, as Potterton grumbled, in sterling.[30] Later, more Butlers were acquired; reproductions of her rooks, pigeons, gardens, and rural scenes around Kilkenny have been sold with continued success in the NGI's shop.

A portrait of Thomas Conolly (NGI 4458) painted on the Grand Tour by Anton Raphael Mengs (1728-79) cost £15,000; bought from Desmond Guinness, it used to hang in the Long Gallery of Castletown. In 1981 Potterton had the perception to acquire the two portraits of Thomas and Ann Congreve by Charles Phillips (1708-77) which can be seen in miniature in the background of the conversation piece set in Mrs Congreve's drawing room (NGI 676) by Philip Reinagle, given to the NGI by Lord Turton in 1914. The portrait of the playwright William Congreve (NGI 4336) by Godfrey Kneller which hangs over Mrs Congreve's chimney-piece in Reinagle's picture was later donated by John Chambers, almost completing the set of Mrs Congreve's drawing room pictures.

At his first Board meeting Potterton announced the bequest by Miss Mabel Willis of a little painting by Landseer of a King Charles Spaniel (NGI 4333), the artist's favourite breed of dog, which complements a

similar dog in Landseer's study of the Sheridan family. In the following year two handsome full-length portraits, of the *Countess of Bridgewater* (NGI 4342) and *Lady Mary Wortley Montagu* (NGI 4341) in exotic Turkish dress by the early Irish artist Charles Jervas (c.1675-1739), were presented by the Dublin antique dealer Louis Cohen in memory of his brother Israel. The Gallery was equally glad to receive £40,000 from an Irish solicitor in memory of his Polish wife, Wanda Petronella Brown; a portrait by Augustus John of Mrs Pamela Grove (NGI 4365) from the FNCI; Richard Moynan's *The Artist in his Dublin Studio* (NGI 4488), presented by his niece; and the bequest of Henry McIlhenny, the American owner of Glenveagh Castle, County Donegal, of Thomas Bridgford's lovely *Two Lovers in a Landscape* (NGI 4516). Bridgford (1812-78) had applied for the Directorship after Mulvany's death in 1869; his other known works are 'rather dull' portraits, nothing like the quality of this painting, which was possibly exhibited in the Royal Academy of 1837 as 'Golden Moments.'[31] Worthy as these gifts were, they could only anticipate the outstanding presentations made to the NGI in the last year of Potterton's Directorship.

Potterton revived Bodkin's practice of regular exhibitions of new acquisitions and four were held biannually during his Directorship. Each was accompanied by catalogues researched by Adrian Le Harivel and Michael Wynne. Other exhibitions held during his Directorship were the memorable *Walter Osborne* exhibition in 1983 and the *Irish Impressionists* exhibition of 1984, visited by 60,000 people. A selection of *Masterpieces from the National Gallery of Ireland*' was shown to great acclaim at the National Gallery in London.[32] There were disappointments; the *James Arthur O'Connor* exhibition received unfavourable comment in the press and the Director had to report that 'attendances at the Exhibition have been worst of all our Exhibitions.'[33]

A major project of Potterton's was the purchase of No 90 Merrion Square, belonging to the Dublin doctor Arthur Chance, which was bought by tender in 1986 for £180,000 as 'an income-producing investment' and paid for out of the Shaw Fund. Potterton had advocated that 'the Shaw Fund can only be used for the acquisition of works of art and for no other purposes'[34] but, like others handling the pot of gold, he changed his mind.

Elegantly restored by the architect Austin Dunphy, hung with a selection of Gallery paintings, furnished with pieces from the Milltown Collection, including four spectacular mirrors dating from the 1750s, backing onto a small formal garden, created in eighteenth-century style, No 90 is preserved as one of the few remaining examples of a Georgian

Upper Room of the 1968 (now Beit) Wing with Dutch 17th century paintings, 1986 (©HLA). The deterioration of the structure was now evident and this long central room was difficult to hang effectively.

town house in Dublin. It would provide a venue for receptions and meetings, for a short time a flat for the Director, and eventually become the headquarters of the Friends of the National Gallery of Ireland, which has operated to support the Gallery's activities, through its individual and corporate members, since 1990. However, its purchase and expensive refurbishment – well over budget, at a time of austerity – was controversial.

At the time that No 90 was being restored, the physical condition of the NGI buildings steadily deteriorated. When the Roderic O'Conor exhibition opened on 3 February 1986, a main fuse blew twenty minutes before guests were due to arrive and the entire 1968 wing was plunged in darkness. The incident was yet another indication of Potterton's troubles as he wrestled with limited funding and staff shortages, as well as difficulties with the fabric of the Gallery. The older parts of the building, both the original Fowke structure and the Milltown Wing, were in disrepair, and even the imposing du Berry extension, which had been in place for less than twenty years, had problems.

Back in 1981 Potterton had found that environmental conditions in the new wing did not conform to acceptable standards for a museum environment. The Gallery needed its own central heating plant with back up; instead it was heated from a turf-fired system serving other

government buildings in the area. There was little he could do during those years of financial restriction; malfunctioning of the Gallery's own temporary air-handling and heating system would have to continue because of government cutbacks.

In December 1982, as usual, this heating system was shut down for the Christmas period, which meant that there was no heat in the Gallery. When the heat was turned on again on 27 December, 'the ventilation fans in the new wing failed to function, steam from the air condition system flooded into the building, relative humidity rose to startling levels, threatening damage to the collection'.[35]

In June 1984 plans were announced by the Office of Public Works for a major refurbishment programme. The first phase was to remove the water-stained French silk wall covering from the Irish rooms and replaster and paint the walls; the second stage would include the 1968 extension.[36] But nothing came of this plan. Instead in 1984 the estimates for the Gallery were actually reduced, from £639,00 to £633,000. Potterton reported: 'the Board may be aware that a number of rooms in the Gallery are now closed on an almost permanent basis on account of shortage of attendant staff. With the Government embargo on recruitment to the Public Service we are now four attendants short (out of twenty-seven) and a further three attendants are out on long-term illnesses.'[37]

In 1987, when a selection of Dutch paintings from the Gallery toured the United States and arrived at the Mint Museum in North Carolina, Potterton commented: 'the Mint is…beautifully appointed and with perfect lighting and environmental conditions. The pictures seemed to be enjoying their life of luxury in contrast to the appalling conditions in which they are maintained at home.'[38]

In the same year a typist's post was not able to be filled under Government embargo, and all typing had to be done by one person who simultaneously had to attend to the Gallery switchboard. Attendant staff were reduced to twenty-two and a vacancy was filled on a job-sharing basis, two attendants working a twenty-hour week simultaneously. The ultra-violet absorbing film on the roof-glazing of the 1968 extension was 'in tatters'. The lanterns over the Milltown rooms were worn out and woodwork decayed. The forecourt was in a deplorable condition. The electronic counter at the entrance to the Gallery, which recorded the number of visitors, broke down. Bad ventilation in the Irish Rooms resulted in a musty smell. After another electrical crash, a temporary fall back system costing £30,000 was installed, which would later be incorporated into a promised major renovation plan costing £5m – but

that was perpetually postponed by the Office of Public Works, which was dependent on the Department of Finance.[39]

Erratic circulation and failures in the obsolete air-handling resulted in reports of paintings 'flaking, cracking and warping.'[40] Murillo's *The Holy Family* and Titian's *Baldassare Castiglione* had to be removed from the walls for repair. Ludovico Mazzolino's *Pharaoh and his Host Overwhelmed in the Red Sea* lost small spots of paint, revealing bare gesso underneath. Gianfrancesco Penni's *Portrait of a Gentleman* was so badly warped that large gaps were visible between the painted panel and its frame. Other paintings, including at least three in the Spanish room, showed visible signs of 'bloom', a cloudy discolouration of varnish caused by damp.[41]

Senator David Norris spoke of conditions in the NGI during a Senate Adjournment debate. He had inspected the premises with difficulty; 'when I went this afternoon to get a really up-to-date view of the situation …about half the Gallery was closed down. I could not see some of the French paintings, I could not see most of the Italian paintings.' In the great picture gallery on the first floor, 'a dirty dingy room', many of the glazing sheets covering the ceiling were cracked, two glazing panels were missing and paint was peeling from the ceiling. Even in the conservation department there was a leak in the roof and the water was caught in a plastic sheet. Elsewhere 'wind was actually whistling through panels and I saw paint in the process of flaking off some of these pictures.'[42]

Still-life with a Mandolin, 1924 by Pablo Picasso (1881-1973), Máire MacNeill Sweeney Bequest 1987 (NGI 4522, ©Succession Picasso/DACS 2004). The most highly prized 20th century Continental painting arrived unceremoniously with the rest of the bequest, in a truck from County Clare, much to the Director's disbelief.

Máire MacNeill Sweeney (1904-87), 1930s (NGI Archive).

Amazingly, given these dismal circumstances, in December 1987 the NGI would receive two sensational gifts. In the preface to his last *Catalogue of Acquisitions* Potterton wrote: 'as a glance at the Catalogue will reveal, the simple title 'Acquisitions 1986-88' is so understated as to be almost comic...In no single year since the foundation of the Gallery in 1854 has it acquired such an array of masterpieces and indeed one would be so bold as to claim that few galleries anywhere or at any time can ever have had such acquisitions within such a short space of time...Needless to say the Gallery could never hope to acquire such works except through gift or bequest.'[43]

The Máire MacNeill Sweeney bequest particularly delighted Potterton in his wish to bring good examples of twentieth-century art into the Gallery. Mrs Sweeney was a Celtic scholar and folklorist, who gave a collection of fourteen pictures and drawings to the Gallery in memory of her husband, John L Sweeney, who had been curator of the Poetry Room in the Lamont Library, Harvard University. Few people visiting her unassuming farmhouse at Corofin in County Clare and making their way to the kitchen, had an idea of the nature of the paintings hanging on the walls of her sitting room.[44] Acquired with the advice of James Johnson

Sweeney, Mrs Sweeney's brother-in-law, Director of the Guggenheim Museum in New York, they included drawings by Paul Klee (1879-1940), Amadeo Modigliani (1884-1920) and Alberto Giacometti (1901-66). Other pictures were an eighteenth-century representation of the *Limerick Hell Fire Club* (NGI 4523) by James Worsdale (c.1692-1767), Jack Yeats' lyrical *The Singing Horseman* (NGI 4524) and a portrait of James Joyce (NGI 4524) by the self-taught Englishman, Francis Spencer Budgen (1882-1971), painted in Zurich in 1919 'in a half-darkened room on account of an eye-attack of J.J.'s.[45] Joyce had been pleased. "I like the pose in your portrait, but...tell the buyer that my size in shoes is a small seven." What might have appeared overlarge feet were enveloped in outsize Jaeger house boots. [46]

However, the true highlights of the Máire MacNeill Sweeney Bequest were *Pierrot* (NGI 4521) by Juan Gris (1887-1927) and a superb Picasso (NGI 4522), *Still-life with a Mandolin.* A fruit dish, wine bottle and mandolin, arranged on a striped tablecloth, are painted in a bold, decorative Cubist mode influenced by Matisse.[47]

In the same year, 1987, Sir Alfred and Lady Beit donated seventeen priceless paintings from their collection at Russborough. After all the copies and misattributions, the NGI at last had a painting by Diego Velázquez (1599-1660) *Kitchen Maid with the Supper at Emmaus* (NGI 4538), a subtle work in brown and ochre, an early *bodegón* or kitchen scene combined with a religious subject. In *Doña Antonia Zárate* (NGI 4539) 'Goya accentuates the dark-haired beauty of the sitter by the masterly use of black and yellow. The black dress and lace mantilla are set off brilliantly against the yellow damask settee...The portrait has an engaging directness and a hint of melancholy.'[48]

Jan Steen's *The Marriage Feast at Cana* 'has been praised in all the literature.'[49] The paintings (NGI 4531, 4536 & 4537) by Jacob van Ruisdael (c.1628/9-1682) and Gabriel Metsu (1629-67) are regarded as their finest works. *A Wooded Landscape* (NGI 4533) by Meindert Hobbema (1638-1709) was considered by the nineteenth-century German art historian Waagen, 'a picture which is equal to a whole gallery.' *Lady Writing a Letter, with her Maid* (NGI 4535) by Johannes Vermeer (1632-75), which has been described as the most beautiful work of art in Ireland,[50] would have especially pleased Bodkin. 'We only lack a painting by Vermeer to enable us to form a comprehensive survey of the great pictorial achievement of the Dutch.

Detail of *Lady writing a letter, with her Maid*, c.1670 by Johannes Vermeer (1632-75), Sir Alfred and Lady Beit Gift 1987 [Beit Collection], (NGI 4535).

Works by Vermeer are so scarce and so enormously expensive that I despair now of ever filling this gap.'[51]

The Beits gave yet more Murillos to the Gallery, the series of six pictures illustrating the adventures of *The Prodigal Son* (NGI 4540-5), which the first Alfred Beit bought from the Earl of Dudley in 1896. Dudley had acquired five of the scenes in 1897; the sixth, *The Return of the Prodigal Son*, had been bought by Queen Isabella of Spain in 1850 and presented to Pope Pius IX. Dudley prised it away from the Pope, giving him in exchange a Fra Angelico, a Bonifazio and 2,000 gold napoleons.

This stupendous gift from the Beits had one drawback. Four outstanding paintings were missing, having been stolen. It was the first time that any gallery received a gift of pictures whose whereabouts were unknown.

The Beit pictures were assembled in the early years of the twentieth century at a time when a number of new South African millionaires were building up collections from members of the impoverished old aristocracy. After making his fortune in South Africa, Alfred Beit, uncle of Sir Alfred, and a friend of Cecil Rhodes, retired to London and started his collection. Many of his masterpieces were bought on the advice of the art scholar, Wilhelm Bode, Director of the Kaiser Friedrich Museum in Berlin, friend and champion of Walter Armstrong.

Inevitably Lane had been associated with the Beits, and was a good friend of Otto Beit, Alfred Beit's brother and father of the NGI benefactor.[52] In 1905 he persuaded Alfred Beit to buy Gainsborough's portrait of his daughter Margaret, on Bode's advice. Lane wrote to Bode: 'I had intended bequeathing it to the Dublin Gallery, but I am obliged to sell it now to pay for the 'Forbes' pictures which have been purchased as a nucleus of a *Modern Art Gallery*.'[53] At that stage of his career Lane was always short of money, and one painting had to pay for the next. There is a suggestion that the Velázquez in the Beit collection, which Bode had sold on to Otto Beit, may have been the unrecognised Velázquez 'Woman scouring dishes' which Lane had cleaned up after acquiring it in a very dirty condition for under £115. 10s. 'I cannot afford it, I'm in low

water just now – but I *must* have it.'[54] Although the size given for Lane's painting does not match the Beit Velázquez,[55] it is tempting to speculate there may have been a mistake in the measurements.

After Alfred Beit's death in 1905, Otto continued to buy pictures with Bode's advice, including the Goya, Gainsborough *Cottage Girl* (NGI 4529), Raeburn (NGI 4530) and Hals (NGI 4532) a doubtful attribution now in the NGI.

On Sir Otto Beit's death in 1930, the greater part of his collection was divided between his widow and son, Alfred; other paintings went to the National Gallery in London, while some were disposed of. In 1946 George Furlong wanted to buy for £2,500 for the NGI a *Madonna and Child* by Luca Signorelli, which had belonged to Sir Otto.[56] Alec Martin was initially enthusiastic, but later changed his mind; 'it was not in first-rate condition and had been much restored'. The purchase was declined by the Board.

In 1952 Sir Alfred, who had received his mother's pictures on her death in 1947, settled in Ireland. He and his wife, Clementine, were living in South Africa where they had become disgusted by the policies of Apartheid. The couple bought Russborough, Lady Milltown's home, by telegram after they had seen it advertised in *Country Life,* and restored the Palladian mansion so that once again its walls glowed with wonderful pictures.

After Sir Alfred joined the NGI Board in 1967, every year he lent a selection of his paintings to the Gallery. In 1976, in a singular act of generosity, the Beits created an artistic foundation, the Beit Foundation, encompassing house, land and paintings, endowed with their own funds, for the benefit of the Irish nation.

Meanwhile they had been robbed. In 1974 an IRA gang, headed by Rose Dugdale, raided Russborough and nineteen paintings were stolen. James White received a ransom note demanding £500,000 and the transfer from British prisons to Northern Ireland of the Price sisters.[57] On this occasion the paintings were recovered within a week from a cottage in County Cork.

Twelve years later there was another robbery from Russborough at a time when the Beits were not in residence. (Over the years the house has been raided by thieves with a worrying regularity, most recently in 2002.) In May 1986, a Dublin criminal gang headed by Martin Cahill, known as the General, stole seventeen paintings, four of which, the Goya, the two Metsus, and the Vermeer, were still unaccounted for when the Beits decided to give the cream of their collection to the Gallery.

In the Dáil pertinent questions were asked. 'It appears that the thieves were able to drive across two fields, break a window and shutter and back in the car or cars to the french window which provided a ready-made platform for them, load up with the paintings and leave at their leisure. This is simply not good enough. Did we deserve this gift at all? There is an old saying: 'Fool me once, shame on you; fool me twice, shame on me.'[58]

Security at the NGI had been yet another problem for Potterton, as a kindly thief had demonstrated back in 1981. He stole a little fifteenth-century panel, and left it in a post box near the College of Surgeons wrapped up with five 18p stamps, addressed to the National Gallery, with a letter denouncing security arrangements.[59] However, over the years very little has been stolen; the most recent item was *The Sleeping Shepherd* by Wilhelm Christian Dietrich (1712-74), a small painting from the Milltown Gift which disappeared in September 1989; nine years later it was recovered from the Dover Street Gallery in London which had purchased it in good faith in an auction in Paris.

At the time of the 1986 robbery at Russborough, discussions about transferring the collection to the National Gallery were under way. For a long time the Beits hesitated. Decisions were achieved with the aid of the Chairman, William Finlay, who had a legal and banking bankground and had joined the Board in 1974. (In 1999, the year he retired, a special lecture was established in his name.)

With the advice of Finlay, the Beits set up the Argus Trust to facilitate handing over the paintings. It announced 'that in procuring the exhibition of the paintings at the Gallery, the Trustees were obliged to be satisfied that the Gallery was a safe and proper place for the paintings.'

It was all very well accepting the paintings and giving the Beits honorary Irish citizenship, but what about the decrepit building in which their priceless gift was to be housed? In January 1988 Mrs Katherine Bulbulia commented in the Senate: 'We have been overjoyed with the munificent gesture on the part of Sir Alfred Beit…This has given added urgency to the problems of the Gallery. We might have allowed the thing to tick over and to have turned a blind eye to it had not these gifts been presented by Sir Alfred and Lady Beit. I do not think it is too much to ask that a small fraction of the value of the gift should be spent to fix the place up so that it would be a fitting home for the paintings that are

already in it, for the Beit collection which we are privileged beyond words to have received.' However, for the second time in a century, a gift from Russborough would provoke the government into taking action about the fabric of the Gallery.

At the same meeting during which the Beit paintings were formerly handed over, Potterton announced his resignation to the Board. Like Langton Douglas, Bodkin and Furlong, he had planned his moment. The reasons for leaving at this moment of triumph are obscure. The Office of Public Works had drawn up extensive plans for a refurbishment, although there was no funding nor a definite date for it to begin. But he was tired of official shabby treatment, and the idea of wrestling with the new Fianna Fail administration may have been daunting. The good sense of his policy decisions, that today appear so necessary in the progress of the NGI, hid the fact that he lacked the persuasive charm of James White. Brian Fallon thought that 'one of Homan Potterton's few areas of weakness was his apparent inability to bring officialdom round to his way of thinking – or in plain English, to flatter the civil servants and the politicians.'[60]

It seems he had never been happy in the job. In 1985 he had written to a friend: 'I don't know whether I like being a Director at all or not, there are some rewards, but one looks back to nice days when one gave all one's time to art history, preparing an exhibition or writing an article and those were good days.'[61]

In his resignation statement 'he accepted…retrenchment as inevitable in the context of the overall economic climate…but regretted that the recession had unfortunately coincided with his entire period as Director…He stated that the dilapidated state of the rooms was an ongoing source of shame to him as Director...' However, 'he felt that, despite most frustrating circumstances, much of what he had set out to achieve for the Gallery had been achieved, viz. the cataloguing of the Collection, the acquisition and refurbishment of No 90 and the imminent establishment of the Friends, together with the possibility that the major refurbishment of the Gallery might now proceed.'[62]

1 Minutes of NGI Board, 14 Sept. 1979
2 NGI correspondence. Press release, before 1 June 1980
3 Liam McAuley, 'Arts Notebook Ireland' *Sunday Times*, 5 Oct. 1980
4 Minutes, 10 April 1981
5 Minutes, 13 June 1980
6 *ibid.*
7 Homan Potterton introduction to *NGI Recent Acquisitions 1980-81* (Dublin 1981) p. 4
8 NGI correspondence. Potterton to John Kelly, TD, 20 Oct. 1981
9 Director's Report 10 Feb. 1984
10 Minutes, 9 July 1983
11 Director's Report 13 April 1984
12 Minutes, 9 July 1982
13 Ivan Gaskell review of *Dutch 17th and 18th Cent. Paintings in the NGI, Irish Arts Review*, vol. 13, no. 4 (Winter 1986) p. 56
14 Director's Report 11 June 1983
15 Homan Potterton, *Dutch 17th and 18th Century Paintings in the NGI* (Dublin 1986) p. vii
16 Benedict Nicolson, 'Dublin Blooms', *The Burlington Magazine* vol. cxxvi, no 972 (March 1984) p. 131
17 NGI correspondence. Agnew to Wynne, 16 July 1982
18 McAuley (as n. 3)
19 Minutes, 10 April 1981. Report on proposed purchasing policy
20 Minutes, 13 Feb. 1981
21 Michael Wynne *NGI Recent Acquisitions 1980-81*, p. 20
22 Press release, 12 Nov.r 1980
23 Homan Potterton, letter to *Irish Times*, 13 Nov.1980
24 Nicolson (as n. 16)
25 Minutes, 9 Oct. 1981
26 NGI correspondence. Agnew to Wynne, 16 July 1982
27 Homan Potterton introduction to *NGI Acquisitions 1984-86* (Dublin 1986) p. vi
28 Quoted Minutes, 8 June 1984
29 Nicolson (as n. 16)
30 Potterton (as n. 27) p. 3
31 Anne Crookshank and the Knight of Glin, *Ireland's Painters 1600-1940* (New Haven & London 2002) p. 245
32 Minutes, 14 June 1985 and Press cuttings
33 Minutes, 13 Dec. 1965
34 NGI correspondence. Potterton to Anne Kelly, 6 Dec. 1983
35 Director's Report 11 February 1983
36 Minutes, 8 April 1983
37 Director's Report 13 April 1984
38 Director's Report 16 Oct. 1987
39 Minutes 1987-88 *passim*
40 John Armstrong, 'Gallery Conditions "Damaging Pictures"', *Irish Times*, 15 Jan. 1988
41 *ibid.*
42 David Norris, Senate Adjournment Debate 'National Gallery Paintings', 10 Feb. 1988
43 Homan Potterton in *NGI Acquisitions 1986-88* (Dublin 1988) p. 1
44 Author's personal information
45 NGI correspondence. Budgen to Sweeney, 6 Dec. 1951
46 *NGI Acquisitions 1986-88* (Dublin 1988) pp. 58-59
47 *ibid.* p. 66.
48 *ibid.* p. 4
49 *ibid.* p. 49
50 Andrew O'Connor and Niamh McGuinne, *The Deeper Picture – conservation at the NGI*, exh. NGI 2000, p. 16
51 Thomas Bodkin, *NGI Catalogue of Oil Pictures in the General Collection* (Dublin 1932) p. x
52 Robert O'Byrne, *Hugh Lane 1875-1915* (Dublin 2000) p. 132
53 Quoted *ibid.* p. 61
54 Lady Gregory, *Hugh Lane's Life and Achievement* (London 1921) p. 27
55 Rosemarie Mulcahy, *Spanish Paintings in the NGI* (Dublin 1987) p. 81
56 Minutes of Special Meeting, 23 Oct. 1946
57 James White interview replayed on John Boorman's *Tribute to James White* RTE compilation, 12 July 2003
58 Dail Adjournment Debate 'Russborough House Art Robbery' 21 May 1986
59 *Irish Times* 15 August 1981
60 Brian Fallon in *Irish Times*, 18 Nov. 1988
61 NGI correspondence. Potterton to Cecil Gould, 12 June 1985
62 Minutes, 11 Dec. 1987

FULL CIRCLE:
BUILDING AND ACQUISITIONS

Two months before his departure in 1988, Homan Potterton, together with William Finlay, Chairman of the Board of Governors and Guardians of the National Gallery of Ireland, conducted the Minister for State at the Department of Finance around the Gallery. 'Deputy Noel Treacy, Minister with responsibility for the Office of Public Works, visited the Gallery on 23rd March, accompanied by one of the Commissioners as well as the architects responsible for the Gallery refurbishment scheme. The Chairman and I took him on a tour of the Gallery and showed him the deplorable conditions there.'[1] This critical exposure helped to change the mind of the government. Something had to be done. After John Armstrong's article in the *Irish Times* on the state of the NGI 'basically rumours are now circulating freely in Dublin that conditions of the Gallery in relation to environment, security and fire risk are unsatisfactory.'[2]

On 10 June 1988 Finlay was able to tell the Board that £5.6m had been allocated for Phase 1 of a refurbishment scheme. Initial funding would come from a new source – lottery money. Potterton may have felt it a good moment to leave.

Who was to succeed him? The Director's position now had a basic yearly salary of £24,648, but the job was uninviting. An article in the *Irish Times* considered 'This is not a good time in Ireland for the Arts, and the rather rundown condition of the National Gallery is a testament to the spending cutbacks of the times. In five years' time or less it may have picked up again, but there are still some years of austerity ahead, which may prove a deterrent to ambitious candidates with big ideas of promotion and publicity.'[3]

For the present it was decided that: 'Assistant Director Mr Raymond Keaveney will report directly to the Chairman.'[4] This arrangement continued week after week, while the Board sifted through applications but remained undecided about who to appoint. 'The Assistant Director

*Raymond Keaveney (b.1948), twelfth Director (1989-),
in the main Italian Room, against Piamontini's copy of*
The Wrestlers, 1989 (NGI Archive).

had been left in a position of first mate who had to run the ship but has
not even been given Captain's powers.'[5]

Applicants for the Directorship were advised that they should have a
minimum of seven years experience in a 'relevant profession', proven
knowledge of European paintings and administrative skills. But it
became apparent that the prolonged period of indecision over the
appointment was for the old, old reasons. Should the position go to an
Irishman or someone from across the water like Alistair Smith of the
National Gallery in London? *Phoenix Magazine* paraphrased the musings of
the *Irish Times* of 1869: 'Is the country so devoid of talent that the Board
had to appoint a Sassenach?'[6]

After eight months of dithering, with rumours of nudging by govern-
ment personalities, at last green smoke blew from the Board Room, and
in Lord Moyne's phrase, a 'green cap'[7] was chosen. The NGI would have a
Director who, in the words of Thomas Ryan, President of the RHA, and
promoter of the dormant portrait collection, could 'recognise a minor
Fenian figure or a member of Grattan's Parliament.'[8]

Raymond Keaveney's first appearance at the Board as Director was on
10 February 1989. 'Gallery Post for Kells Man' trumpeted *The Meath Chronicle;*
most people did not know that much about him. Another Meath man.

Appointed to the NGI as a curatorial assistant in 1979 with the support of his TD, Keaveney became Assistant Director to Potterton in 1981. At forty-one years of age, with a degree in art history from UCD and a particular interest in sixteenth-century Italian paintings and Old Master drawings, he had been running the Gallery since Potterton's departure. It was his second experience as Director, since back in 1985 he had stood in for Potterton when the latter took leave to write the Dutch catalogue. He would exhibit important abilities in which his predecessor was held to be deficient – those concerned with dealing with politicians, trade unions, government officials, staff, and Board members, organising public relations and anything else that touched the welfare of the NGI. The fact that he was Irish and favoured a 'hands-on' approach to his job helped him to weather the storms ahead. At a time of instability his appointment brought a measure of calm and, indeed, expectancy.

The state of the Gallery was not news to him. There were fewer staff, so that rooms had to be regularly closed. An Orientalist exhibition, due to take place and already catalogued, had to be cancelled because of lack of funds.[9] The Gallery, which ranked number three in the British Isles, had a hole in its roof and water in its basement and many rooms closed, as an item on RTE television showed.

However, immediate stopgap measures were planned. 'It is intended that the works carried out over the coming three months will make the south [Dargan] Wing secure against the elements for the next four or five years, after which time some extensive repairs and installations will be effected. During this time much of the collection will be placed in the north [Beit] Wing for display and storage while work goes ahead on refurbishing the entire building. Work will concentrate on replacing the damaged slates, over 70% of which will need to be discarded, repairing structural timbers which have been damaged or rotted, and draught proofing the area. Work will also be carried out on the damaged glazing and screening films...'[10] Keaveney may have felt that he was foreman of a building site rather than Director of a National Gallery.

Changes took place rapidly and the next four years would see paintings taken down stored, and rehung, as the Gallery was transformed. It was presentable to the world in 1990, the year that Ireland was host to the Presidency of the European Union. The refurbishment of the Milltown Rooms and the Shaw Room, hung with chandeliers, was marked by an official opening by the Taoiseach, Charles Haughey, on 9 March 1990, 'that glamorous evening'.[11] Haughey returned, to open a Jack B Yeats exhibition in the newly decorated Room 14, 'a splendid occasion'[12] attended by

1,000 guests. In the following year, when Dublin was designated Cultural Capital of Europe, six exhibitions were held, including one launched by the newly elected President of Ireland, Mary Robinson. (The Gallery had to endure a bomb scare on the 28 November 1991, and the NGI was closed on 5 December 1991, part of security measures during Margaret Thatcher's visit to Dublin.)

The reopening of the Milltown and Shaw Rooms marked the first stage of an overhaul of the three main wings at a cost of £10 million. Included was rewiring, a completely new lighting system, fireproofing, pollution control, a proper security system, and a reception area glittering with marble for its Information Desk operated by volunteers.

Although for much of the time of refurbishment parts of the NGI had to be closed, the steady transformation of the Gallery brought in more visitors. Attendances, boosted by concerts, lectures, and a celebration of Children's Art in May 1992 which attracted an attendance of 36,000,[13] continued to rise dramatically; after the new rooms were opened by Haughey, the number of visitors shot up by a hundred percent, and for the first time since it opened, the NGI recorded an annual attendance of over a million.[14] The increase between 1989 and 1990 resulted in a parallel increase in the Donations Fund, 'giving rise to the ironic conclusion that visitors are more prepared to donate to a refurbished Gallery than to one which is in need of refurbishment.'[15]

This was all the result of a dramatic change of attitude by the government after the 'purgatorial interlude'[16] endured by Potterton. Dr Brian P Kennedy, appointed Assistant Director in 1989, one of whose major tasks over the years was to liaise with the Office of Public Works in their work of updating the Gallery, mused to a reporter how 'the energy of the Department of Finance has been developed in the last three years by learning to say "no" in ten different ways. By doing that, the Government can now say "Yes" to some things, one of which, fortunately, is the National Gallery.'[17]

The new spirit showed by the government continued in 1992, when at a gala dinner, Albert Reynolds, who had succeeded Haughey as Taoiseach, announced that two houses in Merrion Square, Nos 88 and 89, which had been in the hands of the Office of Public Works would be 'made available' to the Gallery[18], and £170,000 from Lottery Funds would be allocated towards their refurbishment; they now provide offices and premises for the library, the expanded administration and the Board Room.

The changes were gradual, spreading over more than five years as the work was carried out in two phases. The 1968 north wing, closed from

Stripped walls of the lower Milltown Wing during refurbishment 1989-90. The first major project of upgrading the old galleries included removing flammable brocade and wadding, rewiring and a new lighting system (NGI Archive).

1993-96 to be completely remodelled and a glass lift inserted in the marble staircase, while the old courtyard, which for a time had provided space for some rain-sodden plaster casts, was eliminated and the space turned into the light-filled Atrium which linked the ground floor rooms and gave access to the Print Gallery and Print Room. On completion there would be thirty-six galleries for displaying paintings, a remodelled gallery for prints and drawings and improved storage accommodation. New lifts and ramps would make the building accessible to those in wheelchairs.[19]

Behind the scenes during the 1990s, there was constant movement of paintings and sculpture to facilitate building work and exhibition preparation. In 1999-2001 IIB Bank sponsored a programme of sculpture conservation by an outside specialist, Jason Ellis. A Senior Curator for the Irish School, Síghle Bhreathnach-Lynch, was appointed. The storage and viewing area for works on paper and miniatures (over eight thousand items) was relocated twice before settling back alongside the Millennium Wing as the Diageo Print Room. Copyright clearance was sought, by the newly established Rights and Reproductions office, for artists who had died less than seventy years ago, as demand for illustrations of works expanded. Education services multiplied; Exhibition,

Upper Beit Wing after refurbishment 1993-96. Almost
completely rebuilt inside, a sequence of rooms
has replaced spaces that had been difficult to
manage. Air conditioning, for controlling
temperature and humidity, considered
unnecessary in the Irish climate by the
authorities in 1968, was finally introduced.

Press and a Development Department (for fund raising), were all set up
with the usual minimal staff.

In October and November 1995 it was planned to close the NGI for a
rehanging of the entire collection prior to a grand opening of the trans-
formed Gallery on 24 November.[20] This had to be postponed until March
1996 owing to a number of unresolved problems, such as those relating to
the drilling of the bore hole for the elevator shaft in the main stairwell
after rock was struck and the provision of new filtration for the lights
and fitting of ventilation fans in the roof space of the 1864 wing.[21]

Forty percent of the paintings needed to be rehung; the Conservation
Department worked through the Collection, treating paintings in need
of attention. A team of assistants from the Courtauld Institute in London
was called in to help in its final phase. Several of the great seventeenth-
century canvases bought in 1854, were framed for the first time with
gallery frames made by an established Roman firm, Alterio Pasquale, and
were installed in the old Queen's Gallery, now displayed as a Baroque
Room.

The Gallery's heating system broke down on 14 May, a reminder of
harsher times. But the OPW had done its work well. 'On Friday 17 May

Mr Michael D Higgins TD, Minister for the Arts, Culture and the Gaeltacht, officially opened the refurbished building in the presence of an invited audience...The newly unveiled building made an immediate positive impact on the assembled public, who were greatly impressed.'[22] The newly decorated north wing was renamed the Beit Wing in 2001.

Ironically, in spite of all the money that was being spent on restoring the building, the NGI with its Director, Assistant Director, Keeper, three curators and four conservators, was still understaffed. Because of inadequate numbers of attendants in the galleries, rooms continued to be closed. At the same time there continued to be a shortage of funds for the purchase of paintings.

Since the grant-in-aid of approximately £100,000 had not kept up with the sums expended on the refurbishment, the Lane Fund had become relatively paltry, and money from the Shaw Fund was directed towards the development of the proposed Millennium Wing in Clare Street, there was not much money available during the early 1990s for the purchase of works of art. In his Director's Report for 1990 Keaveney wrote: 'A notable aspect of expenditure in the year gone by is that only modest sums were expended on acquisitions for the collection. This is essentially a result of not having more realistic sums available for this purpose. The role of a national gallery is to assemble the finest collection possible of national art and to acquire first rate examples of the works of the Old Masters. The modest sums currently available at the disposal of the Gallery make such a task immensely difficult...'[23]

The policy of 'focussing on Irish paintings and expanding the Old Master Collection as funds allow' appeared to reap meagre rewards. Keaveney would be criticised for his modest purchases,[24] although several were significant (prices in Irish pounds). They included the full-length portrait by Hugh Douglas Hamilton of the melancholy widower Richard Mansergh St George (NGI 4548) leaning against his wife's sarcophagus, inscribed *Non Immemor*, or 'Not Forgotten', which had been exhibited to acclaim at the Society of Artists of Ireland in 1801; this was bought in 1992 for £74,109, with the support of the Lane Fund.[25] Another fine Hamilton *Portrait of a young gentleman in Rome* (NGI 4596) was purchased in 1994 for £85,400. In the same year Francis Danby's *The Stag Hunt* cost £79,626. The rediscovered *Still-life with Fish and Game*, costing Stg£12,000, or rather Ir£17,348, once premium, conversion and VAT had been added, was a missing fragment from one of the Gallery's paintings, *Christ in the House of Martha and Mary* (NGI 513) by Jan Brueghel II and Rubens. *Capriccio with Pastoral Figures* by William van der Hagen (active 1720-45), a Dutch painter

who spent twenty-three years in Ireland,[26] was acquired in 1994 for £26,000 while *The Opening of the Ringsend Docks* (NGI 4614) by William Ashford (1746-1824) was bought in 1995 for £72,779 out of the Lane Fund. The splendid showy portrait of the Irishman Richard Wall (NGI 4660), an eighteenth century émigré to Spain who became Spanish Secretary of State, by Louis-Michel van Loo (1701-77) entered the NGI in 1999, bought at Sotheby's, New York, for £246,273.

Gifts to the NGI during this period included *Claude Lorrain Sketching* by Daniel Maclise, bequeathed by Mrs M. Shiell in 1888, *An Ejected Family* (NGI 4577) by Erskine Nicol (1825-1904), a rare portrayal of the troubled Famine era, presented by Michael Shine in 1992, and a portrait by Walter Osborne of writer Stephen Gwynn (NGI 4577), presented by Victoria Glendinning, according to the wishes of the former Governor and Vice-Chairman of the Board, Terence de Vere White, her deceased husband. In 1996 Dublin Corporation offered the Gallery on indefinite loan another rarity, a piece of the city's royal statuary that has survived. The life-size bronze of King George III (NGI 14707) by John van Nost the Younger (1712-80), had languished for eight years in the Point Theatre car park.

The Director and Board continued the policy of acquiring paintings by Jack B Yeats when the opportunity arose. In 1991 five examples of the artist's work were purchased – *Four Scenes in Search of Characters* (NGI 4581-84) for £60,440, and *This Grand Conversation was under the Rose* (NGI 4576), which cost £70,000 (£10,000 from the Friends). (Three years later *The Circus Dwarf*, declined by the Board, fetched £350,000, a reflection of the growing demand for the artist's paintings.) An adieu to his poet brother, *And So My Brother, Hail and Farewell for Evermore* (NGI 4643), was bought at a James Adam sale in 1997 for £95,000. Further works by Jack Yeats came into the NGI by gift. In 1992 the watercolour, *Causeway at Lettermore* (NGI 19395), was bequeathed by Elizabeth Coyne, and in 1994 *June Night* (NGI 4595) was offered by Misses Iona and Catriona MacLeod in memory of their stepfather, Patrick Little, a former Minister for Posts and Telegraphs. *The Gay Moon* (NGI 4636), a recurrent theme of travellers meeting, painted in 1949, was given by Patrick Brennan in 1997 and in the same year Lady Beit gave *The Beggarman in the Shop* (NGI 4638). Of the thirty-six paintings by Jack B Yeats in the NGI, two thirds were given by private donation.

The collection of portraits by John Butler Yeats received a major addition with the self-portrait (NGI 4642) related to the one which the old man had worked at during the last years of his life in New York (Michael Yeats Collection) and which had been commissioned by John Quinn, Yeats' patient patron. It is equally unfinished, in Roy Foster's words

'inevitably and appositely'.[27] This was bought in 1997 from Mrs Kathleen Walsh of New York for £25,000.

The first mention in the Minutes of a concentration on the Yeats family is on 10 July 1992. 'The Director informed the Board that there is considerable political support for the establishment of a Yeats Museum. The Gallery considers, given its extensive holding of paintings by Jack B Yeats, and the prospect of archival material relating to the Yeats family being allocated to the Gallery, that a number of floors in 89 Merrion Square should be reserved for the use of a Yeats Museum...The concept of a separate Yeats Museum is supported by surviving members of the Yeats family.'

In 1990 Dr Hilary Pyle, who had written a biography of Yeats, was given access to the Minutes of the Board meetings when Jack Yeats had been a member. In 1994 'plans for a Yeats Museum were being developed, but there had been difficulty in securing funding for the project...The Director said that he had discussions with Ms Hilary Pyle, the premier expert on Jack B Yeats, requesting her assistance with the foundation of the Yeats Museum and asking her if she would be interested in the position of Curator for the Museum.'[28]

The original idea of housing a Yeats museum in No 89 Merrion Square was discarded. The OPW were requested to prepare a document outlining the plans for the adaptation of the Fresco Room as a Yeats Museum, where the discredited frescos had been displayed, which had been 'removed and placed in storage in the basement area.'[29] Dr Pyle was appointed Curator on a one-year contract. The FNCI gave *Green Cloth Floating* (NGI 4602) by Anne Yeats (1919-2001) to mark the opening due to take place in 1995 and *Women and Washing* (NGI 4613) by the same artist was bought from James Gorry for £3,250 out of grant-in-aid.[30]

In October 1995 a shortage of funds meant that the project had to be put on hold and Dr Pyle was let go.[31] Two months later the situation was reversed when Anne Yeats offered the NGI as gift the entire archive of her uncle, Jack Butler Yeats,[32] and after a break of three months, Dr Pyle resumed her position as Curator of the Yeats Museum. A new schedule allowed the OPW to complete the alteration of the Fresco Room to Yeats Museum while Dr Pyle produced a catalogue of the Yeats' material in the collection.

The Yeats Museum was opened in March 1999 by the Taoiseach, Bertie Ahern. The display of John Butler Yeats' portraits and Jack Yeats' paintings was augmented by lesser works by Elizabeth Corbet Yeats and Susan Mary Yeats, sisters of Jack Yeats, and by his niece, Anne Yeats, who with her brother, former Senator Michael Yeats, was present at the opening.

The whole family was there in the room once designed to house Marsh's Library. The public took to it, and the Yeats Museum is one of the most popular exhibition areas in the Gallery.[33] When it first opened there was a twenty percent rise in visitors coming to the NGI.

The emphasis on Jack Yeats at the expense of other Irish artists in the NGI is a matter for debate. Future exhibitions of the *oeuvre* of William Orpen or Nathaniel Hone's paintings which lie in store, may call for a reassessment of their status as Irish artists.

Today Jack Yeats triumphs with his 'high solitary art uniquely self-pervaded, one with its wellhead in a hiddenmost of spirit, not to be clarified in any other light.'[34] (The words are Samuel Beckett's; in 1995 the NGI bought *A Morning* (NGI 4628) which Yeats sold in instalments to Beckett in 1936). Arthur Power wrote of him in 1943: 'What was vigour before now became almost a frenzy…In his violence he tore down all conventions, ripped up form and colour and produced a tremendous blaze. In this he may be compared to Joyce in literature, except that Joyce was a bitter cynic, while Jack Yeats is a wild romantic.'[35] Like Joyce, Yeats' 'all purples and yellows, frankly vulgar, but dashing and virile'[36] needed many years to gain public acceptance, but he achieved it at last. MacGreevy considered that Yeats 'fulfilled a need that had become immediate in Ireland for the first time in three hundred years, the need of the people to feel that their own life was expressed in art.'

The fact that space to hold exhibitions was limited was an important consideration when the development of the Millennium Wing became a possibility. Potterton's regular Acquisitions Exhibitions had been dropped; the final one featuring the MacSweeney and Beit paintings was hard to follow. Although the perpetual refurbishment plans restricted their scope, exhibitions in the 1990s included *Images of Yeats*; *Nathaniel Hone the Younger*, a showing of Mrs Delany's paper flowers from the British Museum; *The Milltowns, a Family Reunion*; *200 Years of Watercolours*, and, in October 1996, an exhibition of the work of William Leech (1881-1968). It was unfortunate that one of the exhibits, *The Goose Girl*, which had been bought in 1970 for £500 as by Leech, turned out to have the remains of two 'e's from the signature of Stanley Royle (1888-1961), briefly visible after revarnishing.[37] The picture, which had been the shop's most popular image and had adorned many a poster and greeting card when considered the work of an Irishman, lost some of its lustre after being identified as the work of an English artist.

But other exhibitions were triumphant. Although Shaw money might be diverted from buying paintings, the NGI had a little bit of luck.

Wonderful things happened. The first concerned yet another Murillo. *The Meeting of Jacob and Rachel at the Well* (NGI 4578), then obscured by thick brown varnish and unidentified, was given to the NGI in 1987 by Mrs Alice Murnaghan, the widow of Judge James Murnaghan, who had been Chairman of the Board for many years. The Judge had a remarkable collection of paintings, many of which he bought as he walked home from the Four Courts along the quays past the picture dealer, Bennetts of Upper Ormond Quay.[38] His wall-size Murillo, which was put on display in 1993, was identified as one of six huge canvases telling the story of Jacob which were ordered from Murillo and his studio by the Marqués de Ayamonte y Villamanrique. Others are in the Hermitage, the Cleveland Museum of Art and the Meadows Museum in Dallas and one has yet to be found.[39]

In the same year the Murillo was donated, the lost masterpiece, *The Taking of Christ* (NGI 14702) by Caravaggio, was unveiled. Sergio Benedetti, then Senior Restorer at the NGI, remembered his feelings after he first caught sight of it. 'That morning in August 1990, leaving the House of the

The Taking of Christ, 1602, by Caravaggio (1571–1610) unveiled to the public in *Caravaggio, the Master Revealed*, 1993. It was initially displayed with a red taffeta curtain for protection from light, as described in the 1616 inventory of the Mattei family.

Jesuit Fathers in Leeson Street, excited by what I had just seen, I could hardly have imagined that three years later I would see my beliefs realised with an exhibition.'[40]

The Taking of Christ was painted in 1602 by Michelangelo Merisi, known as Caravaggio, for the Roman nobleman, Ciriaco Mattei, brother of Cardinal Girolamo Mattei, the artist's patron. Two centuries later, in 1802, after the break-up of the great Roman collections, it was bought by a Scotsman, William Hamilton Nisbet, from a Mattei descendant, Duke Giuseppe Mattei (who also sold a number of paintings to Cardinal Fesch.) By then the painting was misattributed to the Dutch artist Gerrit van Honthorst. It remained with other paintings in Biel House, Nisbet's family seat in Scotland, until 1921 when, following the death of the last direct descendant of the family, it was unsuccessfully auctioned as by Honthorst by Dowell's in Edinburgh and bought in.[41] A few years later it was purchased by Dr Marie Lea-Wilson and brought to Ireland.

Dr Lea-Wilson was the widow of an RIC officer, Detective Inspector Percival Lea-Wilson, who, in June 1920, was assassinated in the village of Gorey, County Wexford by four men shooting from a passing car reputedly in retaliation for mistreating Republican prisoners in 1916. After his death she became a paediatrician, and working for many years in Harcourt Street Children's Hospital. She was in Scotland some time in the late 1920s where she bought *The Taking of Christ*. In the early 1930s she presented it to the Jesuit Fathers of the house of St Ignatius, who hung it in their dining room and dined under it for sixty years, until the summer's day when Benedetti caught sight of it.

Aloysius O'Kelly's *Mass in a Connemara Cabin*, at present on temporary loan to the NGI (NGI 14780), similarly hung unrecognised in another dining room of a Catholic presbytery in Edinburgh. No one there realised its significance. 'The painting had always been a talking point amongst us. We used to speculate about whether it was in the Scottish Highlands or in the West of Ireland.'[42] In future, members of religious communities may speculate more thoroughly about the origin and worth of obscure paintings on their walls.

Almost three years' research was needed for *The Taking of Christ* to be authenticated as Caravaggio's masterpiece by Benedetti, during which time the discovery was kept secret. The account of following the trail of the Caravaggio to Scotland and subsequently to Dublin, with the aid of documents, receipts and evidence of frames, reads like a detective story. The Jesuit Community in Leeson Street generously agreed that the painting should be placed on indefinite loan to the Gallery in memory

of Dr Marie Lea-Wilson. The public was introduced to the genius of Caravaggio by an exhibition of *Caravaggio and his Followers,* held in 1992, where *The Supper of Emmaus* from the National Gallery in London, also painted for Ciriaco Mattei, was hung beside Carravaggisti paintings in the NGI.

On 16 November 1993, *The Taking of Christ* was unveiled to the public in front of 2,000 guests. The discovery had already been leaked by an Italian newspaper, and by the opening of the exhibition there was great excitement. The occasion was reported on RTE news programmes, on BBC breakfast television, while the story was the subject of an RTE documentary. Benedetti made an appearance on RTE's Late Late Show. Five months later An Post issued a stamp bearing a representation of the painting[43], repeated in 2004 as part of a three year series marking the 150th Anniversary.

Caravaggio, The Master Revealed, which ran from 18 November 1993 to 31 January 1994, attracted over 120,000 visitors, 'making it among the most popular, if not the most popular, exhibition ever mounted by the Gallery.'[44]

The scholar, Sir Denis Mahon, who has known Benedetti for over thirty years, gave him much assistance in his efforts to authenticate the painting, and officiated at the opening. Mahon had been familiar with the Baroque paintings in the NGI for many years; in 1935 he asked MacNamara for photographs of Annibale Carracci's *Crucifixion* and Guercino's *St Joseph* which he had identified from Bodkin's catalogue.[45] Thirty years later he advised MacGreevy of the importance of the NGI's Lanfrancos.

He had begun collecting Baroque paintings at a time when they were unfashionable; in an interview with the author in 2001 he was still delighted at the bargains he had obtained among his seventy-nine works of the Italian Baroque, with additional paintings by French and Dutch artists. He intended to bequeath to the NGI, together with his library, five of his paintings: *Jacob Blessing the Sons of Joseph* (NGI 4648) by Guercino (1591-1666); *The Magdalen* (NGI 4646) by Domenicino (1581-1641); *The Suicide of Cleopatra* (NGI 4651) by Guido Reni (1575-1642); another *Magdalen* (NGI 4645) attributed to Annibale Carracci (1560-1609) and *Abraham's Sacrifice near Bethel* (NGI 4644) by Sébastien Bourdon (1616-71). The Carracci and the Bourdon had belonged to Thomas Bodkin.

The official announcement of the gift of five paintings was made to a delighted Board, in December 1996.[46] Seven months afterwards, on 2 July 1997, 'Sir Denis Mahon made a public statement indicating his intention to give three further Old Master paintings to the NGI...Sir Denis had originally intended to present these...to the Walker Art Gallery in

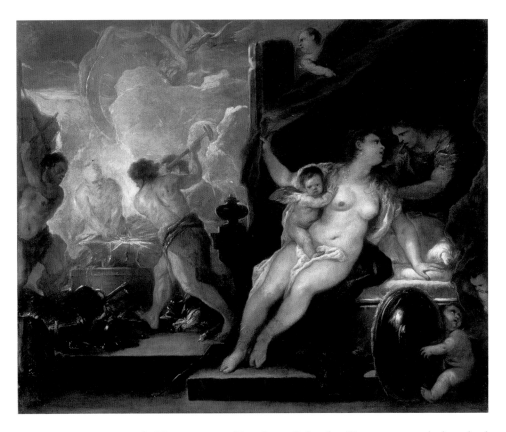

Liverpool. However, on Tuesday 1 July the Trustees stated they had decided to introduce entry charges, a policy to which Sir Denis is vehemently opposed.'[47] The NGI's gain consists of *Venus, Mars and the Forge of Vulcan* (NGI 4647) by Luca Giordano (1634-1705); Guercino's *St John the Baptist visited in Prison by Salome* (NGI 4649) and *St Bruno in Ecstasy* (NGI 4650) by Pier Francesco Mola, whose altarpiece, *St Joseph's Dream*, came into the NGI with the Aducci paintings in 1856. Mahon's gift, was shown at an exhibition *A Scholar's Eye* in October 1997, and today the paintings hang in the general collection.

The Caravaggio made news again on Tuesday 15 April 1997, after a visitor called the attention of an attendant to an insect crawling out from behind the canvas. 'You may think I am mad but...' The incident invited headlines such as that in *The Times*: 'Beetles show Excellent Taste by Choosing £30m Painting for a Snack.' The Minutes reported that 'Dr James O'Connor of the Natural History Museum identified the infestation as the larvae of Biscuit Beetle (*Stegobium Paniceum*) which eat cereals, beverage concentrate, spices and various drugs and can also eat wood, metals and poisonous substances such as strychnine.'[48]

Following emergency treatment by Maighread McParland, a fellow Senior Conservator, Andrew O'Connor, dealt with the infestation of the flea-sized creatures which found the glue used to reline the painting organic-based, soft and easy to chew. Keaveney observed: 'we spend all our time worrying about men in balaclavas coming in to steal our pictures and then you find this tiny thing causing havoc.'[49]

It took time and persistence on the part of the Garda Siochana to defeat the men in balaclavas and retrieve the four paintings still missing out of the seventeen stolen from Russborough in 1987. *Woman Reading a Letter* by Gabriel Metsu was discovered in Turkey at the end of 1990. In 1994 on Thursday 2 September four paintings taken from the Beit collection were recovered by Belgian police at Rotterdam airport.[50] Three belonged to the NGI – the Vermeer, the Metsu that was a companion to the *Woman Reading,* and the Goya.

Seven months later the stolen paintings were returned to Ireland; the event was overshadowed by the death of Sir Alfred Beit and the Board observed a minute's silence.[51] In June 1995 Vermeer's *Lady Writing a Letter, with her Maid* was ceremoniously unveiled by Sir Alfred Beit's friend, Lord Gowrie, in the presence of Lady Beit. Lord Gowrie arranged the sponsorship by Sotheby's of a new frame with pear wood veneer for the painting.[52]

When the recovered paintings were put in the care of the Conservation Department it was discovered that the Goya, which had suffered in the previous robbery, was the only one to have sustained significant damage after being cut from its stretcher and rolled up. The author recalls seeing *Doña Zárate* at the time, much travelled, and much the worse for wear. Her restoration took many months.

Not every Conservation Department has to wrestle with problems like those raised by the biscuit beetle and the General (who was murdered a year later in a paramilitary shooting) but the incidents highlight

the vital role it plays in the wellbeing of the NGI's varied collections. It usually does its work behind the scenes, although, in 1996 the conservators emerged into the Shaw Room in full view of the public to clean *The Marriage of Strongbow and Aoife*, at 309 x 505 cm, the largest painting on display in the Gallery.

The fate of the casts acquired by Mulvany is a sad contrast. A poignant entry appeared in the Minutes in early 1990. 'The Director requests the sanction of the Board to dispose of the ruined pieces. Photographs were circulated to illustrate the state of them. Agreed – 1) those in ruinous condition to be destroyed; 2) those in good condition to be retained; 3). Those in poor condition to be offered to another institution.'[53] Some fifteen survive in store and at the RHA.

While such destruction of an important part of NGI history must be deplored, there was ample redress seven years later with the acquisition of the *Amorino*, by Antonio Canova (1757-1822), the finest piece of sculpture in the NGI. Here was another story of rediscovery. The idealised Cupid had been commissioned from Canova in 1789 by young John David La Touche, of the Huguenot banking family in Dublin and Wicklow, during his stay on the Grand Tour in Rome. Completed in 1791, it was dispatched to Ireland the following year. During the nineteenth century it was inherited by a La Touche descendant who moved to England, where the delicate marble sculpture became forgotten until it was discovered exposed to the elements in the back garden of a house in the West Country.[54] After it was identified, the *Amorino* was acquired for the Gallery for £520,000, particularly encouraged by Sergio Benedetti, and presented by the Bank of Ireland, which had strong connections with the La Touche bank. It was first exhibited to the public on 11 November 1998.

The *Amorino* would have been well outside the Gallery's resources, and those of most potential donors. However, Canova's masterpiece came into the NGI through Section 1003 of the Consolidated Taxes Act (1997) which enables a donor to write off the value of an artwork of national heritage worth more than £75,000 against tax.[55] This enlightened piece of fiscal legislation, drawing on a limited fund, has benefitted other institutions such as the National Library of Ireland. It has enriched the NGI with a number of gifts, beginning with the Yeats Archive in 1996 for £400,000.

Amorino, 1789-91 marble, by Antonio Canova (1757-1822), presented 1997 under Section 1003 (NGI 8358). It was sensitively conserved by Jason Ellis and a vital anatomical detail recarved.

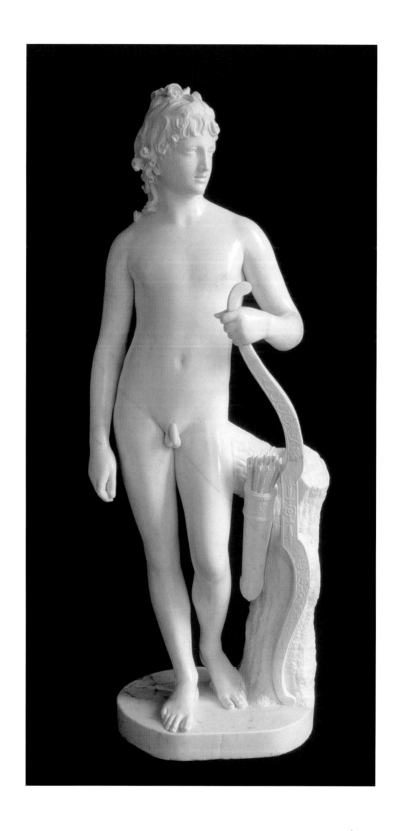

Concessions under Section 1003 have enabled two Carravaggist paintings identified by Benedetti which once belonged to great houses to be recovered and returned to Ireland. In 2001 *Christ disputing with the Doctors* by Juan Do (c.1604-56), which had hung as part of the Old Master Collection in Powerscourt House, was acquired as a gift from IIB Bank, having been purchased for Stg£330,000, while *A Musical Party* by Gerrit van Honthorst (1590-1656) at Stg£300,000 was presented to the NGI by Lochlann and Brenda Quinn. *A Musical Party* had been owned by two Italian cardinals, Cardinal del Monte and Cardinal Francesco Barberini before 1756, when 'Two figures singing and playing on a guitar by Michael Angelo Caravaggio' was purchased for Lord Charlemont by his agent, John Parker. It was displayed at the Marino in Clontarf until it was auctioned off in 1892 with the dispersal of the Charlemont collection. For many years this beautiful painting was thought to be by Caravaggio – an attribution contrasting with *The Taking of Christ* which had been attributed to Honthorst. It is the only Honthorst in the Gallery since the *Wedding Feast* (NGI 1379) purchased in MacGreevy's time (in fact a brothel scene with the usual old woman holding up a coin) is considered by an unidentified Utrecht School artist.

A succession of Irish paintings has also entered the NGI under Section 1003. An Italianate landscape by George Barret, together with a coastal scene by a follower of Claude Vernet in superb rococo frames, acquired through the scheme are at present displayed at Farmleigh.[56] In 2003 Allied Irish Bank presented the glowing *Nature Morte aux Pommes et Pots Bretons* by Roderic O'Conor (1860-1940) valued at over Stg£370,000. A year previously Lochlann and Brenda Quinn gave what he considered 'the most important Irish painting of the past fifty years', *A Family* by Louis le Brocquy which had cost Stg£1.7m from Nestlé Corporation, a record price for a work by a living Irish artist. (In the early 1950s it had been offered for £400 to the Municipal Gallery which turned it down.) In this case the Board abandoned the rule about acquiring works by living Irish artists that in 1954 had deprived the NGI of Yeats' *Bachelors' Walk – in Memory*, now operating a fifty year rule (apart from portraits) to allow for proper consideration.

In October 2001 the NGI was able to announce that, through the work of Professor Ernst van der Wetering who was preparing an exhibition for Kassel and Amsterdam, *The Mystery of the Young Rembrandt*, the NGI's *La Main Chaude* had been identified as an early Rembrandt.[57] The spirit of Walter Armstrong rejoiced. The habit of gaining Old Masters by chance might be said to justify any purchase policy. The NGI will not again have the resources to buy first class works of art on the open market, hence the importance of Section 1003. Although the grant-in-aid from the govern-

ment rose from £263,000 in 1999 to £750,000 in 2000, in a world where millions are needed for good paintings, the NGI will continue in the role of Tantalus.

An early purchase rising from the improved grant-in-aid was *La Rose du Ciel, Cassis* by Roderic O'Conor, at £340,000 then a record price for the artist's work. The increase triggered a new policy on acquisitions and the creation of the Acquisitions Committee, drawn from members of the Board. No longer would there be potential conflict between Director and Board. 'The Director reported that he had widely researched the position in sister institutions internationally...the common practice is to set up a sub-committee comprised of Board members, who would assess proposed acquisitions in conjunction with the Director and curators and validate the credentials of each proposal.'[58]

The Acquisitions Committee held its first meeting on 2 July 2001 and laid out its brief – it would examine possible items available for purchase with a price above £50,000 for which an independent valuation would be sought. Any work of art dating up to the 1950s (except for portraits) would be eligible for its consideration.[59] It began on a clarion note by recommending six works by Thomas Roberts and one by James Arthur O'Connor which were duly purchased in December 2001.

In December 2003 the National Portrait Gallery reopened in the Mezzanine Gallery in the old Dargan wing with the unveiling of *Image of Bono* (aka Paul David Hewson), the singer and pop star, by Louis le Brocquy, perhaps a logical sequence to the portrait of the Bard Carolan that was once on display. Since Henry Doyle opened the National Portrait Gallery in 1884 in the room intended for Marsh's Library, now the Yeats Museum, it has had a chequered history. In Armstrong's time it was moved to the newly built Milltown Rooms on the ground floor, returning to the Dargan Wing in the 1970s, when it was dismantled and a part of the collection transferred to Malahide Castle.

In the new Portrait Gallery, instead of the old crowded assemblies of prominent worthies, patriots, governor generals, kings, martyrs, actresses, portrayed in oils, prints, bronzes, and death masks, the collection assembled now is small, with about sixty of the best or most relevant portraits in the NGI's collection. There are surprisingly few well known political figures or patriots – no picture of Parnell or de Valera or the men of 1916. The selection is made more on the quality of the pictures than following a national theme

The earliest painting is 'Black Tom', *Thomas Butler, 10th Earl of Ormond* (NGI 4687), attributed to Anglo-Flemish painter Steven van der Meulen (active

1543-68). The portrait of the Earl of Cork (NGI 4624) depicts one of the earliest collectors of paintings in Ireland. Francis Cotes (1726-70) painted the eighteenth-century beauty, Maria Gunning, the Countess of Coventry (NGI 417), one of the three daughters of plain John Gunning from Roscommon who were known as 'The Three Graces.' Lady Morgan, painted with panache by René Théodore Berthon (1776-1859), was donated to the NGI in 1860, and was on display when the Gallery opened in 1864. The actor James Quin, whose portrait by Thomas Gainsborough was bought by Walter Armstrong, had his career interrupted in 1718 after he was convicted of manslaughter for having killed another actor in a duel. Other portraits include a young member of the Perceval family (NGI 4626) by Thomas Pooley (1646-1723) bought in 1996 for £5,460; Lord Edward and Pamela Fitzgerald; John O'Leary by John Butler Yeats; Countess Markievicz painted by her husband Casimir Markievicz (1874-1932); and Lady Lavery (NGI 14776, on loan from the Central Bank), striking the pose that used to adorn our bank notes. More recent works include Noel Browne (NGI 4573) by Robert Ballagh (b. 1935); and a series of specially commissioned portraits sponsored by Irish Life plc of contemporary Irish figures, such as a fine double portrait of Nicholas and Mary Robinson (NGI 4659) by Mark Shields (b. 1963), Ronnie Delaney (NGI 4684) by James Hanley (b. 1965) and Gay Byrne (NGI 4686) by John Kindness (b. 1951).[60]

The Library, now housed in the basement of No 89, has been the part of the NGI slowest to gain recognition. For many years there was no librarian, and accumulating and cataloguing books was yet another task of the overworked Registrars. Nevertheless the collection of books has managed to become significant, with a wide selection on Irish art and the art of European countries, and a collection of art journals. The series of catalogues of the NGI, including a number that have been annotated by Directors, back to Mulvany's first catalogue produced in 1864, is almost complete. The Archives include Minute Books, the two Letter Books of correspondence relating to the beginning of the Gallery, contemporary newspaper cuttings, correspondence relating to poor Henry Killingly, acrimonious letters about the Milltown Collection, correspondence concerning Hugh Lane, including an acknowledgement by Lady Gregory of the Board's expression of sympathy after Lane's death, administrative material and accounts, and material relating to pictures, including acquisitions, loans and exhibitions.[61]

During Keaveney's time the number of attendants has risen to around sixty-two, with four senior attendants. This is considered enough, and room closures are rare. Today, since there are so many visitors, boredom is much less of a problem than it was in the bleak old days. Eight cleaners, four men and four women, keep the place in order.[62]

Although much of the Gallery has been transformed during the years of Keaveney's Directorship, the most important programme of the 1990s was the development of the site on Clare Street into the Millennium Wing. As the Duke of Wellington said of Waterloo, it was the nearest run thing you ever saw in your life.

1 Minutes of NGI Board, 8 April 1988
2 Minutes, 12 Feb. 1988
3 Irish Times, 9 July 1988
4 Minutes, 10 June 1988
5 Brian Fallon, Irish Times, 18 Nov. 1988
6 Phoenix, 12 August 1988
7 Bruce Arnold, Magill, April 1999
8 Letter to Irish Times, 8 Oct. 1988
9 Minutes, 12 Feb. 1988 and 8 April 1988
10 Minutes, 14 Oct. 1988
11 Annual Report 1990
12 Minutes, 13 July 1990
13 Annual Report 1992
14 Annual Report 1991
15 Minutes, 12 Oct. 1990
16 Brian Fallon, Irish Times, 19 July 1989
17 Brian P Kennedy, interviewed by Kate Robinson, Sunday Independent, 5 Nov. 1989
18 Minutes, 12 June 1992
19 Chairman in Annual Report 1996
20 Minutes, 9 June 1995
21 Minutes, 13 Oct. 1995
22 Minutes, 14 June 1996
23 Annual Report 1991
24 Anne Crookshank, 'In my view - The National Gallery of Ireland', Apollo (Sept. 1992) p. 166
25 Minutes, 11 December 1992
26 Nicola Figgis and Brendan Rooney, Irish Paintings in the NGI, vol. 1 (Dublin 2001) p. 455
27 Roy Foster, W. B. Yeats – A Life, vol. 2 (Oxford 2003) p. 169
28 Minutes, 16 Nov. 1993
29 Minutes, 24 Sept. 1996
30 Minutes, 9 June 1995
31 Minutes, 13 October 1995
32 Minutes, 8 December 1995
33 Press release, 25 Jan. 2002
34 Samuel Beckett in Les Lettres Nouvelles, April 1954, on the occasion of Yeats exhibition in Paris

35 Arthur Power, 'Jack Yeats', The Bell (June 1943)
36 James Lees-Milne, Ancestral Voices, Diary 17 January 1942
37 Minutes, 13 Dec. 1996
38 SB Kennedy, Irish Art and Modernism (Belfast 1991) p. 119
39 Raymond Keaveney in European Masterpieces from the NGI, exh. Australia and NGI 1994-5, p. 14
40 Sergio Benedetti, Caravaggio – The Master Revealed (revised ed. Dublin 1999) p. 4
41 ibid. passim
42 Interview with Father Ed Hone Parish Priest of St Patrick's Edinburgh, Sunday Times – 3 Nov. 2002
43 Minutes, 10 Dec. 1994
44 Minutes, 11 Feb. 1994
45 NGI Administrative Box 16. Mahon to Registrar, 13 & 19 March 1935
46 Minutes, 13 Dec. 1996
47 Minutes, 11 July 1997
48 Minutes, 13 June 1997
49 Audrey Magee, Ireland Correspondent, The Times, 23 April 1997
50 Annual Report 1995
51 Minutes, 10 June 1994
52 Minutes, 9 June 1995
53 Minutes, 9 Feb. 1990
54 Sergio Benedetti, The La Touche Amorino (Dublin 1998) pp. 24 & 25
55 Minutes, 12 April 2001
56 ibid.
57 Press release, 21 Oct. 2001
58 Minutes, 8 June 2000
59 Minutes, 12 July 2001
60 Gallery News, Sept.-Nov. 2003
61 NGI Archives. Initial list by Maia Sheridan, July 2000
62 Interview with Mick O'Shea, Head Attendant, NGI

CHAPTER TWENTY EIGHT

THE MILLENNIUM WING

Few of those viewing the Millennium Wing in Clare Street, which has been praised for its originality and beauty, realise that it is an architectural compromise. The years of struggle, to acquire the site and build the wing, were full of drama and suspense, which provided curious echoes of the initial difficult ten years of the Gallery's long history. By coincidence, the architects of the wing, Benson and Forsyth, had also designed an extension to the Museum of Scotland in Edinburgh, whose original building was the work of Captain Francis Fowke.

When he was interviewed for the Directorship, Raymond Keaveney had pointed out that the NGI needed to expand. There was a pressing requirement for more space in addition to its existing premises in order to provide the many facilities needed for a modern gallery, particularly for a space to show major exhibitions. There had been some thought of incorporating the old art college behind the NGI with the building complex, but this had been taken over by the government for offices. Closed off to the west by Leinster Lawn, the NGI could only go one way.

An opportunity for expansion occurred in December 1988, when three houses in Clare Street, Nos 27, 28 and 29, which connected with the rear of the Gallery, owned by a syndicate headed by the businessman, Jim Stafford, were put up for tender.

Times were hard, and the Board was cautious. Ignoring Keaveney's proposals, it decided not to tender for the houses, but to wait for developments. At Keaveney's first Board meeting as Director on 10 February 1989, the Chairman, WD Finlay had to announce that the houses had been sold to Mr Roy Strudwick for £718,000. He added that the purchaser was 'aware of the Gallery's interest in the site and the Director is now awaiting the purchaser's reaction.'[1]

It had been Keaveney's idea to acquire and develop these houses on Clare Street, whose dimensions would provide the footprint area for the Millennium Wing. One of his first tasks as Director was to sound out the

Department of the Taoiseach, which declared that no money was available. However, there was the possibility of availing of EC funding for the project – 75% of the cost could qualify as 'tourist infrastructure.' The rest of the money would have to come from other sources of funding. To go ahead and negotiate the purchase of the houses under these circumstances required courage, since the enterprise would involve considerable risk. With no government support and no guarantee of EC funds, the Gallery would have to go it alone.

At this stage Strudwick was in no hurry to part with his newly acquired property. Through Dr Tony Ryan, another member of the Board, Finlay arranged for him to tour the Gallery. Since he had the upper hand, initially he was noncommittal about the prospect of parting with the houses, and at a subsequent meeting made it plain that he did not want to sell. 'Mr Strudwick said he was a developer, not a dealer in sites.' His company, Ryde Development, had already received planning permission to build offices on Clare Street; the Board had only made objections at the Planning Appeal stage.[2]

On 6 June 1989 Strudwick revealed to Keaveney and Finlay the plans that his architects had drawn up for the commercial development of the site, which had received planning permission, and proposed that these could be used as a basis for any Gallery scheme. However, at a Board meeting three days later, Austin Dunphy, the architect responsible for the refurbishment of No 90 Merrion Square, declared this would be impossible. A working party was set up to negotiate with Strudwick; it included John Mahony, the Chairman of the OPW who from the start had been enthusiastic about the purchase of the houses.[3]

By the Board meeting of 14 July 1989, the working party had agreed that the houses must be acquired. It concluded that the site was 'of such paramount importance to the future development of the Gallery that a clear cut offer to purchase the site from Mr Strudwick should be considered.'

At same meeting Keaveney explained to a number of reluctant Governors the 'interrelated reasons' for buying the site. Here was the NGI's last opportunity to expand. The houses on Clare Street offered the last remaining area for potential development in direct proximity to the Gallery. The site would provide extra exhibition areas, and a new location for the restaurant; and it offered street access on Clare Street where there would be a new entrance so that the public did not have to walk around the corner and along the north side of Merrion Square to the old front.

At the Board meeting of 15 December 'the Chairman said that there were two issues. Does the Board want the site, and if so, what route should be employed if the Gallery wishes to acquire the site?' To help Board members make up their minds, Mr Roy Donovan of Lisneys was present, and reported that, in his view, the site had a special value for the Gallery. Anyone could have told them that.

A working party was set up to negotiate a price, and after prolonged negotiation it was agreed that the houses on Clare Street should be purchased for £1.9m, a handy profit for Strudwick. Initially the OPW would buy the site on behalf of the Gallery, on the understanding that the cost should be reimbursed within twelve months.[4]

From the Shaw Fund £600,000 was available. (Potterton had set a precedent for outside purchases when he acquired No 90 Merrion Square with Shaw funding.) Where would the NGI obtain the rest of the money? Since at that time the Gallery was legally unable to borrow, a solution was worked out using the Friends of the National Gallery of Ireland based in No 90. The Friends was a new organisation, first promoted by Potterton, to stimulate interest in art and in general support and aid the Gallery, Arlene Hogan was the initial Administrator to 1998, followed by Maureen Beary Ryan in organising its varied activities of lectures, trips, concerts and buying Irish art for the NGI. Now it was brought into action, as a company limited by guarantee and its members were empowered to borrow the required money. The lenders were Woodchester Bank.

Keaveney also envisaged that in addition to EC money, a considerable cash flow would be generated by organising exhibitions of the NGI's paintings abroad while the NGI was being refurbished. For the rest of the decade much of the energy of the Director and Board would be concentrated on fund-raising.

A Clare Street Committee was formed to consider every step of development and filter decisions through the Board. Finlay chaired it, as well as continuing as Chairman of the Board. For the time being the three dilapidated houses on Clare Street stood empty, in danger of being

vandalised, their fronts boarded to protect passers-by, until the NGI had them pulled down. The actual site clearance was only completed in October 1992.[5]

By 1993 plans for development were formulated, and OPW did a template design for the site with a footprint area of 1,000 square metres, to be submitted to Brussels for European Regional Developoment Funding. The proposed building of five floors would have 5,210 metres in floor area and was costed at a contract figure of £8.6m. Total cost would be £10m. 'The concept…was a clear and workable one, and in the opinion of the OPW a good basis on which to make a submission for European funding.'[6]

Meanwhile Keaveney had become increasingly concerned about the building adjacent to the Clare Street houses, No 5 South Leinster Street, whose owner, Pierce Maloney,was considering using it as a restaurant. There was a danger that its fragile condition would cause legal complications during the construction of the new wing. He sought the sanction of the Board to approach the owner and negotiate the purchase. The advisability of buying the old house next door was disputed by some cautious members of the Board in view of the fact that the slow financing of Clare Street had not yet been finalised. However, they were persuaded as to the merit of adding it to the NGI holdings, and the purchase of this entire building, including the rear, of South Leinster Street, was agreed in February 1995 for the sum of £765,000 plus expenses.[7] The sale was completed by 8 December 1995; a sitting tenant was removed.

The purchase of No 5 South Leinster Street meant that the total site footprint from the Clare Street houses and No 5 would now total 1,700 square metres. In October, 1995 the Arts Minister, Michael D Higgins, was able to announce that the EC would give the NGI £7.5m, the full amount requested before the purchase of Leinster Street; the sum did not take into account the additional space arising from the acquisition of the South Leinster Street house.

Between the 1990 acquisition of the Clare Street houses and 1995 £4m was spent. Part of this was the actual cost of demolishing the houses, but other expenses included interest charges, which at that time were very high.

An international competition was held, with the assistance of the Royal Institute of the Architects of Ireland, to select an architect to design the new extension on the space formerly occupied by the three houses on Clare Street and the still-standing structure of No 5 South Leinster Street. The extension was to be 'a building of its time', not a pastiche. More than ninety applications were received, of whom four

finalists were Irish and the winner was announced in September 1996. The jury, consisting of the Director, Michael O'Doherty, David Mackay, Ted Cullinan, Dr Brian P Kennedy, the Gallery's Assistant Director, and Joan O'Connor and Austin Dunphy, selected the design by the London-based firm of Benson and Forsyth. Professor Gordon Benson was 'an ascetic Scot' and Alan Forsyth 'a gregarious Geordie.'[8] The winning plan for Clare Street was widely approved. *The Architectural Review* thought it 'solid and figuratively rich' and that Benson and Forsyth had explained 'their work with balanced poetic and rational intent.'[9]

During the period 1996-97 there were important changes to the Board. Finlay's last meeting as Chairman took place on 12 April 1996 (although he continued on the Clare Street Committee) and Mrs Carmel Naughton, who had been a Board member since 1991, was elected as the new Chairman. In 2001 her term of office would be extended for six months to cover the completion of the new building. On 13 June 1997 the architect, Austin Dunphy, who had been prominent on the Committee, was replaced by another architect, Arthur Gibney, PRHA, who had similar knowledge and skill essential to advise on the development. From the Gallery staff Dr Brian Kennedy departed for Australia, where he became Director of the National Gallery of Australia in Canberra until 2004. On the side of the Government, in 1997, after Fianna Fail replaced the Rainbow Coalition dominated by Fine Gael, Síle de Valera replaced Michael D Higgins as Minister for the Arts, Heritage, Gaeltacht and the Islands.

On 14 February 1997 Benson attended a Board meeting and 'said that the designs had been developing and improving to meet with the Gallery's requirements to the point where they had now addressed each of the difficult design problems raised. Professor Benson 'showed the Board how each floor of the building was now laid out and where each of the facilities required in the competition brief was located.'

A Board member, Lord O'Neill, 'suggested that consideration would be given to retaining a facade such as 5 South Leinster Street.' However, 'Professor Benson said that if the competition had required the reuse of the facade...his architectural practice would not have applied, because they do not do that sort of thing. His firm builds new buildings, and although they may retain very good old buildings, they do not use facades.'[10]

Following formal approval from the Board, the plans were submitted to Dublin Corporation who, 'enthusiastically endorsing the scheme which would both deliver a major cultural facility and a landmark modern building of distinction,'[11] granted planning permission on 12 May

1997. But there was trouble pending. In the past decade the conservation lobby, concerned with the preservation of Georgian Dublin, after so much had been destroyed in previous years, had greatly strengthened. Before the plans were sent to Dublin Corporation, the Irish Georgian Society had inspected the site and expressed reservations about the extension. The planning permission was open to appeal for a month, and by 12 June, three formal appeals against the design were lodged with An Bord Pleanala, the Planning Board. Two were from the Irish Georgian Society and An Taisce, while the third was from a private individual.

The objections centred around the intention to demolish No 5 South Leinster Street, given the meagre quality of the surviving plaster work and the poor structural state of the unlisted Georgian building. Also to go would be outbuildings at the rear, including a mews building once reputedly used as a ballroom. According to the Dublin Civic Trust, demolition would be 'a loss to the streetscape of South Leinster Street'. There were few enough surviving eighteenth-century buildings in Dublin and, although No 5 had been much altered and was in very bad condition, in the opinion of the appellants, it should be maintained.[12]

The Clare Street Committee knew that there were concerns about No 5 and the 'ballroom' and 'had considered various options regarding its preservation and/or conservation but in light of expert opinion and the huge costs involved, it had been agreed that this was not a viable option.'[13]

With time important, as the European Development funds had to be spent before the end of 2000, the appeal process proved painfully slow. The NGI lodged its response to the appeals on 9 July, and on 15 July a delegation from the Gallery met representatives of the three appellants; 'Professor Benson gave a presentation to explain the basis of the project and the design philosophy.'[14] An oral hearing was held by An Bord Pleanala on 14 October, but not until February 1998 did it come to a decision.

The plans were turned down on the casting vote of the Chairman of An Bord Pleanala, on the basis that the proposed building would infringe on the Georgian streetscape. Although No 5 was not a listed building, it was in a designated conservation area.

Keaveney was showing the Danish ambassador around the NGI when he received the news.[15] The 'huge disappointment, which represented a severe setback after many years of planning,'[16] had to be faced. Later Gordon Benson would describe the loss of the original scheme as 'like a miscarriage.'[17]

The NGI found itself with four basic options as to what to do next. It could seek a judicial review (time consuming and possibly expensive);

abandon the whole idea and sell the site – an alternative that was never really considered; postpone the project; or redesign it.[18] Bravely the Board, with the encouragement of the Chairman, Mrs Naughton, went for the fourth option, and Benson and Forsyth were called in to produce a new draft scheme which would reduce the area of the plan and incorporate Georgian fabric into their landmark modern building. Within a week they delivered a revised version of the new wing. 'The redesign largely meets the original brief and incorporates retaining No 5 South Leinster Street and the rear yard.'[19]

The redrafted plans meant that, because of the imposed need to retain No 5 South Leinster Street and its garden mews, the basic area of the new wing was reduced from 7,000 square metres to 4,400 square metres. Because of this revision, the new wing could not, as planned, accommodate the library, conservation studio, Yeats Museum or auditorium. Space for these facilities had to be found elsewhere.[20] The ballroom had to be retained, a decision which was later considered 'silly' by *Irish Times* architectural correspondent Frank McDonald, who would describe it as 'one of the most curious sights in Dublin…a bizarre, almost archaeological remnant.'[21]

The Chairman, Mrs Naughton, was able to write to Arts Minister Síle de Valera on 20 March 1998, that 'the overall design as submitted by the architects Benson & Forsyth was unanimously agreed and it should be noted that the objectors and Dublin Corporation had sight of these plans and have indicated their support...'The Minister's reply, seeking assurance from the OPW on time and cost, was adequately answered. 'The £13m falls within the norm and is in line with the original scheme. Assuming full permission is granted…the target date should be met.'

At last, on 12 June 1998 'the Chairman of the Clare Street Committee, Mr Finlay, informed the Board that planning permission had been granted by Dublin Corporation...' In the months that followed, the architects,with the NGI staff and the OPW, worked at detailed designs which were put out for tender in December 1998.

Central to the success of the whole project was the generation of money, and a fund-raising campaign had been set in train which continued over the decade. The initial debt for the purchase and management of Clare Street, which, at a time of high interest, amounted to £4m, was slowly reduced and paid off by September 1996.[22] While the Millennium Wing was being built a deliberate decision was made to use the Shaw Fund towards this aim and it was regularly called upon to aid the funding campaign.

A National Gallery of Ireland Foundation set out to raise the balance of the funding required to match the £7.5 million earmarked from the European Regional Development Fund.[23] By September 1996 twelve individuals headed by Martin Naughton, and one major corporation had agreed to become benefactors.[24] Charles Haughey was the Foundation's Chairman, a fact which raised queries among some journalists, but he carried out his remit impeccably, succeeded by former European Commissioner, Peter Barry, and the Foundation duly raised the £5m it was asked to do.

In addition to raising money from benefactors, the NGI worked to generate funds from a series of initiatives, most notably the touring of exhibitions of major paintings from the collection. These were facilitated by the refurbishment of Gallery rooms during the early part of the 1990s.

Master European Paintings from the National Gallery of Ireland – Mantegna to Goya, which opened in Chicago in June 1992 and toured four venues in the United States, had been three years in the planning. This 'quietly stunning'[25] exhibition, sponsored by IBM, the most significant from the NGI ever to have been sent abroad,[26] consisted of forty-four of the Gallery's best pictures, among them Poussin's *Lamentation,* Titian's *Ecce Homo* and David's *Funeral of Patroclus.* In June 1994 another exhibition of European Masterpieces was sent to Australia, and was opened at the National Gallery of Australia in Canberra by the Prime Minister Paul Keating. The exhibition, which moved on to Adelaide, attracted 147,000 viewers. Two other exhibitions were shown to acclaim to Japan, Old Masters from the NGI in 1994, followed by a second, of French paintings in the NGI, in 1997. A total of over a million pounds was raised. A number of paintings, such as the Claude Lorrain, Monet, Rubens' *The Tribute Money* and the Castiglione, were transformed by cleaning.[27]

When Finlay retired as member of the Board, Ken Rohan building contractor and Irish art collector, became Chairman of the Clare Street committee, on which Finlay continued to serve. Early in 1999 the contractor, Michael McNamara & Company, began work on the newly christened 'Millennium Wing' which was project managed on behalf of the Gallery by the OPW.[28]

In June the programme was on schedule, but a month later it was found to be running behind. Then early in August came an unofficial industrial relations dispute. Pickets stood in place for fourteen weeks until 26 October. The Board was told that 'talks between contractor and representatives of BATU took place on 26 and 29 October, with further talks taking place this week. The main contractor hopes to return to

full work on 8 November.'[29] But the talks broke down and the strike continued.

More than a month later on 9 December, Joan O'Connor, who was the Client Liaison Representative on the project, had to report that the 'industrial dispute has been running since 4th August and has also spread to three/four other government sites. The project is now twenty weeks behind. There is concern about cash-flow.'[30] She mentioned the city centre march by striking bricklayers on 8 December. Mr Rohan noted that a mediator had been appointed, which was a positive step. For the moment the Gallery would make no press statements and would remain neutral.

That Board meeting on 9 December was another low point in the Clare Street adventure; however, five days later, on 13 December, pickets were lifted. Time lost through the strike had been something between twenty-four and twenty-eight weeks, and more time was lost because of bad weather.

On 10 February 2000 Ms O'Connor was able to report that 'a meaningful re-commencement on the Clare Street Extension was effected and is progressing well.' McNamara gave a new guideline date of 28 April 2001 for completion; the European Development Funds would be used up before the end of 2000. The architects began to prepare designs for the kitchen, restaurant, the shop, audio-visual room, multimedia suite, reception, cloakroom and bookstore.[31] In July 2000, wearing a hard hat, Síle de Valera laid the foundation stone located at the heart of the building. A sequel to the ceremony on 29 January 1859, when the original foundation stone was laid with an engraved silver trowel by His Excellency Archibald William, Earl of Eglinton, the new stone would be positioned at the intersection of the old and new building, and the description of the ceremony would be incised in Irish. In mid-January 2001 came the breakthrough from the main building to the new wing.

After everything was ready and the building handed over, twelve weeks would be needed to rehang the collection across the Gallery complex and furnish the new wing. Could it be opened by June 2001? Impossible, since 'when the building work was completed there would be other work to be done such as the fitout, installation of equipment, etc. before hanging would take place.'[32] The opening was postponed to January 2002.

At last thought could be given to details. The external sign on Clare Street would read in English and Irish: *The National Gallery of Ireland - Gailearai Naisiunta na hEireann*. Banners would be hung adjacent to the entrance, positioned to draw attention to the new building and publicise

exhibitions as they occurred. The architects 'indicated that, inside, a wall hanging or tapestry measuring ten by four metres was appropriate to the great atrium space.' Mrs Naughton personally commissioned and donated a tapestry designed by Louis le Brocquy to hang in the orientation court; *The Triumph of Cúchulainn* (NGI 12257), based on the eighth-century epic the *Tain Bo Cuailnge*, was woven in Aubusson, France. The largest single work designed by the artist, it took some 3400 hours to complete, involving four weavers for five months. The effect was magnificent, 'a gigantic tapestry with a sea of rainbow teardrops hangs to the side, like the building's personally tailored dream coat'.[33]

Although the Gallery (just) won the race for European Funding, inevitably the project cost far more than had been envisaged when the three mouldering houses had been acquired from Mr Strudwick a decade before. In June 2000, the Fundraising Committee was to raise a further £1m. By the time the sums came to be added up the national currency had changed from Irish punts to euros. The total cost of the Millennium Wing project would be approximately €33m. The European Regional development Fund provided €9.5m and €10.9m came from the Government. The Gallery raised €5m from its own resources (principally the Shaw Fund and shop), while almost €7.6m was raised by the National Gallery of Ireland Foundation through the private sector and individual donors.[34]

The Director and Board put their minds into planning an inaugural exhibition for the Millennium Wing. Having at first envisaged an exhibition devoted to works acquired with the Shaw Fund, commemorating George Bernard Shaw, the Board reconsidered this, desiring a more high-profile exhibition. The Director obliged, and announced to the Board in February 2001 that he had secured the exhibition *Monet, Renoir and the Impressionist Landscape*, consisting of Impressionist paintings from the Museum of Fine Arts, Boston.

The Millennium Wing was opened on 21 January 2002 by Síle de Valera, who pointed out the new 'pivotal role' the Gallery would play in Irish life. 'This architectural landmark will add to and enhance the existing buildings of the National Gallery and will enhance the architectural landscape of Dublin city as a whole.'

The building was received with rapture: 'a delight to the eye'; 'arts new shrine an architectural triumph'; '21st century gothic; austere, clean, neutral and pure'; 'a cultural gem'; 'poetry in three dimensions'… were among the newspaper headlines. Wrestling with the problems of a difficult L-shaped site, linking two buildings on different levels, of totally

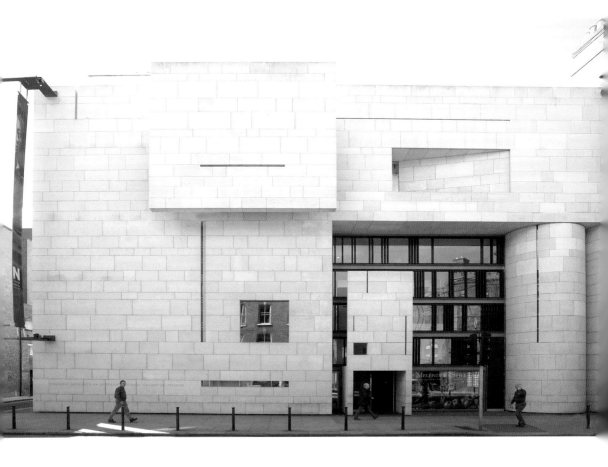

different styles and obeying the strictures of the planning Board, Benson and Forsyth had produced a winner. The wing was as much a work of art as any of the paintings in it.

On Clare Street the facade of pure alabaster-like glazed Portland stone towers adjacent to the old Georgian building yet to be developed. Portland stone, chosen over granite, has been traditional in civic building in Dublin since Georgian times. Inside, beyond the vestibule a huge space rises up to roof level. In Frank McDonald's words: 'the unpainted plaster walls slashed with slits and other apertures, the steel-beamed bridge crossing it at a high level, the grand staircase at the opposite end and the wide openings to the glazed 'Winter Garden' all combine to inspire awe and wonder. Ireland has never seen such a dramatic or dynamic space for art.'[35]

The area immediately beyond the door from Clare Street incorporates the Gallery's shop, while a restaurant spreads over the winter garden.

Exterior of the Millennium Wing by architects (Gordon) Benson & (Alan) Forsyth 1999-2002. The fourth wing of the Gallery combines modernism with reference to Scottish Baronial architecture, Le Corbusier and Charles Rennie Mackintosh.

Orientation Court of the Millennium Wing from the second floor. There are two floors of galleries above a shop, café and restaurant, with access to the rest of the NGI at two levels.

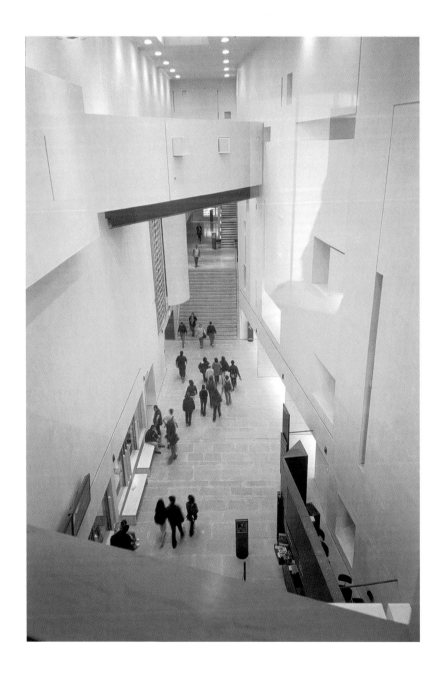

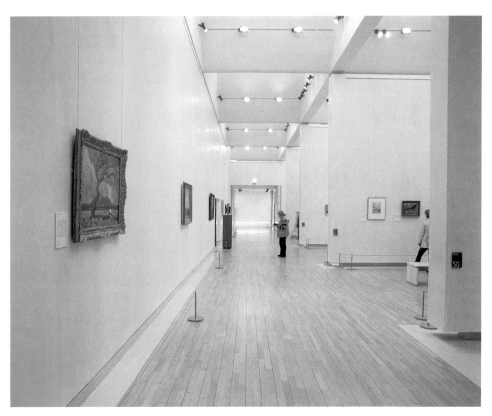

'Paul Henry' in the second floor exhibition rooms, 2002.

The role of the shop and the restaurant (something James White had discovered) as bait to entice people into the Gallery is immensely important. The bridge above the main space, which Gordon Benson compared to 'an electric spark leaping into the void', links two climate controlled galleries fitted to international standards and reserved for loan exhibitions. One of the chief aims of the Millennium Wing had been to incorporate these galleries specifically for this purpose. Previously, exhibitions were held in the Dargan Wing mezzanine and Beit Wing ground floor and were difficult to hang and display, not only because of the limits of space but because paintings from the permanent collection had to be regularly taken down to accommodate each event.

The Millennium Wing is a magnificent compromise, although it must be regretted that the bold concept of the original scheme was lost to the planners, together with the original planning layout. The compulsory retention of No 5 Leinster Street has given further problems. What can a gallery do with a listed Georgian building whose structure cannot be

changed? It cannot have a lift, nor can it be made accessible to wheel chair users, as every public building has to be by law. It can only be used for offices.

The new galleries duly opened with *Monet, Renoir and the Impressionist Landscape* from Boston and it exceeded all expectation. At its conclusion on 14 April 2002 it had attracted 120,000 visitors, including 15,000 school children, so equalling that of Caravaggio in 1993.

Because of the NGI's long-term policy of lending paintings to other galleries and exhibitions, it has accrued a great deal of good will. Galleries all over the world are willing to lend, so that it has every opportunity to attract exhibitions of outstanding importance. No subsequent exhibition has been as successful as the Boston Impressionists generally attracting about 6,000 visitors. However, in the last three months of 2003, *Love Letters – Dutch Genre Paintings in the Age of Vermeer*, consisting of forty Dutch paintings including three Vermeers (among them the Gallery's own), was one of the most beautiful ever to be displayed in Ireland and visited by 35,000.

The refurbished Diageo Print Room opened in January 2003. The NGI's collection of drawings, watercolours, miniatures and prints which are now kept in this spacious and secure area under the most ideal modern conditions away from daylight. Although they do not catch the eye of the casual visitor, and are principally used by scholars, students and researchers, they complement the oil paintings and are an integral part of the artistic heritage in the collection.

Here, Frederic Burton's *Meeting on the Turret Stair* possibly the single most popular picture in the Gallery, is kept in a special wooden case like a shrine. Turner's watercolours from the Vaughan Bequest spend eleven months of the year in their cabinet, after their regular outing in January. The prints section includes a huge number of portrait prints and a number of Old Master prints after paintings in the Collection by such artists as Panini, Chardin, Metsu and Rembrandt. There is an extensive collection of miniatures augmented by 50 bequeathed by Miss Mary A. McNeill in 1985.

Other treasures of the very highest quality are to be found in the Print Room, unless it is their turn to be displayed in the Print Gallery. They include the two pastels by Degas bequeathed by Edward Martyn, the Chester Beatty gifts of works by Meissonier, Segonzac, Picasso, the surprisingly large watercolour by Paul Cézanne, the early drawings acquired from the Wellesley sale by Mulvany, Doyle's contributions to the Collection, the Rossetti drawing and the charming studies by

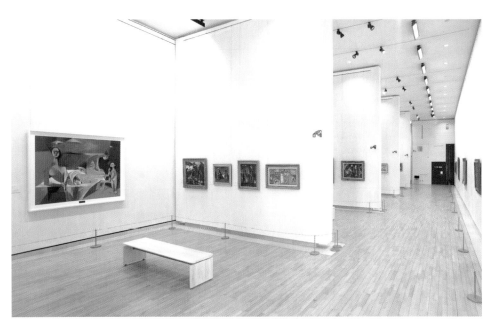

The first floor Irish rooms (1900–c.50) with 'A Family', by Louis le Brocquy (b.1916).

Watteau, and Armstrong's works by Dutch artists. (The majority of Old Masters in the Prints and Drawings Collection were bought before 1914). Here are the two Whistler watercolours, a range of sketches by William Orpen, a pencil sketch by Modigliani and a watercolour by Emil Nolde. The work of Mildred Anne Butler, Flora Mitchell and Rose Barton is preserved in this controlled area, together with drawings used by the Dublin Society Schools, donated in 1966 by the National Museum, which in 1980 also returned to the NGI the beautiful architectural designs for the original building by Francis Fowke and Henry Snell.

The Multimedia room contains a Virtual Reality Gallery. There are two archives, the Centre for the Study of Irish Art, which offers scholars a wide range of research material relevant to the study of Irish art, and the more specific Jack B Yeats Archive Room. This has a curious lozenge shape to contain the artist's sketchbooks, library, literary manuscripts and private papers, much of which was presented by the artist's niece, Anne Yeats. In the small storage area directly adjacent are hung some of the many prints, drawings and watercolours in the Yeats collection.

The gallery on Level Ten, devoted to Irish art covering the first fifty years of the twentieth century, awakens yet again the controversy that

goes back to Mulvany's time – should the main purpose of the NGI be to display Old Masters or Irish art? An outsider, Richard Shone, muses that 'while it is desirable that the Irish School should be adequately represented for local consumption, it could be said that such nationalism is now somewhat out of place and that a greater investment must be made in building the international profile of its collection.'[36]

Nevertheless this display gives a vivid idea of the development of recent Irish painting up to the 1950s. Apart from the carpet-sized *Artist in his Studio*, it lacks a good John Lavery, but shows paintings by William Orpen, demonstrating his influence on artists like Seán Keating, James Sleator and Leo Whelan, all of whose work is represented here. There are paintings by Paul Henry, Gerard Dillon, William Leech, Mainie Jellett, Mary Swanzy and Evie Hone. One of the most striking pictures here is the portrait by Patrick Tuohy of the schoolgirl, Biddy Campbell (NGI 4027), which hangs near Louis le Brocquy's *A Family*. A decade after it was painted she was killed in the London Blitz.

Today the annual grant-in-aid is about €8m, of which some €7m goes on operational overheads, including paying the staff, which at present consists of about 160 people (50 on separate contracts), and €1m for the purchase of paintings. Keaveney had submitted to the government a memorandum stating that under the old grant-in-aid there was simply not enough money to buy paintings at current prices. The NGI was only capable of buying modest pictures where Irish art was concerned. The point was conceded and the purchase grant raised.[37]

Policy worked out between the Director and the Governors fluctuates; there is nothing static about it, nor are there any hard and fast rules. It is possible, for example, that the Portrait Gallery, and the Yeats Gallery may change places. At present the NGI acquires works of art that date back to the 1950s and portraits to the present, but this also can change.

The Millennium Wing is the latest, and probably the last, addition to a meleé of linked buildings that make up the eccentric unit that is the National Gallery of Ireland. The early structures look out onto a scene that is arcadian, the trees of Merrion Square, surrounded by mellow brick houses. Elsewhere one is made aware how the new wing looking onto Clare Street embraces central Dublin, unlike the old buildings which turn their back on the city. Among its visual surprises is a window with a view of the playing fields of Trinity College and the red brick of Finn's Hotel where Norah Barnacle, later the wife of James Joyce, once worked; from other windows there are glimpses of the office where Samuel Beckett's father worked and Oscar Wilde's home on Merrion Square.

The NGI was built on land that was once a slob. In Elizabeth Bowen's words: 'The original lordly plan…commemorated the migration south-wards across the river after the Duke of Leinster had taken his bold decision to sink the foundations of his great new house in a snipe bog.' Even today sandbags occasionally line portions of the basement, since the waters that were home to the Duke's snipe sometimes rise again. The history of the Gallery goes back to the transformation of Merrion Square and the beginning of modern Dublin. Fronting the original building are the remains of the Rutland Fountain commemorating the Duke who attempted to give Dublin a gallery back in the eighteenth century. The house created by Richard Castle behind the Gallery was once home to the Royal Dublin Society, and today, the old links between RDS and NGI are maintained by the presence of two representatives of the RDS on the Board, the President and Vice-President. The original building is an elevational copy of the Natural History Museum by Frederick Clarendon across Leinster Lawn. Criticised at the time for its 'barrack style, and called 'this dreadful deposit', with the addition of the Milltown Wing, the northern facade has achieved a Victorian gravitas. If the once splendid expanse of Leinster Lawn has been taken over by Dáil deputies as a car park and Prince Albert is banished to a shrubbery, the area still has dignity and presence. The sturdy presence of William Dargan on his plinth stands as an example to any passing benefactor to the Gallery.

In 1981 Homan Potterton pointed out the nature of the NGI. '… It contains a smallish number of real masterpieces and a broad range of interesting paintings that are of good quality, although perhaps by lesser painters. Much of the real charm of the Gallery derives from this special and unusual mixture.'[38] Since he made those comments, the Gallery has benefited immeasurably from the acquisition of a number of superb masterpieces, but basically his observations are still valid.

In his 1932 catalogue Bodkin wrote: 'A National Gallery is a prime part of the response to the need which every citizen has for beauty in his daily life. It helps to gratify that laudable curiosity which urges him towards the widening of his experience and the increase of his knowledge; and it stimulates that essentially humanistic sense which makes him desire to take an interest in the continuity of the race and to relate himself and his age to the development and achievements of earlier generations. The man who constantly visits his National Gallery will soon find himself deeply influenced, whether consciously or unconsciously, by the ideals of order, fitness and accomplishment which are inherent in all great works of pictorial art.'[39]

John Sproule, who wrote the catalogue to Dargan's 1853 Dublin Industrial Exhibition would have agreed. 'Art is one of the highest elements of civilisation...the deepest instinct of man's nature is the pursuit of that which is beyond him and above him.'

1 Minutes of NGI Board, 10 Feb. 1989
2 Minutes, 13 October 1989
3 Author's discussion with Raymond Keaveney, 14 April 2004
4 Minutes of Special Meeting, 6 March 1990
5 Minutes, 9 Oct. 1992
6 Minutes, 11 June 1993
7 Minutes of Special Meeting, 23 Feb. 1995
8 Frank MacDonald, 'The Wow Factor', *Irish Times* 19 Jan. 2002
9 Quoted Minutes, 14 Feb. 1997
10 Minutes, 14 Feb.1997
11 Annual Report 1997
12 *ibid.*
13 Minutes, 10 Oct. 1997
14 (as n. 11)
15 Author's discussion with Raymond Keaveney, 14 April 2004
16 Keaveney quoted in MacDonald (as n. 8)
17 Shane O'Toole, 'Gallery Spreads its Wings', *Sunday Times*, 20 Jan. 2002
18 Minutes, 13 February 1998
19 O'Connor quoted Minutes, 20 Feb. 1998
20 Chairman in Annual Report 1998
21 MacDonald (as n. 8)
22 Minutes, 24 Sept. 1996
23 (as n. 20)
24 Minutes, 24 Sept. 1996
25 Roberta Smith, 'Art in Review', *New York Times*, 28 May 1992
26 Annual Report 1992
27 Annual Reports 1994 and 1997
28 Chairman in Annual Report 1999
29 Minutes 1 Nov. 1999
30 Minutes, 9 Dec. 1999
31 Minutes, 13 April 2000
32 Minutes, January 2001
33 Brian Lavery, *New York Times*, 31 Jan. 2002
34 Press release, 21 Jan. 2002
35 MacDonald (as n. 8)
36 Richard Shone, Editorial, *The Burlington Magazine* (July 2002)
37 Author's discussion with Raymond Keaveney, 14 April 2004
38 Minutes, 10 April 1981
39 Thomas Bodkin, *NGI Catalogue of Oil Pictures in the General Collection* (Dublin 1932) p. ix

Chronological Bibliography of Principal NGI Publications

EARLY CATALOGUES

George Mulvany: 1864, 1867 and 1868

Henry Doyle: 1871, 1874, 1875, 1879, 1882, 1884, 1885, 1886, 1887 and 1890

Walter Armstrong: 1898, 1904, 1908 and 1914 (appendix by Hugh Lane)

Robert Langton Douglas: 1920

Thomas Bodkin: 1928 and 1932 (paintings only)

———————————

Catalogue of the Exhibition of Pictures by Old Masters given and bequeathed to the National Gallery of Ireland by the Late Sir Hugh Lane, exh. NGI 1918, cat. by Robert Langton Douglas

Thomas MacGreevy, *Catalogue of Pictures of the Italian Schools* (Dublin 1956)

Thomas MacGreevy, *NGI Concise catalogue of the Oil Paintings* (Dublin 1963)

National Gallery of Ireland 1864-1964 Centenary Exhibition, exh. NGI 1964, cat. by James White

James White, *The National Gallery of Ireland* (London 1968)

David and Tamara Talbot Rice, *Icons/The Natasha Allen Collection* (Dublin 1968)

Michael Wynne, *National Gallery of Ireland Catalogue of the Paintings* (Dublin 1971)

Restored Paintings/Catalogue of Paintings Restored in the National Gallery of Ireland to December 1971 (2nd edition)

Adrian Le Harivel and Michael Wynne (eds.) *National Gallery of Ireland Illustrated Summary Catalogue of Paintings*, introduction by Homan Potterton (Dublin 1981)

National Gallery of Ireland Recent Acquisitions 1980-1981, exh. NGI 1981, cat. by Michael Wynne

National Gallery of Ireland Acquisitions 1981-1982, exh. NGI 1982-3, cat. by Homan Potterton and Michael Wynne

National Gallery of Ireland Acquisitions 1982-1983, exh. NGI 1984, cat. by Adrian Le Harivel and Michael Wynne

Adrian Le Harivel (compiler) *Illustrated Summary Catalogue of Drawings, Watercolours and Miniatures in the National Gallery of Ireland*, introduction by Homan Potterton (Dublin 1983)

Master European Drawings from the National Gallery of Ireland, exh. USA and NGI 1983 (Chapel Hill, Colorado Springs, Milwaukee, New York, Indianapolis, Minneapolis, Santa Barbara), cat. by Raymond Keaveney

Walter Osborne, exh. NGI and Belfast 1983-4, cat. by Jeanne Sheehy

The Irish Impressionists/Irish Artists in France and Belgium 1850-1914, exh. NGI and Belfast 1984-5, cat. by Julian Campbell

Masterpieces from the National Gallery of Ireland, exh. NG, London, 1985, cat. by various authors

Catherine de Courcy, *The Foundation of the National Gallery of Ireland* (Dublin 1985)

Barra Boydell, *Music and Paintings in the National Gallery of Ireland* (Dublin 1985)

George Breeze, *Society of Artists in Ireland Index of Exhibits, 1765-80* (Dublin 1985)

James Arthur O'Connor, exh. NGI, Belfast and Cork 1985-6, cat. by John Hutchinson

National Gallery of Ireland Acquisitions 1984-1986, exh. NGI 1986, cat. by Adrian Le Harivel and Michael Wynne

Homan Potterton, *Dutch Seventeenth and Eighteenth Century Paintings in the National Gallery of Ireland.* (Dublin 1986)

Michael Wynne, *Later Italian Paintings in the National Gallery of Ireland - The Seventeenth, Eighteenth and Nineteenth Centuries* (Dublin 1986)

Marie Bourke, *The Aran Fisherman's Drowned Child* (Dublin 1987)

David Oldfield, *German Paintings in the National Gallery of Ireland* (Dublin 1987)

Christiaan Vogelaar, *Netherlandish Fifteenth and Sixteenth Century Paintings in the National Gallery of Ireland* (Dublin 1987)

Dutch Paintings of the Golden Age from the Collection of the National Gallery of Ireland, exh. USA 1987 (Santa Ana, Midland, Charlotte, Miami, New York), cat. by Homan Potterton

Rosemarie Mulcahy, *Spanish Paintings in the National Gallery of Ireland* (Dublin 1988)

National Gallery of Ireland Acquisitions 1986-1988, exh. NGI 1988, cat. by Adrian Le Harivel and Michael Wynne

Adrian Le Harivel (ed.), *Illustrated Summary Catalogue of Prints and Sculpture in the National Gallery of Ireland* (Dublin 1988)

National Gallery of Ireland Acquisitions 1986-1988, exh. NGI 1988, cat. by various authors

Barbara Dawson, *Turner in the National Gallery of Ireland* (Dublin 1988)

The East Imagined, Experienced, Remembered/ Orientalist Nineteenth Century Painting, exh. Liverpool 1988, cat. by James Thompson

Irish Watercolours and Drawings, exh. NGI 1991, cat. by various authors

Irish Eighteenth-Century Stuccowork and its European Sources, exh. NGI 1991, cat. by Joseph McDonnell

Nathaniel Hone the Younger, exh. NGI 1992, cat. by Julian Campbell

Paul Durcan, *Crazy about Women*, poems inspired by the Collection (Dublin 1991)

Caravaggio and his Followers in the National Gallery of Ireland exh. NGI 1992, cat. by Sergio Benedetti

Master European Paintings, exh. USA and NGI 1992-3 (Chicago, San Francisco, Boston New York), cat. by various authors

Brian P Kennedy (ed.), *Art is my Life - A Tribute to James White* (Dublin 1992)

David Oldfield, *Later Flemish Paintings in the National Gallery of Ireland* (Dublin 1992)

Caravaggio – the Master Revealed, exh. NGI 1993, cat. by Sergio Benedetti (revised edition 1999)

Titian to Delacroix: Master European Paintings from the National Gallery of Ireland, exh. Japan 1993-4 (Yokohama, Chiba, Yamaguchi, Kobe, Tokyo) cat. by various authors

European Masterpieces from the National Gallery of Ireland, exh. Australia 1994-5 (Canberra, Adelaide), cat. by various authors

Alison Fitzgerald, *The National Gallery of Ireland Summary Guide* (Dublin 1996; revised edition by Adrian Le Harivel, Dublin 2002)

French 19th and 20th Century Paintings from the National Gallery of Ireland – Corot to Picasso, exh. Japan 1996-7 (Yokohama, Chiba, Yamaguchi, Kobe, Tokyo), cat. by Fionnuala Croke

William John Leech/An Irish Artist Abroad, exh. NGI, Quimper and Belfast 1996-7, cat. by Denise Ferran

The Art of Pastel, exh. NGI 1996, cat. by Christine Bell

200 years of Watercolours, exh. NGI 1997, cat. by Adrian Le Harivel and Macushla Goacher

Hilary Pyle, *Yeats/Portrait of an Artistic Family* (London 1997)

Marie Bourke, *Experiencing Art at the National Gallery/A handbook for parents, teachers and young people* (Dublin 1997)

Frederic William Burton, exh. NGI 1997, cat. by Adrian Le Harivel

The Milltowns - a Family Reunion, exh. NGI 1997, cat. by Sergio Benedetti

A Scholar's Eye - Paintings from the Sir Denis Mahon Collection, exh. NGI 1997-8, cat. by Sergio Benedetti

The La Touche Amorino – Canova and his Fashionable Irish Patrons, exh. NGI 1998, cat. by Sergio Benedetti

The Deeper Picture/Conservation at the National Gallery of Ireland, exh. NGI 1998, cat. by Andrew O'Connor and Niamh McGuinne

Art into Art a living response to past masters, exh. NGI 1998, cat. by artist printmakers

Marie Bourke and Síghle Bhreathnach-Lynch, *Discover Art at the National Gallery of Ireland* (Dublin 1999)

French Works on Paper from the Collection, exh. NGI 1999, cat. by Jane MacAvock

Highlights of the Print Collection, exh. NGI 1999, cat. by Jane MacAvock

Hugh Lane's legacy at the National Gallery of Ireland, exh. NGI 2000, cat. by Robert O'Byrne

Sergio Benedetti, et al, *The National Gallery of Ireland: Essential Guide* (London 2002)

Treasures to Hold, Irish and English Miniatures 1650-1850 from the National Gallery of Ireland Collection, exh. NGI 2000, cat. by Paul Caffrey, plus revised Summary Catalogue with Adrian Le Harivel

Nicola Figgis and Brendan Rooney, *Irish Paintings in the National Gallery of Ireland Volume 1* (Dublin 2001)

Paul Henry, exh. NGI 2003, cat. by SB Kennedy

D'Irlande... le paysage dans les collections d'arts graphiques de la National Gallery of Ireland, exh. Lausanne and NGI, 2003-4, cat. by Anne Hodge

Love Letters: Dutch Genre Paintings in the Age of Vermeer, exh. NGI and Greenwich 2003-4, cat. by Peter Sutton et al

Luis Meléndez Still Lifes, exh. NGI 2004, cat. by Peter Cherry and Juan J. Luna

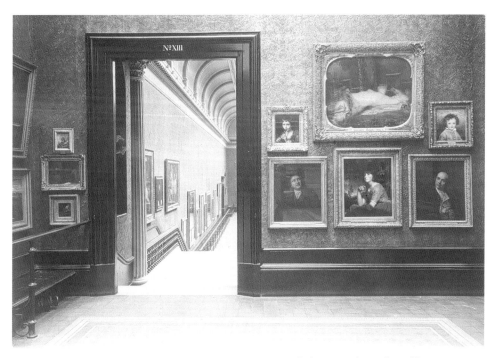

Irish paintings in the upper Dargan Wing, 1936
(NGI Archive). Rothwell's *Calisto* (originally
declined by Mulvany) and his *Smiling child* are
shown with works by Hone and Shee.

INDEX

Orpen, Richard Caulfield (Board member; architect), 247, 249, 250, 290, 292, 307

Orpen, (Sir) William (artist), 214, 223, 226, (228 illus.), 229, 261, 274, 285, 320, 356, 458, 459

Osborne, Walter (artist), (168 illus.), 180, 182, 207, 214, 222, 223, 240, 253, 282, (284 illus.), 346, 411, 430

Osborne, William (artist), 304, 343, 411

O'Shea, Mick (Head Attendant), 374, 394

Ostade, Adriaen van (artist), 208

O'Sullivan, Seán (artist), (360 illus.), 410

Owen, Jacob (architect), 60, 61

The Packet, 67

Padovanino (artist), 85

Pall Mall Gazette, 165

Palma, Antonio (artist), 153

Palma Giovane (artist), 82

Palma Vecchio (artist), 88, 316

Palmerston, Lord (Prime Minister; donor), 66, 76

Palmezzano, Marco (artist), 85, 94, 142, 334, 371

Panico, Antonio Maria (artist), 82, 107, 112, 120, 162

Panini, Giovanni Paolo (artist), 140, 150, 185, 457

Pantoja de la Cruz, Juan (artist), 282, 285

Pascucci, Francesco (artist), 82, 107, 142

Pasquale, Alterio (frame-maker), 428

Pasquin, Anthony, 26

Passarotti, Bartolommeo (artist), 83, 142 ('after Michelangelo')

Passeri, Giovanni Battista (artist), 308, 337

Pater, Jean-Baptiste (artist), (192 illus.), 199

Pedreschi, Louis (attendant), 97, 99, (100 illus.), 143, 172

Peel, Sir Robert (Sec of Treasury), 86, 104

Pellegrini, Giovanni (artist), 93

Pencz, Georg (artist), 117, 142

Penni, Gianfrancesco (artist), 414

Penrose, John (attendant), 325-6

Pensionante del Saraceni (artist), 383

Perceval, Sir John (collector), 21

Perugino, Pietro (artist), 282, 322, (323 illus.), 334, 341

Perronneau, Jean-Baptiste (artist), 321

Petrie, George (Board member; artist), 37, 49, 55, 123, 205, 209, 212

Phidias (sculptor), 101, 189

Phillimore, the Hon. Mrs (donor), 308

Phillips, Charles (artist), 189, 410

Phillips, Claude (critic), 192

Phoenix Magazine, 424

Piamontini, Giovanni Battista (sculptor), 186, 424

Piazzetta, Giovanni Battista (artist), 237

Picasso, Pablo (artist), 357, 362, 365, 407, (414 illus.), 416, 457

PICTURE GRANT-IN-AID, 115, 116, 237, 241-2, 315, 337, 338, 365, 404, 429, 440, 459

Pigot, David, 41, 49, 51, 52, 53, 54, 68

Pigot, John (Board Member), 41, 49, 51, 52, 53, 54, 57, 60, 62, 75, 87, 136

Pilkington, Letitia (diarist), 185

Pissarro, Camille (artist), 362, 408

Place, Francis (artist), 389

Poerson, Charles-François (artist), 82, 142

Pollaiuolo, Antonio del (artist), 113

Pompe, Gerrit (artist), 297

Poncet, François-Marie (sculptor), 33, 146

Pooley, Thomas (artist), 442

Poorter, Willem de (artist), 179, 215

Pordenone (artist), 316

Portarlington, 3rd Earl of (Board member; donor), 136

Post, Frans (artist), 292

Potter, Paulus (artist), 120

Potterton, Homan (Director), 140, 344, 347, 348, 355, 394, **398-422**, (399 illus.), 425, 426, 446

Pourbus, Pieter (artist), 355

Pourbus the Younger, Frans (artist), 206

Poussin, Nicolas (artist), 29, 88, (154 illus.), 155, 186, 199, 206, 229, 239, 243, 264, 451

Powerscourt, 6th Viscount, 41, 301, 386

Powerscourt, 7th Viscount (Board member; donor), 26, 76, 110, 116, 117, 127, (129 illus.), 130, 136, **138-9**, (139 illus.), 141, 153, 155, 163, 164, 169, 173, 175, 193, 205-6, 262

Powerscourt, 8th Viscount, 276

Preti, Mattia (artist), 112, 383

Prieur, Barthélémy (sculptor), 392

Primaticcio, Francesco (artist), 113

Prins, Johannes Hubert (artist), 239

Prior, Thomas, 22

Procaccini, Giulio Cesare (artist), 77, (80 illus.), 82, 142, 383

Procter, Dod (artist), 362

Prud'hon, Pierre-Paul (artist), 82

Punch, 126

Purser, Sarah (Board member; artist), 180, 205, 213, 214, 221, 234, 239, 243, 246, 249, 250, 251, 257, 259, 260, 263, 266, 270, 276, 286, 288, 290, 292, 298, 299, 300, 308, 315, 344, 345, 357

Puvis de Chavannes, Pierre (artist), 214

QUEEN'S GALLERY (today Baroque Room), (cover illus.), (14 illus.), 16, 17, 69, (71 illus.), 108, 116, (177 illus.), 190, 428

Quigley, Daniel (artist), 408

Quinn, Edmond (sculptor), 209

Quinn, John (donor), 209, 276, 290, 303, 430

Quinn, Lochlann (Board Chairman; donor) and Brenda (donor), 440

Raeburn, Henry (artist), 174, 419

Raphael (artist), 92, 93, 101, 112, 113, 116, 158

RAPHAEL CARTOONS, 18, 174, 190, 240

Rathdonnel, Lord (Board member), 246

REHANGS, 142, 174, 190, 278, 318, 327, 333, 354